Federico
Barocci

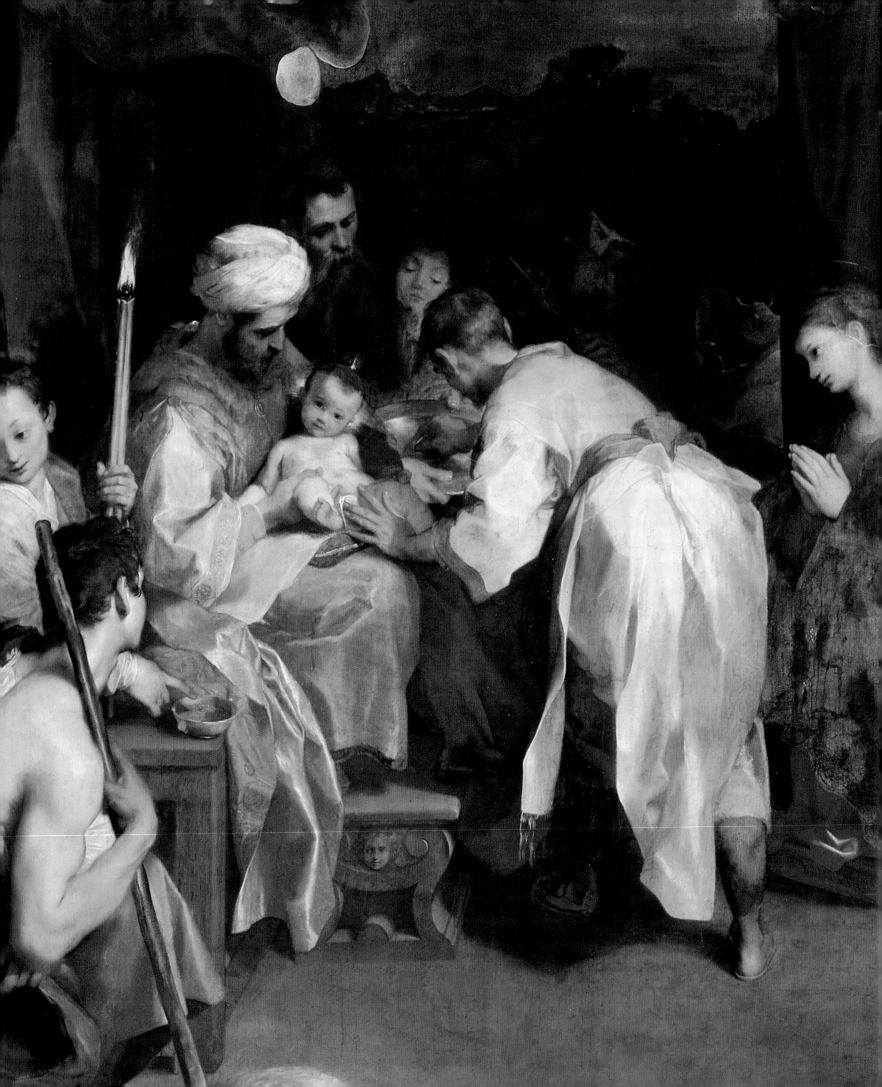

Federico BAROCCI

Allure and Devotion in Late Renaissance Painting

STUART LINGO

Yale University Press
NEW HAVEN AND LONDON

FOR ESTELLE

PUBLISHED WITH THE ASSISTANCE OF THE GETTY FOUNDATION

THE LILA ACHESON WALLACE – READER'S DIGEST PUBLICATIONS SUBSIDY AT VILLA I TATTI

AND THE MILLIMAN ENDOWMENT OF THE SCHOOL OF ART AT THE UNIVERSITY OF WASHINGTON

Designed by Emily Lees

Printed in Singapore

Library of Congress Cataloging-in-Publication Data

Lingo, Stuart, 1961–
Federico Barocci : allure and devotion in late Renaissance painting / Stuart Lingo.
p. cm.
Includes bibliographical references and index.
ISBN 978-0-300-12125-4 (cl : alk. paper)
1. Barocci, Federico, 1528-1612–Criticism and interpretation. I. Title.
ND623.B25L56 2008
759.5–dc22
2008028054

A catalogue record for this book is available from The British Library

ENDPAPERS: Compositional study for the *Lamentation-Entombment*, Amsterdam, Rijksmuseum (detail of fig. 108).
HALF TITLE: Preparatory drawing for the *Institution of the Eucharist*, Cambridge, Fitzwilliam Museum (detail of fig. 157).
FRONTISPIECE: *Circumcision*, Paris, Musée du Louvre (detail of fig. 133).
SECTION 1 OPENING: *Madonna del Popolo*, Florence, Galleria degli Uffizi (detail of fig. 24).
SECTION 2 OPENING: *Last Supper*, Urbino, Cathedral (detail of fig. 134).

CONTENTS

ACKNOWLEDGMENTS

It is with deep appreciation that I acknowledge the many individuals and institutions whose assistance and support has helped this project come to fruition. While the book did not grow directly out of my dissertation, which concerned archaism during the later Renaissance, the idea for a thematic study of Barocci's altarpieces germinated during its completion, and I am profoundly grateful to my advisors, John Shearman and John O'Malley, for their guidance and example. Both of them kindly followed my work on the new project through conference papers and personal discussions, and I have profited equally from their expertise and their encouragement. I only wish that John Shearman could read the book that has finally emerged. He is much missed.

This book would not have been possible without the support of research institutes and fellowships. The Samuel H. Kress Foundation provided generous grants which both made the completion of the dissertation possible and gave me the freedom to think broadly enough to perceive the first outlines of a new project. Villa I Tatti, the Harvard Center for Italian Renaissance Studies, offered me a fellowship and a magical year at a critical moment in the book's development. Since that year the Villa has provided ongoing scholarly hospitality, and a Lila Acheson Wallace publication grant to assist in defraying the cost of illustrations. The Villa's staff provided every form of sustenance, and its extended scholarly community has offered friendship and insight. I am particularly grateful to the director, Joseph Connors, and to Sabine Eiche, Caroline Elam, Iain Fenlon, Allan Grieco, Michael Rocke, and Patricia Rubin for their assistance and encouragement. A Paul Mellon Visiting Senior Fellowship at the Center for Advanced Study in the Visual Arts at the National Gallery of Art in Washington offered the opportunity to develop many of the lines of inquiry opened at I Tatti, and to bring critical portions of the manuscript to completion. I am very grateful to the Dean, Elizabeth Cropper, and to the Associate Deans, Peter Lukehart and Therese O'Malley, as well as to Alexander Nagel, Giancarla Periti, and the stimulating and congenial group of fellows and staff. Alexander Nagel later read the entire book and I am particularly grateful for his support.

Much of the research and writing occurred during the years I worked at Michigan State University, which facilitated the initial research with an Intramural Research Grant. Two colleagues in the department, Kenneth Haltman and Raymond Silverman, provided much encouragement, as did Christopher Celenza in History. Near the end of this process, I moved to the University of Washington, Seattle. There, the School of Art supported publication with the award of a Milliman Endowment grant, and my new colleagues have been remarkably sup-

Detail of fig. 145

portive; Christine Goettler, in particular, discussed the issues raised by the book at length, and read the entire manuscript. In addition, Susan Gaylard was so kind as to read Chapter Five from the point of view of a literary historian.

Beyond the colleagues and friends of fellowship years and university homes, a project such as this teaches one much about the reality of that elusive ideal, the republic of letters. I have been particularly fortunate that Marcia Hall revealed herself as a reader for the press and has provided unfailing encouragement and assistance, and that Robert Kendrick and Wendy Heller generously volunteered to read the later portions of the book concerned with music. Their expertise as musicologists helped me to hone my thinking and spared me a number of infelicities. Frank Salmon provided friendship, hospitality, and wisdom at several critical moments in the development of the project. And a number of friends and colleagues discussed varied issues and offered support as the book took shape. I remember in particular Fabio Barry, Tracy Cooper, Una Roman D'Elia, Francesca Fiorani, Jeffrey Fontana, John Marciari, David Scrase, Nicola Suthor, Ulrike Tarnow, and Ian Verstegen.

The research and writing of such a book would be impossible were it not for the assistance of the staffs of libraries, museums, and research institutes. In the US, my work was particularly facilitated by the library staff of Michigan State University, the University of Washington, and the Center for Advanced Study in the Visual Arts at the National Gallery. In Florence, the staff of the Kunsthistorisches Institut and the Gabinetto dei Disegni of the Uffizi were unfailingly helpful. A special thanks is owed to the staff of Villa I Tatti, particularly to Michael Rocke of the Bilioteca Berenson, to Giovanni Pagliarulo of the Fototeca Berenson, and to Gianni Trambusti, photographer and computer engineer. In Rome I am grateful to the staff of the American Academy, the Ecole Française, the Biblioteca Vaticana, and the Bibliotheca Hertziana, and in Urbino the Biblioteca Universitaria. Alexandra Korey worked with great energy and dedication to obtain many of the photos for the book. At Yale University Press I am particularly grateful to Gillian Malpass for her commitment to this project; to Emily Lees for her careful and tireless work as the designer of the book; and to Katharine Ridler for her sensitive work as copyeditor.

I am profoundly grateful to my late father, Shirley, and my mother, Miriam Lingo, who nourished my interest in art history and provided constant support. My father- and mother-in-law, Allan and Enid Green, have also been deeply engaged in following the development of my work and have offered many kindnesses. My deepest gratitude, finally, is to Estelle Lingo, my companion in life and in the life of the mind. Her conversation, her example, her love and inspiration, lie behind every page of what follows. It is to her that I dedicate this book.

FLORENCE, JULY 2008

AUTHOR'S NOTE

Dimensions are provided for all works by Barocci, but not for comparative images. Barocci drawings for surviving paintings discussed in the text are not dated as his complex preparatory process makes precise dating difficult; drawings related to a particular painting are assumed to fall within the date range for the ideation and production of the painting. Captions for drawings by other artists follow the same procedure.

The range of issues considered in this project made incorporation of the expanding bibliography difficult once the text was completed; every effort has been made, however, to include relevant bibliography through the end of 2007, when the final manuscript was submitted.

INTRODUCTION

And truly in his noble works, he was vago, *and* divoto; *and as in one part he delighted the eyes, so through the other he composed souls, and returned hearts to devotion.*

Giovanni Baglione, *Le Vite de' pittori,*
scultori et architetti (Rome, 1642)

This book traces its origins to two surprises. One was visual in nature. As I considered some paintings and drawings by Federico Barocci (c. 1533–1612) in the course of a very different project – a study of archaism in late sixteenth-century culture – I perceived retrospective elements in his work, particularly in some of his drawings, which I found unexpected and which seemed insufficiently interpreted. As I pursued visual clues, I encountered a textual, and more precisely theoretical, surprise; it became evident that Giovanni Baglione's lapidary assessment of Barocci's achievement in the *Vite* spoke in terms quite different from those generally privileged in the art historical discourses that had interpreted the painter's work to the twentieth century. Indeed, Baglione's distinctive terms had been of marginal interest to most modern scholarship. It struck me, however, that Baglione was sure of what he was saying and that his language deserved attention.[1]

Upon reflection, the fact that I encountered these surprises – pictures that virtually demanded new readings and art criti-

cal terms that evidently delineated fundamental aspects of Barocci's work for his first interpreters but now appeared relatively opaque – seemed itself a surprise. For Barocci is far from unknown. While his name does not resonate in the mental imagination of the "educated general reader" and museum visitor with anything like the pervasive force of Michelangelo's, Barocci seems to have found an avid following among art historians. I can no longer recall how many times a colleague, on hearing that I was "working on Barocci," exclaimed "What a painter!" Indeed, Barocci might be described as both a painter's painter (his brilliant color and brushwork can still impress and intrigue) and an art historian's painter (the remarkable array of evidence that has survived to intimate his methods, meditations, and period receptions of his work fairly compels interpretation). Furthermore, it appears that Barocci's paintings have also captivated many who may have never heard his name until they experience an epiphany before one of his glowing pictures. It can hardly be a coincidence that the Vatican Museums have

chosen to issue glossy postcards, framed prints, and large posters of Barocci's lush *Rest on the Return from Egypt* (c. 1573; see fig. 181) from their Pinacoteca. The Vatican's decision to reproduce this painting in three distinct formats (and prices) suggests that visitors find Barocci's devotional image nearly as compelling as Michelangelo's Sistine Ceiling.

What is it about Barocci's paintings that excites the wide-eyed admiration of a range of viewers that extends from skeptical academics to those "accidental tourists" who stumble upon the *Rest* while lost in the Vatican? At first glance the question appears almost banal. It seems evident why Barocci's paintings attract: glowing color, rich oil glazes, lovely figures, sunlit scenes. This list certainly acknowledges qualities important to Barocci and his contemporaries. His coloring, his handling of paint, his light, and his figures were praised by period writers and imitated by contemporary painters; as modern viewers perceive these qualities too, the appreciation and interpretation of the pictures appears straightforward. Yet it is precisely the assumption that Barocci's paintings offer a self-evident and universal visual appeal that may blind us, predispose us to read the images unreflectively through lenses that obscure rather than clarify. The apparent accessibility of Barocci's pictures, their immediate appeal to "universal" human sentiment, has even led many art historians to appreciate his work in a surprisingly ahistorical way, wittingly or unwittingly collapsing his sensibilities with those of the Rococo, or with certain self-consciously "pious" strands of nineteenth-century painting. "In the dissolving colors and in the smiling charm of the subjects, we seem to have left the solemnity and tensions of the late Cinquecento far behind – in fact almost to have arrived at the carefree world of early eighteenth-century France." Such a statement may constitute a provocative critical observation; it is in fact true that the early eighteenth century maintained an appreciation for Barocci's paintings, and it seems obvious to us now why this should be so.[2] Yet, the frank admission that to a writer in the late twentieth century Barocci's works appear to "have left . . . the Cinquecento far behind" does imply that we tend to read Barocci as something of a historical anomaly, and ultimately as a nearly ahistorical purveyor of light and sweet sentiment. A sustained historical investigation of Barocci's works, however, indicates that far more is at stake than prettiness or sentimentality – indeed, a negotiation of the "tensions of the late Cinquecento" is, I will argue, central to Barocci's endeavor – and that when his contemporaries celebrated his color and his lovely figures, they privileged aspects that some modern visitors to the Pinacoteca Vaticana might find surprising.

These observations are not intended to imply that there is not much important, indeed fundamental, scholarship on Barocci. In fact, his historical as well as artistic importance was recognized already in the seventeenth century. He had enjoyed immense fame during his lifetime, and his impact was registered for the next two centuries. His colorism was fundamental for Rubens, and his specialty – the altarpiece structured as an apparition – helped to develop, popularize, and codify an image type that became a preferred form for altarpiece paintings into the nineteenth century. The seventeenth-century art theorist and biographer Giovan Pietro Bellori recognized Barocci's particular excellence as a painter of religious images and even went so far as to claim that Barocci, rather than Annibale Carracci, could have been the "restorer" of greatness to Italian painting around 1600 had he stayed in Rome rather than retiring to remote Urbino.[3] Barocci's remarkable *fama* was temporarily eclipsed in the nineteenth century, in the general reaction against later Renaissance and Baroque painting. By the early twentieth century, however, his work had already excited interest again. His definitive rehabilitation – and the systematic study of his corpus, career, and influence – was established with the extensively illustrated and revised second edition of Harald Olsen's fundamental *Federico Barocci* (Copenhagen, 1962), the first and still the only English-language catalogue raisonné. The interest stimulated by Olsen's work culminated in the remarkable exhibition held in Bologna and Florence in 1975, which was accompanied by Andrea Emiliani's catalogue (developed into the now standard monograph on the artist in 1985). Art historians – and members of the general public – who saw the glowing canvases gathered in Bologna described the exhibition as one of the most memorable of their experience.[4]

Since this landmark exhibition and monograph, most work on Barocci has occurred in dissertations and short essays, as the insights gained from the juxtaposition of so many of his paintings and drawings began to be assimilated and developed. This work has accelerated from the late 1990s. Jeffrey Fontana's 1998 dissertation has significantly deepened understanding of the painter's early formation and sources; Ian Verstegen has reconsidered the long-standing historiographic conceptualization of Barocci's work as "Proto-Baroque," analyzed his pictorial strategies in the context of rhetoric, and articulated new approaches to his working methods; and Nicholas Turner has published an updated overview of Barocci's career that incorporates some significant new drawings into the already large corpus. Indeed, the study of the drawings continues to develop rapidly, as illustrated by the recent major exhibition at the Fitzwilliam Museum, Cambridge, and work in progress on Barocci's practice as a draftsman by Verstegen and John Marciari.[5]

Much of the work that has been accomplished from Olsen forward is fundamental to any further study of Barocci; I could not have pursued my own work without it. Nevertheless, for a variety of reasons, I did not wish to attempt a new catalogue

raisonné as my contribution to the evolving discourse. In the first place, Barocci's already extensive corpus continues to expand, with occasional discoveries of paintings and more frequent discoveries of drawings. This ongoing accumulation of data prompts repeated adjustments in our understanding of Barocci's artistic development and working methods, but it may be some time before the additions to the corpus and the inflections of interpretation they slowly instate will allow for the creation of a definitive new catalogue that supersedes those of Olsen and Emiliani. Beyond these practical considerations, it is also true that the genre of the catalogue raisonné has become susceptible to criticism on a number of counts. Most of these are ideological and too well known to rehearse. I do not agree with all of them; without Olsen and Emiliani, I could not attempt the present study. But a thorough catalogue raisonné is a demanding and time-consuming enterprise, and most scholars have only so much time. A frequent result is that the conscientious catalogue writer focuses on those questions that pertain most directly to the establishment, expansion, and re-ordering of the corpus. At a certain moment in historiographic development this endeavor is fundamental to understanding a body of work and its import – and beyond accomplishing these tasks, the best catalogues often advance significant interpretations. Olsen and Emiliani effectively established interpretations of Barocci that have stood almost without inflection for several decades.[6] However, precisely because of this long-term stability of interpretive parameters for Barocci's work, it does not seem the best use of resources to revisit and revise the standard catalogues for this book. If one's efforts are of necessity focused on adjusting an established corpus and registering the concomitant inflections of interpretation, there is little time left for a significant re-evaluation of the "state of the question" concerning an artist's work, its historical significance, and the cultural discourses of which it formed a part. Yet a great deal has changed in art history since the fundamental works of modern scholarship on Barocci appeared. Thus it was perhaps inevitable that the initial surprises I experienced as I began to consider his work compelled me to confront issues concerning exactly that "state of the question" in Barocci studies.

This confrontation convinced me that the time is certainly right for a new consideration of the parameters of interpretation. The very way in which pictures (or texts) can suddenly surprise us may indicate that the array of concepts and assumptions we are accustomed to bring to them no longer suffices.[7] In fact, Barocci's work never did fit comfortably within the categories of modern art history. Was he Mannerist? Not really. Baroque? Not quite. What then? The fact that Barocci achieved some of his most significant innovations in the years between the death of Michelangelo (and the conclusion of the Council

of Trent) and the rise of the Carracci has not helped standard modern scholarship deal with the naming conundrum. Not only Barocci but the very decades of his maturity fall between the cracks of art historical periodization. It is thus predictable that most painting in Italy from about 1564 to the late 1580s has been frequently dismissed as uninteresting, or at best investigated as a foil for the emergence of the Carracci; with the Venetian school in part excepted, it tends to be considered either staid, pietistic religious image-making encumbered by Counter Reformation prohibitions, or a mannered, self-absorbed art of artifice, with none of the power of its canonical models. The distaste for this era in modern historiography is certainly one reason that admirers of Barocci often view him as an anomaly.

Like many stereotypes, this pejorative view of the 1560s–1580s contains (even as it distorts) a grain of historical foundation; the Carracci had already critiqued some of their contemporaries for working in formulaic fashion, without recourse to the verities of nature, and the view that much late sixteenth-century painting had become mannered became a leitmotif in seventeenth-century criticism. By the same token, it has long been recognized that much of the stereotype is nothing more than that, and a number of art historians have pointed to the critical importance of developments in religious painting during these decades. However, the very fact that the best-known of these essays remains Federico Zeri's *Pittura e controriforma* – a study of the work of Scipione Pulzone published in 1957 – reveals that a reconsideration of these years is now long overdue. In addition, Zeri's decision to cast Pulzone as the protagonist of a fundamental exploration of religious and pictorial reform during that the late sixteenth century indicates how uneasily Barocci's paintings seem to fit modern assumptions about that period.[8] Yet Barocci was hailed by many contemporaries as the era's exemplary maker of religious art.

The fact that the decades between the death of Michelangelo and the ascendancy of the Carracci (and of Caravaggio) are critical yet under-interpreted – and that it was in these years that Barocci created a number of his most important paintings – convinced me that I should frame my investigation as a thematic study of the principal religious paintings Barocci produced during the 1570s and 1580s. I will analyze a few of his later paintings in some depth but the bulk of my text will consider Barocci's development of a persuasive language for modern religious painting in that fundamental period. To consider this development afresh – and to attend to the numerous historical questions raised in the process – there is a pressing need to put aside for the moment assumptions about Mannerism, Baroque, Proto-Baroque, Counter Reform: these are terms which in any case make contemporary scholars increasingly uneasy.[9] They opened up many fruitful avenues for

3

innovative scholarship during the course of the twentieth century; their current usefulness is less and less clear, however, and nowhere more so than in attempting to attend with sensitivity to the distinctiveness and complexity of the late sixteenth century. I shall therefore from now on employ "mannerism" and "baroque" only occasionally and always within quotation marks; and I shall eschew "Counter Reformation" altogether, preferring instead the much more limited, and historically descriptive, post-Tridentine decades. The Council of Trent was certainly a memorable and extended event, and it did have repercussions. Thus it appears reasonable that many living in Italy during the 1560s, '70s, and '80s could understand some aspects of life to be inflected by the decisions taken at the Council (or at least by the varied actions and debates it stimulated among bishops and other regional authorities). This is quite different, however, from assuming that the world in which they lived was the Age of the Counter Reformation – much less that they understood it in such terms. And I shall be particularly interested in this book in attempting to glimpse some of the frameworks within which Barocci and his early viewers might have reflected on art, religion, and religious art.

This strategy is of course not without its distinct challenges. I am fully aware of the pitfalls of a search for a "period eye," and, as I hope my text will make clear, I have attempted both to remain sensitive to the pressing questions of whose eyes are taken into account, and to pursue a somewhat different approach. I am principally interested neither in "the eye" (an abstraction) nor in "an eye" (the exact shape of historical individuality is resistant to reconstruction) but in certain parameters of possibility within which a number of eyes and minds in a given place and time might have operated. I have also attempted, fundamentally, to respect the sheer complexity of the culture(s) I am approaching; the temptation to simplify and homogenize any past in relation to the present is as pernicious as it is pervasive in historical thinking. I have concluded, however, that if modern historiographic concepts are offering rapidly diminishing returns in the investigation of the late sixteenth century and its painting, a re-orientation of the terms of the discussion may at least reveal other possible trajectories of thinking.

It is in part because the standard terms of much twentieth-century art history have long provided the conceptual apparatus for the interpretation of Barocci's painting that Baglione's distinctive assessment has occasioned little comment, and may appear unhelpful. Yet when Baglione describes Barocci's style as "vago, e divoto" he both sums up a tradition of criticism – these and other closely related terms had already been applied to Barocci's work in the painter's lifetime – and makes a re-markable distinction. Barocci is the only artist, among the many

discussed in the *Vite*, whose style is defined in this way. Evidently Barocci's own contemporaries perceived him as particularly unusual also. They, however, understood him not as a historical anomaly but as deeply engaged with contemporary history. For them, Barocci stood alone because he alone had proven highly able in negotiating the extraordinary challenges facing contemporary religious painting, still the predominant genre in which the developing ambitions of art might be pursued. He was thus not so much anomaly as paragon.

If Baglione's terms are so deliberate, what do they signify? *Vago* and the related noun *vaghezza* (Barocci's style is *vago*, his paintings generate *vaghezza*) are clearly pointed period critical terms that require interpretation. *Divoto* (devout), however, appears self-evident. Yet close attention to the religious and artistic debates of the period reveals an aspect of the perception of the devout that may prove unexpected – archaism. Indeed, it was precisely a quality of retrospection – a self-conscious looking back, a reflective consideration of archaic images in the articulation of new ones – that had struck me in some of Barocci's paintings and drawings. It is becoming increasingly evident that what might be termed an "archaizing aesthetic" inflected the self-representation of a number of religious and political institutions during the second half of the sixteenth century. This phenomenon (which demands further investigation) arose equally from the crises of the sixteenth-century church and from a fundamental crisis of Renaissance identity: the ever more univocal focus on Rome as the locus and arbiter of a normative ancient age of gold beside which all other pasts paled and to which any legitimate modernity should trace its origins. Proud states with "alternative antiquities" – Florence with its vision of Etruscan and Trecento greatness, for instance, or Venice with its self-image as the "other" and ultimately more authentic Rome – might become restive before the increasing assertions of the unique cultural hegemony of the Eternal City. So might some ecclesiastical institutions that located their golden ages far from the banks of the Tiber in the age of the Caesars.[10]

The Capuchins exemplify such ecclesiastical institutions. This new family of friars had been founded in 1527 as a radical reform of the Franciscan Order. They were determined to recover "authentic" Franciscanism, but many friars became convinced that the perfections of early Franciscanism were as lost as antiquity itself. Thus, the recovery of the golden age of Saint Francis would require an effort analogous to that expended by humanists and antiquarians in search of ancient Rome. The Capuchins' study of surviving early Franciscan architecture and painting rapidly evolved from historical documentation to stylistic and ideological filiation, and some convents even built churches modeled on early thirteenth-century Franciscan shrines and created devotional paintings that evoked Duecento

Detail of fig. 134

styles. Negotiations became imperative, however, when these friars began to receive altarpieces paid for by wealthy supporters and executed by prominent painters who would not simply revert to archaic styles. While these patrons and painters were often remarkably sensitive to Capuchin interests, the paintings that emerged from the negotiations between tradition and innovation distilled and re-articulated the friars' medievalizing predilections into thoroughly modern pictorial idioms.[11]

Barocci was a protagonist in this cultural milieu. He was an ambitious modern painter, but one associated by both devotional inclination and patronage with a number of religious institutions that were revaluing traditional images. Indeed, it has long been assumed that Barocci himself became a Capuchin tertiary. It now seems that he did not, but Capuchins and other Franciscans were certainly among his most important and frequent religious patrons (accompanied by confraternities and the Oratorians), and his will confirms his personal filiation with the Franciscan family as a whole and the Capuchins in particular.[12] On a number of occasions, Barocci designed altarpieces for Franciscan or confraternal patrons by reflecting on an archaic image type and painstakingly re-elaborating it through his rigorous and lengthy design process to arrive at a highly innovative religious painting. The particular trajectories of his thought can at times be traced through the substantial legacy of preparatory drawings that survive for a number of his paintings, and through letters that reveal important aspects of his complex negotiations with such patrons.

When Barocci evolved designs dependent on archaic prototypes, he worked to preserve the frontality, centrality, and hieratic dominance of sacred figures – qualities often associated with archaic images – but ultimately represented these qualities as configurations constituted by the enactment of a narrative drama, the Albertian *istoria* that had come to constitute the highest aspiration of ambitious modern painting. Barocci often chose to depict visionary apparitions, for the representation of theophany as apparition offered a compelling solution to fundamental dilemmas of modern religious painting. Almost alone among available forms, the "vision painting" was uniquely equipped to privilege aspects of both iconicity and pictorial drama. The sacred figures confront beholders like icons, may be symmetrically disposed and hierarchically arranged as in the traditional *sacra conversazione*, and are elevated on cloudbanks that definitively separate their realm from the earthly domain of the viewer; but they may also advance, emerging from the pictorial space to involve beholders in the emotionally compelling drama of divine revelation.

It is precisely the emotionally compelling character of Barocci's paintings that excited many period viewers, and a rise in emotional temperature is characteristic of that second criti-

cal component they identified in Barocci's art: its remarkable *vaghezza*. Baglione's *vago*, fundamental to the period perception of Barocci's style, is often translated as "lovely," but it could possess distinctly sensual, even erotic, connotations and might better be rendered as "alluring" or even "ravishing." Such a quality may not seem requisite, or even possible, in a religious image. Indeed, it was well understood in the sixteenth century that "in trying to treat matters of religion *vagamente*, more often than not one merely makes the sacred profane."[13] Yet, as the century progressed, the demand that any successful painting exhibit *vaghezza* became only more imperative. As might be expected from the sensuous valences of the word, *vaghezza* could be closely associated with the body and perceived in those complex compositions of ideal human figures in artful poses – often largely or wholly nude – that characterized much of the painting of mid-century. As the ecclesiastical fresco or altarpiece remained the principal public venue for the exhibition of most painters' work, however, the cultivation of compositions filled with "figures of young men or women that are a little more *vaghe* than usual," as Vasari put it disingenuously, was bound to scandalize some ecclesiastics and pious viewers. In his scathing attack on Michelangelesque painting, the reformer Giovanni Andrea Gilio wrote bluntly that "the *vaghezza* of art" appeals more to such painters than "integrity [*onestà*] and appropriate decorum."[14]

The conflicting demands of religious decorum and artistic virtuosity created a veritable minefield for painters. While statements like Gilio's are often given the last word in modern assessments of the cultural climate in the immediate aftermath of Trent, the picture is frankly far more complex; in the sophisticated critical world of the late sixteenth century, even many viewers who called for strict decorum in religious painting found themselves bored by pictures that only achieved decorum and devotion. Raffaello Borghini's *Il Riposo*, an important art-critical dialogue published in Florence in 1584, is often read as another "reform" text opposing the courtly artifice of the *maniera*. Borghini in fact presents a wide range of views, from the conservative admonitions of Vecchietti to the frank delight in figures "a little more *vaghe* than usual" expressed by Michelozzo. It is certainly true that the dialogue contains numerous condemnations of painters such as Bronzino for "lascivious" figures and other lapses of decorum in religious pictures. Yet in what may come as a surprise to many modern readers, the leading Florentine reform painter Santi di Tito, while much admired for *devozione*, is nonetheless criticized for "lacking *vaghezza* in his coloring."[15] Most of Borghini's interlocutors seem to agree that the ultimate power of painting lies in its capacity to ravish – to *vagheggiare* – the viewer. A religious picture, however, must lure the beholder univocally toward devotion.

For such contemporaries, Barocci's unique achievement was to fashion images that enraptured viewers while avoiding the pitfall of the "lascivious" figures that until then had been a mainstay of *vago* pictures. The assertion that Santi di Tito's pictures lacked *vaghezza* in "coloring" offers a clue to Barocci's strategy, even as it reveals the pervasive importance of *vaghezza* in late sixteenth-century culture. Borghini's interlocutors evidently take it for granted that Santi would not fill his pictures with nudes in the manner of Bronzino; it is for this that they praise his decorum and piety. Yet it is equally taken for granted that *vaghezza* must be cultivated. If it cannot be located in *vago* figures, it must be present somewhere else in the picture: by Borghini's time, color was a critical non-figurative element of painting that could be associated with the requisite ravishing of the senses. Barocci was thus able to displace the sensuous delight of painting from the representation of lovely bodies into more purely pictorial qualities – lush oil textures and glazes, astonishing illusionism in foreground still lifes, and the brilliant colorism that Borghini missed in Santi di Tito.

Period viewers could perceive this displacement of *vaghezza* from the figural realm in part because of recent developments in Venetian art criticism and the experience of Titian; writers such as Lodovico Dolce had begun to identify effects that Titian achieved with oil paint as sensuous in their own right.[16] In the years covered here, Barocci was equally committed to the central Italian legacy and the compelling vision of Titian. His ability to meld the insights and particular achievements of these powerful artistic modernities made his distinctive solution possible. Barocci developed this new sort of visual perception by investing virtually every aspect of several of his most important paintings with meaning, distilling each artistic device and form – not only the narrative drama staged with gesture and expression but even pictorial facture and color – into a powerful signifier. His affecting pictorial lures, however, drew the viewer through delight in color and shimmering illusion into rapt contemplation of images that re-inscribed at their core some of the fundamental values of traditional religious picture making. Remarkably, Barocci was able to employ *vaghezza* to articulate a visually persuasive case for the enduring power of venerable image types, re-seen for a new age.

To understand how Barocci's paintings – or indeed any paintings – might be perceived by late sixteenth-century viewers to meld the *vago* and the *divoto* constitutes one of the principal goals of my book. The valences and implications of the period understandings (the plural is deliberate) of these terms and of their relevance to Barocci's painting are complex enough that their investigation structures the entire text. Approximately the first half of the study is focused on the increasingly self-conscious attempt during the sixteenth century to define what constituted a "devout" image, and on Barocci's reflections on the history of art and of image making as he formulated visual responses to this question. Chapter One explores perceptions of the place of archaism and retrospection in late sixteenth-century culture, investigates those aspects of Barocci's cultural and spiritual milieu that involved him with institutions who wished to maintain or recover venerable image traditions, and introduces a strategy employed throughout the book – the study of Barocci's drawings to reveal meditations on the archaic that he would work through and ultimately veil in finished paintings. Chapter Two is dedicated to the close reading of one of Barocci's most important and richly documented altarpieces, the *Madonna del Popolo* (1575–9, see fig. 24) and the related *Immaculate Conception* (early to mid-1570s, see fig. 2). As the title *Vision and Icon* indicates, I am particularly concerned to investigate Barocci's exploration of the "vision altarpiece" – the theophany presented as apparition – as a means of preserving the hierarchies and symmetries of traditional religious images while generating a narrative drama. The struggles Barocci faced in the ideation of these altarpieces, and some of the resolutions he attained, have implications for the understanding of his entire achievement and ultimately for the understanding of the artistic and religious cultures of early modern Italy. Chapter Three develops some of the arguments of the second chapter with particular reference to critical works Barocci ideated for the Franciscans and the Oratorians, his two most influential patrons among religious institutions. Chapter Four, meanwhile, approaches another fundamental aspect of Barocci's historical reflections that also effects a transition to the second part of the book, which is concerned primarily with the painter's engagement with the developing period discourses of art, rather than with retrospection. I offer readings of Barocci's *Entombment* for the confraternity of the Cross and Sacrament in Senigallia (see fig. 83) and his late, unfinished *Lamentation–Entombment* (see fig. 109) for Milan Cathedral that explore his meditations on *Entombments* by Raphael and Michelangelo in which the interactions of tradition and modernity in the altarpiece had already been explicitly confronted. Beyond his reflections on archaic images, a fundamental tenet of Barocci's enterprise, it seems to me, involved revisiting and rehabilitating salient achievements of early sixteenth-century painting in the wake of attacks by Gilio and others on the *maniera moderna*. Before the Carracci, Barocci attempted to recover the insights of the "High Renaissance" for a different age.

The second part of the book develops the investigation of Barocci's self-conscious modernity through an exploration of the valences of the *vago* in his culture, and of the period understanding that he cultivated *vaghezza* as a feature of a personal style. Chapter Five initiates this exploration with a study of the

meanings, connotations, and uses of *vago*, *vaghezza*, and related terms in period art theory and criticism; the issues raised by Baglione's identification of Barocci's style as particularly *vago* in relation to that of other painters will be examined here at length. Chapter Six probes the profound associations between *vaghezza* and the beautiful body in sixteenth-century thinking about painting, and the crisis a pursuit of the *vago* figure inevitably generated for sacred representations. Barocci's remarkable success in displacing the sensuous allure of *vaghezza* from the body to the glories of representation itself – both the magical play of mimesis in the recreation of the world (in still life, genre) and more purely pictorial qualities of color and facture – is traced in Chapters Seven and Eight. Chapter Nine then opens an investigation of a unique form of *vaghezza* that Bellori identified as central to Barocci's painting – music. For many in the late sixteenth and seventeenth centuries, music was among the ultimate *vaghezze*; Baglione virtually identified the two in a memorable reference to *la vaghezza della Musica*.[17] Barocci's *ut pictura musica* has never been seriously studied. Given the clear statement by the well-informed Bellori that Barocci "called painting music" – and Barocci's evident cultivation of a non-bodily *vaghezza* in the field of color, which was closely related to musical tone and harmony in his period – an investigation of these associations now seems as imperative as it is difficult and of necessity preliminary.[18] Even an initial survey of the terrain, however, indicates that the study of Barocci's development of analogies between sight and sound can open new avenues to a deeper understanding of the remarkable cultural experiments that defined many aspects of the late sixteenth century in Italy and had significant repercussions for the future. Finally, the Conclusion turns from the analysis of the elements that underpinned Barocci's visual thinking and period reception to attempt an *ekphrasis* – or, speaking musically, a sight-reading – of the *Rest on the Return from Egypt* (see fig. 181) that still entrances visitors to the Vatican. In this essay I offer a model for reading (or better, seeing) Barocci's paintings of the 1570s and their historical import in a manner that may appear new and unusual to viewers now, but might have been taken for granted by the painter and the contemporaries who marveled at his accomplishment.

A new interpretation of Barocci's work along the lines I am suggesting is important for a number of reasons beyond the understanding of his personal achievement. Barocci was an artistic protagonist in an age of remarkable religious and pictorial transformations, when artists could be criticized for failing to produce devout images on the one hand or artful images on the other. The fact that he was a highly self-conscious and ambitious painter who pursued his artistic ambitions principally through the production of altarpieces and devotional paintings means that he labored for his entire career near the epicenter of these transformations.[19] Thus his work becomes one of the most compelling sites (perhaps the most compelling site) in which to situate an investigation of developments in artistic and religious thinking that continue to haunt and frustrate the historiography of early modern Italy. Critically, what might Barocci's work reveal about the so-called "reform of painting" that defined much pictorial culture of the late sixteenth century and is often held to culminate in the work of the Carracci? The question is particularly pressing because these pictorial reforms are generally recognized as fundamental to the trajectory of European artistic culture for the next two hundred years, but critical issues concerning their origins and nature remain unresolved and highly contentious. What exactly were the relations between religious and artistic reforms? How much in the transformation of painting was a fundamentally "aesthetic" reformation, generated from within pictorial theory and practice and conditioned by the increasingly accepted contention that painting was an "Art" with its own rules and debates? And how effectively could this new art serve both its own ends and the traditional societal functions still required of images? It is not surprising that some of the best interpretive pages on Barocci as a painter, and on the surface of the *Madonna del Popolo* in particular, are found not where they might be expected but in works such as Charles Dempsey's groundbreaking *Annibale Carracci and the Beginnings of Baroque Style* (1977).[20] Yet Barocci there is of necessity but a brief prelude, if a highly resonant one. I want to refocus the lenses now to place the study of Barocci near the center of a re-interpretation of the critical developments that make Italian painting and culture of the late sixteenth century so important. This, it seems, can best be done through a study of the works for which Barocci was especially admired – his religious paintings, and in particular some of his principal altarpieces.

The sources available for such a study are particularly rich in part because of the distinctive trajectory of Barocci's working life. Barocci probably intended to spend his career in the artistic and religious center of the European world, Rome. He was well aware of the cultural importance of his *patria* of Urbino as the city of Federigo da Montefeltro, the setting for Baldassare Castiglione's *Il Cortegiano*, and – perhaps first and foremost in his mind – the city of Raphael. However, the Duchy of Urbino did not provide an ambitious young artist of the 1550s with the opportunities it once had, and Barocci (like Raphael) took the road to Rome. The brilliant beginning of a career there, however, was cut short by the onset of an intractable malady that ultimately necessitated his retirement to Urbino. This, at least, is the story. Barocci seems to have resisted any efforts on the part of patrons to push him to produce rapidly, and his

return to Urbino certainly removed him from the most intense pressures of work on demand for the vast projects afoot in papal Rome. Whatever the nature of his decision and his chronic illness (sometimes attributed to poisoning at the hands of rivals jealous of his overwhelming talents), Barocci's retirement may ironically have made him even more central to the period search for a new language for religious painting – and more compelling to study in the modern attempt to understand something of the transformations of Italian and ultimately European culture during the late sixteenth and early seventeenth centuries.[21]

Protected by his relative isolation, by the excuse of his *indispositione* (as he termed it), and ultimately by a sympathetic duke and mentor in Francesco Maria II della Rovere, Barocci was able to reflect profoundly on the creation of his major paintings, developing his devotion to drawing to experiment at length with varied possibilities for a project while resisting, or even ignoring, the insistent pleas of importunate patrons. This notorious recalcitrance and sometimes glacial pace of production could irritate even his admirers. The duke himself once wrote to his representative in Spain in complete exasperation, confiding that he had perfected a plan whereby an autograph version of Barocci's *Calling of Saint Andrew* (1580–83; see fig. 167) would be delivered to the Spanish court as a diplomatic gift with two extraordinarily fine horses, but "Barocci has taken so long with this work that the horses are dead."[22] Nonetheless, Barocci's excellence was so prized (and so effectively promoted by both painter and duke) that patrons kept coming, not only from the Duchy of Urbino and adjacent regions but from Rome, from the papacy itself, and from as far away as the Prague of Rudolf II. Since such patrons had to communicate with Barocci (and later often with the duke) through letters rather than in person, we are privileged to have a remarkable array of textual as well as graphic documentation for some of Barocci's most important projects.

During the 1570s and '80s (those forgotten decades) Barocci distilled a vision for a new religious image and a new art of painting that excited the admiration of ecclesiastics, princes, confraternities, the new *cognoscenti* of the finer points of "art," painters themselves, and at least one saint.[23] His sophisticated blending of the salient pictorial styles of a century that had become ever more stylistically self-conscious, and his magical marriage of the alluring beauty of modern painting with the venerable aura of sacred images that continued to command reverence as glimpses of the invisible holy and workers of marvelous miracles, stimulated reflection and discussion as well as admiration. Although his style was consciously indebted to both

history and the competing "modernities" of Rome and Venice, it was recognized already by the end of the 1560s as something powerfully new, a *vera maniera nuova*.[24] In the eyes of contemporaries, it was particularly Barocci's brilliance at "treating affairs of religion *vagamente*" that gave him a unique status. When the great *Crucifixion* for the Senarega chapel in the Cathedral of Genoa was delivered (see fig. 104), Matteo Senarega celebrated Barocci's fusion of the devout and the *vago* in an effusive letter of thanks to the painter: "This painting has but one defect: because it has something of the divine, human praises cannot reach it. Therefore it lives wrapped in silence and awe.... The work is so rich in artifice and *vaghezza* that ... I repeat and confess how, like something divine, it enraptures [*rapisce*], divides, sweetly transforms."[25]

While Barocci's achievement was perceived to be unique, attention to the significance and implications of the terms his contemporaries employed in their attempt to "reach" his painting and assess the artistic, cultural, and religious implications of what was happening can allow an approach to a new vision of the means and meanings of painting at a critical moment in its history, when increasingly self-conscious pictorial imperatives entered into sustained, if difficult, negotiations with religious and social imperatives that continued to retain much of their traditional authority (and indeed were being actively re-invigorated). Many of the ideals and aspirations for painting that coalesced during the late sixteenth century – and are dramatically negotiated in Barocci's paintings and the commentary they occasioned – continued to resonate through the seventeenth century and beyond. Recent linguistic and theoretical investigations of the efflorescence of art theory and criticism in the sixteenth and seventeenth centuries have developed new sensitivity to discourses too often ignored in modern art history, and clarified much that was unclear when the fundamental studies of Barocci were undertaken. Few of the insights and implications of these theoretical studies have been pursued and developed in direct relation to the interpretation of late sixteenth-century painting, however.[26] I hope that the initial reflections which follow may serve as pointers toward new interpretations (or better, toward very old, "original" interpretations) of paintings and cultures that have lived too long "wrapped in silence," but which can reveal complex perspectives – of significance in the formation of early modern cultures – concerning the status and purpose of painting, the construction of a self-conscious "modernity" and its relation to tradition, and the importance, even the viability, of the recovery or preservation of ideal pasts.

PART I

Retrospection and Modernity

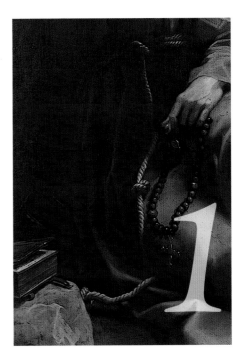

Orders of Reform

"Truly in his noble works he was *vago*, and *divoto*": when the modern reader confronts such period perceptions of Barocci's paintings in texts by Baglione and other writers, it is immediately evident that the quality of the *vago*, of *vaghezza*, requires interpretation. The second half of this book will be devoted to that endeavor. What is clear already is that the word carries a charge of sensuality that makes its relation to devotion exceptional. The meaning and significance of *devozione*, however, may appear transparent. To stand before Barocci's *Immaculate Conception* in Urbino (fig. 2) is to feel included in an intimate group of pious witnesses to the Virgin's benign, billowy apparition, and to delight in warm colors, pink cheeks, and gentle smiles – the apparently conventional pieties, sentiments, and invitations of traditional religious painting. Yet modern viewers looking at Barocci usually bring with them a sense of such painting conditioned by certain pietistic strands in nineteenth and early twentieth-century devotional art. It is not difficult, equipped with such perceptions, to read Barocci's radiant figures as sentimental signs of a sweet and simple piety. To do so, however, courts serious historical confusion and overlooks fundamental aspects of late sixteenth-century conceptions of an effective religious image. Those warm colors and blushing cheeks that modern viewers can read too easily as stimuli to sentimental piety, for instance, may have stimulated as much

sensual *vaghezza* as conventionally pious *devozione* for many early viewers of Barocci's picture. There is also the question why a drawing that is frequently associated with the planning of the *Immaculate Conception* (fig. 1) depicts a vision far different from that realized in the painting – still "sweet," perhaps, but overtly redolent of the venerable traditions of the Madonna della Misericordia.

The sixteenth century is an early moment for which one can definitively document increasing tensions between artful pictorial and sculptural practice and the traditional cultic and devotional functions required of the religious images that continued to dominate much artistic production. If on the one hand an altarpiece had to be *divoto* to succeed as an altarpiece, on the other hand it had to allure the viewer with *vaghezza* to succeed as a painting, a "work of art." As already noted in the Introduction, period commentators realized the extraordinary difficulty of conjoining these two qualities successfully. Francesco della Torre, commenting on religious poetry, observed in the 1530s: "in truth in trying to treat these matters of religion *vagamente* more often than not one merely makes the sacred profane." Given that matters of religion were of paramount importance in ecclesiastical painting, what particular qualities might preserve the sacred from the profane and ensure a *divoto* image in the late sixteenth century? This question is

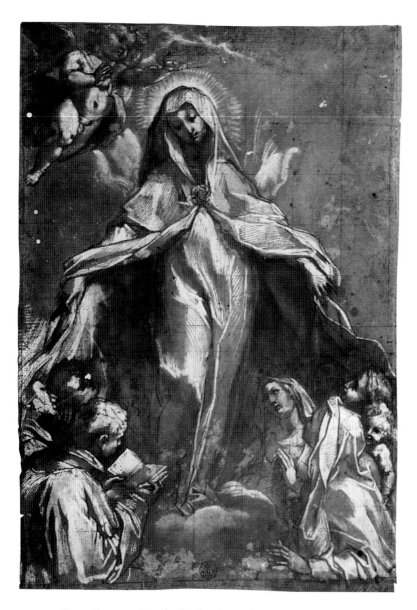

1 Barocci, squared study for the *Immaculate Conception*(?), pen, wash, chalk, and white heightening on paper, 27.5 × 18.9 cm. Florence, Galleria degli Uffizi, Gabinetto dei Disegni, inv.11446 F (r).

be avoided, so that images are not painted or adorned with seductive charm [*procaci venustate*]."[1] To be told that "seductive charm" – often expressed in period painting through beautiful human forms, figures that were, in the memorable formulation of Vasari, "a little more *vaghe* than usual"[2] – is to be avoided in religious images is surely an arresting indication of perceptions of problems in modern religious representation. Such a statement, however, offers a fairly limited sense of the possibilities available for creating persuasive religious art (both terms are of import) in the cultural climate of the late Cinquecento.

For all that he is often dismissed as a pugnacious philistine, Giovanni Andrea Gilio begins to sketch some useful parameters for these possibilities in the second of two dialogues he published in Camerino in 1564, the *Dialogo nel quale si ragiona degli errori e degli abusi de' pittori circa l'istorie*. Gilio's notorious critique of Michelangelo's *Last Judgment* (see fig. 116) has guaranteed the text's fame – if ruining the ecclesiastic's reputation among most art historians – but it is not the attack on nudity and errors in representing scriptural *istorie* that is of immediate interest, for Gilio's injunctions, though more detailed and focused, do not ultimately depart from those offered at Trent in the same years.[3] What makes his intervention distinctive is that he does not simply criticize contemporary abuses; he analyzes issues and seeks solutions. Through the debates articulated in the *Dialogo*, Gilio moves beyond the standard strictures concerning nude figures in religious painting, or the demands that ecclesiastical images narrate sacred stories with transparent clarity and fidelity to the texts, and begins to approach the fundamental issue in defining a new religious art – the question of the appropriate style for devout painting.

STILE DEVOTO

In attending to the comments of Gilio's interlocutors on this issue the modern reader is confronted with a critical, though still under-explored, element in the late sixteenth-century perception of what made an image stylistically devout – archaism. It is well known that Gilio evinces a sympathy for archaic religious images, which he considers more devout, if less artful, than modern pictures, but relatively little effort has been invested in attempting to understand the implications of this position, much less the role of archaism in mid- to late sixteenth-century Italian culture more generally.[4] In part, Gilio's comments have not been much analyzed because they remain relatively preliminary; Gilio seems to have had a fairly imprecise sense of the qualities of older images compared to that attained by a few of his contemporaries. Nonetheless, several statements in the *Dialogo* raise issues that are fundamental to much sixteenth-century thinking about the *divoto* in art.

difficult to answer, not least because many of the period texts that address the issue proceed principally by negation. The problem is exemplified by the lapidary pronouncements concerning images promulgated at the twenty-fifth session of the Council of Trent in 1563. The Council reaffirmed the traditional importance of images in teaching and reminding the faithful of the stories and "mysteries of our redemption," and reasserted against the Protestants that honor and reverence [*honorem et venerationem*] are due to images. Yet the only references to the qualities religious images should possess occur in a warning against modern abuses "that may have crept into these holy and saving practices": no representations of "false doctrine" are permitted, and "all sensual appeal [*lascivia*] must

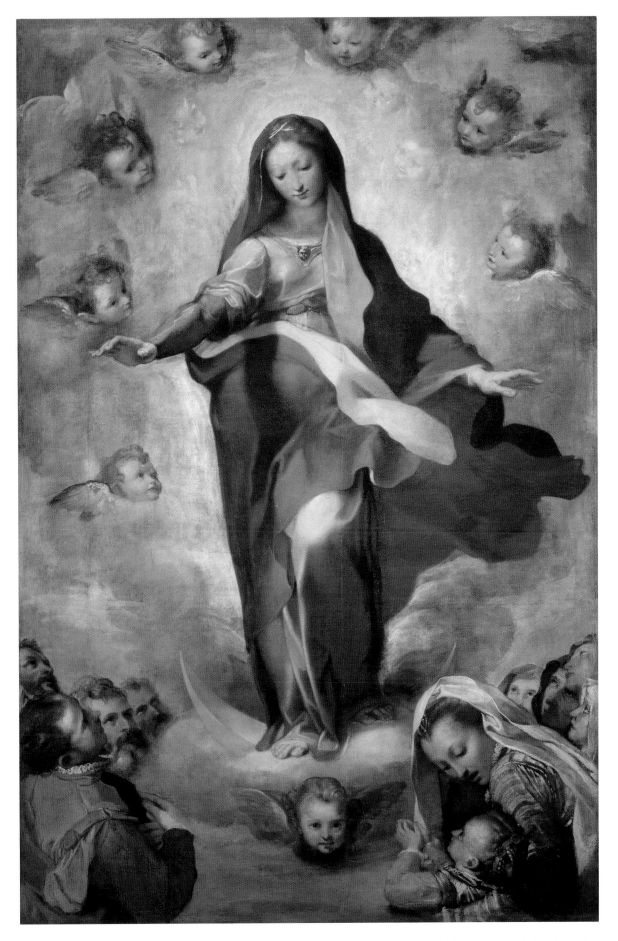

2 Barocci, *Immaculate Conception*, early to mid-1570s, oil on canvas, 217 × 144 cm. Urbino, Galleria Nazionale delle Marche.

Signor Ruggiero makes the critical comments. When asked how one might paint religious images, given that Michelangelo, the great modern, has erred so gravely in his most ambitious attempt on the altar wall of the Pope's chapel, Ruggiero responds that the question is difficult; beyond comments in the thirteenth-century *Rationale divinorum officiorum* of the liturgical writer Durandus, "we have no law or rule for this, if not what is demonstrated by the custom [*consuetudine*] of painters before Michelangelo." Pressed to define this custom, Ruggiero asserts that it involves painting "sacred images that are decorous [*oneste*] and devout, with those signs that were given by the ancients [the term here signifies pre-Cinquecento Christians] as a privilege of sanctity, which has appeared to the moderns vile, awkward, lowly, old, humble, without cleverness and art."[5] Elsewhere in the *Dialogo*, Ruggiero develops the argument along stylistic lines in a brief but fundamental passage, in which he argues that the way forward for modern religious art could be found in a judicious mingling of old and modern approaches to image making. Admitting that modern painting is more "artful" if less devout than traditional painting, Ruggiero suggests: "If [earlier artists] erred in small measure, and [modern artists] err in large measure . . . it would be good to make of that small and this large a measured mixture [*regolata mescolanza*], and find a middle way that rectifies the defects of the one and the other . . ."[6]

Exactly what Ruggiero intends by critical terms such as "*oneste*," "devout," "signs . . . of sanctity" – much less his *regolata mescolanza* of new and old approaches to painting – is not immediately clear, and when he elaborates, he first dwells predictably on the modern taste for nude figures as one of the central "errors" of contemporary religious art. Nevertheless, he proceeds to make a critical point when he asserts that modern artists have "abandoned the custom" of making figures that are devout, preferring instead the artful contortions of the *figura serpentinata*. By contrast, old images tended to present figures frontally; this, as Alexander Nagel has noted, implicated the figure in the "ethical responsibility of clear public address." While Ruggiero admits Signor Silvio's objection that the frontal, iconic figures of old images lack representational sophistication by modern standards and "deserve more to be laughed at than marveled at" as art, it is clear that Ruggiero – and with him Gilio – prefers such "errors" to the decadent artfulness of what he terms the *figura sforzata*, which he criticizes explicitly and repeatedly.[7]

As early as 1522, a related point had been made in northern Europe, in Hieronymus Emser's attack on the iconoclast Andreas Karlstadt. Emser went so far as to assert that the simplicity of early images was deliberate, and did not constitute evidence of "any decline of art." Rather, it served as a strategy to focus the viewer on that which was most important in a religious image, the subject or figure represented. By contrast, "the more artfully images are made the more their viewers are lost in contemplation of the art and manner in which the figures have been worked."[8] Emser's remarkable conclusion that the simplicity of old images reflected stylistic choice rather than lack of skill subverted Vasari's artistic and historical paradigms before they were formulated. Such views were not confined to northern Europe: in Italy, even members of Michelangelo's circle had advanced significant revaluations of archaic images in the 1530s and '40s. Vittoria Colonna in particular was known to appreciate old images. In a poem addressed to the Lucan Madonna icons of Rome, she wondered if their "imperfect" artistry might result from the deliberate selection of a "humble style" on the part of the holy painter.[9] The Portuguese painter Francisco de Hollanda was also part of this circle and his *Dialogues on Painting* claim to record conversations with Colonna, Michelangelo, and their reformist friends concerning art and devotion. While the text is usually cited for the disparaging comments concerning Flemish painting that are attributed to Michelangelo, it also offers brief but illuminating glimpses of more respectful attitudes to the archaic. At one point Hollanda describes a commission given him by the queen of Portugal, who desired him to copy the archaic image of Christ in the Sancta Sanctorum. One of the interlocutors asks: "did you fashion it with that severe simplicity which characterizes old painting . . . ?" Hollanda, a modern painter and admirer of Michelangelo, responds that he had exerted every effort neither "to add nor subtract anything from that severe gravity." It is hardly coincidental that another interlocutor scolds de Hollanda at this point for not having shown his copy to Vittoria Colonna before sending it to Portugal: "you are no friend of the Signora Marchesa, since you omitted to show her a thing so to her taste [lit. 'so hers']."[10]

Colonna's inclinations and Hollanda's striking comments indicate the degree to which, already in the 1530s, archaic styles could be valued, studied, and on occasion imitated in some circles in Italy. Hollanda's particular commission was distinctive, however; artists were asked to copy archaic images with increasing frequency over the course of the sixteenth century, but the vast majority of commissions for religious art continued to require the invention of new pictures for altarpieces or for private devotion. In most cases, it was assumed that the artist would create a work in modern style. If, however, some characteristics of archaic images were held to exemplify the quality of the *devoto* in religious art, how might modern painters respond to Gilio's suggestion of a *regolata mescolanza*?

3 Rubens, *Madonna della Vallicella*, 1608, oil on slate. Rome, Chiesa Nuova (Santa Maria in Vallicella).

ENSHRINING THE ARCHAIC

Perhaps the most obvious *mescolanza* of old and new in Italian religious art of the late sixteenth century involved what Hans Belting has termed the "mise-en-scène" of the archaic within the modern. A venerable sacred image was celebrated and "ornamented" with a pictorial frame constituted by figures of angels executed in a style that stressed the alluring blandishments of which modern art was capable. In this way "art" and "image" were clearly distinguished in both form and role. The modern served as frame and embellishment of the archaic sacred, honoring it and at the same moment demarcating it spatially, stylistically, and historically. Implicitly, the beauty of the modern "frame" functioned as a pictorial lure, attracting the gaze of the passerby to contemplate the archaic image. The Oratorian project to enshrine the *Madonna della Vallicella* in the Order's mother church, the Chiesa Nuova in Rome, with Rubens's glory of angels represents a well known instance of such an approach – though in this case the old image, ordinarily covered by Rubens's *Madonna*, was theatrically revealed on ritual occasions (fig. 3). A less well known Oratorian commission offers critical insights into period perceptions of this kind of montage. In the mid-1590s the Oratorians, recently established in the Marche in San Severino, commissioned Felice

Damiani – a regional painter who worked extensively in the lands of the Duchy of Urbino and who was influenced by Barocci – to paint the high altarpiece for their new church. In March 1595 Antonio Caroli wrote to the "casa madre" in Rome requesting advice in choosing an appropriate subject for the altarpiece. He proposed four options: a *Trinity*, a *Sant'Antonio*, a *Pietà*, or – and this possibility he put first – a painting representing the archaic Vallicella Madonna (at this time still conserved in a side chapel of the Chiesa Nuova). The imitation of the archaic Madonna was to form part of an altarpiece that also contained images of miracles worked by the old icon, thereby lending the composition some structural analogy to the typical arrangement of Duecento saints' panels (see fig. 9).[11]

The response was immediate. Antonio Talpa, who had emerged as one of the principal figures in the Oratory (and was originally from San Severino) wrote to urge his comrades in the Marche to produce a copy of the Vallicella Madonna. Instead of the images of miracles, however, Talpa recommended representing a glory of angels, thus anticipating the solution Rubens offered when the old icon was taken from its chapel and installed over the high altar of the Chiesa Nuova. The painting was to be "like that of the Madonna in Rome that contains the Madonna with her son in her arms, placed in the clouds, surrounded by a glory of little angels, and various cherubim, and below a choir of angels kneeling." Critically, Talpa concluded that such an arrangement "would make a composition that is at once *vaga* and *devota*."[12] The precise and distinctive conjunction of terms through which Baglione later individualized and celebrated Barocci's achievement was already deployed here by an ecclesiastic to describe a painting that commingles the modern and the archaizing. It seems clear that Talpa considered the glory of *angeletti* critical to the composition's *vaghezza*. In addition, his stress on "little angels" in flight around the old image, as distinct from the "angels" kneeling below, may indicate that he intended the glory to be composed at least in part of the putto angels that Barocci himself used repeatedly. This is not insignificant; even Gilio explicitly accepted the artistic presentation of nudes if they were infants, whose innocence could not mislead viewers into "lascivious" thoughts. The putto angel could thus establish a site of figural *vaghezza* that remained decorous in an ecclesiastical setting.[13] While Damiani's painting is lost, Durante Alberti in about 1599 produced an altarpiece for Santi Nereo ed Achilleo in Rome, the titular church of the Oratorian cardinal and historian Baronius, which seems similar to the sort of painting Talpa describes (fig. 4).

Talpa reveals more in further letters. It seems that Damiani had produced his own alternative proposal for the altarpiece in the form of a drawing. The Oratorian was in fact quite taken with the painter's idea, and wrote: "I have seen the drawing of

4 Durante Alberti, *Madonna of the Vallicella Adored by Angels*, c. 1599, oil on canvas(?). Rome, Santi Nereo e Achilleo.

this painter, and it greatly pleases me because of the new invention he wished to execute, expressing his conception very well." However, Talpa concluded that a series of exigencies necessitated a pictorial solution that joined the modern and the archaic. Some of these are critical for an understanding of concepts of the devout in painting around 1600:

> At the High Altar one should represent the image of the Madonna of Rome, through which image the most holy Madonna has been taken as the Protectress of the whole Congregation and the sign under which we fight, and because of this the high altar [of the Oratorian church] in Naples was made with the same image, totally similar to that of Rome. There being thus the intention to represent in this panel the Madonna of Rome, one should not diverge from the drawing but follow it . . . and even if good painters are mortified to copy the inventions of others, nonetheless even with the works of others they can demonstrate their excel-

lence by not simply imitating them, but also in understanding how to improve them. And our painter . . . in Naples was not ashamed to make the same painting [the copy of the Madonna della Vallicella] copied from the same drawing . . .[14]

An overriding concern here is certainly the display of the new church's filiation – with the Oratorians in general and with Santa Maria in Vallicella in particular. However, influential assumptions concerning what is most appropriate at the high altar of a church are also implicit.

The high altar demands the greatest reverence; thus, formal decorum and the integrity of tradition are particularly requisite in the high altarpiece. An unstated corollary follows: side altarpieces can more easily accommodate formal innovation. This cluster of assumptions will prove critical to the analysis of Barocci's mature altarpieces. In addition, Talpa's comments offer further insight into his conception of modern copies of old images. He seems to accept implicitly that archaic pictures, while more devout, do suffer from artistic deficiencies. Modern painters, even in reproducing old styles, can "improve them." Indeed, a striking feature of the proliferating number of copies or adaptations of archaic images produced during the late sixteenth century is the relative softness of the copies, their reliance on modern ways of painting to approximate old forms (see figs 4 and 9–11). While this phenomenon might be assumed to result from an inability to recover, or even perceive, archaic styles fully, Talpa's words indicate that it may also reflect deliberate choice. In pursuing such a strategy of imitation, an artist preserved the iconicity of archaic images, and even elements of their style, while subtly but decisively updating them, making their forms more accessible and appealing to modern eyes. While Barocci never copied an archaic image in a painting, he engaged in several instances of what could be described as the decisive modernization of archaic sources. His procedure, while visually more ambitious and sophisticated than that of an artist copying old images, is demonstrably a response to the sort of spiritual and cultural milieu implicit in Talpa's ideas and assumptions, and an attempt to make images that were "at once *vaga* and *devota*."

RETROSPECTION AND BAROCCI'S MILIEU

Before analyzing salient examples of Barocci's response to archaic image types it is important to understand something of the nature of the religious and cultural environment of late sixteenth-century Urbino, in which he operated for most of his career. Although Urbino was no longer the center it had become under Federico da Montefeltro, the della Rovere dukes

were by no means insignificant patrons of art and culture. The young Barocci matured in a city proud to have been the birthplace of Raphael, and ruled by princes with a passion for Venetian painting. Barocci was formed as a painter between Raphael and Venice – a happy melding of central and northern Italian excellences, at least to Venetian theorists. It should not be forgotten that Raphael and Titian are both the artistic heroes of the fundamental dialogue of Venetian art theory, Lodovico Dolce's *L'Aretino*; Dolce's critiques are leveled not simply at central Italian art in general but at Michelangelo.[15] The Marche had long been something of an artistic border between central and northern Italy. While the lands of the Duchy of Urbino, stretching across much of the Marche and some of Umbria, were certainly "central," the Appenines stood between Urbino and either Florence or Rome, and the relative ease of sea travel down the eastern coast of the Italian peninsula facilitated contacts with Venice and the cities of the Veneto. A desire to emulate the splendid Duchy of Ferrara, and close relations between the Duchy of Urbino and Venice, had encouraged the first two della Rovere dukes of Urbino, Francesco Maria I and Guidobaldo II, to build a collection of Titian's paintings. Barocci's well informed seventeenth-century biographer Giovan Pietro Bellori asserts that the youthful Barocci studied these paintings avidly – perhaps in part from a desire to appeal to this aspect of the taste of Guidobaldo II, his first ducal patron. The assertion can be traced back to Barocci's funeral oration and beyond; already by the late 1560s the young artist had so internalized aspects of Titian's style that the Perugian chronicler Raffaello Sozi could describe him as a "very great imitator of Titian."[16]

Like many another ambitious young artist of mid-century, Barocci was attracted to Rome as well, and to the difficult competition for papal and curial patronage. His early success, beginning with the friendship and aid of Guidobaldo II's younger brother Cardinal Giulio della Rovere, and culminating with commissions for frescoes in the Casino of Pope Pius IV in the Vatican, augured well for a long career at the heart of court life and power in the Eternal City. However, the sudden onset of a desperate illness some time between 1563 and 1565 – whether occasioned through poisoning at the hands of jealous rivals as Bellori claimed or not – apparently led Cardinal Giulio's physicians to the conclusion that Barocci's only hope lay in a return to his native air.[17]

Bellori recounts that Barocci remained so ill that he could not work for four years. Finally,

> Lamenting above all the fact that he could not paint, one day he prayed to the heavenly Virgin with such conviction that he was heard. Feeling an improvement in his health, he

made a small painting with the Virgin and Christ Child who blesses the young Saint John and presented it as a votive offering to the Capuchin fathers of Crocicchia, two miles outside Urbino, where he would often stay on a farm of his.

The *Madonna di San Giovanni* (fig. 5), dating from the middle of the 1560s, marks Barocci's first known contact with the Capuchins, the most radical reform branch of the Franciscan family; the painter remembered these friars again in his will more than forty years later.[18] He would work for Marchigian Capuchins repeatedly in his career, and for the Conventuals, the "unreformed" branch of the Franciscan family who (not without a certain irony) were the official "protectors" of the Capuchin reform at this time. Indeed, it could be argued that Barocci's spiritual and patronal world in Urbino was anchored by contacts with the Capuchins, other Franciscans, and the confraternities that had long been closely associated with mendicant orders. The *Madonna di San Giovanni*, the *Virgin and Child Appearing to Saints Francis and John the Baptist* of the mid-1560s (the so-called *Fossombrone Madonna*; see fig. 41), the late *Stigmatization of St Francis* of 1595 (fig. 8), and the lost late *Immaculate Conception* were all painted for the Capuchins, while the *Madonna di San Simone* (see fig. 177), the *Perdono* (see fig. 52), the Fossombrone *Stigmatization*, the *Immaculate Conception* (see fig. 2), the *Beata Michelina*, the workshop *Virgin and Child with Saints Geronzio, Mary Magdalene, and Donors* (see fig. 37), the *Christ Taking Leave of the Virgin*, and the Perugia *Deposition* (see fig. 85) were all produced for Franciscan patrons or at least in a Franciscan ambient (as in the case of the *Deposition*, in Perugia's cathedral but in a chapel dedicated to San Bernardino). Two of Barocci's four autograph prints are also of Franciscan subjects: one reproduces the *Perdono* while the other depicts a novel representation of the *Stigmatization* not replicated in Barocci's paintings (see fig. 75). Finally, important regional confraternities commissioned a number of other significant paintings, such as the *Madonna del Popolo* (see fig. 24), the Senigallia *Entombment* (see fig. 83), the *Calling of Saint Andrew* (see fig. 167), and the *Circumcision* (see fig. 133).[19]

Both the Franciscan family and many confraternities were involved in preserving or reviving traditional and archaic imagery during the late sixteenth century. The Capuchins played a particularly critical role in this endeavor. Founded in 1527, they forged the most radical successful reform of the Franciscan Order. From the beginning, the new friars made use of the nascent study of art history and archeology and employed images as well as texts to articulate the historical arguments that defined and legitimized their position. Indeed, they may have been the first religious order to develop a foun-

5 Barocci, *Madonna di San Giovanni*, c. 1565, oil on canvas, 151 × 115 cm. Urbino, Galleria Nazionale delle Marche.

dation story focused on the historically informed perception of old paintings. Gioseffo Zarlino's *Informatione intorno la origine dei Reverendi Frati Capuccini* of 1579 traces the origin of the Order to the "art historical" epiphany of a lapsed Observant Franciscan friar, Paolo da Chioggia. The Observants were the leading reform branch of Franciscanism in the 1520s, and it was generally assumed that they continued to uphold the original, authentic Franciscan existence (unlike the unreformed Conventuals). Paolo had left the Observants, however, as he had come to suspect that their modern life was no longer a pure imitation of that of Francis and his first companions. As Paolo

was passing through the duomo of Chioggia one day, his gaze was suddenly arrested by an archaic painting – not because it was a venerated image but because he suddenly perceived in it critical historical evidence. Zarlino writes:

There was at that time in the Duomo a part of an old altarpiece [*pala*] . . . painted and gilded . . . And in this altarpiece there were painted a number of figures of some saints, about a foot tall, among which . . . was placed that of the glorious Father Saint Francis, depicted . . . with the pointed hood in pyramidal form, like that which all of your Congregation

6 Church of San Damiano, Assisi.

7 Church of the Capuchins, Urbino.

[the Capuchins] also wears today, and which one sees in another old altarpiece, in which is painted the aforesaid saint receiving the stigmata from Christ.

Paolo observed a number of details in the painting that convinced him that Francis had worn a habit much different from that now considered "Franciscan"; he came to realize that this old image contained compelling historical evidence that the original Franciscan experience was indeed, even in the very form of its dress, not that embodied by contemporary Observants. He made himself a habit in imitation of the one represented in the archaic panel and re-emerged in Chioggia looking "very like that picture which he had seen in the Duomo."[20] In their quest for authentic Franciscanism, early Capuchins came to embody, to vibrantly re-present, archaic paintings.

While Fra Paolo's initial interest in the old painting might be read as purely iconographic, his final embodiment of it points ultimately in another direction. Zarlino implies that Fra Paolo had deployed some knowledge of the history of pictorial style to conclude that the picture was old enough to provide evidence of practices close to the time of Saint Francis. Knowledge soon became filiation; the Capuchin study of medieval images rapidly progressed from the search for historical evidence to the search for models for what could be called

a Paleo-Franciscan visual environment. The new friars not only looked "like old pictures" themselves as they pursued their apostolate, but they also began to investigate early Franciscan architecture and to build convents and occasionally churches based on Duecento models. In particular, a number of Capuchin churches throughout central Italy evince what appears to be a self-conscious similarity to San Damiano in Assisi, the little church in which Francis had experienced the miracle of the speaking Crucifix that instructed him to "go and rebuild my church," thus initiating his lifelong mission (fig. 6). In Barocci's immediate environment, both the Capuchin church at Pietrarubbia, founded in 1531, and that at Urbino, completed by the mid-1590s, are "San Damiano revival" buildings (fig. 7). In the background of Barocci's *Stigmatization* for the high altar of the Urbino friars, the new church is represented as a mute witness to events from the life of Francis (fig. 8). Barocci depicts it in its original form, with the round oculus window over the portico instead of the later rectangular window that alters the appearance of the façade today; the similarity between the church outside Urbino and San Damiano is remarkable.[21]

Capuchin research also seems to have stimulated renewed veneration of the early images of Francis. The new friars' interest in the Duecento dossals and icons spread rapidly through the entire Franciscan Order, and a number of old images were

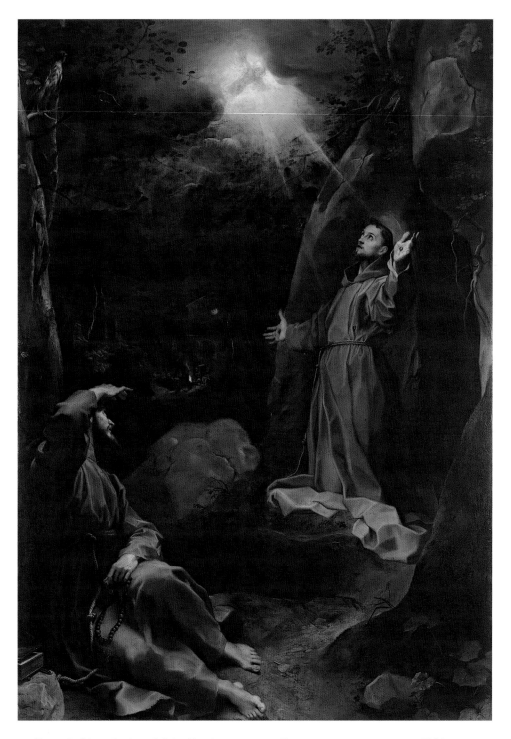

8 Barocci, *Stigmatization of Saint Francis*, c. 1594–5, oil on canvas, 360 × 245 cm. Urbino,
Galleria Nazionale delle Marche.

honored with more prestigious collocations, or with painted glories of angels analogous to those created for numerous archaic Madonna icons in the same years. This phenomenon was particularly evident in Conventual churches; not only were the Conventuals allied with the Capuchins against the Observants in the late sixteenth century, but it was also the Conventuals rather than the Observants who usually occupied the largest and most opulently decorated of the Duecento Franciscan basilicas that housed significant repositories of medieval images. The Conventuals of Florence, for instance, honored the important early Francis dossal (c. 1245–50) preserved in their basilica of Santa Croce by removing it from the column on which it hung and translating it "with the greatest solemnity" into the Bardi Chapel (intriguingly, frescoed by

9 Master of the Bardi Saint Francis Dossal, *Bardi Dossal*, mid-thirteenth century, tempera on panel. Florence, Santa Croce.

10 Copy of the *Bardi Dossal*, c. 1600, oil on canvas. Colle di Val d'Elsa, San Francesco.

Giotto, the most famous of the *primitivi* then as now) to become the chapel's altarpiece (fig. 9). In an extraordinary gesture, these Conventuals or their brethren in the Tuscan city of Colle di Val d'Elsa commissioned a full-size copy of the dossal, probably around 1600, for the Conventual convent of San Francesco there (fig. 10).

Colle was rising in prominence in Medicean Tuscany at this time and was the seat of a prominent, reform-minded bishop early in the Seicento. Evidently, the friars of the Conventual house there wanted their own "early" image of Francis. This remarkable painting is successful enough in imitating archaic style that a nineteenth-century guidebook to Colle could still mistake it for a product of the Duecento.[22] However, the style of some of the figures in the historiated scenes, and especially of the two angels above the head of Francis, gives away the work's true date (fig. 11). Even though the lettering of the scroll

11 Detail of fig. 10.

between the angels evinces a sustained effort to replicate archaic lettering, the forms of the angelic figures themselves are softened and modernized compared with their prototypes. The Colle "Bardi dossal" may in fact represent a sort of limit case of precisely the kind of imitation that Talpa appears to recommend in copies of the Vallicella Madonna, which could successfully evoke the archaic form and spiritual force of the original, while subtly "improving" it by inflecting its formal language in the direction of modern visual taste (Durante Alberti's less radical evocation of an archaic Madonna in his altarpiece for Santi Nereo ed Achilleo is the more usual outcome of such retrospection; see fig. 4). Given the frequency with which old images were framed by a glory of angels in modern style, it may not be coincidental that it is the angels in the Colle "dossal" that are among the most modernized figures in the image.

The Conventual Franciscans, as custodians of many of the grander Franciscan churches – including the Basilica di San Francesco at Assisi – seem to have come to see themselves not only as protectors of the Capuchins but in particular as curators of the Franciscan artistic legacy. This attitude was especially pronounced in Assisi, where the Conventual Fra Ludovico da Pietralunga wrote a guide to the venerable Basilica and its many treasures, probably in the 1570s. Fra Ludovico credits much of his material to a lost guidebook by his friend, the Assisan painter Dono Doni, who had been consulted by the friars concerning the restoration of the Basilica's stained glass windows. Doni is a compelling if provincial exemplar of the new age. Well aware of recent artistic developments, assessed by Vasari as a "very competent painter," a generous and courteous person (Vasari may have relied on Doni as a guide when he visited Assisi), and an amateur scholar with a particular interest in the art history of his town and region, Doni seems to have cultivated an ability to shift pictorial modes between modern and retrospective styles in some of his commissions.[23]

The Capuchin and Conventual investment in the preservation and occasional imitation of archaic images may well have had some impact on Barocci's sensibilities; in any case, his piety seems to have been largely philo-Franciscan. In his will, Barocci provided first for his brother and sister and then left everything else he possessed to the various Franciscan houses in and around Urbino, including the Capuchins of Crocicchia and Urbino, the Observants, and the Conventuals, in whose church of San Francesco – with its high altar adorned since the 1570s with his *Perdono* (see fig. 52) – he requested burial.[24] Barocci has long been assumed to have been particularly close to the Capuchins; it is even generally believed that he became a Capuchin tertiary, or lay brother, himself. This assumption, current in the literature since Harald Olsen's *Federico Barocci* of 1962, now seems unsubstantiated.[25] Nonetheless, Barocci's will, and Bellori's story of the

votive offering to the Capuchins of Crocicchia, imply that the artist had long and close spiritual relations with the new friars; he would certainly have understood the visual argument offered by their San Damiano-style church just outside Urbino.

Barocci was also an ambitious painter, however, who had sought fame in papal Rome and continued to project an image of himself as one of the most innovative and important painters in Europe even from his retirement in Urbino. By the 1580s his reputation had reached as far as the Spanish court and that of Rudolf II in Prague. Despite his noted piety, his apparent inclination toward Franciscan spirituality, and his links with a number of religious organizations invested in the revaluation of old images, Barocci remained an artist who would have been "mortified," to borrow Talpa's expression, simply to imitate archaic images. During the 1570s in particular, when Barocci was just establishing himself as the leading regional painter for the Marche and neighboring parts of Tuscany, and working largely for confraternities and Franciscans, he was forced to wrestle repeatedly with the tensions inherent in expressing his pictorial ambitions through commissions from conservative institutions. His sensitivity to the desires of these patrons, however – coupled with all he had learned of modern art from the study of Titian, from his years in Rome, and from early travels to "all the most renowned cities of Italy" – allowed Barocci to evolve powerful images that met the needs of both devotion and art, and that defined fundamental elements of his approach to painting from that decade forward.[26]

DRAWING ON THE ARCHAIC

Not long after Barocci recovered his ability to paint and offered the *Madonna di San Giovanni* to the Capuchins of Crocicchia, he was commissioned to produce an altarpiece depicting the Crucifixion for the chapel of Pietro Bonarelli della Rovere in the now destroyed Chiesa del Crocifisso Miracoloso in Urbino (fig. 12). Bonarelli was one of the leading courtiers of Duke Guidobaldo II; thus the commission was important as it gave Barocci the opportunity to establish himself with patrons in the inner circle of the duke. A number of compositional drawings survive to document Barocci's painstaking labor in designing the altarpiece. One in particular is critical here, for it indicates that while Barocci resisted overt archaism in finished paintings, he was not at all insensitive to archaic sources in his generation of particular figures (fig. 13). This drawing is a complete compositional study, and appears to indicate that a fairly advanced stage of design had been achieved.[27] It is intensely emotive and dramatic, as is the final painting, which may reflect a response to the remarkable *Crucifixion* that Titian had finished for San Domenico in nearby Ancona some eight years before

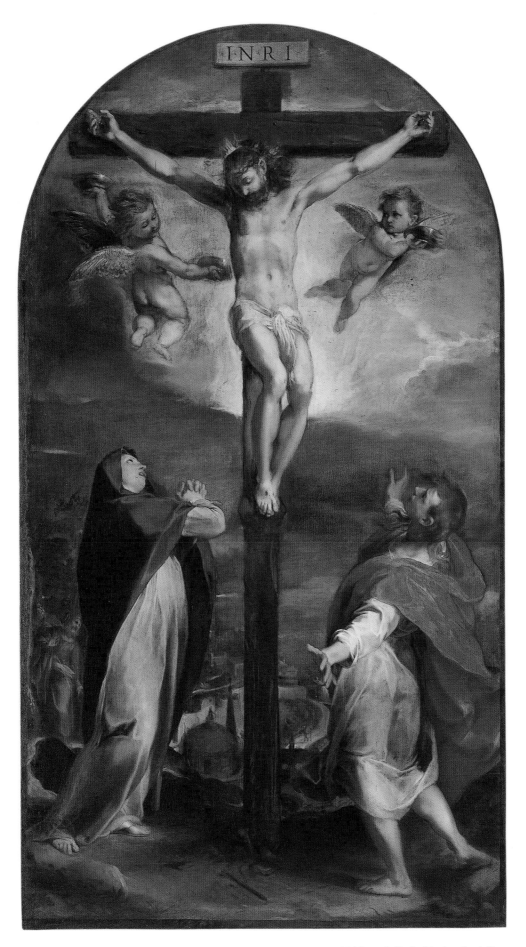

12 Barocci, *Crucifixion*, c. 1566–7, oil on canvas, 288 × 161 cm. Urbino, Galleria Nazionale delle Marche.

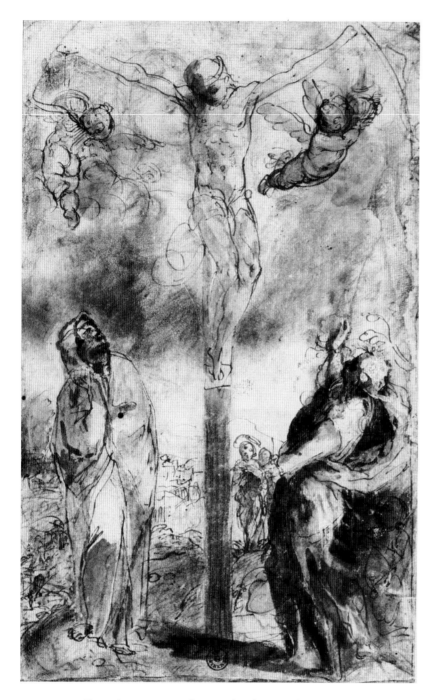

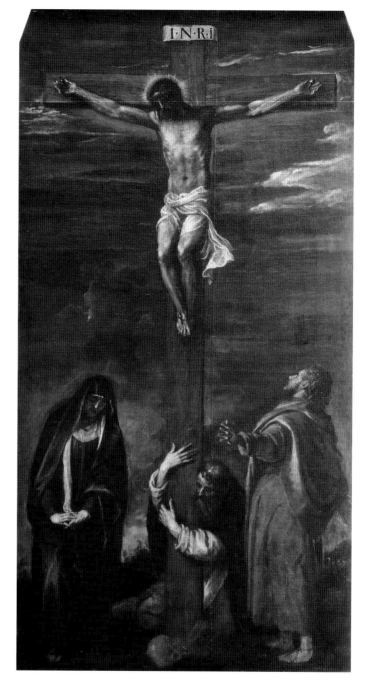

13 Barocci, preparatory drawing for the *Crucifixion*, pen, wash, chalk, and white heightening on paper, 37.3 × 23.2 cm. Florence, Galleria degli Uffizi, Gabinetto dei Disegni, inv. 11416 F.

14 Titian, *Crucifixion*, 1558, oil on canvas. Ancona, San Domenico.

(fig. 14). However, the figure of the mourning Virgin in Barocci's preparatory drawing is radically different from her painted counterpart in the finished altarpiece, and different from Titian's figure as well. Her form – frontal, enclosed, hunched beneath the arm of the Cross with hands twisted together in grief under her sharply angled head – reminds one inevitably of archaic traditions of representing the mourning Virgin that stretched back into the Duecento. A Crucifix attrib-

uted to the Master of Saint Francis that hung in Perugia's San Francesco al Prato can illustrate the point (fig. 15). The figure of the Virgin in Barocci's drawing, however, may refer to these archaic prototypes at least in part through a knowledge of the latest Crucifixion drawings of Michelangelo – for which Paul Joannides has stressed the importance of archaic sources (fig. 16).[28] While it would seem implausible that the aged master would have given the young Barocci such privileged access to

15 Master of Saint Francis, *Crucifix* (double-sided), c. 1260–80, tempera on panel. Perugia, Galleria Nazionale dell'Umbria.

16 Michelangelo, *Christ on the Cross between the Virgin and Saint John*, early 1560s, chalk and white heightening on paper. Windsor, Windsor Castle, Royal Library.

his drawings, the Barocci study lends some weight to the story told by Bellori of Michelangelo's admiration of the young Urbinate's drawing, and his encouragement.[29]

Another visual clue to Barocci's interest in the later Michelangelo – and a strong premonition of the piety of the works of the mid-1560s – occurs in a fresco created late in Barocci's second sojourn in Rome, the *Annunciation* (fig. 17). A serious and shocked Virgin twists from her devotional reading

to confront an angel who has flown into her chamber from behind her left shoulder. The surviving drawings all depict this rare motif, and both the finished fresco and one of the sheets of sketches seem to indicate a knowledge of Michelangelo's late series of drawings on the theme of the Annunciation (fig. 18), or at least of paintings Marcello Venusti created from these drawings.[30] One begins to wonder whether encouragement from Michelangelo may have been a cause of the apparently

17 Barocci, *Annunciation*, 1561–3, fresco. Vatican City, Casino of Pius IV.

18 Michelangelo (attr.), *Annunciation*, c. 1545, chalk on paper. New York, Pierpont Morgan Library.

intense jealousy that Barocci is said by Bellori to have excited among other young artists during his second sojourn in Rome.

The *mescolanza* of archaic and modern sources that inform the Urbino altarpiece – and the insistence on distilling both archaic and modern sources into something distinctly new through an elaborate preparatory process – became characteristic of Barocci's practice in the 1570s. Nor was he an isolated figure in this regard. The Virgin in the *Crucifixion* drawing exhibits similarities not only to early painting and to late Michelangelo drawings but also to figures in a number of *Crucifixion* altarpieces in Rome (which, however, generally postdate Barocci's invention by a decade or more). This group of post-Tridentine Roman paintings is exemplified by Scipione Pulzone's *Crucifixion* for the Oratorians at Santa Maria in Vallicella (fig. 19). Scipione may have based his composition upon Titian's Ancona altarpiece as well – the outstretched arms of Saint John are similar – but the overall impression of the painting melds modern elements with "archaic stylization," as

Zeri recognized long ago.[31] That quality is perhaps most accentuated in the remarkable figure of the Virgin, who appears to be generated from both archaic sources and some of the heavy later female figures in the sculpture of Michelangelo, such as those of Rachael and Leah on the tomb of Julius II in San Pietro in Vincoli. The presence of similar figures in a number of the Roman *Crucifixion* altarpieces that were produced in some quantity in the decades immediately following the Council of Trent indicates a phenomenon in the devout painting of the late sixteenth century that could reward further investigation.

Barocci, however, became determined to transform his figure of the Virgin from the archaizing model he initially employed into a more dramatic and modern form. His painstaking "outworking" from an archaic source is well documented in a number of surviving drawings. In a drawing in Florence (fig. 20), for instance, the Virgin crosses her arms over her chest in a manner not dissimilar to motifs in some of the late Michelangelo *Crucifixion* studies, while a drawing in Berlin (fig. 21)

28

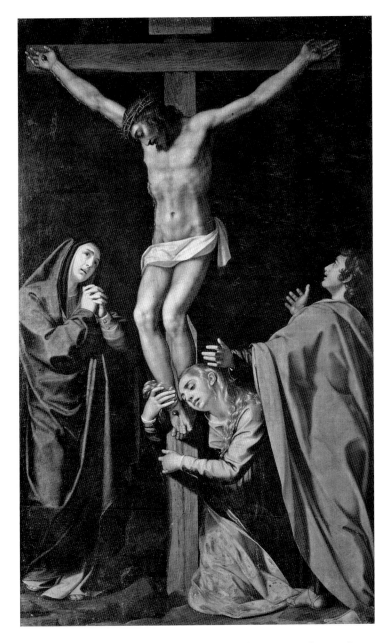

19 Scipione Pulzone, *Crucifixion*, 1585–90, oil on canvas. Rome, Santa Maria in Vallicella.

figure again through a nude study of a workshop assistant, evidently to perfect the posture of the limbs before rethinking how best to drape the figure in the definitive pose. The figure of Saint John underwent a similarly elaborate gestation, and a detailed nude study in Berlin indicates that he was intended to clasp hands before his chest at a fairly advanced stage of the design process. Barocci thus returned late to the ideation of John with outflung arms. While this figure is obviously based on Titian's John, Barocci heightened the dramatic force of the gesture and quickened the emotionally charged movement of the figure.[32]

Barocci's altarpiece, then, distills both archaic and contemporary sources into a powerful and distinctive image. It is telling, however, that the modern models he selected were produced by artists who in their own right were sensitive to older art. This sensitivity is now increasingly recognized in the work

20 Barocci, study for mourners in the Bonarelli *Crucifixion*, pen, wash, chalk, and white heightening on paper, 21.5 × 17.3 cm. Florence, Galleria degli Uffizi, Gabinetto dei Disegni, inv. 11554 F (r).

displays a trio of figure and drapery studies that approach the final pose. The Virgin here clasps her hands again but her pose is rethought to heighten elements of drama and movement, and her figure is no longer the enclosed form of the Florentine compositional study. The middle figure in the Berlin drawing is critical, for it demonstrates Barocci considering and re-considering the position of the Virgin's arms. Before he settled on the solution adopted in the altarpiece, he briefly experimented with a pose in which hands are clasped together but arms are lowered – an idea that must reflect meditation on the figure of the Virgin in Titian's Ancona canvas. Once the higher position of the arms had been established, however, Barocci studied the

21 Barocci, studies for the figure of the Virgin in the Bonarelli *Crucifixion*, chalk on paper, 28.2 × 42.7 cm. Berlin, Staatliche Museen, inv. 2-1974 (4176)

of Michelangelo. It should be recognized as well in that of Titian. His Ancona *Crucifixion* itself indicates a profound, if subtly deployed, understanding of traditions and prototypes – and the Ancona altarpiece is not an anomaly in his career, as will be seen, particularly in works for Marchigan patrons. Indeed, Barocci's early ability to distill both "artful" and *divoto* sources into a seamless *regolata mescolanza* seems to have pleased religious patrons in the Marche immediately; an early copy of the Bonarelli *Crucifixion* was ordered for the Capuchin church in Macerata and a number of other copies were made.[33] Further, both Borghini and Bellori recall that Barocci executed a *Crucifixion* for Cardinal Giulio della Rovere, now lost, which is usually dated to the time of the Bonarelli painting or slightly later, around 1570; Olsen believes it provided the model for the *Crucifixion* represented over the altar of the Porziuncula in the background of Barocci's *Perdono* (see fig. 52).[34] If Olsen's hypothesis is correct, Cardinal della Rovere's *Crucifixion* contained the sort of strikingly archaizing Virgin depicted in the Uffizi drawing for the Bonarelli painting, for the painting within the *Perdono* clearly resembles not the Bonarelli altarpiece but the Uffizi drawing.

The possible employment of the drawing in the background of the *Perdono*, however, does not mean that the Cardinal's painting was produced after the Bonarelli *Crucifixion*. If indeed the image within the *Perdono* does record the appearance of the lost picture, the *Crucifixion* for Cardinal Giulio could well have been produced before Bonarelli's altarpiece; the Uffizi study would thus represent the endpoint of one project and the genesis of another. If this were the trajectory of invention, though, the della Rovere *Crucifixion* would have been the most overtly archaizing image that Barocci ever produced. I would not discount the possibility of such a picture, especially as a meditation on late Michelangelo drawings for a churchman who was at once a connoisseur and a reformer. All other available evidence, however, seems to indicate that Barocci always worked outward from initially identifiable sources in his drawings to paintings in which any source had been profoundly rethought and distilled into something new. This appears to have been particularly true when the source was an archaic image type. Thus the altarpiece represented in the background of the *Perdono* may record not a finished painting but the Uffizi drawing itself, in which Barocci recognized the appropriateness

of the archaic elements to the recreation of the Duecento altarpiece in the Porziuncula. Such a hypothesis is lent further support by a telling decision: Barocci truncated the *Crucifixion* in the background of the *Perdono* in such a way that the side of the composition with the "modern" figure of Saint John is hidden by the door to the Chapel; only half of Christ, and the Duecentesque Virgin, remain visible.[35]

The great *Deposition* of 1567–9 in Perugia (see fig. 85), which established Barocci as an artist of emerging stature beyond the confines of the Marche, does not display any overtly retrospective elements either in the finished altarpiece or in surviving drawings. However, Barocci returned to meditate on an archaic theme in the early 1570s, in the remarkable drawing (now in the Uffizi) that attempts to modernize the *Madonna della Misericordia* (see fig. 1). The issues he confronted in this drawing can be linked to the production of two major altarpieces, the *Immaculate Conception* for the chapel of the Compagnia della Concezione in San Francesco, Urbino (see fig. 2), and the *Madonna del Popolo* for the Confraternity of the Laici of Arezzo (see fig. 24). Documents and drawings associated with these projects offer some of the richest surviving evidence of Barocci's negotiation of modernity and reprospection.

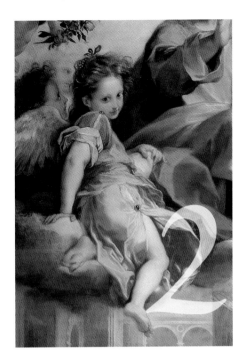

Vision and Icon

Barocci's experimentation with retrospection is particularly well documented during the 1570s and early '80s, arguably the period in which he worked most intensely and frequently for religious institutions invested in the maintenance or recovery of old visual traditions. The documentation is of two types. First, so many of Barocci's preparatory drawings survive that one can often follow critical stages in the painter's elaborate design process. Drawings for several altarpieces – particularly the *Perdono* (see fig. 52), the *Immaculate Conception* (see fig. 2), the *Madonna del Popolo* of 1575–9 (fig. 24), and the *Visitation* (see fig. 77) – offer compelling indications of Barocci's meditation on aspects of traditional images as he planned paintings that became innovative, distinctly modern works of religious art. Second, the numerous letters that record the often difficult discussions between Barocci and the Confraternity of the Laici in Arezzo during the ideation of the *Madonna del Popolo* make clear that the confraternity desired something Barocci understood to be an archaic image, and offer tantalizing indications of some terms of the debate – and the negotiation – between retrospection and modernity in the period. The *Madonna del Popolo* is among Barocci's most complex creations and was recognized in his lifetime as one of his principal paintings. Given its importance and its rich documentation, the *Madonna del Popolo* – with the *Immaculate Conception* from San Francesco in Urbino, a painting

intimately related to the Aretine altarpiece – becomes central to the investigation of the creative interplay of retrospective and modern tendencies in Barocci's altarpiece production and by extension in much of post-Tridentine painting.

HISTORY, MYSTERY AND THE MISERICORDIA

The confraternity that commissioned the *Madonna del Popolo* was the dominant lay fraternity in Arezzo and traced its origins to the thirteenth century. While it had developed under Dominican guidance and patronage, by the fourteenth century it was most closely associated with the Pieve of Arezzo instead of San Domenico, and came to be called the Fraternità dei Laici to distinguish it from a fraternity of canons already long established in the Pieve. The confraternity's official name, however, was the Fraternità di Santa Maria della Misericordia and public charity was at the core of its identity. By Barocci's time the Fraternità had become so powerful that it was not only the leading charitable institution in Arezzo but even supervised and supported elements of the civic fabric of the city, ranging from libraries to water supplies.[1] The Confraternity's self-representation was intimately linked to its name and activities; for centuries it had both commissioned numerous images of the Mis-

alone except for cherubs and two adolescent angels. These angels, however, hold the Virgin's mantle out from her sides so that she assumes the appearance of a Madonna of Misericordia. No tiny figures cluster beneath the mantle; the gesture is a sign for Saint Roch, and for the figures in the door of the Palazzo and on the steps before it. The old symbolic image has been reconceived as an apparition, the icon as event. This is not strictly speaking a picture of the Madonna della Misericordia, but its reconceptualization of the potential of such a picture offered fertile possibilities for reflection as painters confronted the venerable theme.

When, about a decade later, Bartolomeo was asked to execute a fresco of the Misericordia for the Monte di Pietà (a dependant of the Fraternità dei Laici), he confronted the challenges

22　Bernardo Rossellino, *Madonna of the Misericordia with Saints Lorentinus and Pergentinus*, 1434, pietra bigia. Arezzo, Museo Statale d'Arte Medievale e Moderna (on loan from the Fraternità dei Laici).

23　Bartolomeo della Gatta, *Saint Roch interceding with the Madonna before the Palace of the Fraternità dei Laici*, 1479–80, tempera on panel. Arezzo, Museo Statale d'Arte Medievale e Moderna.

ericordia – a medieval image type in which diminutive figures of the faithful found shelter under the outspread mantle of a monumental figure of the Madonna – and also encouraged the dissemination of the iconography in Arezzo. The institution's predilections are exemplified by Bernardo Rossellino's Misericordia relief of 1434 over the entrance to the Palazzo of the Fraternità on Arezzo's Piazza Grande (fig. 22), which projects the confraternity's visual self-representation decisively into the public sphere in the heart of the city.[2]

Radical hierarchies of scale that distinguished the Virgin from her devotees had always characterized medieval images of the Misericordia. While the non-naturalistic exigencies of such a composition seem to have been accepted well into the Quattrocento (as in Rossellino's relief), ambitious artists were becoming increasingly uncomfortable with the traditional representation of the theme by the latter part of the century. In Arezzo a case in point is a painting Barocci would have seen, Bartolomeo della Gatta's remarkable *Saint Roch interceding with the Madonna before the Palace of the Fraternità dei Laici* (fig. 23). This work was commissioned by the fraternity in 1479, in the wake of a particularly virulent outbreak of the plague in Arezzo in 1477–9; it came to Arezzo's Museo Statale from the audience hall of the Palazzo della Fraternità itself.[3] Della Gatta depicts a monumental figure of Saint Roch in the foreground of an extensive perspective panorama of the Piazza Grande of Arezzo, with the façade of the Palazzo in the center-left background. Directly above and before the upper gallery of the Palazzo, on axis with the *Misericordia* of Rossellino that adorns the portal, hovers an apparition of the Madonna. Distinctively, her figure is small, to reflect height and distance. She stands on a cloudbank,

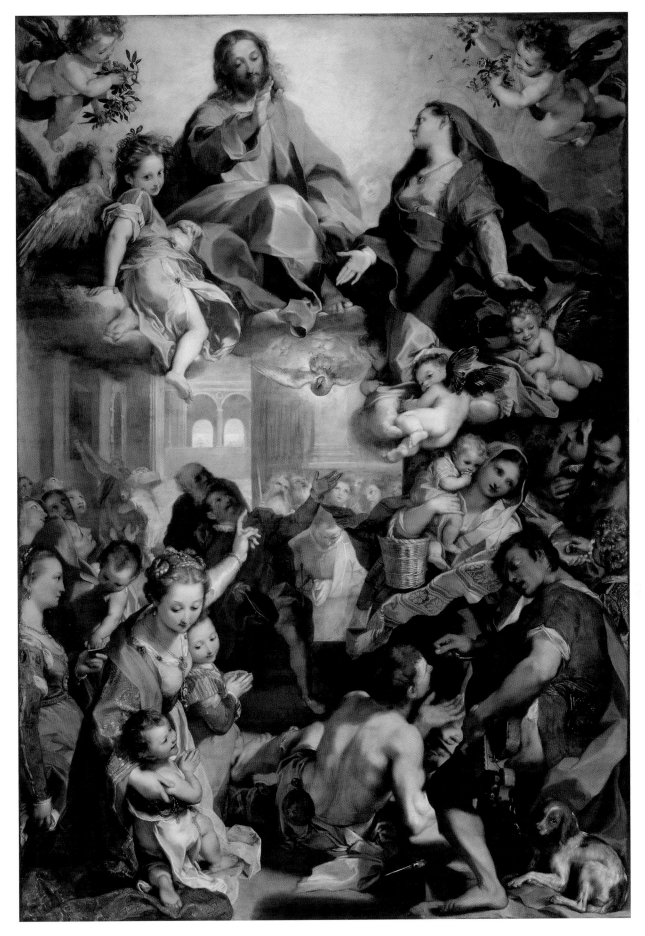

24 Barocci, *Madonna del Popolo*, 1575–9, oil on panel, 359 × 252 cm. Florence, Galleria degli Uffizi.

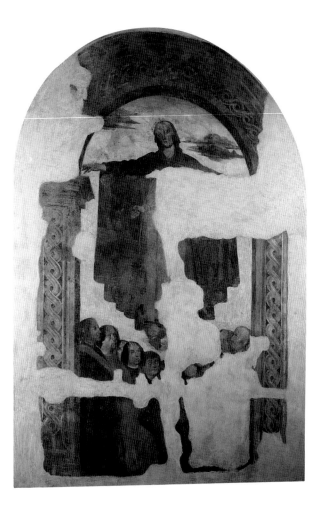

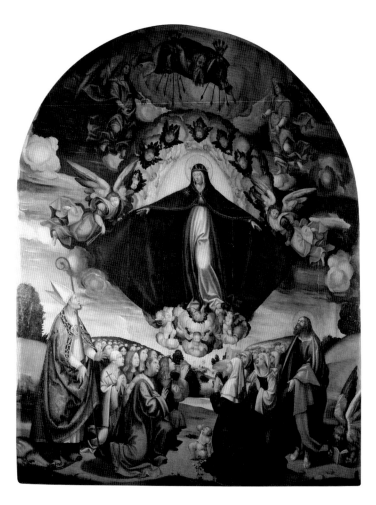

25 *Madonna of the Misericordia*, probably designed by
Bartolomeo della Gatta, c. 1488, largely executed by
Domenico Pecori and/or Angelo di Lorentino, early
sixteenth century, fresco. Arezzo, Museo Statale d'Arte
Medievale e Moderna.

26 Domenico Pecori, probably with Fernando de Coca and
Niccolò Soggi, *Madonna of the Misericordia*, c. 1510s, tempera and oil
on panel. Arezzo, Museo Statale d'Arte Medievale e Moderna.

of the theme directly. He evolved an unusual composition,
apparently derived in part from images of the Assumption, in
which the Virgin hovers above a group of kneeling devotees
whose portrait-like features may mark them as once–identifiable
members of the confraternity (fig. 25). Given the tall, vertical
format in which the faithful kneel in adoration and the Virgin
is raised well off the ground, her figure and those of her devo-
tees can remain at the same scale. The work betrays the assis-
tance of collaborators and has often been given to Domenico
Pecori, an important follower of della Gatta in Arezzo. Even for
a relatively provincial artist such as Pecori, by the early sixteenth
century the traditional image of the Misericordia seems to have
become difficult to embrace without adjustments. Pecori
designed an altarpiece of the Misericordia for the Compagnia
della Madonna in the Pieve of Arezzo (fig. 26) – a painting,
again, that Barocci can hardly have failed to notice when he
journeyed to Arezzo to sign the contract for the *Madonna del*

Popolo. Following the example of his master, Pecori experiments
overtly here with a format that attempts to maintain some qual-
ities of the traditional composition while rationalizing issues of
scale and space.[4] Critically, he also endeavors to heighten the
dramatic potential of the image as apparition. While the Virgin
in the fresco floats suspended above her devotees in ethereal
stillness, the figure in the panel is at the center of an active theo-
phany, with billowing clouds, awestruck beholders, and angels
that pull open her mantle to protect the reverent faithful from
the arrows of divine castigation that the figure of God the
Father threatens to hurl from on high. Such a dramatic repre-
sentation of the moment of theophany – the act rather than the
icon of *misericordia* – became important to Barocci as he re-
thought the old theme in his own terms.

If painters from the late fifteenth century onward became
increasingly disturbed by the archaisms of scale and space in
traditional representations of the Misericordia, the rectors of the

27 Rosso Fiorentino, *Madonna of the Misericordia*, c. 1528–9, chalk on paper. Paris, Musée du Louvre.

confraternity of the Misericordia seem to have become equally determined to reassert and maintain critical aspects of the venerable composition during the course of the sixteenth century. This desire arose not merely from conservative taste, but reflected as well the apotropaic roots of the image; traditional forms encoded the confraternity's purpose of displaying, honoring, and attracting the Madonna's protection. Thus the rectors were insistent even when they could command the services of some of the most important and innovative painters of the period. Rosso Fiorentino, for instance, resided in Sansepolcro, Città di Castello, and Arezzo for some time after fleeing the Sack of Rome in 1527. Vasari records that "for the Rectors of the Fraternità" Rosso "designed a panel that he would paint with his hand . . . in which there was Our Lady with the people under her mantle . . ." Rosso departed without executing the painting but Vasari owned his preparatory drawing of about 1528, which still survives (fig. 27).[5]

What is immediately striking in this drawing is the interplay between Rosso's distinctive figures and a deeply conservative, even archaizing, attempt to resolve the tensions inherent in the composition. Rosso employs the convention of kneeling devotees and raises the Virgin on a pedestal to preserve a single scale for all the participants. The problem of scale is resolved through these compositional maneuvers, but only at the expense of generating a new problem – that of space. Rosso rejected the idea of structuring the image as an apparition and thereby took a step back toward the more traditional composition in which the Virgin is simply present, rather than appearing. This decision raises significant issues for the spatial interaction between the figures. If the Virgin does not hover above her devotees as a vision but rather stands among them, they must somehow find their place of shelter literally under her outspread mantle. The depiction of a large number of naturalistically scaled figures – even though they kneel – under the cover of the Virgin's

mantle generates insurmountable difficulties for the rational placement of figures in space. Indeed, while Rosso packs eighteen worshippers into the space immediately before and around the figure of the Madonna, his resort to graphic shorthand for the faces of figures clustered under the mantle as it sweeps down behind her may register hesitation about how such a conservative composition might be fleshed out in modern style. Barocci later faced an analogous problem and registered it with an even more obvious shift in figural corporeality, in his own drawing engaging the Misericordia theme (see fig. 1).

Several decades after Rosso left Arezzo without producing a painting, the Fraternità seems to have persuaded Vasari to articulate a similar composition (fig. 28). This work has been afforded relatively little attention and it is often claimed that both its date and its purpose are unclear. It can be established, however, that the painting occupies an important place in the history of the confraternity during the sixteenth century. It was to have been the central motif in the baldachin the *confratelli* carried when they processed with the relics of Saints Lorentino and Pergentino, the titular saints of their church. The commission for the baldachin had been given to Bartolomeo della Gatta and stipulated that a tondo of the Misericordia should compose the central element; Gatta apparently died before executing the project, which was then entrusted to Domenico Pecori. Pecori's

28 Giorgio Vasari, *Madonna of the Misericordia*, mid-1560s, oil on silk. Arezzo, Museo Diocesano.

version was in turn destroyed in a fire; in the wake of this loss, the fraternity turned to Vasari. His stylish forms, coupled with his respect for the visual traditions of the fraternity, pleased both the *confratelli* and the citizens greatly; indeed, the confraternity directed a remarkable letter of thanks to the painter.[6]

Vasari's composition clusters at least twenty-five kneeling worshippers around a statuesque Virgin. Her figure is slightly elevated on a pedestal and her robe held open by nude putto-angels – one of the work's few modernizing innovations. Remembering Gilio's remark that infants or small children may be portrayed nude in religious paintings, one can sense palpably Vasari's attempt to introduce decorous modern inflections to a rigorously conservative, even archaic composition. If the angels reflect Vasari's endeavor to generate a touch of acceptable figural *vaghezza*, many of the adults in the painting are reduced to busts or even fragments of faces as they crowd beneath the Madonna's mantle. Yet evidently the members of the confraternity were satisfied; beyond their letter of thanks, they proceeded to commission Vasari to design a chapel for them in the Pieve of Arezzo and to provide the altarpiece. However, on June 27, 1574 Vasari died, before he could execute the painting. The *confratelli*, unsure how to proceed, solicited advice from Onofrio Roselli, Arezzo's representative at the Florentine court of Cosimo I. Roselli responded that the fraternity should consider Barocci.[7]

Roselli's suggestion, coming as it does from a resident of the ducal capital of Tuscany with its sophisticated court and illustrious artistic traditions, may seem surprising. Yet it is a sign of how effective Barocci was becoming in projecting his *fama* even from Urbino. Vasari himself had already recognized the young painter as a "youth of great promise" on the basis of the early Roman works.[8] While Barocci's illness and retirement to Urbino had temporarily truncated his development and obscured his nascent fame, by 1568 he had secured the commission for the *Deposition* for the cathedral of Perugia (see fig. 85) and by the early 1570s he had finally attracted the interest of his duke, Guidobaldo II della Rovere. Guidobaldo commissioned the initial version of the *Rest on the Return from Egypt* (see fig. 181 for a surviving variant) as a diplomatic gift for Lucrezia d'Este of Ferrara, betrothed to his son and Barocci's future mentor Francesco Maria II, and may have commissioned the remarkable portrait of Francesco Maria in armor after his triumphal return from Lepanto. It is thus feasible that *cognoscenti* around the Florentine court had become aware of the painter's talents; after all, Urbino maintained good relations with the Medici and Ferrara remained one of the cultural centers of the peninsula.[9]

Whatever lay behind Roselli's suggestion, the rectors of the fraternity accepted his advice immediately and wrote to Urbino on October 30, 1574 to ask Barocci to produce "a panel, with figures which represent the mystery of the *misericordia* or

another mystery and *historia* of the blessed Virgin."[10] This phrasing indicates flexibility concerning the choice of subject, despite the confraternity's traditional investment in Misericordia imagery. Nonetheless, Barocci seems to have read between the lines with concern and reached the conclusion (correctly, as events transpired) that a Misericordia was desired; he responded with alacrity:

> The desire to represent the mystery of the *misericordia* does not seem to me to [provide] a subject that is very appropriate for making a beautiful painting. If your Excellencies do not mind, one could do another mystery, for there are other *istorie* of the glorious Virgin which are more appropriate and with more beautiful inventions, such as the Annunciation, the Assumption, the Visitation, and other *istorie* which will please your Excellencies more.[11]

The use of the words "mystery" and "istoria" is telling in these letters. While it is difficult to be precise or systematic in describing the deployment of these terms in late sixteenth-century discourse on painting (or theology), one can discern that they encode deliberate, even polemical strategies in the correspondence between Barocci and the rectors. The *confratelli* stress "mystery" in their letter, though they include the phrase "another mystery and *historia*," neatly joining the two terms in sound theological tradition, with the divine mystery inherent in all scriptural stories taking pride of place.[12] Yet Barocci the modern painter responds in a manner that stresses the distinction between the terms rather than their relation – and overturns the rectors' implicit hierarchy of concepts. He too identifies the Misericordia as a mystery, and initially introduces his own suggestions as "another mystery"; but he then reverts to "*istorie*" to describe all his proposed options for the subject. Indeed, the Annunciation, Assumption, or Visitation are all subjects that involve dramatic action, while the Misericordia is first and foremost the image of a concept, a *misterium par excellence*.

Barocci's hesitation to represent a Misericordia, his sense that the subject is "not appropriate to make a beautiful painting," and his determination to distinguish the *istoria* of the ambitious post-Albertian painter from the "mystery" dominant in traditional, symbolic images indicate his perception of a critical pictorial problem. For Barocci, compromises of the sort articulated by Rosso or Vasari and encouraged by the fraternity's conservative taste were no longer satisfactory. At least at this moment, Barocci also seems to have been unsure how a modern painter would successfully represent something that was principally a "mystery," a symbolic image, rather than an image that expressed the mysteries of the sacred through the mechanisms of dramatic narrative, which were most accessible to the language of modern painting. Indeed, Barocci's comments point

up the distinctiveness of Vasari's accommodation to the apparent wishes of the confraternity: for Vasari, of all painters, had been notorious for insisting on license when painting altarpieces. In 1549, he had agreed to paint an altarpiece for the Martelli family chapel in San Lorenzo in Florence only on the condition that he be allowed to use his artistic fantasy – his *capriccio* – to create a dramatic subject from the life of Saint Sigismund. The Martelli who was to be commemorated was indeed named Sigismondo, but his heirs had intended to commission an altarpiece of the Virgin and saints. Vasari, however, asserted that such a composition would yield "little honor" compared to an *istoria* that dramatized a "horrifying scene," full of action, emotion, and artistic inventions well outside "common usage."[13] Whether Vasari proved more accommodating with the Fraternità dei Laici because of his particular devotion to the leading confraternity of his natal city, or because of a chastened attitude concerning the decorum of public religious paintings in the late 1560s, after Trent and Gilio – or both – remains unclear.[14] Nevertheless, Barocci, despite his well attested piety, insisted that he be allowed to execute an *istoria* and not simply apply a cosmetic veneer of modern pictorial rhetoric to a medieval composition. It may well be that his conviction arose from a recent personal experience; when he responded to the rectors, Barocci had probably just confronted the challenge of ideating a compelling image of the Immaculate Conception for an altar in San Francesco in Urbino.

THE *IMMACULATE CONCEPTION* AND THE ALTARPIECE AS VISION

The *Immaculate Conception* (see fig. 2) was produced for an explicitly Franciscan and confraternal context. According to Bellori, it adorned the altar of the Compagnia della Concezione in San Francesco, Urbino, and the worshiping figures included portraits of members of the confraternity.[15] The painting is in mediocre condition and must have been already deteriorating in Barocci's lifetime, since he is recorded as having repainted it in his old age. A restoration in 1972 revealed the largely autograph nature of the work, refuting the long-standing belief that the picture was an over-restored ruin or a studio work.[16] Further, surviving preparatory drawings reveal a fascinating hidden history of the painting's genesis. The drawing in the Uffizi (see fig. 1) is generally believed to record Barocci's first solution for the altarpiece. If this is true, Barocci overlays the theme of the *Immacolata* with a strikingly retrospective representation of the Madonna della Misericordia, perhaps because of some stipulation that the confraternity members in the painting be blessed by the Virgin's official protection. She spreads a voluminous mantle over the faithful in the manner

of late medieval Misericordia images, while an angel floats above her to the left and holds a crown over her head (one assumes a symmetrical angel to the right). The angel, like Vasari's, is a nude putto rather than the clothed adolescent of most earlier representations of the theme for the fraternity in Arezzo, and Barocci resolves the unnaturalistic disparities of scale characteristic of traditional Misericordia images by rendering the Virgin's devotees as half-length figures, cut off by the frame and thus able to nestle under her mantle while remaining naturalistic in scale. Nonetheless, the spirit of the composition remains decidedly retrospective and may reflect a response to a request for an old image type of the sort evidently desired by the rectors of the Fraternità dei Laici.[17]

Whether the Uffizi drawing reflects the initial compositional idea for the painting in Urbino remains slightly unclear, it seems to me, despite the currency of this assumption in the Barocci literature. Its obvious Misericordia iconography, with none of the symbols of the Immaculate Virgin (such as the crescent moon that appeared in the painting) could even imply that the drawing reflects a first attempt by Barocci to accommodate the Aretine rectors' request, despite his expressed hesitation. Yet the Uffizi sheet is closely linked to a group of drawings clearly related to the invention of the Immaculate Conception. Further, the extensive letters and the final contract between Barocci and the rectors of the Laici indicate that the painter negotiated a compromise subject for what became the Madonna del Popolo, and thus would never have felt compelled to experiment extensively with an overtly retrospective solution; the Uffizi drawing, however, is highly finished and squared, representing a fairly advanced stage in a design process. Peter Humfrey has pointed out that the Council of Trent "did not lend unambiguous blessing" to the controversial doctrine of the Immaculate Conception, and that the imagery of the Madonna della Misericordia had been frequently employed since the Quattrocento as a vehicle for Immaculatist ideals.[18] It is difficult to see why the Compagnia della Concezione might have perceived any necessity for such a strategy; their Franciscan protectors were established partisans of the Immaculatist position. Nonetheless, it is true that the crescent moon is absent from some other drawings that can be securely associated with the preparation of the Urbino painting. In any case, the rigorous iconographic distinctions sought in some modern art history were rarely so fixed in the late medieval or early modern eras.[19] While none of the available evidence establishes the exact relation of the Uffizi drawing to the Immaculate Conception or to the Madonna del Popolo, it is clear that critical aspects of the drawing relate to issues Barocci faced in both projects, which were probably undertaken at nearly the same time and for confraternities desiring representations of divine "mysteries."

Indeed, while a dearth of written documents prevents an exact dating of the Immaculate Conception, it is tempting to place it (as both Olsen and Emiliani do) just before the Madonna del Popolo and to read its genesis as an experiment in which Barocci struggled to infuse an iconic and symbolic composition with new energy. His reluctance to attempt a Misericordia for Arezzo would thus arise directly from his frustration with the difficulties of ideating the painting for Urbino. As the development of the Immaculate Conception can be followed in greater detail through surviving drawings than can that of the Madonna del Popolo, I shall trace the remarkable trajectory they delineate.

Barocci's decisions and hesitations on the Uffizi sheet offer indications of his approach to the challenges posed by "representing" a retrospective image type. His initial solution is remarkably similar to those ventured by Rosso and Vasari. This is not to say that Barocci knew either image at this time (he would later have been able to see Vasari's painting during his eventual trip to Arezzo to finalize the contract for the Madonna del Popolo). The similarity between the images may indicate the extent to which institutions such as the Fraternità dei Laici continued to demand traditional images throughout the sixteenth century, and the fairly restricted scope within which visual compromises between old compositions and new styles could be articulated. Indeed, Barocci would have known a composition similar to that of Rosso or Vasari among the Titians in the collection of the della Rovere. Much patronage in the Marches also evinced a taste for traditional images – even, for certain subjects, at the ducal court itself. Prominent painters seem to have been willing to adapt to these exigencies on occasion. At about the time Barocci probably conceived the Uffizi drawing, Titian himself was asked by Duke Guidobaldo II to produce a Misericordia – or more precisely, "a standing Madonna, with a number of people under her mantle" (fig. 29). While Guidobaldo is better known for commissioning Titian's Venus of Urbino, when he requested a Misericordia from the great Venetian he evidently desired a work dominated by tradition, not by the "vaghezza of art." Today the painting is thought to contain significant workshop interventions and, indeed, the duke explicitly allowed Titian this option because of the painter's advanced age. The surviving correspondence, however, indicates that Titian promised to execute the picture himself; however loosely he interpreted this pledge, several letters indicate that he did a significant amount of the painting.[20] He portrays the faithful kneeling, so as to overcome archaic hierarchies of scale, but his image nonetheless recalls the spirit of its prototypes.

Even in Venice itself confraternities devoted to the Misericordia might expect highly traditional images from important

29　Titian and workshop, *Madonna of the Misericordia*, 1573, oil on canvas. Florence, Galleria Palatina.

30　Agostino Carracci, *Madonna of the Misericordia* (after a painting by Veronese, now lost), 1582, engraving. London, British Museum.

artists. Between the late 1560s and his death in 1588, Veronese produced a *Misericordia* for the Venetian Scuola Grande della Misericordia. The painting is now lost but its appearance is recorded in an engraving by Agostino Carracci which demonstrates that Veronese attempted to avoid the theme's compositional and spatial difficulties by depicting only two devotees as representatives of the faithful (fig. 30). However, a drawing (Pushkin Museum, Moscow) by Veronese indicates that he wrestled with additional strategies for enlivening and modernizing the theme, including turning the Virgin's body at an angle to activate her pose. Forward movement is implied in some of the sketches on the page; but the final solution, as was the case with Barocci's *Immaculate Conception*, calms dramatic activity to heighten the contemplative, symbolic, and traditional valences of the composition.[21]

While recalling responses such as those of Rosso, Vasari, and Titian to the exigencies of the Misericordia type, the proposal Barocci advanced in the Uffizi drawing distinguishes itself in critical ways. Barocci's decision to let the lower edge of the composition truncate the figures of the worshippers – it is not even clear whether they kneel or stand – dramatically lessens the space they occupy and allows the Virgin to tower over

them, yet maintains consistent figural scale. This strategy heightens the impression of the Virgin's hierarchical dominance at the very moment that it facilitates rational spatial relations between her figure and those of her devotees. Further, in a fundamental decision that inflected his planning from this point on, Barocci presents the Virgin standing on clouds. He thus decisively separates her numinous realm from that of her devotees in a manner that at once enhances the representational modernity of the image and recalls the venerable meanings inherent in the original iconography with unusual power; the device effectively accomplishes what distinctions of scale had instated in medieval images of the Misericordia.

In the *Immaculate Conception* in particular, the distinctive balance of intimacy and distance between the sacred and the faithful that had been established in traditional depictions is compellingly represented in modern visual language. In old images the Virgin's devotees were diminutive yet clustered directly against her towering figure and under her mantle. In Barocci's reconceptualization, the clouds of theophany separate the Virgin's space from that of the faithful; yet the depiction of devotees leaning out of the picture space, their forms truncated by the lower frame as if by a railing, and the Virgin close to

41

31 Raphael, *Madonna di Foligno*, c. 1511–12, tempera and oil on canvas (transferred from panel). Vatican City, Vatican Museums.

them, nearly overshadowing them, re-inscribes an intimacy of proximity while maintaining the reverence due the Queen of Heaven. Barocci's particular strategy for modernizing the image of Misericordia, however, signals his adoption of the "vision altarpiece" that itself had a venerable history but had been powerfully developed in modern form by Raphael in altarpieces such as the *Madonna di Foligno* (fig. 31), the *Sistine Madonna* (fig.

32), and the *Transfiguration*. These paintings had proposed compelling solutions to one of the fundamental challenges of sixteenth-century altarpiece design, that of negotiating the tensions between devotional, liturgical, and compositional tradition on the one hand and pictorial modernity on the other. The sort of altarpiece Raphael evolved became a significant form during the sixteenth century, and perhaps the dominant

32 Raphael, *Sistine Madonna*, c. 1512–14, oil on canvas. Dresden, Gemäldegalerie.

form for the seventeenth and early eighteenth-century *pala* in Italy; Barocci's commitment to it, coupled with his success as a painter of religious images in the eyes of his contemporaries, may well have contributed to its triumph.

Barocci's investment in the "vision altarpiece" demands significant further consideration. The Uffizi drawing, however, stands near the beginning of this trajectory and demonstrates first and foremost the painter's struggle with other problems with which the theme of the Misericordia confronted him. Indeed, while the upper portion of the drawing seems fairly resolved, one senses Barocci's rising dissatisfaction as he worked up the lower half of the sheet. Behind the finished foreground figures are outlines for the heads of a number of additional devotees under the Virgin's mantle as it sweeps down behind her. The summary nature of these figures in relation to the foreground is remarkably reminiscent of Rosso's drawing for the fraternity, but the disjunction of finish between the two figure groups is even more pronounced in Barocci's study. The positions of the figures behind and below the Virgin, and under her mantle, may have seemed plausible in a quick pen sketch.

or *gonfaloni* in particular, the Madonna appears on a cloud – sometimes with her devotees raised on a cloud as well – above their city. Several examples survive from Umbria, and Barocci would surely have known the type. While *gonfaloni* are often described simply as processional banners, evidence from the fifteenth and early sixteenth centuries indicates that they were frequently displayed over altars when not deployed in processions. Thus, in *gonfaloni* Barocci might have found a genre of images that was intimately linked with the histories and traditions of confraternities and could also serve as a model for altarpiece design.[22]

While Barocci may have reflected on any number of *gonfaloni*, one not far from Urbino might have become of particular importance for him in planning the *Immaculate Conception*. In Gubbio (the old "second capital" of the dukes of Urbino) Sinibaldo Ibi, a regional follower of Perugino, had produced in 1503 a two-sided *gonfalone* depicting Saint Ubaldo on one face and the Madonna della Misericordia on the other (fig. 33). The pose of the Madonna, the fact that she is raised on a small cloud and is in the process of being crowned by angels, and even the depictions of some of her devotees indicate that Barocci might have looked to this work or one very like it as a model of a more or less traditional Misericordia. Although Barocci rejected the diminutive scale of Ibi's reverential lay figures, the poses of two of the women exhibit intriguing similarities to figures in the Uffizi drawing. The female worshipper closest to the center of the Gubbio composition, hands upraised in a gesture of awe, reminds one immediately of the foremost female devotee in Barocci's drawing. By itself, this resemblance might be passed over. However, once one notices the figure at the viewer's extreme right in Ibi's composition, who faces the beholder, clasps her hands in prayer, inclines her head sharply inward and up toward the towering Virgin – and thus bears an uncanny resemblance to the figure to the Virgin's left in the Uffizi drawing – the analogies between the two images begin to seem more than coincidental. Such connections should not be pushed far – but noting them may clarify that Barocci was looking in some detail at traditional representations of the Misericordia as he ideated the Uffizi drawing, and that confraternal *gonfaloni* could have provided particular inspiration.

Both Ibi's painting and Barocci's Uffizi drawing present relatively still, contemplative compositions, but the clouds in the *gonfalone*, and in particular the opulent *mandorla* that frames the Virgin, make clear that Ibi is presenting his Madonna as an apparition, for the *mandorla* had long been the traditional sign for apparitions and for the Virgin's Assumption.[23] This concept of apparition, of vision, became fundamental for Barocci as he began to think through possibilities for energizing the static traditional compositions adopted by Vasari, Titian, and Rosso. In

33 Sinibaldo Ibi, *Gonfalone of Saint Ubaldo* (with Saint Ubaldo on the obverse and the Madonna of the Misericordia on the reverse), 1503, tempera on cloth. Gubbio, Pinacoteca Comunale.

Yet once the volume of these figures was studied through the copious application of white highlights, the presence of some of them became spatially untenable. To maintain a consistent scale, several figures would have to be imagined as standing in a space extending well behind the Virgin – but this would undermine the necessary illusion that her cloak covered them.

It seems to have been at this point of frustration that Barocci began to experiment further with the conventions of the vision altarpiece. Although he had raised the Virgin on a small cloud, he had not "activated" the clouds as frame and vehicle for a dramatic theophany. The Virgin stands on a support that clearly indicates her heavenly existence (rather than on a material, manufactured pedestal), but she is static, present as a cult object or icon, rather than riding on the clouds, sweeping forward to encounter her earthly worshippers in the manner of the Virgin in Raphael's *Madonna di Foligno*. There were numerous provincial Quattrocento prototypes for the solution Barocci attempted in the Uffizi drawing. In many confraternal banners

34 Barocci, compositional study for the *Immaculate Conception*, pen, wash, and charcoal on paper, 23.7 × 18 cm. Paris, Musée du Louvre, inv. 2855.

the Uffizi drawing Barocci already replaced the pedestal employed by Vasari and Rosso with a cloud; in another drawing (generally assumed to be later; now in the Louvre) he begins to transform his initial, relatively static composition into something with real dramatic power (fig. 34). The entire background is now filled with the clouds of the Virgin's sudden apparition among the faithful, one of whom hails her arrival with upraised arms. Barocci here enshrines the Virgin in a cloudbank distinctly reminiscent of the old *mandorla*. This cloudbank effectively obviates the need to depict figures who might be behind the Virgin – one can see a few hazy faces, no more – and allows an emotional focus on her interaction with the figures before her, over

whom she spreads her arms in a dramatic, encompassing blessing. Here, this gesture bears the total symbolic weight of divine protection. The Virgin no longer extends her cloak over the faithful; the cloak becomes instead the sign of her precipitous theophany, as it is whipped across her body by a gust of wind.

For the final painting Barocci arrived at a more considered version of this composition that heightens both its artistic elegance and the effectiveness of his restatement of Misericordia imagery. Barocci maintained from the Louvre drawing a composition enveloped in the clouds and vapors of the Virgin's apparition. His solution privileges the dominance of visionary space exemplified in Raphael's *Sistine Madonna* over the split-level arrangement of most vision altarpieces, which preserve a fully articulated earthly space below that of the heavenly apparition. The complete lack of a ground plane, and the sense that the Virgin is moving forward toward her awed devotees (and toward those who stand before the altar) must have made this a particularly effective image when placed over its altar, especially when the clouds of incense before the altar began to blur the precise demarcation between the vaporous air of the painting and the space before it. This is an altarpiece at once august and intimate.

Despite the numerous similarities between the Louvre drawing and the final painting, in the latter the movement of the Virgin is quieted in comparison with her dramatic apparition among the faithful in the former. While modern, graceful, and activated, the painted figure of the Virgin reassumes some measure of the cultic aura privileged in the Uffizi drawing. This is first apparent in her gestures and those of her devotees. The Virgin still conveys divine mercy and blessing through a gesture similar to that in the Louvre drawing, but the energy is less urgent and her arms are lowered again toward the height at which they had supported her mantle in the original scheme. This revision lends greater poise, balance, and queenly decorum to the Virgin – and a greater sense of *Misericordia* to the composition. Hints of this evolution are evident in the Louvre drawing itself, which demonstrates that Barocci was particularly concerned to establish the optimal pose of the Virgin's right arm; pen lines indicate positions both above and below the one he highlighted in the study. The highest position, while heightening the drama of the composition, may have skirted too close to traditional poses of judgment to be appropriate to the Misericordia.

Barocci's rethinking of the Virgin's gesture is paralleled by his rethinking of those of the faithful. No longer are there any out-flung arms: the adults are quietly, humbly reverent and the child on the right no longer twists away in surprise and fear at the Madonna's appearance. This little girl still figures beautifully a response of awe and wonder to the sudden approach of the Virgin. Now, however, she leans backward, supported by her encouraging mother – whose head covering provides a miniature, personal cloak of *misericordia* for the child – to offer a wide-eyed prayer to the Madonna who towers over her.[24]

One of the most evident revisions of the Louvre composition is the treatment of the Virgin's robes. Barocci has maintained the concept of windswept drapery, but he has re-elaborated the mantle in a way that makes his image more reminiscent of its archaic Misericordia prototypes. While in the Louvre drawing the Virgin's mantle whips across her from her right but does not billow out to her left, in the final painting the drapery on her left is lifted by the wind in such a way that it flows gracefully out of the confines of her cloudy *mandorla* and almost touches the edge of the picture. In so doing, it symbolically covers all the women and the little girl, as if it were held over them by the Madonna's arm. Barocci has heightened this allusion by covering the front of the Madonna's entire left arm with the blue cloak, while in the Louvre drawing it blows back over her shoulder.[25] However, as the wind motivates the arrangement of the Virgin's drapery, consistency demands that her robe not billow equally over the men; Barocci compensates here by emphasizing the blessing and protecting gesture of the Madonna's right arm, extended forward over her male devotees. He also reverses the inclination of her head from that in the Louvre drawing so that it inclines toward the men.

A further detail may be noted. In the painting, Barocci's cloudy *mandorla* has become mistier, less delineated than in the Louvre drawing. In this respect it is "modernized," recalling the Raphael of the *Sistine Madonna* once again. Yet Barocci has recast a modern pictorial device he developed from Raphael – that of the angelic putti of cloud vapor who become flesh as they approach the foreground – to allude more forcefully than Raphael's images to earlier sources. For it was common in late medieval and fifteenth-century depictions of apparitions of the Virgin or of Christ to articulate the *mandorla* with evenly spaced cherub heads, as Barocci does here.[26]

For the *Immaculate Conception*, then, Barocci expended much effort to hold old and new, retrospective and innovative, in creative tension. If the painting pleased his patrons, they may have found particular satisfaction in the degree to which he managed to preserve a number of the qualities of old images in what was essentially a modern painting. Indeed, even some twenty years after Barocci struggled to modernize the themes of the Misericordia and the Immaculate Conception, an artist as prominent as Federico Zuccari could still produce a remarkably retrospective *Immaculate Conception* for a confraternal and Franciscan setting precisely analogous to Barocci's – the altar of the Compagnia della Concezione at San Francesco in Pesaro, by this time the principal court city of the dukes of Urbino

35 Federico Zuccari, *Immaculate Conception*, 1592, oil on canvas. Pesaro, San Francesco.

36 Claudio Ridolfi, *Madonna of the Misericordia*, c. 1620, oil on canvas. Saludecio, San Biagio.

(fig. 35). Modern writers who comment on this painting are often nonplussed by what one scholar described as its "rigid iconic stasis."[27] The picture is in fact closer in some respects to Barocci's Uffizi drawing than to his finished painting – particularly in the traditional composition of the figure of the Virgin and in the detail of the putto angel holding the crown over her head – though the cherub head that looks directly at the viewer from below the Virgin's feet appears to indicate Zuccari's close observation of Barocci's altarpiece.

Indeed, Barocci's Uffizi drawing (or possibly a cartoon made from it) seems to have been known well beyond the artist's studio and generated something of a following. It is, for

instance, the evident model for the *Misericordia* attributed to Claudio Ridolfi in San Biagio in Saludecio (fig. 36). This painting follows Barocci's drawing in most of its details; several other altarpieces can be identified as closely related adaptations and seem to predate Ridolfi's version, which can be placed around 1620. Further, the vogue for paintings after the Uffizi drawing can be traced at least as late as Alfonso Patanazzi's *Misericordia* of 1662–3 for Santa Maria del Piano in Urbania, close to Urbino.[28] Even in the ambience of Barocci's own studio, unknown collaborators, evidently with the master's permission, employed elements from the Uffizi sheet in the *Virgin and Child with Saints Geronzio and Mary Magdalene, and Donors* that was

37 Workshop of Barocci, *Virgin and Child with Saint Geronzio, Mary Magdalene, and Donors*, 1590s, oil on canvas, 270 × 213 cm. Rome, Sodalizio dei Piceni.

painted some time around 1590 for the altar of the Misericordia in San Francesco at Cagli, south of Urbino (fig. 37). The collaborators were provided with new drawings by Barocci for some figures, but they also borrowed from his *Madonna del Popolo*, the Louvre *Circumcision*, the *Madonna di San Simone* (see figs 24, 133, 177), and the Uffizi study – in particular here the notion of figures behind the Virgin and completely under her cloak.[29] While the atmosphere of the painting has been modernized, the recourse to an archaistic detail of the Uffizi drawing that seems to have troubled Barocci is striking, as is the critical fortune of that drawing into the seventeenth century. Yet, as noted earlier, a taste for retrospection can be documented in the Marche at this date not only among local confraternities and similar institutions but also occasionally at even the highest social and cultural levels. Despite the retro-

spective elements in Zuccari's solution in the altarpiece for Pesaro, a period viewer as sophisticated as Barocci's mentor and patron Duke Francesco Maria II wrote to his agent in Rome: "If you bump into Zuccaro the painter, tell him . . . I have seen the painting done by him for the Compagnia della Concettione here [Pesaro], which appeared so *vago* and beautiful to me . . ."[30]

The ways in which a contemporary observer could perceive *vaghezza* in a painting such as Zuccari's may be explained in part by Talpa's description of the composition, "at once *vago* and *devoto*," formed by a retrospective image of the Madonna della Vallicella surrounded by a glory of angels in modern style. Zuccari's painting could be described loosely as an analogous type of composition. However, this "two-styles" solution – whether articulated in two distinct images or within a painting by a single hand – is one with which Barocci could never be comfortable. If Barocci scholarship is correct in dating the production of the *Immaculate Conception* just before the commission for the *Madonna del Popolo*, Barocci's immediate and concerned reply to the request from the Fraternità dei Laici for a *Misericordia* is a powerful indication of the extent of his struggle to reconcile stylistic modes and eras in the Urbino painting, and his desire never to repeat the experience.

THE MODERN MISERICORDIA

The rectors – evidently in need of an altarpiece – accepted Barocci's initial rejection of their preferred traditional image and quickly responded that the painter should come to Arezzo to inspect the chapel and its lighting so that he could better accommodate his picture to the space, "and so that we can agree more quickly or easily on the quality of the figures and the sort of *istoria* that can be done there."[31] The rectors' univocal use of *istoria* here indicates that they even seem to have registered Barocci's linguistic hint concerning the type of painting he would be willing to produce. Despite these overtures, Barocci replied immediately to excuse himself from travel to Arezzo "because of my indisposition" and urged the rectors to send him a drawing of the chapel that indicated illumination, to select the *istoria*, and "for the rest leave the work to me."[32] Barocci's reluctance to travel proved fortuitous for history, as it occasioned the voluminous correspondence between the painter and the somewhat frustrated rectors, who continued to insist that Barocci journey to Arezzo. Despite the richness of the correspondence, it is not clear whether the rectors accepted Barocci's blunt advice to choose a subject and leave the ideation of the painting to him. However, the final contract implies significant negotiation between the painter's desire for an *istoria* and that of the confraternity for an image that remained close

to their preferred "mystery" of the Misericordia. The critical stages of these negotiations may have been oral and unrecorded in letters, as the persistent rectors at last prevailed on a reluctant Barocci to appear in person to finalize the contractual arrangements. In the contract, signed on June 18, 1575 in Arezzo, the subject of the painting is not given a specific name but is rather described: "The *historia* of the said panel shall be the most glorious Mary *Deipare* always Virgin interceding and praying to the Lord Jesus Christ her son for his benediction to the populace, who shall be likewise painted and represented in the said panel with decorum and beauty and grace, according to the conditions and qualities of the figures there painted."[33]

In a very real way this description accommodated the desires of both painter and confraternity. From one perspective, the contract calls for Barocci to produce a version of a Misericordia, though the term is not employed. The fact that what Barocci eventually created could be viewed as a Misericordia by period eyes is demonstrated by Bellori himself – hardly an unsophisticated viewer – who offers a detailed analysis of the dramatic elements of the panel but identifies it without hesitation as a "painting of the misericordia."[34] Bellori followed Raffaello Borghini, who within a few years of the painting's completion described it as "the panel of the *Madonna della Misericordia* with many figures belonging to this *misterio*, and this work is much renowned, and done with great art. . . ."[35] Borghini's understanding, from his position in Arezzo's capital, Florence, that the painting represented the *misterio* of the Misericordia indicates that in some sense Barocci had managed to give the rectors what they ideally wanted. From Barocci's perspective, however, the language of the contract opened up the possibility for the complex pictorial experiment that became the *Madonna del Popolo*. The very fact that the subject is described rather than named stresses its identity as an *istoria*, and it is no accident that *istoria* is the word agreed on to introduce the description of the subject. Barocci had been freed to re-interpret and re-elaborate the traditional image of the confraternity in the compelling visual language for which he was becoming famous.

Even before close acquaintance with its rich documentation, the attentive observer senses that the *Madonna del Popolo* is the result of great reflection, effort, and indeed struggle. The measure of the struggle can be taken not only from what can be discerned about the development of the *Immaculate Conception* but also from a simple comparison of the images: the project that produced the *Madonna del Popolo* is so similar in initial conception to the *Immaculate Conception*, yet so different in final appearance. The altarpiece for Arezzo required far longer than the one year stipulated in the contract, and at one point the impatient rectors wrote that they hoped the painter was expending "study and diligence, and still such solicitude that the

[panel's] decorum, and perfection are not lessened. . . ."[36] While the letter was occasioned by the painter's slow progress, the phrasing implies concern lest Barocci compromise decorum in his transformation of the *Misericordia*. Barocci only answered such concerns with assurances that the painting was nearly finished and reminders that the cause of his slowness stemmed from his illness.[37] When, however, late in 1578, the rectors refused to provide the second contracted installment of Barocci's payment because the painting remained incomplete, the painter's simmering indignation broke through. "I esteem my honor much more than receiving the money you promised," he wrote, and added that while his chronic illness had slowed the process of painting, he had nonetheless "done with the work twice what I promised."[38] The constituent elements of Barocci's exceptional investment of thought and labor as he ideated a new kind of altarpiece for the Fraternity are not documented in the letters and only partially in surviving preparatory drawings. However, by reading back and forth between the painting, drawings, the contract and letters, traditions of confraternal imagery, and the trajectory of the development of the *Immaculate Conception*, one can begin to sense something of the nature and extent of the thinking that lies behind the Aretine altarpiece. Barocci seems to have proceeded principally along two lines: he adapted elements from a tradition of confraternal imagery that had already begun to elaborate the most traditional *Madonna della Misericordia* compositions, and he joined these with the structure and drama of the modern vision altarpiece.

The stipulation in the contract that Barocci's painting should represent the Madonna interceding with Christ on behalf of the populace raised the possibility that the theme of Misericordia could become active while implicitly remaining within the parameters that the rectors deemed satisfactory for confraternity images. There are numerous precedents for just such a "narrativization" of the Misericordia in some important confraternal *gonfaloni* that survive from nearby Umbria. In addition to the *Madonna della Misericordia* strictly defined as an iconic image of the Madonna sheltering the faithful under her cloak, there had long been a *gonfalone* iconography of the Madonna actively interceding with her Son for a populace. One early Cinquecento example that Barocci probably knew was a *gonfalone* in the Cathedral of Perugia, painted by Berto di Giovanni in 1526 during a devastating outbreak of plague (fig. 38).[39] There Christ and the Virgin appear with saints and angels over Perugia. The city is accurately represented on its hill in the distance. An angry Christ raises a sword to strike down the imploring, terrified citizens in the foreground below him, but the Virgin catches his upraised arm, restraining the blow while gesturing with her other arm toward the populace she has been invoked to protect.

38 Berto di Giovanni, *Gonfalone of the Duomo of Perugia*, 1526, tempera on cloth. Perugia, Cathedral of San Lorenzo.

This *gonfalone* exhibits striking compositional similarities to Barocci's solution in the *Madonna del Popolo*, but its mood, of judgment averted rather than of blessing, is entirely different; a salient theme in the *Madonna del Popolo* is clearly the blessing Christ offers the people of Arezzo in response to the charitable works promoted by the Fraternità dei Laici. In the *Madonna del Popolo* the Virgin both blesses the act of almsgiving herself – her left hand rests in a gesture of consecration over the dona-

tion of alms at the right-hand side of the image – and indicates it to a receptive Christ, who offers a serene benediction. The Perugian Cathedral banner represents, in fact, an earlier attempt to modernize the traditional Misericordia image as it had often appeared in *gonfalone* and to heighten the element of *istoria*. Nonetheless, while Berto enhanced dramatic elements, he adhered to a long tradition of *gonfalone* imagery that stressed the Madonna's role in appeasing divine wrath. Such images of the Misericordia on *gonfalone* had rarely been entirely static. Almost without exception, they had depicted a small image of Christ or God the Father at the top of the composition, hurling arrows of divine wrath down on a helpless populace, who were saved only by huddling under the shield of the Madonna's mantle, which shattered the shafts and mollified the wrath of the Almighty.[40] An early modification of this theme in the direction of Berto di Giovanni's (and ultimately Barocci's) more Christocentric presentation is exemplified by the *gonfalone* of Santa Maria Nuova, often attributed to Benedetto Bonfigli, also from Perugia and thus accessible to Barocci (fig. 39).[41] Here an iconic, austere Christ replaces the Virgin in the center of the composition; the Virgin floats to Christ's right on a lower cloud and, with the assistance of saints, intercedes for her people with pleading expressions and gestures rather than an outspread mantle. However, this image was identified in 1472 as the "*gonfalone* of the Glorious mother Mary always virgin."[42] Such a perception clarifies how Barocci's painting could be called "the panel of the *Madonna della Misericordia*" and eventually the *Madonna del Popolo*.

Gonfaloni such as these could have provided compositional suggestions for Barocci but little thematic material, as their tenor was far different from the image of sunlit blessing that he sought. An extraordinary example of a "blessing" adaptation of Misericordia imagery does exist, however, in a fifteenth-century confraternity image Barocci would have known well. Bonfigli's *gonfalone* for the Confraternity of San Bernardino da Siena in Perugia (fig. 40) may provide the critical link between the *gonfalone* tradition and Barocci's ideation of the *Madonna del Popolo*, for it conjoins a remarkably gentle scene of Christ's blessing with something not usually present in *gonfalone* Misericordia imagery – a populace actively engaged in devout works, rather than depicted in fearful contrition and prayer. This combination of blessing and good works directly foreshadows both the mood and the theme of Barocci's *Madonna del Popolo* – and it had not been explicitly envisioned in Barocci's contract, which seemed to imply a more usual presentation of the genders and ranks of the populace. Bonfigli's remarkable image hung in the great Oratory raised to the Franciscan Observant leader in Perugia and formed the centerpiece of the famous "nicchia di San Bernardino," a religious

39 Benedetto Bonfigli, *Gonfalone of Santa Maria Nuova*, 1472–3, tempera on cloth. Perugia, Santa Maria Nuova.

40 Benedetto Bonfigli, *Gonfalone of San Bernardino da Siena*, 1465, tempera on cloth. Perugia, Galleria Nazionale.

and civic landmark which Barocci surely visited as he worked on an altarpiece for the chapel of San Bernardino in Perugia's cathedral. Indeed, the Oratory is annexed to the Church of San Francesco al Prato, where Barocci studied Raphael's Baglioni *Entombment*, a painting on which he later reflected at length when he produced his own *Entombment* (see fig. 83) for a confraternity in Senigallia.[43] In Bonfigli's image, San Bernardino

replaces the Madonna on the lower cloud to Christ's right and gestures to his Perugian devotees below. The slightly off-center Christ hardly seems to require the intercessory gesture. There is no hint of judgment here; the whole rationale for Christ's apparition seems predicated upon his benediction for the people of Perugia. The sky is filled with angels making music or carrying baskets of roses – no arrows have been brought –

and Christ offers his blessing freely and gently, looking down benignly on the Perugians who, led by their clergy and civic magistrates, devoutly present candles and cloths for use in the feast of San Bernardino.

One other critical detail may confirm a connection between Bonfigli's *gonfalone* and Barocci's *Madonna del Popolo*. The figure of Christ in *gonfaloni* with Misericordia themes had nearly always been represented clothed in a loose robe that left much of his torso exposed, revealing his side wound. In *gonfaloni* in which Christ became the central or most monumental figure, as in that of Santa Maria Nuova in Perugia, this characteristic was particularly stressed. Christ is there the Judge and the Virgin intercedes for a populace as she will intercede for all on the Day of Judgment. Yet in Bonfigli's *gonfalone*, Christ wears not only an opulent golden damask robe but also a brilliant blue tunic that completely covers his side, as the lower hem of his robe covers his feet. Thus the only perceptible stigmata are in the hands that bless and hold the banner of victory – and here the wounds have become golden like the robe, gilded in victory rather than red as reminders of suffering. This invention effects a rare portrayal of Christ's post-resurrection body as entirely glorified. In Barocci's *Madonna del Popolo*, Bonfigli's distinctive representation seems both registered and developed in a remarkable direction. Here again, Christ is fully clothed, so that his side wound is hidden, but his hands and a foot are clearly visible; indeed, the Virgin even seems to indicate Christ's foot with her right hand. Yet there are no more wounds. Christ's blessing for the Aretines is offered from a heavenly vision in which the distance between earth and heaven is clear, but the division between earth and heaven exemplified in the Crucifixion has been abolished. The stigmata that demand justice and judgment have, at least in this happy moment of cosmic harmony, miraculously evanesced.

Even the space in which this remarkable vision occurs seems to indicate Barocci's deep and distinctive reflection on Bonfigli's image. It is notable that Bonfigli has not chosen to depict the whole of Perugia in the background but rather the field before the great church of San Francesco al Prato and the Oratorio of San Bernardino. This combination of setting and scene allowed Perugia as a whole to be included in the benediction, while also focusing attention on the Oratory of the confraternity for whom the banner was produced – all the while facilitating a more modern representation than that permitted by the usual depiction of entire towns in the lower portions of such banners. Barocci, too, represents only an exemplary portion of Arezzo. It seems likely that this is the Piazza Grande in which the fraternity was based; but the very fact that the background is obscured by the mists that trail from the theophany appears intentional, and perfectly calibrated for the

"mission" of the *Madonna del Popolo*. For the message of the great altarpiece as Barocci conceived it is both specific and general, both local and universal. The setting and its actors have their own reality, but they also represent a greater space, and a larger community, than was possible to encompass in naturalistic representation.[44]

When Barocci set out to rethink radically the imagery of the Misericordia in the *Madonna del Popolo*, then, he might well have remembered Bonfigli's *gonfalone* of San Bernardino, and that of Berto di Giovanni at Perugia Cathedral. While the extreme activation of traditional iconography that characterizes the *Madonna del Popolo* may have been developed in relation to Berto's painting, the mood, the blessing of good works, and the approach to the depiction of a civic setting find their closest analogues in the *gonfalone* of San Bernardino. Such a tradition was one that Barocci could – to some degree – inhabit. Yet *gonfaloni* and calculated retrospection were only half of the delicate, complex equation that produced the *Madonna del Popolo*. Barocci's search for an image that fused the dramatic action of *istorie* with evocations of traditional iconography and composition ultimately drew him to the vision altarpieces cultivated by the mature Raphael. Barocci had already designed an altarpiece based on Raphael's *Madonna di Foligno* (see fig. 31) for the Capuchin church of Fossombrone (fig. 41).[45] In the *Madonna del Popolo*, he returned again to the hierarchical division of heavenly and earthly zones, and the cloud-demarcated, forward moving apparition that had characterized Raphael's great Roman altarpiece.

If the young Raphael had broken with the strictures of the traditional altarpiece in the Perugia *Entombment* (see fig. 87) – an *all'antica* disruption of the altar image that transformed it into an Albertian *istoria* with *dramatis personae* who stride right to left across what had once been a stable picture plane with iconic figures – the mature Raphael reflected profoundly in the *Madonna di Foligno* at Santa Maria in Aracoeli about what it meant to create a high altarpiece in a thoroughly modern but equally devout form. The Aracoeli was a church and a place much venerated in Rome. According to tradition, it was atop this hill overlooking the Capitoline that the Emperor Augustus had been granted a vision of the Virgin and Child. This idea, with its attendant implications of narrative drama, proved critical to Raphael as he reflected on how to create a modern high altarpiece. In his reflection, Raphael turned not merely to the *all'antica* sources that have been stereotyped as his only interest but also to consideration of the more recent Christian visual tradition.[46] First, he returned to the traditional form of the *sacra conversazione*: a frontally oriented Virgin and Child are placed high and centrally above and between two symmetrically disposed groupings of saints (and in this case the donor).

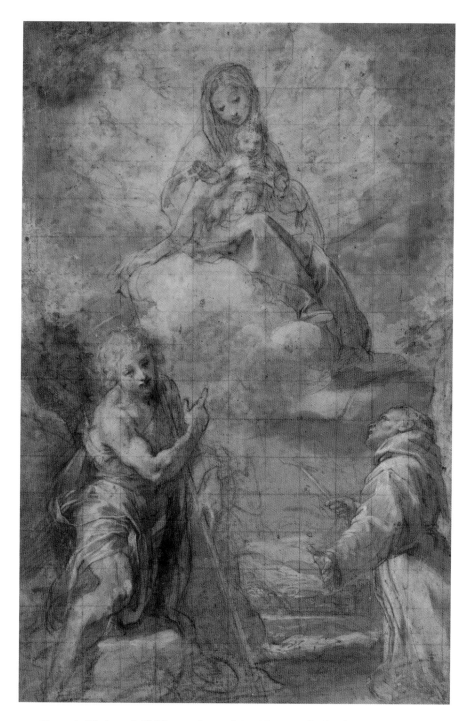

41 Barocci, *Virgin and Child appearing to Saints Francis and John the Baptist*, compositional study for the Fossombrone altarpiece, pen, wash, chalk, and white heightening on paper, 38 × 25 cm. London, British Museum.

However, Raphael represented this traditional composition as an apparition. This critical maneuver allowed the compositional formula of the older image type to be preserved but side-stepped the most pressing difficulties it presented to modern painters. The painter could now transform the traditional altarpiece into a narrative drama. Nevertheless, though dramatic, the vision, with its distinct division between heavenly and earthly realms, actually re-inscribed some of the sense of awe and divine distance that had traditionally constituted the aura of the liturgical image.

A well-known art historical *topos* contends that the fifteenth century (and even the fourteenth century) developed the *sacra conversazione* into a true conversation by transforming the iconic isolation of figures in early polyptychs into a representation of

emotional and psychological interchange between figures in a unified visual field; increasingly, this interchange was extended to viewers before the image. However, these interactions were generally subdued, in part because of traditional concepts of altarpiece decorum (the altarpiece was concerned first with the presentation of holy figures for veneration, not with narrative drama) and in part because the evidently ahistorical nature of the interaction of saints gathered around the Madonna and Child underscored the atemporal, eternal essence of the community of faith.[47] Yet as pictorial illusionism developed, an important implication of this atemporal character was visualized with ever greater mimetic conviction. Many of the great *sacre conversazioni* of the fifteenth century stress the quotidian nature of divine presence: they bring the holy close, to the floor of a contemporary chapel or to a chamber in a contemporary palace. Such paintings articulate what Robert Scribner has called a "naturalization of the sacred."[48] The illusionism of presence generated in such Quattrocento painting facilitated a particularly intimate engagement with the spectator – but it left the divine potentially compromised and made its presence ambiguous. Divine presence was domesticated, brought into a chapel or chamber as if the holy figures had simply stepped across an invisible *limen* between heaven and earth and were now wholly in the world. This form of representation confused the mechanics of sacred presence. Had holy figures simply stepped into earthly space? Or was the viewer present before a vision, but one with none of the clouds and pomp of divinity? These issues, brought to their highest pitch in Venice by the power and conviction of Giovanni Bellini's *mimesis*, may be exemplified by two Venetian altarpieces of the 1510s: Marco Basaiti's *Agony in the Garden with Saints* (fig. 42), and the *Saint Jerome in Meditation with Saints Christopher and Louis of Toulouse* by the aged Bellini himself (fig. 43).

Such paintings appear to reflect on issues implicit in earlier *pale*, for instance Bellini's *San Giobbe* altarpiece (fig. 44). There, while the presence of the sacred was "naturalized," the structure of the picture proffered a rationale; divine figures appeared above the altar in an illusionistic chapel space that mirrored that of real chapels across the nave. Nonetheless, the remarkable mechanics of the illusion could raise questions about the nature of the apparent presence of these sacred figures from a number of periods in a space continuous with that of the viewer.[49] In the later Bellini, however, a representation of a contemporary chapel – inhabited by two attendant saints in the traditional manner of the *sacra conversazione* – opens onto an illusionistic depiction of Saint Jerome praying. There are now two spaces, two scenes, perhaps two temporalities, and certainly two "levels of reality" presented. What exactly is the viewer to see, to understand by this representation? Does one kind of vision

42 Marco Basaiti, *Agony in the Garden with Saints*, 1510, oil on panel. Venice, Accademia.

open behind another? Does a vision appear behind an illusion? Or does the figure of Saint Jerome in a landscape constitute the mimetic fiction of an altarpiece, an illusion within an illusion? Might the distinction between the spaces occupied by Saint Jerome and the saints before him represent an attempt to enliven a traditional composition while beginning to rationalize the different temporalities of the saints? This impression is heightened by a consideration of the Basaiti panel, which depicts, beyond the illusionistic chapel with quiet saints, a view onto the Agony in the Garden. The idiosyncratic composition represents a remarkable attempt to integrate narrative into the heart of the *sacra conversazione* without making the altarpiece itself a univocally narrative image, as Raphael did in the Baglioni *Entombment*. Yet, in Basaiti's illusion – in contrast to

ABOVE 43 Giovanni Bellini, *Saint Jerome in Meditation with Saints Christopher and Louis of Toulouse* (Diletti Altarpiece), 1513, oil on panel. Venice, San Giovanni Crisostomo.

RIGHT 44 Giovanni Bellini, *San Giobbe Altarpiece*, c. 1478–80, oil on panel. Venice, Accademia.

Raphael's *Entombment* – viewers appear to be able to step from the chapel into the Agony as simply as they might step up through the altar and into the pictorial space in Bellini's *San Giobbe* altarpiece. All these paintings, then, provoke the question: what delimits sacred space from quotidian space?

Representations of saints were legitimate objects of veneration – an old idea vigorously defended at Trent. Ambiguity as to the status and presence of painted holy figures, who should display themselves for reverence and honor, was intolerable to the faithful; a return to iconic stasis was intolerable to most sixteenth-century painters. To a tradition at such a crossroads, the

vision altarpiece provided compelling answers. It created a narrative out of an icon while preserving the principles of frontality and centrality that structured traditional religious images. The vision occasions action, psychological and emotional interchange, and dramatic movement; but the direction of this movement may be oriented towards the viewer rather than across the picture plane, thus preserving the clear and symmetrical arrangement of holy figures, easily identified and venerated, that was frequently demanded by churchmen and easily accommodated in traditional, non-narrative compositions. Representations of visions also clarified the spatial relations –

55

and the hierarchy – between heaven and earth through the mechanism of clouds. Unlike the little cloud pedestals of many Quattrocento *gonfaloni*, Raphael's clouds served as true curtains to the drama of theophany. Occasionally, as in the *Sistine Madonna*, they came to fill the background as fully as the gold ground of a Trecento panel. Barocci's recourse to precisely this strategy in his *Immaculate Conception* is not coincidental.[50]

It is the *Madonna di Foligno* (see fig. 31), however, which is central to a discussion of most of Barocci's representations of visions, including the *Madonna del Popolo*. Indeed, the impact of the Aracoeli panel on altarpieces for the next two centuries is incalculable, and even by the nineteenth century its force was not entirely spent; Ingres's *Vision of Louis XIII* is unthinkable without Raphael's example. As the *Madonna di Foligno* is fundamental for Barocci's conception of the vision altarpiece, the mechanics of the panel should be analyzed briefly. The Virgin and Child, while they now hover before the donor and saints (and before those gathered in the church) as if enthroned at the center of a traditional *sacra conversazione*, can be imagined to have been swept up to the picture plane from the distant background, riding the clouds of the thunderstorm.[51] This implied dramatic action, apparently just completed, engages the saints in an emotional reaction to the Madonna's sudden appearance before them; they actually act out before the viewer their functions of intercession and mediation that motivate the prayers of the faithful. The saints are both part of the vision presented to the viewer and, as figures on earth rather than in the clouds, are also the mediators between viewers and the divine heart of the image, the figures of Christ and his mother. The complexity with which Raphael works out this mediation is both beautiful and moving.

At the lower right the patron kneels, his hands clasped in prayer – a model for the pious viewer. His patron saint, Jerome – his beard blown by the wind generated by the Virgin's arrival – rests a hand paternally on the donor's upturned head, while extending the other arm deep into the picture space in a gesture of wonder and reverence as he looks up at the Virgin and Child imploringly, interceding for his devotee.[52] The Virgin responds to this intercession with a gentle, queenly gravity and the Child has already begun to climb down toward the donor, stepping off his mother's lap onto the clouds. He tugs at her mantle, pulling it out toward himself as he steps down: but in so doing, he pulls it out toward the donor as well. That this gesture could be interpreted as an allusion to the old iconography of the Misericordia is dramatized by Titian, who reflected on elements in Raphael's altarpiece repeatedly during the late 1510s and early 1520s. In the *Pesaro Madonna* (fig. 45), the Child steps out vigorously into the air toward the donor's kneeling family and an interceding Saint Francis, and reaches back to pull his mother's

veil forward toward the group as well. In the *Madonna in Glory* in Ancona (fig. 46) – Titian's most overt homage to the *Madonna di Foligno* – the Child is given the univocal role of leaning forward vigorously to bless the donor (and the viewer), while an adolescent angel is added to the composition to raise the Madonna's heavy blue mantle toward the adoring Saint Francis. Such youthful angels had traditionally held the Madonna's robe in numerous Quattrocento images of Misericordia.[53]

This relation of the holy figures to the donor inside the painting, however, is only half the drama, the *istoria*, that articulates the *Madonna di Foligno*. As Christ steps down, he seems to have seen Saint Francis, who stares up at his Lord in ecstatic wonder, his eyes nearly rolling back in his head, and gestures with one of his wounded hands to the viewers before the image. Christ's

45 Titian, *Pesaro Madonna*, 1519–26, oil on canvas. Venice, Santa Maria Gloriosa dei Frari.

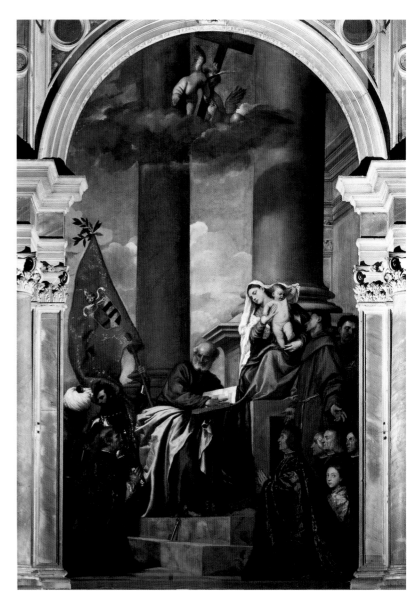

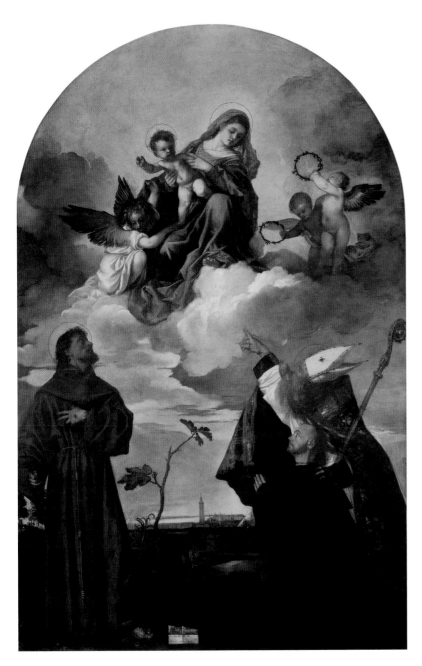

46 Titian, *Madonna in Glory with Saints and Donor*, 1520, oil on panel. Ancona, Pinacoteca Civica.

his action as he steps off his mother's lap, off the Throne of Wisdom, down toward the humble donor below. Finally, Saint John the Baptist makes direct eye contact with the beholder. His gaze compels the attention of viewers and his gesture indicates what they should do: revere the Holy Virgin and her Son, and pray to the saints (in particular Francis) that they will intercede for the faithful. John was Christ's precursor, his herald in the wilderness. John was also the precursor of Francis, in the sense in which Francis was revered as an *alter Christus*, and he and Francis were often seen as analogous, both "heralds of the Great King."[56] Thus it is appropriate that these two are paired, Francis *alter Christus* privileged with the most intense interaction with the Christ, John the one who points the faithful to the Child.

Barocci must have studied the *Madonna di Foligno* intently during his years in Rome and in the ideation of the altarpiece for the Capuchins of Fossombrone (see fig. 41). When he wrestled with the creation of an effective composition for the *Madonna del Popolo*, the lessons of the *Madonna di Foligno* were still much in his mind. The apparition of Christ and the Virgin above representatives of the *popolo* of Arezzo expresses both the serene faith of Bonfigli's great Perugian *gonfalone* and the august yet impassioned sacred drama of Raphael's altarpiece. As in Raphael's panel, in which the Virgin and Child have swept forward across a landscape on clouds of theophany that have left a rainbow (and a thunderstorm) in their wake, the apparition that motivates the action in the *Madonna del Popolo* trails mist across the piazza and literally overshadows a group of devotees in the near middle ground. In a critical compositional drawing (fig. 49), Barocci worked to take full advantage of the dramatic possibilities – the potential for elements of *istoria* – inherent in the vision altarpiece. Yet a comparison of the drawing with the finished painting reveals that Barocci continued to evolve subtle revisions that actually heightened traditional elements of the painting while taking nothing from the narrative drama he had labored to create; indeed, the changes increased dramatic movement, while also enhancing the altarpiece's ecclesiastical decorum and evocation of tradition.

In the drawing, the dove of the Holy Spirit descends obliquely toward the viewer's right; its flight directs attention to the man offering alms in the right foreground. In the finished painting, the dove is "frontalized" and hovers facing the spectator. Only its head breaks the strict frontality of its body to turn slightly to witness the act of almsgiving, now performed by a young boy on the right margin. The recipient of alms has also changed; rather than the reclining beggar, a young woman with an infant rushes forward, hand outstretched, generating a turbulent drama out of the act of charity. Yet as she sweeps forward, the woman's shawl billows behind her so that it appears to "touch" – in the surface pattern of the panel – the upflung arm

recognition of his own wounds in Francis was held to be one of the qualities that made Francis a particularly effective intercessor.[54] Here Christ may shrink slightly from them, and from the crosses that both Francis and Saint John the Baptist, standing behind him, hold – and the pious viewer may experience a moment of fear that the infant Savior will negate the initiation of the Misericordia and pull his Mother's drapery about him in fear, recalling Raphael's invention in the Bridgewater Madonna.[55] Francis' intercessory plea prevails, however. While Christ's full humanity – and the horror of his sacrifice – is dramatized by the crosses and stigmata, his love is dramatized by

47　After Perugino, *Assumption of the Virgin*, c. 1482–3, metalpoint, pen, wash, and white heightening on paper. Vienna, Albertina, inv. 4861.

48　Domenico Ghirlandaio, *Coronation of the Virgin*, 1484–6, tempera and oil(?) on panel. Narni, Palazzo Comunale.

of a reverent kneeling man in the middle ground. This visual conjunction generates a shrine-like shape, directly under the dove and on the center vertical axis of the image, which encloses a figure adjusted only slightly from the drawing. This is the frontal figure of the kneeling knight at prayer. In the painting he is moved definitively to the center, his yellow cape revealing a red cross as a symbol at the heart of the altarpiece, directly above the cross on the altar below. To insist further on the point, the knight's praying hands are juxtaposed to the cross-like sword hilt of the kneeling gentleman in front of him, and to direct the viewer's attention Barocci reconfigures the prayerful gestures of the two children in the left foreground. While in the drawing only the little boy had hands clasped in prayer, in the painting he is joined by his sister and their prayerful gestures function as arrows to point at the praying knight and the act of charity, even as their mother points them (and the viewer before the altar) to the yet higher thing: the apparition of the sacred itself above the piazza in Arezzo. Barocci had learned from the *Madonna di Foligno* and its progeny to employ participants in the experience of apparition (not saints now but citizens like the

viewer) both to direct attention and to model response. Furthermore, in the very process of heightening drama, he has been equally conscious of focusing his composition ever more insistently on a vertical central axis, in which the dove of the Spirit hovers frontally above a still, softly illuminated prayerful shrine which is the coincidental and ephemeral – but in paint eternal – consequence of dramatic action. This is Barocci's answer to the misty rainbow in the *Madonna di Foligno*.

The Christian knight and citizen of Arezzo at the core of the *Madonna del Popolo* has a history that looks back to Raphael's own sources. Perugino's now lost, early 1480s altarpiece of the Assumption for the Sistine Chapel (fig. 47) and the many adaptations of it place the apostle Thomas in prayer in the middle of the composition (several *Ascensions* which borrow the composition replace Thomas with the Virgin). At nearly the same moment that Perugino created his altarpiece, Ghirlandaio's famed *Coronation of the Virgin* for the Franciscans of Narni – which became a model for Franciscan altarpieces throughout central Italy – placed Saint Francis himself, the great intercessor, in this privileged position (fig. 48). Thus this figure became a

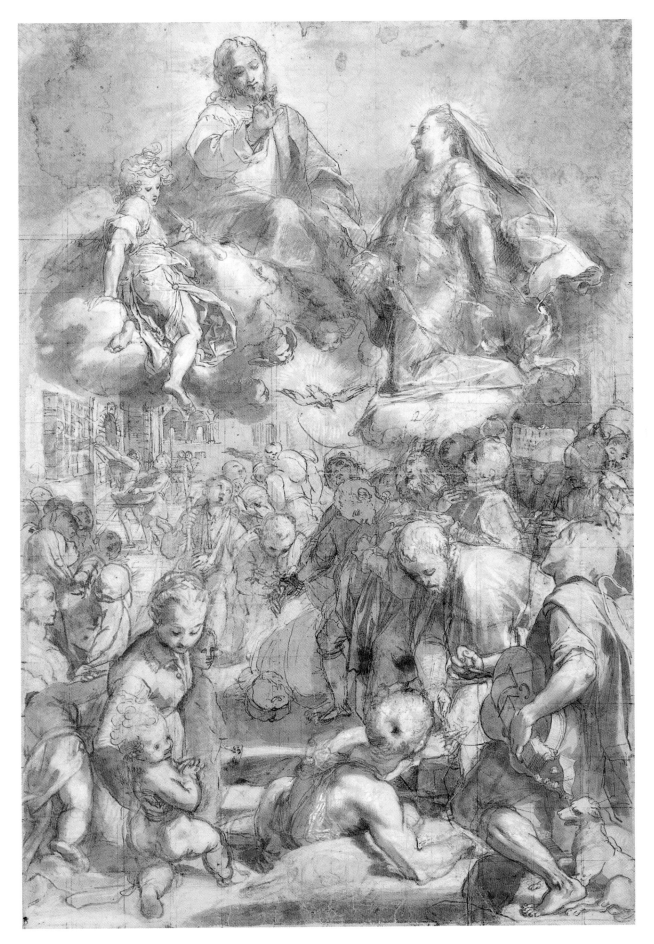

49 Barocci, compositional study for the *Madonna del Popolo,* pen, wash, chalk, and white heightening on paper, 55 × 38.3 cm. Chicago, Private Collection.

leitmotif in a number of large altarpieces, structured as glorious visions, which were cultivated by Perugino, Pinturicchio, Francia, and other painters who instated the so-called *maniera devota* on the eve of the ascendancy of Vasari's *terza maniera*.[57] Their vision, which commingled the softness and luminous light and color of modern painting with aspects of tradition, provided yet another element in Barocci's revisioning of the altarpiece. The figure of the Aretine knight who kneels at the heart of the *Madonna del Popolo* offers one sign of this filiation and of Barocci's distinctive rethinking of a source in his articulation of a new *maniera devota* for confraternal patrons. For the figure has been transformed from apostle or saint to citizen.

Even Barocci's famous coloring, central to his cultivation of decorous pictorial *vaghezza*, plays a critical role in highlighting the praying knight and more generally in negotiating three-dimensional space and two-dimensional pattern in the altarpiece. In general, the brilliant, shimmering color heightens the impression of the painting as vision rather than mere representation; specifically, the knight's yellow robe brings him forward toward the surface of the picture plane – though he is a background figure – and links him with the golden light of heaven. Barocci's manipulation of the tensions between three-dimensional space and two-dimensional form here is critical to the creation of a modern image that revivifies aspects of tradition, and an artful image that, in its very forms and its *vaghi colori*, encourages ecstatic contemplation. There will be more to say about the structuring and affective potential of color in this painting in Chapter Eight.

It is unclear whether Barocci's patrons understood or appreciated his remarkable efforts, which, as he asserted in that memorable phrase, were "twice what I promised." Since Gualandi's publication of the bulk of the correspondence between painter and patrons, the rectors' infamous letter of June 30, 1579 has been cited to indicate that the panel's reception was ambivalent at best. The rectors launched their attack in this letter by asserting that "the panel does not achieve the quality that was anticipated." They may have been referring principally to the physical rather than the pictorial composition of the panel, for they proceed to complain that within ten days of arrival the paint had begun to crackle. However, their second barb leaves no doubt that an attack on the painting's "vision" constitutes part of their intent. They write that Barocci must be able to imagine the unhappiness that the deterioration of the panel has caused "to some of our people. We say 'some' as on the other hand there are those who do not feel that this need cause any great sadness as it is not the loss of a very excellent thing." This venom was in part surely the result of the rectors' frustration with what they perceived to be Barocci's glacial pace of work and difficult personality.[58] Nevertheless, with this letter as the only evidence, it would

be easy to suspect that their comments register the disaffection of some in Arezzo with the visual distance that separated Barocci's invention from the *Misericordia* the brothers initially desired. However, there is now evidence that many in the confraternity, the *cognoscenti*, and the larger citizenry of Arezzo found the painting beautiful and compelling. A recently published notarial act, dated June 4, 1579 – just a few weeks before the infamous letter – demonstrates that the fraternity drew up a document in Barocci's presence that rehearsed the contract and the expenses for the painting, noted that Barocci had consigned the panel, and stressed that "several expert men and virtually the entire city assert that the aforementioned panel is excellent, beautiful, and handsome and made with the greatest study and diligence and perfection."[59] Such a statement indicates that Barocci's distinctive attempt to integrate tradition with artistic modernity was indeed perceived as a success, at least in visual terms. Later, even in the relatively conservative Marche, the perception that Barocci's invention was suitable for a confraternity dedicated to the Misericordia appears confirmed by a simplified workshop adaptation of the Arezzo composition for the Oratory of the Confratelli della Misericordia in Pesaro (fig. 50).[60]

50 Collaborators of Barocci, *Misericordia*, after 1580, oil on canvas, 350 × 210 cm. Greco (Milan), San Martino.

The *Madonna del Popolo* was certainly admired by artists and *cognoscenti* in Florence; by April 1583 Francesco I had asked an emissary to request that Barocci produce a portrait of Francesco Maria II della Rovere for the Medici gallery. The writer, Simone Fortuna, stresses that the Grand Duke's interest was kindled because "he has been hearing Federico Barocci most highly praised as a rare painter." In particular, "the fame of Federico has come [here] through the panel he sent to Arezzo, judged so beautiful that here today he is given the first place among the painters."[61] Indeed, the young Florentine painters Cigoli and Gregorio Pagani undertook a pictorial pilgrimage to Arezzo to study the *Madonna del Popolo*, with which Cigoli was so impressed that he traveled to Perugia to study the *Deposition* (see fig. 85), this time with Passignano as a companion. The panel was still so valued in eighteenth-century Florence that it was finally purchased from the fraternity by Grand Duke Pietro Leopoldo in August 1786.[62] If Barocci's negotiation of the tensions between modernity and retrospection in the altarpiece remained compelling two centuries after the painting was first placed over its altar, however, the seamless fusion of tradition and innovation which he sought – important for the Seicento and evidently still appreciated in the Settecento – could no longer be as clearly perceived after the articulation of more overtly retrospective styles for much religious art during the nineteenth century. The profundity of Barocci's reflection in this seminal altarpiece means that the *Madonna del Popolo* will reappear repeatedly in the remainder of the book; it is of particular importance to the consideration of *vaghezza* and of musical painting. For the moment, however, other aspects of his negotiation with tradition merit consideration.

History into Mystery

Barocci's careful recalibration of the compositional drawing for the *Madonna del Popolo* to create an altarpiece in which the vigor of the narrative drama was subtly restrained, and contemplative, even "iconic" elements of the composition were enhanced, may come as a surprise, given the painter's evident strategy of working away from initial retrospective conceptions in the *Immaculate Conception* and in the figure of the Virgin for the Bonarelli *Crucifixion* (see figs. 20 and 21). However, the Louvre drawing for the *Conception* (see fig. 34) indicates how Barocci could work from archaic sources to a dramatic *istoria* before articulating a *regolata mescolanza* of these characteristics in a finished painting. A tendency to work out a number of dramatic enactments of the *istoria* to be represented in a composition, and then to distill *istoria* into *misterio*, is amply demonstrated by surviving drawings from the planning of two critical altarpieces that bracket the *Madonna del Popolo* chronologically, and thus may offer further insight into a process that can only be glimpsed in the creation of the Aretine altarpiece. These are the *Perdono* (fig. 52 – with its surviving polychrome oil sketch [fig. 51]) of the mid-1570s, for Franciscan patrons in Urbino, and the *Visitation* (see fig. 77) of the mid-1580s for the Oratorians at Santa Maria della Vallicella in Rome.

❧

THE *PERDONO* BETWEEN TITIAN AND THE "STIGMATIZATION FROM ABOVE"

About a year after Barocci signed the contract for the *Madonna del Popolo*, he notified the confraternity's rectors that he had completed a project in Urbino and now would be able to work without distraction on the altarpiece for Arezzo. It is generally agreed that he must refer to the *Perdono*, the high altarpiece of the Conventual Franciscan church of San Francesco in Urbino and one of Barocci's most important paintings. The *Perdono* was the third painting Barocci created for the church of these friars, who later oversaw his will and provided him with burial. He had produced the *Madonna di San Simone* (see fig. 177) for a private altar in San Francesco during the late 1560s and probably had just completed the *Immaculate Conception* for the Compagnia della Concezione, based in the church.[1] This time the friars themselves offered a commission. The *Perdono* was at least the second high altarpiece produced by Barocci for Franciscan patrons but the first for the powerful Conventuals. While he had chosen a visionary representation of the *sacra conversazione* for the Capuchins' *Fossombrone Madonna* (see fig. 41), for San Francesco he was called to represent an actual vision. The *Perdono*, like the *Immaculate Conception* and the *Madonna del Popolo*, is another important site for the study of Barocci's nego-

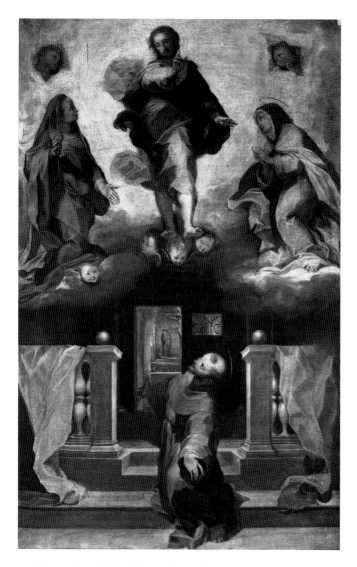

51 Barocci, study for the *Perdono*, oil on canvas, 110 × 71 cm. Urbino, Galleria Nazionale delle Marche.

tiation of retrospective sources and compositions in his major altarpieces of the 1570s. Before one can understand the composition of the *Perdono*, however – or its tissue of visual references – its iconography must be clarified, for the theme was rarely depicted in altarpieces.

The story of the *Perdono* provided the rationale for an indulgence that the Franciscans claimed as a particular mark of spiritual and ecclesiastical power and prestige. However, the privilege had been much contested and perhaps because of this the representation of the miracle had never consititued a salient, pervasive element in Franciscan iconography. According to the most elaborate version of the story, Francis was assailed one bitter January night by fierce temptations while in prayer at the little church of the Porziuncola on the plain below Assisi. Running outside to combat the temptation, Francis stripped and hurled himself into winter-denuded rose bushes to mortify

the flesh. Miraculously, the roses offered up beautiful blossoms wherever the saint's blood flecked the stems and his temptations evaporated. Angels appeared to comfort him and led him back into the church and up to the altar, miraculous roses in hand. Christ and the Virgin then appeared in a vision and Christ promised Francis a plenary indulgence for all pilgrims who would visit the Porziuncola from Vespers on the first of August to Vespers on the second; this was the feast of Saint Peter in Chains and probably the anniversary of the Porziuncola's consecration. The story concludes with the confirmation of the indulgence by Pope Honorius III when he was shown the miraculous blossoms by Saint Francis.[2]

Substantial difficulties were encountered, however, in the promulgation of the indulgence. Before the time of Francis, the Church's only significant plenary indulgence had been the *Indulgentia de Terra Sancta* for merit acquired on crusade. The Franciscans had been responsible for the extension of this indulgence to noncombatants who aided the crusading effort; now they claimed that Francis had obtained from the pope a wholly new indulgence simply for pilgrimage to the Porziuncola. Such a radical concession to the new order undercut the Crusade indulgence and infuriated the bishops who administered it; they perceived the new indulgence as yet another mendicant encroachment on their traditional privileges. In addition to hostility from the regular clergy, the Franciscan claims were undermined by the fact that no reference to the indulgence was recorded in the more official early lives of Francis, such as Saint Bonaventure's *Legenda maior* of 1266. Indeed, it was not until the late thirteenth and early fourteenth centuries that the indulgence was promoted and defended aggressively by the order – and not until the late sixteenth-century reaffirmation and recovery of early Franciscan traditions that the iconography of the *Perdono* became important in Franciscan imagery and pilgrimage to the Porziuncola came to be strongly promoted.[3]

In 1569 the Observant Franciscans inaugurated construction of a vast modern basilica to enshrine the tiny Porziuncola, much as painted glories of angels in modern style framed archaic but venerated icons in some late sixteenth-century chapels. The Conventual Franciscans clearly felt a sense of rivalry with the Observant guardians of the Porziuncola. It was precisely in these decades that the Conventuals at the Basilica di San Francesco that overlooked the Porziuncola from the hill of Assisi attempted to focus interest on the unique importance of their vast repository of early Franciscan art and to restore their church as the ultimate "paleo-Franciscan" shrine in distinction to the new building and decorative program overseen by the Observants in the valley below.[4] Faced with the prestige the Observants were garnering as custodians of the locus of the newly popular

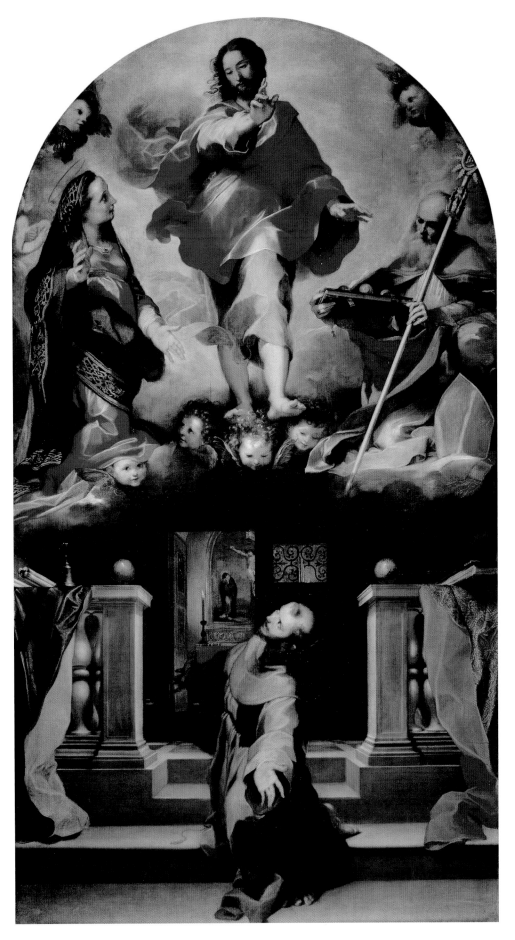

52 Barocci, *Perdono*, c. 1574–6, oil on canvas, 427 × 236 cm. Urbino, San Francesco.

53 Francesco Villamena, *Life of Saint Francis*, narrative of the vision and concession of the indulgence of the Perdono d'Assisi from Andrea Putti's *S. Francisci historia cum iconibus in aere excusis* (Rome, 1594), sheets 24–7, engraving. Bologna, Biblioteca Comunale dell'Archiginnasio.

Porziuncola indulgence, the Conventuals also began to insist that the episode and its indulgence were part of the heritage and privilege of all Franciscans. It seems more than coincidental that much of the late Cinquecento efflorescence of *Perdono* imagery can be associated specifically with Conventual houses.

The interest of the Assisan painter Dono Doni in the Basilica's medieval pictures and glass, and his consultations with the friars concerning the restoration of the windows of the church, has already been noted. In the years when the Observants were building at the Porziuncola, the Conventuals at the Basilica also entrusted to Doni one of the few commissions for new painting that they undertook, a frescoed *Vita* of Saint Francis for the convent's great Sixtus IV cloister. Although these frescoes have largely been obliterated, their appearance is probably recorded in the extensive print series *The Life of Francis* published by the Assisan engraver Francesco Villamena in 1594. Villamena's series indicates that the frescoes contained the story of the *Perdono* and even stressed it by narrating it through four successive scenes (accompanied by explanatory inscriptions) that portrayed Francis in the rose bush, Francis escorted into the church by the angels, Christ and the Virgin appearing to the saint as he knelt with the roses before the altar, and finally the Pope's confirmation of the indulgence (fig. 53).[5]

Rapid popularity for the frescoes was achieved through Villamena's prints. Barocci had already engraved his *Perdono* in 1581 – one of only four engravings he ever attempted – and in 1588 this plate was copied by Villamena himself, thereby ensuring yet wider distribution of Barocci's image.[6] Thus it seems that the inventions of Barocci and Doni were instrumental in articulating and promulgating a post-Tridentine *Perdono* iconography. Their versions are remarkably different. The distinctive

approaches could of course have been occasioned by the very different contexts of a narrative fresco cycle and a high altarpiece. However, another Conventual altarpiece that represents the *Perdono* and evinces knowledge of both Barocci's and Doni's solutions adopted salient iconographical elements from the *Life* frescoes even though its style is far more indebted to Barocci. This is Francesco Vanni's *Perdono* for San Francesco in Pisa (fig. 54), a church that housed major early Franciscan paintings, including one of the most significant early icons of Francis and Giotto's *Stigmatization* (now in the Louvre). It seems that Vanni's painting was commissioned in the 1590s and formed part of a series of new altarpieces for the church which featured the work of Tuscan "reform" painters: Vanni, Santi di Tito, Cigoli, Passignano, and Jacopo d'Empoli. The choice of the *Perdono* for one of the altarpieces indicates the ongoing Conventual promotion of the theme in the wake of its representation in Assisi and Urbino.[7]

Barocci's altarpiece was, as far as I know, the first significant sixteenth-century high altarpiece that took the *Perdono* as its principal subject, and as such surely constituted a point of reference when the Conventual friars of Pisa commissioned Vanni to produce another altarpiece representing the theme.[8] In addition, Vanni was a noted Sienese follower of Barocci and his painting indeed exhibits predictable signs of a study of Barocci's art. However, the notable differences between the two altarpieces indicate that Vanni seems to have developed his conception of the vision principally from the textual narrative and its visualization in the frescoes of Doni or their reproductions in Villamena's *Life*. As in Villamena's plate twenty-six, Vanni's Francis kneels just before the altar, accompanied by the two angels who have escorted him into the Porziuncola, while

Christ and the Virgin appear in a vision above him and to the left. In contrast with Doni–Villamena, and in a clear response to issues particular to the altarpiece as a form, Vanni's figure of Christ has come to occupy the center of the heavenly zone; but Francis is off-center, as is the representation of the altar. Further, Vanni elaborates the iconography of both Barocci and Doni–Villamena to insist upon elements in the narrative that would assist the Franciscans in their promotion of the veracity and significance of the indulgence. The angels display the harvest of miraculous rose blossoms in their robes for all to see, two putto-angels hand Francis the actual parchment of the indulgence, and Christ not only blesses his saint but also, looking at the interceding Virgin, opens his side wound to the viewer.

In some iconography of the early modern Church, the water from the side wound of Christ was portrayed as assuaging the torment of souls in Purgatory.[9] The indulgence of the Porziuncola was precisely intended to rescue souls from the penance of Purgatory. Thus, Vanni's painting becomes not only an *istoria* of the vision but a visual commentary on its purpose and effect for the faithful – and, with the representation of the indulgence itself in the center of the image, immediately below Christ, a documentary validation of the event's historical reality. That the element of historical documentation was particularly valued in this altarpiece is stressed by the fact that Francis wears a Capuchin habit, a notable departure from the Assisi frescoes as recorded by Villamena. For Conventual Franciscans to allow their founder to be depicted in a habit different from their own in an altarpiece in a Conventual church seems to represent a remarkable admission. That they did so must depend not only on the position of the Capuchins under nominal Conventual guardianship at this time but also and in particular on the perceived importance of the image of the *Perdono* as a historically credible recreation of a disputed event. By the 1590s, it seems, the Capuchins had convinced most authorities that theirs was the habit of Francis and his first companions. Why the habit had changed over the centuries, and whether such changes were acceptable, remained disputed points – but the historically accurate portrayal of Francis demanded a Capuchin habit. As the Capuchin historian Bernardino da Colpetrazzo proudly asserted in the 1590s: "it has become so clear to everyone that this is the true habit of Saint Francis that even the modern painters now represent the saints of the Order with the pointed hood, because they see that in all the old churches Saint Francis and the other saints of the Order are all depicted in the same type of habit . . ."[10] Colpetrazzo's assumption that "modern painters" are looking at old images is telling, given what can be perceived of Barocci's own practice.

While Vanni's altarpiece is effective at melding the functions of narrative, vision, historical document, and decorous liturgical

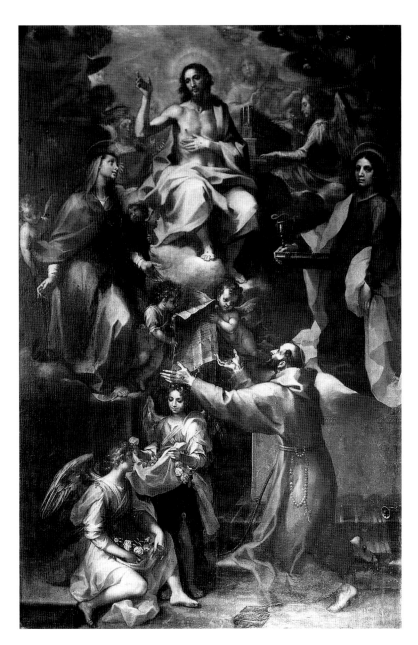

54 Francesco Vanni, *Perdono*, 1590s, oil on canvas. Pisa, San Francesco.

aid, some of the means through which it represents *istoria*, in addition to its iconographical details, are clearly conditioned by the more overtly narrative sequence in a fresco series, such as that by Doni recorded in Villamena's engravings. The critical interchange among the Virgin, Christ, and Francis even "reads" fundamentally from left to right. The centrality of Christ and the display of the side wound do reinforce the nature of the altarpiece as an object in which viewers may venerate Christ and the saints, appropriately disposed in relation to their importance, and as an image that forms the critical backdrop to the celebration of the eucharist. Yet the Virgin and Christ appear to have approached Francis somewhat from the left; the altar is off-center to the right, for instance, Francis turns from it to the left

55 Barocci, preparatory study for the *Perdono*, chalk on paper, 15.2 × 13.1 cm. Florence, Galleria degli Uffizi, Gabinetto dei Disegni, inv. 11504 F.

to witness the vision, and the angels who present him the document confirming the indulgence angle it sharply to direct it to him as he kneels in profile toward the right. Barocci thought through the event in remarkably similar terms as he planned the *Perdono*, as demonstrated by a drawing (fig. 55). Here too the narrative proceeds across the picture plane – if at a sharp angle – rather than directly forward and Francis kneels, off-center, on what appear to be steps. The schematic nature of the drawing does not allow for absolute certainty in reading the arrangement of space in the lower portion of the composition, but it seems most plausible to argue that Francis kneels on the

steps of an altar, the corner of which is demarcated by the particularly dark vertical line to the right of center in the composition. This would indicate that Barocci initially intended to arrange the space in which Francis kneels much as Vanni would, with neither saint nor altar in the center of the lower portion of the image. Additionally, as in Vanni's painting, the clouds of the divine apparition in the drawing come so near the earth that the saint's head and shoulders break into the heavenly zone. Heaven and earth are distinguished, but intimately connected.

Barocci has effected a subtle yet fundamental change, however; his narrative moves forward and from right to left

instead of left to right. Such movement – opposed to the usual direction of narrative reading in text – seems calculated to stabilize the pictorial composition, to make a painting that could be at once an effective narrative and an effective liturgical image. Indeed, right-to-left narration became a tactic much used in narrative altarpieces during the Seicento. For instance, Pietro da Cortona's *Procession of San Carlo Borromeo*, the high altarpiece of San Carlo ai Catinari in Rome, effectively heightens the dramatic charge of the sacred *istoria* it visualizes – the saint processing the cross through plague-stricken Milan – by orienting the movement not left to right across the picture but forward out of the picture and toward the left (fig. 56). Such a strategy at once subtly calls attention to the difficulty of the action performed, addresses beholders aggressively, and effectively holds the saint's image near the center of the composition. He is forever moving into the center "against" the implicit direction of narrative progression; the candle flames indicate that even the wind blows counter to this difficult but determined motion. There will be more to say about such compositions in the next chapter, when the narrative devices of Barocci's Senigallia *Entombment* can be compared to those of Raphael's Baglioni *Entombment* (see figs 83 and 87). Barocci later also employed a right-to-left narration in the *Visitation* (see fig. 77).

For the *Perdono*, however, Barocci's ultimate solution is radically different, and rejects any significant lateral narration. He rigorously centralizes the composition, ensuring that both Francis and Christ occupy the respective centers of the heavenly and earthly zones. There is vigorous narrative action – indeed, more vigorous than anything in Vanni – but the principal axis of action is now oriented precisely perpendicular to the picture plane to accommodate the centralized composition. As in the *Madonna di Foligno* the heavenly vision sweeps forward, blowing back the drapes on the railing before which an ecstatic Francis kneels and irradiating his foreground space with light while casting the body of the church into deep shadow. Barocci makes another related decision: he reinstates a distinct and hierarchical division between the levels of heavenly apparition and earthly space. Francis' head is no longer in the clouds. He is as central on earth as Christ is in heaven, but the two levels of reality no longer meld into one another. Heaven does not simply fill the room. It is perceptible only through privileged vision – through the visions of saints, which ordinary beholders may witness through the miracle of pictorial representation – and specifically through an apparition that opens in the air above human height. The figure of Christ insists on this point as he steps powerfully forward off his cloud, his left foot extending into the air precisely over the head of Francis. His outstretched hand forms a blessing that seems to respond to the Virgin's intercession, and as his forward stride sweeps his mantle back behind

56 Pietro da Cortona, *Procession of San Carlo Borromeo with the Holy Nail among the Plague Victims*, 1667, oil on canvas. Rome, San Carlo ai Catinari.

him, the trailing garment begins to evanesce into invisibility as it dematerializes into the blinding light of Heaven.[11]

While the Christ of the *Perdono* is vigorous, preparatory drawings reveal that Barocci worked to restrain the figure he presented in the final painting. One of these drawings represents an initial ideation of the figure of Christ that is distinctly different from the ultimate solution (fig. 57). The dependence of the drawing on the Christ of Raphael's *Transfiguration* has sometimes been remarked, but Barocci's figure is considerably

57 Barocci, preparatory study for Christ in the *Perdono*, chalk, charcoal, and white heightening on paper, 40.5 × 28.1 cm. Florence, Galleria degli Uffizi, Gabinetto dei Disegni, Inv.11374 F.

58 Titian, *Resurrection*, 1542–4, oil on canvas. Urbino, Galleria Nazionale delle Marche.

more dynamic and leans forward as he advances. For the painting, Barocci chose a middle path between his initial dramatic conception and the relatively composed figure of the risen Christ from the standard that Titian had painted for the Urbino confraternity of Corpus Domini, of which Barocci himself was a member (fig. 58).[12] Barocci's interest in Titian's figure seems important, for the Christ on the Urbino standard is far less activated than Titian's earlier risen Christ from the Averoldi polyptych in Brescia (fig. 59). Indeed, the Corpus Domini Christ ultimately recalls models such as Bellini's figure in the *Resurrection* commissioned in the 1470s by Marco Zorzi for San Michele in Isola (fig. 60). Titian's return to a relatively conser-

vative source, decades after his creation of a far more monumental and energetic Christ in the Averoldi altarpiece, must reflect to some degree the nature of the commission and the desires of the confraternity. For a Franciscan high altarpiece in Urbino, Barocci's recourse to this figure is a telling appropriation of what might be termed "conservative modernity." Barocci, however, has increased the sense of movement in his figure of Christ; while Titian's figure hovers, Barocci's advances forcefully toward the viewer – and toward Saint Francis.

Directly below Christ, Francis strains forward to see the advancing figure that comes to overshadow him. His figure descends ultimately – as does that of his Saviour – from figures

ABOVE 59 Titian, *Resurrection* polyptych (Averoldi Polyptych), 1519–22, oil on panel. Brescia, Santi Nazaro e Celso.

RIGHT 60 Giovanni Bellini, *Resurrection*, 1476–9, oil on panel. Berlin, Staatliche Museen.

in works of Raphael and Titian, particularly those of Francis in Raphael's *Madonna di Foligno* (see fig. 31) and perhaps Titian's *Pesaro Madonna* (see fig. 45). This figural type had already been taken up and developed by Barocci for the Francis in the *Fossombrone Madonna* (see fig. 41) and in the figure of San Bernardino in the right corner of the Perugia *Deposition* (see fig. 85). In the *Perdono*, though, Francis has both arms flung wide, thereby heightening the impression of the picture's perpendicular relation to its spectators as he leans sideways toward the space of the viewer (instead of back into the picture as in the Raphael sources) to see up into the heavenly vision that has swept over him.

The rigorous focus on the arrangement of narrative movement – and even dramatic narrative gesture – perpendicular to the picture plane allows for two apparently contradictory impulses. On the one hand, the dramatic possibilities of the *istoria* are actually enhanced by the stress on movement toward the spectator. On the other hand, as is the case with the *Immaculate Conception* and the *Madonna del Popolo*, the positing of narrative action as emerging from the picture plane rather than progressing across it enables the generation of a compo-

sition that is perfectly symmetrical and maintains the centrality and cultic significance of its principal sacred actors. This is the icon that comes to meet us, the image that is always in the process of becoming the perfect cultic icon of the presence of the divine over the altar. Even between the oil study and the final painting, Barocci continued to negotiate the fertile tension between drama and iconic presence through the manipulation of subtle but significant details. Consider, for instance, the interplay between three-dimensional space and two-dimensional pattern that was important in the *Madonna del Popolo*. In the study (see fig. 51), the brightly illuminated face of Saint Francis is set off before the dark, shadowed wall behind. In the painting this basic disposition is retained but Francis' face has been moved so that the edge of his beard just touches the edge of the door opening that reveals the lit chapel in the background. Such an adjustment, threatening the clear demarcation of distances and at the same instant stressing the saint as the vital connection between the space coterminous with our own and the space of the depicted old chapel, only heightens the sense that Francis is part of an eternal pattern and hierarchy as well as an actor in a particular drama in a particular space and time.

Barocci returned repeatedly to the general sort of compositional organization he established in the *Perdono*. It seems telling, however, that there is evidence that he did not simply reuse the solution in later paintings but worked his way to it afresh from drawings that reveal less rigorously centralized narrative structures. For instance, the *Madonna of the Rosary*, which he produced for the Confraternità dell'Assunta e del Rosario in Senigallia between 1589 and 1593, exhibits clearly the legacy of the solution for the *Perdono*, even in details (fig. 62). The Virgin and Child sweep forward on clouds borne by angels and out of a heavenly, shimmering golden tunnel of light that is filled with the vaporous forms of cherubs. While it is hard to be sure, given the inevitable wear of centuries, the farthest edge of the Virgin's robe seems to begin to evanesce into the form-dissolving light of heaven as it streams back to her left, even as Christ's robe clearly does in the *Perdono*. A remarkable study appears to support this reading, as the strong outlines that define the edges of the Virgin's robe fade out in precisely this area (fig. 63). Beyond these details, however, it is obvious that the composition of the Senigallia altarpiece is predicated on that of the *Perdono*. The Virgin and Child are in the center of a clearly demarcated heavenly register, while Saint Dominic kneels, nearly in the center of the lower earthly register, and looks up in adoration, much as Saint Francis does. Dominic here is moved just slightly off-center so that the rosary the Virgin prepares to drop to him will come to rest in the portion of his habit that he holds up before him; it is this, rather than his body, that must occupy the middle of the lower register of the image. Nonetheless, another study indicates that Barocci had first ideated a composition in which the zones of heaven and earth were not rigorously separated and in which a central Virgin conveyed a rosary to a Saint Dominic who knelt before her and well to her left (fig. 61). The analogy with the early compositional idea for the *Perdono* is striking. The evidence of this drawing is one of several indications that Barocci did not simply reuse figures – or compositions – as facilely as is sometimes assumed in the literature. He does appear to have sought a perfect figural embodiment of certain characters or states of being, and a perfect compositional resolution for a series of altarpiece types as well (particularly the apparition and the biblical or hagiographical narrative). However, as exemplified in the creation of the *Madonna del Rosario*, he could re-find a solution rather than simply reusing it. The trajectory of his thinking as he ideated the great Senigallia vision demonstrates his unflagging commitment to the generation of drama, of *istoria*, first in all his paintings – and at the same moment the compelling power of the compositional solutions, hovering between retrospection and innovation, that he developed during the 1570s.

Indeed, in the *Perdono* Barocci must have arrived at a composition that he found particularly appropriate for an altarpiece

61 Barocci, study for the *Madonna of the Rosary*, pen on paper, 25.2 × 15.2 cm. Florence, Galleria degli Uffizi, Gabinetto dei Disegni, inv. 11470F (v).

(and specifically a high altarpiece), for while his solution allows both for the maintenance of cultic focus and the generation of an arresting and emotionally charged drama, it does not allow for a straightforward or complete narration of the textual *legenda*. In order to heighten the centralized organization of the picture, its focus on critical cultic figures, and its intense visionary and liturgical character, important subsidiary actors such as the smiling angels holding the miraculous roses have been eliminated. Nor is there even a rose to be seen – only

62 Barocci, *Madonna of the Rosary*, 1589–93, oil on canvas, 290 × 196 cm. Senigallia, Palazzo Vescovile.

63 Barocci, compositional study for the *Madonna of the Rosary*, oil, pen, chalk, and white heightening on canvas, 54.5 × 38.5 cm. Oxford, Ashmolean Museum.

objects for liturgical celebration. Thus Barocci's *Perdono* is not a strict recounting of the historical event, a didactic visual argument that would document the validity of the Porziuncola indulgence through a representation of all its particulars. There is no parchment handed to Francis, nor, crucially, is the saint in a Capuchin habit; here he is, as were his friars in this church, a Conventual. The principal arguments of this painting are not those of the sort of historical documentation pursued by Vanni. This is not to say that history is unimportant in the *Perdono* – it is fundamental and pervasive. Yet it is another kind of history that lies at the core of Barocci's invention – not a quest for the accurate historical presentation of certain iconographic signs, such as the "authentic" Franciscan habit, but a meditation on the history of some fundamental Christian image types.

When Barocci revised the figure of Francis he had adapted from Raphael's model and depicted the saint kneeling with outstretched arms while looking up toward heaven, he turned to venerable traditions of Franciscan imagery. If the style of Barocci's figure depends on Raphael, its type has become that of the Francis of the Stigmatization. Indeed, in the first known written appreciation of the altarpiece, Raffaello Borghini identifies it as a *Stigmatization*.[13] This is provocative; while Borghini's choice of terminology might be dismissed as misinformed, it is nonetheless telling that the iconographic type of Francis, and his relation to the apparition of Christ above, recalled ineluctably to period viewers that most fundamental of Franciscan images. There is more to Barocci's invention than a simple recourse to a well known iconography, however. For it is no ordinary Stigmatization tradition to which he has referred. The usual depiction of the event relied on a narrative that read across the picture plane, much like an Annunciation. The seraph appears (often as a fairly small figure) in one of the upper corners of the image and Francis receives the divine impress at the other side of the composition. This arrangement had been prevalent since at least the early Trecento. Yet there had been an alternative type that coexisted with the overtly narrative composition during the Duecento, which might be termed a "Stigmatization from above." In such compositions, Francis kneels or stands directly below the seraph, and is thus centralized in an image that also stresses a hierarchical division of heavenly and earthly levels. At the same time, this arrangement frequently necessitated that Francis assume poses more contorted and emotionally charged than those required in the more standard arrangement of the scene.

The "Stigmatization from above" figures prominently in Duecento Franciscan imagery, from panel paintings to reliquaries. A reliquary of Limoges manufacture, for instance, offers a notable depiction of the composition (fig. 64), as does an enameled cross also from Limoges. On the front of the cross the *Crucifixion* is represented, with Saint Peter below, the Virgin

64 Reliquary of Saint Francis of Assisi (Limoges, shortly after 1228). Paris, Musée du Louvre.

and Saint John the Evangelist in the side terminals, and an angel above. On the reverse, however, Francis is depicted in the place of the crucified Christ, with the stigmatizing seraph above him in the position of the angel on the front.[14] The "Stigmatization from above" appears as well in one of the great windows in the nave of the Basilica in Assisi, in which an animated Francis nearly crumples to the ground under the force of the seraphic vision and the impress of Christ's wounds.[15] It can also be found in a number of *Stigmatizations* in the historiated panels of late thirteenth-century dossals of Francis, particularly in a group of panels associated with Guido da Siena (fig. 65). In all these cases – crosses, tall Gothic lancet windows, small side panels in a dossal – the very format could encourage a vertical ordering of the composition. That the physical exigencies of such objects did not demand a vertically ordered composition, however, can be succinctly demonstrated with reference to

66 Seal of the Franciscans of Ghent, 13th century, plaster impression. Rome, Museo Francescano.

65 Follower of Guido da Siena, *Saint Francis Dossal*, third quarter of the 13th century, tempera on panel. Siena, Pinacoteca Nazionale.

Franciscan seals. During the thirteenth century, the "Stigmatization from above" was prevalent enough to appear even on some of the order's seals, such as that of the Franciscans of Ghent (fig. 66). Here again, the sharply vertical oval shape of the object might seem to demand such a composition. However, the iconographic type appears to have fallen into such obscurity during the Trecento and Quattrocento that most Franciscan seals from this period insist on a diagonal arrangement of the composition.[16] Yet, while virtually never seen between the early Trecento and the late Cinquecento, the "Stigmatization from above" re-emerges during the late sixteenth century as a principal compositional type, even in the sort of paintings that had traditionally accommodated across-the-picture narrations of the Stigmatization. Orazio Gentileschi's *Stigmatization* altarpiece in Rome's San Silvestro in Capite is a prominent late example (fig. 67).

This revival of the "Stigmatization from above" flourished at the intersection of concerns that preoccupied painters on the one hand and representatives of religious institutions invested in the recovery of fundamental elements of venerable image traditions on the other. In artistic terms, such a composition lent itself to the creation of figures in difficult postures, a pre-

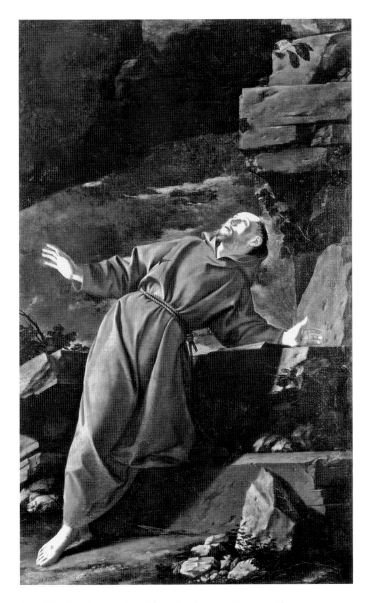

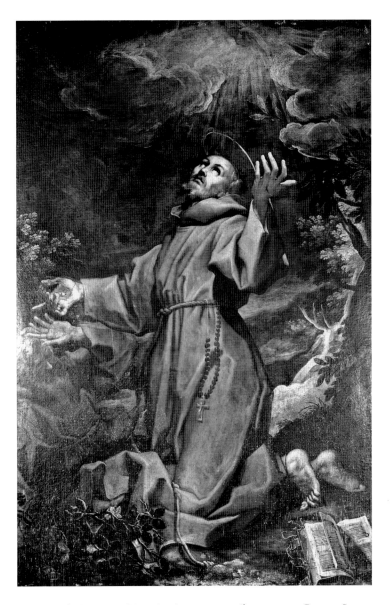

67 Orazio Gentileschi, *Stigmatization*, c. 1605–15, oil on canvas. Rome, San Silvestro in Capite.

68 Ferraù Fenzone, *Stigmatization*, c. 1595, oil on canvas. Rome, Santa Maria in Trastevere.

occupation of much Cinquecento painting that may be exemplified by Paolo Pino's dictum: "in all of your works you should have at least one figure in a complex posture [literally "forced"], mysterious and difficult, so that for this you will be considered talented by those who understand the perfection of art."[17] Despite the attacks of critics like Gilio against Michelangelesque figures in artificial poses, such preferences did not entirely disappear with the advent of reforms in painting during the latter part of the century. The "Stigmatization from above" not only allowed for such a figure but actually encouraged it as an integral part of the image's narrative structure. In addition, this twisting figure in a complex pose would not be merely an appropriate ornament of art; the strain of, and on, Francis' body only served to heighten the drama of the event

and the emotionalism – the representation of *affetti* – that was both an aspiration of ambitious painting and a critical component of effective religious painting during the late sixteenth and early seventeenth centuries. A powerful visualization of both of these points is offered in the *Stigmatization* by the Marchigian painter Ferraù Fenzone, still *in situ* as a chapel altarpiece in Santa Maria in Trastevere, Rome (fig. 68). Here, Francis' contortion is artifice to a purpose. Fenzone's allusions to the composition of Michelangelo's complex *Libyan Sibyl* from the Sistine Chapel – culminating in the near quotation of the left foot with its famously pronated big toe – registers his figure as one of art in the tradition of the great master in Rome. Yet, while it is artful, the saint's posture appears necessitated by the presence of the seraph directly above him, and

both the pain and the ecstasy of the scene are heightened by the silent eloquence of Francis' body.

The revival of the "Stigmatization from above" also addressed the desire of many Franciscans in the Cinquecento to study and revalue the earliest Franciscan image types and to restore crucial elements of the traditional visual language and decorum of the altarpiece. In particular, this composition placed Francis at the center of the image once more, an icon over an altar that could be dedicated in his honor. It thus provided an ideal means to conjoin two of the principal concerns of much post-Tridentine painting which often proved remarkably difficult to integrate – on the one hand the clear and affecting narration of a sacred story and on the other the creation of a compelling liturgical image with the principal holy figures at or near its center. The demand for narrative clarity was stressed repeatedly in texts of the Tridentine period and its implications are obvious. However, the demand for compositions that privileged decorous images of saints appropriately disposed and hierarchically arranged – while equally critical – was often discussed in relatively roundabout ways. For instance, it might be asserted that the identification of important figures should be clarified through legible iconographic signs, or that sacred figures should not be portrayed with artifice simply for its own sake, much less incite even a hint of "lasciviousness." Such issues are noted in a variety of texts, from the decree of the Council of Trent that concerns images to treatises on art by ecclesiastics ranging from Gilio to Federico Borromeo. The perception that the image of the principal holy figure should be placed in the center of a composition (and often be oriented frontally) so that he or she might be properly approached and reverenced seems understood to the point that it is not belabored in treatises. While alluded to by Gilio, this idea finds its most trenchant textual documentation not in theory but in letters and contracts. The most copious evidence, however, is found in the pictures themselves; a remarkable number of post-Tridentine reform images take significant pains to ensure this centrality. By looking at a few examples of both written and painted testimony the import of the evidence may become clear.[18]

Cardinal Carlo Borromeo, writing of images in the *Instructiones Fabricae et Supellectilis Ecclesiasticae*, makes a telling observation: "From the bearing, the *position* [author's emphasis], the adornment of the person, the whole expression of sacred images should fittingly and decorously correspond to the dignity and sanctity of their prototype."[19] A striking altarpiece that both clarifies and presses some of the implications of such a statement is Alessandro Allori's *Madonna and Child with Two Angels and Saints Francis and Lucy*, signed and dated 1583, from the chapel of the "Casino Felice" of Villa Montalto, the Roman suburban retreat of Pope Sixtus v (fig. 69).[20] Allori has taken a

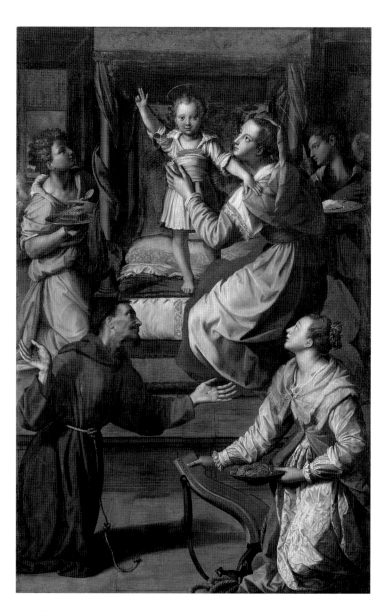

69 Alessandro Allori, *Madonna and Child with Angels and Saints Francis and Lucy*, 1583, oil on canvas. Cardiff, National Gallery.

domestic scene in the Holy Family's bedchamber and transformed it into a strictly symmetrical image with an iconic representation of the Christ Child. The bed, usually represented from the side in such scenes, is oriented now so that the viewer is situated at its foot. Its hangings thus form a baldachin for Christ, whose narrative act of stepping forward to bless the spectator is ritualized through a completely frontal and nearly frozen presentation of his body, which not incidentally is clothed despite his youth. Even the Virgin is completely subordinated to the *Salvator Mundi*.[21]

Allori's altarpiece represents an example chosen almost at random. Literally hundreds of period paintings present analogous features. Indeed, enough drawings survive from the late Cinquecento that one can even locate cases that replicate

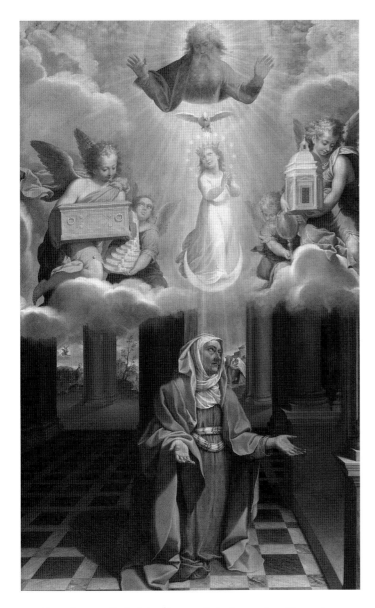

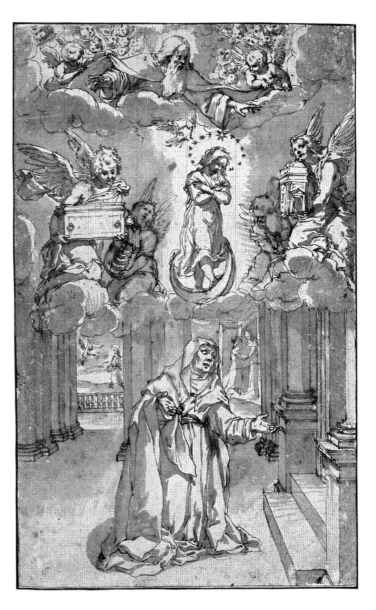

70 Bartolomeo Cesi, *Saint Anne and the Immaculate Conception*, 1600, oil on canvas. Bologna, Pinacoteca Nazionale.

71 Bartolomeo Cesi, study for *Saint Anne and the Immaculate Conception*, pen and wash on paper. Madrid, Museo del Prado.

Barocci's particular trajectory in the development of the *Perdono* from a diagonal to a centralized, vertically oriented narrative composition. One of the most striking of these occurs in the altarpiece of *Saint Anne and the Immaculate Conception* by Bartolomeo Cesi, a preferred painter of Cardinal Paleotti (fig. 70). In a carefully finished drawing, Cesi has already settled on a composition that places the figure of Saint Anne in the lower center of the image directly below the visionary figure of the Immaculate Virgin who descends toward her on rays of light, sent from God (fig. 71). However, Cesi positions God off-center to the viewer's left here, and angles His form so that He seems to be entering the scene slightly from the left. The dove of the Holy Spirit He has released flies diagonally down toward the hovering form of the Virgin. This arrangement – somewhat

idiosyncratic perhaps, given the rigorous centralization of the remainder of the composition – reflects an attempt to inject movement into the scene and to facilitate the reading of the action by organizing a critical aspect of the drama in a progression from left to right. In the painting, however, God and the dove of the Spirit have been rigorously centralized and frontalized, their motion quieted into iconic stasis. A second drawing documents Cesi's careful graphic articulation of the reorientation (fig. 72).[22]

A final example of an altarpiece that insists on the centralized and frontalized presentation of the principal sacred figure returns the discussion to the "Stigmatization from above" and offers a further trace of written evidence with which to reconstruct period parameters for perceptions of some of the quali-

In a controversial article Charles Hope has argued that art historians misconstrue period perceptions when they describe altarpieces as tending ever more toward what might be described as a "narrative mentality" during the fifteenth and sixteenth centuries. While he concedes that artistic ambitions and means changed during the period now called the Renaissance, and that many altarpieces came to employ more narrative devices than they had before, Hope's contention is that even pictures that appear to be narratives, such as the *Annunciation* or the *Stigmatization*, were actually perceived by period viewers first and foremost as representations of a particular saint. The angel of the Annunciation or the seraph of

73 Gaspare Celio, *Stigmatization of Saint Francis with Pope Sixtus V*, early 1590s, oil on canvas. Vatican City, Congregazione per la Dottrina della Fede.

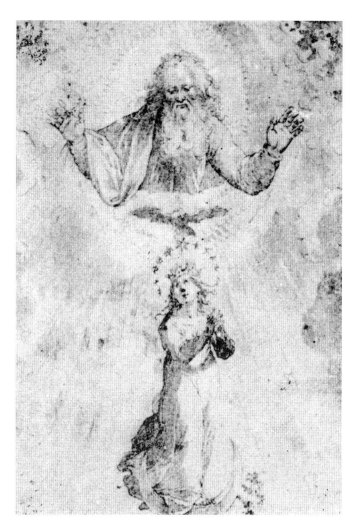

72 Bartolomeo Cesi, study for God the Father and the Virgin in *Saint Anne and the Immaculate Conception*, pen, wash, and chalk on paper. Milan, Pinacoteca di Brera, Gabinetto dei Disegni.

ties of such compositions. Gaspare Celio painted the *Stigmatization with Pope Sixtus V* in the early 1590s as the high altarpiece of the church of San Francesco that was annexed to the Ospedale dei Medicanti next to Ponte Sisto in Rome (fig. 73). The church was destroyed to make way for the Lungotevere in the late nineteenth century. Celio describes his work himself as "the picture at the high altar, in oil, with the Saint, who receives the stigmata, and Sixtus V, by Cavaliere Gaspare Celio." The language chosen for the description is instructive and not unique to this painting: "the Saint, who receives the stigmata . . ." The work is perceived first as an image of Saint Francis and then as an image of the Stigmatization conceived as a narrative *istoria*. By employing the compositional type of the "Stigmatization from above," Celio has heightened the effectiveness of the visualization of this concept and allowed the figure of Francis to assume its rightful place in the center of an altarpiece dedicated in his honor.[23]

the Stigmatization are not then so much actors in a drama as the salient attributes of the saints so presented.[24] Barocci's insistence on describing the project he was willing to undertake for the Fraternità dei Laici as an *istoria* rather than a *misterio* indicates that such perceptions were embattled at least by the late Cinquecento; in general Hope might be said to stress continuity over two centuries of remarkable artistic and cultural development without assessing the impact that representational transformations might exercise on perceptions of subject and iconography. His sources are generally conservative (legal contracts or statements by ecclesiastics) rather than the sort of documents, such as Barocci's letters, that might most clearly reveal increasing fissures in the old assumptions concerning religious painting. However, Hope's principal contention is not unfounded and perhaps has not been given the prominence it merits. If Cinquecento (and indeed some Quattrocento and even Trecento) artistic practices were altering the perception of religious pictures and putting old certainties and emphases into question, many of the post-Tridentine statements and strictures concerning ecclesiastical picture making were intended to ensure that paintings in churches would once again become vehicles for the devout and decorous representation of the company of Heaven. Trent's lapidary pronouncement that "due honor and reverence is owed" to images of the saints represents not only a rebuff to the Protestant disdain for image devotion but also a defense of the most venerable sort of Christian image, and an implicit reminder that while sacred *istorie* taught much and were to be commended – as indeed the fathers did – it was the sacred figures, not the story, that were objects of veneration in altarpieces.

Further, the textual evidence that Hope does trace reveals important assumptions held by many ecclesiastical and lay patrons, probably including the Aretine rectors. The texts in question are particularly interesting for their repeated stress on placing the "central" figures in an altarpiece in the physical center of the image. A remarkable number of contracts, for instance, explicitly state that the most important figures must be depicted "in the middle of the panel."[25] One document especially, in which a priest complains about the pernicious effects of an innovative composition by Titian, elucidates that the centrality of the principal sacred figures was about more than a clear and hierarchical system of identification – it had serious liturgical implications as well. The priest had to officiate before Titian's Treviso *Annunciation* (fig. 74). This altarpiece is notable for the highly idiosyncratic insertion of a portrait of Broccardo Malchiostro, the painting's donor, in the center of the image. Although Malchiostro kneels in the background, his figure is represented in the critical space between the Virgin and the angel, who are arranged in a sharply diagonal

composition that radicalizes the elements of dramatic *istoria* possible to envision in an *Annunciation*. The figure of the Virgin occupies the foreground but this did not prevent the priest from asserting with considerable anger:

> When I go to say mass at the altar of the chapel of messer Broccardo . . . and I see the image of messer Broccardo there, I am thoroughly contaminated, because one is making reverence to that figure and not to the image of the Madonna; and when the bishop was here he did everything well, apart from the fact that he should have had that image of messer Broccardo removed, so that it wasn't in the middle of the altarpiece: and anyone who scrubbed it out or dirtied it would be doing a good thing.[26]

One could not imagine more telling testimony. The priest takes for granted that one "makes reverence" to the central figure in an altarpiece first. When that figure is not appropriate the instinctive act of reverence is misdirected and becomes not simply mistaken but contaminating.

74 Titian, *Annunciation*, c. 1520–23, oil on panel. Treviso, Duomo.

The "Stigmatization from above," then, succeeded in replacing centered representations of subsidiary figures – or empty space, a common byproduct of images such as the Annunciation that frequently employed "across the picture plane" narrative progressions – with that of Francis, refocusing the altarpiece on the figure of the saint in whose honor the altar was dedicated. The recourse to this formula also exemplifies the manner in which much late Cinquecento ecclesiastical painting melded aspects of archaic compositions with modern style in the search for a visual language that could reinvigorate devout imagery for a new age. In Barocci's *Perdono* the connection of his figure of Saint Francis to the revival of the "Stigmatization from above" is clarified by one of Barocci's four autograph prints, which replicates the Francis from the Urbino altarpiece precisely as the Francis of the *Stigmatization* (fig. 75). Indeed, one wonders whether a drawing for the altarpiece was copied to make the plate, for the figure in the etching is identical to its pictorial model except that it is reversed, indicating that the cutting of the plate followed an image oriented as in the altarpiece. As in the altarpiece, the Francis here is at once a figure of devotion, an effective expressive figure in a dramatic *istoria*, and a figure of artistic complexity, deliberately exceeding its models in Raphael and Titian in *difficoltà* (indeed, a number of drawings record Barocci's painstaking study of the kneeling, turning, leaning pose of Francis in the *Perdono*). Directly above the centered figure of Francis in the etching, right at the top margin of the sheet, the seraph appears to impress on the saint the wounds of the Savior. One begins to see why Borghini could have misconstrued the *Perdono* as a *Stigmatization*.[27]

Despite the rigorously centralized composition Barocci evolved for the *Perdono*, however, the only overt archaism of style in the altarpiece occurs in the painting within the painting, the *Crucifixion* that represents the altarpiece of the Porziuncola's inner chapel. Since Barocci placed Francis further from the altar than Vanni would, he was able to depict more of the chapel space and thus to represent the altarpiece before which the viewer is to imagine Francis had been praying when assailed by temptation. The chapel is softly lit by the candles that illuminated the saint's nocturnal devotions. Francis is now granted a direct vision of the glorious light of Heaven that floods the foreground of the *Perdono*, but this reward comes after long vigils of prayer illumined by the flickering candles of faith. And while the saint now sees a pre-Judgment vision of his risen Lord, this privilege is predicated on his faithful journey down the *Via Crucis*, aptly symbolized both by his assumption of a pose associated with the Stigmatization and by the *Crucifixion* altarpiece before which he has held his vigil.

This painting within the painting is not simply a *Crucifixion*, however; the portion of the painting visible through the open

75 Barocci, *Stigmatization of Saint Francis*, c. 1581, etching and engraving.

door to the chapel virtually matches the representation Barocci had developed in the compositional drawing for the Bonarelli altarpiece (see fig. 13). It is particularly telling that Barocci composed the *Perdono* in such a way that only the portion of the *Crucifixion* with the figures of Christ and of the archaizing Virgin can be seen. The more modern, dramatically activated figure of Saint John, who had appeared already in the drawing and was retained with slight revisions in the final painting, is here largely obscured by the wall and grill that demarcate the chapel space. The drawing may not have been widely known in Urbino, but the Bonarelli altarpiece certainly would have formed part of the sacred visual repetoire of Barocci's fellow citizens, and Barocci could have expected at least a fair number of the *Perdono*'s spectators to be capable of supplying the missing

figure of Saint John in their imaginations. Barocci seems to have relied on this knowledge to generate yet another layer of significance in his remarkable figure of Francis. Francis' pose – which Barocci evolved through careful nude studies conserved in the Uffizi – not only recalls the figure of the saint of the *Stigmatization* but also, in the outstretched arms, that of Saint John in the Bonarelli *Crucifixion*. Critical aspects of the figure's meaning are thus embodied in visual form, in a manner that is distinctly Barocci's. Francis beholds Christ in glory and receives the unique privilege of the Porziuncola indulgence because he is the saint who most fervently wished to be present to the suffering of Christ, and indeed to conform himself to Christ's suffering and death. Barocci's carefully calibrated composition links Francis' vision of the risen Christ to the John-like vigil he had kept before the representation of the dying Savior and foreshadows the ultimate apparition of Christ to Francis, when the saint would receive a privilege even greater than the indulgence offered here. In the *Perdono*, the representation of the Crucified Christ hangs directly below the visionary resurrected Christ who overshadows Francis, just as the dove hovers below the feet of Christ in the *Madonna del Popolo* – as an intermediary between zones. Barocci has ensured that Francis inclines his head in just such a way that he reveals the lower portion of the cross to the viewer before the altarpiece. In this manner his figure becomes also a modern interpretation of those Duecento and Trecento images of Francis kissing the foot of the cross in scenes of the *Crucifixion* (see e.g. fig. 15). Further, the cropping of the *Crucifixion* focuses attention on Christ and his mourning mother, both of whom are glorified before the awestruck saint. Yet one wonders why the depiction of the mourning Virgin derives from the archaizing figure in the drawing.

Within the logic of a learned, historically sensitive approach to a representation of the *Perdono*, such a fragment of overt archaism could provide a note of historical authenticity, a sort of visual sign of the date of the events represented. This explanation, however, fails to account for the absence of any other authenticating signs in Barocci's painting. There is no close adherence to the textual narrative of the event; there is no concern to portray Francis in the original habit; there is no attempt to recreate the "Paleo-Franciscan" architectural setting of the Porziuncola that was just then being enshrined as an architectural icon on the plain below Assisi. The architecture depicted in the altarpiece is simple indeed; yet it conforms to the vocabulary of ancient form that was standard in the 1570s.[28]

The viewer confronts instead a religious painting that is both an effective liturgical image and a pictorial meditation on the means and ends of religious painting in the 1570s. Barocci's decision to "cut" the *Crucifixion* (precisely in the middle of both it and the *Perdono*) by the frame of the chapel's door, effectively erasing the figure of John, accomplishes more than heightening the impression that this *Crucifixion* is an archaic image by obscuring its most "modern" figure. The painter's maneuver isolates the figures of Christ and the Virgin in the composition and juxtaposes their apparently archaic pictorial representations with the reality of their glorious apparition. To push the point in metaphorical terms: in the background the viewer perceives a representation of Christ and the Virgin broken, illuminated only by the flickering light of faith that shines in the darkness, Christ's divinity apparent as a sign but veiled by death (and by archaism). These figures are venerable and decorous symbols of the holy, and provide an appropriate focus for devotional prayer. Yet they are only signs, and appear as such when the heavens open and the holy personages are miraculously present. The vision is reality, the old image only the schema. This is to paraphrase, without its positive inflection, the distinction that Vittoria Colonna had delineated between the archaic and the modern; the archaic represents the fundamental *disegno*, while the modern adds the valences of illusionism effected through color and light.[29] The archaic image has much to recommend it and its centralized, symmetrical organization, its decorum, its legibility, are all preserved in the vision. In the clouds and light of theophany as represented by the new art, however, the sacred figures appear to come to life.

Barocci's pictorial strategy here, his claim to both paint paintings and bring them to life, could be read univocally as a visual argument that the powers of modern art consign archaic images definitively to history, even if some of their qualities may be appreciated and incorporated into current religious painting. However, Barocci's particular claims of pictorial modernity may be more complex than this. It has been noted that, unlike much of Barocci's work, the brushwork in the *Perdono* is in general extremely smooth, the marks of pictorial process often virtually invisible. In contrast, the Bonarelli *Crucifixion*, completed some seven years before, contained a number of highly painterly passages recalling the later work of Titian, for instance in the face of Christ (fig. 76). Such painting makes Barocci's reversion to a relatively brushless approach in the *Perdono* seem all the more calculated. Here something descended from Leonardo's *sfumato* takes precedence over the vigorous brushwork of Titian that insists on the materiality of making. Barocci's cultivation of *sfumato* was particularly noted by early commentators; the description of his style in the *Visitation* (fig. 77) as "so sweet, *sfumata*, and *vaga*" offered by Baglione encapsulates a sensitive perception of the salient qualities of Barocci's work as an artist (Baglione here takes the devout quality of the painting for granted).[30] In privileging *sfumato* over the perceptible brush in the *Perdono*, an ambitious and still young painter was expressing the range of his modernity; there will be more to say about

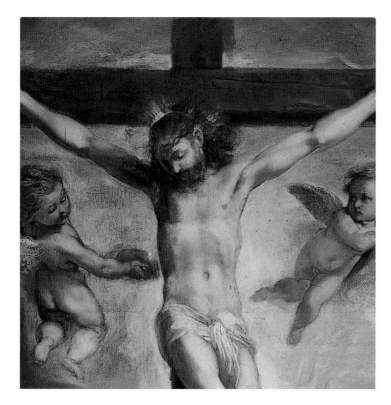

76 Detail of fig. 12.

this in considering color in the *Madonna del Popolo*, in which different modern modes are dramatically juxtaposed. Yet while Leonardo intended his famous technique to make of painting a virtually unmediated image of nature, free of the artist's individual "distortion" of illusionistic representation, at least two qualities inherent in the mechanics of *sfumato* offered particular resources to a religious painting attempting to approach the representation of the the invisible.

First, the technique "understood" the limits of delineation – a knowledge particularly appropriate to the task of representing that which was ultimately beyond the power of the eye alone to comprehend – and discovered a compelling means for representation to evoke what it could not depict. Daniele Barbaro noted perceptively that "to make the contours soft [*dolci*] and *sfumati*" in a painting leads the viewer "to understand what one does not see."[31] *Sfumato* was particularly appropriate to the representation of visions; the technique both heightened the "realism" of the mist-filled vision and thematized through its very mechanics the ultimate inability of vision to fix the divine. The sacred figures are so brightly lit, so present, yet full comprehension of their forms forever eludes the eye. Second, a different, but not entirely unrelated, "brushless" technique had been employed in some early fifteenth-century Netherlandish religious painting as a device for disguising art, erasing the human signs of making and alluding to

the unmediated image of the divine. Particularly in Eyckian images of the Holy Face, "brushless painting" could both celebrate the legendary portrait of Christ "not made with human hands," a sort of divinely generated self-portrait, and the astonishing virtuosity of the painter who could represent such a *sui generis* sacred image.[32] Whether Barocci was aware of this tradition is unclear and his surface in the *Perdono*, with the weave of the canvas visible in places, can in no wise be compared directly to Netherlandish "brushless" images of the Holy Face. Nor has he entirely renounced the quick, schematic paint handling that had become a virtuoso element of the *Crucifixion*; some passages in the drapes that hang over the chapel rail and the highlights (on the Sanctus bell and in the eyes of the saint) testify to an ongoing interest that re-emerged fully in the *Madonna del Popolo*. Nonetheless, Barocci seems to have labored here to create an image that was for him notably unmarked by heavy traces of the artist's brush.

This is nowhere more evident than in the face of Francis himself, on which Barocci expended particular labor. According to Lazzari, Barocci revised the head repeatedly and even appears to have remained unsatisfied once the painting was finished; the final version is painted on paper laid down over the surrounding canvas.[33] In Francis' painstakingly worked face one sees the generation of a new kind of icon and a vision of holiness for the modern age. In its *sfumato* (*maniera si dolce, sfumata, e vaga*) it is more than modern and fuses the perfections of Leonardo with the living flesh of Correggio. In its renunciation of the vigorous bravura brushwork of Venice, however – brushwork that had formed the face of Christ from thick paint in the Bonarelli *Crucifixion* – it hints at a brushless ideal that has profound if submerged links to one of the earliest devices through which the first artists of "modernity" had employed their skills to point to the holy image not made with hands. In Barocci's *Perdono*, retrospection and innovation, humility and artistic ambition meet to produce an altarpiece that is not meant to appear painted but rather – in a manner at once simple and profound – to *appear*.

ICON, NARRATIVE, AND SACRED PORTRAITURE IN THE VALLICELLA *VISITATION*

Barocci's altarpiece of the *Visitation* (fig. 77) for a side chapel in the Chiesa Nuova, the mother church of the Oratorians in Rome, may at first glance have little in common with a high altarpiece such as the *Perdono*. The *Visitation* seems to offer a clear, lateral presentation of a narrative from scripture – one of those, in fact, proposed by Barocci to the Aretine rectors as an

77 Barocci, *Visitation*, 1583–6, oil on canvas, 285 × 187 cm. Rome, Chiesa Nuova.

78 Barocci, compositional studies for the *Visitation*, pen and wash on paper, 21.9 × 32.5 cm. Paris, Institut Néerlandais, Fondation Coll. Lugt, inv. 5483 (r).

alternative to a more conceptual painting such as the *Miseri-cordia* – and thus can stand as a straightforward sacred *istoria*. It is not a vision, nor does it interpret archaic or esoteric icono-graphies. Nevertheless, the number of drawings that survive allow for a fairly detailed reconstruction of Barocci's prepara-tory process and demonstrate a particularly intriguing trajec-tory of pictorial construction.

It has frequently been observed that the Oratorians were committed to the study, and often the revaluation, of the tra-ditions of Christian imagery. Indeed, Oratorians were at the forefront of Paleo-Christian studies, particularly interested in the history of image use in Christian worship, and eager to dis-seminate adaptations of the archaic Vallicella *Madonna*, as exem-plified by the letters of Talpa considered in Chapter One.[34] However, the Oratorians were also sophisticated patrons who desired to fill their impressive new church in Rome with altar-pieces by the best modern painters. Their desire to obtain a sig-nificant painting by Barocci was strong: they solicited the aid of Cardinal Pierdonato Cesi, one of their most important sup-porters and the primary donor in the building of Santa Maria in Vallicella, to persuade the Duke of Urbino to convince the

slow and recalcitrant painter to contribute an altarpiece to their sacred gallery. Barocci must have realized that this gave him the opportunity to establish himself back in Rome and he accepted the commission.[35]

Given this opportunity and this challenge, it is no surprise that surviving drawings for the *Visitation* indicate that Barocci began designing with ideas for a dramatic and even busy nar-rative in mind. From the beginning, however, he wrestled to accommodate narrative to the traditions and exigencies of the altarpiece. Important drawings on two sides of the same sheet articulate compositions in which the Virgin advances toward the viewer. On one side, this action occurs on a diagonal, with the Virgin moving forward and slightly to her right as Elizabeth descends the steps to greet her (fig. 78). The articulation of the action, however, allows Elizabeth to occupy a higher position in the composition than the Virgin, who ascends toward her. As if to compensate, Elizabeth is conceived as advancing away from the spectator, her face lost in *profil perdu*. On the other face of the sheet, Barocci has conceived the Virgin as advanc-ing straight toward the viewer, stressing her frontal and central position – but here the exigencies of narrative drama dictate

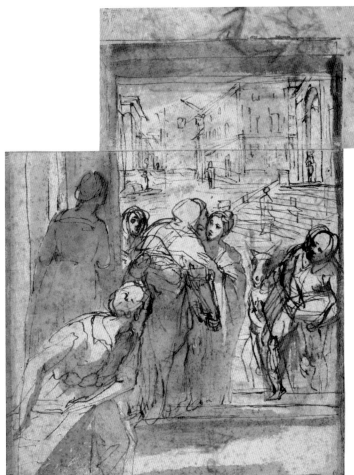

79 Verso of fig. 78.

80 Barocci, compositional study for the *Visitation*, pen and wash on paper, 27 × 17.6 cm. Copenhagen, Statens Museum for Kunst, inv. 7404–5 (r).

that the Virgin's body be partially obscured by the figure of Elizabeth, who proceeds into the image with her back again to the spectator and still occupies a higher position (fig. 79). Subsidiary figures such as Joseph, Zacharias, and servants compete for attention against an elaborate urban backdrop as Barocci analyzes the possibilities of narrative drama raised by the biblical *istoria*. The solutions explored in these drawings are more or less identical with that represented in another drawing, in which the number of subsidiary figures – both servants and background figures – is increased (fig. 80).

On a third sheet, however, Barocci has abandoned the attempt to depict the Virgin frontally in favor of bringing her into the foreground; she now advances obliquely from the left, in the direction of "textual" reading (fig. 81). This solution places the Virgin literally and theologically "before" Elizabeth, and Elizabeth here stoops deeply – bows, as it were – as she descends toward the Madonna. Yet now it is the Virgin's figure that must be angled away from the viewer. Barocci must have

realized immediately two shortcomings of this revision; in subsidiary sketches on the same sheet, he reversed the direction of the Virgin's motion and turned her upper body so that her shoulders are perpendicular to the picture plane rather than angled into it. This reversal of narrative movement is crucial because Mary now advances against the standard reading direction in a way that slightly slows the action. The shift in the angle of her torso is also fundamental. While the Virgin still climbs steps that recede into the picture space, her body is presented to the viewer in profile. However, her face remains hidden in *profil perdu*, as she embraces the figure of Elizabeth deeper in the picture space.

In the sketch at the lower left of the sheet, however, Barocci touched on a solution that he developed dramatically in a cluster of sketches on the verso (fig. 82). Here, in two studies on the left, he draws the decisive, dark penstrokes that bring the Virgin's head into strict profile – the profile of old aristocratic portraits, a profile rigorously distinguished from the *profil*

87

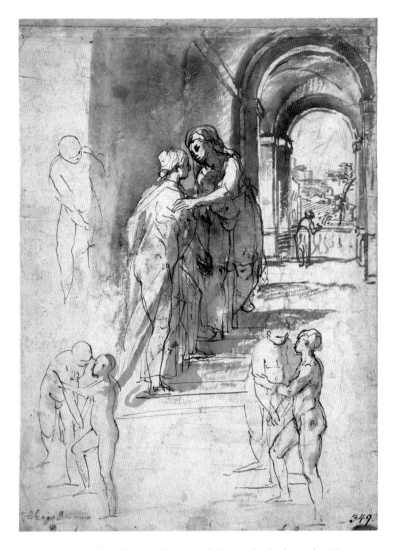

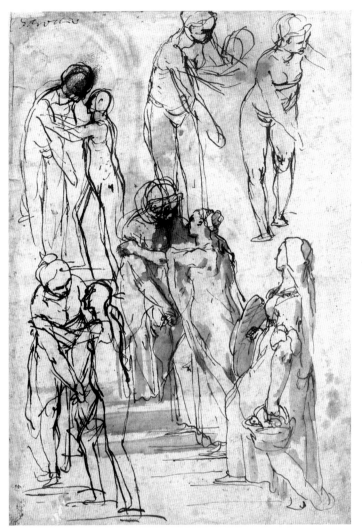

81 Barocci, studies for the Virgin and Saint Elizabeth in the *Visitation*, pen and wash on paper, 20.5 × 28.1 cm. Stockholm, Nationalmuseum, inv. NMH 412/1863 (r).

82 Verso of fig. 81.

perdu he maintains for the face of the maidservant in the more worked-up central study (and in the painting). In the altarpiece, this aristocratic image of the Virgin, frozen just as she is forever stepping up, against the implicit flow of narrative reading, to assume her rightful place at the center of the altarpiece, sets her instantly apart from the other figures. Despite her youth and sweetness, she is a noble and sacred figure, the Queen of Heaven and a modern icon.[36]

What seems remarkable about this design process is that Barocci here was working for patrons who seem to have placed little restraint on his invention. By the 1580s, the painter was pushing himself to fuse the power of modern painting with the strengths of tradition. More than any other painter in central Italy during the 1570s and '80s, Barocci was able to create an artistically compelling version of the *regolata mescolanza* of old and new in religious art that reformers desired – and, decisively, to press all the skills of modern painting into service to revivify tradition. This skill, this power, seems to have arisen from a series of initially painful but ultimately fruitful negotiations with mendicant and confraternal patrons invested in the revaluation of venerable image types and the recovery of some of their salient qualities.

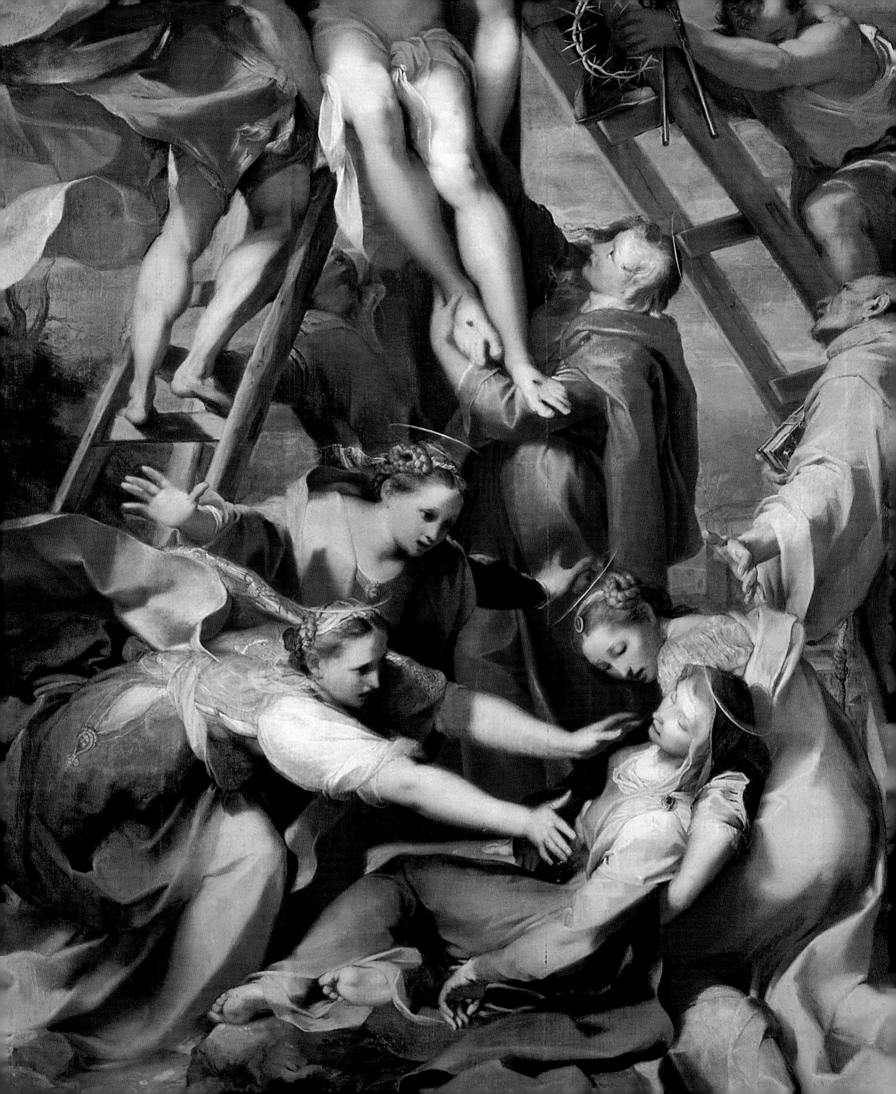

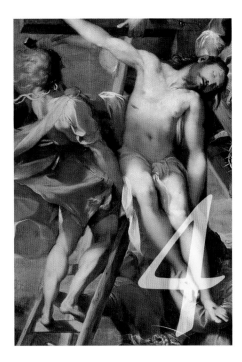

The Legacy of the Renaissance
and the Contemporary Cult Image

The *Dialogo degli errori de' pittori* of Bishop Gilio discussed in the first chapter is one of a number of texts that indicate perceptions of a crisis in religious art by the 1560s. While most art historians still identify the type of art critiqued by Gilio and defended by Vasari as "mannerist," a number of salient issues that could contribute to tensions between the developing aims of art and the traditional appearance and functions of the altarpiece were already in play during the period commonly termed the High Renaissance. The insufficiencies of these venerable art historical rubrics have become more and more apparent in recent historiography. One difficulty with the designation "High Renaissance" – particularly as applied to developments in central Italian art from about 1500 to 1520 – is that it for too long represented an attempt to identify an art of undisturbed perfection, a "canonic" art having little to do with the febrile and occasionally bizarre inventiveness of much art just before and after the supposed golden age of equilibrium. This conceptualization does serious injustice to the entire late fifteenth and sixteenth centuries, and specifically to the "High Renaissance" itself, which may with equal ease be viewed as a period of intense experiment and polemic. It is true that contemporary observers

recognized that remarkable artistic developments were occurring at the beginning of the sixteenth century and that these were perceived to be achieving a level of perfection thitherto unattained. Yet for much of the century the accomplishments of its first two decades were perceived to be more continuous with what followed than most twentieth-century art history was prepared to accept. Further, the transformation that Varsari perceived from the "hard" and "studied" figures of the fifteenth century to the lovely and "living" figures of a number of *terza maniera* artists ineluctably located a fundamental element of the distinctive power of modern art not merely in an idealized naturalism but particularly in the affecting representation of the body, and ultimately in the stimulation of desire in the beholder. This quality, which has been called "Petrarchan," indeed contributed to the increasing suspicion of "the moderns," in Gilio's recurrent phrase, in the cultural debates that developed during the course of the century.[1]

Perhaps it would be as well to call the modern art Barocci admired, following Vasari, simply the *terza maniera* or the *maniera moderna*. Vasari's term captures the period sense that great changes had occurred from the time of Leonardo onward,

Details of fig. 85

while avoiding an impression that the art of the early sixteenth century is one of a distant and porcelain perfection, which historiography could cut off from developments beyond central Italy and after about 1520. Barocci was deeply invested in Raphael's Madonnas and great altarpieces, and in aspects of the legacy of the Sistine Ceiling, particularly elements of coloring that had come to be associated with so-called *maniera* painters such as Salviati. He was equally committed to the art of Titian, however. In other words, he was a partisan of what he would have recognized as the *maniera moderna*, representing the great developments in both central and north Italian art from Leonardo onward.[2]

When Barocci looked to the art of central Italy, he was particularly drawn to the achievements of Raphael and to certain qualities in the work of Michelangelo. Yet, as historians such as Alexander Nagel have begun to insist, the innovations introduced by these "canonical" artists during the early sixteenth century were not universally or serenely embraced. A number – particularly those of Michelangelo – came to be implicated in the increasing attacks on modern art as the century wore on.[3] One advantage of studying developments in the second half of the century is that these years witnessed a proliferation of both visual and written sources that acknowledge, and at times attempt to overcome, the tensions between aspects of the new art and its traditional religious functions. There are, however, several images from early in the century that already appear to exemplify both some of the problems and some of the possible responses that came to form a critical legacy for later artists, theoreticians, and patrons. As an ambitious painter in the second half of the century, Barocci both inherited a double canon of antique and earlier sixteenth-century art, and confronted the rising challenges to this canon as a decorous visual vocabulary for religious art. Barocci's distinctive accomplishment was grounded in his determination to find ways to link the languages of modern painting to the venerable traditions of Christian art and worship. In this process he revisited and revalued some of the innovations and experiments of those first decades of the *maniera moderna* that have come to be called the High Renaissance.

THE *ENTOMBMENT* OF SENIGALLIA AND THE ALTARPIECE BETWEEN *ISTORIA* AND *MISTERIO*

While his articulation of the "vision altarpiece" offered an appropriate solution for a number of projects, Barocci confronted the challenges posed by strictly narrative altarpiece painting as he ideated one of his most important commissions

of the 1570s, the large altarpiece of the *Entombment* for the Confraternità della Croce e Sacramento in Senigallia (fig. 83). This confraternity had been founded at the end of the fifteenth century and originally used a small church outside the walls of the city. By the 1560s, however, the brothers had established an oratory near the cathedral and were considering its enlargement. It seems to have been in this context that they began to desire an altarpiece; hitherto the only image on their altar had been a representation of the fraternity's *impresa*, their symbolic insignia. By the late 1570s, word that Barocci was "excellent in this art of painting" had reached the brothers – Barocci was just completing the *Madonna del Popolo* for the leading fraternity of Arezzo – and they decided to entrust the new altarpiece to him in a meeting of February 3, 1578. Barocci, probably frustrated with the long and arduous process of ideating and executing the *Madonna del Popolo* for exacting and difficult confraternal patrons, demanded the significant sum of 600 scudi, and it was more than a year before negotiations lowered the price to 300, something the brothers felt they could afford. The contract was made in July 1579 and the painting consigned by May 1582. A remarkable number of drawn and painted studies survive to testify to Barocci's painstaking elaboration of this altarpiece.[4]

The confraternity's decision to replace a simple decoration on an altar dedicated to the Eucharist with an elaborate altarpiece finds significant analogies elsewhere. In Venice, for instance, the chapel of the Holy Sacrament in San Giuliano was donated by Francesco Locadel to the local Scuola del Sacramento in 1544 on the strict condition that the altar receive no decoration apart from an image of Christ on the door of the tabernacle. As has been noted, this attitude may reflect a reformist piety that wished to minimize the employment of altarpieces. While the Council of Trent reaffirmed devotion to the sacrament of the Eucharist – indeed, an increasing number of altars after mid-century were given strictly Christological dedications, and Christological themes were often employed in altarpieces even when the altar honored a saint – Trent also reaffirmed the role of sacred images. While a number of altars dedicated to the Holy Sacrament were indeed distinguished by large tabernacles that took the place of altarpieces, in the chapel at San Giuliano, as in the Oratory of the Cross and Sacrament in Senigallia, earlier and simpler altar imagery was discarded in favor of elaborate altarpieces. In the case of San Giuliano, the altarpiece was sculpted – thus particularly expensive – and the project, undertaken in the 1570s, expressly contravened the wishes of the chapel's founder.[5]

When the brothers of the Senigallia confraternity decided to transform the decoration of their altar, they commissioned from Barocci an altarpiece of impressive size. Its format – apparently chosen at least in part by the painter, since he also later

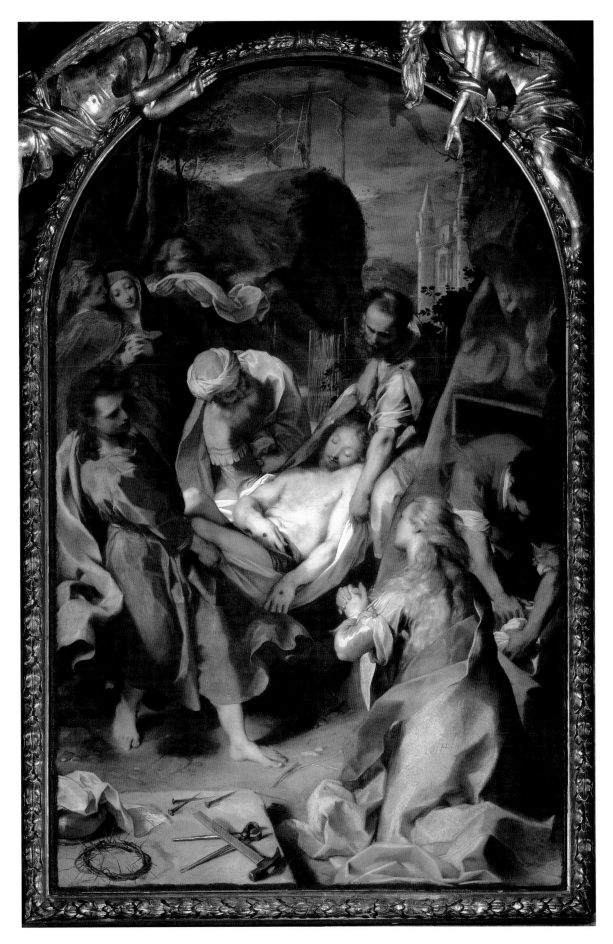

83 Barocci, *Entombment*, 1579–82, restored and revised by Barocci 1606–8, oil on canvas, 295 × 187 cm. Senigallia, Santa Croce.

84 Barocci, studies for the Senigallia *Entombment*, chalk on paper, 20.1 × 31.5 cm. Berlin (Dahlen), Staatliche Museen, inv. KdZ 20359 (4294) (v).

designed the original framing – is that of a tall vertical arch.[6] The representation of the three crosses on a distant cliff dominates the upper center of the canvas; the crosses are dramatically illuminated from below and behind by a setting sun, which is obscured by the brooding, shadowed cliff-face. A chalk drawing demonstrates Barocci's careful study of the light effects on the workers who, their labor accomplished, carry away the ladders used to remove Christ's body from the cross (fig. 84). Directly below these distant crosses in the two-dimensional composition of the picture plane – as has been seen, often of great importance for Barocci – is the body of Christ, now brought to the foreground of the painting's illusionistic space, carried forward from the Virgin who stands unsteadily in the

left middle ground. The bearers are represented just as they rotate Christ's body so that it appears nearly frontal to the viewer who stands or kneels before the altarpiece. In the fiction of the narrative action, the figure of John has just begun to stride across the canvas as he pivots the body of the Savior and advances toward the open tomb at the right. Between the viewer and the body of Christ, the praying figure of the Magdalen models an appropriate response for beholders. Opposite her, in the lower left foreground, the instruments of the Passion compose a compelling contemplative still life laid out on a block of stone (the door of the tomb or the lid of the sarcophagus) that is represented just above the Oratory's actual altar, Christ's "other" tomb. The painted crosses at the central peak of the composition, the Corpus Christi at the heart of the altarpiece, and the physical cross that would be at the center of the altar itself form a powerful vertical, central axis of the altar ensemble, and with the implements displayed in the still life also allude to the *impresa* that had provided the altar's initial embellishment and proclaimed the confraternity's identity. There will be more to say about the ways in which the painting relates to the altar, and the insistence on cross and *corpus* in Barocci's composition. What must have been immediately apparent when the new painting arrived was the transformation of the confraternity's altar decoration; Barocci radically elaborates symbolic representations of the cross and sacrament to which the *confratelli* devoted themselves to create a complex and dynamic narrative, the *istoria* that was one of the glories of modern painting.

In doing so, however, Barocci reflected carefully on the integration of narrative drama with the decorum and liturgical symbolism appropriate to an altarpiece. Further, he seems to have reflected specifically on some early sixteenth-century paintings that had wrestled powerfully with just these issues. I have in mind principally Michelangelo's unfinished *Entombment* of about 1500 (fig. 86) and Raphael's Baglioni *Entombment* of 1507 (fig. 87). Pontormo's Capponi chapel altarpiece of 1525–8 (fig. 88) may also have inflected his thinking. Barocci certainly knew Raphael's painting intimately and the Senigallia *Entombment* is both a homage to and a critique of his compatriot's remarkable achievement. It is well to focus first, then, on Barocci's interpretation and transformation of the Perugia altarpiece.

Barocci may have become acquainted with the Baglioni *Entombment* very early, as he is known to have visited a number of cities in Italy to look at art in his youth and Perugia in any case lay between Urbino and Rome. It is certain that he studied it intensely during an extended residence in Perugia from late 1567 to Christmas of 1569. He was there to paint the great *Deposition* for the chapel of San Bernardino in the Cathedral (fig. 85). Such a prolonged stay away from Urbino after his

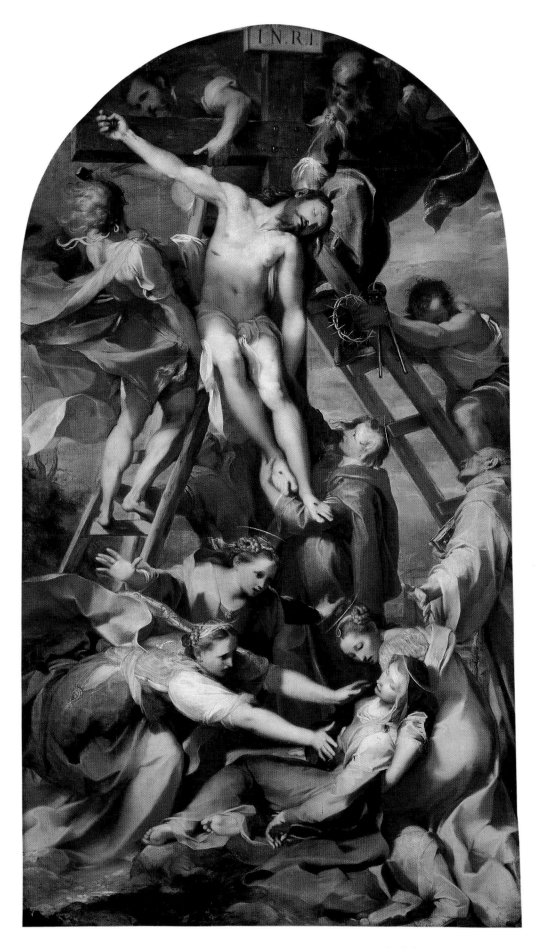

85 Barocci, *Deposition*, 1567–9, oil on canvas, 412 × 232 cm. Perugia, Cathedral.

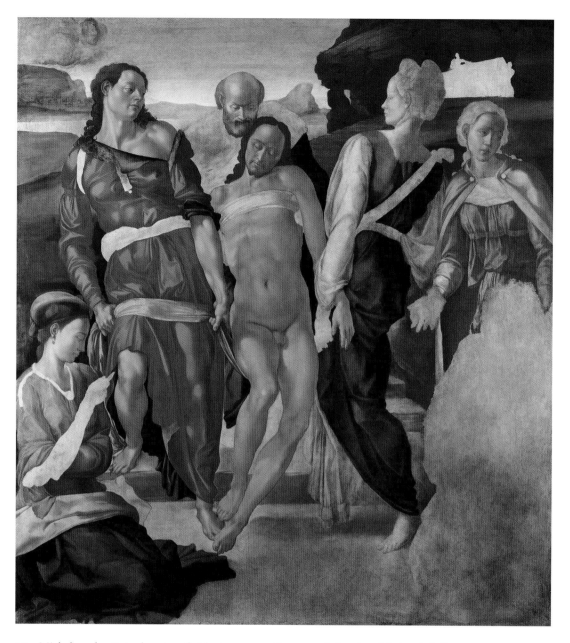

86 Michelangelo, *Entombment*, unfinished, c. 1500, oil on panel. London, National Gallery.

return *in patria* from Rome was extremely unusual, but the years in Perugia gave Barocci the opportunity to forge strong new friendships and also to study numerous important paintings that embellished the city; they exercised an influence on his pictorial imagination for some time to come.[7] A number of these paintings were Quattrocento confraternal *gonfaloni*; as already discussed, memories of some of these had proved instrumental in the ideation of the *Madonna del Popolo*. Nonetheless, among the modern masters, it was the young Raphael who dominated Perugia and Barocci would surely have studied altarpieces such as the Ansidei *Madonna* in San Fiorenzo dei Serviti (fig. 89) and, first and foremost, the *Entombment*, just blocks from the cathedral in the major Franciscan church of San

Francesco al Prato. Raphael's dramatic narration of a critical moment from the Passion, made for a Franciscan setting and a locus of Bernardine devotion, would be an obvious, fundamental point of reference for the young Barocci, determined to make his name with a major Passion altarpiece in a chapel dedicated to San Bernardino.[8]

Barocci's response to Raphael in the Perugia *Deposition* is both forceful and subtle, an exemplary case of powerful artistic *imitatio*, which has little to do with the modern idea of imitation.[9] One cannot make out any direct imitations, but the figure of the younger man who leans back precariously from the left-hand ladder as he struggles to support the body of Christ seems virtually unthinkable without reflection on both

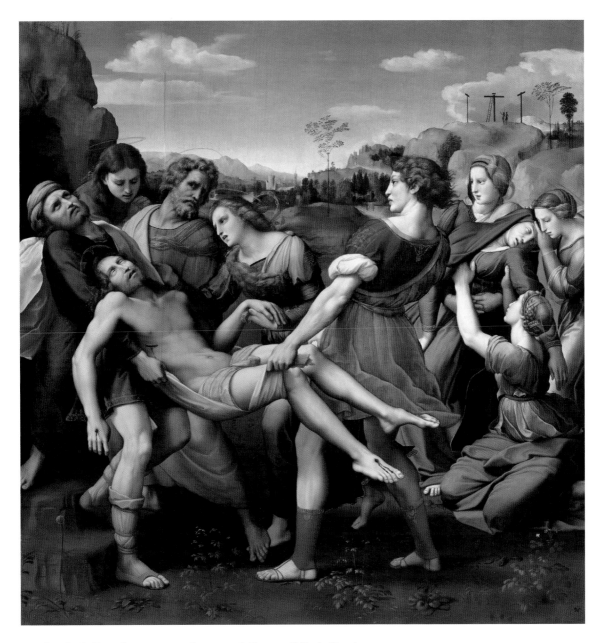

87 Raphael, *Entombment*, 1507, oil on panel. Rome, Galleria Borghese.

of the principal bearers in Raphael's *Entombment*. Barocci's figure has the youth and upper body of Raphael's younger bearer, and Barocci deliberately amplifies the drama already inherent in the windswept hair and drapery of Raphael's figure. Meanwhile, the precarious pose and billowing cloak of Barocci's figure seem to elaborate elements of the struggling, bearded man who supports Christ's torso in the Baglioni altarpiece. No other figures evince such clear filiation, but period Perugian viewers would probably have recalled Raphael's distraught Magdalen in Barocci's women who rush to aid the fainting Virgin and might have associated the complex, twisting figure of the woman who supports the Virgin's body with the young woman who twists to catch the fainting Virgin in

the Baglioni painting. They could even have connected the extreme inclination of San Bernardino's head, as he responds to the drama from the right edge of the composition, with the similar pose (developed ultimately from Perugino) that Raphael employed for the figure of Saint John the Baptist in the Ansidei altarpiece. Barocci had already seen how Raphael had developed such a figure during the Roman years, for instance for the figure of Saint Francis in the *Madonna di Foligno* (see fig. 31); and, given Barocci's early tour of the great cities of Italy, he probably knew Titian's revision of this figure for the Saint Francis in the *Pesaro Madonna* (see fig. 45). While Barocci carried this wider range of references in his head, however, his confrontation with the Baglioni altarpiece allowed him to study

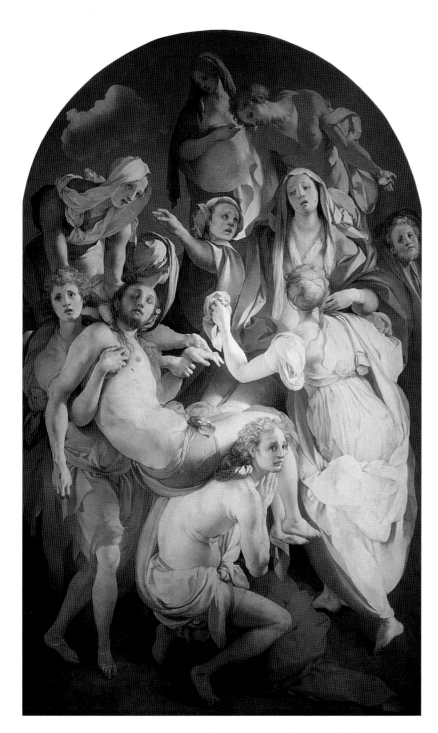

88 Jacopo Pontormo, *Entombment*, 1525–8, oil on panel. Florence, Santa Felicità.

the roots of Raphael's articulation and development of critical figure types – and of a powerfully narrative altarpiece. More than a decade after his intense engagement with Raphael's painting, Barocci for the first time approached his own version of the *Entombment*. His memories – and certainly drawings he had made in Perugia[10] – became crucial as he faced the issue of *imitatio* again and this time with an insistence made greater by the identity of subject.

89 Raphael, *Madonna and Child with Saint John the Baptist and Saint Nicholas of Bari* (Ansidei Madonna), 1505, oil on panel. London, National Gallery.

The most immediate and fundamental changes that Barocci effects are to reorient the direction of the narrative and to reconceptualize the spatial organization of the drama. In Raphael's panel (see fig. 87), the three crosses on the distant hill are depicted at the extreme right. The mouth of the tomb is in the shadows at the extreme left and the narrative progresses across the picture plane between these points. Christ has been carried down the distant slope of Calvary to be mourned by the Virgin, who is in the right foreground, below and before the crosses. One must assume that not long before the figure group composed a Lamentation or Pietà as the Virgin held the body of her Son. Indeed, drawings that document Raphael's early ideas for the Baglioni painting indicate that he first conceived the altarpiece as a Lamentation, with the body of Christ laid across the center foreground and surrounded by mourners (fig. 90). One can follow Raphael nearly step by step as he transforms the contemplative *Lamentation* into a dramatic Albertian *istoria*, a Christian reinterpretation of the ancient sarcophagus reliefs of the *Carrying of the Dead Meleager* that

Alberti had specifically recommended as exemplary *istorie*. In the first stages of this transformation, however, exemplified in another drawing, Raphael maintains Christ's body as a *figura* for the Eucharist (fig. 91). He has just been lifted off his mother's lap and as the bearers prepare to remove him to the tomb, the Virgin kneels before the body for a final prayer of farewell. In some sense, the composition at this moment is both a Lamentation and an Entombment. It is also a narrative that places the emphasis on cultic devotion to the *corpus* of Christ.

Raphael's painting breaks apart these moments in the narrative sequence and privileges the emotional drama of the Passion narrative rather than the figural, liturgical symbolism traditionally associated with the representation of the body of Christ over the altar. Mary has been shifted to the far right of the composition. She has evidently risen from holding the body of her Son and, as another drawing indicates, has attempted to follow the funeral cortege (fig. 92). In the painting, however, she is overcome with her own *compassio* and swoons back into the arms of the other women. It is only Mary Magdalen who rushes forward to embrace the body of Christ as male disciples

carry it to the tomb at the far left. Their transport of the body raises a critical point. While it is generally assumed that the body of Christ is in the center of Raphael's picture, this is not strictly true. Christ's knees are in the center of the picture; if one follows the narrative fiction, his body, already displaced from the cultic core of the altar panel, is moving rapidly "off-

92 Raphael, *Entombment*, study for the Baglione *Entombment*, c. 1507, pen on paper. London, British Museum.

stage" into the shadows of the tomb at the extreme left. This impression of Christ's de-centeredness is only heightened by a startling detail in the lower center of the picture. There, just over the actual cross that would have occupied the center of the altar, and just where the priest would elevate the host, the consecrated *corpus* of Christ, the left foot of the young bearer crushes a plant as he labors toward the tomb. An impression of fragility is heightened by Raphael's pointed depiction of a dandelion gone to seed at the lower left, below Christ's head and right arm; the young bearer could come perilously close to shattering this delicate beauty as he pivots the body of Christ to ascend to the upper left of the composition and the tomb.

Of course, these are highly inventive narrative details and symbolic implications are hardly absent – the dandelion, if crushed, will only disseminate its seeds. However, the removal of both Christ and the Virgin from the center of the altarpiece raises critical issues for the liturgical symbolism and decorum of altar paintings. The force of altarpiece conventions – and the normative power of the specific traditions constituted by altarpieces depicting the Lamentation, the Pietà, or the Man of Sorrows – is indicated by the evidently arduous process through which Raphael created the Baglioni *Entombment*, which began as a composition predicated on traditional assumptions about the nature of altar imagery.[11]

It has been remarked repeatedly that one of Raphael's principal sources for the reconceptualization of an altarpiece as an Albertian *istoria* was Mantegna's dramatic engraving of the *Entombment* (1465–70; fig. 93), an artist's exercise in the creation of a compelling *istoria*, in a medium far removed from the conventions and traditions of the altarpiece. By employing Man-

93 Andrea Mantegna, *Entombment*, 1465–70, engraving.

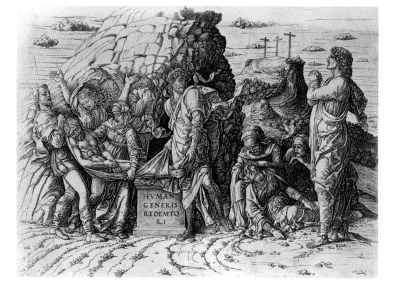

tegna's print to aid him in reconceiving the possibilities of representation in an altarpiece, Raphael overtly privileged Albertian concepts of the centrality of the *istoria* in the creation of "art" to a degree that had few if any precedents in altar painting. Yet Raphael's radical rethinking of altarpiece tradition represented only an extreme response to a cluster of tensions between modern painting and traditional function that seem to have been perceived by a number of artists around 1500. Indeed, one painting that may have encouraged Raphael to heighten the narrative potential of his image was Michelangelo's *Entombment* of 1500 (see fig. 86). That composition already represents – as Alexander Nagel has argued at length – a powerful and sensitive attempt to rethink the possibilities of altarpiece painting.[12]

One might in fact imagine that Michelangelo's painting represented a particularly sensitive response to Raphael's dramatic break with tradition were the respective dates of the two altarpieces unknown. For Michelangelo has employed the powers of modern painting to present a compelling narrative drama in an unexpected way. Narrative had almost always been depicted in painting – in medieval wall frescoes, in representations of the Annunciation – in a manner analogous to textual reading, that is, across the plane of the picture. In this respect, Raphael's picture is not innovative. Its great innovation is not to have invented a new mode of narration but to have transferred a narrative mode one might expect in a scene from a frescoed Passion cycle to the altar panel. The care and study Raphael employed in this process are extraordinary; one might note, beyond his decision to have the dramatic action proceed against the standard direction of textual reading, the emphasis he places on the struggle of the narrative motion. This strategy is exemplified in the figure of the young bearer who approaches the center but has both feet firmly planted (in sharp distinction to the Magdalen just behind him) as if his progression is suddenly arrested, and also leans forcefully backward.[13] Such a device seems intended to compensate in part for the displacement of the body of Christ from the iconic core of the image, and the element of hesitation or confusion Raphael introduces into his picture's narrative motion may have been important to Barocci as he ideated his late *Lamentation–Entombment*, discussed in the conclusion to this chapter. However, Michelangelo employed a more radical narrative strategy and at the same moment – through the very device of this strategy – ensured that the body of Christ remained in the center of the panel, upright and frontally presented, an object for cultic adoration rather than simply the pitiful corpse of Alberti's Meleager relief.

Michelangelo's critical innovation was to employ Alberti's perspective as the fundamental organizing device for his Albertian *istoria*. The bearers of Christ have just removed him from the lap of the Virgin (evidently the unfinished figure in

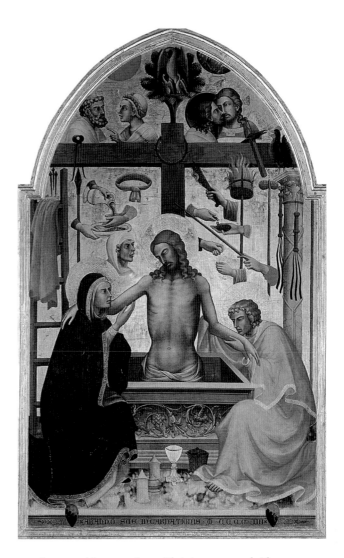

94 Lorenzo Monaco, *Arma Christi*, 1404, panel. Florence, Accademia.

the right foreground) and are carrying him directly back into the picture, toward a distant tomb. This compositional arrangement, at once simple and profound, allows for the creation of a picture that is a compelling narrative and at the same moment a kind of iconic cult image, akin to a Man of Sorrows employed as the focus of an altarpiece. An unusual example of such a composition that Michelangelo would likely have known is the *Arma Christi* of Lorenzo Monaco (fig. 94). Michelangelo's painting thus becomes at once a modern *istoria* and an effective altarpiece, a decorous pictorial frame for the celebration of the Eucharist (particularly for the elevation of the Host). Nagel has pointed persuasively to sources in Fra Angelico and Rogier van der Weyden as fundamental for Michelangelo's distinctive composition.[14] Between these images and the *Entombment*, there intervenes a type of composition developed in the late fifteenth century in which a narrative that had been depicted laterally is reoriented perpendicular to the picture plane in a manner that

implicates the viewer as a figure in the heart of the drama and at the same moment brings an iconic quality to the representation. A painting such as Antonello da Messina's *Annunciate Virgin* (c. 1475–6; Galleria Nazionale, Palermo), which transforms an iconic half-length image of the Madonna into a figure who looks up from her reading and responds to the viewer's approach as the Virgin responded to Gabriel, exemplifies the genre. The viewer's contemplation may become astonishment as the realization sinks in; it is one's very spectatorship that activates this "icon" into narrative, and the beholder is compelled to assume the position of the angel. The narrative occurs across the charged space between viewer and panel and is no longer contained within the panel. Leonardo himself experimented with this radical concept in a lost depiction of the angel of the Annunciation approaching with a lily and a seraphic smile – an image that cast the dumbfounded viewer into the role of the Virgin.[15] Michelangelo's painting is distinct from such images, not least because it contains all the characters necessary for its narration. Yet the frontal confrontation of the figure of Christ with the viewer, his ideation as both cult figure and participant in narrative drama, and the viewer's implicit place in the scene as the completion of the circle of mourners around the Virgin, may owe something to the experiments with "perpendicular" narration and the engagement of the viewer that characterized paintings such as Antonello's.

Raphael's solution rejected both this sort of address to the viewer and the carefully calibrated compromise between the claims of Albertian narrative and those of cult that Michelangelo had articulated. Predictably, perhaps, the Baglioni *Entombment* was admired and discussed principally as a work of art during the sixteenth century and finally was removed from its altar and placed in the private gallery of Cardinal Scipione Borghese as one of his principal artistic prizes.[16] As a cult object, however, there is some indication that the painting engendered resistance. It does not seem coincidental that Raphael's great Roman altarpieces – the *Madonna di Foligno*, the Sistine *Madonna*, and the *Transfiguration* – all re-engage in compelling (if diverse) ways with the centralized, frontal compositions that Raphael had decisively abandoned in the Perugia panel. There are practical reasons for this reconsideration of tradition, including subject matter and collocation (the *Madonna di Foligno* and the Sistine *Madonna* were both designed to adorn high altars, for instance, while the *Entombment* was the altarpiece for a side chapel). However, there may be more to the issue than this. Michelangelo's *Entombment* was also intended for a side altar, as was a painting that might be read as a response to both Raphael and Michelangelo – Pontormo's *Entombment* (see fig. 88) in Santa Felicità in Florence, another painting that Barocci could well have seen, both on his now definite early

trip to Florence and on his return visit in 1579, just as he was beginning the Senigallia altarpiece.[17]

The exact action occurring in Pontormo's complex painting remains under discussion. It is clear, however, that the body of Christ has just been removed from the Virgin's lap – as in the versions by Michelangelo and Raphael – and that it has been brought forward from the Virgin toward the foreground. His body is no more in the center of the composition than Raphael's Christ, and in this Pontormo clearly departs from Michelangelo's rigorously cultic composition. Pontormo is nonetheless at pains to relate his composition integrally to the viewer, the altar, and the chapel space. Indeed, the position of Christ, carried forward and down from the Virgin, could indicate that his body may be about to be lowered into the altar itself – an extraordinary "entombment" that would relate the altarpiece in the most rigorous way to the officiating priest, any other viewers, and the chapel setting.[18] Whatever the exact destination of the movement, Pontormo is clearly reinterpreting Raphael's experiment through renewed reference to Michelangelo. While the lateral action of Raphael's painting separates its narrative direction from a direct integration with the space of the chapel and the viewer, the organization of Michelangelo's and Pontormo's compositions perpendicular to the picture plane motivates a forceful relation between picture and viewer – and in the case of Pontormo's panel, between narrative action and chapel space as well. However one reads the consequences of this relation between the picture and the space before it, the connection is predicated on Pontormo's essential revision of Michelangelo's scheme; the action proceeds out toward the viewer's space (at least in part) instead of receding univocally away from it. This trajectory, fundamental to the mechanics of Raphael's *Madonna di Foligno* and Sistine *Madonna* as well, proved critical for Barocci's thinking at Senigallia.

One other painting may have reinforced for Barocci important ideas concerning the integration of narrative and cult image in Passion altarpieces – Lorenzo Lotto's *Entombment* for the confraternity of the Buon Gesù in Jesi, not far from Urbino (fig. 95). Lotto's painting indicates his awareness of Raphael's great Perugian altarpiece (the way in which the crosses are painted on the distant hill to the right reads as a clear reference) but Lotto's conception of the action and the composition are distinctive.[19] The figures have come forward but the tomb is now in the central foreground, directly above the altar, and the bearers are in the very act of placing Christ into this altar tomb. Thus the composition combines considerable drama with a certain cultic stasis and allows both Christ and the Virgin – who mourns directly behind his body – to inhabit the center foreground of the image. The confraternity was devoted to the Holy Name of Jesus, and Barocci would also have registered Lotto's

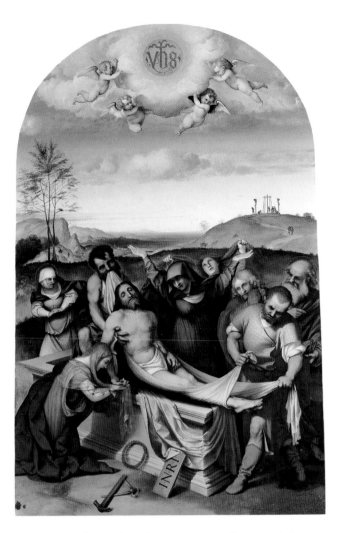

95 Lorenzo Lotto, *Entombment*, 1511–12, oil on panel. Jesi, Pinacoteca Civica.

ing already contained this particular figural invention. While Barocci need not have seen the engraving to know the figure type, other details of his drawing indicate that he returned directly to this source that had proved important for the invention of the altarpieces that had transformed the representation of the Entombment. For instance, the figure who supports Christ's lower body in Barocci's sketch is not imitated from the analogous figure in Raphael's panel but is conceived in a dramatic twisting, turning posture that seems a reinterpretation of the bearer who pivots Christ's lower body in Mantegna's print. Barocci has obscured any sense of direct imitation by depicting his figure from the back. Yet the very strangeness of the pose in a scene that should read simply as a lateral narrative, given the apparent location of the tomb, indicates the possibility of a filiation from Mantegna. Further, the third bearer in Barocci's drawing clearly reaches across Christ with the right arm; this figure, which has no analogy

96 Barocci, compositional sketches for the *Entombment*, pen on paper, 13 × 15.7 cm. Florence, Galleria degli Uffizi, Gabinetto dei Disegni, inv. 18227 F.

clear incorporation of relevant symbols into the panel, both overtly (in the IHS sunburst supported by angels) and within the representation of the historical narrative (in the wooden tablet inscribed INRI that has been taken from the cross and laid against the tomb). The foreground still life of which this tablet forms a part may also have made an impression.

Barocci's painting and its surviving preparatory studies indicate that he reflected intensely on both Raphael's interpretation, which he knew so well, and on what one might describe as the alternative modernity, which grew out of Michelangelo's remarkable experiment. Indeed, one of Barocci's early preparatory drawings neatly juxtaposes versions of both solutions (fig. 96). In the lower right, bearers carry the body of Christ, possibly toward what appears to be the tomb at the extreme right. The bearer who supports Christ's upper body leans backward at a dramatic angle as he steps back toward the tomb, in a pose apparently borrowed directly from the analogous figure in Raphael's painting. However, Mantegna's remarkable engrav-

in Raphael's composition, seems adapted from the distraught female bearer in Mantegna. Such details offer precious indications of how thorough Barocci was in his reconsideration of the theme. He turns back specifically to his memories of Raphael's painting, however, for the figure of Christ and depicts him with the limply hanging arm that Raphael had adapted from ancient reliefs depicting the carrying of the dead Meleager, a model Alberti had specifically recommended for imitation in *istorie*.

The sketch that shares the lower portion of the sheet with this dramatic, lateral narrative rendition, however, presents a completely different solution. Here Christ is held up frontally for the viewer, precisely in the manner of Michelangelo in every way but one: Barocci was determined to rationalize the mechanism by which the body of Christ is supported and carried. The bearers who flank Christ support his thighs so that they project toward the viewer while the lower legs hang. Christ's upper body, meanwhile, is both raised toward the viewer by a bearer just behind his shoulders, yet is clearly slumped in death. The image of the Savior thus lacks the full cultic presence of Michelangelo's Corpus Christi. Further, although Barocci's scheme represents a more naturalistically plausible image of the transport of Christ's body – while maintaining a frontal presentation of the body – the foreshortened, spread thighs of Christ could well raise issues of decorum in a finished altarpiece. Ultimately, Barocci would follow Michelangelo neither in revealing the genitals of the Savior nor in privileging the cultic presentation of the body in a manner that could dampen a sense of narrative drama or appear un-naturalistic. Nonetheless, Barocci does seem to have been concerned to present this narrative drama as oriented toward the viewer rather than laterally, and to establish a liturgically appropriate focus on the body of Christ, placed in the center of the image.

In this drawing, then, Barocci establishes the poles between which he would elaborate his invention, and begins to meditate on their implications. What links his two ideas on this sheet, however, is the notion – ultimately derived from Mantegna – of turning movement. For it does not seem that the bearers in the "frontal" solution simply hold Christ up to the viewer, or carry his body forward out of the picture space or back into it. While the forms are delineated quickly, with few penstrokes, it is evident that both the flanking bearers are in the process of turning, or at least walking in a manner that forces them to cross legs as they proceed. It may well be that the upper portion of another drawing (fig. 97) represents a more advanced stage of design for the bearer to the viewer's right, in which Barocci is thinking in more detail about the figure's difficult pose – legs crossed, the left arm crossing the torso to the right while the head twists left, and the right arm extended behind the body.

97 Barocci, study for a bearer in the *Entombment*, chalk on paper, 32.2 × 19.7 cm. Berlin, Staatliche Museen, inv. KdZ 20228 (4441) (r).

The fact that the figure's attention is directed left, away from the body of Christ, may be important, as the Uffizi sketch (see fig. 96) indicates a seated figure here. It is possible that this seated figure is the Madonna, occupying the very position she was given in Michelangelo's *Entombment*. If so, Barocci has created in this sketch a narrative remarkably close to that articulated by Michelangelo. However, here the bearers, having picked Christ up, are in the act of turning to proceed back to the tomb, which may be the barely sketched doorlike form in the central background. Barocci captures the action in that instant when the body of Christ comes into a position that is oriented frontally to the viewer before the image. If the tomb is indeed the form in the background, this quick pen

drawing records Barocci's most pervasive engagement with Michelangelo's *Entombment* composition; but both here and in the adaptation of Raphael's lateral composition, the distinctive inventions of Barocci's "High Renaissance" models are additionally inflected through the turning motions that help structure Mantegna's composition. One could hardly wish for a clearer or more complete illustration of the parameters within which Barocci found his distinctive resolution to the issues posed by the *Entombments* of these powerful predecessors.

A third drawing illustrates Barocci's struggle to hold potentially competing goals in creative tension (fig. 98): a figure ultimately derived from a conflation of Raphael's two principal bearers backs dramatically toward the picture plane as he supports the lower legs of Christ. However, while this figure is derived from Raphael, his form is rendered in decisive penstrokes that delineate a rippling musculature. It is as if a figure by Raphael has been drawn by Michelangelo – or perhaps more precisely, this drawing responds to Raphael's own reflections on Michelangelo.[20] The struggling figure is not only a stylistic sign of Barocci's principal visual sources, however; he is also made the critical actor in the articulation of the composition's dramatic and liturgical function. The inclination of his body and his downward gaze seem to indicate a visual fiction in which he leans out toward and looks down on the altar itself. Here Christ's body is being brought directly out toward the viewer, and into a dramatic relation with the space before the canvas. This narrative drama, however, only reinforces the symbolic and liturgical relation between the biblical story and the altar tomb, and between Christ's historical action and its representation in every eucharistic celebration. While only a fragment of the composition is studied in this sketch, the gaze of the bearer (presumably directed toward the center of the altar) and the angle of the narrative progression both imply that the *corpus* of Christ would occupy a position near the center of the composition. In his elaboration of the action, Barocci has also subtly but significantly rethought the way in which the body of Christ is presented. The manner in which it is carried forward, cradled in its sheet, resolves the potentially indecorous presentation of the lower body while still allowing viewers to contemplate the gently upraised, centrally positioned head and torso of the Savior.

The finished painting maintains many of the insights achieved in this drawing but re-elaborates aspects of the narrative composition. It is characteristic of Barocci in this period that the altarpiece presents the action as advancing toward viewers rather than receding away from them. (It may be equally typical of Michelangelo that his figures often move away from the viewer, as in his *Entombment*; this predilection is exemplified in the Christ of the *Medici Madonna*, who turns

98 Barocci, study for the *Entombment*, pen and wash on paper, 27.4 × 16.1 cm. Florence, Galleria degli Uffizi, Gabinetto dei Disegni, inv. 1417 (r).

away from the engagement with the viewer one might assume in such an image to nurse at his mother's breast.) Again and again during the 1570s, Barocci resorted to compositions that depicted a visionary apparition that moves toward the viewer – in the *Perdono*, the *Immaculate Conception*, the *Madonna del Popolo* – even when such a solution was not demanded by the subject. Just after the Senigallia *Entombment*, too, he created his most dramatic version of a narrative *istoria* oriented toward the viewer in the *Martyrdom of San Vitale* (see fig. 143) for the eponymous medieval church in Ravenna. Here the saint is

99 Barocci, squared study for the lower portion of the Senigallia *Entombment*, pen, wash, and white heightening on paper, 26.6 × 37 cm. Florence, Galleria degli Uffizi, Gabinetto dei Disegni, inv. 11326 F.

clearly thrown forward and down – into the well in the painting, surely, but also by implication into the altar tomb just below the altarpiece, which was dedicated in his honor, and, as Joseph Connors has pointed out, into the actual holy well that stood near this altar in the church.[21] Barocci's study of the body of Christ brought directly forward and supported by a bearer who looks out of the image and down at the altar indicates that the painter had already explored the connection between action and altar extensively before the Ravenna commission. The drawing may also indicate his awareness of Pontormo's Capponi altarpiece, with its distinctive response to the issues forcefully engaged by Michelangelo and Raphael.

Barocci's ultimate solution for the *Entombment* integrates his reflections in an image that maintains much of the dramatic power of Raphael's altarpiece (and of Mantegna's engraving) while reinscribing the body of Christ as an image for contemplation and veneration. The most radical fusion of narrative action and cultic site – expressed in the developed study of Christ and a bearer – has been moderated in a manner that subtly refocuses attention on the contemplative aspect appropriate to an altar image. Barocci replaced the dramatic immediacy with which Christ's body advances toward the viewer's space in the drawing with a more lateral trajectory for the young bearer and a mediating foreground zone that is dominated by two instructive models for viewers – Mary Magdalen and the still life with instruments of the Passion. This transformation of the foreground accomplishes at least two purposes:

it establishes a certain distance between the viewer and the sacred core of the picture and it shapes the viewer's response to both the *istoria* and the *corpus* of Christ. Mary Magdalen's Petrarchan tresses of tangled gold and her remarkable mantle signal her alluring *vaghezza*, but Barocci's Magdalen turns inward to adore the body of Christ with clasped hands that have become ruddy as a sign of the force with which she presses them together in her grief and concentration. She is the human model of the devotee that the viewer should imitate; here Barocci clearly seems to recall Michelangelo's solution, which included a young woman in the foreground who gazes intently at something in her hand (which a drawing reveals to be nails and the crown of thorns). Raphael's Baglioni painting offers no similar figure.

Unlike Michelangelo, however, Barocci separates his figure of devotion from the devotional still life that occupies the other half of the lower foreground. This still life is the portion of the painting nearest the viewer; it mediates between those before the altarpiece and the body of Christ that they venerate. It is, further, critical to any discussion of narrative reading and the trajectory of narration, for Barocci has placed it at the point at which a left to right reading of the image would commence, nearest the viewer and the left edge of the painting. This placement represents a decisive reorientation from a worked-up, squared drawing that positions the still life at the right bottom edge of the image (fig. 99). Placing the still life at the left makes it (to adapt a term usually applied to human actors) the "thing

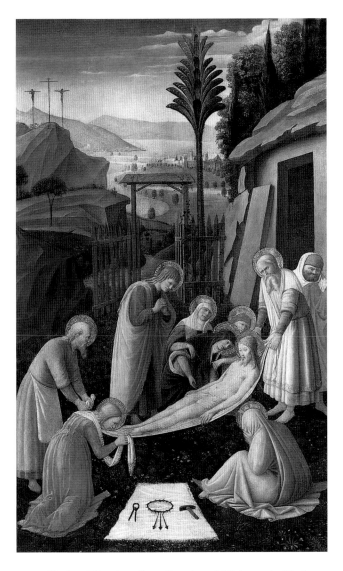

100 Circle of Fra Angelico, *Carrying of Christ to the Tomb*, c. 1450, tempera on panel. Washington, DC, National Gallery of Art.

rangement visualizes the functions of the devotional still life with particular complexity.

The drawing with the still life in the right corner of the composition helps to reconstruct the development of Barocci's construction of this critical liminal zone of his painting. The drawing is a fragment of a large and highly finished compositional study, and the still life has been rendered in great detail. It is telling that Barocci simplified the form of the metal vessel significantly in the final painting. He also removed the cloth on which the implements are laid (analogous to the presentation of the instruments of the Passion in the circle of Fra Angelico panel) in favor of representing the objects directly on the door to the tomb or lid to the sarcophagus, with its compelling allusion to the altar table. Other changes between drawing and painting are more subtle but no less telling.

Barocci is at pains in the painting to allude repeatedly to the form of the cross throughout the picture's central axis. Around this axis the figures themselves compose a diagonal cross both in surface pattern and in spatial arrangement, with Christ at its center. Directly above and far behind him stand the historical crosses of Golgotha. Their reverberations fill the picture. Below and before the body of Christ, for instance, even the hammer and pincers have been laid down in a manner that the viewer suddenly realizes makes a cross, with one arm pointing to Mary Magdalen (and beyond to the tomb) and the other down to the altar with its actual cross. It is no coincidence that Barocci has oriented the hammer so that its heavy head weights this indication of the altar cross; it is a visual anchor for the picture.

Such details in the still life had already been registered in the drawing. However, two final but critical nuances appear only in the painting. First, the nails in the drawing are heaped in a tight group of three; in the canvas, two overlap in a nearly cruciform pattern while the third is separated to serve as an insistent pointer, indicating the tomb toward which the bearers proceed. This third nail also appears to point, in the surface pattern of the image, to yet another cross formed by the seemingly casual manner in which objects are strewn on the earth. Virtually in the center of the foreground – in the position occupied by the trampled plant in Raphael's Baglioni panel – lie three little fragments of straw that compose a cross directly on axis with the crosses on the hill, the Corpus Christi, and the cross on the altar. It seems that Barocci remembered even an apparently inconsequential detail of Raphael's narration, and has here transformed it. For Barocci, God was in the details, a statement that describes equally the painter's remarkable recall of the crushed plant and the fragile dandelion head in the Baglioni picture, his meditation on their implications, and his revision of the source in his own painting. The most evident revision involves a heightening of overt symbolism: a cross

which presents" in the painting. Thus the viewer's experience of the Corpus Christi is both mediated and introduced through this assemblage of the instruments of the Passion.[22] The still life – one of the most precisely painted portions of the altarpiece – is also constructed in a way that advertises its descent from a tradition of still life as a pictorial stimulus to contemplative piety that figured more frequently in fourteenth- and fifteenth-century painting than in that of Barocci's day. An *Entombment* from the circle of Fra Angelico provides a striking example of the phenomenon (fig. 100). Here the pincers, hammer, crown of thorns, and nails are laid out precisely in the center of the foreground on a cloth that insists on an analogy with Christ's winding sheet; this cloth, through its sharp foreshortening, actually points to the body of Christ. Barocci employed his own still life in a remarkably analogous manner but his ar-

made of straw (like the straw from the crib of the Nativity) radicalizes and focuses Raphael's more evocative, open-ended detail. More subtly, however, Barocci also rethought the relation of object and action. It is particularly telling, for instance, that Barocci's young bearer will definitely not trample on the straw. His weight-bearing foot has come down just short of it – indeed, the emphatically planted foot serves as another pointer for the fragile "reed cross" – and with his next stride his right foot will clear it and land beyond it. This one apparently casual detail says much about Barocci's observation of, and revision of, both the particular details and the principles of figural narration privileged in his sources.[23]

Barocci's determination to present the narrative action in his altarpiece in such a manner that Christ's body occupies the center of the image and faces the viewer finds analogies in the procedure adopted by Michelangelo for the unfinished *Entombment* (see fig. 86). However, Barocci clearly wished to incorporate aspects of the overt narrative drama that had made Raphael's Baglioni altarpiece (and Mantegna's print) a compelling image. To accomplish the fusion of these two apparently opposed goals, Barocci evolved a remarkable composition that actually employs the dynamic movement and engagement of the bearers to heighten the sense that Christ is the still center of a whirlwind of activity, the fixed point around which circles of human action and devotion rotate. Christ's body is positioned on a diagonal, between the lateral presentation of Raphael's painting and the frontal view privileged by Michelangelo. However, Christ's lower legs are hidden by the figure of the forward bearer and his body is in shadow up to the waist. Thus only his upper body – the portion of his figure that is most frontal, most upright, most central – is highlighted by light. The implications of this arrangement conjoin naturalism and the supernatural, history and mystery.

Elements of naturalism in the illumination of the Corpus Christi are immediately obvious. The light that illuminates the foreground appears to emanate from a source above, in front of, and to the left of the scene. Indeed, Barocci was concerned to clarify how the picture would be lit, and stressed to the *confratelli* in Senigallia that without proper lighting "paintings can never show what they really are."[24] There is also a significant light source deep within the painting, however; the setting sun obscured by the distant cliff of Calvary, which should cast the foreground into twilit shadows, appropriate to death, mourning, and the tomb. The fact that it does not, of course, may be ascribed to the presence of a source of external illumination before and above the painting; but Barocci seems to have employed the evident and mundane fact of external lighting to particular effect. His decision to make much of the crepuscular light source within the painting – the painstaking chalk study

(see fig. 84) of the effect of the setting sun on the forms of the crosses and laborers takes on added significance here – suddenly heightens the sensation that the brilliant light flooding across the upper body of Christ from on high is something more than daylight streaming through a window. The spotlight that is thrown on the foreground group, after the darkness and shadows of the twisting path from the distant hill, is pregnant with the hope of Resurrection – of the return of light and the Son – that the faithful worshiping before the altarpiece believed had indeed come to pass. In this one respect Mary Magdalen is not a complete and sufficient model for the believing beholder. She grieves and worships, and pious beholders are implicitly urged to join her; the request to weep over the sufferings of Christ was one of the salient leitmotifs in late medieval and early modern devotional literature. Yet within the context of the biblical narrative unfolding here, Mary cannot yet know that her Savior will rise. The late sixteenth-century beholder, by contrast, is enjoined both to participate in the suffering and grief that the narrative articulates and to recognize in the suffering servant the Savior who is radiant and glorified. The necessity for this dual approach – grief for historical suffering, veneration and praise to the God who suffered and died yet lives eternally – dictates the necessity in Barocci's mind for an image that presents the figure of Christ both as an actor in a historical drama and a cult figure, ever present to the faithful and illumined by a light that is at once the light of creation and of revelation.

This imperative to fuse history with mystery in the altar painting may also explain the notable insistence on groupings of three in the painting. Three is first and foremost the number of the Trinity, the ultimate mystery of Christian thought. It is also the number of days that separate the death from the Resurrection of Christ. That there are three crosses at the peak of the image is historically necessary, but before them stand three trees, below those three mourners. Three bearers support Christ. Three (rather than the requisite two) bits of straw form the cross that suddenly appears out of the confusion of nature just below and before the body of the Savior. While it was common in period painting to represent three rather than four nails in the Crucifixion, a treatise as demanding as Paleotti's concluded that the number was "indifferent" and that painters might represent either three or four nails. Indeed, while Barocci seems to have always employed the three-nail solution, Paleotti notes that both approaches were employed in his day in the diocese of Bologna, "even if the one with three nails is more common."[25] Given the other details, it may be more than coincidental that Barocci highlights only three nails in his still life. Finally, the manner in which Christ's body is carried allows for the presentation of only three wounds: those in the hands and the ultimate wound in the side. In a remarkable conjunction

of artistic virtuosity and pictorial theology, Barocci managed to pose the body of Christ in a way that presents these wounds in a nearly vertical line, with the preeminent side wound at the top. This apparently natural, but in fact carefully arranged, representation places each of this trinity of wounds on the central vertical axis of the image that runs from the crosses in the painting down through the *corpus* of the Savior to the cross on the altar and ultimately to the chalice and the host that the priest elevates at every mystical "representation" of the Passion. This detail, made possible by a pose that is apparently the momentary consequence of dramatic action, emblematizes the manner in which Barocci's Christ is both a participant in an edifying *istoria* and a cult image in a liturgical apparatus. He is at once the Christ of history and of eternity, a participant in transience and a symbol of permanence and hope.

Around this silent center that is both part of human history and beyond it swirls an arc of action. While the windswept vestments clearly owe something to Raphael, their heightened level of agitation recalls Mantegna's engraving (see fig. 93). Indeed, Barocci's figure of the mourner behind the Virgin, who presses a billowing cloth to her face, is close even in detail to the figure just beside the opening to the tomb in the print. Barocci's narrative, too, owes a critical concept to Mantegna. In Raphael's *Entombment* the narrative fiction implies that the bearers have removed Christ from the cross in the right background, brought him to the right foreground where the Lamentation has occurred, and then carry him across the foreground and back to the extreme left middle ground and the opening of the tomb. In Michelangelo's alternate narration (see fig. 86), the bearers have raised Christ up out of his mother's lap in the right foreground and carry him directly back into the picture toward the distant tomb. While Mantegna's narrative does not stress the centrality or cult status of the body of Christ in a manner appropriate for an altarpiece, it does present the action as advancing from the distant background to the tomb directly in the central foreground. This fundamental organizing principle seems to have made a deep impression on Barocci: in his painting, Christ replaces the tomb at the center of the image, but the relation of narrative to space is fundamentally indebted to Mantegna's invention. In Barocci's narration, Christ has been taken down from the cross in the high central background, evidently brought down an arduous and twisting path, and here approaches the tomb in the foreground, the sarcophagus in proximity to the altar.

It is possible that Barocci looked at Mantegna here through the work of Raphael, not the Baglioni *Entombment* but a later work that is too often forgotten in discussions of Raphael's contributions to the history of the altarpiece. Often known simply as *Lo Spasimo*, the *Way to Calvary* of about 1516 is a major paint-

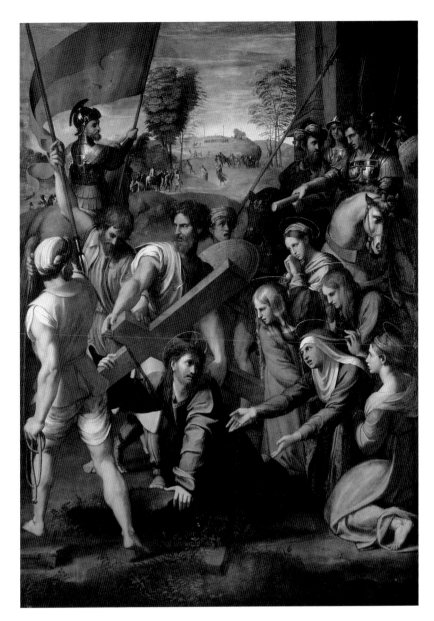

101 Raphael, *Way to Calvary* (*Lo Spasimo*), c. 1516, oil on canvas (transferred from panel). Madrid, Museo del Prado.

ing from Raphael's maturity in which he substantially rethought the relation between narrative and the presentation of holy figures in an altarpiece *istoria* (fig. 101). The work has until recently been little discussed, in part because it is often thought to exhibit much studio assistance, and is assumed to have suffered badly as it was destined for Palermo on a ship that sank. Vasari and Borghini both record, however, that the painting floated in its case to Genoa, where it was rescued and found to have surprisingly little damage. It remained in Genoa until 1573 (when it was sent again to Palermo) and was considered a miraculous work for its very resistance to the elements.[26] If Barocci included Genoa on his youthful tour of the "most illustrious cities of Italy" he could have seen it. In this important moment

102 Barocci, study for the Madonna and a companion in the
Entombment, chalk on paper, 11.3 × 26 cm. Würzburg, Martin
von Wagner Museum der Universität, inv. 7173.

103 Michelangelo, *Rondanini Pietà*, 1564,
marble. Milan, Castello Sforzesco.

in Raphael's conception of the narrative altarpiece, he combines
lateral and vertical action in a manner that seems of significance
for Barocci. The two crosses already in place on Golgotha are
precisely in the upper center of the background and Christ is
below and before them in the central foreground. He has clearly
emerged from the city gate in the right middle ground and will
in a moment turn to proceed back to the distant hill. As he
struggles from right to left across the picture plane, however, he
falls under the weight of the cross and arrests this narrative pro-
gression. His body is angled toward the viewer, and precisely in
the center foreground; his gaze back to the Virgin further locks
his figure into its position of (temporary) stasis at the cultic core
of the image, even as activity swirls around him.

Barocci, too, makes his Christ the centered figure in an arc
of action. Like the figures of Christ in each of the *Entombments*
that provided models, Barocci's figure may have lain, until

moments ago, on the lap of Mary, who now struggles to remain
standing; she is faint but she does not fall as do the figures of
the Virgin in the Mantegna and Raphael. A remarkable drawing
(fig. 102) approaches the study of the Virgin and the young
woman who supports her almost as if the scene to be repre-
sented is a Pietà in which the body of Christ is held up in a
standing position – like Michelangelo's final Pietà (fig. 103).
While the figural group is slightly altered in the painting, an
allusion to the theme of the Pietà might just remain. Barocci
had depicted the Virgin fainting in the Perugia *Deposition* (see
fig. 85) but he never depicted her unconscious in suffering in
a painting again. Many ecclesiastical reformers detested the
long-standing tendency to represent the Virgin in a full *com-
passio* with Christ, both because such representation under-
mined the uniqueness of Christ's sacrifice and because it was
deemed unseemly that the Virgin should entirely lose control

104 Barocci, *Crucifixion with the Virgin, Saint John the Evangelist, and Saint Sebastian,*
1596, oil on canvas, 500 × 318.5 cm. Genoa, Cathedral.

of her emotions.[27] It seems particularly important that Barocci
appears to have begun planning the Senigallia *Entombment* with
the idea of a figure of the Virgin in a state of collapse; a drawing
that is associated with the painting portrays the Madonna being
supported in a seated position, her head inclined down, perhaps
in a swoon (fig. 105). Barocci moves away from this idea deci-
sively in his decision to depict the Virgin standing. In a later

Crucifixion, however – the great altarpiece in Genoa (fig. 104) –
he returns to the idea but approaches the delicate issue of the
Virgin's state by stressing her suffering, but also her ability to
maintain consciousness in that suffering. He further alludes to
her similarity to Christ, while maintaining a distinction. Christ
is dead on the Cross; the Virgin is clearly alive and will not
faint. Yet her pain has caused her to collapse against the thigh

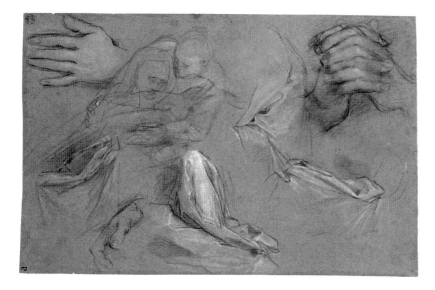

105 Barocci, study for the Madonna in the *Entombment*, charcoal and white heightening on paper, 27 × 42.5 cm. Berlin, Staatliche Museen, inv. KdZ 20362 (4300).

of the kneeling Saint John. In this remarkable grouping, one senses an evocation – adjusted to maintain decorum – of Michelangelo's famed Pietà drawn for Vittoria Colonna and much reproduced in engravings (figs 106 and 107). There, the dead Christ is nested between the Virgin's legs as she looks up in pain and wonder. The drawing of the Virgin supported by the young woman (see fig. 102) may indicate that a similar evocation is intended in Barocci's distinctive solution to the issues in the Senigallia painting. The Virgin experiences a suffering akin to Christ, a suffering that is so Christ-like that she may assume a pose associated with the dead Christ, but the distinction between their experiences is nonetheless made clear. She remains a human mourner, suffering, but conscious. It is not she who dies for the sins of the world.

Directly before the Madonna's unsteady figure in the *Entombment* the central drama occurs. The three bearers round the corner of the cliff-face into which the tomb is cut, and begin to turn to pivot Christ's body toward the sarcophagus.

106 Michelangelo, *Pietà*, 1538–40, chalk on paper. Boston, Isabella Stewart Gardner Museum.

107 Giulio Bonasone after Michelangelo, *Pietà*, 1546, engraving. London, British Museum.

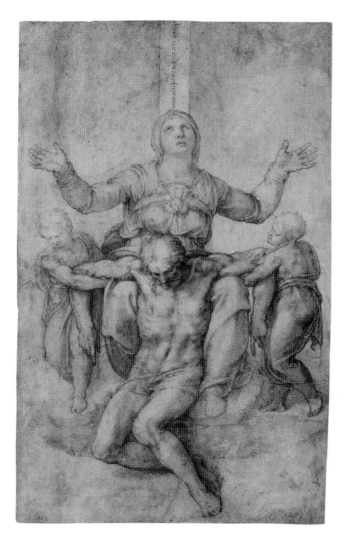

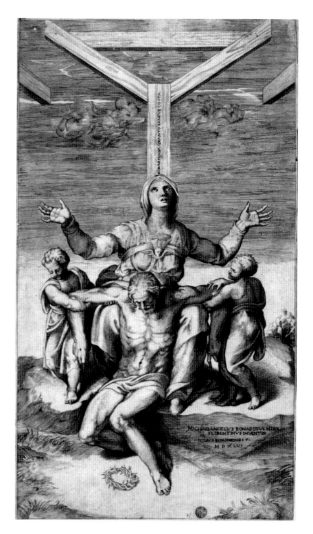

In the foreground, the young male bearer leans sharply back and out toward the viewer as he strains to support Christ's weight. His figure remains similar to the one articulated in the pen drawing (see fig. 98), but he is turning to cross the picture space rather than emerging from it. His gaze now rests, not on the altar, but on the Magdalen, whose distraught and praying figure – with that of the young man preparing the sarcophagus – blocks immediate access to the tomb. This was Barocci's final tactic in a complex strategy to control and still the increasingly powerful spiral of action he constructed around the quiet body of Christ. Despite the powerful forward stride of the young bearer, Christ's body will not be hidden from the faithful as the bearers pivot him toward the tomb. Two apparent accidents of history prevent the imminent destabilization of Christ's cultic presence: Mary Magdalen is in the way and a workman has not yet finished cleaning the sarcophagus. These apparently banal details force the procession of *istoria* momentarily to a halt. In that moment, suspended forever in Barocci's painting, history and mystery meet in the floodlit body of Christ that hovers above the altar and its cross, his wounds miraculously aligned with the upheld chalice. At the same moment, the achievements of the *terza maniera* come into a rich and distinctive relationship with venerable aspects of Christian imagery and liturgical decorum. This is surely part of what was meant when period observers hailed Barocci's paintings as "at once *vago* and *divoto*."

INSOMMA COSA STUPENDA: BAROCCI'S *LAMENTATION-ENTOMBMENT* AND THE ENDS OF RELIGIOUS PAINTING

Barocci, like Michelangelo, returned to the representation of the dead Christ in a late project left unfinished at his death. Unlike Michelangelo's personal testament, however, Barocci's work was the result of a prestigious commission for the cathedral of Milan. The Chapter of the Cathedral had approached the aging painter already in 1592, but nothing seems to have come of the attempt to persuade him to undertake another significant project. Then in 1597 the Chapter sought again to convince this "most lovely painter" (*pictor pulcherrimus*) to create a Nativity for the cathedral. Once more, the documentary trace disappears after this initial notice. Yet by February 24, 1600 Barocci was involved in a new commission, for a large altarpiece that was to figure "the Lord taken from the cross with the Madonna and the Maries and Saint Michael to the side and a bishop." This language seems to indicate a Deposition or perhaps a Lamentation. What Barocci finally produced, however, was a narrative that hovered in the liminal moment between

Lamentation and Entombment (fig. 109). There is no name for this in art historical vocabulary. For purposes of both convenience and precision, I will refer to the painting in the most descriptive manner possible, as a *Lamentation-Entombment*.[28]

The destination of the altarpiece was the transept chapel of San Giovanni del Buono, a seventh-century bishop of Milan whose relics had been translated to this space in 1582. Previously the chapel had been dedicated to the Archangel Michael, hence the inclusion of bishop and archangel as witnesses to the scene.[29] At the same time, Barocci was commissioned to produce a second altarpiece depicting the "*istoria* of Saint Ambrose and Theodosius." This project was quickly delegated to Alessandro Vitali, with Barocci presumably providing some direction, but the old master seemed intensely and personally engaged with the *Lamentation-Entombment*. Remarkably, given Barocci's usual pace of work, by July 12, 1600 Ludovico Vincenzi could write from Urbino to his brother Guidobaldo (employed at Milan Cathedral) that "Barocci has almost finished the cartoon, and if it pleases God that he can complete this work I believe that Milan will be very satisfied with it, as it is a stupendous thing [*insomma cosa stupenda*]." By the end of 1601, Ludovico records that Barocci "has already begun the painting for Milan."[30] Nevertheless, in 1608 the chapter sought the intervention of the Duke of Urbino and Barocci's friend, Francesco Maria II, in the hope of pressing Barocci to finish the painting. The painter wrote in that year to reassure the chapter that the cartoon was complete and that he had "half sketched out the work." Despite these efforts, Barocci died in 1612 with the altarpiece still incomplete.[31] The painting was eventually consigned, in an unfinished state and with some work by Barocci's assistant Ventura Mazzi, in 1629. While there was discussion of having Mazzi finish it, this never seems to have been accomplished.[32] Nonetheless, the painting remained over its altar, a testament to the esteem in which Barocci was held as a painter of altarpieces. Although its unfinished state raises real difficulties of interpretation, Barocci's second attempt to interpret the *Entombment* and the events immediately preceding it demands a brief discussion, for in this work for Milan, Barocci rehearsed once more at the end of his life the issues and sources with which he had wrestled to create the *Entombment* of Senigallia.

In one critical respect the relation between the two paintings is even closer than one might assume. During the very years in which he worked on the project for Milan, Barocci reworked the Senigallia altarpiece. The *Entombment* had been an immediate success; it was frequently copied by artists and its design was disseminated in a print executed by Philippe Thomassin between 1585 and 1590. Bellori relates that one of the artists who wished to copy the painting attempted to obtain a tracing of the entire

composition and through his "temerity . . . penetrated the color and the outlines and ruined the work." A letter written by Barocci to the confraternity offers direct confirmation of Bellori's description: "I, along with your Lordships, have had great worry over the painting that has been traced and cleaned, and in addition to your letter I have not failed to inform myself about it through my apprentice. From what he has told me I believe its hard use responsible for the injury to it . . ."[33] The records of the meetings of the confraternity also confirm Bellori's information and add that beyond the damage done by negligent copyists, "our altarpiece has become so damaged by mouse urine" that it had deteriorated seriously. The decision was taken in December 1606 to ship the work back to the aged Barocci in Urbino for an autograph restoration that would take two years and cost the significant sum of 150 scudi.[34] It is well known that Barocci returned again and again to elements in his important paintings as he elaborated a new work. This time, however, the Senigallia *Entombment* actually stood again in his studio as he meditated on the new altarpiece. It is only to be expected, then, that the similarities between the works are numerous; the differences, however, are also pronounced.

In the first place, Barocci's conception of the subject for the Milan altarpiece diverges in a fundamental way both from his solution in the *Entombment* and from its predecessors in Raphael, Michelangelo, Pontormo, and Mantegna (see figs 83, 86–8, 93): in Barocci's late painting, the body of Christ has been returned to the lap of the Virgin. The principal narrative moment is thus moved back from the carrying of Christ to the tomb toward the more static depiction of the Lamentation that preceded the Entombment: hence the title by which the picture is commonly known in the Barocci literature. I say "toward," however, because it seems clear on close observation that it is not simply a Lamentation that is represented. It is, rather – and precisely – that excruciating moment when those who will carry Christ to the grave bend to lift him from his mother's lap. This is perhaps the most emotionally charged instant in the Deposition–Lamentation–Entombment sequence; it is also a moment when icon and narrative are held in a tense equilibrium. Christ still lies in the central vertical axis of the image, his upper torso raised onto the Virgin's lap in a position that allows it to function as an object of cultic veneration and in clear relation to the host raised before and below it at every Eucharist.

The two figures are arranged so that the quietly grieving Virgin can also occupy the center of the image. A representation of the Lamentation – or better, the Pietà – thus exists as an image within the image at the core of this painting. Further, the iconic – and thus atemporal – reading that may be elicited in compositions of the Pietà or in some presentations of the

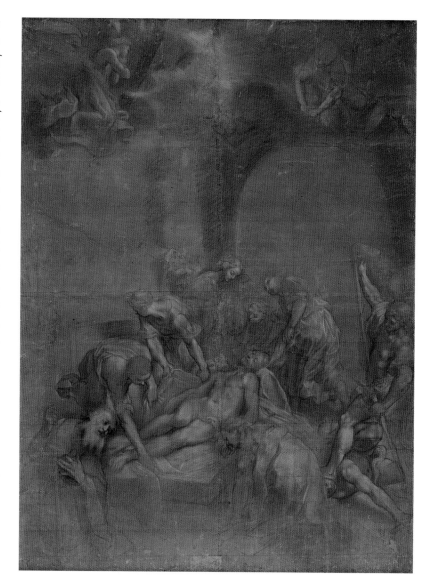

108 Barocci, compositional study for the *Lamentation-Entombment*, charcoal and chalk on paper, 105 × 77 cm. Amsterdam, Rijksmuseum, inv. 2749.

Lamentation is actively encouraged by the presence of the adoring bishop saint who kneels close to the wounded feet of Christ. Surface and depth are manipulated with great sensitivity in the presentation of San Giovanni del Buono. In the spatial illusion of the painting's perspective construction, the bishop is clearly brought slightly forward from Christ and implicitly separated from the space of historical drama. Thus, in the lower left foreground – the exemplary position of the "one who presents" – he mediates between the viewer in the chapel and the sacred core of the image. This function is made even more obvious in a highly developed study for the painting conserved in Amsterdam, which presents Mary Magdalen slightly farther into the picture space than the bishop and kneeling to face Christ (fig. 108). Yet in the surface pattern of the composition

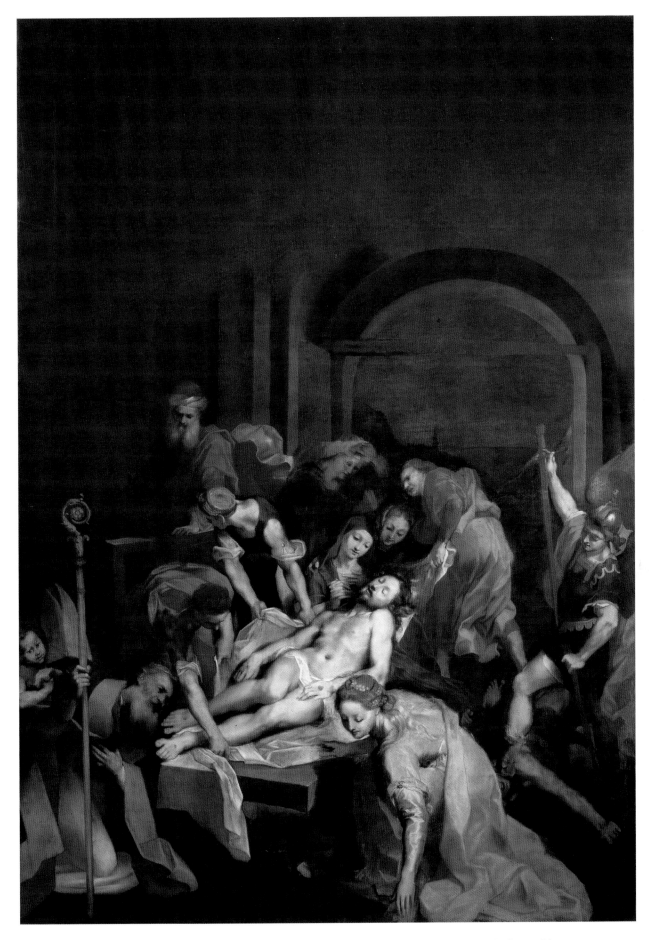

109 Barocci, *Lamentation-Entombment*, unfinished, begun in 1600, oil on canvas, 401 × 288 cm. Bologna, Pinacoteca Nazionale.

110 Simone Peterzano, *Lamentation-Entombment*, c. 1573–8, oil on canvas. Milan, San Fedele.

of both drawing and painting, the bishop also appears to kneel to kiss Christ's feet – a response that a tradition of devotional painting depending from Mantegna's *Dead Christ* actively encouraged.

Around the still center of the Virgin and her Son, however, *istoria* begins to assert its claims. Three male bearers take hold of the cloth on which Christ lies, and the rear bearer has already begun to move toward the tomb. The figure of the Magdalen, meanwhile, has been notably altered from the

cartoon. Instead of kneeling to mourn and adore Christ, she here places one hand on the cloth and reaches down with her other hand to an object at the lower margin of the image. This object is unclear but it might be her drapery or her ointment jar. Her fingers only brush it; they do not grasp. Barocci was always careful about gesture and action. The Magdalen can thus be imagined to have set down her jar, or adjusted her drapery, a moment ago, and to be releasing her grip. She is perhaps about to assist in the carrying of Christ to the tomb.

The depiction of the critical transitional moment that characterizes Barocci's invention, while not as common as the representation of the Lamentation, the Pietà, or the Entombment, did have a number of precedents. Raphael had considered versions of the idea in drawings (see fig. 91). Earlier, the school of Fra Angelico panel provides a rare, strikingly developed example of just this theme (see fig. 100). Joseph of Arimathea and Nicodemus are shown lifting the body of Christ off the Virgin's lap to carry it to the tomb. She leans forward for another embrace but is gently restrained by the mourning women so that the entombment may be accomplished. However, the bearers do not yet move. The effect is remarkably similar to the invention finally favored by Barocci; in the Milan altarpiece too the Virgin is restrained, although so gently that the gesture of the woman who comforts and holds her could almost be overlooked. Finally, from Barocci's lifetime and a church in Milan, Simone Peterzano's *Lamentation-Entombment* (fig. 110) depicts a distinctive reading in which Christ has already left the lap of the Virgin but has been set down on the lid of his sarcophagus to be mourned for another moment; the position of Barocci's Christ accomplishes an analogous purpose.[35] While the imagery of this distinctive moment – between Lamentation and Entombment, between icon and narrative – was never codified, the enduring desire to depict it was predicated ultimately upon responses to some of the still influential late medieval literature on the life of Christ. The late thirteenth-century *Meditationes Vitae Christi*, for instance, contains an extensive passage describing the Lamentation and the Entombment; it gives particular emphasis to the moment of Christ's separation from the mourning Virgin, who must be persuaded to release his body.[36]

Barocci's decision to reflect upon this precise subject seems predicated on his investment in conjoining iconic and narrative qualities in his altarpieces. It is telling that he has chosen a moment a few seconds before that evident in the Fra Angelico school panel or in Raphael's drawing (see fig. 91). One still sees the Pietà, composed as a devotional image. Indeed, some of Barocci's drawings focus solely on the Pietà of Mother and Son and many focus on achieving an ideal pose for the body of Christ. One compositional drawing seems to

111 Barocci, preparatory drawing for the *Lamentation of Christ*, chalk, wash, and white heightening on paper, 34.9 × 27.4 cm. England, Private Collection.

112 Antonio Campi, *Pietà with Saint Anthony of Padua and Saint Raymundus of Peñafort*, 1566, oil on canvas. Cremona, Cathedral.

envision a true Lamentation in which the upper body of Christ is held up to be displayed to the viewer (fig. 111). The effect is that of transforming Mantegna's famous and influential devotional image of the foreshortened and abject body of Christ into a cultic image appropriate for an altar; a strangely similar solution was invented by Antonio Campi in the painting usually called a Pietà in Cremona Cathedral (fig. 112).[37]

It is predictable that Barocci, like his great predecessors, would become determined to infuse the Lamentation with an element of narrative drama, but in his final invention for the Milan painting the *istoria* is just beginning and has not yet displaced the *corpus*. Given that Christ has been laid out and displayed in the foreground, the tomb must lie deeper in the picture space; as in Michelangelo's unfinished *Entombment* (see fig. 86), Christ is to be carried back into this fictive space to be interred. At the head of Christ, the figure of the young bearer – probably Saint John – has become nearly a reversed image of his ancestor who advances in the Senigallia *Entombment* (see fig. 83). The action he initiates as he begins to

pivot Christ's body seems to indicate that Barocci had continued to reflect on Mantegna's great print.

Something, however, is going wrong. The figure of Saint John appears out of proportion, almost as if in shot perspective. Further, the logic of his action is unclear. One would assume that Christ would be lifted forward off the Madonna's lap and clear of her body to be then carried back to the tomb, indicated by the gesturing figure in the upper left of the figural composition. John, however, strides directly back on a diagonal toward the sepulcher. The fact that the middle bearer looks back to the tomb as he begins to lift Christ confuses the issue further: is he simply in an interchange with the bearded figure (Nicodemus or Joseph of Arimethea?) who gestures toward the tomb, or are the bearers really going to attempt to follow John, and thus be forced to lift Christ over the Virgin? The dramatic actors appear exiled from one another and strain ineffectually around the Pietà that constitutes the devotional core of the image. What is one to make of this apparently inept narration by a master of subtle control of narrative details?

117

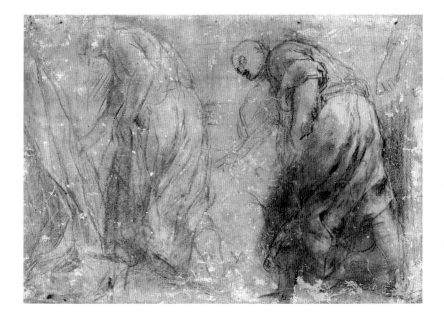

113 Barocci, study for Saint John in the *Lamentation-Entombment*, chalk on paper, 29 × 42.8 cm. Paris, Musée du Louvre, inv. RF 28990.

The most obvious conclusion would be that Ventura Mazzi added the figure of Saint John in a bungled attempt to finish his master's painting. However, this figure appears in the worked up study (see fig. 108), which is generally considered an autograph document of Barocci's intentions for the composition. Indeed, it is known from Vincenzi's letter of 1600 that Barocci

114 Barocci, study for the *Lamentation-Entombment*, chalk on paper, 19.8 × 24.5 cm. Berlin (Dahlen), Staatliche Museen, inv. KdZ 20481 (3732).

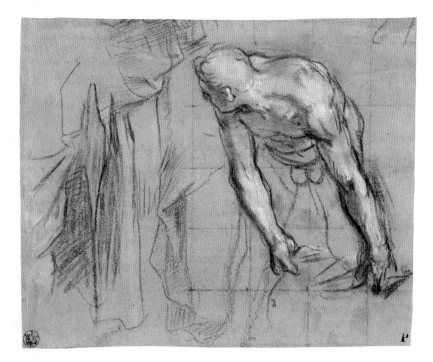

had nearly completed a cartoon, and from Barocci's letter to the chapter of the cathedral in 1608 that he had "finished the cartoon, and half sketched out the work." Further, a number of clearly autograph drawings demonstrate advanced stages for most of the figures depicted in the Amsterdam sheet, including a study for Saint John himself (fig. 113). It was also noted in period deliberations concerning the employment of Mazzi that he was uniquely equipped to complete the painting as he both understood his master's style and "has his drawings."[38] Could Barocci simply have been getting old? This seems an unsatisfactory explanation. There are no analogous weaknesses of composition or narration in the late, unfinished *Assumption of the Virgin*, which in fact was repeatedly praised, even in its incomplete state, by seventeenth-century observers (fig. 115). Further, Duke Francesco Maria II della Rovere, who knew Barocci well, records his death with a distinctive statement: "Federico Barocci of Urbino, the excellent painter, died at 77, at which age the eye and the hand served him as they did when he was young."[39]

A remaining possibility is perhaps the strangest, but it may just make sense: Barocci intended the confusion. Such a reading is supported not only by the Amsterdam drawing and the study of Saint John but also by the existence of a number of other drawings of the bearers who lift Christ's left side and effectively work at cross purposes with John (fig. 114). It may be lent further support by the very coloring of the painting, which has been at least blocked in. There will be much more to say about Barocci as a colorist later; suffice it now to point out that, as in everything, he was careful, deliberate, and calculating. For example, Saint John's tawny mantle, rich pink-red robe, and (unfinished) dull grey sleeve establish a somber background echo of the golden mantle, soft pink robe, and pale purple-blue sleeve of the Magdalen directly below and before him in the foreground. On the other side of Christ, meanwhile, the bishop's rich tawny mantle parts to reveal a flaming orange-red lining; the bearer just above him is vested in analogous colors. One could go on (the diagonal established, for instance, by the pink of the Magdalen's robe, the pink sleeves of the bearer just beside the Madonna, and the pink mantle that flies out behind the running female figure in the left backround is instructive). This "harmony" of coloring indicates an advanced stage of autograph planning. These are skills that may be taught, of course, but the handling here seems particularly distinctive, deliberate, and sophisticated.

If the "mistake" is intentional, one might ask how this inflects the reading of the painting. The bearers – narrative, history, *istoria* – are confused. They attempt to accomplish all that they can see to do as human actors – to bury their dead leader – but in their grief, they act at cross purposes. They will have to begin

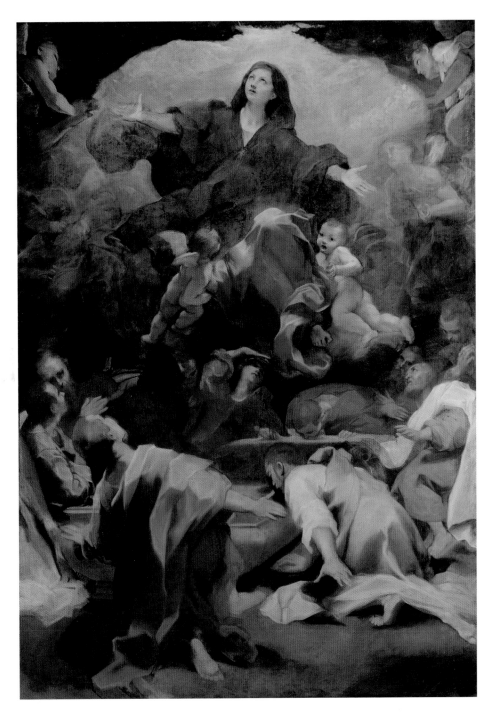

115 Barocci, *Assumption*, unfinished, begun c. 1605–12, oil on canvas, 239 × 171 cm. Urbino, Galleria Nazionale delle Marche.

again. Meanwhile, the body of Christ displayed over the altar remains the still center in this confusion, the eternal, present for contemplation and for the perpetual reenactment of the Passion that is the core of the Mass. Narrative and eternity are held in a balance that approximates their balance in the Mass itself. If this reading has merit, it seems that Barocci at the end of his life offered a *summa* of his reflections concerning the status of modernity and tradition in the narrative altarpiece, the

interplay of icon and narrative. The *Lamentation-Entombment* is both his final homage to, and his ultimate critique of, his great Renaissance predecessors. It is not, however, a tranquil resolution; the tensions between narrative and icon are so strong here that they continually threaten to disrupt any sense of hard-won balance. Barocci's final engagement with the difficult intersection of tradition and innovation in the narrative altarpiece ends in (deliberate) narrative confusion, and even perhaps finds in

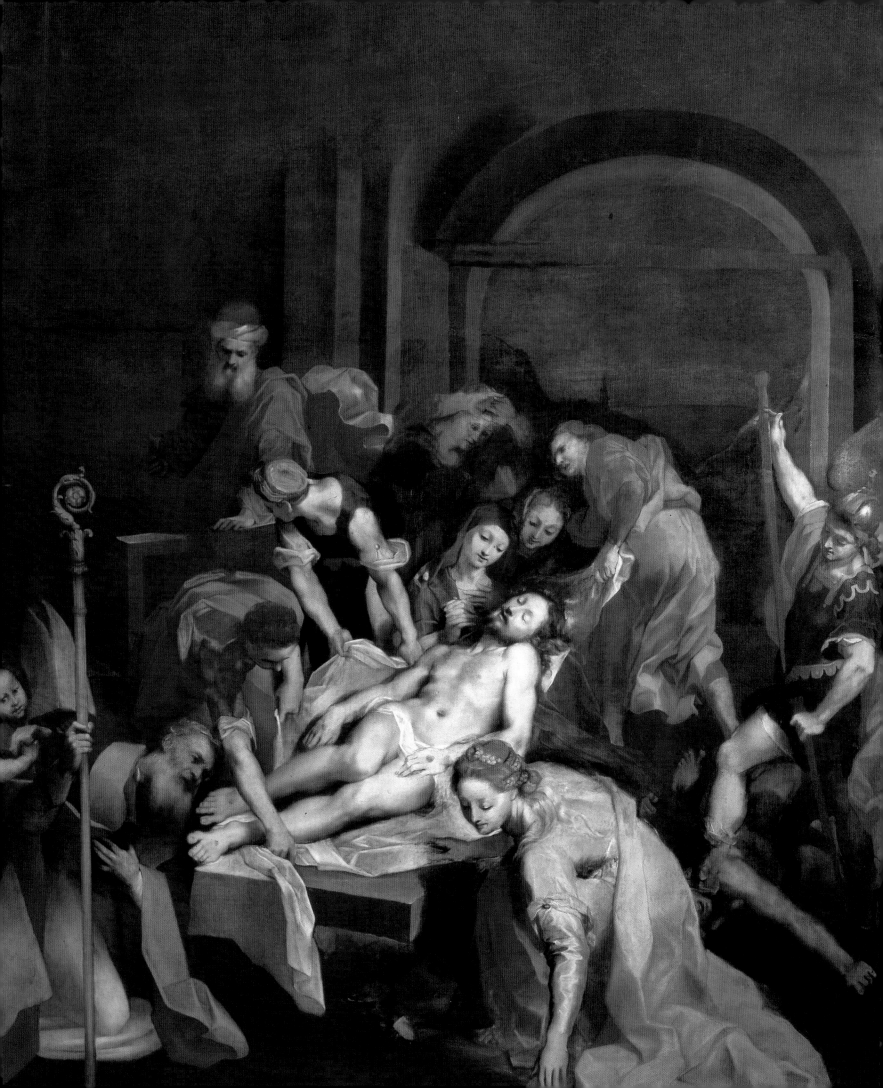

that confusion a solution that effectively disciplines the tendency for narrative to overwhelm icon in dramatic representations of emotive sacred histories. It is not surprising that the unfinished painting was displayed proudly over an altar in Milan Cathedral – but exerted little impact. Indeed, the radical devices it proposes are so unusual that they have not even been noticed in the historiography. At the end of his life, after having generated a remarkable series of solutions to the dilemma of the modern altarpiece in vision paintings that influenced painters and viewers for two centuries, Barocci returned to the ultimate struggle for a painter such as he – the creation of a sacred *historia* that was at once strikingly dramatic and iconically stable. In the painting for Milan, he finds himself suddenly alone among his contemporaries as he articulates an almost unreadable, deeply idiosyncratic essay, and one that perhaps betrays a new pessimism about the ultimate role of dramatic *istoria* in the altarpiece. His last work documents an unresolved struggle to represent his God – and to represent, for a new age, the achievements of his great predecessors in the *terza maniera*.

PART II

The Quest for Vaghezza

What's in a Word?

VAGHEZZA IN THE LANGUAGE OF CRITICISM

Barocci was a painter with great artistic ambitions. He was also a painter who was committed to an environment that engaged him in sustained reflection on and production of religious pictures. One might say that his highly self-conscious artistic ambitions were worked out principally in the field of the altarpiece, and that he was deeply engaged in the challenging negotiation between liturgical image and art object. His contemporaries frequently perceived his accomplishment in this light; it is no coincidence that two of the terms often chosen to describe Barocci's works were *vago/vaghezza* (or the related *grazia*) and *divoto*. To consider how a painting might be *vago* as well as *divoto* one needs to return again to the assessment of Barocci by Giovanni Baglione. While Baglione's *Vite* were only published in 1642 – thirty years after Barocci's death – the Cavaliere was then at the end of a long career near the center of Roman artistic life, a career in which he had been well placed to hear the art critical discussions of the late Cinquecento and early Seicento. He was, predictably, particularly well informed about the reception of works in Rome. Indeed, one of Baglione's touchstones for the assessment of Barocci's art is the *Visitation* in the Chiesa Nuova of San Filippo Neri (see fig. 77):

And when this style, so beautifully *sfumata*, *dolce*, and *vaga* was seen, it greatly pleased all the artists, who were amazed: and this happened in the time of San Filippo Neri, who was so devoted to the Image of that painting for the devotion that it also contained within itself, that he would stay in that chapel to pray almost continually.[1]

This passage is important for a number of reasons, not least for its identification of an *Imagine* in the *quadro*, a distinction between terms that may imply recognition of a certain retrospective core in the painting. Precisely these words, in fact, are employed in documents concerning Rubens's high altarpiece for the Chiesa Nuova in Rome to distinguish the new painting by a noted artist from the archaic *Madonna della Vallicella* that it enshrined (see fig. 3).[2] It seems that Barocci's effort to reconceptualize the narrative drama in the *Visitation* so as to stress the aristocratic and cultic presence of the Virgin (even as she participated in an *istoria*) could indeed have produced an altarpiece that contemporaries could read as a modern painting containing a venerable *imago*. Yet what does Baglione's characterization of Barocci's style as "*sfumata, dolce, e vaga*" signify, and how is it related to the devotion his pictures apparently both

"contained" and excited? *Vaga* is the critical term here and perhaps the least immediately understood of the three. Baglione had noted earlier in the *Vita* that Barocci "had a *vaga* style," and he concluded with the assertion that opened this book: "And truly in his noble works, [Barocci] was *vago*, and *divoto*; and as in one part he delighted the eyes, so through the other he composed souls, and returned hearts to devotion."[3] This lapidary sentence is crucial for understanding the period reception of Barocci's achievement, perhaps even for understanding Barocci's own sense of his achievement. It is richer and more pointed than it may appear, and it is demonstrably deliberate. Baglione may not offer philological precision in his use of language, but *vago* and *vaghezza* seem not to be terms he uses casually, or with the frequency of *grazia* or *bella* or *buona*, when characterizing a painter's style (he not infrequently concludes that an artist had a *buona maniera*). While the first part of this study may have offered a fair picture of some of the salient qualities that could have made a picture appear *divoto* to late sixteenth-century eyes, the significance of the *vago* for Barocci's achievement – and for the period in general – remains to be fully understood.

One reason most of the modern literature has largely ignored the possibility of employing such period terms in an effort to interpret pictorial form (and to assess the nature of Barocci's achievement) is surely the long-standing tendency to belittle the relevance of late sixteenth-century art theory and criticism to the making or viewing of period painting. A number of scholars from Charles Dempsey forward have argued for the importance of the rich seventeenth-century art literature to the formulation of a historically nuanced understanding of the achievement of the Carracci. At the same time, the textual study of early modern art criticism and theory has developed significantly. While this literature has generally focused on the texts as texts, and has not discussed images in a sustained manner, some of it has proved fundamental in reclaiming the importance of theory and criticism for the period and in considering the range of critical terms employed in early modern discourse on the arts.[4] Rarely, however, was a painter's style so succinctly, consistently, and precisely defined in period criticism as that of Barocci. His case thus presents a distinctive opportunity to explore how a cluster of related critical terms could be employed to register the success of religious pictures in the context of period assumptions and desires for art and for devotion.

VAGHEZZA, DESIRE, AND THE ARTFUL BODY

What was Baglione thinking when he wrote that Barocci had a "*vaga maniera*," and how closely might his use of this phrase, and his sense of its aptness to the painting of Barocci, relate to the theory and criticism of Barocci's lifetime? To answer this, it will be necessary to gain at least a rough sense of the early modern parameters of meaning and connotation for *vaghezza* and its related nouns and verbs, and their historical trajectories of usage during the sixteenth and early seventeenth centuries. Philip Sohm has stressed that part of the power and malleability of *vaghezza* lay in the perception of its relation to two distinct verbs – *vagare*, to wander, and *vagheggiare*, a more complicated word which can be translated "to gaze fondly" but which also implies a strong sensual, even sexual desire. The common employment of "loveliness" as an English translation of *vaghezza* hints at this valence but lacks the complexity – and the undertone of real desire – that could inhabit the Italian word. "Allure" might be a better, if still rough, approximation. Either translation, however, hints at another association: both the allure of *vaghezza* in life and the character of the *maniera vaga* in art were often construed as feminine qualities or characteristics. *Vaghezza*, whether painted or "present," is linked to cosmetics and the allure and blandishments of lovely women – qualities sometimes praised but often condemned in period discourse, particularly in ecclesiastical or moralizing texts.[5] The word is, in fact, doubly feminized, first in its relation to the allure of love and sensual desire and again in its wandering, unstable quality. Indeed, it seems no coincidence that Agnolo Firenzuola's *Dialogo della bellezza delle donne, intitolato Celso* (1548) proves to be one of the fundamental sites in which a period understanding of *vaghezza* is displayed and one of the important sources, too, for late sixteenth-century conceptions of pictorial beauty and *vaghezza*. It was Firenzuola who claimed that *vaghezza* involves both wandering and desiring; these qualities demand particular attention in the discourse surrounding the creation of *vaghezza* in much mid-to-late sixteenth-century painting and in that of Barocci in particular.[6] That *vaghezza* could have multiple valences in period criticism proved fundamental for Barocci's ability to generate a "chaste" *vaghezza*.

Indeed, while the potent connection of *vaghezza* with the discourses of love and sensual desire is of particular import for a consideration of the art theory (and practice) of the second half of the Cinquecento, this is not to say that the wandering connotations of *vagare* were unimportant to Baglione's description of Barocci's style, or even to Barocci's production. The possibility that a great painter might "wander" as he created a pictorial invention had been articulated and valorized in the most decisive terms as early as the beginning of the sixteenth century. In a famous letter to Isabella d'Este, Pietro Bembo recounts that he had spoken to Giovanni Bellini about painting a work for the duchess. Bellini had expressed himself "most inclined" to serve; however, Bembo feels compelled to warn Isabella that "the invention . . . must be accommodated to the

fantasy of him who must produce [the painting], for he does not like many definitive conditions to be put upon his work, since he is accustomed – as he says – to always wander [*vagare*] as he wishes in paintings." This penchant to *vagare* as one wishes in painting became ever more important during the sixteenth century, and came both to involve the spectator and to lead to unusual and controversial fashions. By the time of Barocci's maturity, Archbishop Paleotti was criticizing painters whose devotion to the discourses of "art" made them desire to paint *grotteschi* and similar inventions that encouraged the imagination (apparently both that of the painter and the viewer) to "go wandering capriciously." [7] While Barocci did not indulge in the mania for *grotteschi* – and despite the fact that his paintings frequently direct the eye of the spectator vigorously through the manipulation of gestures, gazes, spaces, and even light and shadow – a certain indefinite, at times "wandering" quality seems inherent in the very *sfumato* that Baglione saw as one of the touchstones of Barocci's style. The quality of sensual allure that often inheres in *vaghezza*, however, offers particularly rich avenues for interpretation as one attempts to understand the challenges and possibilities that confronted religious painting during the late sixteenth century. Indeed, the notion of wandering itself frequently proves laden with sensual connotations.

While Firenzuola may be said to have insisted on the relation of *vaghezza* to both wandering and desire, he ultimately defined the word as fusing three concepts – motion or wandering, desire, and beauty. He (more precisely Celso, the speaker at this point in the dialogue) explains the tight interrelation of these concepts. Wandering motion can generate desire in those who witness it, for one who "wanders here and there seems to arouse in others a greater desire . . . than one that stands still and which we can see at our ease." As desire leads to love, and "it is not possible to love something that is not or does not seem to us beautiful," *vaghezza* comes to be identified with a particular kind of beauty. However, the sequence works equally in the other direction. The beauty of *vaghezza* is particular in that it "has within it all those elements whereby anyone who looks upon it is obliged to become charmed (*vago*), that is, desirous; and having become desirous, his heart is always wandering to pursue it and enjoy it, his thoughts travel to her, and he becomes a vagabond in his mind." [8] The discussion of *vaghezza* comes at the end of a long consideration of the beauties of parts of the body, in a section concerned with harder to define qualities: *leggiadria*, *grazia*, *vaghezza*, *aria*, *maestà*. Of these, only *vaghezza* is given a preponderance of sensual overtones that link it indissolubly to the "discourses of the body" that have dominated much of the text thus far. Indeed, in defining *venustà*, Celso expressly separates it from the sensual and physical love of the earthly Venus, associating it with the loveliness

of the celestial Venus instead. Related strategies freight most of the terms with moral overtones, or at least undertones. Such concerns hardly appear in the discussion of *vaghezza* and then only to temper the sensual appeal the word evidently carries. If, Celso holds, one says that a certain young woman is *vaghetta*, this indicates that she has a certain *lascivetto*, a certain *attrativo*, and a desirability that has to do with appetite (*ghiotto*), though "mingled with virtue." [9]

Firenzuola's ultimate emphasis on the sensual qualities of *vaghezza* and on its relations to the attractions of physical beauty and desirability was matched by the usage of the word in mid-to-late sixteenth-century art criticism, which often focused on its involvement with love, desire, allure. By the 1580s, Lomazzo could write of "*vaghezza*, which is nothing else but a desire and a longing [*brama*] for something which delights." He added that its quality might be illustrated by observing one who, desiring "his beloved," becomes caught up in efforts to "admire and contemplate all her parts, to the point that those around him notice and laugh at it." [10] By 1612, the first dictionary of early modern Italy, the *Vocabolario* of the Florentine Accademia della Crusca, draws a significant distinction between the meanings of the verb *vagare* and *vaghezza*/*vago*. The *Vocabolario* is a particularly rich source in that its definitions are illuminated by quotations from the Italian literary classics of the Trecento and include Latin words that the academicians considered the nearest equivalents or synonyms to the Italian word they were attempting to define. Further, the dictionary's definitions of *vago*, *vaghezza*, and indeed a number of other art critical terms remain remarkably consistent through various Seicento editions, indicating that a similar understanding of these words could be shared by a writer from around 1600 and Baglione.

While *vagare* is defined as one would expect – "to wander" – the *Vocabolario* privileges aspects of *vago* and *vaghezza* that relate them most closely to the verb *vagheggiare*. [11] *Vagheggiare* is definitively a lovers' word, defined first as "from *vago*, for a lover, or to incline to love, that is to stare fixedly at one's beloved with delight, and attention." This sounds remarkably like Lomazzo on *vaghezza*. The dictionary's illustration of the use of *vagheggiare* in Italian literature (predictably, perhaps, through a quotation from Boccaccio) only highlights its amorous, sexual quality: "He had for a long time loved, and desired [*vagheggiata*], the wife of Messer Francesco." [12] In the entry for *vaghezza*, meanwhile, there is no mention of a relation to *vagare*; the definitions are concerned exclusively with qualities of sensual allure. *Vaghezza* is equated first with "desire," then "delight," and finally with "a beauty that makes one *vagheggiare*." [13] It is only in the definition of *vago* that the relation with *vagare* reappears, and only as one of five possible meanings. *Vago* can signify "what brings desire, the beloved, the lover"; "desirous"; "that in

which one takes pleasure and delights"; and "wandering"; and it can find synonyms in *graziosa* and *leggiadro*. *Leggiadria* is an important concept that was related particularly to the pleasing movements of young women; *graziosa*, meanwhile, we now tend to translate simply as "graceful." At least by the time of the *Vocabolario*, however, *graziosa* could be defined with a surprisingly sensual valence and a close relation to *vaghezza*: "beauty . . . which allures, and enrapts one into love."[14]

It thus seems remarkable that Baglione conjoined the sensual valences of *vago* and *vaghezza* with piety and devotion to characterize Barocci's art. Nevertheless, the perception that a marriage of these seemingly incompatible qualities was important in modern religious art can be traced well back into the sixteenth century and can be found even in the reform circle around Vittoria Colonna. *Vaghezza* and the *vago* had first been terms of literature and its critical discourses but came to be increasingly applied to the visual arts during the fifteenth and especially the sixteenth centuries as nascent art theory, criticism, and history appropriated the far more developed language of literary criticism to their new purposes. A 1540 letter by Francesco della Torre concerning poems by Marcantonio Flaminio highlights the ambivalence of "sacred *vaghezza*" in a manner that reveals something of what was at stake in asserting that Barocci's greatness lay in his ability to conjoin the *vago* and the *divoto*:

> I have received from him [Cardinal Reginald Pole, a friend of Colonna] verses by Messer Marcantonio, and when I have collected some others that are now with one of my friends I will send you those as well, which in my judgment will satisfy you much more, since they are that much more *vaghi* and more beautiful [*venusti*] when they treat of matters that are more capable of *vaghezza*, for in truth in trying to treat these matters of religion *vagamente* more often than not one merely makes the sacred profane: and I believe it is a difficult thing to do well, and with dignity. These others are of pastoral and amorous subjects . . .[15]

It is clear that Flaminio has thought *vaghezza* to be desirable for modern religious poetry. Equally clear, however, is the unease of a friendly reader witnessing the poet's struggle to accommodate allure and devotion, and the admission that while *vaghezza* is clearly a desirable stylistic quality, it is most naturally at home in "pastoral and amorous subjects." That *vaghezza* could be perceived to be a quality not only distinct from but even opposed to "devotion" in discourse on painting during these years is clarified by another letter, of 1524, in which Federico Gonzaga, Duke of Mantua, requests Baldassare Castiglione to aid him in acquiring a work by Sebastiano del Piombo. The duke will take anything "so long as it is not about saints, but is some picture that is *vago* and beautiful to look at." As Alexander Nagel has pointed out, the phrasing implies "that religious images tend not to belong to the category of pictures that are lovely and beautiful to look at" and that secular subjects are more appropriate for the display of artistic excellence. They are by nature "more capable of *vaghezza*."[16]

It would be easy to conclude from such sources that the chasm between the *vago* and the *divoto*, so tentatively bridged in poetic experiments in the circle of Pole and Colonna, must have widened definitively during the post-Tridentine decades. Yet it is precisely at the height of what is still too generically called the "Counter-Reformation" that one finds an assumption, even among some ecclesiastics, that just this conjunction of qualities is essential. The commission given to Felice Damiani by the Oratorians of San Severino Marche (discussed in Chapter One) exemplifies this. It should now be clear that Antonio Talpa's determination that the altarpiece represent an archaizing depiction of the *Madonna della Vallicella* surrounded by a glory of angels painted in modern style to "make a composition that is *vaga* and at the same time *devota*" constitutes a remarkable statement.[17] Talpa's formulation indicates that by the 1590s Baglione's specific conjunction of terms, the *vago* and the *divoto*, could be employed to describe a model and express an ideal for modern religious images. That such a statement comes from the period of Barocci's great later works for the Oratorians in Rome might just indicate that Baglione formed his assessment of Barocci's achievement in part out of memories of the early reception of Barocci's altarpieces for the Vallicelliana.

Talpa's evident perception that joining the beauties of modern artistic style with retrospection could produce an effective contemporary religious painting, at once *vago* and *divoto*, elucidates trenchantly why someone like Federico Gonzaga would not have thought strictly religious paintings likely to be "beautiful to look at." It also throws into high relief the extent of Barocci's achievement; in an age when Talpa could assume that the way to attain both alluring loveliness and unquestionable piety in an image was to effect a *mise-en-scène* of the archaic within the voluptuous frame of the modern, Barocci fused both elements into one alchemical pictorial compound, and a compound that appeared thoroughly modern artistically, revealing its profound negotiation with tradition subtly and to the contemplative gaze. Barocci effected this alchemy through particular pictorial strategies which the remainder of this book will investigate. There was also, however, a perhaps unexpected linguistic bridge between the *vago* and the *divoto*, inherent in their very definitions, which Barocci could exploit as well.

In the 1612 *Vocabolario*, *divoto* is defined predictably as "One who has devotion" (*divozione*). *Divozione*, however, is defined in

highly active terms: "Affection, and ready fervor toward God, and toward sacred things; the Desire to do immediately that which belongs to the service of God."[18] Affection, fervor, desire – these elements of the religious imagination are of course those most closely joined with the emotions of human love and sensual desire. Intriguingly, the academicians seem themselves to have sensed this possible connection. While their definitions of *vaghezza* and the *vago* privilege the realm of *cose amorose* – both in the definitions themselves and the quotations from Boccaccio and Petrarch that illustrate usage – one possible meaning of *vagheggiare* is given as "simply to regard with delight." Here both the Latin synonyms of *aspicere* and *contemplari*, and the choice of literary illustration, are telling. The Latin verbs signify considered gazing and contemplation, and the literary quotation is suddenly from Dante; instead of a character in the *Decameron* gazing fondly on the lady of his desires, a line from the *Paradiso* indicates an attitude at once more contemplative and "artful." Dante asks his reader to consider the design of the cosmos and, delighting in the creation of God, to "begin to *vagheggiar* in the art of that master."[19]

Ultimately Barocci attempted to generate just such a sensation, such a "spiritualized *vaghezza*," from his paintings. They allure and attract the gaze, but his melting colors and sweet figures lead viewers simply "to regard with delight" or to "delight in the art of that master" rather than encouraging aggressive desire for the possession of represented beauty. This is not to say that Barocci ignored the cultivation of figural *vaghezza* – he did not, as will become evident – but his contemporaries never seem to have perceived even his lovely young women as "lascivious" in the manner of beautiful nudes by Bronzino. Their allure was always somehow, to paraphrase Firenzuola, "mingled with virtue," and indeed it seems that those who first wrote about Barocci's art ultimately located the roots of his *vaghezza* elsewhere. To recover something of what contemporaries saw, one needs to explore the specific ways in which *vaghezza* and its cousins could be employed in speaking about pictures. *Divoto* seems to have remained remarkably consistent in meaning and, as a term used to describe a pictorial style, it was employed at least from Cristoforo Landino's characterization of Fra Angelico's *maniera* in the late fifteenth century, discussed at the end of this chapter. During the Cinquecento and Seicento, *vago* and *vaghezza* also remained fairly consistent in definition but their range of connotation, and patterns of critical usage, developed in the art critical literature in ways which need to be understood.

Leon Battista Alberti was, predictably, among the earliest writers to employ *vaghezza* in theoretical reflections on art. In his autograph Italian version of *De Pictura*, Alberti uses the word rarely – indeed it is usually thought that he does not employ the term at all, for it attained its greatest diffusion much later. Sohm has pointed out that when Alberti's Latin version of the treatise on painting was translated into Italian for publication in 1547 by Lodovico Domenichi (who apparently did not know the original Italian manuscript), *vaghezza* was introduced frequently into passages where Alberti had never employed it.[20] It is telling, however, that Alberti's own Italian version employs the word in a critical argument in Book Three. Section 55 lays out the fundamental principles of "how we should become learned" in painting. For Alberti, the basis of visual knowledge is knowledge of all the variable outlines and surfaces of things, with particular reference to the depiction of the human figure. As the painter comes to understand the parts of the body and their relation,

> He should be attentive not only to the likeness of things but also and especially to beauty [*bellezza* – *pulchritudinem* in Alberti's Latin version], for in painting *vaghezza* [*pulchritudo* in the Latin] is as pleasing as it is necessary. The ancient painter Demetrius failed to obtain the highest praise because he was more interested in representing the actual likeness of things rather than making them *vaghe*. Therefore, excellent parts should all be selected from the most beautiful [*belli* – *pulcherrimis* in the Latin] bodies, and one should always work with study and industry to learn much *vaghezza* [*pulchritudinem*].[21]

I have included Alberti's Latin word choices because they reveal something important about his vernacular choices. It might be thought that Alberti employs both *bellezza* and *vaghezza* for the Latin *pulchritudo* simply to vary his vocabulary, but he makes no such effort in the Latin version, despite the fact that Latin possesses synonyms for *pulchritudo*. It seems rather that *vaghezza* was a fundamental concept in Alberti's notion of a naturalism enhanced by affecting beauty. Alberti's commitment to affecting painting runs like a leitmotif throughout *De Pictura*, and he had reiterated it just pages before this passage, when he asserted in the opening to Book Three that painting succeeds when it "holds the eye and the spirit of those who regard it."[22] From the very origins of Renaissance art theory, then, it was demanded that the best modern painting attract and hold the gaze. For Alberti, it seems that one of the principal qualities that allowed painting to "hold the eye" was *vaghezza*. Furthermore, in his text the locus of *vaghezza* – as indeed of the *istoria* and of ambitious painting itself – was the body and the creation of compositions of beautiful bodies. Thus at its very instauration in art theory *vaghezza* is inextricably bound to the body and its allure. Ironically, despite the far greater frequency of *vaghezza* as a term in Domenichi's 1547 Italian translation of Alberti's Latin

116 Michelangelo, *Last Judgment*, 1536–41, fresco. Vatican, Sistine Chapel.

I have not found anyone with the courage to copy quickly what Michelangelo has newly painted, because it is a large and difficult work, since it contains more than 500 figures, and of a kind that to copy even one of them would give the painter pause for thought; even though the work is of such beauty as Your Illustrious Lordship may imagine, there is no lack of those who condemn it. The very reverend Theatines are the first to say that it is not good to have the nudes displaying themselves in such a place, even though he has paid great attention to this, and only in about ten out of so great a number can one see anything indecent. . . . But the Reverend Cornaro who has looked at the fresco for a long time put it well, saying that if Michelangelo wanted to give him a painting of only one of these figures he would gladly pay him whatever he asked, and he is right, because to my mind these are things that cannot be seen elsewhere.[24]

Sernini expresses what had by his day become a commonplace among educated viewers: the principal beauty and art in painting resides in the masterful representation of the nude. Michelangelo's work is overwhelming because it confronts its viewers not with one but with hundreds of perfect nudes, hundreds of models of art. A churchman who is also an admirer of art would pay Michelangelo anything just to have one of those figures; the religious story and purpose of the work as a whole seems almost to matter less than the artistic perfection of its parts.

While Cardinal Cornaro may have been able to negotiate between his faith in God and his belief in art, others could not. The Theatines had already raised a basic issue of decorum; the Pope's chapel is no place for "nudes displaying themselves." Some two decades later, an ecclesiastical critic who was more incisive in his understanding of art than many Theatines leveled a more pervasive and damning critique of Michelangelo's fundamental artistic commitments. In his *Dialogo degli errori de' pittori*, which was published in 1564, just after the conclusion of the Council of Trent, the reformer Giovanni Andrea Gilio launched a general assault on "the painter that delights in making the figures of saints nude, which always takes away from them a great part of the reverence which one owes to them. But the *vaghezza* of art – which few will delight in – pleases [such a painter] more than *onestà* and appropriate decorum."[25] Gilio understood that the nude was the ultimate sign of the artifice and allure of modern painting. For him, two many modern painters had become deeply invested in the increasingly self-conscious artifice and self-absorbed theoretical concerns of the new art, and in the overwhelming effect its virtuosity might have on the *cognoscenti*. Yet most public paintings were still religious works, frescoes and altarpieces in

version – a difference that signals the rapid expansion of the concept's usage during the Cinquecento – Domenichi failed to realize that *vaghezza* had been Alberti's distinctive choice as a translation of *pulchritudo* in this section. Domenichi simply uses *bellezza*, repeating it without variation.[23]

While the rising prominence of *vaghezza* in art criticism by the mid-Cinquecento is attested by Domenichi's translation, the word's association with the body and sensual beauty was making its frequent deployment increasingly controversial. Even before the Council of Trent, Michelangelo's *Last Judgment* became a flashpoint for criticism of religious painting that was too invested in art and its ideal, the perfect body (fig. 116). Less than a month after the fresco had been unveiled, a letter of November 19, 1541 from Nino Sernini, an agent of the Gonzaga in Rome, to Cardinal Ercole Gonzaga already encapsulates the issues:

churches. They had roles to play within the larger society. It was not simply that nude figures were inappropriate in the Sistine Chapel, but that nudes formed to show artifice and seduce the eyes of connoisseurs and other painters lacked both decorum and the transparency of the sign to the signified. Instead of operating principally as effective images of the saints and thereby instructing and inspiring the faithful, these figures first signified the canons and lures of the new painting and its *all'antica* learning. Gilio perceived as fully as Sernini or Cardinal Cornaro (if from a different perspective) that the language of Michelangelo's *Last Judgment* was the body:

> seeing himself before such a large field in which he could show, in such a multitude of figures, all the lovely things a body could do through means of twists [*sforzi*] and other poses, he didn't want to lose the opportunity to leave for the future the memory of his marvelous brilliance. And this is the marvel: that no figure which one sees in this painting does the same thing as another, or resembles another. And for this feat he put aside devotion, reverence, historical truth and the honor that one owes to this most important and great mystery.[26]

Further, it is telling that Signor Ruggiero, the speaker here, has just accused Michelangelo of behaving "like a lover" before his favorite lady as he created the *Last Judgment*. For all his evident attempts to marginalize the charge of *vaghezza* as something "few delight in," a display of art for those who understand it, Gilio and many others seem to have worried increasingly that the allures of modern painting provoked raptures that could come dangerously close to those of sensual love – and that could lead the unwary astray.

Some artists and art theorists worked hard to defend the *vaghezza* of art – and its highest locus in the beautiful representation of the ideal body – in the midst of the changing cultural climate after mid-century. In a passage of great significance from the *vita* of Fra Angelico, Vasari acknowledges that *vago* painting frequently involves the representation of lovely youthful bodies, but offers a spirited defense of *vaghezza* as a critical artistic quality and one in keeping with religion when well used, in decorous fashion:

> And truly, such a consummate and extraordinary talent [*virtù*], as was that of Fra Giovanni, cannot and should not be granted if not to a man of the holiest life; for those who occupy themselves with ecclesiastical and holy things must be ecclesiastics and holy men, for as one sees, when such things are done by persons of little belief, who little value religion, they frequently make dishonorable appetites and lascivious wishes enter the mind, so that there arises blame for

the work's disreputable aspect, while one praises it for its artifice and artistic quality [*virtù*]. But I would not wish that anyone misunderstand, interpreting the awkward [*goffo*] and inept as devout, and the beautiful and good as lascivious, as some do, who, seeing figures of a young woman or of a young man which are a little more *vaghe* and more beautiful and adorned than ordinary, single them out immediately and judge them lascivious, not being aware that they very wrongly condemn the good judgment of the painter, who holds the Saints, who are celestial, as much more beautiful than mortal nature even as [the beauty] of heaven surpasses earthly beauty, and all our works. And what is worse, they show their souls to be infected and corrupt, finding evil and dishonorable desires in those things in which, if they were lovers of good, as in their blind zeal they wish to demonstrate, they would perceive the longing for heaven and the desire to make them acceptable to the Creator of all things, from whose absolute perfection and beauty every perfection and beauty is born. What might such men do – or might it be believed they would do – if they found themselves in the presence of living beauties with lascivious ways, with the softest words, with movements full of *grazia* and with eyes which enrapture unsound hearts, when the mere image and as it were shadow of the beautiful moves them so? But I would not, however, want anyone to believe that I would approve those figures that are painted little less than totally nude in churches, for in such one sees that the painter did not have that consideration that the place demanded: for, though one wishes to display what one knows, one must do so with the necessary regard for circumstance, and have respect for the persons, the times, and the places.[27]

Most obviously, this passage illustrates vividly the emotionally charged, alluring, sexual connotations of the *vago* in Vasari's culture, its intimate relation with the human figure, and its close link to *grazia*, which as has been seen can also be charged with amorous tonalities. Beyond this, much in the passage may be read as a polemical response to the atmosphere of censorship and suspicion exemplified by the critiques leveled at Michelangelo and at the *Last Judgment* in particular. I have quoted the passage as it stands in the 1568 edition of the *Vite*, that is, four years after the publication of Gilio's *Dialogo*. A closely related passage had existed in the 1550 edition, well before Gilio (though after the inception of debate on Michelangelo's *Last Judgment*), but there are several important alterations in the later version. Giovanni Previtali has noted acutely that Vasari, feeling his position to be increasingly embattled, prudently moved the passage from the opening of the life of Angelico to its center – and that he added the final passage

containing the disclaimer of any personal approval of "indecorous" images in churches.[28]

What is not noted is that Vasari also added the attack on the personal character of self-righteous critics that forms the bridge of the passage. That this was an increasingly common, and perhaps persuasive, counterattack on the "ecclesiastical" view of art is attested by an intriguing statement by Archbishop Paleotti (though in this case the issue is one of frankly secular art): "Those who wish to defend similar sorts of profane images, whether pictures or statues or medals or other sorts of things, are accustomed to cover themselves with various excuses, and principally to say that these things are neutral, and that everything in them depends on the intention and the character that a person has."[29] Paleotti's assertion that those who would defend "profane" images "say that these things are neutral" raises a critical issue. In effect it reveals that Vasari's angry assertion, while trenchant, presents a problem in the conceptualization of art: for while Vasari defends art, he effectively if unintentionally belittles the power of images, the power of art itself, to move, change, and even "ravish" the beholder. Ironically, it was the ecclesiastics like Gilio and Paleotti who openly acknowledged this power and with it the need for its proper use. Barocci believed in the power of art also, and the period assessment of him perceives this commitment. He strove for an art that was truly *vago*, in that it enraptured the beholder into love and delight in the image – but he labored as well to ensure that this rapture would be conducive not to lust but to devotion, so that "as in one part he delighted the eyes, so through the other he composed souls, and returned hearts to devotion." To accomplish this feat, Barocci turned to some developing concepts of *vaghezza* that were not linked directly to the figural loveliness celebrated by Vasari. Foremost among these "other *vaghezze*" was that of color.

COLOR, FACTURE, AND THE LURES OF PAINTING

By the mid-sixteenth century *vaghezza* was employed with increasing frequency – particularly in northern Italian writing on art – to denote a beauty that distinguished modern painting from its antecedents. While this beauty was often exemplified with reference to the conquest of the representation of the lovely figure that was one of the supreme accomplishments of the modern age, it could also be located in other aspects of painting: *vaghezza* became part of the *non so che* characteristic of the best in modern painting, an excellence and loveliness that exceeded the quantifiable. Beyond its established associations with the body, *vaghezza* came to be particularly linked to the allure of color. The "wandering" or indeterminate aspect of

the word is again relevant here, though often as a quality that stimulates enraptured gazing. As with figural loveliness, coloristic *vaghezza* might be praised for the generation of exceptional beauty or regarded with ambivalence and associated with the feminine and the illusory or mendacious allure of cosmetics; even non-figural *vaghezza* was as dangerous as it was potent and had to be properly handled by the artist. In the *Dialogo* of 1548 by the Venetian painter Paolo Pino, the term already connotes a *non so che* critical to good painting. However, Pino's particular concern that neither beautiful color nor alluring figures be mistaken for that *vaghezza* he celebrates paradoxically indicates how important color had become to the perception of *vaghezza* in painting:

> How do you like the *vago* painter? He pleases me exceedingly and I tell you that *vaghezza* is the seasoning of our works. I do not however signify with *vaghezza* beautiful ultramarine of sixty scudi an ounce, or beautiful lake, for colors are also beautiful in and of themselves, in their boxes; nor is a painter lauded as *vago* if he gives to all his figures rosy cheeks and blond hair, serene airs, and [shows] the earth all clothed in beautiful green: true *vaghezza* is not other than *venustà* or *grazia*, which arises from a combination or rather just proportion of things, so that, as the pictures have these qualities themselves, they have something of the *vago* as well and the painter is honored.[30]

While he is very quick to critique facile understandings of *vaghezza*, Pino here not only foregrounds it as the "seasoning" of painting but also identifies the ideal painter as a *pittor vago*. The ground for Barocci's performance and its reception was being laid.

A few decades later, Lomazzo linked *vaghezza* more firmly and positively with color; having described color possibilities and arrangements in a chapter entitled "How one arranges colors in *istorie*," Lomazzo concluded that his suggestions form "all the foundation of the necessary *vaghezza* that colors must have when disposed in painting: if this is understood and observed, the works will succeed in being appropriate, *vaghe*, and delightful to the eye."[31] This friendship of *vaghezza* and color, important by the mid-Cinquecento, became a commonplace in the Seicento, as when Giovanni Battista Agucchi praises the *vaghezza de'colori* of the Carracci.[32] However, throughout the period, the suspicion of the ease with which beauty of coloring could become superficial, "cosmetic," remained and provoked repeated warnings. Lomazzo, for instance, while admiring aspects of coloring, followed Pino in admonishing the artist not to be attracted by the beauty of colors in and of themselves. Painters must learn how to use color so that their art, rather than simply the beauty of colors, would be manifest; and they

must not lose sight of *disegno*. He laments that "in these times painters are more attracted by colors than by *disegno*, by the *vaghezza* rather than the power of art." Barocci's painting forestalls such critiques by attending deeply to *disegno* and by employing color to contribute to meaning rather than simply to "ornament," as will be seen.[33]

By the late sixteenth century, nonetheless, color had become so important to the discourses surrounding *vaghezza* that even some Florentine theorists could both associate *vaghezza* particularly with color and see it as a necessary aspect of great painting; even on the Arno, that is, *disegno* by itself might not be enough, though it remained literally and figuratively fundamental. Such issues are especially clear in Raffaello Borghini's *Il Riposo* of 1584. Borghini's is often viewed as a "reformist" text and indeed some of its speakers repeatedly level serious charges against the altarpieces of painters such as Bronzino, whom they condemn for "lascivious" figures that may be great art but have no place over the altar. It might be assumed, then, that painters like Santi di Tito would emerge as the artistic heroes of the dialogue, and in fact there is no lack of praise for Santi when *disegno* or *devozione* are considered. One discussion of his work concludes: "he is a very skilled painter, and understands the things pertaining to *disegno* extremely well."[34] However, that *disegno* alone does not make for the best painting in the eyes of some of Borghini's interlocutors is clarified in several discussions that include consideration of Santi's achievement. At one point, Sirigatti, a wealthy collector, Knight of Santo Stefano, and amateur sculptor who tends to offer sober praise of works he discusses, asserts: "But returning to the Carmine, I see the Mother of the Savior of the world ascending to heaven, painted in a panel with the Apostles by the hand of Girolamo Macchietti . . . with relief and with good *disegno*." Michelozzo – who emerges as a vigorous defender of art and *vaghezza* in the dialogue and a harsh critic of works he perceives as deficient in these qualities – immediately responds: "All this pleases me . . . but the *colorito* could be more *vago*, as is the case also in the panel by Santi di Tito of the *Nativity*, which otherwise pleases me greatly . . ."[35] While the speakers agree that Santi was capable of working effectively with color, Michelozzo, at least, does not seem to feel that he often succeeded. A few pages before his highly qualified praise for the *Nativity*, Michelozzo had already responded to an encomium of Santi's *Raising of Lazarus* in Santa Maria Novella by interjecting: "Yes, but you neglect to say . . . that the *colorito* is not too commendable" (fig. 117).[36] By the 1580s Borghini was registering a distinctive tension that is critical to the understanding of Barocci's achievement; a religious painting must have *vaghezza* as well as devotion and good *disegno*. The quintessential Florentine attainment of a *vaghezza* achieved through *disegno* – the beautiful nudes in difficult poses for which

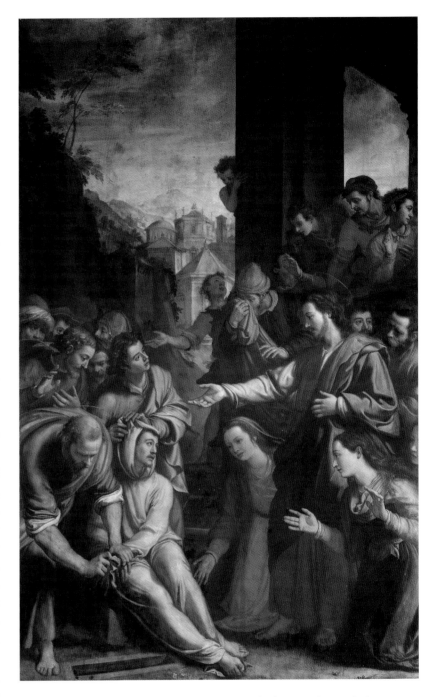

117 Santi di Tito, *Raising of Lazarus*, 1576, panel. Florence, Santa Maria Novella.

Bronzino was condemned – was no longer fully acceptable in the new cultural and spiritual world. Yet *vaghezza* somehow had to play a salient role in any ambitious modern painting. Color was an obvious field in which it could be cultivated.

There were other "non-lascivious" aspects of painting that could also be considered *vaghe* by the mid-sixteenth century and Barocci investigated all of them in his effort to displace the locus of *vaghezza* in his paintings from the charged site of purely figural painting centered on the ideal nude. Baglione's

118 Titian, *Venus and Adonis*, 1554, oil on canvas. Madrid, Museo del Prado.

description of the style of the *Visitation* as "so beautifully *sfumata*, sweet, and *vaga*" is particularly telling in this context, and is a valid summation of the style of most of Barocci's mature paintings. The delights for the eyes with which Barocci's images are filled – exemplified in the *Visitation* (see fig. 77) by the sparkling passages of painting in the rendition of the basket with its chickens, or of the donkey (who makes eye contact with the spectator) – the commingled gravity and gentle sweetness in the expressions and the actions, the mystery of form and contour created through a *sfumato* that gently forces the beholder to continue to look, to attempt perpetually to see: these qualities are frequently privileged in Barocci's art and can indeed enrapture, hold, and move the viewer. Here, some of the highest artistic and technical accomplishments of contemporary painting are employed to draw spectators out of themselves into a contemplation that begins with a "delight in the art of that master" and which can in many cases become devotional as well.[37] These displacements of *vaghezza* from the body did not

entirely drain the word of its sensuous power, however, as can be illustrated with reference to an apparently unlikely association, that of *vaghezza* and actual pictorial facture.

Beyond his evident investment in *disegno* and his borrowings from both Lombard and Venetian *colore*, Barocci seems to have experimented with Venetian as well as central Italian ways of applying paint. In an important essay of 1995, Elizabeth Cropper has observed how a letter by the Venetian critic Lodovico Dolce valorizes developments in Titian's facture as sensuous in their own right, and relates them directly to representational sensuality. Dolce, comparing the figure of Venus in Titian's *Venus and Adonis* (fig. 118) to the Cnidian Venus that so inflamed an admirer that he ejaculated on it, is prompted to extol the unique powers of modern painting:

if a marble statue could, with the shafts of its beauty, penetrate to the marrow of a young man so that he left his stain [*macchia*] there, then what should this figure do which is

made of flesh, which is beauty itself, which seems to breathe? The picture in question also includes a painterly piece [*macchia*] of landscape, of such quality that the reality is not so real. Here on top of a little hill, at no great distance from one's sight, there is a little Cupid sleeping in the shade . . . and round about there are very wonderful bright gleams and reflections of sunshine, which light up and gladden the whole landscape.[38]

It would be easy to overlook Dolce's repetition of the word *macchia* were one not sensitive to what Cropper identifies as the Cinquecento "expectation that the beauty of works of art should have a seductive power . . . and that the beholder and the painter alike were positioned in relation to the image as the lover to the beloved." Dolce has in fact made an extremely suggestive linguistic and critical maneuver. His wording elides Titian's new and controversial technique of applying paint with the stain left by the amorous admirer of the ancient sculpture; and in the midst of this new, sensuous manner of painting lies Cupid.[39]

MANIERA VAGA: ASPECTS OF THE EARLY MODERN PERCEPTION OF BAROCCI'S STYLE

If one returns to Baglione's formulation of the significance of Barocci's style with some of these varied facets of period perceptions of *vaghezza* in mind, its precision may be understood more fully. A survey of the *Vite* reveals that Baglione described the style of very few artists as *maniera vaga*. A number of subjects, things, and works could exhibit *vaghezza* – gardens and their fountains, ornaments, the Palazzo del Tè, a loggia with the story of Psyche by Cigoli, beautiful figures (in particular, it seems, nudes and putti), and fine coloring. Music is singled out once as a distinctive field of *vaghezza*. In Barocci's painting, issues raised by the figural *vaghezze* of the nude and putti, by still life and genre – and by the non-figural *vaghezze* of color and of music – demand further investigation.[40]

If certain subjects or sorts of works might be strong candidates for the exhibition of *vaghezza*, however, it remains striking that Baglione considers few painters to exemplify *vaghezza* as a salient component of their personal style, rather than as an element of individual works. Barocci is first among the select group of painters whose very *maniera* exhibits *vaghezza* before any other artistic quality: Baglione states that Barocci "hebbe maniera vaga," then returns to stress that the *Visitation* revealed his "maniera si bella sfumata, dolce, e vaga," and finally concludes with the remarkable conjunction of "vago, e divoto" to sum up what makes Barocci's work distinctive as a whole. The

only other painters so completely identified with the *maniera vaga* are specifically described as followers of Barocci: Francesco Vanni cultivates a "Barocci-style *vaga maniera*, done with love," while his coloring in particular is "so *vaga*," and Antonio Viviani creates from his study with Barocci "una maniera assai vaga."[41] I have found only three painters beyond these *Barocceschi* whose style is also described as *vaga* at some point in their *vite*: Raffaellino da Reggio, the Cavaliere d'Arpino, and Marcello Venusti. These might seem idiosyncratic choices. Critically, Baglione does not associate any of these painters so univocally with the *maniera vaga* as Barocci and the *Barocceschi*. Careful attention to the aspects of their styles that Baglione does highlight as *vago*, however, can clarify his perceptions and the way in which he employs critical terms.

Raffaellino da Reggio is perceived both by Baglione and by modern art historiography as a particularly promising painter who died tragically young. Baglione describes his style as *gratiosa*, *bella*, and *buonissimo*, and highlights particular works for their *gran spirito*, their *franchezza*, even their *gran maniera*. Of these terms, only *gratiosa* and *bella* might ordinarily be associated with *vaghezza*. In summarizing Raffaellino's achievements, however, Baglione notes that "in those days one spoke only of Raffaellino da Reggio, and all the young [painters] sought to imitate his beautiful manner; he had so much softness, and harmony of coloring, relief, and strong design and drawing, and *vaghezza* in his manner." Raffaellino's manner is thus seen to conjoin a range of qualities, mingling force and relief with softness and *vaghezza*. It may be that Baglione admired him precisely for his successful union of apparently disparate qualities.[42] Notably, such a union was perceived in Barocci's work by some of the earliest commentators. Lomazzo, for example, praises Barocci (along with Tintoretto, Veronese, the Bassani, Correggio, and a few other painters) as "giving to their pictures force and sprightliness in the actions and *leggiadria* [that partial synonym of *vaghezza* reappears] in the colors." Lomazzo's characterization of Barocci as a strong as well as lovely painter is a useful corrective to the modern notion – already nascent by Bellori's day – of his work as univocally delicate, "feminine," even "sentimental," and indicates how Barocci might have cultivated a *maniera vaga* without allowing himself to be entirely marginalized in contemporary theoretical discourse as charming but "feminine."[43]

Marcello Venusti may appear the most unlikely candidate for a *maniera vaga*. Indeed, Baglione casts his appraisal of Venusti in a highly distinctive manner. Throughout most of the *vita*, he describes the painter's style not as *vago* but as *assai buona*, suitable for painting "things worthy of being remembered," and extremely *diligente*. It is only near the end of the *vita* that *vago* is joined with competence, diligence, and devotion as Baglione

119 Marcello Venusti, *Noli me tangere*, c. 1577–9, oil on canvas. Rome, Santa Maria sopra Minerva.

sums up: "his mode of painting was very devout, diligent, and *vago*."[44] Even if Baglione does not celebrate Venusti as among the best artists of his age, modern historiography has in general seriously underestimated the period appreciation of his paintings. It has recently been pointed out that in the works he produced with Michelangelo, it was precisely the conjunction of Michelangelo's superb *disegno* with Venusti's skills as a colorist that was particularly valued.[45] Some of Venusti's paintings in Santa Maria sopra Minerva in Rome, for instance, exhibit coloring that may illuminate Baglione's perceptions. This is particularly true of the altarpiece of the *Noli me tangere* (fig. 119, first

chapel on the right), and in the vault of the Cappella del Rosario, both of which exhibit a handling of color and paint with some of the brightness and beauty of Barocci's works of the 1570s.[46] Further, the conjunction of artistic ambition that Venusti expresses through his re-elaborations of inventions by Michelangelo with his evident commitment to the *divoto* in religious painting could have encouraged an observer such as Baglione to see a similarity between Venusti's painting and that of Barocci. The principal sources of artistic ambition may have differed (as might the relative success of the paintings as compelling works of art) but the shared desire to produce artful pic-

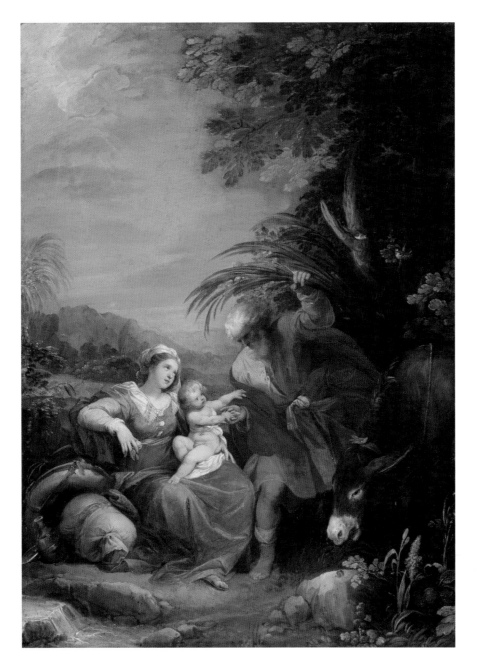

120 Cavaliere d'Arpino, *Rest on the Flight into Egypt*, 1596–7, oil on copper. Boston, Museum of Fine Arts.

tures that were also devout (and successfully married *disegno* and *colore*) may help to explain Baglione's position. As late as the mid-eighteenth century Venusti's coloring, specifically, could still be perceived as *vago*. Pellegrino Orlandi was summing up a long trajectory of early modern reception when in 1763 he described Venusti as "a man precise in drawing, masterful in composition, diligent in finishing, *vago* in coloring, and disposed to serve."[47]

Finally, a careful reading of the *vita* of the Cavaliere d'Arpino makes clear that Baglione is not convinced that d'Arpino's works were always successful: the *vita* is peppered with references to works not executed "with very good taste."[48] However, when the Cavaliere was at his best, his manner struck Baglione as *franca*, *assai buona*, often *bella* – and in one assessment, *vaga*. In the last case, d'Arpino had painted at the foot of the pontifical staircase in the Lateran palace the arms of Sixtus v with allegorical figures of Religion and Justice (now lost), "done in that *vaga* manner of his."[49] D'Arpino for Baglione is a complex case, and his association with a *vaga maniera* is far from univocal. That d'Arpino's style might at times express *vaghezza*, however, is clear: many of his paintings seem engaged with the values of *vaghezza*, both corporeal (lovely youthful figures) and pictorial (lovely color, virtuoso and at times visible brushwork; fig. 120).[50]

Baglione's very hesitation to regard *vaghezza* as a fundamental stylistic attribute of most of the painters he considered only highlights the impression that he was writing something deliberate and pointed when he insisted that the salient characteristic of Barocci's manner was its fusion of the *vago* and the *divoto*, and that he identified a distinctive and recognizable *maniera* when he stressed *vaghezza* as the salient component in Barocci's artistic style. Nor were these insights solely those of Baglione or retrospective understandings developed during the Seicento. Other, earlier sources clarify that the cultivation of *vaghezza* in painting was ever more valued during the sixteenth and early seventeenth centuries; that it was both challenging and compelling to join it with the devout in religious painting; and that it was used with specific reference to Barocci's painting at least as early as the 1590s. On October 5, 1596, Matteo Senarega wrote Barocci to congratulate him on the completion of the *Crucifixion* for the Senarega chapel in Genoa Cathedral (see fig. 104). Bellori reproduced the letter in his *Vita* of 1672. While its flowery language and use of some art critical terminology might lead one to assume that the text is Bellori's invention, Michael Bury's discovery of the original in archives in Genoa both confirms Bellori's integrity in this instance – his transcription is virtually identical to the original – and offers a remarkable example of how a major Barocci altarpiece might be described by a sensitive patron. Senarega's assessment deserves to be quoted in full:

> To the very Illustrious Signor Barocci, Painter in Urbino:
> This painting has but one defect: because it has something of the divine, human praises cannot reach it. Therefore it lives wrapped in silence and awe. The most holy Crucified One, although appearing to be already dead, nevertheless breathes life and paradise to us, demonstrating what was in effect the case, that he willingly of his own consent suffered death, out of love for us, and for the well-being of all. The *dolcezza* of the Virgin Mother is so great that at a single glance it wounds and heals, inspires compassion and consoles, and indeed it appears as if the divine spirit deep within the wounds of Christ enters her to know if it must pierce her again with the death of her beloved son or restore to her the salvation of the human race. Thus, driven by diverse feelings, filled with wonder [*stupore*] and holy pity [*pietà*], she abandons herself in her new son [Saint John the Evangelist] who, moved tenderly by wonder and charity, also responds to her. In Saint Sebastian one sees expressed the true colors and proportions [*numeri*] of art, to a degree that perhaps the ancients never attained, much less the moderns; and as a whole, the work is so rich in artifice and *vaghezza* that it does not leave room for anything but a desire to imitate it. And these holy

angels, how they too express vivid feelings of wonder and pity! I repeat and confess how, like something divine, the painting enraptures [*rapisce*], divides, *dolcemente* transforms.[51]

This remarkable letter foreshadows Baglione's discussion in striking ways. Barocci's style is described as *dolce*, as "rich" in *vaghezza*, as full of art but also of devotion. The work instructs, yet also enraptures (one of *vaghezza*'s principal effects) and transforms. One senses viscerally how Barocci's achievement was beginning to be understood and celebrated through the valences of a cluster of terms, with *vaghezza* and *devozione* at their core. Barocci's triumph in the eyes of his contemporaries was not so much that he exhibited an interest in *vaghezza* – this was in any case increasingly considered *de rigueur* – but that he cultivated a *maniera vaga* as his signature style with such commitment and success. While other painters might be more or less *vago* in manner in particular works, and more or less outstanding as painters, Barocci was nearly alone in creating a manner that was always *vago*, and *dolce*, and artistically excellent – and successfully joined with the *divoto*.

At virtually the same time as Seneraga drafted his remarkable letter to Barocci, Antonio Talpa concluded that an archaizing representation of the *Madonna della Vallicella* framed by a glory of angels in modern style would "make a composition that is *vaga* and . . . *devota*."[52] In fact, one can trace the roots of this pairing of qualities, which Barocci's period perceived as so difficult yet essential and which Baglione later employed to encapsulate Barocci's achievement, back into the fifteenth century: in other words, to a period near the origins of the perceived triumph of newly powerful naturalistic styles in painting. It may prove useful in conclusion to consider the historical and critical roots of the tense marriage of the *vago* and the *divoto*; only thus will the full implications of the parameters within which Barocci's religious paintings were discussed and understood in early modern critical discourse emerge.

A late fifteenth-century antecedent of Baglione's characterization of Barocci's style may be found in Cristoforo Landino's assessment of Fra Angelico, touched on earlier. In a dense paragraph in the introduction to his commentary on Dante's *Divine Comedy*, Landino sums up the talents particular to a variety of the great Florentine painters. The first two terms he uses to describe the work of Fra Angelico are *vezzoso* and *divoto*. In a fundamental discussion of Landino's text, Michael Baxandall in 1972 illustrated the multivalent nature of *vezzoso* with reference to John Florio's Italian–English dictionary of 1598, the first of its kind. Florio's choice of English words to translate the Italian term ranges from "wanton," "blithe," "coy," and "pleasant" to "pert" and "full of wantonesse."[53] All this makes *vezzoso* sound remarkably like a precursor of the Cinquecento's

preferred *vago*; indeed, the first definition of *vezzoso* offered in the *Vocabolario* of 1612 identifies the word with "that which has in itself a certain grace and is pleasing." The Latin synonyms of *venustas* and *elegans* are identical to those chosen for the definition of *vago* that related it to *grazioso* and *leggiadro*, and the quotations are from Boccaccio: the first, in which young ladies are hailed as *vezzose donne*, makes the relation of the words clear enough.[54] It is possible that *vezzoso* could be employed as a relatively mild synonym for *vago*; in any case, Landino's characterization of the art of Fra Angelico as both *vezzoso* and *divoto* might be said to have created a kind of template to describe that rare sort of artist who combined real piety with the sensuous naturalism that modern achievements in painting made possible. Furthermore, as Baxandall proceeded to demonstrate, *vezzoso* was associated particularly with coloring by Alberti.[55]

When he turned to analyze Landino's understanding of *divoto*, Baxandall produced a literary parallel of considerable interest through the investigation of sermon styles. A Quattrocento preaching treatise noted that:

> There are four styles of preaching . . . the first style is more keenly exact [*subtilis*] and is for men who are wise and expert in the art of theology. . . . The second style is more easily accessible, and is for people newly introduced to theology. . . . The third is more elaborate, and is for those who want to make a display. As it is unprofitable, it should be avoided. The fourth style is more devout and is like the sermons of the saints which are read in church. It is the most easily understood and is good for edifying and instructing the people . . . The fathers and holy doctors of the Church, Saint Augustine and other saints, kept to this style. They shunned elaboration and told us their divine inspirations in one coherent discourse.[56]

Paired with the crucial element of artistic *vaghezza*, such a concept of the *divoto* accords perfectly with Barocci's religious narration. His *istorie* are like sermons, easily understood. They also, through his cultivation of *vaghezza*, appeal powerfully to the emotions, and reveal "divine inspirations" through the power of artistic visualization.

Barocci's images obviously appear immensely different from those of Fra Angelico. It could be assumed, therefore, that the apparent congruence of critical terms has little relevance, but this would be to miss the discovery of a remarkable cohesion, over a period of two hundred years of art critical discourse, of qualities considered most appropriate to excellent religious painting. These qualities were perhaps put into words after Fra Angelico's death. Yet the terms used by Landino to characterize the Frate's art, and their synonyms, seem to have set a

touchstone of expectation for a certain kind of painting that was still current in the age of Baglione. Even Vasari – usually perceived as no lover of "devout" painting – was entranced by a few works of Fra Angelico. In general, Vasari seems to have been suspicious of the "sweetness" of the so-called *maniera devota* painting of about 1500, practiced by Perugino, Francia, the young Raphael, and others, which forms a link between the lovely yet pious naturalism of Fra Angelico and Barocci's style.[57] A passage from the *vita* of the conservative Florentine painter Sogliani is typical. Vasari describes Sogliani as "a person full of religion" and writes: "His death caused great sorrow, for he was a good man, and because his style much pleased, with its pious air, such that it pleased those who, without delighting in the labors of art and in bravura passages, loved respectable, simple, *dolci*, and *graziose* things."[58]

The "simple" *vaghezze* of Sogliani's painting were not for Vasari those of true art, but he felt compelled to admit that the case was different for Fra Angelico. Vasari was lured into love of panels by the Frate almost against his will. While he never used the term *vago* to describe Fra Angelico's style, Vasari twice mentioned that Angelico's painting had the quality of so enrapturing beholders that they could not stop looking. He claimed that some small figures in a "heavenly glory" in an altarpiece predella "are so beautiful that they seem truly in paradise, and one cannot, once one has noticed them, stop looking at them."[59] Vasari also admitted having been stunned by the *Coronation of the Virgin* which he saw in San Domenico in Fiesole (fig. 121), in which:

> Jesus Christ crowns Our Lady in the midst of a choir of Angels and an infinite multitude of Saints, so many in number, so well-crafted and with such varied expressions and diverse airs, that one senses incredible pleasure and sweetness in looking at them . . . for all the Saints that are there are not only alive and with delicate and sweet airs, but all the coloring of that work seems to be by the hand of a saint or an angel . . . and I for myself can in truth affirm that I never see this work without it appearing to me a new thing, nor do I ever part from it satiated.[60]

Such an assessment seems close to Baglione's sense of the effect of the conjunction of the *vago, e divoto* in Barocci – and to San Filippo Neri's experience of ecstasy before the *Visitation*. All is sweetness, heavenly light, fine technique, marvelous coloring, and the experience of an image that asks one to keep looking, to keep contemplating, to be caught up in wonder and devotion at each viewing, and never to tire of returning to look again. Barocci's means – *sfumato*, shifting stylistic modes – are often distinct from those of Fra Angelico but the connections in the language of critical discourse may be more than coin-

121 Fra Angelico, *Coronation of the Virgin*, c. 1450, tempera on panel. Paris, Musée du Louvre.

cidental. Another aspect of the period appreciation of Barocci's fusion of the *vago* and the *divoto*, of modernity and tradition, may be the manner in which the very words of criticism implicated him not only as a new Raphael, as a *grandissimo imitatore* of Titian, as a follower of Correggio, but also, at least implicitly, as a new Fra Angelico for a new age. Indeed, while I know of no explicit period comparison between the two painters, Fra Angelico was enjoying renewed fame in the second half of the century, particularly in reform circles. Beyond Vasari, Gabriele Paleotti employed him as an example of a painter of devout life and mind, whose work reflected his interior state,

and Pius v commissioned Bartolomeus Spranger to copy one of Angelico's representations of the *Last Judgment* – a telling choice, given the presence of Michelangelo's version in the pope's own chapel.[61]

This fusion of the *vago* (or *vezzoso*) and the *divoto* that Landino perceived as Fra Angelico's achievement was realized anew in the work of Barocci, at a time when it was considered both essential and "difficult to do well, and with dignity." It is surely this achievement that underlay the amazement Baglione recorded in artistic circles in Rome at the unveiling of the *Visitation*. In addition, Baglione may have accomplished

something more than recording a period perception of Barocci's achievement; he may have registered something of the painter's own purposes. Barocci's paintings are so well calibrated to the expectations encapsulated in such praise that he seems to have labored self-consciously to exemplify such qualities in his work, thereby to enrapture his beholders into the pure love of devotion. As Pietro Bacci writes of San Filippo Neri, when the saint sat down in a small chair to pray before the *Visitation*, "he was ravished, without realizing what was happening, into the sweetest ecstasy."[62]

Figures of Vaghezza

THE ALLURE OF FIGURES AND THE DESIRING BEHOLDER

Ancient narratives that describe the triumph of pictorial illusionism as an ability to deceive the eye (such as Pliny's stories of the grapes of Zeuxis and the curtain of Parrhasios) are often presented as the fundamental touchstones for Renaissance thinking about representation. Yet these formed only one of the discourses through which the development and achievement of the arts was discussed, analyzed, and celebrated during the period. Another critical discourse – to which the first was in fact intimately linked – was that of affect, of desire. Here, Pygmalion and the statue that responded to kisses (albeit only after the intervention of a goddess) was the story that spoke most compellingly of the conquest of nature in form; a marble come to loving life was both more mimetically potent and more alluring than grapes that attracted hungry birds or a fictive curtain that piqued a painter's curiosity. This discourse of affect was also deeply engaged with questions of origins and of ultimate purpose and it located the origins of representation in the passionate attempt to fix and hold the image of the beloved. Whether it was Pliny's tale of the young woman who traced the profile of her departing lover on a wall or Alberti's location of the birth of painting in the story of Narcissus, the

origin of art was perceived to be bound up with the desire to hold onto the presence or perfection of the mortal beloved.[1] This perception inevitably placed the representation of the body at the center of artistic striving, and with it the fraught question of whether the visual arts could also represent spirit and soul. From Pygmalion's prayers to Venus, through Petrarch's frustrated poetic longing for Simone Martini's *Laura* to speak and Donatello's imprecation to an unfinished sculpture – "Speak, damn you, speak" – to Anton Francesco Doni's assertions that Michelangelo's *Dawn* and *Night* in the Medici Chapel ravished viewers with their beauty and indeed at times came to life, stupefying and briefly "petrifying" human admirers, the leitmotif of the power of the naturalistic image of desire and its affective potential runs like a silver thread through Renaissance criticism. The desiring beholder is crucial in such discourses, and indeed, Elizabeth Cropper has argued that this figure stands near the center of the practice and theory of painting in sixteenth-century Italy.[2]

Cropper focuses on the figure of Lodovico Dolce and his remarkable assessment of the achievements of Raphael and of Titian. However, it is often assumed (though not by Cropper) that Dolce and in a different milieu Vasari represent the ultimate valorizations – ultimate in time as well as quality – of the achievements of the *terza maniera* in central Italy and Venice

before the strictures of the post-Tridentine decades. Yet the idea (and ideal) of the image as an object and product of desire had become entrenched by mid-century, as had the centrality of the ideally lovely body as a critical topos for representation; it is remarkable how potent elements of this cast of mind remained during the post-Tridentine years. Their persistence is nowhere clearer, perhaps, than in the *Avvertimenti* of the early 1580s that Ulisse Aldrovandi addressed to Cardinal Gabriele Paleotti. Paleotti had specifically requested that Aldrovandi and others whose opinions he respected comment on a draft of his *Discorso intorno alle imagini sacre e profane*, his reflections on the current status and the potential directions for religious painting. The common assumptions concerning Paleotti's treatise and its moralizing positions are too well known to rehearse here. Some will be queried later; it is essential to bear in mind, however, John Shearman's reminder that ecclesiastical theorists such as Gilio and Paleotti were well educated and more sophisticated than is often imagined.[3] Yet given the obvious fact that, whatever his sophistication and level of culture, Paleotti was a reforming churchman with pedagogical and liturgical aims for painting, some of Aldrovandi's comments seem extraordinary. Paleotti's demand that religious images be affecting, for instance, was vigorously supported by Aldrovandi, but the manner in which the eminent scholar advances his arguments is arresting and deserves to be quoted at length:

> Your most illustrious Lordship illustrates very wisely the varied and diverse effects that can be caused by pious and devout images. Concerning this issue, therefore, I will not hesitate to tell you of that statue of the Cnidian Venus, formed of Parian marble, which was placed in its temple . . . and was so beautiful that it drove Caricle virtually insane, seeing that he exclaimed upon seeing it: 'O Mars, most fortunate among the gods . . . !' and running [to the statue] he kissed it with his lips, extending his neck upwards as far as he could. And driven mad by the beauty of this statue, he remained all day long in that temple; as soon as he would awake he would run to [the sculpture], and every hour his love for this beautiful and gracious statue burned more intensely. And if a statue of uncolored marble had this effect, what should works do that are colored and painted in life-like fashion?[4]

While he perhaps wisely neglected to mention the "stain" that the young man was said to have left on the statue as an ultimate testimony to his obsessive love, it is striking that Aldrovandi decided to illustrate the affective power that an image – and in particular a religious image – should possess by reference to the Cnidian Venus. Aldrovandi's tone is open to interpretation; he might have been teasing an ecclesiastical

friend whose tolerance he trusted. Yet whatever his exact intention, the assumptions that underlie his eagerness to remind the Cardinal of the Venus of Cnidas constitute a potent reminder of just how ingrained such ideals of the affecting power of the image had become by the late sixteenth century.

The peculiar context of Aldrovandi's text is also a visceral reminder of the minefield that ambitious artists were increasingly forced to negotiate by the 1570s and 1580s. On the one hand, successful images had to possess the alluring power of the Cnidian Venus; indeed, modern paintings should be able to ravish viewers with even greater force than the most beautiful ancient sculptures, given the newly perfected prowess painters such as Titian could bring to the representation of sensuous color and the softness of flesh. In fact, in his encomium of the unique affecting powers of modern painting, Aldrovandi seems possibly aware of some passages from Dolce, perhaps even the remarkable *ekphrasis* of Titian's *Venus and Adonis* for Philip II (see fig. 118) in Dolce's published letter to Alessandro Contarini: "if a marble statue could, with the shafts of its beauty, penetrate to the marrow of a young man so that he left his stain there, then what should this figure do which is made of flesh, which is beauty itself, which seems to breathe?"[5] Dolce aggressively highlights the sensuous charge evoked in Aldrovandi's slightly more restrained phrasing. On the other hand, Christian paintings – the production of which continued to occupy most of the energies of most painters during the late sixteenth century – must fuse this alluring power with impeccable piety and devotion, in forms that carry no hint of the "lasciviousness" that characterized the sensuous appeal of the ancient pagan cult object.

From the unveiling of Michelangelo's *Last Judgment*, the gravity of this double bind for modern art had been clear. By the time Aldrovandi wrote his *Avvertimenti*, the issue had become both pressing and pervasive enough that it forms one of the leitmotifs of Raffaello Borghini's *Il Riposo* of 1584 – perhaps the most significant, and certainly the most extensive, work of art criticism to emerge in Florence in the wake of Vasari. *Il Riposo* has been relatively marginalized in most modern historiography as a culturally conservative and intellectually derivative work.[6] The positions articulated by the interlocutors, however, offer some of the clearest extant presentations of the extraordinary challenges artists faced in the late sixteenth century. As Borghini's characters discuss works on view in the major churches of Florence, they return again and again to the paintings of Bronzino. Repeatedly, they conclude that while these are often (if not always) impressive artistically, they as often fail in their religious function because of "lasciviousness" in the depiction of particular bodies. Bronzino sought to be a master of the nude in the great Florentine tradition,

specifically (though not exclusively) in the tradition of Michelangelo and of Pontormo – whose infamous frescoes in the choir of San Lorenzo (now lost), as full of nudes as Michelangelo's *Last Judgment*, are subjected to particularly vicious criticism.[7] Yet the situation with Bronzino is complex: his figures are sometimes simply so beautiful, so "ravishing," that they compel admiration in spite of their indecorousness.

When the group considers Bronzino's altarpiece of *Christ in Limbo* in Santa Croce (fig. 122), for instance, Michelozzo – who is cast as a relatively inexpert yet perceptive and critical viewer – commences unabashedly: "before the panel of Bronzino . . . I feel the greatest pleasure in admiring the delicate members of those beautiful women." He is immediately reproached by Vecchietti – the host and in some respects the most conservative member of the group:

> We have already discussed . . . how incorrect sacred figures are when made so lasciviously. Now I will say to you in addition that they are out of place not only in the churches, but in any public place, for they give a bad example, and induce vain thoughts: and the artists who have made them repent with contrite hearts in old age, as the sculptor Bartolomeo Ammannati clearly confesses in a printed letter to the members of the Accademia del Disegno, in which he says that he did badly to have made many statues nude, and declares himself without excuse, but asks God for pardon, and warns others not to fall into such a grave error. And how little Bronzino merits praise in this work, you yourself have shown by admitting that you delight in looking at those lascivious women . . . ; considering the softness of their members, and the *vaghezza* of the faces of those young women, one cannot help but feel some carnal stimulation, which is completely contrary to what one should experience in the temple of God.[8]

It is no coincidence that *vaghezza* appears here as a quality of compelling representations of beautiful figures – Vasari's "young men or women a little more *vaghe* than usual" (or, in the case of Bronzino's altarpiece, a good deal more *vaghe* than usual). Indeed, its power is recognized trenchantly by Vecchietti: if one looks at this picture, he says, one cannot help but be allured by the softness and *vaghezza* of these figures. This is, in fact, exactly the difficulty; modern art claims such powers of compulsion, but in exercising them through the allure of sensuous figures it compromises its status as a vehicle for the representation of Christian mysteries.

Nonetheless, the degree to which figural *vaghezza* retained its power even in the 1580s is emblematized by the fact that Vecchietti's harsh reproof does not prevent Michelozzo from returning to his theme a few pages later in a particularly strik-

122 Bronzino, *Christ in Limbo*, 1552, oil on panel. Florence, Santa Croce.

ing fashion. The group has admired two altarpieces by Santi di Tito, who is usually considered among the principal "reform" painters of Florence in modern art historiography. Indeed, in *Il Riposo* Santi repeatedly figures as a paragon of devotion and *honestà*, and Vecchietti praises both altarpieces "for the observation of the sacred history, for their [quality of] *honestà*, and for the things that belong to the painter, which are well managed." Vecchietti here succinctly lays out the critical areas in which the modern painter of religious images must succeed, but what exactly were the parameters of "the things that belong to the painter?" A discussion of Santi's *Resurrection* (fig. 123) reminds Michelozzo of the *Resurrection* by Bronzino in Santissima Annunziata (fig. 124), and he derails the moralizing discourse by interjecting: "having spoken of the Resurrection has made me think of a painting by Bronzino in the Annunziata which depicts this mystery." Vecchietti immediately attempts to forestall this association: "Let us please not speak of that . . . because it contains an angel that is so lascivious that it is an indecorous

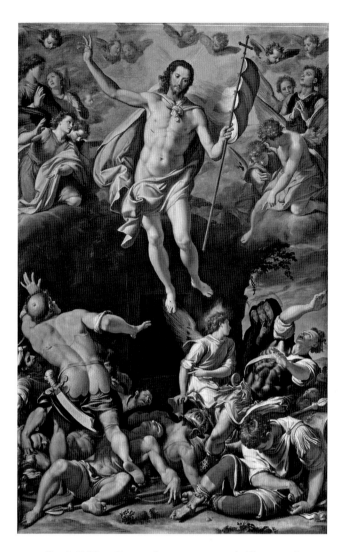

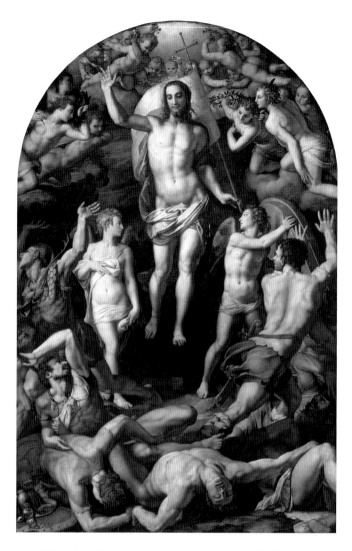

123 Santi di Tito, *Resurrection*, c. 1574, panel. Florence, Santa Croce.

124 Bronzino, *Resurrection*, 1549–52, oil on panel. Florence, Santissima Annunziata.

thing." It is hard to be sure to which figure he refers, as both angels that flank the risen Christ exhibit the beauties of youthful bodies, but he probably indicates, as will be seen, the androgynous angel to the viewer's left, who stands passively and alluringly in a *Venus pudica* pose. Michelozzo reluctantly defers to Vecchietti but not before making a bold statement: "if I had such a beautiful figure in my house . . . I would admire it very much, and hold it dear as one of the most delicate and soft figures one could see . . ."[9]

Michelozzo's appeal to what might be termed a "decorum of place" allows him to admire Bronzino's figure while sidestepping the issue of its appropriateness in a religious setting; he ripostes deftly here to Vecchietti's earlier insistence that "lascivious" figures were inappropriate "in any public place." However, the problem was not so simply resolved, as Borghini was evidently aware.[10] In the development of *Il Riposo*, despite his putative conservatism, Borghini did not let the issue of the

appreciation of figural *vaghezza* drop, even in discussions of religious paintings displayed in churches. Some eighty pages after Vecchietti's condemnation and Michelozzo's implicit acknowledgment that the angel in Bronzino's *Resurrection* might be more appropriate in a private and domestic setting than in a church, the group comes round to the *Christ in Limbo* once more. This time Sirigatti, who generally offers positive yet sober comments on works of art, maintaining an "aesthetic distance" that Michelozzo often collapses, takes up the theme that Michelozzo had first laid out: "I now turn to the panel of Bronzino representing Christ in Limbo, in which I see the most beautiful arrangement, gracious attitudes, the members [of figures] well understood, *vaghissimi* colors, beautiful flesh painting, heads very well done and drawn from life, and everything very well studied, and done with great art."

Here Sirigatti offers somewhat different and more technical emphases than had Michelozzo; the stress on the colors as

exemplifying *vaghezza* is critical and this displacement of focus from figures to more purely pictorial qualities will be assessed in some detail in Chapter Eight. Nevertheless, Sirigatti still praises the beautiful painting of flesh and the "members" of the figures that had excited Michelozzo. The interlocutors may be imagined as looking at Michelozzo at this point, for he immediately and demurely replies, "I don't have anything to say about this . . . except that I see Messer Baccio takes great delight in admiring it, even as I too consider it beautiful and *vaga* to behold." Michelozzo had been criticizing works fiercely for artistic faults in the preceding passages, so his very opening, the coy "I don't have anything to say . . . except," already implies a strong endorsement of Bronzino's painting. Baccio Valori, the savant of the group, admits that he had been considering the painting with great pleasure but offers what Michelozzo himself later identifies as a "platonic" assessment: "I delight in regarding those beauties . . . which were given to us by the great giver of all good things . . . But don't hesitate to offer your opinion, if you have anything to say against such beautiful things."

Valori in essence offers a variation of the position sketched out in Vasari's defense of contemporary painting in his *vita* of Fra Angelico: "But I would not wish that anyone misunderstand, interpreting the awkward [*goffo*] and inept as devout, and the beautiful and good as lascivious, as some do, who, seeing figures of a young woman or of a young man which are a little more *vaghe* . . . than ordinary . . . judge them lascivious, not being aware that they very wrongly condemn the good judgment of the painter, who holds the Saints, who are celestial, as much more beautiful than mortal nature even as [the beauty] of heaven surpasses earthly beauty . . ."[11] Michelozzo, however, while insisting on his appreciation of Bronzino's painting, undercuts the status and even the possibility of maintaining Valori's position: "I like your platonic opinion . . . and if everyone could look with such intention, it would never be necessary to make sacred pictures differently; but I don't know how this continence and holy thinking will work for others, or if it does, how long it can last in looking at things that so stimulate the senses." At this point Vecchietti once again interposes himself to redirect discussion, dismissing Michelozzo's leading question with "Let us not stray from our straight path . . . as the way remains long and time is brief." With that, he turns the group's attention to the *Resurrection* by – predictably – Santi di Tito.[12]

Michelozzo has unceremoniously exposed the difficulty of holding a "platonic" understanding of Bronzino's painting but, as he had already pointed out and just reminded his friends, this does not lead him to condemn the painting or enjoy its beauties the less. Certainly, Borghini casts Michelozzo and Vecchietti as representatives of two poles among possible late sixteenth-century responses to *terza maniera* religious painting.

Yet his foregrounding of just these extremes highlights the tension that many viewers felt between desire and devotion in looking at modern altarpieces, a tension that recourse to ideals of "platonic" looking could not entirely resolve. While Borghini is often seen as a conservative and wrote after Trent's unequivocal declaration – one of very few the fathers issued concerning visual art – that "all forms of lasciviousness are to be avoided," he himself may not have been entirely convinced by Vecchietti's "Tridentine" positions. Borghini devotes the third and fourth books of his treatise to a vast assemblage of lives of artists both ancient and modern, recounted by Valori, Vecchietti, and Sirigatti (though with extensive reference, whenever possible, to Pliny or Vasari). Sirigatti narrates the lives of a group of modern artists that includes Bronzino. His discussion of Bronzino's achievement – uncontested by the other members of the group – effectively stands as the dialogue's last word on the subject. Among the works Sirigatti chooses to highlight are the *Christ in Limbo* and the *Resurrection*. He celebrates without condemnation the "many beautiful nudes, both male and female" in the *Christ in Limbo* and praises the painting as "done in a beautiful style, with good *disegno* and *vago colorito*."[13] He immediately proceeds to consider "the panel of the Resurrection of our Lord . . . in which one sees an angel of remarkable beauty." As Maurice Brock has recently noted, Sirigatti's next sentence is "In the house of Jacopo Salviati is a picture by him of Venus with a satyr, a very beautiful painting." Sirigatti thus implicitly equates the artistic qualities and ambitions of an altarpiece with those of a private mythological painting and does not insist on a "decorum of location" or condemn the angel in the Annunziata altarpiece.[14]

Indeed, this angel seems to have achieved a sort of cult status among *cognoscenti* in late sixteenth-century Florence. It is also celebrated without equivocation – with its pendant figure – in Francesco Bocchi's 1591 *Le Bellezze della Città di Fiorenza*, a guidebook written by a local luminary with numerous contacts with reform circles in the post-Tridentine decades. The following year Bocchi published the *Opera . . . sopra l'imagine miracolosa della Santissima Nunziata*, which represents a critical moment in the revaluation of the *primitivi* and an important document of retrospective leanings in late sixteenth-century ideals of religious art. In the *Opera*, Bocchi goes so far as to conclude that the late medieval *Annunciation* venerated in Santissima Annunziata surpasses the works of both Michelangelo and Raphael in what could be termed "the beauty of holiness" (fig. 125).[15] Bocchi rationalizes this inversion of the standard period notion of artistic development by asserting that the *Annunciation*'s most beautiful element, the head of the Virgin, was painted by angels as the human artist slept. Further, in assessing the implications of his assertion, it is important to

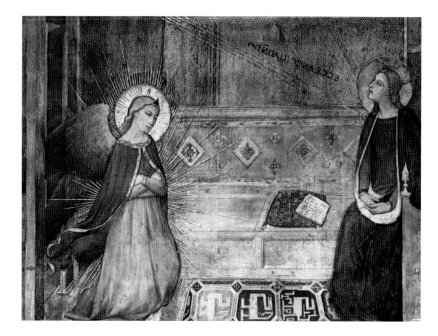

125 Anonymous Florentine, miraculous image of the *Santissima Annunziata* (detail), c. 1340, fresco. Florence, Santissima Annunziata.

understand that Bocchi's Florentine *campanilismo* was great and the venerated image in the Annunziata perhaps the quintessential sacred image of the city. In his 1971 introduction to a facsimile of Bocchi's guide to Florence, John Shearman stressed the author's wide-ranging taste and literary culture, and concluded that the *Opera* "is much more obviously a Counter-Reformation document" than *Le Bellezze . . . di Fiorenza*. Nonetheless, it may come as a surprise – at least to our age – to read Bocchi's comments in the guide to Florence concerning Bronzino's *Resurrection*, an altarpiece that stood in the choir of Santissima Annunziata itself, virtually in sight of the holy image. After describing the figure of Christ ("painted with dignity, and colored in a delightful, soft, and sweet manner"), Bocchi proceeds: "Two angels are praised and admired, as they are of the most beautiful appearance; one of them raises the stone of the sepulcher with a gracious movement, and the other, as is fitting, is of a rare beauty, as appropriate to his truly angelic nature."[16] This second angel, singled out for his "rare beauty" as he stands in a pose akin to that of the Cnidia, seems to be the one that entranced Michelozzo and Sirigatti and scandalized Vecchietti.

Bocchi implies that viewers may appreciate the figures from a "platonic" perspective as he stresses that their overwhelming beauty is "fitting" and "appropriate" to their angelic nature. As already seen, however, Borghini's Michelozzo questions the possibility that ordinary mortals might hold such ideal positions consistently. The "proper" appreciation of figural *vaghezza* in religious painting depended on the presence of ideal viewers

with the philosophical and theological equipment – and the personal devotion – to maintain with Saint Paul that "to the pure, all things are pure." As Michelozzo indicates, this ideal was far from the experience of the "ordinary" viewer, even among the most educated class. As Sirigatti's final encomium to Bronzino and Bocchi's celebration of the angels in the *Resurrection* equally demonstrates, however, the appreciation of figural *vaghezza* remained a powerful element in the sophisticated reading of images even after Trent's demand that "all lasciviousness is to be avoided" and even among viewers sympathetic to ecclesiastical reform.

FIGURES OF INNOCENCE – *PUTTI* AND CHASTENED *VAGHEZZA*

For the painter (and the viewer) the possible paths out of this minefield seem to have been arduous and poorly marked. An effective synthesis of *vaghezza* and *devozione* was, as already stressed, considered extremely difficult in the period and yet increasingly deemed necessary. The potential resolutions that could be perceived at the time were varied and incomplete. Some of the most interesting approaches privileged the displacement of *vaghezza* in painting from figures to more pictorial aspects such as color and facture; Barocci's employment of these will be the focus of discussion in the following chapters. Nonetheless, the need for artists to demonstrate their command of the figure remained – even Titian's art was one of figures, as Dolce's dialogue states repeatedly in its *paragone* of the skills of the great Venetian with those of Michelangelo – and the problem of figural *vaghezza* continued to haunt painting and sculpture well into the seventeenth century. Dolce offered one important option in his encomium of Barocci's compatriot Raphael in the *Aretino*. In contrast to the impropriety of Michelangelo's Sistine nudes, Dolce's Aretino asserts,

> the upright Raphael always maintained . . . decency in all of his creations. As a result, even though he generally gave his figures a soft and gentle air which charms one [*invaghisce*, the effect of *vaghezza*] and sets one on fire, he nonetheless invariably preserved, on the faces of his saints and above all on the face of the Virgin Mother of Christ, an indefinable quality of holiness and godliness (and not only in the faces, but also in each and all of the movements) – a quality which seems to remove every illicit thought from the minds of mankind.[17]

Such thinking might well have been of import to Barocci in his attempt to reclaim the achievements of the "High Renaissance" – particularly those of that other great master of painting from Urbino – for a new age. Indeed, figures such as

the Magdalen in the Senigallia *Entombment* (see fig. 83) might be said to possess the alchemical mixture of properties Dolce admires. Nonetheless, the strategies behind Raphael's difficult achievement remain little defined, and the nature of his ability to create "figures of *vaghezza*" that "set one on fire" while maintaining an "indefinable" quality of holiness seems as indefinable as the achievement itself. It is telling that Dolce's celebration of this holy *non so che* in Raphael's sacred figures relates not merely to the censure of Michelangelo in the Sistine, but is placed close to what verges on a defense of the erotic drawings that Marcantonio Raimondi engraved in *I Modi* (probably 1524). Immediately after the passage being considered, meanwhile, the figure of Aretino, having offered a few additional criticisms of Michelangelo, turns to celebrate Raphael as a master of mythological paintings and the lovely nude. In Dolce, *vago* figures of beautiful adults seem ultimately resistant to dissociation from the mythological, the nude, and the "profane," highlighting how the creation of figures at once *vago* and *divoto* remained a serious artistic and cultural challenge. A partial response to this challenge, however, and one important for Barocci's art, depends on what is perhaps a surprising maneuver: the replacement of the ravishing adolescent angels favored by painters such as Bronzino in the Annunziata *Resurrection* with putti and children.

During the late sixteenth century, representations of nude children constituted a site in which the portrayal of the body and the softness of flesh could be pursued without great risk of generating the lascivious thoughts that might be provoked by adolescent or adult beauty. Even Gilio, in the midst of his attack on the indecorousness of figures in Michelangelo's *Last Judgment*, is unequivocal on this point: "Thus I say that, if we see those [private] parts in little children, we are not scandalized, given the innocence and purity of [young children], without malice and sin . . . But if we see [such things] in men or women, shame and scandal arise." He was echoed by the ecclesiastic Rinaldo Corsi in a sermon (around 1570), recorded in a manuscript in Bologna, that is couched as a "Discorso sopra l'onestà delle Imagini." Corsi is polemical enough to structure his argument around three pairs of antitheses: God–Devil, salvation–perdition, clothed–nude. Even so, "little boys" (*putti*) may be represented nude, for in them "the gift of innocence serves as an ample and rich ornament."[18]

That the depiction of the unclothed limbs and pink flesh of putti could generate a form of figural *vaghezza* – even while remaining "innocent" – seems attested both by the employment of such figures in countless altarpieces and by a number of comments in period criticism. Bocchi, for instance, just after describing the loveliness of the two adolescent angels in Bronzino's *Resurrection*, continues: "At the top one sees a Choir of little

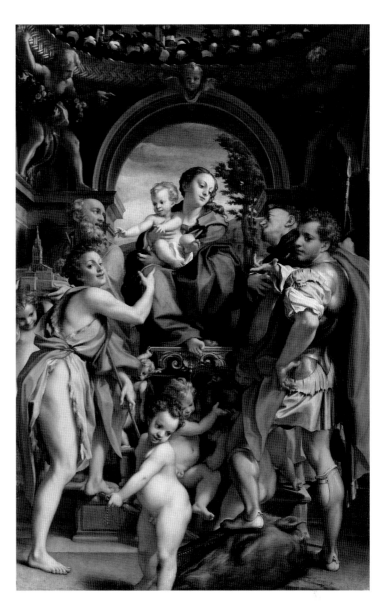

126 Correggio, *Madonna of Saint George*, before 1530, oil on panel. Dresden, Gemäldegalerie.

angels [*Angeletti*] that approach the Savior, enflamed by happiness, and by a singular *vaghezza*." The upper portion of the altarpiece contains two groups of angels. In the lower group are four angels who are just a little younger than their striking counterparts below, and perhaps right on the cusp of the age at which the innocence of the child's body, as described by Gilio, gives way to the proto-adolescent who could be an object of desire, particularly in period homoeroticism.[19] The group "at the top," however, is composed exclusively of joyous putti.

In the seventeenth century, Francesco Scannelli echoes and elaborates such perceptions in a remarkable encomium on Correggio's putti in the *Madonna of Saint George* (fig. 126). While he notes the beauty of the adolescent Saint John who is "in large part unclothed, according to custom" (John actu-

ally appears moderately clothed but is posed so as to display the full length of his leg), Scannelli lavishes particular attention on the putti in the scene. The *angeletto* who hands Saint Jerome the model of the city of Modena "manifests a stupendous beauty," while Correggio's genius excels itself in the "capricious game" the foreground putti play with the armor of Saint George, an invention "that can never be praised enough." He concludes:

> They are all expressed with such rare truth to life, formed as if with palpitating and living flesh, that they forever stand as a sure compendium of the most exquisite beauty, and I believe that one can also say with every reason that these figures contain in their excellence both the perfections of ancient and of modern art, and cannot be viewed by artists and connoisseurs of painting without generating varied effects of stupefaction . . .[20]

Thus Scanelli regards Correggio's putti as not only "living" creatures of "palpitating flesh" but also as a "compedium" of "all the perfections" of ancient as well as modern art. He had noted earlier that the game of the putti with the armor of Saint George reminded him of a painting particularly praised in antiquity, in which two putti were represented in such a way that they demonstrated to viewers "their innocence and simplicity, appropriate to their action and their age."[21] What is critical here is the implication that the figure of the putto could become a privileged site both for the painting of soft flesh in the manner of Correggio or Titian and for the display of a painter's profound grounding in the art of antiquity – in which, after all, the putto had played a significant role. For a painter of altarpieces in an ecclesiastical culture increasingly inflected by pronouncements such as those Gilio leveled against Michelangelo's adult nudes, the figure of the putto angel became a new kind of sign of art; it was a figure of innocence, but one in which both "the antique, and modern perfections" might be embodied.

It is striking how often Barocci displays nudity principally through the representation of putti rather than adolescents or adults. This tendency is particularly noticeable in his distinction between types of angels. While Bronzino or Michelangelo might depict largely nude adolescents as angels, Barocci always presents putto angels nude or seminude, and adolescent or adult angels largely or completely clothed. In this respect his practice is similar to that of a reform painter such as Santi di Tito; it has been noted that Santi never included nudes in his religious paintings, with the exception of putti and infants.[22] The care with which Barocci maintains such distinctions in his works is pervasive enough that – particularly given the cultural discourses operative from at least the 1560s – it may indicate a deliberate strategy in his pursuit of *vaghezza* in the angelic

figure. Further, while many painters employed *angeletti* and *angeli* within the same picture, Barocci often chose to represent only one type in any given image. A survey of his principal mature works reveals that the two sorts of angels mingle only in the *Madonna del Popolo* (see fig. 24), the *Madonna of the Rosary* (see fig. 62), and the late, unfinished *Assumption of the Virgin* (see fig. 115). Nude putti are privileged in the *Martyrdom of Saint Sebastian* (see fig. 128), the *Holy Family* in the Casino of Pius IV, the Urbino *Crucifixion* (see fig. 12), the *Madonna of San Simone* (see fig. 177), and the *Martyrdom of San Vitale* (see fig. 143); they return to dominate later altarpieces such as the Vallicelliana *Presentation of the Virgin* (fig. 127) and the Roman version of the *Institution of the Eucharist* (fig. 130). Meanwhile, adolescent clothed angels are the heavenly intermediaries in paintings such as the *Circumcision* (see fig. 133), executed for a confraternity in Pesaro, and the *Last Supper* for the Sacrament Chapel of Urbino Cathedral (see fig. 134).

I offer this list (incomplete but representative) because I wonder if a pattern may not be discernible in it, not systematic, perhaps, but nonetheless deliberate. It is striking that nude putto angels are privileged in a cluster of paintings executed during, between, and shortly after the intense experiences of Barocci's two sojourns in Rome during the late 1550s and early 1560s, and again in two important late works produced for Rome, the *Presentation of the Virgin* for the Oratorians and the *Institution of the Eucharist* for the family chapel of Pope Clement VIII. Both of these late altarpieces were produced for critical sites in the peninsula's religious and artistic capital, and for institutions or individuals known for their investment not only in religious imagery but in art as well. Barocci would have been perfectly aware that painters had lined up to study and discuss his great altarpiece of the *Visitation* for Santa Maria in Vallicella when it was unveiled in 1586 and that the Oratorian fathers had intended to fill their church with paintings by the leading masters of Italy (and ultimately of Europe). Pope Clement, meanwhile, involved himself intensely in Barocci's process and made a series of significant observations and requests.[23]

The group of early works would have been no less important to Barocci at the time of their creation. The *Martyrdom of Saint Sebastian* (fig. 128) was commissioned to adorn an altar in Urbino Cathedral – an acknowledgement that the young artist was establishing himself as the leading painter in his native city. Here Barocci exhibited his skill with the nude figure not only in the putti but in the figure of Saint Sebastian himself; Sebastian's virtual nudity is acceptable as appropriate to the story but his form is derived from Michelangelo's Haman from the lunettes of the Sistine Ceiling (fig. 129). The young painter, home from his first visit to Rome, is plainly demonstrating his growing mastery, combining the foreshortening of Michel-

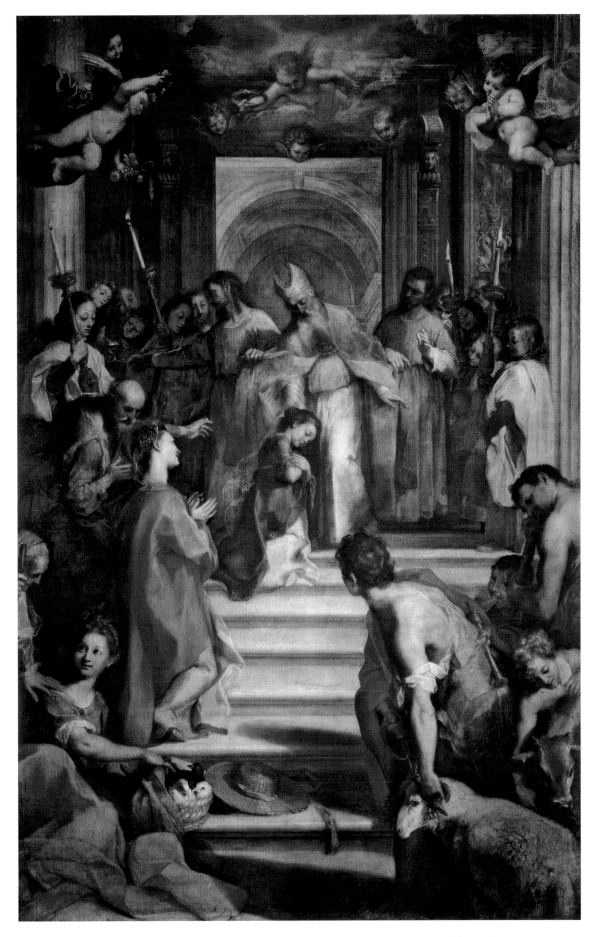

127　Barocci, *Presentation of the Virgin*, 1593–1603, oil on canvas, 383 × 247 cm. Rome, Chiesa Nuova.

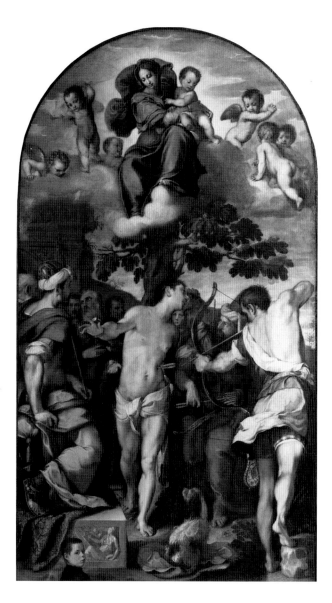

angelo with references to Titian's coloring and the figures of his Ancona *Madonna* (see fig. 46). The *Holy Family* in the Casino of Pius IV, meanwhile, gave Barocci the opportunity to work on an important, and intimate, papal commission back in Rome, and the Bonarelli *Crucifixion* and the *Madonna of San Simone* – this last another painting for an altar in Urbino Cathedral – are among Barocci's significant commissions soon after his return to Urbino and long convalescence. They represent some of the first fruits of his determined attempts to build a regional patronage network and a reputation as a learned painter in his enforced early retirement back to the Marches.[24] In all these works putto angels constitute critical components of Barocci's essays in figural nudity; they form a secure site in which he can decorously display his skill in rendering the "members" of the body and its softness, "colored and painted," as Aldrovandi would put it, "in lifelike form."

While it might appear that the nude putti in religious paintings are so "innocent" as to have little to do with *figure vaghe*,

the most extreme reform painting of the late sixteenth century could eschew even such nudity. It is remarkable how frequently, for instance, both putto angels and the infant Christ are robed in pictures by Scipione Pulzone and Durante Alberti. Alberti's altarpiece for the church of the Capuchins in Norcia exemplifies both this phenomenon and the pressures to display the body even in reform painting: Alberti has clothed the infant Christ with translucent drapery (fig. 131). Scanelli's impression that Correggio's putti embodied all the perfections of both modern and ancient art may serve as a coded reminder of the multivalent charge of the lovely *fanciuletto*. Not only was the soft pink flesh of putti a perfect vehicle for the representational powers of modern painting, but the putto as a genre had also been revived from antiquity. For all the apparent innocence of its form, the putto was also a figure of artifice – indeed, a privileged figure of artifice – in the twin desires it could excite: the longing for antiquity and for the Pygmalion effect, for that moment when the figure made by art became tender flesh. This combination of artifice and of "real presence" in the image could be ambivalent in sacred spaces, even in the guise of the putto. It was at least partly such concerns that occasioned the veiled putti and infant Christs of some reform painting. Furthermore, it may be that the privileging of clothed adolescent angels in some of Barocci's works for Marchigian confraternities – such as the *Circumcision* for the Compagnia del Nome di Dio in Pesaro – or in the *Last Supper* for the Sacrament Chapel of Urbino Cathedral (figs 133 and 134) actu-

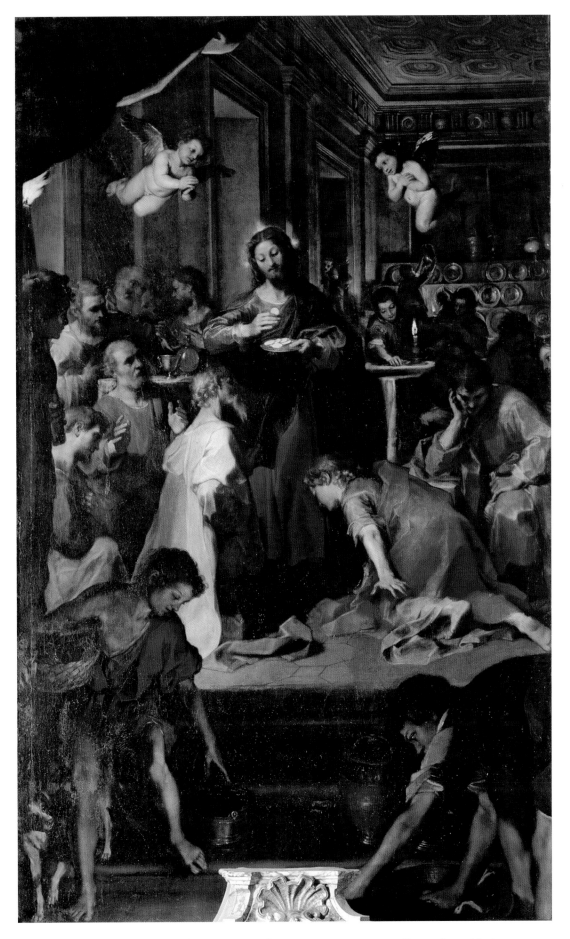

130 Barocci, *Institution of the Eucharist*, 1603–7, oil on canvas, 290 × 177 cm. Rome, Santa Maria sopra Minerva.

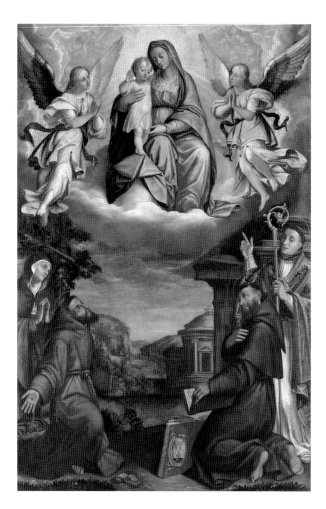

131 Durante Alberti, *Madonna and Child with Angels and Saints Clare, Francis, Bonaventure and a Franciscan Saint,* 1590–91, oil on canvas. Norcia, Museo.

chapel in Santa Maria sopra Minerva, the painter appears to have concluded that the display of putti was not enough. In the finished painting (see fig. 130), the putti angels who hover decorously above Christ's head are mirrored in the composition by the figures of the two serving boys who wash dishes in the foreground. Their rolled-up sleeves and hiked-up tunics are arranged to reveal Barocci's skill at painting the soft flesh and articulated musculature of the proto-adolescent body, while he covers enough of their forms – and keeps them just young enough – to remain within the bounds of ecclesiastical decorum. Scannelli particularly praised a similar figure in his discussion of altarpieces by Correggio. In the *Madonna of Saint Sebastian,* Scannelli meditates at length on the figure of the little girl, at the beginning of adolescence, who hands the model of Modena to San Geminiano (fig. 132). Her beauty "ravishes the spirits of viewers, and makes them languish, in love and stupe-

132 Correggio, *Madonna of Saint Sebastian,* c. 1524, oil on panel. Dresden, Gemäldegalerie.

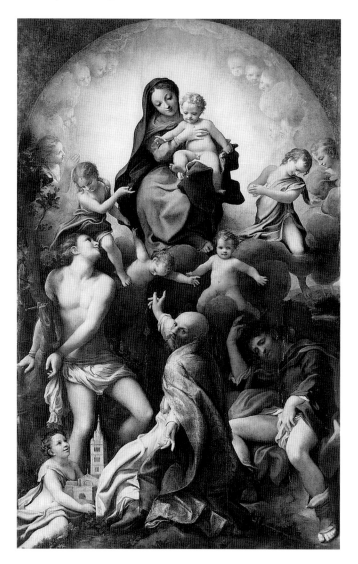

ally reflects a negotiation with tradition that constitutes a conservative alternative to the employment of putti. After all, it had been usual for angels in fourteenth- and much fifteenth-century religious painting to be clothed adolescents, before the increasing prominence of the putto in many later images.

Yet despite the famous attacks leveled against Michelangelo's nudes, the widespread condemnations of any adult pictorial nudity in religious painting during the post-Tridentine decades, and the great potential of the putto as a "figure of art," Barocci seems to have perceived that the adolescent or adult nude figure was still considered a critical, even necessary, sign of art and of *vaghezza*. Indeed, for all their fleshy softness, the bodies of infants or of young children could not exemplify the perfection of proportions – or ultimately the full charge of *vaghezza* – that might be found in the ideal bodies of adolescents or young adults. Thus, when at the end of his career Barocci received once again a papal commission in Clement VIII's request for the *Institution of the Eucharist* for the Aldobrandini

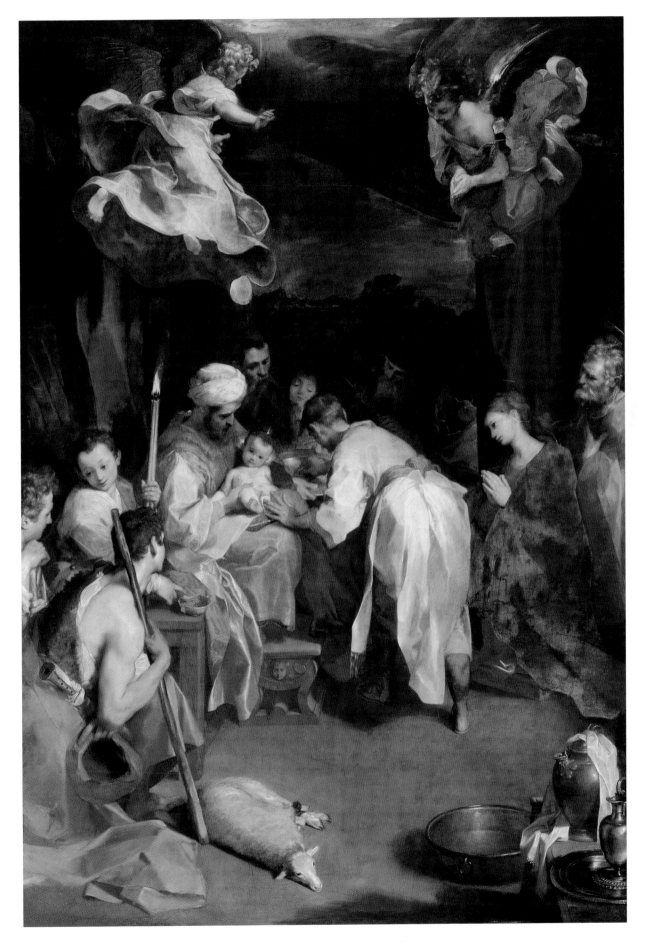

133 Barocci, *Circumcision*, 1590, oil on canvas, 374 × 252 cm. Paris, Musée du Louvre.

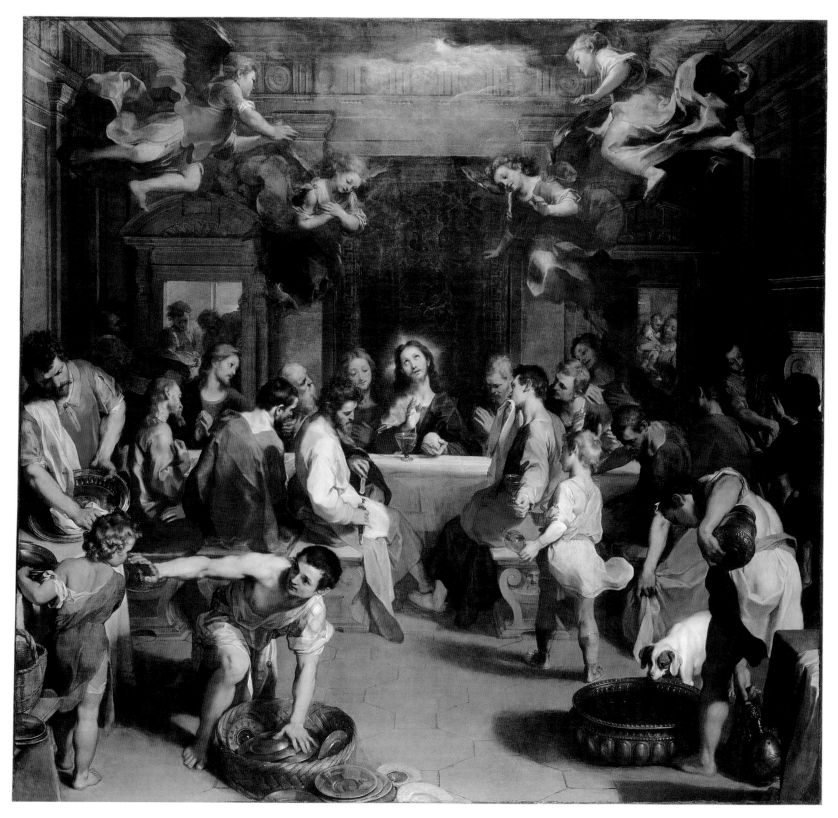

134 Barocci, *Last Supper*, 1592–9, oil on canvas, 299 × 322 cm. Urbino, Cathedral.

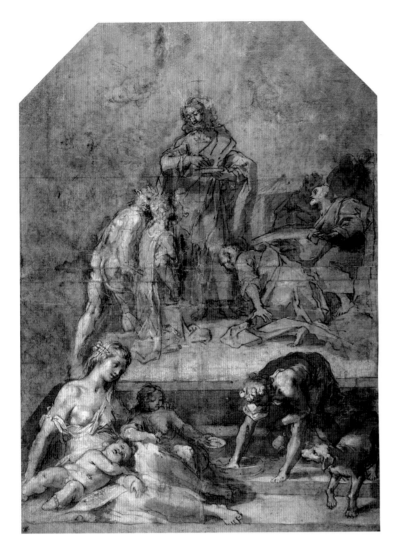

LEFT 135 Barocci, preparatory study for the *Institution of the Eucharist*, pen, wash, chalk, and white heightening on paper, 48 × 34.3 cm. Derbyshire, Chatsworth House, Devonshire Collection, inv. 361.

ABOVE 136 Copies after marble *Sleeping Cupids*, from the album *Busts and Statues in Whitehall Garden*, 17th century, pen and wash on paper. Windsor, Windsor Castle, The Royal Library.

fied, every time that they consider her as she deserves."[25] This is an important, if late, indication of a possible reason why Barocci often employed proto- or early adolescent figures in his paintings. Such figures could "ravish" the senses of viewers into the contemplation of beauty with a force that was perhaps greater than that offered by the figure of the putto, while remaining just within the tightening parameters of figural decorum in religious painting.[26]

FIGURES "A LITTLE MORE *VAGHE*"

What one of the initial *modelli* for the Aldobrandini chapel reveals is that Barocci first essayed something most unusual for him – the frontal presentation of a voluptuous young woman with bared breast (fig. 135). This figure would disappear in the final painting and when it has been remarked in the historiography, it has been read as a sort of lapse on Barocci's part, a "mannerist" *repoussoir* figure with little purpose. Barocci did actually work to give the figure a function: she seems evidently an unusual fusion of a beggar and a figure of Charity, as she

tends two children, including a nude and sleeping "putto." This putto may represent a significant gesture of art, and not only in relation to the desiderata for vital figures and references to antiquity. Within the modern "canon" there may have been a particular reference operative in this figure. Its form, with the right arm slung across the sprawled, sleeping body, recalls sleeping Cupids from the Gonzaga collection in Mantua as recorded in a drawing now in Windsor: some of these are antiquities, but among them may be a representation of Michelangelo's famous lost *Sleeping Cupid* (fig. 136). Barocci's possible allusion to both the antique and to Michelangelo in this putto exemplifies his investment in the putto figure as a vehicle for art. It also implies that alluding to inspiration from Michelangelo might at times have remained important for Barocci, at least in a work destined for such a situation.[27]

While the infant's mother may represent Charity, the rarity of such a figure in Barocci's work implies something more; for a major commission for an aristocratic private chapel in Rome, Barocci seems to have concluded that he would have to re-engage with the cultivation of figural *vaghezza* through the creation of a partially clothed adult who was "a little more *vaga* than usual." The slightly earlier *Last Supper* for Urbino (see fig. 134) has no such figures; even the angels are clothed (though the young washing boys, like their counterparts in the Roman altarpiece, show enough of backs, arms, and legs to indicate

Barocci's mastery of the figure without lapsing into "lasciviousness"). In the rejected compositional drawing for the Roman painting, Barocci also depicted a muscular figure of the devil in the act of tempting Judas. The unusually well informed Bellori notes explicitly that the pope "did not like the devil to be seen on such familiar terms with Jesus Christ and to be seen on the altar" and urged Barocci to remove this figure. Bellori does not mention the dramatic presence of the young woman with bare breast in the same drawing, but her disappearance from the painting leads one to suspect that the pope also commented unfavorably on her.[28] Had Barocci then simply mistaken his audience and the cultural situation in contemporary Rome?

What for Barocci may appear a most unusual attempt to foreground the figural *vaghezza* of the female body in an altarpiece actually recalls his first surviving painting, the *Saint Cecilia* altarpiece of the mid- to late 1550s (see fig. 173). This painting is so evidently a juvenile work by a painter who proceeded to develop with great rapidity that it is rarely given much comment in the art historical literature. As might be expected, however, the first commission that the young Barocci received for an altarpiece in the cathedral of his native city, and the second significant commission he received in quick succession after returning from his first study trip to Rome, would be an occasion to display his learning and ambitions. He does this not only through the obvious reference to Raphael (see fig. 174) but in addition through a greater display of female figural *vaghezza* than was present in his famous prototype. While the reorganization of the saints to privilege young female figures must have been a response to patronal exigencies, Barocci's transformation of Raphael's voluminous draperies into surprisingly gauzy fabrics that reveal much anatomy – particularly in the upper body of Saint Catherine of Alexandria on the viewer's right – and are obviously meant to attract the attention of *cognoscenti* is probably the painter's choice. This probability becomes the more clear if one considers the highly worked preparatory drawing rediscovered in 1966 (see fig. 176). While the figure of the Magdalen is largely clothed in the painting (though note her bare forearm, which had been decorously hidden by sleeve and shadow in Raphael's famous Magdalen) her entire back is nude in the drawing and her remaining drapery alludes more insistently to the "dancing maenad" type than does the drapery of the final figure. It seems quite possible that it was the patrons' discomfort with this alluring, stylish import from the recent Roman vocabulary of painters such as Salviati that led to the somewhat chastened figure in the painting.[29]

After this early experiment, Barocci generally eschewed adult nudity unless it was virtually required by the scene represented: the figure of Christ on the cross, for instance, or of the Saint Sebastian who appears both in the early altarpiece representing his martyrdom and in the later *Crucifixion* in Genoa (see fig. 104). Such figures were permitted, perforce, even by most ecclesiastical reformers. Federico Borromeo dedicates an entire chapter of his *De Pictura Sacra* (1624) to the nude, stressing that nude figures have no place in religious painting unless their presence is necessitated by the *misterio* represented.[30] In the nearly five decades between the *Saint Cecilia* and the *Institution of the Eucharist* (see fig. 130) Barocci adhered relatively closely to just such thinking and largely displaced his effects of *vaghezza* into other aspects of painting. The closest analogue to the female figure in the drawing for Pope Clement's altarpiece is the nursing mother in the left foreground of the *Martyrdom of San Vitale* (see fig. 143) – and it seems no coincidence that this altarpiece was commissioned for a major church of the famously intellectual monastic order, the Cassinese congregation of Benedictines. It provided another opportunity for Barocci to demonstrate his powers to many who might never pass through Urbino or Fossombrone or other interior towns for which he had produced altarpieces. Yet even here the viewer cannot see the mother's full breast – her nipple is just hidden by her slight turn away and by her suckling infant – and the child hides its genitals with its hand. Indeed, the only revelation of the nipple of a nursing mother in Barocci's painted work is found in a private devotional painting of the 1570s, the *Madonna del Gatto* (fig. 137). Here, the references to the theme of the Madonna of Humility might convince one that the revealed breast was "necessary to the mystery represented"; indeed, Barocci seems to have followed Borromeo proleptically with remarkable care. The Milanese churchman later made the nursing Virgin a salient example in his discussion of nudity: "It is not appropriate in any way to represent the Virgin who nurses her son if this is not done with the greatest modesty, which is not done by painters who uncover the throat and the chest of their figures, without necessity and in a very bad manner."[31] Barocci took great care to have the Christ Child draw his mother's green wrap across her dress in such a way that it covers most of the flesh of her chest and upper breast.

The painter's recourse to a significant display of female nudity in the compositional drawing for the pope's altarpiece, then, remains striking. It would be easy to read this unusual gesture in the light of Barocci's memories of mid-century taste in Rome, and proceed to interpret it simply as a mistake based on an outdated sense of decorum. It does seem that Barocci may have overstepped the decorum Clement deemed acceptable, and it is true that his direct memories of painting in Rome dated to the middle of the preceding century, when paintings by Salviati and Vasari were still new. Yet, given Barocci's profound sensitivity to issues of decorum in the 1570s and 1580s – and his "avant-garde" ability to displace *vaghezza*

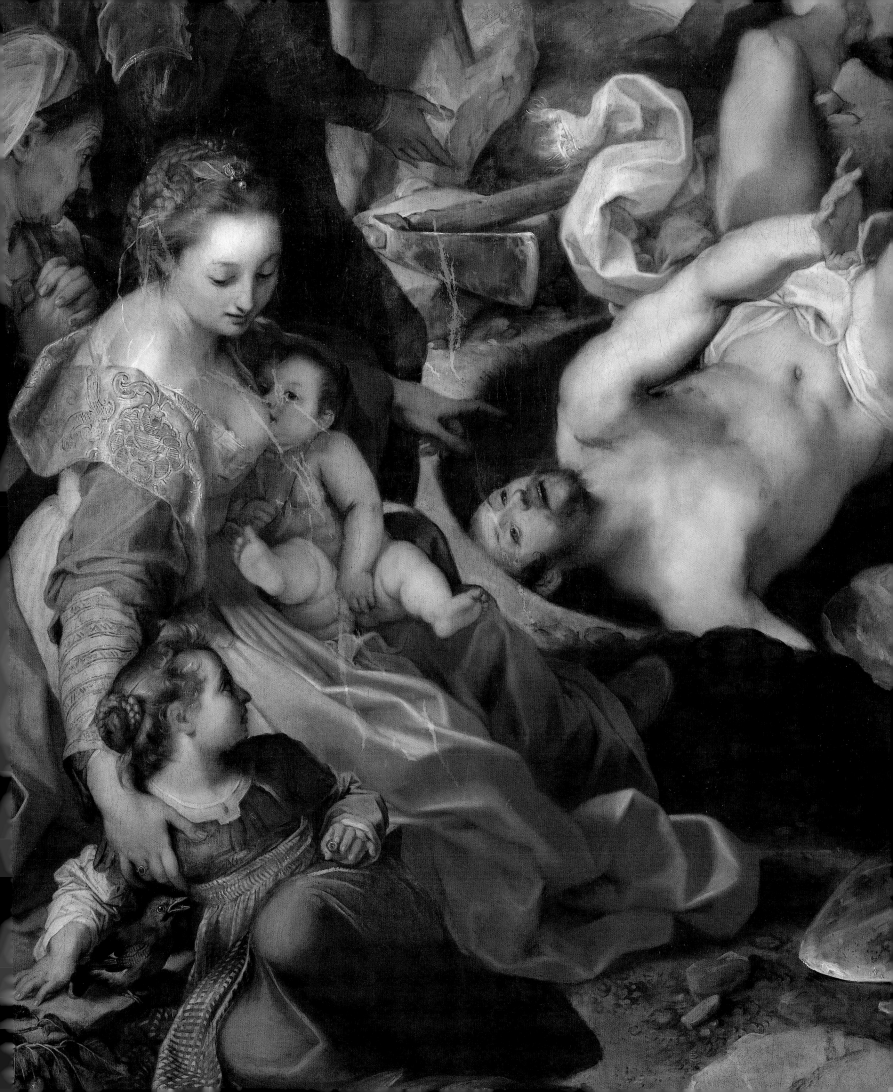

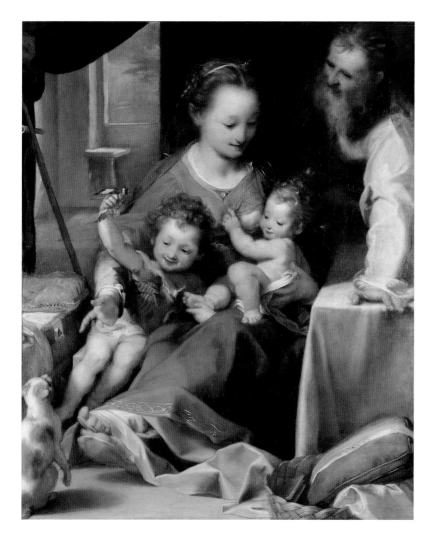

137 Barocci, *Madonna del Gatto*, c. 1574–5, oil on canvas,
112.7 × 92.7 cm. London, National Gallery.

from Vasari's "young men or women" to putti, color, and passages of paint – it seems hardly credible to accept the unstated implications of such a position, which in effect reads the aging Barocci simply as an out-of-date provincial. The *Presentation of the Virgin* (see fig. 127) that he had completed for the Oratorians in Rome just before the pope's commission exhibits no such misunderstandings; on the contrary, it offers a virtuoso display of several sorts of decorous *vaghezza*, from the figural (the rosy shoulders of the shepherd, young cowherd, and blind beggar to the beholder's right and the soft pink flesh of the putto angels) through other forms of compelling pictorial mimesis (the acolyte blowing on the newly lit incense burner, for instance) to the ravishing pictorial passages of the lining of the priest's robes. If Barocci concluded that a greater display of the overtly sensual *vaghezza* of female nudity – a *vaghezza* that would have occasioned an appreciative if embattled encomium from Borghini's Michelozzo – might be appreciated in the private chapel of an aristocratic family (even if the family of the

current pope), he was both making discriminating distinctions between types of altarpiece and audience, and acknowledging that the crisis of *vaghezza* had not been entirely resolved by the increasing recognition that it could be a property of things besides ideally beautiful adolescent or adult bodies.

This is the difficulty repeatedly acknowledged in a work as ostensibly concerned with decorum as Borghini's *Il Riposo*. The cultivation of *vaghezza* could not be ignored by an ambitious painter, even in religious painting. If a situation prohibited the deployment of figural *vaghezza*, other means to create a *vaga* effect had to be found. Barocci became one of the period's most brilliant exponents of these other means, particularly color: but in certain circumstances, recourse to figural *vaghezza* remained compelling, if controversial. At least two issues arose in the circumstances of the creation of the *Institution of the Eucharist* that may have impelled the painter to consider once again a recourse to the unique power of the *vaghezza* of youthful beauty. First, as noted by Roberto Zapperi, the Aldobrandini and Pope Clement were themselves not averse to the lure of figural *vaghezza* in the decoration of their chapel; Ippolito Buzio's sculpted *Prudence* from the tomb of Silvestro Aldobrandini exhibits just the sort of off-one-shoulder, breast-revealing drapery Barocci chose for his figure (fig. 138).[32] In addition, body-revealing armor allows for the "clothed revelation" of the navel and nipples of the figure of Justice that is paired with Prudence (see fig. 140), and the early adolescent angels designed by Stefano Maderno to sit on the pediments of the wall tombs are entirely nude (figs 139 and 140). It thus appears ironic that Nicolas Cordier's *Charity* (see fig. 139) directly across from Buzio's *vaga donna* is fully clothed.[33]

Beyond his probable knowledge of the other decoration intended for the chapel, Barocci's calculations may also have been informed by his memory of Matteo Senarega's encomium of the *Crucifixion* for Genoa (see fig. 104). Senarega's letter concludes by singling out the nearly nude figure of Saint Sebastian for praise: "In Saint Sebastian one sees expressed the true colors and proportions [*numeri*] of art, to a degree that perhaps the ancients never attained, much less the moderns; and as a whole, the work is so rich in artifice and *vaghezza* that it does not leave room for anything but a desire to imitate it." It does not seem accidental that Senarega's celebration of this figure as the privileged site for the display of the "colors" (the "living flesh" praised since Dolce as a principal achievement of modern painting) and the "numbers of art" (the ideal figural proportions that undergirded excellence in the modern art of the body) is immediately followed by his conclusion that "artifice and *vaghezza*" dominate the work as a whole.[34] The connection he implies between such figural perfection and the "*vaghezza* and artifice" that must characterize important paintings could have

LEFT 138 Ippolito Buzio, *Prudence*, c. 1604, marble. Rome, Santa Maria sopra Minerva, Aldobrandini Chapel.

BELOW LEFT 139 Nicolas Cordier and others, tomb of Lesa Deti, 1600–11, marbles. Rome, Santa Maria sopra Minerva, Aldobrandini Chapel.

BELOW RIGHT 140 Nicolas Cordier and others, tomb of Silvestro Aldobrandini, 1600–11, marbles. Rome, Santa Maria sopra Minerva, Aldobrandini Chapel.

provided considerable food for thought as Barocci planned one last altarpiece for Rome, and for the chapel of a pope's family.

Another issue that may have inflected Barocci's decision to experiment once again with overt figural *vaghezza* involves two aspects of lighting: first, an evident concern that the chapel's illumination would not show the altarpiece to good advantage, and second, the possibility that Barocci had always envisioned a night scene for the painting. In poor natural lighting or in the shadows of a night scene, the possibilities for coloristic *vaghezza* could be seriously compromised. Worries about the lighting in the chapel are well documented and date to the earliest planning for the picture. The pope had recognized in a letter of August 13, 1603 that a *Cena* (as the painting is called

in the correspondence) presented serious problems of composition in the vertical space allotted for the altarpiece, but he expressed confidence that the *valore* of Barocci could overcome all difficulties. It may not be a coincidence that in the next phrase he encourages Barocci and the duke to direct any questions "about the lighting or anything else" to his Maestro di Casa. By August 27 plan drawings of the chapel had been requested and already received in Urbino, and by the 31st an elevation drawing of the altar wall façade; with this in hand, the duke wrote with concern that "it seems to us that the illumination [of the chapel] is very strange."[35] This concern does not seem to have elicited a response; the results were somewhat unfortunate. While Barocci clearly attempted to overcome the effect of backlighting created by the window above and behind the altarpiece by employing strong, rich colors for the drapery of the principal figures and a flaring torch to justify the brilliant illumination he casts on them, one of Bellori's comments about the painting was that its effect was ruined due to its poor lighting. Twenty years earlier, Barocci had written to the Senigallia confraternity that commissioned the *Entombment* that the proper lighting of a painting was of paramount importance and that without light "pictures can never show what they are."[36] He would surely have shared the concerns of his duke and mentor when it came to the Aldobrandini commission – and he certainly realized the implications of the situation for heavy reliance on subtle and virtuoso handling of *vaghi colori*.

Further, in the course of negotiations, the pope made clear that he assumed that the *Cena* would occur in a nocturnal ambient; in a letter laying out his response to drawings that Barocci had sent, he asked that artificial lights be added to the composition "to stress that this most holy institution [of the Eucharist] occurred at night." While this may indicate that Barocci was not initially considering a night scene, he had certainly been experimenting with dark settings and night scenes increasingly since the 1580s. For instance, the Senigallia *Madonna of the Rosary* (see fig. 62), while illuminated by heavenly light, appears before a darkened landscape. The Urbino *Stigmatization of Saint Francis* (see fig. 8) is clearly a night scene, as are the Madrid *Nativity* (1597) and the Galleria Borghese *Saint Jerome* (1580s–1590s). Finally, the *Beata Michelina* (c. 1606) receives her vision before a stormy and darkened landscape. The setting for the Urbino *Last Supper* of 1592–9 is unclear (see fig. 134); the scene is artificially floodlit from the front, which allows for some of Barocci's famous display of beautiful coloring; but the significant light sources all come from within the room (the heavenly glory, the fire) and the window embrasure beside the fireplace is dark, while what appears to be the afterglow of a sunset illuminates the windows visible through each of the two doors. Several of the paintings in this loose group

exhibit little *vaghezza de' colori* and indeed only the most restrained figural *vaghezza*. However, in a Roman altarpiece for a papal family chapel, Barocci would have understood that the spare austerity of the *Stigmatization* – for the reforming Capuchins, after all – was out of place.[37]

While Barocci apparently miscalculated when he attempted to reintroduce significant female nudity in the foreground of the *Institution of the Eucharist* – there may well have been a distinction in the Pope's mind between the altarpiece itself and allegorical figures on the tombs – it remains telling that the accepted replacement for his initial figure was the pair of lightly clothed serving boys who, it could be hoped, would provide the delights of figural *vaghezza* while remaining just on the decorous side of desire. A study for the little boy with his back to the viewer in the left foreground of the Urbino *Last Supper* indicates how much care Barocci put into the revelation of the body beneath drapery in such figures (fig. 141). Although he studied many figures in the nude before clothing them, here

141 Barocci, preparatory study for the *Last Supper*, charcoal and white heightening on paper, 28.4 × 20.3 cm. Berlin, Staatliche Museen, inv. KdZ 20209 (4409).

he devotes particular attention to revealing the form of the buttocks beneath the boy's shifting drapery. To witness an aged and evidently devout painter wrestling with such pictorial negotiations is to sense both the continuing lure of the body and the uneasy relations between the demands of art and those of the chapel and the altar in a culture that was no longer that of Rome in the early sixteenth century. The allure of figural *vaghezza*, and the continuing significance of the body as the privileged site for the display of art, finally forced Barocci into an ambivalent position as he attempted to ideate Clement's altarpiece. He had been perhaps more successful in his remarkable cultivation of what might be termed "alternative *vaghezze*" in the altarpieces of the 1570s, '80s, and '90s. These – the illusionism displayed in representations of still life or animals, and the purely pictorial qualities of facture and color – seem to have represented for contemporaries the critical means through which artists might introduce *vaghezza* into devout painting. Barocci's particular strategies in such experiments deserve further scrutiny.

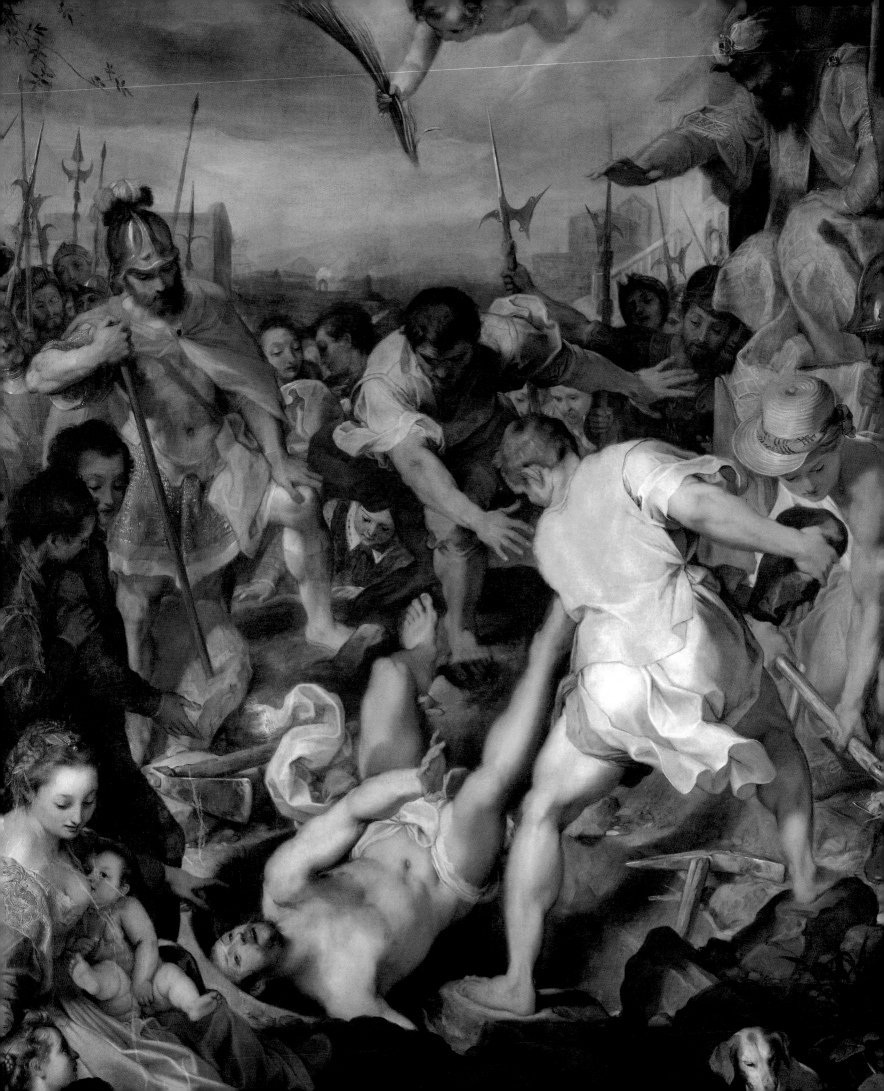

Other Vaghezze

PAINTING THE LOVELINESS OF THE WORLD

VAGHEZZA AND *PARERGON*

Somewhere in most Barocci altarpieces – usually in the foreground – the beholder confronts not the principal subject of the painting, but incidental elements, marginalia. While much modern art historiography would instinctively identify these elements through recourse to now standard labels (still life, animal painting, genre), it may be useful to consider two period designations. Vasari grouped such sorts of representation together as "pittura di cose piccole," not a bad phrase to keep in mind when reflecting on Barocci's little dogs that regard us with soulful eyes, or sacks of bread set down at the margin of a painting, or a scene of cherries fed to a hungry bird that occupies the space between the viewer and the martyrdom of a saint in an altarpiece. The other word that seems particularly relevant is *parergon*. That this term is much employed in postmodern discourse should not obscure the fact that *parergon* was a critical term that was well known in the early modern period. It had been deployed already in ancient theory by Quintilian to indicate the embellishments added to an oration and by Pliny to serve an analogous purpose in discussing painting. By the 1630s, the important scholar of antiquity and painting

Franciscus Junius defined still life explicitly as a *parergon*. In Barocci's case, the *parerga* that mediate access to the sacred *istorie* and *misteri* that occupy the center of most of his paintings are ordinarily representations of still life, animals, and children. Barocci never effected the apparent inversion of foreground and background, center and periphery, that formed an important *leitmotif* of some evidently religious paintings by northern contemporaries; he would not have painted an image like Peter Aertsen's *Christ in the House of Mary and Martha* (fig. 142).[1]

While his *parerga* remain in a sense on the margin, Barocci nevertheless often literally foregrounded them, even in major public altarpieces. They constitute physical and compositional thresholds to the sacred scenes and characters beyond. Viewers must look through them to see the *istoria*. Unlike the incidental details in some altarpieces by *maniera* painters, Barocci's *parerga* almost always offer a means to understand and respond to a painting's religious subject. In an extreme case, the symbolism of the trussed lamb that stares out at the viewer with soulful eyes as it lies at the feet of the adoring shepherd and directly below the bloodied Christ Child in the *Circumcision* (see fig. 133) is so obvious that the representation only escapes heavy-handedness (if at all) through the exceptional depiction

142 Pieter Aertsen, *Christ in the House of Mary and Martha*, 1552, oil on wood. Vienna, Kunsthistorisches Museum.

of the lamb as a creature and as a work of art. The viewer is compelled to consider the magical conjuring of the animal's material presence even as its symbolic presence is registered. A visually educated period viewer would also have registered, it seems to me, the fact that this effect of physical presence is created through manifestly pictorial means: Barocci has created not a transparent representation but a self-consciously pictorial presence, overtly and skillfully juxtaposing detailed handling (in the face of the lamb) with loose, deft brushwork to evoke the fur of the body. Thus the figure operates as a pictorial signifier of artistic command, as a visually entertaining *parergon*, and as a symbolic object all at once. It is no accident that the lamb is both in the foreground and low; it marks the limen between the material world and the sacred core of the image, which is both higher and farther from the picture plane.

Barocci's *parerga* are rarely this insistent and univocal in their symbolic charge but the operations they perform seem usually to follow the pattern just sketched. Again and again, their sheer pictorial presence lures beholders into a contemplation that eventually becomes bound up with questions concerning the fundamental significance of the painting, both as a work of art and as a compelling religious image. The *parerga* represent one of Barocci's several responses to the problem of generating *vaghezza* without leading the mind to lascivious thoughts. For while lovely young women and men could certainly be *vaghe*, other created things might be as well and so might be their very modes of representation, as revealed by Dolce's elision of the *macchia* on the Cnidian Venus with the *macchia* of landscape in Titian's *Venus and Adonis* (see fig. 118).[2] Even Gilio, so often considered dour by art historians, opens his notorious *Dialogo degli errori de' pittori* with a long poetic evocation of the beauty

of the spring of 1561 – a spring particularly appreciated as it followed an especially harsh winter – with its *vaghi fiori* and *vaghi uccelli*. After several pages of this, the discussion of painting begins with a consideration of whether modern painters can possibly represent the full beauty of nature or even recreate the vivid, translucent presence of Zeuxis' bunch of grapes. The interlocutors conclude rather conventionally that they cannot: "if we consider the kinds of flowers, of fruits, of plants, of birds, of animals, that one sees in the loggias of the palace of the Pope, the Chigi, and in other palaces in Rome, even though they appear beautiful and *vaghe*, nonetheless they do not have that natural color and that *vaghezza* that those [ancient paintings] mentioned by Messer Polidoro must have exhibited."[3]

Animals and plants were no substitute for *istorie* as the principal subject of painting, but the convincing representation of the natural world had been adduced as a particular challenge for painters by writers throughout Italy – as well as north of the Alps – for most of the sixteenth century. As Gilio's passage indicates, the representation of plants and animals could stimulate a kind of *vaghezza* if enough illusionistic skill and perfection of coloring was achieved; not coincidentally, the discussion also stresses that the virtuoso representation of "cose piccole" had an antique pedigree and thus might constitute yet another field in which the moderns must compete with their outstanding ancient predecessors. In his turn, Cardinal Paleotti elaborates on the "chaste" sensual delight that could emerge from viewing creations of nature beautifully represented; his comments offer compelling indications of how some devout late sixteenth-century viewers might have registered and interpreted Barocci's displacement of *vaghezza* from alluring human figures to other, less potentially lascivious natural creatures. Paleotti considers the painter's office to be analogous to that of the orator or preacher and demands of Christian images what Saint Augustine demanded of Christian orators: *Delectare est suavitas, docere necessitas, flectere victoriae*. The Christian painter is to "work to form [a painting] in such a manner, that it will be effective at giving delight, at teaching and at moving the emotions of whoever looks at it."[4] Predictably, Paleotti perceives a hierarchy in these three parts and implies that the stimulation of delight is the least of the components of sacred oratory or art. Nonetheless, he devotes the chapter that immediately follows his definition of Christian painting to a celebration of delight and alerts the reader that he wishes to "explain the greatness of this delight and to make known that it is much greater than perhaps it is commonly esteemed to be."[5]

Paleotti proceeds to identify three sorts and levels of pleasure: "animal" or "sensual," obtained through sensory response; rational, obtained when one applies reason to consider what one has perceived through the senses; and finally spiritual plea-

sure, which surpasses the pleasures of both the senses and of reason and is given through faith to "clean and innocent souls through the singular grace of God." Paleotti insists that virtually everything pleasurable that may be perceived through the senses allows for the experience of all three levels of response and pleasure. Some of his thinking here is highly conventional: but in that, precisely, consists its particular usefulness in attempting to sketch parameters for what any fairly educated religious viewer might have brought to the contemplation of an altarpiece during the 1570s and '80s.

In elaborating his contention, Paleotti gives the example of seeing something beautiful, a bright night sky filled with stars. When one first steps outside and looks up, one is struck by "such beautiful color" and by the different sizes, lights, and movements of the myriad stars: "from this variety and beauty the sense [of sight] feels the greatest pleasure." Having been cheered by this sensation, one proceeds to contemplate the sky further, considering with the rational faculty the relative sizes of heavenly bodies, their courses, and their possible effects on the earth: "the intellect relishes this greatly and is happy." Finally, if illuminated by God, one begins to consider how excellent the maker of all this beauty and perfection must be and how "by way of these created things [God] makes a stairway for humans to enter into eternal things and excites the desire for heavenly goods."[6] While this much is largely conventional, Paleotti concludes by applying these standard theological concepts directly to painting and insists once again that in and of itself sensual delight is not bad, or forbidden by Christian teaching, so long as this first and most basic delight from the stimulation of the senses is enjoyed "in the right way." His text will be quoted at some length, for it provides one template with which to approach the still life and genre details that crowd the foregrounds and margins of many of Barocci's paintings:

And since Christian law does not forbid any of these sorts of delectation, so long as they occur in an appropriate way, so that one does not destroy the things of nature but rather gives them perfection, using them as steps and ways to come to the high goal of eternal beatitude: therefore from the holy images of which we speak, a Christian may likewise enjoy each of these three sorts of delectation, of the senses, of reason, and of the spirit. Regarding the senses, it is completely evident to all that, as the sense of sight is more noble than the others, it receives from pictures marvelous pleasure and recreation from the variety of colors, from shadows, from the figures, from the ornaments and from the diverse things that may be represented, such as mountains, rivers, gardens, cities, landscapes and other things. Concerning rational delight . . . it is said by the sages that as man among all the animals is

born with incredible abilities to imitate, thus he feels a great delight and taste for imitation by natural instinct. . . . And this imitation, which one perceives so clearly in painting, can bring even greater delight when [pictures] suddenly appear to make things present to [viewers] . . . and in the guise of the omnipotent hand of God and of nature, God's minister, to bring to life in an instant humans, animals, plants, rivers, palaces, churches and all the works that one sees in this great machine of the world. . . . There remains the third delectation, which is born of spiritual cognition, of which there is no doubt that . . . it brings much greater and more perfect delight. . . . From which we wish to conclude that, beyond the two preceding [sorts of delight], which are easy for anyone to experience, follows this third which, as much as it is more excellent than the others, so much so may it be awakened in noble souls by means of pious images, as is said by an author: "Delight in paintings, if thoughtfully considered, encourages our love of heaven, as they remind us of their origins. For who ever loved a river but hated its source?"[7]

A text such as Paleotti's may begin to illuminate the importance of Barocci's *parerga* to his project of creating visually and spiritually compelling altar paintings. The children, animals, and still life elements that often introduce the viewer into Barocci's altarpieces would, it seems, have afforded Paleotti (and others with similar mental equipment) immense sensual, rational, and spiritual delight. In what may come as a surprise to many twentieth-century commentators, Paleotti fully supported the initial, "innocent" yet "sensual" reactions of viewers who delight in the portrayal of an endearing dog in the margins of one of Barocci's canvases. He also condoned, and even encouraged, appreciation of the pictorial skill with which Barocci represents – "imitates," the distinctive human act – creatures such as the lamb in the *Circumcision*. Such a compelling act of mimesis offers both sensual and rational delights, and the transition to spiritual considerations as the mind meditates on the implications of the lamb's nature and presence in this scene, and the eye rises literally and metaphorically from the lamb to the Child above, is structured and encouraged by Barocci in such an obvious manner that it becomes accessible to virtually any viewer with the most rudimentary understanding of Christian symbolism. Barocci is not always so obvious, so helpful; but nearly all his *parerga* lend themselves to the sort of contemplation suggested by Paleotti.

This fact in its turn suggests one reason why Barocci was deemed so successful at conjoining *vaghezza* and *devozione*, at fusing art and piety. Myriad elements in his paintings – Paleotti's "figures, animals, plants, rivers, palaces, churches" – lure the eye with sensual (but not lascivious) beauty, stimulate the delecta-

tion of reason through magical mimesis, and finally encourage a symbolic or analogical meditation upon those forms and their representation that draws viewers into the realm of spiritual contemplation. With few exceptions, even the loveliest adult human figures who act in Barocci's sacred *istorie* embody all these effects as well, but Barocci's distinctive ability to make his pictorial "ornaments," his *parerga*, appeal to all levels of cognition results in religious paintings that virtually overflow with pictorial delight and with spiritual instruction and "recreation." Any number of Barocci's altarpieces offer examples that indicate the extent to which his *parerga* are both very much what they seem and glowing limens to another realm of understanding. The representations of still life, animals, and children constitute the most obvious of Barocci's signifying *parerga*. Yet Paleotti's linkage of the delights afforded by the representation of "animals and plants" to that produced by depicting "palaces and churches" indicates that even architectural details and backgrounds could be "ornaments" of painting that delighted the eye. The visual delight and instruction afforded by what one might call these "signifying spaces" will be investigated at the end of this chapter.

READING THE MARGINS OF THE *VISITATION*

It may be useful, however, to begin with a consideration of "*cose piccole*," those depictions of still life, animals, or apparently incidental "genre" figures. An excellent site for considering the functions of such *parerga* is the Vallicelliana *Visitation* (see fig. 77), produced for the Oratorians, an order at once devout and intent on obtaining modern art by "the best masters." What is it that the weary Joseph sets down at the bottom margin of this painting, so close to the altar below? The metal jug probably holds wine. And the sack? Perhaps bread. The painting does not tell us. Yet even in making the viewer wonder, such a still life in action, as it were, engages the senses, the reason, and ultimately the spirit. This painting was the favorite image of San Filippo Neri, the focus of many of his meditations. It is not hard to see why. The scriptural narrative is reenacted with deceptive simplicity by dignified and distinctive figures (the preparatory work underlying this achievement will be clear from the conclusion of Chapter Four). At the same time, the presentation of these figures and of the "ornaments" of the picture – even the very pictorial surface – is effected with beauty of color, powerfully compelling mimesis, and consummate skill in handling paint (the remarkable chickens emerging from the servant's basket illustrate all these points). Furthermore, much in this painting is both itself and a marker that points toward something else. If one visualizes assisting at

Mass or meditating in this chapel (as San Filippo Neri was wont to do) with even a basic understanding of liturgy and symbolism, it is not hard to imagine the train of speculation that could be prompted by Joseph's action of setting those two items down so near the altar.

The very issue of their identities stimulates the sensual and rational mind: the attentive viewer marvels in the joys of mimesis and then begins to consider "what manner of things these may be." It is all the more compelling that one cannot be sure of the precise material identities (the "accidents") of the substances in the sack and the jug. This mystery concerning *cose piccole* focuses the (rational) mind on questions that ultimately encourage reflection on the greater *misterio*, involving "ultimate things," that is enacted repeatedly on the altar below the painting. For the associations prompted by Joseph's action do not end in iconographic or analogical reflection on the still life conceived merely as an assemblage of objects; as so often, Barocci reveals further "mystery" through his very presentation of narrative – or more precisely through what could be termed the unintended side effects, the *parerga*, of the actions performed to stage the *istoria*. To release his burden, Joseph must stoop, but to a pious viewer in the chapel, he could appear to bow, both to his burden – simple substances of earth that may hold immense spiritual promise – and to the bread and wine consecrated on the altar below. By implication, in the logic of the pictorial composition, he bows also to the Virgin, though in performing his immediate action he is not even aware of her for the moment. As he bows, he – equally "by coincidence" – reveals the donkey, which fixes us with penetrating gaze. The human actors in Barocci's sacred *istorie* rarely meet the viewer's gaze; it is most frequently animals that do so, and the *Visitation* is no exception. We as viewers become aware that we are also under scrutiny by one of the chickens, while none of the people – even Zachariah, who faces in our direction as he rushes from the house to assist Elizabeth in greeting her holy cousin – seem at all aware of our presence.

These animals – in particular the donkey – signify in unexpected and compelling ways as one contemplates the image. It seems no accident that it is the donkey that makes the most insistent eye contact with the beholder. Such a creature is surely not Alberti's ideal interlocutor, but in Barocci's work one makes the first contact with the world within the image through such figures. The donkey is among the least of God's creatures, a recalcitrant beast of burden, the poor "brother Ass" that for Saint Francis was the body itself (San Filippo Neri would have been well aware of this and of the manner in which Christians might perceive truths about their material selves as they considered the animal before them). This is not the body of *vaghezza*. Yet the donkey was privileged to be present at the

Nativity of the Lord, and to carry the Holy Family to safety in Egypt. The donkey is a figure of journeying: its presence reminds the viewer of the Holy Family's travel to this momentous meeting with Elizabeth, of their journey to Bethlehem and the Nativity, of their flight into Egypt, and even, ultimately, of Christ's fateful entry into Jerusalem, "riding upon an ass." As Marc Fumaroli has remarked, reflection on the figure of the donkey allows the beholder to enhance the narrative possibilities of this sober image and the drama latent in its decorous balance. It may be no accident, as Fumaroli stresses, that when San Filippo was caught up into ecstasy before this painting, he experienced a vision, not of the Visitation, but of the Virgin and Child: that is, of the ultimate historical and spiritual fruit of the longer narrative trajectory perceived only in part in the *istoria* visualized here.[8] The operations of *parerga* evident in the *Visitation* exemplify how Barocci might employ such devices to delight the senses, to engage the mind, and to sway the spirit. Analogous readings could be offered of a number of his other altarpieces, but having observed a cluster of *parerga* at work in one image, it may prove useful to isolate the varied species of *parerga* and consider their specific operations.

THE OBJECTS OF STILL LIFE AND THE SANCTIFICATION OF THE MUNDANE

It is often noted that Barocci returned repeatedly to certain figural types, both evolving them and reemploying them over his long career. The Saint Francis in the lost Fossombrone altarpiece (recorded in a drawing; see fig. 41), Saint John with outflung arms in the Urbino *Crucifixion* (see fig. 12), and the figure of San Bernardino at the right side of the Perugia *Deposition* (see fig. 85) are all fruits of Barocci's early study of Raphael (the Saint Francis in the *Madonna di Foligno*, see fig. 31) and Titian (the Saint Francis of the *Pesaro Madonna*, see fig. 45). Barocci's experimentation and reflection allowed him to evolve a figure very much his own in the Francis of the *Perdono* (see fig. 52). Having created this ideal type, he reemployed its defining gesture and even entire pose for a certain kind of figure for the rest of his career, though he always (a point not generally recognized) subjected the figure to adaptation and refinement. His search for a language of "perfect gestures" forms a critical part of this figural research. One may follow, for instance, the excited forward motion of Joseph, arm outstretched, from the versions of the *Rest on the Return from Egypt* (see fig. 181) and the nearly contemporary *Madonna del Gatto* (see fig. 137) through its transformative distillation into the figure of the begging mother who rushes to receive alms in the *Madonna del Popolo* (see fig. 24), to echoes in the figure of Joseph in the late Prado *Nativity* and even to the figure of the

turbaned older man, perhaps Nicodemus, who directs the bearers toward the tomb in the unfinished *Lamentation-Entombment* for Milan Cathedral (see fig. 109) – a figure for the first time, at the end, mournful rather than joyous, his gesture extending into the darkness of the picture's unfinished depths rather than out toward the light.

Perhaps because the significance of Barocci's restless search for figures and gestures that are perfect vehicles for particular sorts of identity and affect has been underestimated, it does not seem to have been noted that he often works with objects in an analogous fashion. Consider for a moment the flask and sack near the lower edge of the *Visitation* (see fig. 77). Why might one suppose the sack to contain loaves of bread? The question may seem banal; the probability that the metal jug contains wine and the proximity of both elements to the altar seems reason enough. Yet a survey of Barocci's works (something that most early viewers of the *Visitation*, of course, could not pursue) reveals an important "prehistory" of this motif through the painter's development and manipulation of similar details and elements in other works. In the *Rest on the Return from Egypt* (see fig. 181), for instance, created about a decade before the *Visitation*, the corner of a loaf of bread actually protrudes from the sack that lies, with the Virgin's sunhat and a flask, beside her feet. As she reaches with a small silver bowl to collect clear water from a stream, it might be inferred that her flask contains wine. Another flask, canteen-like and wrapped in wicker, accompanies the central beggar in the *Madonna del Popolo*. Here it could plausibly contain wine or water, though its position directly behind the area in which the priest would elevate the elements of the Eucharist might again imply wine. Bread is not in evidence in the Aretine altarpiece because it is needed: daily bread is something beggars must seek and this one has his hand outstretched.

The same flask, or one very like it, returns in the foreground of the *Martyrdom of San Vitale* (fig. 143), paired once more with a loaf of bread protruding from what appears to be a small satchel that has been hurriedly set down. As in the *Visitation* these elements lie close to the altar; here their connection is only reinforced by the narrative drama of the work, in which the martyred saint is hurled forward and down into a well (and by extension into the altar/tomb before and below the represented space, and ultimately into the actual holy well that in Barocci's day still existed near this altar in San Vitale in Ravenna).[9] However, there is a difference in the *Martyrdom* that registers some of the richness of Barocci's employment of everyday objects as bearers of significance. When Joseph gently deposits the sustenance of a family he knows to be holy, chosen by God, at the end of a day's journey, one may assume that he – a saint – could sense that there is meaning in the substances

and the actions of his life that lies beyond the mundane, meanings that God will make apparent in the fullness of time. When the beggar in a Christian society receives sustenance from a Christian charity it is possible that he will pray over it, perhaps even meditate – as preachers might well ask of him – on the possible analogies between his crust of bread and sip of watered wine and the presence of Christ made manifest in the Eucharist celebrated by the same confraternity that has given him the means to sustain immediate life. In the narrative action of the Ravenna altarpiece, however, it seems evident that the bread and wine have been set down without thought – certainly without reflection – by one of those intent on burying the martyr alive. Presumably this is the young man with his back to the viewer, who hurls a stone on top of the falling saint; in a few moments he will pick up the shovel he has laid down beside his lunch and contribute to the work his companion in the straw hat has already begun. When the saint has been fully buried, the young man will attend to his restorative meal.

Borrowing Paleotti's discourse, the figure may be said to be entirely sensual, certainly able to enjoy his wine and bread but unconcerned about further reflection; he cannot imagine the possible connection of such things to the spiritual life, much less to a "new covenant." It is for the pious viewer before the painting to notice what those within the picture ignore and to realize that God works through the things of this world even when human actors ignore or actively oppose the divine purpose. The young man surely does not realize, for instance, that he has set his shovel down in such a way that its blade becomes a gleaming arrowhead pointing down toward the cross on the altar – and toward the elevated host itself during the drama of the Mass. Nor does the officer behind the well realize that he has positioned his staff in such a manner that it ultimately leads the eye back through the saint to the same liturgical objects, the cross of Christ's sacrifice and (during Mass) the host that literally represents the body of the Lord. Nor does the halberdier in the middle ground behind the young rock-hurler realize that he holds his weapon in such a manner that it forms a kind of cross against the sky, one whose point both indicates the nude putto angel descending with San Vitale's palm of martyrdom and unwittingly (and vainly) opposes that holy descent. In fact there are three halberds that stab the sky here – an allusion to the three crosses? Barocci's composition allows for this obvious line of thought but does not insist on it. His objects are objects in the world, objects in the *istoria* – and they make sense as part of their stories. Bellori noticed how the seemingly irrelevant *parerga* of the little girl in the left foreground, who was feeding cherries to a bird before turning in shock to witness the death of the saint, could signify something of import to the religious narrative and to cultic devo-

tion at the saint's shrine: Barocci had depicted cherries, Bellori wrote, to demonstrate that the saint's martyrdom occurred in June.[10] Paleotti might have said that Bellori had attained rational cognition, perhaps even begun to enter into spiritual cognition; he had relished Barocci's detail on the sensual level, then considered why its presence might be significant in a rational manner and for a religious purpose. Perhaps there is a further degree of spiritual insight that might be attained here. The composition of the girl and her bird balances that of the bread and wine, and three cherries remain on the branch, in a tight group. Barocci does not force one to draw inferences here, or with the halberds, or in many other instances. What he does is to layer rich possibilities into his sensual depiction of the objects of nature and the everyday; there is always more to say, more to reflect on, more at which to wonder.

Barocci frequently accomplishes this enrichment of possibility by a device already encountered in the *Visitation*; he activates the objects of still life (or better, the *cose piccole*). While in some paintings bread and wine constitute an element of representation that is literally still, in the *Visitation* Joseph sets them down, arranges the relevant objects before one's eyes. In the Ravenna altarpiece the shovel is discarded in a peculiarly active position; the officer rams his baton of command into its particular and telling angle, which may shift at any moment; and the halberdier swings his spear to the sky as he leans forward to witness the saint's demise. All these objects are in use or about to be used. It is only in the split second of moving drama frozen by the painter's brush that they cohere, for an eternal instant, into suggestive configurations pregnant with implications. Objects that are held or set down in a manner that focuses and directs the attention of the beholder constitute both the core elements of Barocci's "still life in action" and one of the types of *parerga* that Barocci evolved, re-adapted, and reemployed over the course of a number of projects. For instance, the sharp base of the staff of San Simone's halberd is already a silver arrow pointing to the altar cross in the early *Madonna di San Simone* (see fig. 177). Then in the *Madonna del Popolo* (see fig. 24), the sharp tip of the base of a walking staff that has been laid down by one of the beggars is angled so that it also indicates the altar. That this is deliberate is made clear, for the metal tip suddenly catches a highlight against a backdrop of deep shadow. Such details constitute the prehistory of the shovel in the *Martyrdom of San Vitale*.

The importance of the staff in the *Madonna del Popolo* was registered in a wash sketch after the altarpiece by Francesco Vanni, who made an artistic pilgrimage to see the painting (fig. 144). Although Vanni was principally interested in establishing the play of light and shadow across the dramatic figures in the work, he noted the gleaming point of the staff and captured it as a sharp arrow of pale paper with a dark wash of shadow brushed

143 Barocci, *Martyrdom of San Vitale*, 1583, oil on canvas, 392 × 269 cm. Milan, Pinacoteca di Brera.

144 Francesco Vanni, study after Barocci's *Madonna del Popolo*, probably 1586–7, chalk and wash on paper. Oxford, Ashmolean Museum, n. 737.

quickly all around it. The form of the staff is not depicted; it is present only as a ray of light in the dim shadows. In a wash drawing that studies light effects, this is an efficient and meaningful way to register form. Yet the attention Vanni paid to a seemingly marginal detail in a relatively undetailed drawing seems to indicate that he understood Barocci's painting well. It is just such a detail that – if one follows Paleotti and admits that for many late sixteenth-century viewers even the compelling painting of lights and shadows could produce delight – might have stimulated a brief *frisson* of visual *vaghezza* that was then transformed seamlessly into spiritual contemplation of the ways in which God might use the most mundane objects and actions

to reveal the workings of the sacred in the world. Vanni's attention to such details would have been critical in his ability to create, in Baglione's memorable phrase, his "Barocci-style *vaga maniera*, done with love." Indeed, as Vanni probably realized, Barocci employed such devices so often that they became a leitmotif of his production. In addition to the examples already considered, the figure of Saint Nicholas of Bari in the *Perdono* (see fig. 52) holds his crozier in such a way that it, too, points to the altar and its cross below – and directs viewers to their model and intercessor Francis in the process. Later, when Barocci created the *Institution of the Eucharist* as the altarpiece of the Aldobrandini chapel, small silver or pewter plates became the critical objects

(see fig. 130). Elements of still life in a genre scene, the plates are being washed and arranged. Their proximity to both the appearance and the location of the paten on the altar requires no comment. The everyday and the incidental – portrayed in all its particularity and "real presence" – has become caught up in sacred drama and the universe of spiritual contemplation.

Even Barocci's most obviously devotional still life is composed both to direct one's attention and to generate wonder at how the unreflective actions of human beings and of nature may create patterns and arrangements through which God speaks meaning. The composition of instruments of the Passion in the foreground of the Senigallia *Entombment* (see fig. 83) confronts the viewer like a devotional still life from a fifteenth-century *Lamentation*. In its stillness and physicality, the hard materiality of suffering and death is brought close to the pious viewer who stands before the altar. In addition, there seems an almost ritual care in the arrangement of the objects that echoes the painstaking liturgical arrangement of the instruments of the Mass on the altar itself – an analogy that would have possessed particular relevance for the officiant. Yet Barocci does not allow his still life to remain entirely still, entirely contemplative. It is part of a drama, as indeed are the ritual objects of the Mass. The nails were casually set down, perhaps, but they point aggressively toward the dark mouth of the tomb, as does the cruel pincer below them. The hammer has been dropped over this pincer to form a cross, even as the hammer is itself a kind of cross, and points – like the staffs and halberds and walking sticks of earlier paintings – at the altar cross. The handle of the hammer, meanwhile, indicates the point at which two of the nails cross; and the nails themselves point out not only the tomb but also another cross, embedded in nature – the reeds that lie between the leading foot of Saint John and the flowing robe of the Magdalen. This detail might pass unnoticed except that Barocci floods it with light and situates it so that it connects, like a spark of energy, the figures of John and Mary Magdalen. Where two of the reeds nearly touch the edge of Mary's robe in the surface pattern of the painting, her garment sweeps back to reveal an intense orange-red lining that matches the passionate flush of her face as she sees the dead Lord. I have noted already, in Chapter Four, how Barocci transformed a detail from Raphael's Baglioni *Entombment* to create in the cross of reeds a remarkable microcosm at the heart of an altarpiece. Yet how is one to suppose these reeds have come together in this configuration? The wind? The passage of feet? The viewer is virtually forced to meditate on such questions and to come to perceive in a seeming accident of nature the hand of God. In the process, this inconsequential detail, made of negligible substance, becomes a second center of the painting. It is nature's luminous ground for the spotlit body of the Savior, the *parergon*

that lies close to the heart of the *ergon* itself. It is ultimately a brilliant microcosm of all material creation that, as Paul writes, waits breathless for its fulfillment in God's plan. Paleotti's pious viewer could take delight, indeed.

There is another point to be made about the still life elements in Barocci's paintings and it is frankly surprising. For all their evident care, Barocci's *cose piccole* seem to have been *parerga* in his process as well as his composition; that is, they were created, like ornaments, near the end of his long and painstaking process of pictorial generation. I hasten to acknowledge that this cannot be known with absolute certainty, but in nearly every case that can be documented, *modelli* and composition drawings from a fairly advanced stage of planning do not yet depict such details or actions. Even the worked-up compositional drawing for the *Madonna del Popolo* (see fig. 49) does not exhibit the beggar's pointing staff, while highly finished studies for the *Martyrdom of San Vitale* do not contain the still life of bread and wine (fig. 145). Further, in this drawing, the shovel that will point to the

145 Barocci, compositional study for the *Martyrdom of San Vitale*, pen, wash, charcoal, and white heightening on paper, 33.9 × 22.5 cm. Paris, Musée du Louvre, inv. 2858.

146 Barocci, compositional study for the *Last Supper*, 1590s, charcoal, wash, and white heightening on paper, 110 × 109 cm. Florence, Galleria degli Uffizi, Gabinetto dei Disegni, inv. 819 E.

altar cross in the painting points away from it and is much smaller. Indeed, even the signifying arrangement of the three halberds to the viewer's right in the altarpiece – crosses against the sky and vain opponents of the divine purpose – is not yet fully registered in this detailed study, or even in a squared drawing that notes most of the detail of the solution achieved in the painting.[11] An analogous phenomenon in another pair of paintings is still more surprising. The central paten-like dishes positioned at the center of the lower edge of the Urbino *Last Supper* (see fig. 134) are not yet present in the beautiful *modello* (fig. 146), despite the fact that the basket of dishes to the left and the dog staring soulfully at the viewer from beyond the large basin to the right have already been worked out with great care. This is

not an altarpiece but a lateral; however, the ultimate inclusion of the central group of plates in a chapel dedicated to the Most Holy Sacrament could imply that Barocci is evoking Eucharistic associations. This supposition might appear to be confirmed by his similar handling of the foreground of the later Roman *Institution of the Eucharist*, that is, of course, an altarpiece. The painter appears to have simply adopted a compelling device from an earlier composition. Yet the early *modello* for the Roman painting (see fig. 135) indicates a far different idea, with the plate of the begging child occupying the central place, while the later *modello* (see fig. 157) – significantly revised in the direction of the final composition – has no stack of paten-like plates at all. These entered only at the last stages of execution.[12]

This phenomenon is akin to the procedure that drawings reveal for Raphael's invention of the *Disputà* for the Stanza della Segnatura. They indicate that the monstrance, which appears to be the fulcrum of the entire fresco, was introduced late in the design process.[13] While none of the material objects in Barocci's paintings take on quite such centrality – and one certainly hesitates to identify the monstrance in the *Disputà* as an object of still life, a *parerga* – the procedural analogy is nonetheless surprisingly close. Barocci seems to have wrestled first with the figural arrangement of the leading actors in his *istoria*. Slowly, as the composition developed, he arrived at the creation of a group of objects that, even if apparently marginal and mundane, also become actors. His creative process is, as it were, the mirror image of the viewing process of a "Paleottian" beholder. Barocci thought through the figural enaction of sacred *istorie* first and then progressively heightened pictorial *vaghezza*, whether that of color and technique or that afforded by the luminous portrayal of objects and incidental creatures. This process made it all the easier for him to envision effective roles for *parerga* beyond the purely sensual and ornamental, *parerga* that allow viewers to move easily from sensual delight to rational investigation to spiritual enlightenment. Although he invented them late in the design process, however, the importance such *parerga* held for Barocci may be evoked by his strategy in signing the *Martyrdom of San Vitale* (see fig. 143). Barocci inscribed his name and the date in proud Latin majuscules on a rock in the lower right foreground. Against this rock rest the bread and wine of the worldly young man who helps to inter the saint, on it lie his garments, beside it the shovel that points like an arrow at the altar cross. A nursing female dog, meanwhile – the animal analogue to the human mother in the left foreground – has emerged from foliage behind the rock to perch on it and to confront a lizard at the extreme right corner of the canvas. Barocci's decision to surround the signature that marks his ambition as a painter with this cluster of objects and activity can stand as a sign of his investment in the compelling representation of the myriad details of the material, the sensual, world, through which viewers may at times perceive the traces of the divine.

Much of this section has been based on close readings of visual details, without recourse to period texts apart from the citation of some evocative passages in Paleotti and one specific reference in Bellori that does not directly connect *parerga* to meaning except insofar as the cherries in the *Martyrdom of San Vitale* recall the season of the saint's death. I would maintain that it is something of a compulsion among art historians forever to desire textual support for every aspect of art historical reading. In much art historical work one must sooner or later confront the daunting challenge of illuminating the ways

in which images speak in distinct, non-textual and non-linear fashion; certainly the images I have been considering repay attentive, informed looking. Nonetheless, if one were to desire more textual indications from viewers in early modern Italy that Barocci's *parerga* in particular registered something of the qualities I have been tracing, an intriguing passage could be noted in a lengthy manuscript guide to Rome, written by a religiously conservative French visitor who seems to have spent some time in the city during the 1670s. The writer has become incensed at an altarpiece in Santa Caterina da Siena a Magnanopoli, which occasions an extended attack on "lascivious" sacred paintings and the rather extreme accusations that most painters "only want to please the eyes of libertines" and that painters themselves are "ordinarily lascivious people." The visitor speaks with great approval of the censorship of such art he sees in certain circles in Rome and then turns, suddenly, to an encomium of Barocci. Barocci, he asserts, was one of the best painters of his age and a worthy follower of Titian and Correggio. He even surpassed them in one critical particular: he never painted a work that was not devout.

Such statements were conventional by this date and could come straight from Bellori or Baglione. However, the writer proceeds to illustrate his point by asserting that Barocci "had the habit of always placing in his painting some*thing* [italics mine] that was agreeable, while the others [painters] sought to achieve this [agreeable effect] with the liberty they gave to their figures. For example in a painting of the martyrdom of Saint Vitalis at Ravenna there is a magpie that flaps its wings with a little child who puts a cherry in its beak, which shows the talent that he had to give grace to the smallest things." The example from the Ravenna altarpiece could have been gleaned from Bellori, but the visitor's contextualization of this detail as an illustration of both the way in which Barocci brought grace even to the *cose piccole* of his works and his ethical choice to display his artistry in *parerga* rather than in the cultivation of overly sensual figural *vaghezza*, is particularly striking and must reflect ideas gathered from an acquaintance with other sources. Indeed, the writer explicitly praises an untraced text by Giovanni Battista Capponi of the University of Bologna, *De multiplici pictorum in sacris abusu diatriba*, which he describes not only as a critique of abuses in sacred painting but as an "encomium of the celebrated Barocci."[14] It seems that even in the 1670s, and in varied parts of Italy, viewers might still perceive how effectively Barocci's figures of animals and children could operate as substitutes for and displacements of the lovely bodies that so often carried the charge of pictorial *vaghezza*, and could stimulate pleasure and admiration without arousing those "lascivious" thoughts that caused scandal and led the mind astray.

INNOCENT EYES AND DISTRACTED LOOKING: FIGURES OF ANIMALS AND CHILDREN

It has already been noted that it is often animals or children who meet the viewer's gaze in Barocci's canvases, rather than the adult dramatic actors in the sacred *istorie*. In what seems to be the only instance of a central actor meeting the viewer's gaze, Christ joins the trussed sheep in regarding the beholder from the *Circumcision* (see fig. 133); but here he is a child, indeed an infant. Often, too, animals – and sometimes children – are represented close to critical elements of still life. The trussed sheep in the *Circumcision* is juxtaposed not only to the Christ Child but to the ritual basins of the temple, with which it shares the foreground; a dog confronts a lizard beside the bread and wine in the *Martyrdom of San Vitale*; the hurdy-gurdy player's dog gazes out at us with engaging innocence as it rests beside the walking staff that points to the altar cross in the *Madonna del Popolo* (see fig. 24); the donkey whose gaze rivets one's attention in the *Visitation* (see fig. 77) is revealed as Saint Joseph stoops to set down his "still life" near the altar. Such potentially significant conjunctions are exemplified in the endearing figure of the little boy near the right margin of the late *Presentation of the Virgin* (see fig. 127), who looks soulfully at the beholder while he nibbles a piece of bread.

The gaze of animals and children is both innocent and simple. This is critical to their function in Barocci's paintings in at least two ways. First, they may thematize the state of mind appropriate to pious viewing – "clean and innocent," as Paleotti put it. Every period viewer, too, would have known that arresting statement of Christ concerning children: "it is to such as these that the kingdom of Heaven belongs."[15] Second, representations of an endearing dog with a silky coat or a seminude child with soft pink flesh allowed for the generation of sensual *vaghezza* that would not be considered as conducive to the lascivious thoughts that might be provoked by adolescent or adult human beauty. Some aspects of this alternative figural *vaghezza* – particularly in the figure of the putto – have been highlighted in the preceding chapter, but the children and animals exemplified by the dog in the *Madonna del Popolo* or the little boy in the *Presentation* offer related yet different connotations from those embodied in the putto. They belong to our world, the world of mortal creatures, not that of angelic beings. Further, the children who meet our gaze or perform actions of import for us as viewers of Barocci's paintings are frequently (though not always) older than infant putti and younger than the proto-adolescent serving boys whose figures are just this side of those "young men or women a little more *vaghe* than usual" that could cause such consternation. When three- to nine-year-old

children are represented, they may be figured as occupying a unique state of teachable innocence: they experience the world innocently but also simply and need to be taught to see in a more mature manner. Herein lies the critical distinction. If mortal children in Barocci's compositions often function both as "figures of innocence" and as figures that emblematize the sort of licit sensual viewing that Paleotti describes at length, they can also indicate ways of seeing that must ultimately be surpassed. Adult viewers first delight in the sensual – or child-like – manner of seeing, but eventually reflection convinces them that they must move beyond childlike delight to embrace a way of seeing that remains innocent yet is more mature. In this sense, children in particular assume in Barocci's altarpieces the double significance they hold in the New Testament. Christian viewers must "become like little children" in innocence, but with Saint Paul they must also remember that "when I was a child, I used to talk like a child, and see things as a child does, and think like a child; but now that I have become an adult, I have finished with all childish ways."[16] The *Madonna del Popolo* predictably offers one of the best sites for examining Barocci's use of both animals and children to instill sensuous delight – and then to call pious viewers to "higher" seeing.

Of all the figures in the great altarpiece from Arezzo, only two look out at the beholder. From the heavens, a lovely angel, figured as a child of eight or nine – about the age of the little girl in Correggio's *Madonna of Saint Sebastian* (see fig. 132) that Scannelli reports threw viewers into raptures – gazes on those before the altarpiece with innocent love and welcome.[17] Below on earth, and in the right foreground, the beautifully painted dog fixes the viewer with soulful eyes. In the compositional drawing (see fig. 49), the angel gazes down at an act of alms-giving within the painting and the dog barks eagerly; neither looks at the beholder. Barocci's decision to alter both figures in the painting, then, reflects deliberation about appropriate inter-locutors for those who stood before the altarpiece.

It is possible – though nothing is forced on the viewer by Barocci – that one notices the dog first. Certainly the priest, at work at the altar, would be close to this figure and indeed would stand just between the dog and the excited child in the left foreground who turns from his prayers to gaze enraptured on the animal's loveliness. This dog is truly a lovely creature: one can virtually feel the silken fur, and the brown eyes that fix us are deep and full of that availability for affection that so enamors humans of dogs. The dog enlists sympathy as well, for it and for the beggar whose companion it is. The beholder may wonder if the creature has had enough to eat; it is not a coincidence that the dog lies directly below the critical narrative gesture of the figures on earth, the giving of alms to the mother with an infant child. We as viewers thus share the interest and

delight in the dog that is expressed by the boy in the left fore-ground. He, too, is a figure of delight, partly nude and a little older and larger than the putto angels who support the cloud on which the Virgin rides. He leans decisively back toward our space to obtain a better view, both of the dog and of the hurdy-gurdy player, and he is fascinated by both.

Yet as viewers delight in this innocent *vaghezza*, they become aware that the little boy is poised to pray. Indeed, one can surmise that he has just been praying to the heavenly apparition under the devout guidance of his mother. Allured by the rustic joy of the hurdy-gurdy's earthy music and the creaturely loveliness of the dog, he has become distracted. The sensual delight he experiences is innocent, but it now interferes with his ability to attend to heavenly things. He has also compromised the devotions of others. His mother is forced to turn and enfold him gently with her rosary-bearing hand, directing him with a theatrical gesture to look inward and upward; his agitation has also distracted his serious elder sister, who looks back from her devotions. Paleotti's viewer must now realize that while initial delight in Barocci's sensually compelling representation of an animal, a child, or a genre figure (the hurdy-gurdy player) is acceptable as an innocent stimulation of the senses, greater delights – those of reason and the spirit – await and demand that the gaze ultimately focus elsewhere. If viewers follow the insistent gesture of the devout mother and raise their eyes, they exchange the gaze of the homeless dog for the gaze, shy yet knowing, of the little angel who welcomes them – late-comers though they are – to the glories of heaven. It is no accident that the boy is directly below this angel. As Christian viewers turn from delight in the one to delight in the other, they preserve sensuous delight – remember how Correggio's similar figure "ravished" viewers even as she performed a devout religious function – yet add the higher delights and put away any sensual distraction. As they look from the child who does not notice them to the angel who does, they "put away childish things" and "see face to face."

SIGNIFYING SPACES: SETTING AND MEANING IN THE ALTARPIECE

The inclusion of architectural settings in Barocci's altarpieces under the rubric of other *vaghezze* might seem tendentious. Yet as has been noted, Paleotti could associate the depiction of buildings with those of animals, plants, landscapes, and "all the works of the great machine of the world" as sorts of representation that could produce innocent sensual delight, a "chaste *vaghezza*." It is notable, too, how often Baglione, in what is evidently a considered deployment of the term in the *Vite*, perceives elements of architecture as *vago*. Onorio Longhi's garden

gate to the Altemps vineyard just outside Rome is *assai vaga*, for instance, while a fountain in Rome is "the beautiful, and *vaga* architecture" of Francesco Volterra.[18] Of course, such structures associated with gardens might partake of the *vaghezza* that even Gilio associates with the beauties of renewed nature. Baglione repeatedly refers to gardens as spaces that are *vaghissimi*. However, the balustrade before Pope Clement VIII's great Altar of the Sacrament in the transept of San Giovanni in Laterano is also described as *vaga*, as is the entire church of Sant'Anna dei Palafrenieri (among others).[19] In the most general statement he makes about modern architecture, Baglione identifies fundamental qualities of *terza maniera* building as *vaga*:

> Bramante . . . Raphael, Giulio Romano, and Michelangelo . . . revived the true magnificence of ancient architecture; in the composition of their works there is great art . . . the elements [of buildings] demonstrate harmony, and *vaghezza*, and their proportions were so well understood that, following their example, good masters today can with lovely symmetry and *vaga* harmony among parts . . . undertake and happily complete works and buildings.[20]

The musical implications of Baglione's "*vaga* harmony" will have to be explored in the concluding chapters. For the moment, a discussion of Barocci's painted architecture is relevant because one can perceive in his works a strong link between the meaningful deployment of objects in still life compositions on the one hand and the "signifying articulation" of architectural settings on the other. The first is the microcosm, the second the macrocosm. The one genre of representation invests objects in the space with significance, the other the architectonic compartment of the space of action itself.

Barocci is not usually discussed as a painter of architecture, except with reference to his oft-noted penchant for including details from the cityscape of Urbino – particularly the Ducal Palace – in the background of many of his paintings. Yet Bellori writes that Barocci studied architecture seriously and at an early age, under the tutelage of Bartolomeo Genga:

> When Battista [Franco] left Urbino, Federico moved to Pesaro and stayed in the house of Genga, who granted him permission to study the paintings of Titian and the works of the other principal masters that were then in the Duke's gallery there; and at the same time Genga taught him geometry, architecture, and perspective, in which subjects he became learned.[21]

Vittorio Venturelli had said as much in 1612 in Barocci's funeral oration, given before citizens who had known the painter well. Venturelli argued that Barocci joined to "the most profound understanding" of the rules of *istoria* and of pictorial technique

and style "an exact knowledge of mathematics, perspective, and architecture, necessary competencies for an excellent painter."[22] Much visual evidence, from the care with which Barocci arranges signifying details in the surface pattern of his compositions, to his evident skill with perspective, to specific architectural references in his paintings, seems to bear out these assertions. In one of his earlier surviving drawings, from the happy years in Rome at work in the Casino of Pius IV, Barocci ideates an illusionistic ceiling decoration with architectural elements soaring in sharp foreshortening above putti who bear heraldic arms (fig. 147). Nor did he ignore the study of specific architectural monuments in Rome: he seems, for instance, to have been enamored of the Tempietto of his compatriot Bramante (fig. 148); it anchors the *all'antica* cityscape in the surviving version of *The Flight of Aeneas from Troy* and returns in the background of the late *Madonna Albani* (figs 149 and 150). John Shearman has noted that the latter work might have been painted by assistants with the use of autograph drawings, one

147 Barocci, drawing for the decorations of the Casino of Pius IV, 1561–3, pen, wash, and white heightening on paper, 27.5 × 30.9 cm. Florence, Galleria degli Uffizi, Gabinetto dei Disegni, inv. 907 E (v).

148 Bramante, Tempietto, c. 1502. Rome, cloister of San Pietro in Montorio.

149 Barocci, *Madonna Albani*, unfinished, start date unknown, oil on canvas, 114 × 81 cm. Rome, Banca Nazionale del Lavoro.

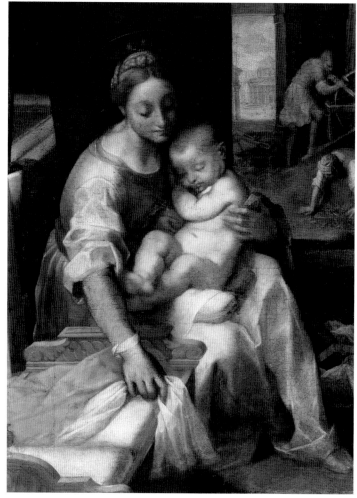

of which could well be the careful study of Bramante's building that is generally accepted to have been produced by Barocci as he planned the *Flight of Aeneas* (fig. 151).[23]

There are, however, a number of differences between Bramante's building and Barocci's redaction of it in both the drawing and the painting. Instead of three steps that lead to a stylobate that is cut on the entrance axis for additional steps, Barocci's "revision" exhibits a circular base of four steps. Little piers punctuate the balustrade above the Doric entablature of the lower story. The pilaster strips of the Tempietto's drum have been developed into a full order of Doric pilasters. Finally, the building has been re-conceived as an ancient temple: Barocci has replaced Bramante's distinctive metopes, with their Christian spiritual symbols, with more strictly *all'antica* metopes. Two

ABOVE 150 Barocci, *Flight of Aeneas from Troy*, 1598, oil on canvas, 179 × 253 cm. Rome, Galleria Borghese.

RIGHT 151 Barocci, study of Bramante's Tempietto (possibly for the *Flight of Aeneas*), c. 1588, pen, wash, chalk, and white heightening on paper, 45.7 × 42.1 cm. Florence, Galleria degli Uffizi, Gabinetto dei Disegni, inv. 135 A.

179

152 Bramante's Tempietto, from Sebastiano Serlio's *L'Architettura: Libro Terzo* (Venice, 1540), plate XLIII.

153 Illustration of the Column of Trajan and obelisks, from Sebastiano Serlio's *L'Architettura: Libro Terzo* (Venice, 1540), plate LXII.

of the more visible alterations – the different arrangement of steps up to the colonnade and the transformation of the articulation of the drum – are also found in Serlio's woodcut of the Tempietto in the *Terzo Libro* of his architectural treatise, published in Venice in 1540 and extremely well known (fig. 152). These indications that Barocci may have referred to Serlio are only strengthened when one notes that a depiction of the Column of Trajan stands beside the Tempietto in the background of the *Flight of Aeneas*: Serlio included woodcuts of both the entire column (fig. 153) and some of its details in the same book of his treatise. It seems more than coincidental that Barocci pairs these two monuments – an ancient landmark and an "anciently modern" one – in the background of his *Flight of Aeneas*. The decision to transform Bramante's Doric frieze to "historize" the temple, to make it fully appropriate for a scene from ancient history, indicates the care with which Barocci thought through every detail of an *istoria*.

Barocci's repeated recourse to the form of the round temple – versions appear in a number of his paintings – may imply something about his intellectual interests in architectural form and setting; Serlio expressed the opinion of many ambitious

architects and patrons when he opened his Book Five, on temples, with the assertion that "because the circular shape is the most perfect of all the forms I shall begin there."[24] Yet Barocci's careful adaptation of Bramante's Tempietto exemplifies two qualities of his fictive architecture that are even more central to his project: learned sensitivity to the significance of particular architectural orders, and a knowing use of architectural history. Barocci expressed his architectural learning and sense of decorum most decisively in a few later paintings in which he calibrated the order and ornament of spaces not only to impress the eye but also to set the tone of a sacred *istoria* and to signify fundamental aspects of its message through that "classical language of architecture" first codified in writing by Vitruvius and developed by Renaissance theoreticians and builders. This is particularly clear in the *Last Supper* (see fig. 134) and the *Institution of the Eucharist* (see fig. 130). In both cases, surviving preparatory drawings illuminate a particular trajectory in Barocci's thinking: his transformations of the backgrounds of these paintings between compositional studies and finished works reveal a particular sensitivity to the language of the ancient orders and its potential to inflect the atmosphere and interpretation of the scene.

154 Interior of San Francesco della Vigna, Venice.

The beautiful and highly polished *modello* for the *Last Supper* represents an advanced stage of planning (see fig. 146); by and large, only incidental details were altered between this drawing and the finished painting. However, one detail is far more than incidental. In the *modello* the room is articulated by the Corinthian order; in the painting, the space has become Doric. The late transformation of the order is as remarkable as the articulation of the space so overtly with an order; for all Barocci's evident familiarity with architecture, he had rarely ideated detailed architectural settings for his pictures. Indeed, he had at times moved from more to less architecture in the planning of a picture. For instance, the elaborate vista of a piazza and street that defines the background in a study for the *Visitation* is radically simplified in the finished altarpiece (see figs 77 and 80). The *Last Supper*, though, presented a particular issue: the *istoria* called for a setting in the defined space of a chamber, and for an architecture of a dignity befitting the holy sacrament that was represented in the painting and celebrated in the chapel. Given this, it is not surprising that Barocci ultimately decided to create a space articulated by the Doric order. Serlio had codified a tradition of interpreting the Doric when he asserted:

> The ancients dedicated the Doric work to Jupiter, Mars, Hercules and to a few other robust gods. However, after the incarnation of man's salvation, we Christians must proceed in a different way. When we have to build a temple conse-

crated to Jesus Christ our Saviour, or to St. Paul, St. Peter, St. George or other similar Saints, since they . . . were manly and strong in leading out their lives in the faith of Christ, the Doric type is suitable for Saints of this sort.[25]

Here Serlio develops Vitruvius's statement that the "Doric column came to exhibit the proportion, soundness, and attractiveness of the male body."[26] The connection had already been made, however, by Renaissance builders and theoreticians. It is possible that Bramante's choice of Doric for both the Tempietto and the Tiburio over the shrine of Saint Peter in the Vatican reflects Peter's heroic status as a male martyr.[27] At about the same time, the Observant Franciscan church of San Salvatore overlooking Florence was articulated with the Doric order as well. About three decades later, Jacopo Sansovino based the interior articulation of his Observant Franciscan church of San Francesco della Vigna in Venice on the nave of San Salvatore; it appears that the employment of the Doric in both these churches is a conscious sign for a reformed, strict religious observance within the grammar of the orders (fig. 154). This suspicion is confirmed in the case of San Francesco della Vigna by the remarkable *Memoriale* that the guardian of the convent, Fra' Francesco Zorzi, drafted concerning Sansovino's model for the project. Zorzi stressed that the church should be built in the Doric order, "for this is appropriate to the saint to whom the church is dedicated, and to the friars who officiate in it."[28] The Doric occurs frequently in sixteenth-century Observant

155 G. B. Mariani, *Santa Maria degli Angeli presso Assisi*, engraving depicting the state of the basilica before the damage of the earthquake of 1832 from Domenico Bruschelli's *Assisi città serafica* (Rome, 1821).

architecture, notably in the immense Basilica of Santa Maria degli Angeli outside Assisi, built to enshrine the tiny "Paleo-Franciscan" church of the Porziuncula (fig. 155).[29]

If the Doric was so evidently the order of choice for a representation of the *Last Supper*, however, it seems suddenly odd that Barocci first articulated the scene in the Corinthian Order. Moreover, why – having been through the process once – did he replicate the shift from Corinthian to Doric in the Aldobrandini *Institution of the Eucharist*? A drawing recording a developed stage of planning for the altarpiece reveals that Barocci again initially ideated the space as Corinthian (fig. 157). Once more, the painter's apparently facile reuse of figures or solutions proves on closer inspection to be anything but that. In thinking about the proper architectural setting for the altarpiece, Barocci again performed the extensive work of ideating the scene as Corinthian, only to change it eventually to Doric once more. Here the re-elaboration of a process to reach a solution already achieved elsewhere is doubly strange, first in that an old and infirm Barocci invested time and energy in this way, and second in that he did not settle on Corinthian for the painting, given that the altarpiece is framed on the altar wall by four sumptuous Corinthian columns (Barocci was apparently well informed about the chapel's architecture and decoration). Further, one might imagine that Barocci had a natural affinity for the Corinthian order. *Vaghezza*, after all, was frequently associated with feminine beauty, allure, and ornamentation, and there was no more "feminine" order than the Corinthian. Vitruvius had distinguished it from the feminine but "matronly" Ionic by relating it particularly to the slender proportions of a lovely maiden, and Serlio developed such think-

ing in largely predictable ways. In discussing the Roman triumphal arch at Pola, he described it as a "Corinthian work, which is so very rich in ornaments." He noted that the form of the column bases on the arch actually follows that of the Doric order, but "the delicate carving makes it Corinthian."[30] When he came to analyze the order in detail in Book Four, Serlio asserted of its style and proportions: "The Corinthian capital was derived from a Corinthian maid."[31]

Barocci's possible predilection for "Corinthian style" may be indicated by his very insistence on ideating both versions of the Last Supper first in that order, despite the evident appropriateness of the Doric. At the very beginning of his career, in one of his early surviving paintings, the Urbino *Martyrdom of Saint Sebastian* (see fig. 128), Barocci had ornamented the pilaster that dominates the left background with a Corinthian capital of the late Quattrocento type that he could have seen throughout Urbino, particularly in some of the spaces of the Ducal Palace and in the pilasters on the upper story of the large della Robbia portal for San Domenico (fig. 156). Further, it may be that once, when the mood and decorum of the sacred *istoria*

156 Portal of San Domenico, Urbino.

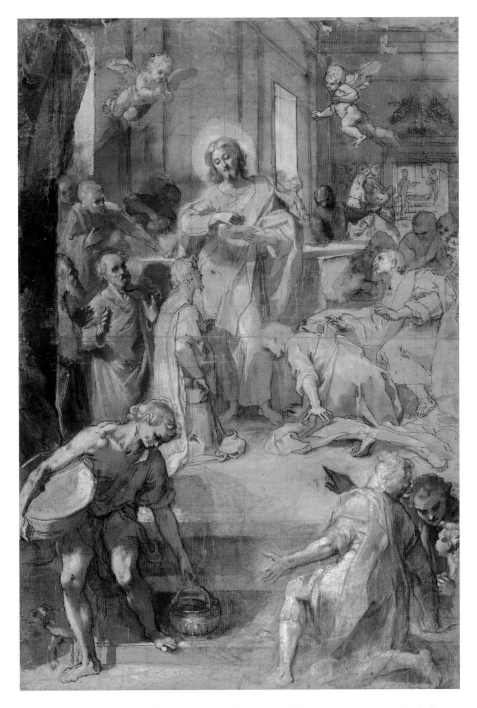

157 Barocci, preparatory drawing for the *Institution of the Eucharist*, pen, wash, chalk, oil, and white heightening on paper, 51.5 × 35.5 cm. Cambridge, Fitzwilliam Museum.

and *misterio* could be perfectly served by the Corinthian – the *Presentation of the Virgin* (see fig. 127) – Barocci did in fact employ that order to articulate the setting for the Virgin's entry into the Temple in a major Roman altarpiece. Neither the bases nor the capitals of the august columns and pilasters that flank the entrance to the Temple are visible, but the very richness of the forms that may be seen – fluted shafts, a richly carved pilaster beside the door (redolent of some of the Quattrocento

doorframes in Urbino's Ducal Palace), and the ornate frame of the door itself – together with the painting's focus on a maiden, all allude to a Corinthian sense of delicacy, loveliness, and celebration. Just after Serlio's assertion, adapted from Vitruvius, that the Corinthian order "is derived from a Corinthian maid," he continued: "I would certainly say that if you have to build a sacred temple in this Order, you should dedicate it to the Mother of our Savior Jesus Christ, the Virgin Mary, who was

not only a virgin before, but was a virgin during and also after giving birth." What he added, however, may appear surprising: "In the same way this Order, having such a character, is suitable for all those Saints, male and female, who led a virginal life." Serlio here extended the association of the Corinthian with the form of a maiden to employ it more generally as a symbol of virginity. Thus, the order could be as fitting for Christ – or for a church dedicated to Saint Peter – as was the more obviously appropriate Doric. Such thinking may constitute one of many reasons for the fact that Bramante's Tempietto in honor of Saint Peter is Doric, but the great basilica dedicated in honor of the same saint is Corinthian. It may also indicate why Barocci thought it appropriate to articulate the *Last Supper* and the *Institution of the Eucharist* first as Corinthian scenes.

Yet while the Corinthian order could provide a decorous symbol and setting for such sacred *istorie*, and might have been an order with resonance for aspects of Barocci's stylistic self-presentation, the fact remains that in nearly all Barocci's major paintings in which an architectural order may be identified that order is Doric (and probably in one case Tuscan). Indeed, the Doric may even ultimately dominate the *Presentation of the Virgin*. For all its ornate splendor, the entrance to the Temple need not necessarily be identified as Corinthian. Doric columns might take fluting on a noble building and the elaborate doorframe, on closer inspection, is nearly identical in decoration to the two doorframes in the background of the *Last Supper*. Further, it seems that the interior of the Temple, which is glimpsed through the open door behind the priest, derives closely from Bramante's choir of Santa Maria del Popolo in Rome (fig. 158). Such filiation offers both further evidence of Barocci's study of Bramante's buildings in the eternal city and a testament to Barocci's ever sensitive thinking about every aspect of a painting: what better architectural setting and "emblem" could one desire for a Roman altarpiece dedicated to the Virgin than a representation of the choir of the Roman church dedicated to her protection of the city's people? Yet Bramante's choir, as is always noted, is a space particularly distinctive for its august simplicity; while the inaptly named "serlianas" in the central bay of the choir employ Tuscan columns, the barrel-vaulted bay that immediately precedes the apse has no columnar order at all. In Barocci's adapted view, the wall that precedes the view into the choir is articulated with the round discs in the spandrels of the arch that feature on Vignola's famous formulation of a Doric arcade (fig. 159).

If the Doric and the Tuscan haunt even an image devoted to the Virgin in Barocci's mature work, it is surely no coincidence that the Tuscan order may articulate the background of the Franciscan *Perdono* (see fig. 52). Here again, as is the case

158 Choir of Santa Maria del Popolo, Rome.

with the entrance columns for the Temple in the *Presentation of the Virgin*, the pair of columns that flank the entrance to the inner chapel of the Porziuncula cannot be seen in their entirety. Their shafts are unfluted, however, and one can clearly see their bases; these display the simple single toros molding that can only be associated with the Tuscan or the Doric, and in Serlio's Book Four is solely associated with the Tuscan order (though Barocci's columns lack the round plinth that Serlio, following Vitruvius, recommends; fig. 160).[32] Whether Barocci was engaged in distinguishing between Tuscan and Doric in the *Perdono* is not entirely clear. He probably knew something of the great Doric sanctuary that Alessi was raising during those years to enshrine the primitive Franciscan sanctuary of the Porziuncula. Given Zorzi's explicit demand for the Doric in a Franciscan Observant building, John Onians seems correct when he reads Alessi's austere Doric at Assisi as a sign of Observatist rigor and reform – particularly in such an immense

church, which might be perceived as grandiloquent by many reformed friars, and in a church dedicated to the Virgin, for whom Corinthian was recommended by Alessi himself.[33] If Barocci viewed the "Porziuncula order" in his *Perdono* as Doric, he would almost certainly have intended viewers to read the space as one of primitive rigor and reform (though articulated through the revived antique orders rather than "orderless" medieval building). If he intended the Tuscan, however, he might have been attempting to envision the space of the early chapel as yet simpler, yet more humble, than the Doric that articulated the grand if austere modern basilica that enshrined the venerable sanctuary.

Barocci was probably well aware of the frequent Capuchin suspicion of any employment of classicizing architecture in reformed Franciscan buildings. He had already had significant contacts with local Capuchins, and eventually he supplied the high altarpiece for the overtly medievalizing "San Damiano

revival" church the friars constructed just outside Urbino (see figs 7 and 8). At the beginning of the seventeenth century, the Capuchins' leading architectural theorist, Fra Antonio da Pordenone, summed up the uncompromising position of the more rigorous among the friars when he wrote, in the introduction to a manuscript treatise on Capuchin building, "it is not for us to observe the Doric, or the Ionic, but rather simplicity, and poverty . . ."[34] It is in this intellectual climate that some early Capuchins investigated the first Franciscan architecture as a model for their own. When Barocci painted a "portrait" of the archaizing Urbino church in the background of the *Stigmatization* for its high altar, there may have been more to the decision than sensitivity to patronal taste and a sense of what one might term historical decorum. The "church within the church" certainly accommodates the taste of the friars who were to have the painting and makes a statement that their new church was entirely appropriate to the time of Saint Francis

himself; it was a building brought back to life from the distant, holy past. Barocci pursued analogous choices in the setting of ancient drama: one need only recall his Tuscan and Doric city in the background of the *Flight of Aeneas from Troy* (see fig. 150). However, this example returns the argument to the initial question: why, when Barocci articulated a painting with classical architecture, did he ultimately always settle on one of the simplest orders, after repeated experimentation with their more elegant and opulent siblings? The *Flight of Aeneas* offers some initial clues.

The Trojan War was clearly understood to be a relatively early event in "classical" antiquity, predating the foundation of Rome. Serlio, in his presentation of the "Five Styles of Buildings," had not spoken of a history of the orders but only of their relative forms and the implications these carried for an order's meaning, gender, and appropriate use. Yet Vitruvius had earlier offered a basic outline of the development of these orders in ancient Greece that located the Doric as the earliest to be invented, followed by the Ionic and the Corinthian.[35] Vitruvius did not speak specifically of the relative antiquity of the Tuscan *genus*, but one might assume that its simple forms, clearly related to those of the Doric, identified it as an early order as well. Thus when Barocci articulated the cityscape of Troy with Tuscan and Doric buildings, he was potentially making a sophisticated historical argument, through visual means, for the early date of the events depicted. The setting is not just "antique"; it is a particular and early setting.[36] An analogous mode of visual argument may be operative in the *Perdono*. While Barocci's Conventual Franciscan patrons here (and for that matter most Observants, such as those at the Basilica of Santa Maria degli Angeli outside Assisi) did not embrace the architectural austerity of the most radical Capuchins during the late sixteenth century, they were clearly cognizant of Capuchin critiques and concerned to display architectural restraint and decorum. Within the classical language, the Tuscan and the Doric were the obvious signs of reformed sobriety. Indeed, even Fra Antonio da' Pordenone eventually admitted as much. In 1623 he revised his manuscript treatise, perhaps in the expectation of publication. Where the original version had asserted "it is not for us to observe the Doric, or the Ionic," the revised text simply notes that "it is not fitting for us to observe all the rules of Architecture, but only those of simplicity and poverty." The exclusion of any specific reference to the orders is notable; its implications are realized a few pages later, when Pordenone gives the measurements and design for a simple Doric column, presumably the "highest" order he felt could be adapted for Capuchin building.[37]

Thus even the Capuchins came to accept, if grudgingly, that the simplest ancient orders might provide a compelling sign for Franciscan simplicity, sobriety, and poverty. These orders may have also, at least to some minds, stood for history, for a return to an "early" and implicitly purer style. It is notable that some of the sympathetic discussion of archaic images during this period held that old paintings had already expressed the basic concepts of good *disegno*, to which modern art added colors, elegance, ornament, and the impression of living flesh.[38] It may not be too farfetched to sense the potential for an analogy between old and modern painting and between a Doric and a Corinthian order. I would not push such a reading; there are obviously many situations in the late Cinquecento when it evidently would not pertain, when the relevant discourses were exclusively concerned with gender, or relative simplicity or opulence, or with appropriate symbolism for the function or dedication of an edifice. As I have noted elsewhere, the thinking of the late sixteenth century in terms of visual meaning and symbolism could be deliberate but was not totalizing or rigorously systematic. However, in a work such as the *Flight of Aeneas*, by a painter as engaged in issues of art history as one has seen Barocci to have been, a historical discourse might just join the stylistic discourse. In the *Perdono*, a Tuscan or Doric articulation of the chapel of the Porziuncula could function, within an *all'antica* context, exactly as the representation of the "San Damiano revival" church functions in the background of the Capuchins' *Stigmatization*.

We have thus returned to the persistent issue of Barocci's creative negotiations of retrospection and modernity in religious painting, and this may provide a way to perceive the changes in the architectural order of the *Last Supper* and the *Institution of the Eucharist*. The Aldobrandini painting, enshrined in an opulent Corinthian frame, is both a thoroughly modern painting with rich glowing color, beautiful figure painting, an *all'antica* setting – and a modern image that, through its very choices among possibilities for contemporary articulation, is also in its way as reformed and holy as those archaic Madonnas that were being enshrined in opulent Corinthian tabernacles at just this time. Barocci's painting is not archaic, nor is his choice of architectural setting. It is the architectural "order" of the *Institution of the Eucharist* that is reformed; in a way Aretino perhaps never imagined, it is "anciently modern." The architecture's forms are thoroughly fashionable in the *all'antica* language of building, but they also recall something particularly ancient as well as sober and upright. Barocci's painting is thus both a lovely work of art and a reformed religious image, partaking at once of the compelling mimetic and affective power of modern painting and of the sacred power and the aura of historical authenticity that were perceived as salient qualities of the old icons. His painting is surrounded by the architectural *vaghezze* of rich marble Corinthian columns and the colored

marbles that excited Baglione; the setting within the image, then, can become a sober counterpoint to the opulent celebration of the image in the altar decorations that enshrine it.[39]

One further aspect of this Doric setting is relevant here and it will have resonance for the consideration of analogies between painting and music that will conclude this study. The Doric, of course, was understood to have originated as the order of the Dorians. They likewise had a musical mode named for them and some analogy between certain musical modes and architectural orders had long been recognized.[40] While architectural theorists tended to agree on the character of the orders, sixteenth- and early seventeenth-century musical theorists were notoriously inconsistent. Nonetheless, it may be important that several of the leading theorists of the time agreed that the Dorian mode in music was "honest," "serious," and, critically, "devout." It could also be considered somewhat sad but was often perceived to be "sweet" and "pleasing" as well.[41] In this conjunction, at once pleasing, serious, and devout, theories of the affect of the Dorian order in music begin to echo the very conjunction between devotion and *vaghezza* perceived to be achieved in Barocci's painting. The rich cluster of period associations for Dorian music – sad, serious, pleasing, honest, devout – may provide another nuance in seeking to understand why Barocci framed the intimate, serious, and devout communion of the Apostles with a Doric structure.

∾

These reflections on architecture may ultimately have something to say about Barocci's "other" *parerga*, and indeed his lovely, "modern" figures. What the viewer confronts in Barocci's marginalia are objects and creatures, often appealing in and of themselves, the representation of which gives sensual delight while leaving the mind undistracted by lascivious thoughts. Without this distraction to arrest and derail the "progress" of thought, one is able to pass through and beyond the sensual delight that first allured the eye, to rational and ultimately spiritual contemplation. The principal actors in Barocci's sacred *istorie* lend themselves to a strangely analogous viewing process. Beholders may be captivated by their luminous (though clothed and chaste) beauty, then struck rationally by the care and decorum with which they act their roles in sacred drama. As viewers contemplate the mystical meanings inherent in the sacred drama, however – the *misterio* at the heart of any sacred *istoria* – they may become aware that certain critical figures assume poses or forms that hint at holy and venerable image prototypes, images nearer the source of divine revelation than those of the modern age. The rosy cheeks of a Barocci Madonna are veils of *vaghezza* through which the pious viewer, moving from sensual and rational delight in beauty and the power of imitation, may at times perceive the spiritual presence of an august prototype. The lures of color, light, and blushing beauty are not just veils, however; they have their own roles to play in Barocci's assertion of artistic modernity and in his cultivation of artistic affect. The devices of color and the brush – perhaps the ultimate "other *vaghezze*" – deserve separate study.

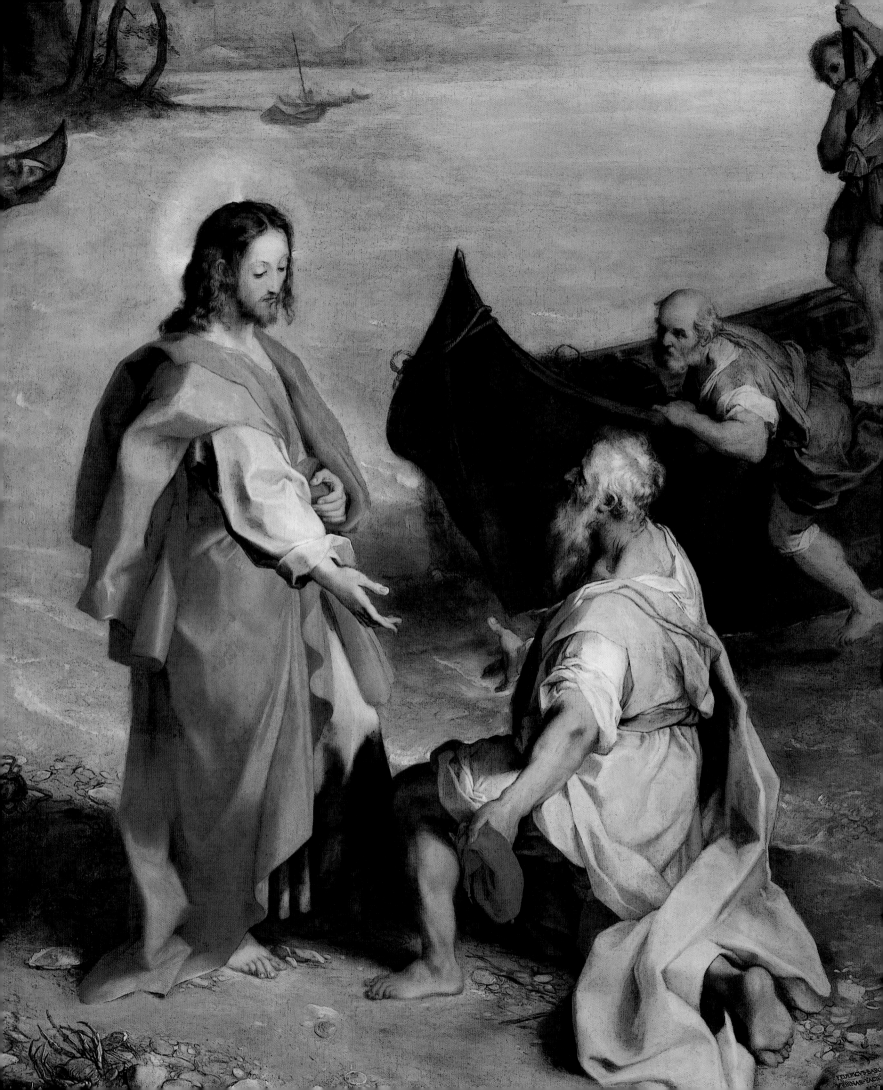

Colors of Vaghezza

ORNAMENT, DESIRE, AND SPIRITUAL FERVOR IN BAROCCI'S COLORING

The main problem of coloring resides, then, in the imitation of flesh, and involves diversifying the tones and achieving softness. Next one needs to know how to imitate the color of draperies, silk, gold and every kind of material . . . One should know how to simulate the glint of armor, the gloom of night and the brightness of day, lightning flashes, fires, lights, water, earth, rocks, grass, trees, leaves, flowers and fruits, buildings . . . , animals and so on, so comprehensively that all of them possess life, and never surfeit the admirer's eyes.[1]

In this rich passage, Lodovico Dolce sums up the relation of *colorito* to the pursuit of an art based ultimately on the figure, and by implication the critical role of coloring in relation to *disegno*; if *disegno* ensured a brilliantly ideated and composed work, *colorito* ensured that the representation "achieved softness" and "possessed life." Dolce also builds a "colored bridge," however, from the body to those "other *vaghezze*" I have been considering: "flowers and fruits, buildings . . . , animals and so on." In the representation of the varied *parerga* with which a figural composition might be adorned, *colorito* – encompassing both color and facture – plays a salient role. Further, and ultimately, it is the power of coloring that both infuses represented

objects with life and ensures that the viewer can never have enough of gazing on them. This is a critical point. It is evident that for Dolce, as for most commentators in the sixteenth century, painting was first and foremost an art of the body. In this Dolce would have agreed with Vasari and Michelangelo; he stressed somewhat different means to the end but that end remained the creation of compelling compositions centered on human figures and their actions. The beauties of color and facture that awaken "pictorial desire" could and should, in Dolce's mind, be applied to the representation of the lovely body. Who could forget Dolce's comparison of the Venus in Titian's *Venus and Adonis* (see fig. 118) to the Venus of Praxiteles: "if a marble statue could, with the shafts of its beauty, penetrate to the marrow of a young man so that he left his stain there, then what should this figure do which is made of flesh, which is beauty itself, which seems to breathe?"[2] Yet the power of color and facture to sway the viewer – to stimulate a desire in looking that is never satiated – this power can also operate outside the contours of the lovely body, can operate even in the representation of grass. Coloring can thus become another field, as it were, another *campo* of painting in which *vaghezza* may be cultivated. This is why it is ultimately color – or more

properly *colorito*, the art of applying paint as well as color – that is the golden thread linking all of Barocci's "other *vaghezze*" together.

THE POWER AND AMBIVALENCE OF COLOR

Our consideration of Borghini's *Il Riposo* has already revealed that coloring had become deeply inscribed in the discourses of pictorial *vaghezza* by the late sixteenth century, even in Florence. Well before Borghini, Benedetto Varchi, in his *Lezzione* of 1546, had admitted that a common assertion of the superiority of painting over sculpture came from "those who argue from *vaghezza* and delight, that one takes more from painting than sculpture, particularly regarding color."[3] Precisely such arguments, however, could embroil proponents of coloring in the one issue that could prove an Achilles heel: the perennial association of lovely color with cosmetics and the feminine. If Vasari may be credited, Michelangelo had gone so far as to dismiss oil painting itself, with its melting colors, as an *arte da donna*.[4] Such gendered perceptions and stereotypes led inevitably to suspicions and cautions concerning over-reliance on the innate beauty of pigments and on the potential for the *vaghezza de' colori* to cover critical defects in *disegno*. These caveats were offered as eagerly by the proponents of coloring as by its detractors and occupied north Italians as deeply as writers from Florence or Rome: as noted, both Pino and Lomazzo raised objections to the facile use of colors simply for their innate loveliness, or to appeal only to the "masses" who do not understand the finer points of *disegno* and invention. The recommendations of Dolce, at the end of the extensive encomium on the importance of *colorito* quoted in part earlier, may serve as a *pars pro toto*. Having established the critical importance of coloring in holding the viewer's gaze, rapt with desire, on a painting, Dolce hastens to clarify his position: "And let no one think that what gives coloring its effectiveness is the choice of a beautiful palette, such as fine lakes, fine azures, fine greens and so on; for these colors are just as beautiful without their being put to work. Rather this effectiveness comes from knowing how to handle them in the proper way."[5]

For Dolce coloring is far more than cosmetic, and – when properly undergirded by effective *disegno*, a point he is at pains to make throughout his discussion – provides the ultimate verisimilitude that makes paintings "live." Dolce's assertion that a locus of skill in coloring lies in the painter's expertise in blending and composing colors as relatives rather than absolutes is echoed and developed by other Venetian writers. As Moshe Barasch observed long ago, while Venetian theorists admitted and condemned the unintellectual, "popular" appeal of lovely

colors in and of themselves, the Venetians in particular were concerned to associate the refined colors which result from skillful and artistic blending and application with the learned, and thus to establish an honorable social basis for the appreciation of tonal color as well as *disegno*.[6] Dolce himself develops the distinction he has drawn between effective coloring and simple *vaghezza de' colori*, the beauty of colors "just as they are," unmanipulated by the skill of the painter, in the published letter to Gasparo Ballini. Having praised Raphael's coloring, he criticizes unsophisticated painters and viewers who simply enjoy rich colors that "gorge the eye." But Dolce wants to make clear that no one should perceive his critique as an attack on *colorito* – or even on the employment of colors beautiful in themselves. Indeed, "I am not in fact saying that beautiful colors are not ornamental. But if it comes about that the beauty and perfection of draftsmanship is not embodied under the coloring and along with the coloring, the effort is pointless – just like beautiful words without the substance and sinew of sentence structure."[7]

This vision of the relation between *disegno* and *colorito* seems congruent with the practice of Barocci. Well traveled in his youth, culturally ambitious as a painter, and associated with a court that cultivated strong ties both to Venetian and central Italian cultures, Barocci may be assumed to have been conversant with many of these issues. His unwavering determination to join unimpeachable skills in *disegno* and invention with coloristic virtuosity appears calculated to ensure that his paintings were appreciated by the widest possible range of potential viewers. It is more than *campanilismo* that enabled some contemporaries to celebrate Barocci as a second Raphael and no accident that others could rank him among the greatest followers of Titian. Indeed, the attitudes put forward in Dolce's *L'Aretino* may be particularly relevant to Barocci's cultural situation and predilections; it is well to remember that both Titian and Raphael were Dolce's pictorial heroes. And while *disegno* certainly provided the "substance and sinew of sentence structure" in Barocci's compositions, color was critical – and not only for the artistic imperative of making paintings that "lived."

The *vaghezza* that was associated with color offered Barocci an exit from the apparent conundrum inherent in the search for a pictorial language that was equally *vago* and *divoto*. Through the cultivation of lovely coloring, Barocci might sidestep the pitfalls of figural *vaghezza* and create pictures that allured the eye without recourse to the "lasciviousness" of the lovely body. Of course, the association of the *vaghezza de' colori* with female cosmetics not only provided another link between the beauties of color and those of the body but also gendered the *vaghezza* of coloring in a manner that generated recurrent ambivalences about its cultivation. But Barocci could combat any notion that his paintings were "merely feminine" through his rigorous cul-

tivation of the "sinews" of *disegno* and any insinuation that coloring was unsophisticated, appealing only to the fascination of the masses with all that glitters, through his virtuoso blending and manipulation of pigments. His handling of color exhibits an artifice and virtuosity that becomes as distinctive a signature as his consummate draftsmanship; the excavation of its subtleties will occupy much of this chapter.

COLORED LURES OF DEVOTION

As a painter focused on the creation of religious images, however, Barocci might also use to his advantage what one could term the "social ambivalence" of the overt attractions of beautiful coloring. For the beauties of color could appeal to a wide range of viewers. If well handled, coloring could impress the learned – at least those who had read Dolce – by revealing the art with which the painter blended and employed colors (in tandem with *disegno*) to effect a compelling and "alluring" representation that held the gaze. The beauty of the colors generated by this sophisticated blending, however, could also ravish those "simpler" beholders who experienced a relatively unreflective sense of wonder before the glowing, jewel-like surfaces of richly colored oil paintings. The ability of color to speak across educational, cultural, and social boundaries – and of the *vaghezza* of color to enrapture without generating bodily desire – could make it a particularly effective tool in the hands of an artistically ambitious painter of devout pictures. Cardinal Paleotti himself recognized this distinctive potential of coloring and thus became one of the only period theorists who offered an unequivocal endorsement of beautiful coloring as perhaps the quintessential *vaghezza* to be cultivated in religious painting.

Paleotti's discussion of these issues is remarkable for his frank admission of the gravity of the challenges facing the painter of religious pictures, particularly altarpieces. Since altarpieces were religious images intimately related to church liturgy and ritual – but at the same moment public paintings, often displayed in significant urban sites – they had to accommodate not only the exigencies of the church but also appeal to any who might encounter them. A great altarpiece of the late sixteenth century had to be an effective backdrop to liturgy, an effective vehicle for meditation or prayer, an impressive work of art; had to appeal to both rich and poor, to *contadino* and *cognoscento*; and had to allure the gazes of all these sorts of viewers, from vastly different backgrounds, interests, and intentions in looking, and hold their gazes until gazing became contemplation and devotion.

The Cardinal's recommendations concerning this challenge for religious painting are worth considering in some detail. Although he begins his assessment of the painter's audience with a predictable list – men, women, children, nobles, commoners, rich, poor, learned, unlearned – he rapidly develops a distinctive grouping for these generic categories. He concludes that the audience for religious paintings can best be analyzed under four headings, some of which bridge the pat gender and class divisions with which he began. These four audiences comprise the artists themselves, who are, after all, expert in the distinctive field of image production and reception, and will consider issues of "art" even as they engage with the image as a religious object; the *letterati*, those who understand the historical, sacred, and poetic literatures that underlie much in public pictorial art, and who will praise or blame a painting from their sense of its aptness to the stories, doctrines, and concepts it visualizes; the *idioti*, the unlettered faithful who make up "the greater part of the people" and whose need for visual preaching provided "the principal reason religious paintings were introduced"; and finally a distinct group, the "spirituals," those saintly figures who are particularly privileged by God to see with spiritual sight. Sacred painting must reach all these people, all the time. To do so, according to Paleotti, painting must of necessity both appeal to the mind and sway the affections. Painting must, in effect, function like Paleotti's "starry sky" discussed in the last chapter. It must attract the eye with sensual delights that are nonetheless innocent of carnal desire, then appeal to the mind with its rational sophistication, and finally point both mind and heart toward the Creator of all that is delightful, all that is profound. To appeal to the mind art must be based in *disegno*, under which Paleotti groups most of the "artistic" qualities of painting – including color. To appeal to the emotions, paintings "must be made in such a way that two qualities are operative; one, that the senses are swayed, and the other, that the spirit and devotion are excited."[8]

It is in this context that Paleotti makes some notable assertions about the role of color in religious painting. While he has classed *colorire* as an aspect of *disegno*, recognizing at once the "elevated" status of skillfully managed coloring and its theoretical subordination to *disegno*, he also perceives unambiguously positive possibilities for the overt loveliness of beautiful colors in religious pictures – precisely the aspect of coloring that had aroused the greatest suspicion in many period discourses on painting. Paleotti turns to a Psalm in which four principal qualities are itemized that must be observed in divine worship: "belief and beauty in His sight, holiness and magnificence in worshipping Him."[9] Then he offers a rough "translation" of these qualities into painting: "holiness and magnificence" refers to the ability of effective religious painting to reach and uplift the "spirituals" and the learned respectively; "belief" may be generated by a compelling representation of sacred mysteries through the arts of *disegno*; and "beauty" refers principally "to the *vaghezza de' colori* and to grace or rather beauty, qualities

that for the most part will please the unlettered" (Vasari might question Paleotti's understanding of *grazia*). He returns a page later to elaborate: "the third sort of people whom it is necessary to satisfy are the unlettered, who make up the majority of the community." As such persons do not understand the subtleties of art, they may praise a mediocre work that attracts their eye more than a work that the learned would perceive as excellent. Paleotti insists that this fact should not lead good artists to abandon the subtle excellences of fine painting; rather he wishes that painters take care to add to "artifice" and fine finish "that grace so commended by Apelles; so that, with the *vaghezza* and variety of colors, now bright, now dark, now delicate, now rough, according to the nature of the subjects, and with a diversity of ornaments, with the appeal of landscapes where appropriate, and with other beautiful inventions, the eyes of the unlearned will be drawn to gaze at [the paintings]."[10]

Here Paleotti offers a comprehensive case for the pastoral importance of all those "other *vaghezze*" – not only color but "a diversity of ornaments" including the beauty of landscapes (and one may surmise by extension the representation of the natural world in general). At the core of his case, however, is color, and he advances the clearest written apology I know from the period for the pastoral efficacy of coloristic *vaghezza* in religious painting; Barocci's images may well advance the period's strongest visual apology. Although Paleotti makes no argument for the potential appeal of coloring to the learned here, he has admitted *colorire* earlier in his discussion as an "elevated" element of painting, and Barocci might well have argued that while the evidently lovely nature of his colors – the simplest aspect of *vaghezza de' colori* – could *invagische* the unlettered viewer, even a Dolce would admire the brilliance and sophistication with which he handled those lovely colors. Indeed, it was Dolce himself, or rather "Aretino" in Dolce's *Dialogo*, who not only valorized *colore* but also stressed that "images are not only, as is said, the books of the ignorant, but (almost like stimuli of a highly agreeable kind) awaken the wise also to devotion – lifting both the former and the latter into contemplating the subject which they represent."[11] Barocci's approach to coloring delighted the simple, made him worthy of consideration as a new Raphael and a *grandissimo imitatore di Tiziano*, and enraptured all sorts of viewers into a chaste *vaghezza* that led into the contemplation of sacred "histories and mysteries."

COLORS OF ARTIFICE

The affective quality of Barocci's color demands significant consideration. First, however, it is important to understand something of the nature of his coloristic artifice. For while the brilliant palette that characterizes much of Barocci's painting

during the 1560s, '70s, and '80s could certainly fill all manner of viewers with delight, some of the specific strategies he utilized as a colorist in these decades seem to have been perceived in the period as displays of virtuoso artifice and even, perhaps, as analogous to elements of figural *vaghezza*. The lines by Dolce that open this chapter indicate clearly that even color could not escape all association with the body in sixteenth-century thinking about art, and that color had to be handled with artifice to be considered artful, not merely cosmetic. While color did not present post-Tridentine painters of altarpieces with the obvious snares inherent in the pursuit of figural *vaghezza*, the successful cultivation of *colore* still required something of a tightrope act. The coloring in Barocci's paintings, particularly as he experimented with the creation of a pictorial language during the 1570s, reveal remarkable traces of his feats of balance.

It is telling that Paleotti, having offered an encomium to the appropriate "allure" of color, immediately feels compelled to clarify that he is not giving the painter license to represent activities or figures that would appeal to sensual appetites; the first such activities he itemizes are "lascivious dances." The presence of the body lurks just below the surface of any discourse on the "pleasure" to be drawn from painting in this period. For Paleotti color provides a clear alternative, a means to generate sensual pleasure that is innocent and is not implicated in the appetites of and for the body. But other evidence from the period suggests that some strategies of coloring and paint application might be associated more or less directly with the artfulness and *vaghezza* found in the artfully represented body – even when these strategies were not themselves employed in the coloring of nude figures. I have already discussed Cropper's insightful recognition of Dolce's linguistic sleight of hand whereby the sexual *macchia* that stains the perfect body of the Cnidian Venus becomes the term used to describe Titian's painterly "stain" of a landscape with a sleeping Cupid. Dolce's implication that in Titian's art one thing might transmute into something other clearly registers a careful observation of the characteristics of the painter's *pittura di macchia*. One need only glance at the *Annunciation* in San Salvatore, Venice (fig. 161), to witness the way in which Titian's thickly loaded brush, sweeping across the canvas, can both "represent" the lily blossoms that symbolize the Virgin's purity and transform them before the viewer's wondering eyes into the flames that speak of divine inspiration. Here representation becomes more than itself.[12]

In the *Annunciation* the transformative power of the brush in contemporary oil technique works clearly and persuasively to enhance the viewer's pious contemplation. Yet Dolce implies that the loose and vigorous facture of the later Titian could be linked to more earthly passions as well, even in its most apparently abstract gestures. Further, beyond Venice, some other kinds

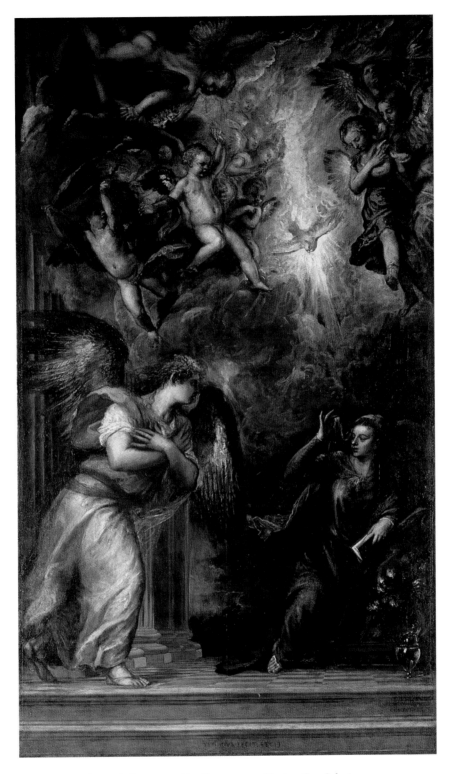

161 Titian, *Annunciation*, 1559–66, oil on canvas. Venice, San Salvatore.

of coloring and facture that rose to new prominence during the sixteenth century may have taken on connotations of artifice that made them suspect in religious painting. *Colori cangianti*, which became so important in the Cinquecento painting of central Italy, provide a particularly illuminating example. *Cangianti* or "changing colors" were composed of non-natural-istic color shifts within a passage of drapery; the effect was similar to that of shot silk.[13] Pink highlights, for instance, might shade not into pink darkened with black but into lavender. *Cangianti* represented an old coloring device that had been forcefully revived and developed by Michelangelo in the lunettes of the Sistine Chapel ceiling. From Michelangelo's

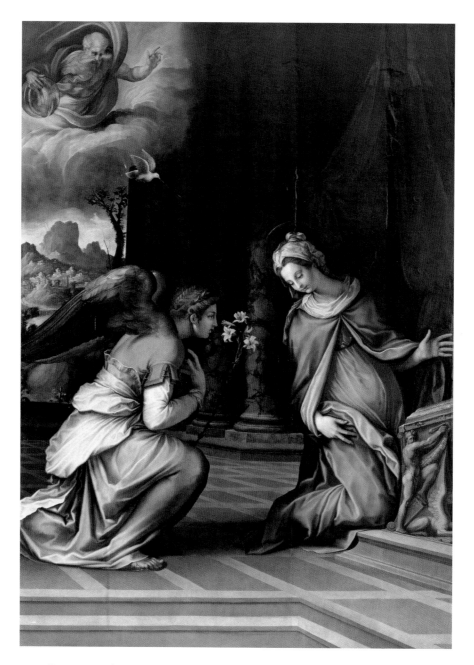

162 Francesco Salviati, *Annunciation*, before 1544, oil on panel. Rome, San Francesco a Ripa.

example, *cangiantismo* came to be associated decisively with central Italian painting and with some of the so-called "mannerists" in particular. An altarpiece such as Francesco Salviati's *Annunciation* from San Francesco a Ripa, Rome (fig. 162), represents the sort of recent central Italian painting that Barocci might have admired during his early study in the papal capital; the shoulder of the angel in this painting exhibits precisely the sort of vibrant *cangianti* that Barocci later employed in the lower foreground of the *Madonna del Popolo* (fig. 163).[14]

The employment of *cangianti* for modeling offered significant advantages when creating a compelling surface: the shifting, vivid hues brought greater coloristic life to the representation of garments, enriching the pictorial surface with brilliant tones instead of the muddy shadows or desaturated highlights that could result from simply lightening or darkening a color to model it. Yet *cangiantismo* had its detractors. It could be rejected as ultimately non-naturalistic, as Leonardo had done when he downplayed brilliant color and color-change modeling to privilege subtleties of light and shadow in modeling form.[15] Alternately, *cangianti* might be condemned as purely virtuoso artistic ornamentation, exhibiting art and the skill of the painter at the expense of clarity of form, and distracting the eye from

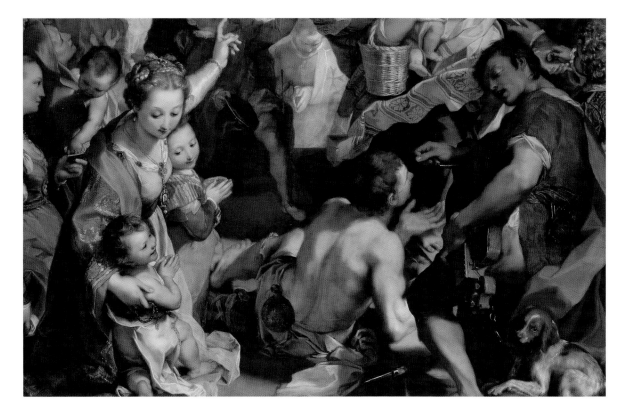

163 Detail of fig. 24.

sober sacred narratives. Indeed, in poetic theory ornament and poetic license had long been associated with rhetorical color: through recourse to the Horatian *ut pictura poesis*, painters might both elevate the status of their activity as colorists and associate themselves with poets through the skillful deployment of color as sophisticated ornament.[16] David Summers in 1987 went so far as to argue that *cangianti* could be perceived as the coloristic analogue to nudes, to the *figura serpentinata*, to foreshortening, and to wet drapery. The aesthetic body makes its reentry. For the Florentine Anton Francesco Doni, *cangianti*, as part of artful style, could also be associated with the fantastic and the *bizzarie* of nature, such as the shifting hues on the shells of insects.[17]

Such associations of *cangianti* with the fabulous, and perhaps also with the artful body, may illuminate the decisive prohibitions against the employment of *cangianti* in the robes of the Virgin or Christ pronounced by some period reformers and even some art theorists and painters. Lomazzo, for instance, stresses in his *Trattato della pittura, scoltura et architettura* of 1584 that the painter must reflect carefully on the coloring appropriate to the vestments of the varied figures in a panel, and advises specifically: "for example, it would not be appropriate to give *color cangiante* to [the robes of] our Lady, under any circumstances, as many do, who further give it also to Christ and to God the Father, without anyone warning them about this."[18]

This passage is the more remarkable if one remembers that Lomazzo could both identify *cangianti* explicitly as a *vaghezza* of painting and praise it as one of the art's highest ornaments. He begins a discussion of *cangianti* by noting that "the employment of this *vaghezza*" has come to be greatly developed in modern painting and asserts that it affords "the greatest delight and pleasure that one can offer the viewer with color." Indeed, even "a silk cloth alone, which in its highlights has one kind of color and in shadows another, in its diversity gives the highest and ultimate *vaghezza* and *leggiadria* to painting." The idea that well deployed *cangianti* offer the highest level of *vaghezza* in painting seems critical in assessing Barocci's commitment to coloring as a nonfigural *vaghezza*. Nonfigural, at least, in the purely representational sense, for delightful coloring could obviously exert an allure that found analogies, if not identity, with that exerted by the *vago* body. Lomazzo's list of appropriate uses of *cangianti* begins with the draperies of the "nymphs of the fields."[19]

It seems no coincidence, then, that even as he was cultivating his emulation of Titian, Barocci also pursued the distinctive artifice and *vaghezza* of *cangianti*. Barocci utilized *cangianti* most intensely in a number of paintings from his youth and early maturity, from the 1550s into the 1580s; vivid passages of shot color became increasingly rare in his later paintings, though a subtle play of *cangianti*, transformed through a painterly appli-

195

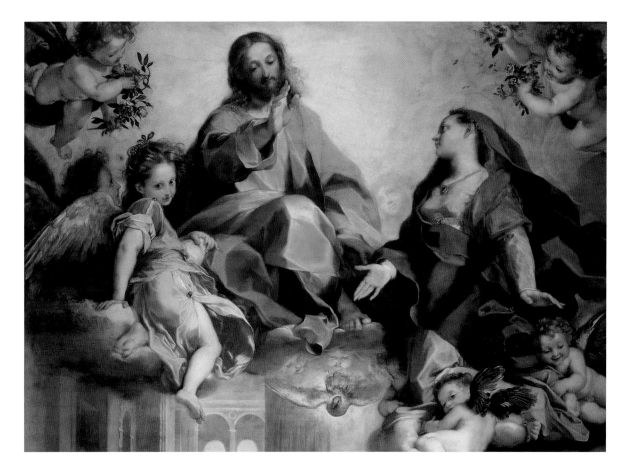

164 Detail of fig. 24.

cation that owes much to Venetian practice and creates a far different effect from central Italian shifting colors, reappears on the lining of the priest's robe in the *Presentation of the Virgin* (see fig. 127). However, even during the decades in which Barocci seems to have been most invested in the exploration of passages of *cangianti* of the central Italian sort derived from Michelangelo's practice, he was careful in his application of them to sacred figures. A simple *cangiante* in the mantle of Saint Nicholas of Bari in the *Perdono* may represent Barocci's only employment of shifting color in the robes of a saint in an altarpiece (see fig. 52). Despite the fact that it had still been relatively common when the young Barocci was in Rome for painters to display *cangianti* in the robes of saints, and even in those of the Virgin and Christ, it is telling in light of statements such as Lomazzo's that Barocci never, after the *Perdono*, applied shifting color to the robes of a saint in an altarpiece and that he scrupulously avoided *cangianti* in the robes of the Virgin and Christ even in the *Perdono* and in his other altarpieces as well. The only hints of *cangianti* in the heavenly realm of the *Madonna del Popolo* (fig. 164) – the painting that immediately succeeded the *Perdono* – come in the garments of the forward adolescent angel and they are muted even there, applied in a painterly style that makes

their effect quite different from the flashy color changes on the robe of the girl in the foreground of the lower portion of the panel. Insofar as they occur in the figure of the angel, furthermore, they may be justified by recourse to a long tradition that associated *cangianti* specifically with the visualization of the otherworldly aura of angels. As early as the treatise of Cennino Cennini, a discussion of *cangianti* was prefaced by "If you want to make a *cangiante* drapery for an angel . . ." Indeed, Marcia Hall has noted that the practice was employed primarily for angels during the Quattrocento.[20]

COLOR MODES IN THE *MADONNA DEL POPOLO*

The *Madonna del Popolo* (see fig. 24) in fact provides an ideal site for analysis of Barocci's coloring strategies in the 1570s. Its color is complex and a recent cleaning allows for particularly detailed consideration.[21] A brief investigation of its surface may shed light not only on Barocci's use of *cangianti* but also on what emerges as a distinctive deployment of multiple coloristic strategies, appropriated both from central Italy and from Venice, for particular purposes and areas within a large religious paint-

ing. Within the altarpiece Barocci's approach itself alters significantly when one looks from the figures of citizens in the lower foreground to those of the Virgin and Christ above. The center-left foreground of the earthly realm is dominated by a young, aristocratically dressed woman accompanied by two young children (see fig. 163). She encourages her toddler to turn his delighted attention from the blind beggar's endearing dog to the heavenly vision. This figural group arrests the beholder's attention not only because of its spatial prominence and the gestures and expressions that contribute overtly to the narrative of the *istoria*, but also for the striking *colori cangianti* that articulate the lining of the mother's mantle and the dress of her older child, the poised and serious daughter. The lining of the mother's cloak shifts between tawny gold and lavender-gray blue (significantly, blushing with dim red in the shadows across her shoulder and back), while the dress of her daughter is more high-keyed, shifting from a blue close to the mother's to a bright orange red (much like the *cangiantismo* that articulates the shoulder of the angel in Salviati's *Annunciation*; see fig. 162). Directly above them in the heavenly realm, the robes of Christ are colored in a manner that links his figure with those of his central devotees; but Barocci's handling of the Savior's drapery seems almost to comment on the issues of decorum surrounding the use of *cangianti* in post-Tridentine religious pictures (see fig. 164). Christ's inner robe is a celestial gray tinged with smoky blue, while his mantle is orange-red. These two colors closely parallel the lavender-gray blue and orange-red of the dress of the young girl who is directly below him; but while the colors of her dress swirl across the surface of a single fabric in an *artificioso* display of *cangiantismo*, the analogous colors of Christ's garments define two distinct pieces of clothing.[22]

In avoiding *cangiantismo* entirely the potential drawback is loss of coloristic interest in the modeling of specific garments; indeed, portions of Christ's inner robe are simply shaded with an admixture of black for the shadows or white for the highlights. However, it seems that Barocci reflected on this issue and concluded that a shift to a mode of painting inspired by Venetian art (particularly by Titian) for elements of the figures and ambient of the heavenly realm would both constitute an appropriate painterly means of representing the rich form-dissolving glory of heaven and heighten visual interest in the robes of Christ and the Madonna without resort to *cangianti*.[23] This strategy may be most clearly perceived in the inner robe and veil of the Madonna. She is far enough forward – as the mediator between hopeful viewers and Christ – that her garments are not infused with as much of the golden light that emanates from the opening to heaven as is the right side of Christ's red mantle. Barocci nonetheless transforms the upper part of her robe into an area of compelling pictorial interest, not through

cangiantismo but through Venetian techniques learned in part from the Titians he had studied in the collections of the dukes of Urbino at Pesaro.[24] Particularly in the left sleeve of the Virgin, the pale pink color of the illuminated fabric is painted loosely over the shadow color, with varying color saturation, while highlights of white touched with gold are spun into a spidery, gauzy web over the whole. The Virgin's soft green veil, too, as it wraps around her shoulder, is registered through quick, broad brushstrokes that reveal the sleeve beneath, describing the gauzy thinness of the veil and providing the interest of bravura brushwork at one and the same moment.

Though there are painterly passages in the lower section of the altarpiece, only marginal details in the garments worn by the Aretines in the lower foreground are created through analogous techniques. Barocci thus seems to have done something remarkable here: he has shifted coloristic strategies in the midst of a painting. On the performative level, Barocci effectively demonstrates through such a shift his artfulness, his virtuoso command of two of the period's dominant, quite distinct, modes of coloring. He has also employed a shift in stylistic mode to register a different reality and to convey meaning: while the aristocratic silks of the noblewoman and her daughter glitter with the sheer surface beauty of material color, the Virgin's veil and sleeve are modeled by layers of color that emerge to sight in and through one another. This parallels the rendition of Christ's left shoulder and sleeve, in which the paint that "materializes" the golden light of heaven both suffuses the orange-red mantle and, in the highlights, literally spills over it. Lines and patches of yellow paint streaked into the red of the mantle (for instance in the folds just above Christ's left hand) offer coloristic interest akin to the *cangianti* below, while not privileging the highly artificial, ornamental appearance of *cangianti*. By shifting technique, Barocci not only demonstrated his command of varied styles and sidestepped the question of the decorum of *cangianti* in the robes of figures such as Christ or the Virgin: he also found technical, pictorial means of speaking visually about the levels of heaven and earth, and their corresponding sources of natural and supernatural illumination. The daylight of earth illuminates the surface of objects; the mixed light, natural and heavenly, which shines on and in the apparition, not only lights surfaces but can spill over them like liquid and illuminate them from within.

Victor Stoichita has noted that a prominent strategy in Spanish paintings of visionary experience during the seventeenth century involved a related shift of technique between the realms of heaven and earth, with objects on the earthly plane delineated clearly (in a manner akin to some period still-life painting) while the heavenly apparition is represented in a distinctly looser, more painterly manner. Barocci's practice did

not conform strictly to this pattern; he varied his technique even in the still life and genre elements of his paintings, as seen in the lamb from the *Circumcision* (see fig. 133). It seems clear, however, that he employed distinct technical and coloristic modes to inflect the differentiation of earth and apparition in the *Madonna del Popolo*. Shifts in technique between the representation of elements of earth and of heaven had been pioneered in distinctive ways by Raphael and his school, by Correggio, and by the Venetians. The Veronese painter and theorist Cristoforo Sorte, in his *Osservazioni sulla pittura* published in 1580 in Venice, is explicit about some qualities of this approach: in representing heavenly figures, Sorte stresses that "colors that are too determined or substantial should not be used; on the contrary they should be soft and suave, capable of representing a superhuman substance and . . . divinity." Concerning the appropriate light, he notes: "Moreover, it should be understood that the divine things that sometimes appear are always accompanied by a most graceful splendor bathed in a very soft light, which does not frighten or fill with dread, but fills the viewer with wonder and reverence."[25]

These passages stress the softening of color, outline, and corporeal modeling considered necessary for the presentation of heavenly figures and the pervasive golden light that should characterize representations of heavenly visions. Barocci employed all these devices in the *Madonna del Popolo*, but he also worked to unify heaven and earth in terms of light and atmosphere, while still visualizing their distinctive hierarchy of being and of "seeing." In the lower background, the piazza is veiled in the vapors trailed by the cloud of divine apparition, while the forms and colors in the foreground are manifest and clear. The heavenly realm is more uniformly painterly in representation, pervaded as it is by the nebulous mist and light that attends any naturalistic visualization of cloud as the vehicle of theophany; nonetheless, the figures of Christ, the Virgin, and the forward angels are clearly modeled in light, color, and shadow. While Christ's red mantle of sacrifice is forcefully modeled where it flows over his foreground knee, however, the portion of the robe covering his left arm – farther back into the picture space – begins rapidly to dissolve, to become saturated by the golden light of heaven, too bright for mortal eyes to penetrate. Barocci had experimented with a more extreme version of this device in his representation of Christ's robe in the *Perdono* (see fig. 52). There, Christ's robes sweep back behind him in dramatic fashion as he strides forward from the cloud of theophany: as they do so, the garments are virtually consumed by light, their forms vanishing into the white gold of the blinding brightness of heaven. In the *Madonna del Popolo* Barocci maintained a greater integrity of form in Christ's robes, even if he allowed the aura of heaven to shine through and

spill over the physical substance of that portion of the robe that is farthest from the picture plane.[26]

Such subtle adjustments are not without significance. Sorte made clear that the rendition of heavenly figures progressively "consumed" by light, their colored garments evanescing into gold and white, was both a visualization of the true nature of such figures and a device of art, a *bellissimo artificio*. A painter who represented figures that receded into a heavenly apparition only with "strong colors" and bodies delineated as clearly as those perceived in the natural light of earth simply wished to please "the ignorant, whose eyes are surfeited only by the fullness and the *vaghezza* of colors, without moving beyond that to [consider] what the image is; it suffices that it appears beautiful to them. But to me it would seem that it would be more appropriate to satisfy those who are thoughtful and understand the truth . . ." Sorte praised Veronese's altarpiece of the *Martyrdom of Saint George* explicitly for representing the "figures in the clouds" with "soft colors, and divinely illuminated by supernatural splendor" (fig. 165).[27] Veronese's solutions in this particular painting are in fact remarkably akin to Barocci's in the *Madonna del Popolo*: background angels and attendant figures evanesce into the heavenly light but the principal holy characters are all clearly delineated and richly colored, even if their garments are not simply rendered with the unmodulated brilliant colors that would appeal only to the "ignorant."

Giulio Romano had already discovered the pitfalls of applying the "truth" and "artifice" of the form-dissolving power of heavenly light too consistently. He had designed – to the point of sending a fully colored drawing – a fresco of the *Coronation of the Virgin* for the shrine of Santa Maria della Steccata in Parma (fig. 166). When Michelangelo Anselmi had executed the fresco after Giulio's drawing, the brothers of the confraternity who administered the church and cared for its holy image wrote Giulio in some distress, with several complaints about the painting. Giulio's response survives and indicates that in addition to iconographic concerns, the patrons had expressed strong dissatisfaction with his strategies of coloring and lighting, particularly because these involved a loss of color and clarity of form in the figures of important members of the heavenly glory. Giulio gently but firmly protests that the patrons had seen and approved his colored drawing. He then specifically defends his approach to color and form: because figures from the New Testament and Christian saints are higher and farther into heaven than figures from the Old Testament, he had decided to represent the New Testament figures with garments of light-drenched colors, and with bodies that were beginning to be absorbed by light; the Old Testament figures who occupied the foreground, farther from the most intense splendor of heavenly

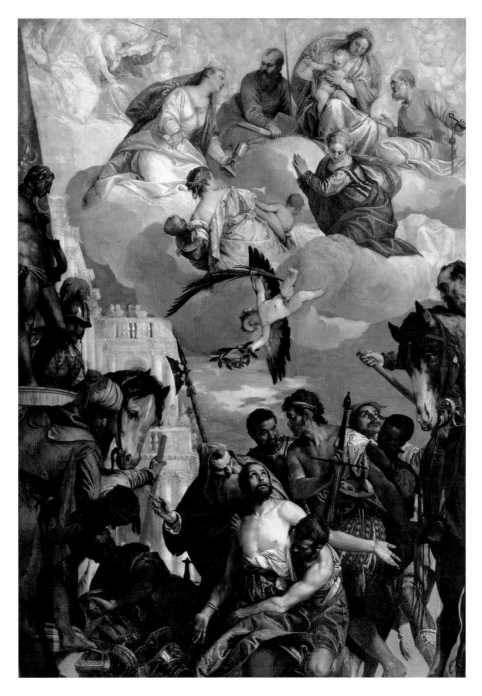

165 Paolo Veronese, *Martyrdom of Saint George*, 1560s, oil on canvas. Verona, San Giorgio in Braida.

light, were frescoed in brighter colors and with more vigorously delineated forms. For Giulio, the relative placement of the groups reflected the enhanced status of the Christian figures, and the resultant strategies of coloring and lighting were logical responses to their position; the representation of their forms was both *verosimile* (as a rational reconstruction of a gathering that neither artists nor patrons had been privileged to witness) and artful, *artificisio*. Nevertheless, the patrons had been scandalized. Their precise positions are not known but the parameters can easily be imagined. If the figures from the New Testament and Christian tradition were more important, more "elevated" than those of the Old Testament, then the New Testament figures should be more clearly visible, more brightly colored. A way of thinking that had emerged from an understanding of the represented holy figure as an icon clashed with a search for pictorial verisimilitude and artfulness in representing a liminal exchange between this world of matter and the ultimately invisible realm of heaven. Giulio attempted to articulate his

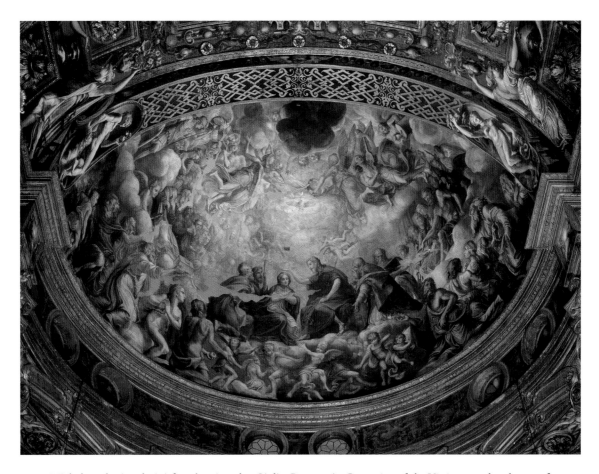

166 Michelangelo Anselmi (after drawings by Giulio Romano), *Coronation of the Virgin*, completed 1542, fresco. Parma, Santa Maria della Steccata.

position to the patrons: "I wanted everything – the bodies and the draperies – to be the color of flame and ever more dazzling and annihilated the farther away they were [from the foreground]; in those [figures] that are on this side of the heavenly light [literally "the flame"], like adam and Noah and those other patriarchs, one can make the colors more manifest and delimited." Despite this explanation of the pious imperatives that underlay a striking pictorial strategy, the frescoes were revised and some forms made "more manifest."[28]

For his part, Barocci carefully avoided the possible pitfalls of this sort of virtuoso coloring and paint handling, while still employing shifts in technique to visualize the space of theophany, pervaded as it is by the illimitable splendor of heavenly light. In the *Perdono*, he allowed Christ's robe to evanesce into light as it sweeps back toward the opening of heaven from the advancing Savior, but he did not compromise the "real presence" of Christ's "icon." This very negotiation points at once to the depth of Barocci's meditation on Christian image traditions and the profundity of his distillation of these traditions through the strategies of the most modern sort of painting. In the *Madonna del Popolo*, meanwhile, Barocci offered an even

more subtle negotiation, an even more pervasive resolution, of the problem of representing that magical boundary between earth and heaven. By visualizing the apparition as trailing misty vapor across the piazza, Barocci was able to ensure that both the spaces of earth and of heavenly apparition become indistinct as one moves toward the background. He thereby effectively avoided the danger that heavenly figures become less visible, less present than figures on earth – an effect that might compromise the painting's presentation of the holy in the very attempt to make a visual statement about the nature of the holy (and, ultimately, its invisibility). However, Barocci insisted on differences in the manner in which forms become indistinct in the two realms of existence. While the illumination of Barocci's heaven dissolves form into glorious golden light, the mists trailing through the piazza drain color well before form evanesces, as is clearly visible in the figures of the confraternity brothers who offer clothes to prisoners in the left background. On earth, some delineation remains but color vanishes. In the heavenly distances, by contrast, form is assumed into color and light, those most pictorial of substances. It seems telling that the heavenly distances that cannot be penetrated by mortal eye

200

become "purely" color and light in many of Barocci's works; there will be more to say about this in the concluding consideration of Barocci's conception of pictorial "music."[29]

COLORS OF THE SOUL

There is another coloristic device, superficially related to *colore cangiante*, that Barocci employed with his other pictorial means to enhance the "reading" of his sacred *istorie*. This is Barocci's distinctive use of effects of reflected color and it is a device that begins to transform the discourses of artifice, verisimilitude, and decorum into that of affect. In the left foreground of the *Madonna del Popolo*, behind the woman with her two children, an older woman with a dusky red cloak over her head gazes reverently at the sacred apparition as she holds a toddler on her shoulder. She is so wrapt in contemplation that she fails to notice that the child has become fascinated with the presumably devotional book held by a young woman at the extreme left. This woman, staring straight ahead and deep in meditation, is also heedless of the child. As the toddler reaches to touch the book, his already rosy-cheeked face is suffused with red, as is his reaching forearm. A mild version of this effect has already been noted, as the lining of the robe of the young mother takes on ruddiness in its shadows – on that portion of the robe, incidentally, toward the woman in red and the reaching child. The naturalistic explanation for such sudden charges of color is clearly to be found in the representation of reflected light from the red robe of the older woman – a kind of naturalized *cangiante*, a color change occasioned by a real optical phenomenon rather than predicated on artifice and convention.[30] However, this "bleeding" of color, particularly where it suffuses the child with the red of fire as he reaches to explore the prayerbook, seems to hint at supranaturalistic ways in which Barocci can employ color to visualize meaning. Such a suspicion is confirmed by the development of this device in a slightly later painting, the *Calling of Saint Andrew*, completed in 1583 (fig. 167).

Christ confronts an Andrew whose heart is fired by a sudden sense that he is in the presence of the Messiah. Andrew has rushed to shore from a fishing boat that is just being beached; even Peter is left behind by his alacrity. As the saint-to-be kneels reverently before Christ, cap in hand, the shadowed front of his yellow garment suddenly glows a rosy red. While this may be understood as reflected light from Christ's soft orange-pink-red robe, it seems here clearly unnaturalistic in degree; it is, in effect, a strong but unusual instance of changing color. The effect might be described as literally supranaturalistic: viewers are privileged to observe not merely an optical reflection but the visualization of the reflection of

Christ's sanctity onto his follower and of the emotional temperature of Andrew's heart "that burned within him." Alberti had long since highlighted the coloristic effect of reflected light; in *De Pictura* he had noted how the face of a figure in a bright green meadow will appear greenish. Here, Barocci radicalizes this sort of naturalistic effect to open a coloristic window onto the soul. Alberti had also stressed that painters have only the movements of the body with which to reveal the movements of the soul.[31] Barocci moved beyond this univocal emphasis on gesture and expression in *istorie*. Color reflection, in the *Calling of Saint Andrew*, becomes a means of speaking visually about emotional states that cannot be entirely conveyed by the outward gestures of the body and a means of heightening the spiritual and emotional connections between critical figures in sacred narratives.

A nude figure study for the painting orients the crucial interaction on a diagonal, with Andrew farther into the picture space than Christ. This position turns the body of the saint toward the spectator; had the painting been so composed, viewers could have read Andrew's facial expression clearly and experienced the full drama of his agitated pose. However, such a composition would have necessitated turning the figure of Christ slightly away from the viewer; Barocci at some point concluded that this would not be appropriate. The painting places both men more nearly parallel to the picture plane but Christ, as befits this most important of figures, is turned just slightly toward the beholder and illuminated from the front and side. Andrew must therefore be cast into profile – indeed his shoulders and torso edge past profile, turning slightly away from those outside the picture in his univocal focus on the figure of Christ before him – and be lit in such a way that his face falls into shadow. It is at this moment, when the "movements of the body" cannot be fully perceived, that Barocci enlists the expressive potential of color to reveal the "movements of the soul."[32]

In the *Calling of Saint Andrew*, Barocci dramatized inner life through color in addition to form and gesture; in the *Madonna del Popolo*, he distinguished the figures of heaven from those of earth through pictorial technique and lighting. In both pictures (though in distinctive ways) he employed all the resources of the new painting to carry significance and to move the souls of beholders. In such expressive use of color, Barocci might be said to have radicalized a perception that was beginning to be expressed in art theory, even by some theorists generally understood to be committed to the primacy of *disegno*. Giovanni Battista Armenini, for instance (whose *De' veri precetti della pittura* was published in 1586, three years after the completion of the *Calling of Saint Andrew*) asserted the importance of coloring to narrative art: "Even though the *storie* and inventions may be delightful in themselves because of the subject, if the

coloration, *which is the means of explaining the inventions* [italics mine], is not agreeable to the eyes of the beholder, one will never be able to produce the effect that the poet does. From united and harmonious colors that beauty is brought forth which enraptures the eyes of the ignorant and stealthily enters the minds of the wise."[33]

Armenini's assertion that coloration is "the means of explaining the inventions" is as intriguing as his explicit admission that well handled coloring will not merely "enrapture the eyes of the ignorant" but also "stealthily enter the minds of the wise." Admittedly, this passage occurs in the midst of a complex discussion which both arises out of and returns to a consideration of coloristic beauty as a necessary artful ornament (as rich language in poetry) and as an element of painting which provides uncomplicated pleasure for the eye. Yet however brief or undeveloped, Armenini's assertion of the significance of color for "explaining" pictorial *istorie* and inventions indicates the existence of a manner of thinking about color that can be found elsewhere in period literature and was particularly developed in writing about religious painting. Indeed, it is striking that writing specifically concerned with art and religious reform both anticipated and developed the implications of a remark such as Armenini's. Gilio, even in 1564, stressed that color works with gesture, with the "movements of the body," to convey emotion. Early in the dialogue, Messer Silvio, in comparing the painter's means of depiction with those of the poet, introduces color and says: "It may seem difficult to the painter to make figures express with color happiness, melancholy, languidness, audacity, timidity, laughter, weeping and the other passions of the soul. But if he rightly considers the circumstances and the force of art, he will find that he can do so *vagamente* and easily."[34] A comment from Lomazzo's *Trattato dell'arte della pittura* of 1584 may help to clarify and extend Silvio's implicit assumption that colors signify: "Because all colors have a certain quality, different from one color to the next, they cause diverse reactions in whomever regards them."[35]

That an ecclesiastic critic generally perceived to be univocally conservative could seem suddenly *au courant* theoretically in the valuation of the potential of coloring should not surprise as much as it may. It is still too often assumed that ecclesiastics like Gilio and Paleotti were only concerned with painting as "illustration." They were concerned with "accuracy" in the visualization of sacred *istorie*, to be sure, but they were above all concerned with ensuring that religious painting "moved" beholders. Paleotti says this directly. Utilizing the oratorical rubric of delighting, teaching, and moving – *delectare, docere, flectere* – Paleotti opens his first chapter concerning the ways images may move the beholder with: "there remains the third part, which is not only proper to, but is the principal part of

painting, and that is to move the souls of the beholders . . ."[36] Thus it is only to be expected that that apparently unlikely treasure trove, Aldrovandi's *Avvertimenti* to Paleotti, would offer some consideration of color as one of the ways in which painting may become expressive. I have already noted Paleotti's investment in color and Aldrovandi's insistence on the alluring charge that even religious painting must have in the modern age. In his consideration of Paleotti's remarks on color, the scholar observes: "color is in truth an accidental property in things, which gives great aid in understanding their substance."[37] Aldrovandi is assessing how color reveals the particular mixing of the four elements in a body and so is speaking in terms of identity rather than describing the emotional reaction of a figure, but his assertion that color "aids greatly" in understanding the "substance" of an individual may easily be extended from simple identity to shifting psychological and emotional states; it is precisely this that Barocci seems to accomplish in the *Calling of Saint Andrew*.

It is a comment by Federico Borromeo that perhaps comes closest, among period statements about color and its importance in religious painting, to describing the range of operations performed by Barocci's coloring:

Colors are like words, that are understood by our eyes no less clearly than the words of language by our ears, and the design [*disegno*] of the figures . . . one could say would be concepts and arguments. And because painting is a kind of argumentation and sermon which is understood even by the ignorant, but is not for this less dear to the learned . . . and as it is most important for the orator that the things he offers have affect and power, and may move souls, so likewise will it be important that colors and designs are able to generate devout thoughts in human minds, and fear and sadness, when it is necessary for us to have them.[38]

There are significant echoes of Dolce here: colors are beautiful words, *disegno* is structure – Dolce's "substance and sinew." For Borromeo, though, the pastoral, homiletic effect of the "beautiful words" of color is particularly critical. *Colore* works with *disegno* to move "even the ignorant" with the emotive charge of great religious "mysteries and histories," without compromising the esteem in which painting is held by the learned. As colors are like words, so their intriguing combination and variation is like poetical color, an artful ornament but one with potentially powerful signifying capabilities. It is, after all, the well chosen word that drives a *concetto* to the heart, that awakens the spirit to receive a communication. To a period that insisted both on artifice and devout stimulation in religious painting, coloring provided a privileged space in which non-lascivious *vaghezza* could be cultivated at the same moment that

167 Barocci, *Calling of Saint Andrew*, 1580–83, oil on canvas, 315 × 235 cm. Brussels, Musées Royaux des Beaux-Arts.

the *affetti* were both expressed and quickened. Antonio Calli, in his intriguing, little-noted *Discorso de' colori* of 1595, encapsulates this positive view of the potential of color: "Therefore colors both delight and move the soul." He goes on, nonetheless, to offer a particularly compelling distinction between the superficial color that was often condemned in period theory and color as an essential component of visual thought. When colors work only to please the eye with their brilliance or harmony, merely "superficial" delight is generated. When, however, viewers can perceive symbolism or another form of significance in colors, the soul "is completely filled with the carefully judged passion presented to it."[39]

This is the work of Barocci's coloring: it both delights the eyes and fills the soul with "carefully judged" passion. The late sixteenth-century critical discourses that both stimulated and were stimulated by the coloristic experiments of painters including Barocci and Titian ultimately underlay important aspects of Bellori's beautiful and sensitive *ekphrases* of Barocci's paintings. Bellori read Barocci's canvases with great care; in describing the experience of viewing the Loreto *Annunciation* (see fig. 193), the altarpiece for the chapel of the dukes of Urbino in the Basilica there, he registers a range of nuances of meaning evoked by the bodily poses, facial expressions, and gestures of the Virgin and the Angel. Then, reading the form of the Angel closely, he adds: "not only in [the angel's] contours and stance does it demonstrate itself to be agile and light, but also the color itself reveals its spiritual nature, tempered subtly in the yellow shirt and in the iridescent [*cangiante*] red tunic with the pale-blue wings, almost rainbow blue."[40]

THE *VAGHEZZA* OF COLOR AND RETROSPECTION

Predictably, Barocci found components for his distinctive development of reflected and bleeding color effects in Venetian painting, particularly in that of Titian. Paul Hills has written perceptively of the signal importance of "themes of metamorphosis" in much Venetian art and literature during the sixteenth century. In describing Titian's rendering of the Ovidian images of transformation that were central to much of his mythological art, Hills observes: "In Ovid's fables gods are made flesh or beast, and nymphs transformed into constellations. Titian's painterly technique is extended to realize states of becoming and their attendant terrors and exhilarations. . . . The blush of Europa turns the sky to flame. The energy of colouring is a metaphor for life, its quickenings and extinctions."[41] Hills also registers the importance of the Venetian mosaic tradition to Titian's *pittura di macchia*. Mosaic could have provided Barocci with considerable food for thought, as its techniques incorpo-

rated *cangiante* shifts of color within forms alongside the speckled coloristic modeling of surfaces that could be considered an ancestor of *pittura di macchia*; one might say that the techniques of mosaic contained the roots of prominent stylistic devices recognized as central or north Italian during the mid-sixteenth century. Furthermore, a frequent characteristic of mosaic modeling – especially prevelant in the San Marco mosaics in Venice – offers an antecedent to a device critical in Barocci's emphasis on reflected light. Outlines of figures in mosaic, and particularly outlines of flesh, are often established with rich orange-red tesserae. The faces and hands of the angels in the *Hospitality of Abraham* from the atrium of San Marco clearly illustrate this tendency; a detail of a figure from *Joseph Gathering Corn*, also in the atrium, shows the technique applied extensively (fig. 168). Both Titian, in figures such as the putto in the Marciana *Wisdom* (and in the hand of the personification herself; fig. 169), and Barocci, in numerous paintings from the 1570s and 1580s, experimented with and developed the expressive possibilities of the flushed flesh contour. With Barocci, the modernization of such a device could inspire a range of details, from the red that often infuses elbows, wrists, and knuckles, and plays between the fingers of many of his figures, to the red cheeks and nose that delineate the *profil perdu* of the Magdalen in the Senigallia *Entombment* (see fig. 83). Often this device, related in appearance to bleeding or reflected color yet distinct from it, seems to have been employed to heighten the impression that Barocci's figures are alive, with palpitating, soft skin under which blood courses. In some cases, however – the Senigallia Magdalen may be one of these – the technique appears to move beyond a distinctive evocation of the flush of

168 Detail of *Joseph Gathering Corn*, mosaic in the atrium of San Marco, Venice, 13 century.

169 Titian, *Wisdom*, 1560, oil on canvas. Venice, Libreria Marciana.

life toward the visualization of a high emotional temperature. Here it merges with Andrew's glowing drapery as an affective pictorial gesture, illuminating the motion of the soul not only through the gestures of the body but through its very color.

Hills is persuasive when he draws analogies between the long tradition of mosaic in Venice and some of the distinctive innovations of sixteenth-century Venetian painting. It seems equally clear that Barocci adapted some of these innovations for his own purposes, principally through his study of Titian. What is less clear is whether Barocci meditated on mosaics himself. If he did so, such reflection must emerge as yet another instance of his investment in employing selective retrospection to construct an ambitious pictorial modernity. It would be unwise to assume that Barocci thought as much about mosaics as his Venetian models may have. There is, however, some subtle yet telling visual evidence to suggest that he was at least aware of critical aspects of the mosaic tradition and their transformation in contemporary Venetian painting. Hills notes that Titian, from his earliest works, was fond of occasionally

enlivening passages of drapery with patterns reminiscent of tesserae. The device first appears in the golden rectangles that give a mosaic-like gleam to the lower border of the red drapery on which Venus reclines in the *Sleeping Venus* usually believed to have been begun, at least, by Giorgione (fig. 170). While here the kinship to mosaic seems clear, the penchant for analogous patterns later reappears in the representation of checked kerchiefs or sashes in a number of Titian's works: the *Entombment of Christ* of about 1520 offers a clear example (fig. 171). Here the effect is akin to that of rows of tesserae, sublimated into a fabric's pattern.[42]

The *Madonna of the Rosary* in Senigallia is one of Barocci's major later altarpieces (see fig. 62). The painting was produced for the Confraternità dell'Assunta e Rosario, and Marilyn Aronberg Lavin noted long ago that this double dedication surely spurred Barocci to create a dynamic picture that conflates the imagery of the Donation of the Rosary with that of the Assumption, and Saint Dominic with Saint Thomas.[43] The altarpiece provides another instance of Barocci's remarkable

205

170 Giorgione (completed by Titian), *Sleeping Venus*, c. 1510, oil on canvas. Dresden, Gemäldegalerie.

development of the vision altarpiece into a dynamic, dramatic sacred *istoria*.[44] Yet, as noted when discussing Barocci's extensive experimentation with the genre of the vision altarpiece in Chapters Two and Three, he frequently employed the distinctive features of the vision painting to reinscribe some of the values of traditional religious images into ambitious modern pictorial compositions. Indeed, in the case of the *Madonna del Rosario* several preparatory drawings depicted the exchange between the Virgin and Dominic on a diagonal, facilitating an across-the-picture reading of the narrative action (see fig. 61). In the final altarpiece, the direction of this action was made vertical, with all the principal holy actors positioned on the central vertical axis of the picture. A similar process of moving from narrative toward icon had occurred in the preparation of the *Perdono*. Furthermore, in the *Madonna del Rosario*, there may be an additional gesture of retrospection. In his rendering of the Virgin's robes, Barocci had recourse to a device closely analogous to that employed in the *Sleeping Venus*. A pattern of squares resembling tesserae appears on significant portions of the Virgin's mantle. The "net" demarcating the squares shows the dark blue of the Virgin's robe, while the squares themselves flash with gold.

Barocci here seems to take Titian's device back toward its origins: the pattern that plays and flickers across the Virgin's mantle inevitably evokes (or perhaps *invokes*) both mosaic and

the gold striations of Byzantine drapery. In a thoroughly modern, dramatic vision altarpiece, with the apparition structured as a sacred *istoria*, Barocci's depiction of the Virgin's robe is a pictorial gesture that at once embodies Venetian modernism and recalls venerable traditions of representing the Mother of God. I have already shown how Barocci could use coloring in the *Madonna del Popolo* not only as virtuoso artifice and mode of meaning but even as an element that negotiated the tensions in that painting between retrospection and modernity. The shimmering yellow robe of the knight who kneels to pray in the center of the panel in the near background is caught by the light in such a way that his figure is brought forward toward the surface of the picture plane and linked with the golden light of heaven. Barocci's manipulation of the tensions between three-dimensional space and two-dimensional form in the *Madonna del Popolo* is critical to the creation of a highly modern image that revivifies aspects of tradition. In the Senigallia painting, the relations between the artifice and *vaghezza* of coloring and the traditions of the religious image are even more explicit. The Virgin is the Byzantine *Theotokos* brought to palpitating life, the icon become vivid apparition.

In his coloring as in all of what Baglione later called his *virtuose fatiche*, Barocci strove for a *vaghezza* illumined by *divozione*. Klaus Krüger has stressed that Alberti effectively relocates the quasi divine power of painting and the image from

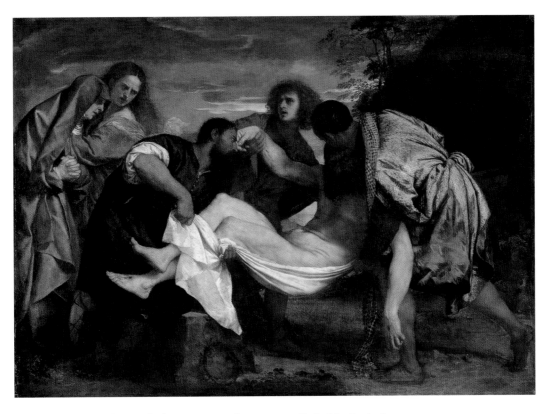

171 Titian, *Entombment of Christ*, c. 1520, oil on canvas. Paris, Musée du Louvre.

its potential as a vehicle or portal for divine presence to its status as a product of the "fantasia" of an inspired (*quasi uno iddio*) artist. As Krüger argues, the repercussions of this transformation ultimately drove aesthetic and religious experience apart, despite strenuous efforts by late sixteenth-century reform theorists to hold them together in reductive fashion. At the moment that these theorists were struggling with blunt instruments, however, Barocci was visualizing a compelling fusion of the allure of modern painting and the power of Christian pictorial tradition.[45]

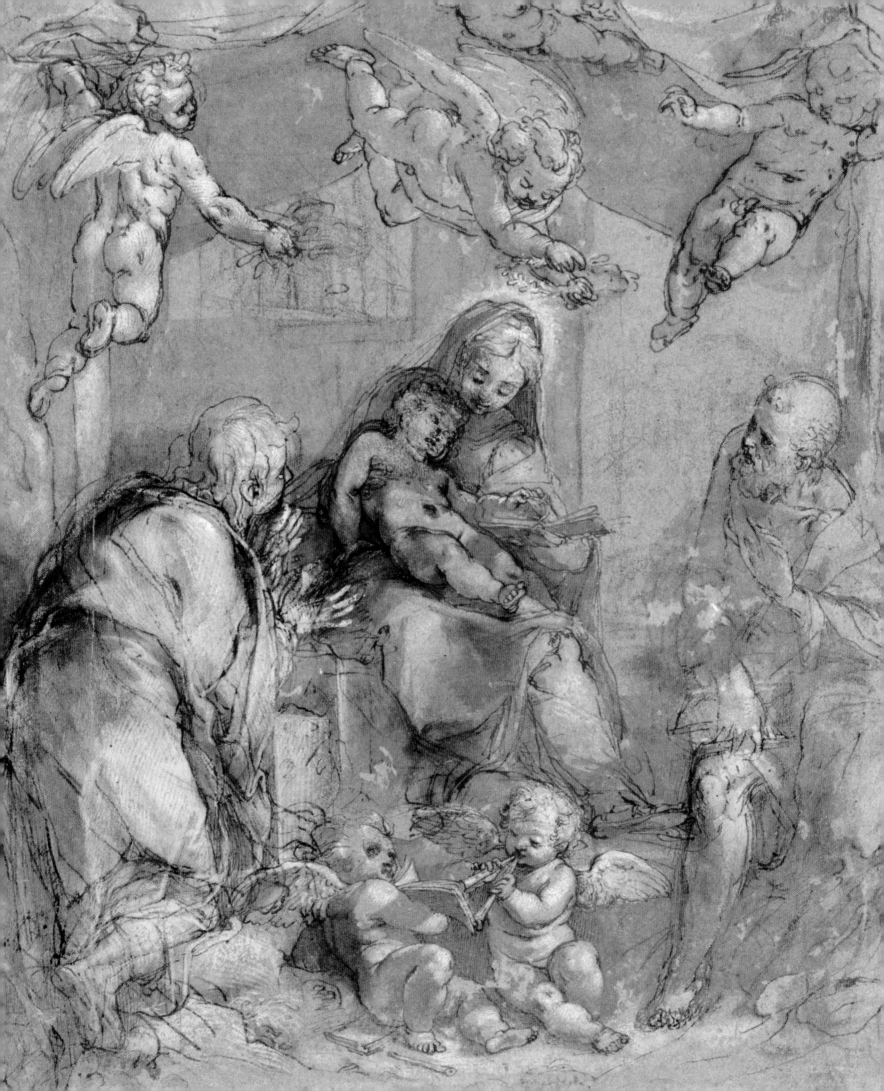

Ut Pictura Musica

Giovanni Baglione's biography of Barocci contended that the master's style might best be understood as a fertile compound of the *vago* and the *divoto*, as we have seen. When Giovanni Pietro Bellori offered the most extended early modern assessment of Barocci's achievement in *Le Vite de' pittori, scultori, ed architetti* (Rome, 1672), he developed some distinctive implications of this understanding. In particular, Bellori stressed the importance of color in Barocci's work and, in this context, asserted that Barocci identified painting as analogous to music:

> As regards the coloring . . . he distributed the hues in proportions and sought to find the right proportions between one color and the next so that all the colors together would have a sense of harmony and balance among them . . . And he said that just as the melody of voices delights the ear, so likewise the consonance of colors accompanied by the harmony of outlines brings pleasure to the eye. He therefore called painting music, and questioned one time by Duke Guidobaldo as to what he was doing, he replied "I am harmonizing this music," pointing out the picture he was painting.[1]

Bellori's assertion that Barocci privileged a concept one might term *ut pictura musica* over the standard *ut pictura poesis* of Horace may offer a key that opens up fundamental aspects of

Barocci's pictorial ideal. More generally, Bellori's claim implies that a consideration of the painting–music analogy in Barocci's work could illumine an important moment in the rise of the *topos* of *ut pictura musica*. The theme of music as an analogue to painting occurred with increasing frequency over the course of the sixteenth century and was certainly flourishing during the next century. Its rhetorical codification into a twin of *ut pictura poesis* was a later development, however, and thus the rise of the theme of musical painting in the early modern period has never been accorded the extended study that Rensselaer Lee's *Ut Pictura Poesis* of 1967 represents for the Horatian analogy.[2]

The fact that Bellori's *vita* was published some sixty years after Barocci's death might encourage skepticism in assessing his claims, some of which are clearly inflected by his ideological positions. Nonetheless, recent research has tended to confirm rather than undermine the veracity of a number of details in the Barocci biography, even if one might query aspects of Bellori's use of the information he gathered and remain suspicious of elements of his elaborate (and ideologically driven) account of Barocci's involved preparatory process. Bellori claimed that he based his biography of the painter "on the recollections of his life gathered by Signor Pompilio Bruni, who most kindly presented them to me and who, being a maker of mathematical instruments, carries on both the school and the

172 Paolo Veronese, *Marriage Feast at Cana*, 1562–3, oil on canvas. Paris, Musée du Louvre.

reputation of the Barocci in Urbino."[3] Bruni's "recollections" were evidently extensive and detailed, for they appear to have given Bellori access to precise pieces of information and documents from Barocci's lifetime and his immediate circle of friends and patrons.

For instance, as a means of praising Barocci's *virtù* and the sustained quality of his work, Bellori notes that the painter, even in extreme old age, maintained "a keenness of eyesight so strong that he never had to use glasses, and still retained every faculty of his mind." While such a statement could seem little more than a rhetorical flourish, the paired details of sharp eyesight and mental acuity are precisely those stressed in the entry in the private diary of Francesco Maria II della Rovere, Duke of Urbino and friend and patron of Barocci, that documents the painter's death: "[Today] Federico Barocci of Urbino, the excellent painter, died at seventy-seven years of age, at which age the eye and the hand served him as they had when he was young."[4] Even more telling is the impressive letter that Bellori inserts in his discussion of Barocci's *Crucifixion* for Genoa Cathedral (see fig. 104). This text, full of rich *ekphrases* of elements of Barocci's painting, and laden with current art critical terms, is said by Bellori to have been written by Matteo Senarega, Doge of Genoa, on receipt of the picture for his family chapel. The letter seems just the sort of document that

a theoretically inclined writer of artists' biographies in the late Seicento would invent. Yet, as already noted, an autograph version has recently come to light in the Senarega archives; it is almost identical to the text that Bellori transcribes.[5]

BAROCCI AND THE REPRESENTATION OF MUSIC

Even if Bellori's claim that Barocci drew some analogy between painting and music has substance, however, the fact remains that Bellori never developed his tantalizing assertion and that it has remained largely unscrutinized in the historiography of art.[6] If the statement could point to a richer understanding of Barocci's painting, and of the history of the theme of *ut pictura musica*, how might the delicate thread left by Bellori be followed? One obvious tactic would be to consider the representation of music in Barocci's works, as depictions of music making permeated much late Renaissance painting; one thinks of angel musicians in altarpieces, or "concert" pieces, or even the consort of instrumentalists in Paolo Veronese's *Wedding Feast at Cana* (1562–3), which – according to a Seicento tradition still generally accepted – portrays the leading painters of Venice among the musicians (fig. 172).[7] If this tradition is accurate, Veronese's painters' consort provides arresting visual evidence for the increasing identifica-

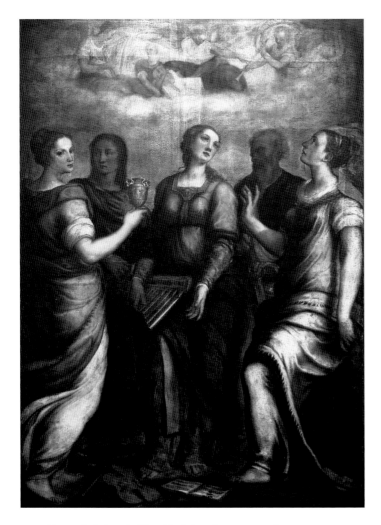

173 Barocci, *Saint Cecilia with Saints*, late 1550s, oil on canvas, 200 × 145 cm. Urbino, Cathedral.

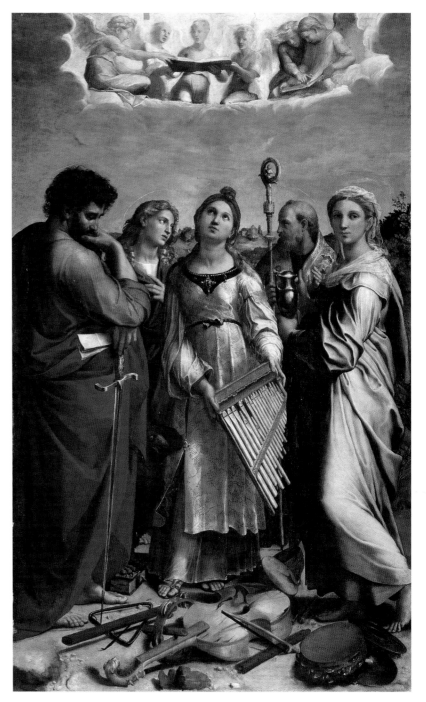

174 Raphael, *Saint Cecilia with Saints Paul, John the Evangelist, Augustine and Mary Magdalene*, c. 1513–16, oil on canvas (transferred from panel). Bologna, Pinacoteca.

tion of painters with music during Barocci's lifetime. Barocci himself was compelled to think about music from his youth: his first surviving painting is an adaptation of Raphael's very musical *Saint Cecilia with Saints* (figs 173 and 174).

The circumstances of this early commission remain unknown, though Barocci's painting can be dated with some certainty to about 1555–6; this places it shortly after his first trip to Rome and immediately subsequent to his earliest documented picture, the lost *Saint Margaret* for the confraternity of Corpus Domini in Urbino, for which the young painter received final payment on January 1, 1556.[8] Barocci's *Saint Cecilia* remains *in situ* over an altar in Urbino Cathedral, a location of obvious prestige. As is often remarked, the principal model for the young painter's altarpiece is not Raphael's actual painting but the apparently well known related engraving by Marcantonio Raimondi, which had already been employed for maiolica design in Urbino (fig. 175). Raimondi's engraving is related closely to a highly finished drawing attributed to Giovan

Francesco Penni; drawing and print both seem to record one of Raphael's early ideas for his altarpiece.[9]

Differences between Raimondi's engraving and Raphael's painting are numerous and extend from the poses and attitudes of figures to the very presentation of instruments and music. It is often noted, for instance, that Raphael's painting involves an allusion to the superiority of vocal polyphony over instrumen-

175 Marcantonio Raimondi, engraving of *Saint Cecilia*, 1515–16. Bologna, Gabinetto Stampe e Disegni della Pinacoteca Nazionale.

The young Barocci appears to have taken Raimondi's print as his starting point, but he made a number of modifications. These begin with the very identities of the saints. The new arrangement of figures presumably responded to patronal demands, but it has the effect of privileging young female saints. Thus, issues of both figural and alternative *vaghezze* are already raised in Barocci's first surviving painting, an altarpiece in which he represents both female beauty and music. Barocci also develops a representation of the musical theme that is distinct from his sources; this may well represent his own thinking rather than the desires of a patron, and it lays the foundations for much of his later reflection about painting and music. A surviving drawing offers clues about the developments in Barocci's thinking as he wrestled to design a sophisticated altarpiece for this important early commission (fig. 176).[12]

176 Barocci, compositional study for *Saint Cecilia with Saints*, pen, wash, chalk, and white heightening on paper, 31.6 × 22.8 cm. Stuttgart, Graphische Sammlung, Staatsgalerie, inv. 1338.

tal music. Cecilia turns her gaze from the abandoned instruments at her feet – instruments with a diverse range of possible associations, from the Dionysiac cymbals and tambourine through pastoral and amorous recorders to the more Apollonian viola da gamba that holds pride of place directly before her – and forgets even her *organetto* as she contemplates a vision of a heaven in which angels perform exclusively vocal music.[10] In Raimondi's print, by contrast, the qualities of both heaven and earth are represented through instrumental music. What seems to be a large recorder lies on an open book of music at the feet of Cecilia, near a tambourine and a lyre-like harp. The angels, meanwhile, play a contemporary (if incorrectly strung) harp, a triangle, and what appears to be a lira da braccio, the quintessential humanist solo instrument of the early and mid-Cinquecento, particularly prized by those poet-musicians who wished to accompany their own singing with a bowed string instrument that could play complex chords as well as melodic lines.[11]

In the drawing, Barocci minimizes the Dionysiac and pastoral instruments: only one tambourine and part of a recorder (or just possibly a shawm) are visible. The tambourine lies, not coincidentally, at the feet of the Magdalen, whose drapery flutters back over her leg like that of a maenad. She is also partially nude, though her half uncovered chest is turned discreetly away from the viewer. It is no surprise that more drapery was added to her figure in the final painting, destined for an altar in the Cathedral (though Saint Catherine of Alexandria is still represented in remarkably revealing drapery). As we have seen, Barocci rarely experimented again so decisively with female figural *vaghezza*.[13] Even in the drawing, despite the arresting figure of the Magdalen with her discarded tambourine – which disappeared in the painting, along with the Magdalen's nude back – Barocci emphasizes rather the higher stringed instruments exemplified by the viol at Cecilia's feet in Raphael's altarpiece, which Barocci replaces with a lira da braccio and a harp. The fact that the harp is incorrectly strung precisely in the manner depicted in Raimondi's engraving confirms Barocci's reliance on the print for particular details. However, his decision to depict the elevated instruments played by Raimondi's angels as discarded on the earth seems to indicate an important revision of the print, which takes the *modello* back toward Raphael's ultimate pictorial invention. Yet Barocci's heaven, unlike Raphael's, includes instruments. He does not copy Raimondi's instrumentation but rather depicts two angels who hold – but do not play – instruments that seem to have been selected with care. The angel on the viewer's left holds what appears to be a tenor viola da gamba, the other angel a trumpet. It seems significant that neither angel plays; in fact, the angel with the trumpet makes a gesture of awe as Cecilia experiences her vision. It is as if Cecilia's sight of heaven provides the "celestial music" for which she discards even the finest instruments of earth. This is a crucial detail: the idea that divinely inspired vision itself is the ultimate music, the highest harmony, proved critical to Barocci's conception of *ut pictura musica*.[14]

Barocci's painting retreats from this idiosyncratic representation of angel musicians who do not make music. He returned to Raimondi once more and represented a heavenly consort that includes a harp (now correctly strung – observed from an instrument rather than copied from Raimondi), a lira da braccio, and a trumpet, this last apparently just played or about to be played, as the angel holds it close to the lips. A recorder lies on the ground, accompanied still by a detailed lira da braccio, directly below that played by the heavenly angel. The separation of earth and heaven is no longer figured principally through the representation of different sorts of music but through pictorial means: Barocci's angels are but dimly perceived, through the haze and color loss of the light-filled mists that veil the apparition. This shift in visual style to figure a different realm of experience – which Barocci developed into one of the salient characteristics of a mature painting such as the *Madonna del Popolo* – is another early clue to what became his lifelong quest: to convey the power of painting, its music, its poetry, its very meaning, not merely through representation but through paint and the act of painting itself. It may be this devotion to the centrality of painting and its distinctive means of signifying that explains what otherwise appears a striking and disconcerting fact: in an age abounding in the depiction of angel musicians, Barocci never again represented the music of heaven. Indeed, he represented the playing of music only once more in his long career. The very subject of this representation, however, is telling: it is the blind beggar who cannot see the heavenly apparition that dominates the *Madonna del Popolo* and so continues to play – blindly – his loud and base hurdy-gurdy (see figs 24 and 163).

The survival of many of Barocci's drawings, however, allows one to establish that he did not simply abandon the representation of angelic music immediately after painting the *Saint Cecilia*. He literally worked out the issue in the design process for two altarpieces of the 1560s and 1570s – the *Madonna di San Simone* of about 1567 (fig. 177) and the *Madonna del Popolo*. The *Madonna di San Simone* was also painted for an altar in Urbino Cathedral, the third such commission for the young Barocci.[15] In a highly developed preparatory drawing, Barocci follows a fairly common period practice and places two music making angels (here nude putti angels) at the feet of the Virgin (fig. 178). One – who turns to look outward – holds a part-book for his companion, who plays double pipes that evoke the *auloi* of antiquity. Another pipe or small recorder lies on the ground at their feet. In the final painting, however, these angels have simply vanished. One might argue that this change is motivated by nothing more than practical exigency. While both drawing and painting are vertical format, the drawing is considerably wider, allowing more room in the space before the Virgin's feet and between the figures of the flanking saints. If the space over the altar ultimately necessitated a narrower painting, this might provide a sufficient reason to eliminate the musical angels. No such issue, however, is operative in the case of the *Madonna del Popolo*.

This large altarpiece has already been discussed as a culminating work of Barocci's early maturity, one of his most famous paintings during his lifetime, and a work in which Barocci meditated deeply about the role of tradition in the formation – or rather reformation – of a powerfully affecting modern visual language for religious painting. The subject of the painting had been spelled out in the detailed contract that Barocci

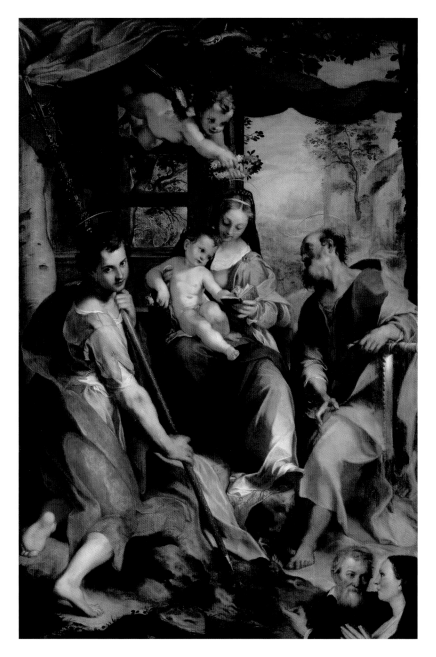

177 Barocci, *Madonna of San Simone*, c. 1567, oil on canvas, 283 × 190 cm. Urbino, Galleria Nazionale delle Marche.

rosined wheel turned by a crank at the base of the instrument. This wheel acts as an endless bow, providing a continuous stream of sound as the player forms melodies over drone accompaniment. In its earliest history, during the high Middle Ages, the hurdy-gurdy was well regarded, perhaps because of its association the development of polyphonic music. During later centuries, however, its reputation seems to have declined dramatically. By 1636, the French theorist Mersenne was summing up a long tradition when he noted the specific association of the instrument with beggars and the blind: "If men of distinction usually played 'la Symphonie' [the hurdy-gurdy] . . . it would not be as scorned as it is. But because it is played only by the poor, and especially by the blind who make their living with this instrument, it is less esteemed . . ."[17]

It thus seems no coincidence that Barocci's player is both a beggar and blind, his head turned unheedingly from the heavenly vision he cannot see. Although indigent, he is blind even to the alms offered inches from his head. In the highly finished compositional drawing for the painting, however, he can in some sense "see" and turns his head adoringly up to the blessing Christ (see fig. 49). The change effected between drawing and painting seems clearly intended to play up the debased state of the beggar, who blindly continues his raucous earthly music when he should be attending to the vision of heaven. Yet, if he could not actually see the vision, could he at least hear its music, as one often can in period painting? This question points up a small but fundamental adjustment between drawing and painting. In the drawing, Barocci depicted the principal adolescent angel who accompanies the Virgin and Christ holding what seems to be a recorder. As was already the case in the compositional drawing for the *Saint Cecilia*, this angel does not actually play the instrument. Nevertheless, even the representation of the recorder was redacted for the painting: the angel grasps only a surprisingly substantial puff of cloud.

The *Madonna del Popolo* is an *exemplum* of Barocci's mature pictorial practice concerning the representation of music. No angelic music – or elevated earthly music – is ever depicted. Nor is any elevated instrument ever represented as a still life detail, a *parergon*. There are no viols or lira da braccios lying in the corners of Barocci paintings after the *Saint Cecilia*. Rustic instruments, however, are depicted in two later altarpieces as attributes of shepherds. In the *Circumcision* of 1590 and the *Presentation of the Virgin* of 1592–1603, attending figures of shepherds who bring sacrifices to the temple have shawms tucked into their clothes (see figs 133 and 127). The shawm, a double-reed ancestor of the oboe with a strident tone, was frequently associated with shepherds, satyrs, and creatures of the wild; its presence in Barocci's paintings is thus a perfectly readable sign for "shepherd." Yet in both these later altarpieces, the rustics

signed on June 18, 1575, which stressed that the Virgin should be portrayed interceding with Christ "for his benediction for the populace, painted and represented . . . with decorum and beauty and grace, according to the conditions and qualities of the figures there painted . . ."[16] This stipulation goes some way toward explaining the crowded piazza scene in the lower portion of the composition with its depictions of all ranks and sorts of Aretines, from noble women, toddlers, and confraternity members to assorted beggars, including the prominent hurdy-gurdy player. His distinctive instrument is a cranked (rather than bowed) fiddle, its strings vibrated by a heavily

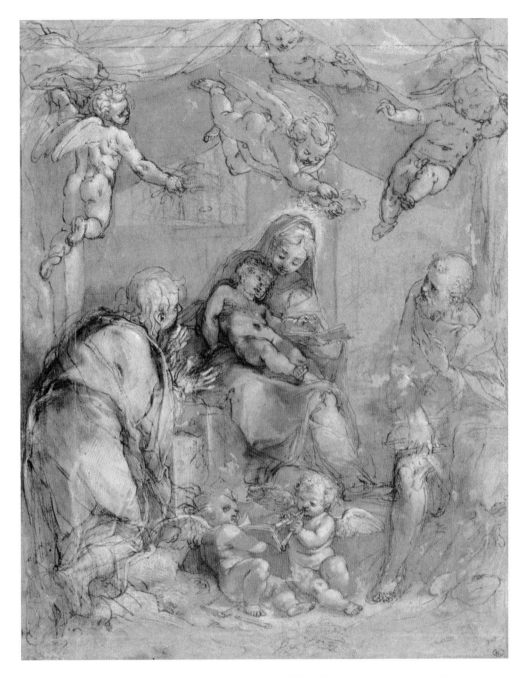

178 Barocci, compositional study for the *Madonna of San Simone*, pen, wash, and white heightening on paper, 30.8 × 24.4 cm. Paris, Musée du Louvre, inv. 2849.

gaze reverently at the sacred mystery enacted before them and their instruments remain silent. They, unlike the blind player of the hurdy-gurdy, have "seen" the heavenly harmony before them. They would not turn from it to make their rough music, nor would they attempt to serenade the infant Christ or the young Virgin with the piercing tones that are the only ones their instruments can command.[18] There thus exists a clear if unusual trajectory in Barocci's thinking concerning the pictorial representation of music making and instruments. Although in his first surviving painting he depicted the sort of musical

glory of angels contemporary observers might expect, he chose never to represent – to narrate – the making of angelic music again. That this was a considered decision, reached through the preparatory processes for altarpieces of the two decades following the *Saint Cecilia*, seems demonstrated by the evidence of the drawings for the *Madonna di San Simone* and the *Madonna del Popolo*. For the fifty-five years of his long career after the early *Saint Cecilia*, Barocci insisted on representing only the music of beggars and shepherds; after the *Madonna del Popolo*, even this music never sounds. Iconography as a strategy to

understand the interplay of the two arts thus fails: One must search elsewhere for signs of Barocci's supposed fascination with the music of painting.[19]

PERFORMING PAINTING

Bellori's text itself provides the clues. First, the relevant passage occurs in the context of a discussion of color. Second, Barocci's comment that he was "making music" is not part of an abstract theoretical discussion but is offered in the context of the act of painting. Color and performance are the golden threads. Indeed, it has been noted that the developing comparisons between painting and music during the sixteenth century not only associated color increasingly with musical tone, and the harmonies of music with well-managed coloring, but also compared painters particularly to musicians as performers rather than composers. In other words, painters were performers.[20] An example of this sort of thinking occurs in the 1548 *Dialogo di pittura* of the Venetian painter and theorist Paolo Pino. Pino based his assertion of painting's status as a liberal art on its links with the Quadrivium and focused on invention (*disegno*) as the fundamental quality that demonstrated the intellectual status of the pictorial arts. However, he proceeded to insist that as with musical composition this invention must be manifested in performance. Even though painters had to express themselves through the work of the hand, "this act should not be termed mechanical, for the intellect has no other means but the senses through which to express itself and make clear its meaning. . . . It happens that some say the act of painting [*operar*] is a mechanical act because of the diversity of colors and the outlines [drawn by] the brush, just as the musician raises his voice and deploys his hands with various instruments; but we are all liberal . . ." It is this sort of thinking that underlies Veronese's consort (see fig. 172), represented in the act of "harmonizing their music," to employ the words Bellori ascribes to Barocci.[21]

Indeed, an increasing number of artists – almost always painters – were associated with music during the course of the sixteenth century and some even portrayed themselves as musicians; Garofalo, for instance, proudly holds a bass viol in a self-portrait. Such an instrument, Orphic and courtly, associates the painter with the humanist musician poet and with Castiglione's courtier. As has been noted by Katherine McIver, Castiglione's contention in *Il Cortegiano* that skill in amateur music making was a requisite accomplishment of the successful courtier may have conditioned Vasari's identification of a number of artists in the *Vite* as excellent musicians, who might – as was the case with Giorgione – be invited to the soirées of the nobility in large part because of their musical ability. It is striking that Vasari lays particular stress on the association of music and

painters in Part Three of the *Vite*; while only a few artists are associated with music in Parts One and Two, McIver remarks that some thirty-six artists are noted for musical interests or skills in Part Three. This is itself a critical sign of the rising importance of the musical analogy in the sixteenth century, and of the links that could be perceived between the new art, the new music, and their respective cultures. Further, Vasari seems to have shared with the Venetians the by then relatively common notion that pictorial color needed to be "harmonized" in a manner that found analogies (at least as it could be described through language) in the harmonization of music.[22]

Yet even if the act – the performance – of painting, and certain pictorial qualities such as color, might be closely associated with music, pressing questions remain about how far a painter of major public works in the late sixteenth century might pursue an ideal of *ut pictura musica*. Performance was important but how, for instance, might analogies with music – and beyond practice, with music theory and criticism, which will become fundamental for my analysis of Barocci's approach – assist the ambitious painter to create compelling visual narratives? All the principal literary genres that served as models for ambitious public painting – the text of the Bible, epic and didactic poetry, and history – involved narrative. It was precisely the *istoria* that Alberti had identified as the ultimate goal of painting and (with the mathematics of perspective) as a key component of painting's claim to be a liberal art. In post-Tridentine Italy, many ecclesiastical patrons and theorists demanded that religious painting rigorously adhere to the strict historical parameters of sacred *istorie*. Barocci was deeply committed to upholding and advancing the dignity of painting, and thus committed equally to the idea of *istoria* – in both its Albertian and post-Tridentine guises – and to the creation of paintings that registered as powerfully affecting *istorie*. Indeed, the negotiations concerning the *Madonna del Popolo* make clear that Barocci resisted the confraternity's desire for a Misericordia both because such an image was outdated visually (hierarchies of scale, for instance, seemed no longer admissible in a *bella tavola* for Barocci) and because even with stylistic adjustments a Misericordia composition would remain relatively conceptual and iconic, rather than narrative and dramatic.[23]

It could, nonetheless, be asked what it would mean for an artist of the late Renaissance, invested (as Barocci was) in profiting from the rich pictorial innovations of both the central and north Italian schools, to paint religious *istorie*. Visualizing a narrative effectively through gesture, action, pose, and facial expression would certainly be critical. Yet it has been seen that Barocci, from his earliest paintings, was particularly engaged in adding to all these expected devices the power of what one might call purely pictorial means: paint texture and application,

sfumato and shadow, and above all color and light. In Barocci's hands, these are not merely artistic devices, enhancing the aesthetic experience of the image; they can also function to carry significance, sometimes with more power than the representation of gesture or expression, as in the red that flushes Saint Andrew's tunic around his heart as he responds to Christ in the *Calling of Saint Andrew* (see fig. 167). Indeed, it may be in part because one tends to look first at facial expression and gesture in judging a narrative image that Barocci is seen too often as a "sentimental" artist, rather than one who, in the words of his admirer the Doge of Genoa, could create a painting that "enraptures, divides, sweetly transforms," and ultimately "lives wrapped in silence and awe."[24]

Precisely this employment of uniquely pictorial elements (such as texture and color) for affective ends, as ambitious painting strove to equal (or best) language at recounting *istorie*, finds remarkable analogies in period music. Much music of the late sixteenth century was composed to serve as an effective vehicle for poetic words; the comparison of music and poetry was as commonplace as *ut pictura poesis* and was forcefully articulated by late Renaissance theorists who wished to recover the mythic power of ancient Greek music, in which the affect of compelling poetry was deepened through impassioned musical performance.[25] Just as Barocci could pursue affect through reflected color as effectively as through gesture, so the musical means for affective expression of the text went far beyond competent singing and declamation of the words. Such means extended to the very level of instrumentation. First, while instrumentation remained flexible in this period, choices could at times express aspects of identity. The character of Apollo or of Orpheus in a late Cinquecento *intermezzo*, for instance, would be unlikely to appear with a hurdy-gurdy or a bagpipe; one would expect him to play the lira, the viol, or perhaps the lute or harp.[26] Further, the affective potential of proper instrumental accompaniment for the declamation of poetry had already been stressed in Castiglione's *Il Cortegiano*, in which reciting poetry while accompanying oneself on the "viola" is praised as the greatest form of music for the courtier to perform, and the accompaniment is seen to "add such beauty and efficacy to the words that it is a great marvel."[27] However, the ultimate effectiveness of such music depended on factors beyond the mere choice of instrumentation. The arrangement of harmonies, rhythm, and melody were essential. This was governed by the rules of counterpoint, and inflected by the affective use of the varied characters of the musical modes to stimulate certain responses in the souls of listeners. The deployment and function of modes in the actual practice of polyphonic composition was debated at the time and still is. The richness of the concept of mode articulated in period theoret-ical and critical discourse, however, may have been vital in stimulating the imagination of artists and art theorists.

COMPOSITION AND MODE: *UN' ARMONIA E MUSICA, DIRÒ COSÌ, PITTORESCA*

Both the general notion of "composition" and ideas concerning color, mode, and tone stimulated analogies between painting and music during the sixteenth and early seventeenth centuries. Analogies between musical tone and harmony and pictorial color became particularly insistent, and I shall ultimately concentrate on these. The idea of a parallel between pictorial composition and musical composition (understood as the arrangement of voices, the effective deployment of low and high sonorities, and the variation of rhythm), however, was elaborated in Florence in 1564 by Vincenzo Borghini in a manner that offers rich analogies to Barocci's highly "composed" paintings. Borghini stresses that he is concerned not with music in general but with "vocal music that accompanies [poetic] verses." Furthermore, he seeks analogies between such music and the painting of *istorie*, not any painting. In fine painted *istorie*, "there is a part that in a certain way corresponds" to great musical interpretations of poetic texts. This is: "a harmony, a composition, an apt . . . disposition of the parts one with another, so that . . . everything is well disposed and composed, not confused . . . and as high and low voices combined together with reason and order make sweetest harmony and consonance, so in the composition of a panel there is a composition of large things with small, of distant things with near, from which results a consonance and harmony most pleasing to the eye . . ."[28] After elaborating on the effective pictorial composition of things near with things distant, Borghini turns to the question of the arrangement of actors in the *istoria*, praising figures "disposed in such a way that one figure does not impede another, nor does one raise an arm and cover the face of a principal figure . . . but [all figures] are placed with judgment, order, and grace." The issues here are virtually identical to those articulated by the Capuchin Fra Francesco Maria, in a letter to Cardinal Federico Borromeo, in which he praises the late and unfinished *Assumption* of Barocci. Even with the crowding necessitated by including "all the twelve Apostles," Fra Francesco writes, the work "is made with such study that one sees them all and no one impedes another." Borghini concludes, meanwhile, that from the careful construction of figural compositions "there is born a harmony and music, which I will call 'pictorial;' where one does not find this, even if the particular figures are well done, one will not call the picture or panel good, because it will be lacking its principal element . . ."[29]

Borghini stresses a carefully conceived pictorial "order" as painting's closest analogy to music. His remarks imply a particular interest in the ways in which both figural arrangement and proportion, and careful attention to gesture and the "movements of the body," can create a "most pleasing" painting that is akin to "the sweetest music." With his words in mind, several of Barocci's recurrent compositional strategies take on new interest. The arrangement of "things large and small, things distant and near" in the *Madonna del Popolo* seems virtually an illustration of the complex, sophisticated sort of pictorial composition that Borghini praises, one that employs all the painter's skills – composition, proportion, perspective, color, light and atmosphere, pose and gesture of individual figures – to create a compelling *istoria*. Indeed, Borghini itemizes all these aspects in his detailed elaboration of basic points.[30] In particular, one can imagine him admiring the "music" of gesture that Barocci generates in the panel. Gestures in the *Madonna del Popolo* are often powerful, demonstrative; they operate, however, in a tight relation with other gestures that amplify, echo, mirror, or balance them. The effect is – as Borghini might well have remarked – strangely akin to points of imitation in standard sixteenth-century contrapuntal polyphony. For instance, the little child embraced by his mother in the left foreground has hands clasped in prayer. Their pointing gesture actively directs the gaze to the mirroring prayer gesture of the kneeling knight in the center middle ground, whose image, enshrined carefully by the gestures of other actors, is physically and conceptually at the heart of the painting. In the shadows under the apparition, the knight's gesture is echoed by that of an older bearded man; not coincidentally, his praying hands direct the gaze back toward the mother and her children. The first child's sister, meanwhile, is also praying; as she turns to look back at her agitated sibling, the position of her hands shifts to indicate – unbeknownst to her but instantly evident to a viewer contemplating the painting – the gesture of charity performed at the right edge of the composition. Here a poor mother stretches her arm vigorously to receive alms; her gesture, too, relates to a series of outflung arms elsewhere in the painting.

This mother's very motion generates significant relations with other figures. For example, in Chapter two I noted that the begging mother's cloak appears to touch the upraised arm of the kneeling gentleman who reveres the divine apparition. This link between their figures is multivalent and far from casual. While its principal purpose may be to frame, even to enshrine the critical figure of the kneeling knight, the parallel between the gestures of this wealthy man and this poor woman links them in another fashion. His gesture hails the holy; her gesture grasps the sacred work blessed by the divine. In like manner, the Madonna's downturned left hand blesses

the act of charity received by the upturned hand of the beggar directly below her. In the foreground, meanwhile, the children's mother urges them to look to heaven. Her insistent pointing gesture connects with that of the reverent gentleman who throws up his arm in awe as the apparition sweeps past. Note how carefully Barocci has considered the position of this mother's hand, even her index finger. As the finger curves to indicate the Virgin and Christ, it passes just between the gentleman's head and shoulder but does not extend beyond his silhouette; the effect is that the mother's gesture ends in the active shoulder of the man, whose upflung arm thus echoes and continues her gesture, while in a varied form (farther back, more in shadow) and turning the motif in a new direction with new inflections. This passing of a motif from one "voice" to another, weaving it throughout a complex composition and enlivening its fundamental identity through appropriate embellishment, is particularly characteristic of late sixteenth-century sacred polyphony. A glance at the opening of Palestrina's admired *Missa Papae Marcelli* illustrates this musical "language of gestures" (see fig. 191).[31] Yet even as Barocci accomplishes this musical passing of motifs, he observes a distinctly pictorial rule stipulated by Borghini: while the woman's gesture connects with, overlaps that of the man, her hand does not block any important portion of his figure. One could go on with such observations: the man's upflung arm is almost mirrored, reflected, by Christ's. Christ raises his arm in light to bless, his hand facing palm down toward his people. The gentleman acknowledges this from the shadows of earth, his hand facing palm up toward his savior; and so on. The *Madonna del Popolo* presents a particularly complex composition, but one can observe similar care with figural placement, with the relation of gestures and bodies to one another, with the careful and sophisticated manipulation of space and spatial relations, in many of Barocci's paintings.[32]

Borghini's text, then, supplies what are perhaps surprising resources with which to speak about the analogies between the figural elements of painting and musical composition. A related analogy – which has received particular attention both in the late sixteenth century and in art historiography – is that between musical and pictorial "modes." Period theorists often stress that specific moods or states of mind are associated with particular musical modes; casting a piece into a well chosen mode, and using the subtleties of accidentals to nuance particular passages, could thus ensure that, if well performed, the composition would move listeners toward certain feelings and reflections.[33] Nicolas Poussin's famed letter of 1647 to his friend Chantelou is generally considered to be the first clear instance in which the modes (in this case specifically the ancient Greek modes) are directly related to the practice of

painting in a sustained way.[34] Nevertheless, Poussin seems to have summed up, codified, and expressed more pointedly than before a discourse that was already operative in the late Renaissance. When Lomazzo, for example, noted that "because all colors have a certain quality, different from one color to another, they cause diverse affects in the beholder," he implicitly related the affective theory of colors to ancient musical theory, which had bequeathed to the moderns the idea that particular modes could arouse listeners to distinct reactions.[35] When discussing gesture, Lomazzo made his dependence on music theory explicit, arguing that painters who represent the passions effectively through the poses and movements of bodies are like musicians who choose modes to move their listeners to certain emotions.[36] Poussin stressed his own ability to shift mode for affective purposes in another letter to Chantelou: "I am not at all like those who always sing in the same mode. I know how to vary the mode when I want." This pointed statement was elaborated by Félibien: "As Poussin told me, singers change their mode to suit the piece and so should painters."[37]

COLORS OF MUSIC, HARMONIES OF PAINT

Poussin adapted much of his language concerning the modes from an important musical treatise of the late Renaissance, Gioseffo Zarlino's *Le Istituzioni harmoniche* (Venice, 1558; this is the same Zarlino who, as noted in Chapter One, had located the origins of the Capuchin reform in the careful consideration of old images). There, in addition to the discussions concerning the "ethos" of the various modes that were consulted by Poussin, one finds also the development of analogies between the intervals and harmonies of music and those of color. Zarlino notes:

> Consonances are the more pleasing [*vaghe*] as they depart from simplicity, which does not delight our senses much . . . because our senses prefer composite to simple things. For this reason the ear reacts to the consonances in the same way that the eye reacts to the principal colors from which all the intermediate colors are composed. As white and black are less agreeable than the mixed shades between them, so the principal consonances are less agreeable than the other, less perfect, consonances.[38]

There are at least two aspects of this passage to highlight in relation to pictorial theory and Barocci's practice. First, Zarlino's idea that complex and subtle musical intervals and harmonies are *vaghe* offers an analogy in the realm of musical thought to Barocci's cultivation of *cangiantismo* and a Titianesque "mode" in his paintings; such coloristic devices heightened *vaghezza* in

painting, even as related harmonic strategies heightened *vaghezza* in music. One may recall Lomazzo's assertion that skillfully handled *cangianti* give "the highest . . . *vaghezza* and *leggiadria* to painting."[39] Second, Zarlino's assumption that colors, like musical tones and chords, are related through intervals, and can be managed so as to produce varied effects, alerts one to the late Renaissance fascination with the correspondences between color intervals, intervals of sound, and their related emotional valences. Indeed, an important aspect of sixteenth-century musical theory (and practice) was its development from a principal focus on the mathematics of music – most of the earliest Renaissance comparisons between painting and music stress their shared foundation in the mathematics of proportion and (particularly for painting) perspective – to include an equal fascination with the perception-driven quality of affecting sound, and the possibilities for musical intervals and modes to move the listener through the aural "colors" of tone and their affecting modulations.[40]

The possible analogies between musical intervals and harmonies and those of color had provoked enough interest by the late sixteenth century that a painter such as Arcimboldo could attempt to elaborate exact correspondences between particular tones and colors.[41] While Arcimboldo is frequently described as seeking to establish "scales" of color, the more proper term would be "modes." This is more than a technical distinction. Poussin's letter – inspired by Zarlino – illustrates the particular emotive power and distinctiveness that modes could be believed to possess. Susan McClary has recently stressed that precisely during Barocci's lifetime, modal thinking and experimentation reached something of a final flowering in the world of the Italian madrigal. Arcimboldo's distinctive experiment is symptomatic of an age in which a number of musicians and musical theorists attempted to establish ever more subtle gradations between musical intervals.[42] Bellori, while inhabiting a charged musical universe, may have had such issues in mind when he stressed Barocci's desire to find the perfect gradations between one tone and the next in his coloring. Yet most painters – and here one may plausibly include Barocci – were equipped neither with the expertise nor the interest to follow analogies between painting and music to the degree of an Arcimboldo. The more general comparisons between harmony and color, and analogies between pictorial and musical composition and mode, would have been sufficient for them. Simple but compelling ideas – the melody and harmony of colors accompanied by line – are ultimately what Bellori highlights in his account of Barocci's statements.

While Barocci's use of remarkable color "harmonies" and related pictorial strategies to move his viewers can be traced through a large number of his most important paintings of the

1570s–1590s, the *Madonna del Popolo* once again may serve as the exemplary case. A number of the coloristic strategies Barocci employed in the *Madonna del Popolo* were analyzed in the last chapter, in particular the "shifting of mode" effected between the zones of earth and heaven. The contrast between the use of *cangianti* in the foreground of the earthly zone and the reliance on more Venetian devices for the coloring of important figures in heaven both highlights Barocci's command of the coloristic rhetorical ornaments of the leading schools of Italian painting and allows for a pictorial language that adds another layer of significance to the language of gesture, pose, and facial expression. Both these aspects of coloring find analogies in the musical theory and practice of the late sixteenth century. For as in painting, ornaments and harmonies could be put to expressive purposes in music.

The second half of the century saw a progressive efflorescence of virtuoso elaboration and ornamentation. Such ornamentation was often improvised – the ultimate in performing one's art – but an increasing number of texts described the practice or even offered detailed instruction, with written out musical examples. As early as 1552 Adrian Petit Coclico related in his *Compendium musices* that parts left plain were "raw" or like unseasoned meat; transformed through ornamentation they become "seasoned . . . with salt and pepper."[43] Like rhetorical color in poetry, or color as *artificioso* ornament in painting, such devices were not merely ornamental but could contribute or heighten nuances in the music. Certain embellishments – *trilli*, passing notes, and similar ornaments – had been recognized by mid-century as having potential emotive affects. For the Venetian viol and recorder virtuoso and theorist Silvestro Ganassi, such effects were inevitably linked to particular variations of interval: "the lively and augmented grace will be that which varies by a third or more or less . . . the sweet or mild [grace] will be that which varies by a semitone."[44] Statements like these hint at why Arcimboldo was invested in establishing precise intervals between colors.

Ganassi's perception of the varied emotional tenor of ornaments indicates how a discussion of certain forms of ornamentation leads directly into a consideration of color as "mode" and meaning. When Barocci shifts from the employment of *cangianti* for figures on earth in the *Madonna del Popolo* to a more Venetian approach for the heavenly apparition, he effects a maneuver remarkably analogous to the shifting of mode within a single piece of music – an issue under discussion increasingly during the second half of the sixteenth century, as will be seen. His varied techniques generate different ornaments, different emotional tenors, and ultimately distinct valences of meaning. Barocci both distinguishes through his performance of painting his virtuoso abilities with differ-

ent approaches to coloring and in addition employs a shift in stylistic mode to register a different reality; he has found technical, performative pictorial means of visualizing the levels of heaven and earth and their corresponding sources of natural and divine illumination. He also does all this in a single painting. This point is worth stressing, for it might easily be assumed from a cursory reading of late sixteenth-century music theory or of Poussin's letter that varied modes could be employed for compositions of one sort of affective character or another, but that each composition was a unity. That is, one motet might be happy, one sad, and modes should be adjusted between these compositions – but not within them. However, a complex image such as the *Madonna del Popolo* encourages a "multimodal" articulation. While its overriding tone is one of celebration and appreciative devotion, it joins reverence with surprise, eagerness, and grave seriousness in the varied responses of the human actors, and ultimately seeks to "marry" the distinct realms of heaven and earth.

The shifting of modes within a given piece of music was controversial in the theory of the period but emerged as a point of debate as composers became more and more committed to marrying expressive texts with music and employing melody and harmony to explore the nuances of each line, each word, rather than simply representing musically the most general mood of the text. In practice effective emotive shifts could be created through shifts in musical texture – another useful analogy to Barocci's painting. The theoretical investment in modal thinking, however, meant that flexibility concerning modal unity in the interest of expression was discussed by a number of writers and was particularly promoted in theoretical discourse by the idiosyncratic and polemical Nicola Vicentino in his *Antica musica ridotta alla moderna prattica* (Rome, 1555). Vicentino worked for much of his career in the entourage of Cardinal Ippolito d'Este and so would have been known to Lucrezia d'Este, the ill-fated, music-loving Duchess of Urbino.

Throughout his text, Vicentino returns repeatedly to a central theme: "Music set to words has no other purpose than to express in harmony the meaning of the words, their passions and effects."[45] Vocal music, for Vicentino as for Borghini, is analogous to the painted *istoria*. Yet, like a painting, music must express the meaning of the words through its own unique devices. According to Vicentino, the rules governing the employment of mode, proper harmonies, melodic writing – indeed all the rules of music – may also be stretched, distorted, and broken if doing so heightens the affect of the musical expression of words. He argues with specific reference to architecture and architectural painting. There are buildings that combine varied orders, he asserts, and yet seem all the more

beautiful and rich for it. In the decoration of buildings, the "illusions" of space created by painting in effect break down the univocal "structure" of the edifice, yet do so in a manner that fascinates and delights the confused eye. So the skilled composer "may use artifice to make various mixtures of fourths and fifths from other modes [than the fundamental mode of the piece] and thus to adorn the proportioned composition according to the effects of the consonances applied to the words . . ."[46] Such statements, translated into the discourses of painting, offer insight into Barocci's technique of shifting pictorial approach in the midst of the *Madonna del Popolo* to, as it were, set a distinctive portion of "text." Vicentino's comments may also heighten awareness of the intimate bond between ornament or artifice and expression. The composer's introduction of elements of "other modes" into a piece both "adorns" the composition and responds intimately to the shifting moods and meanings of particular words or phrases.

Vicentino goes even farther, however. He warns the composer to use care when "writing sacred works that anticipate the response of choir or organ." Here, for the obvious reason that given passages in such works "expect a reply," the composer should "seek to maintain the design of the mode." But particularly in vernacular compositions, all such constraints may be dispensed with. There are many sonnets, for example, that

> begin cheerfully and then at the end are full of sadness and death, or vice versa. On such words, a composer may forsake the modal order in favor of another mode, for no choir needs to respond to the mode. On the contrary, the composer's sole obligation is to animate the words and, with harmony, to represent their passions – now harsh, now sweet, now cheerful, now sad – in accordance with their subject matter. This is why every bad leap and every poor consonance, depending on their effects, may be used to set the words. As a consequence, on such words you may write any sort of step or harmony, abandon the mode, and govern yourself by the subject matter . . .[47]

Among theorists publishing in the 1550s Vicentino's position was relatively radical. Claude Palisca has stressed that "while Gioseffo Zarlino's *Le istitutioni harmoniche* of 1558 stood for the status quo, Vicentino led the avant-garde."[48] By the time Barocci was planning paintings like the *Madonna del Popolo* the situation had developed, and some leading madrigalists were already practicing aspects of what Vicentino preached. Further, for all that he may be seen as relatively conservative, even Zarlino had noted that harmonies should follow the varied effects of specific words in a text. While he certainly promoted the notion of modal unity more than Vicentino (admonishing the musician to "consider the nature of the mode in which he wishes

to write a composition") and was concerned not to exceed the bounds of musical decorum, Zarlino nonetheless stressed that the musical representation of individual words through harmonic variety was essential. The composer

> should take care to accompany each word in such a manner that, when the word denotes harshness . . . and other things of this sort, the harmony will be similar to these qualities, namely, somewhat hard and harsh, but not to the degree that it would offend. Similarly, when any of the words express complaint, sorrow, grief, sighs, tears, and other things of this sort, the harmony should be full of sadness.[49]

The very "colors" of music, its harmonies and intervals, should thus respond to the shifting inflections of the text. Barocci's practice as a colorist might be said to negotiate between pictorial positions analogous to the theoretical stances assumed by Vicentino and Zarlino. The care with which Barocci employed devices such as *cangiantismo* indicates his concern "not to offend," as Zarlino would have put it, by exceeding decorum too far in his expressive artifice. Meanwhile, the "modal" variations Barocci introduced within pictures allies his painting with some of the musical practices promoted by avant-garde composers and theorists. Vicentino's notion that the rules of melodic and harmonic composition could be creatively deformed by composers in search of heightened expressivity in particular passages seems to "resonate" with one of Barocci's most distinctive coloristic practices, the exaggeration of reflected color as exemplified in the *Calling of Saint Andrew* (see fig. 167). As Andrew's robe suddenly glows red in shadow at his chest, both taking on the color of Christ's robe and registering Andrew's fervor at this moment, color reflection becomes a means of "speaking" visually about emotional states that cannot be entirely conveyed by the outward gestures of the body, and of connecting distinct but related figures in the sacred drama. In the connection of figures – of motifs – such coloristic effects find remarkable structural analogies to the points of imitation through which motifs were passed between voices in period polyphony. Yet, as the writings of Zarlino and particularly Vicentino make clear, Barocci's strategy in the *Calling of Saint Andrew* also finds distinctive analogies to the rising insistence in late sixteenth-century musical discourse that not only must the mode (or modes) of a piece respond to its textual subject, but so also must the particular harmonies respond to the varied nuances of passion and meaning conveyed by individual words and phrases. In his exaggeration of color reflection Barocci stretched the "rules" of naturalistic painting; it is his particular skill with paint that enabled him to do so in a manner that heightens affect and pictorial variety without "giving offense." Barocci's unique ability to "harmo-

nize the music" of painting in such ways is a fundamental aspect of his creation of an art at once full of *vaghezza* and of devotion.

If Barocci's emotive, affecting employment of reflected colors to paint emotional states seems virtually a transposition into painting of the musical ideal that would inflect each passage of a text with distinctive harmonic devices, it indicates in addition a deeper affinity between Barocci's pictorial devices and those of music. Just as Castiglione had noted that musical harmonies add such expressiveness to poetic words "that it is a grand marvel," Barocci's pictorial harmonies put fundamental and distinctive devices of the painter's unique non-verbal art to work as effective signifiers alongside the naturalistic representation of expressions and gestures that are more commonly understood to drive pictorial *istorie*. One must be careful here to avoid the methodological pitfall of applying modernist assumptions to the early modern period, in particular the notion – critical to the formulation of the *ut pictura musica* in the nineteenth century – that the foregrounding of artistic means entails, ultimately, a heroic emancipation of the visual or aural arts from literature or from "imitation" in the Aristotelian sense.[50] Nothing could have been farther from Barocci's mind or those of his musical contemporaries. Both music and painting were still wedded to poetry in the late sixteenth century; the Orphic song and the Titian mythology that magically transmuted poetry into paint were among the highest artistic ideals and models for this culture.

It was music first, nonetheless, before poetry, with which Barocci seems to have identified painting. To "call painting music" implies a recognition that music and painting have distinctive languages that are non-verbal and that they must represent poetry, history, and the *affetti* through a skilled use of sounds or colors, shapes, and light, rather than first and foremost through words. In this they are analogous to one another and distinct from the poetry they both emulate. It is because of this insight that Barocci did not represent music in painting, as many contemporaries did; this would have been merely analogous to representing *istorie* through bodily movement. Although Alberti had stressed that the painter had only the "movements of the body" through which to visualize the "movements of the soul," Barocci employs the analogies between the colors of paint and those of music to dramatize the movements of Andrew's soul through color in addition to form and gesture. He employs all the resources of the new painting to visualize the "movements of the soul" and through this to move the souls of beholders. For him, painting is the "art of arts" and music is most like it.

Leonardo had already advanced a *paragone* of painting with poetry and music and, perhaps for the first time, concluded that

painting was superior not only to music but even to the art form it ostensibly "imitated," poetry:

> Painting acts through a more noble sense than poetry, and renders the figures of the works of nature with more truth than the poet. And the works of nature are far more worthy than words, which are the works of man, because there is the same proportion between the works of man and the works of nature as between man and God. Therefore, it is a more worthy thing to imitate things in nature, which are actual similitudes in fact, than to imitate facts and the words of men in words. And if you, poet, want to describe the works of nature with your simple profession, by feigning different places and the forms of various things you will be overcome by the painter's infinitely [greater] proportion of power.[51]

Indeed, Leonardo placed poetry third in his *paragone*. Only music could approach painting, for only it had parts and harmonies analogous to those of painting; in comparison, reading or reciting literature was a purely "linear" experience:

> a poem . . . does not result in any grace other than what is heard in music if each tone were heard only by itself at various times, which would not compose any harmony [*concento*]. It is as if we would want to show a face part by part, always covering up the part which was shown before. Oblivion does not allow any proportionality of harmony to be composed because the eye does not embrace a proportionality . . . at one and the same time in such demonstrations. A similar thing happens with the beauties of anything feigned by the poet; since their parts are said separately at separate times, the memory does not receive any harmony from them.[52]

Yet, while music is like painting in that it is composed of a harmony of multiple parts that are lacking in poetry, it fails to equal or surpass painting because it is not an art directed to the "first" sense – vision – and because its glorious harmony of tones only comes to life through ephemeral performance, in sounds that cannot endure. The coloristic and atmospheric harmonies of painting, by contrast, endure for centuries, and are always present for fresh contemplation:

> Music is to be regarded none other than the sister of painting since it is subjected to hearing, a sense second to the eye, and since it composes harmony from the conjunction of its proportional parts operating at the same time. . . . Yet painting excels and rules over music, because it does not immediately die after its creation the way unfortunate music does. To the contrary, painting stays in existence, and will show you as being alive what is, in fact, on a single surface. O mar-

velous science, you keep alive the transient beauties of mortals! These [beauties] are more permanent than the works of nature, which are continuously changed by time . . .[53]

Music – more even than poetry – was painting's "sister," for both arts were based on harmonies created by multiple and varied parts of the work being presented to the relevant sense at once, rather than in the linear fashion of verbal description or narration. For Leonardo, however, despite all music's similarities to the art of painting, its major shortcoming lay in the quick decay of sound. Its lovely harmonies did not last "long enough to let you . . . consider" them carefully, and if one wished to experience musical harmonies more fully, the music needed to be "reborn" – played again. Yet too much repetition would lead inevitably to frustration, boredom, and a loss of engagement with what once seemed compelling.[54] Still, in his elevation of both painting and music over poetry, Leonardo made one further point that could have held particular interest for Barocci, who was first and foremost a painter of religious subjects. Leonardo admitted that painting dealt with the visible world, the "representation of visible things": music, meanwhile, concerned itself with "invisible things." Leonardo concluded his *paragone* by asserting: "the poet remains as far behind the painter in the figuration of corporeal things as he remains behind the musician in the figuration of invisible things."[55]

Leonardo does not consider corporeal things inferior to "invisible things" as he argues for the superiority of his painting. But to place the invisible above sense reality was a standard spiritual *topos* of the era. Indeed, part of the discipline some ecclesiastical reformers wished to place on religious painting was to insist that it accept the limited purview of "illustrating" scripture and hagiography. These critics argued that painting – inferior to language – could only represent the sensible, material world and narrate stories in a straightforward manner; its self-aggrandizement in the hands of contemporary virtuosi could not elevate it above this task and indeed only corrupted it, replacing its direct presentation of human stories with contorted nudes, ornamental and "senseless" *grotteschi*, and other bodily "excesses." It is telling that several reformers would restrict or overtly condemn the fashion for *grotteschi*. In cultivating such inventions, painters attempt to create a new world; but as the only tools at their disposal are things visible, they can only make monstrous hydrids of corporeal creatures as they vainly struggle to extend the range of painting into the imagination.[56]

Barocci was a painter who constructed his career and his artistic self-fashioning from the visualization of divine "mysteries and histories," but he strove, throughout his work, to enlist the full potential of modern art into the service of the religious image. While he would not resort to the bodily excesses that brought the religious pictures of many of his contemporaries into suspicion – the uncovered back of the bacchic Magdalen in the early *Saint Cecilia modello* was not repeated – he sought other, less controversial means of enhancing the artistic fascination of his painting.[57] These means were first and foremost those of color and technique. Despite warnings about excessive reliance on the "unnatural" artifice of *cangiantismo* from some reformers – and vigorous condemnations of the cosmetic blandishments of pretty pigments in artistic treatises – color was widely accepted as a pictorial lure for the viewer. An ecclesiastic like Paleotti could even encourage the use of beautiful coloring to attract the eye of passersby to contemplate a religious painting. Nevertheless, while Paleotti's text offers numerous passages of use in interpreting the pictorial trajectory I have been following, he ultimately limits the painter severely. Agreeing superficially with Leonardo but drawing fundamentally different conclusions concerning the power and centrality of painting, Paleotti stresses that "as the office of the painter is the imitation of things . . . as they are shown to the eyes of mortals, he should not trespass these confines, but leave it to theologians . . . to expound (lit. "to expand to") other, higher and more hidden thoughts."[58] Barocci, however, strove to employ the artfully sensuous lures of lovely color to make painting "show forth" for the viewer the invisible longings of the heart and the blinding glories of heaven. His art claimed for painting the Philostratan superiority of imagination, *phantasia*, over mere imitation: "for imitation can only create as its handiwork what it has seen, but imagination equally what it has not seen."[59] Barocci's painting gloried in the visible but, ultimately, like a kind of music, it "spoke" about the unsayable, the invisible, even the inaudible. Light and color were his harmonies and with them he attempted to touch that which was beyond words, beyond sound, and virtually beyond the reach of human sight.

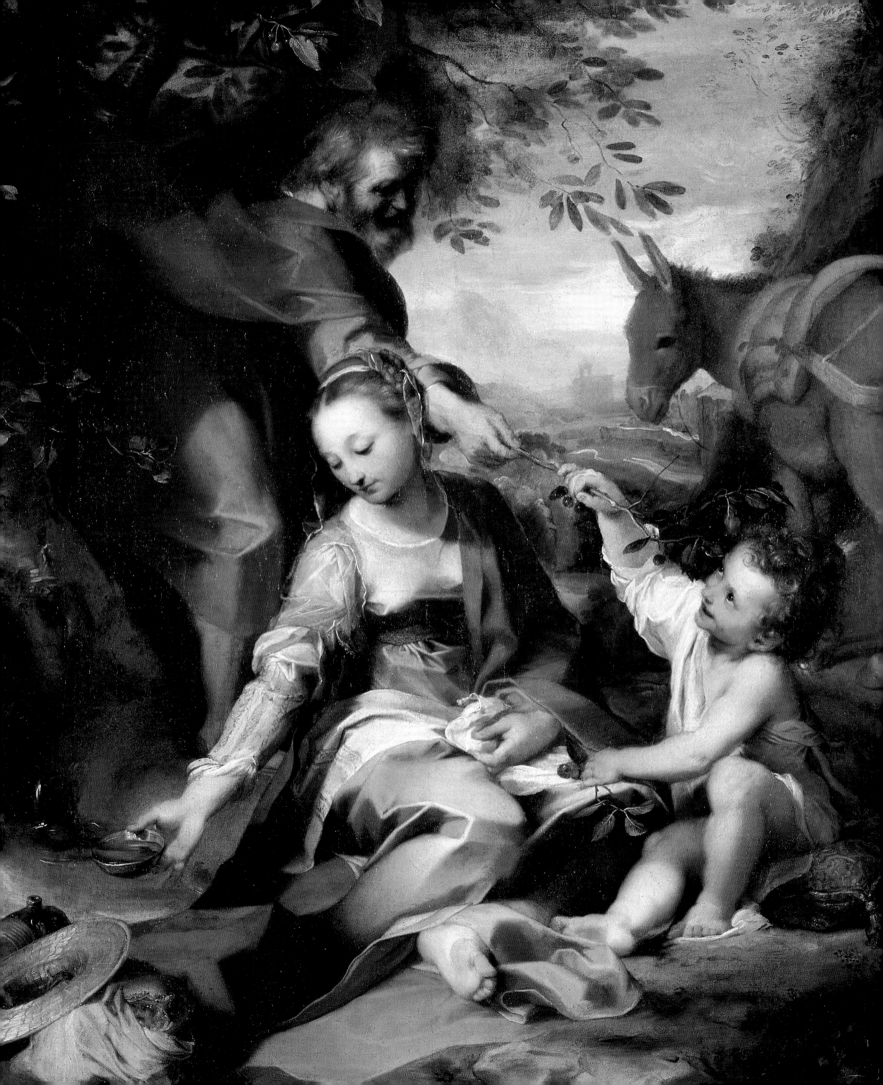

CONCLUSION

Sight-Reading the Vatican Rest on the Return from Egypt

AN APPROACH TO EKPHRASIS

For Duke Guidobaldo, the father of Francesco Maria, Barocci did a small easel painting of the Virgin resting from her journey from Egypt; she sits and with a cup draws water from a spring while Joseph lowers a branch of apples, offering it to the Christ Child who laughs and holds out his hand. This painting was sent as a gift to the Duchess of Ferrara, and because it was admired, a replica was painted and another one done in gouache with life-size figures, which Count Antonio Brancaleoni sent to the Pieve of Piobbico, his castle.[1]

THE CONTEXT OF A DISTINCTIVE INVENTION

The version of the *Rest on the Return from Egypt* now in the Vatican (fig. 181) is described by Bellori here as a "replica" (it actually seems to be a close variant) of the painting – now lost – that was commissioned by Guidobaldo II della Rovere, Duke of Urbino, as a gift for Lucrezia d'Este of Ferrara in celebra-

tion of her impending marriage to his son and heir, Francesco Maria. This initial *Rest* represents an early instance in which Barocci, returned to Urbino, found significant court patronage.[2] The variant ordered by Count Antonio Brancaleoni (fig. 179; now much damaged) appears to be the one engraved by Cornelis Cort in 1575 (fig. 180). Barocci elaborated the composition once more to produce the picture now in the Vatican for a friend from Perugia, Simonetto Anastagi. While the condition of this painting is far from perfect, more of its surface is legible – and its coloring is far richer – than the other surviving version. The painting dates to about 1573 but Barocci and Anastagi seem to have become close when Barocci stayed in Perugia in the late 1560s to work on the *Deposition* (see fig. 85) for the cathedral there. Anastagi was a member of literary circles in Perugia, and the friendship he and the painter forged is yet another indication of Barocci's intimate relations with a number of "virtuosi," as Bellori puts it.[3] The fact that the original version of the invention was ideated in response to the first real

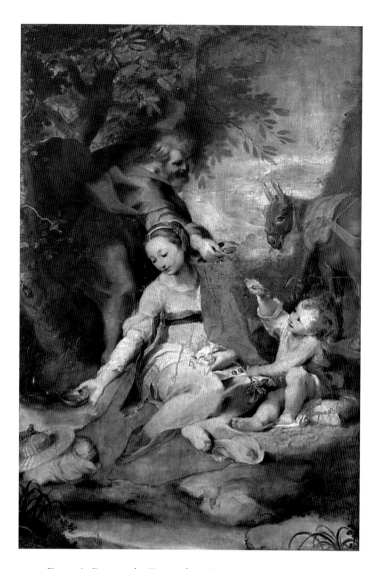

179 Barocci, *Rest on the Return from Egypt*, c. 1573, oil and tempera on canvas, 190 × 125 cm. Piobbico, Santo Stefano.

180 Cornelis Cort after Barocci, *Rest on the Return from Egypt*, 1575, engraving. London, British Museum.

interest the Duke of Urbino had shown in an ambitious young painter resident in his capital, that variants were created for a Marchigian courtier and for a friend and collector with intellectual leanings, and that Cornelis Cort issued a noted engraving of the composition, all imply that the *Rest on the Return from Egypt* was an important painting – or rather cluster of paintings – for Barocci, through which he would have wished to express his distinctive excellence and enhance his rising fame. Indeed, though the Vatican version was produced for private devotion and for a friend, its deceptively simple appearance belies a rigor and complexity that encapsulates many of Barocci's evolving pictorial strategies. A consideration of these strategies in this particular painting can demonstrate how aspects of Barocci's production, analyzed thematically in earlier chapters, might be integrated in a close reading of one relatively simple-seeming painting from the critical decade of the

1570s. Such a reading may then provide an initial model that can facilitate the interpretation of several important and often more complex compositions.

In fact, nothing about this painting is as simple as it might appear. Even the subject seems to be unusual, for Bellori's phrasing – "viaggio d'Egitto" instead of "viaggio in Egitto" – implies that the theme is the rest on the return from Egypt instead of the more common rest on the flight into Egypt. It would be easy to assume that Bellori is incorrect here, or simply casual in his turn of phrase. The rest on the return from Egypt was a rare subject; the standard source for the iconography of the Holy Family resting by a fruit tree and fountain comes from a description of the rest on the flight into Egypt in the Apocryphal Gospel of the Pseudo-Matthew. However, Correggio's *Madonna della Scodella* (fig. 182), clearly one model for Barocci's invention, was identified as a return from Egypt in early sources, and

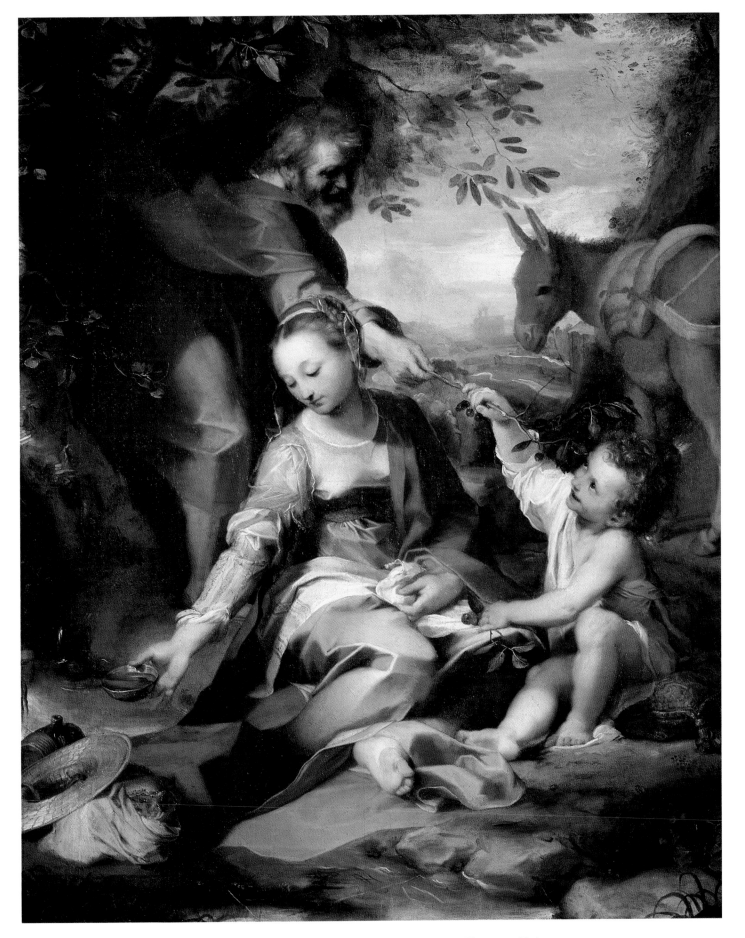

181 Barocci, *Rest on the Return from Egypt*, c. 1573, oil on canvas, 133 × 110 cm. Vatican, Pinacoteca Vaticana.

182 Correggio, *Madonna della Scodella*, mid-1520s, oil on panel. Parma, Galleria Nazionale.

Borghini's *Il Riposo* describes Barocci's *quadretto* in 1584 as "the glorious Virgin, who returns from Egypt." The fact that this seems to be an unusual variant of a standard subject can only have stimulated Barocci's powers of invention and constitutes a situation analogous to those out of which he produced the *Madonna del Popolo* and the Urbino *Immaculate Conception* – not to mention the *Perdono*, which was a most unusual theme.[4]

For this commission for a private painting rather than an altarpiece, Barocci shows little sign of the retrospection that sharpened the *divoto* quality of several of his altarpieces over the ensuing two decades; indeed, in the *Rest on the Return from Egypt* some of his clearest gestures are toward Correggio. Nonetheless, he reflected carefully on the tensions between the

cultivation of *vaghezza* and the maintenance of pious decorum. He meditated, also, on a variety of sources in the art of the *terza maniera*, on how these might be re-employed, reformed, and revalued in the artistic and religious situation of the 1570s. The visual sources of the work are particularly rich and woven together with a sureness that presages the revaluation and revision of Michelangelo and Raphael in the Senigallia *Entombment* (see fig. 83). In the *Rest on the Return from Egypt*, the response to Correggio's *Madonna della Scodella* is so clear that Barocci has at times been seen to imitate Correggio here; Bellori's conclusion that Barocci "resembled . . . Correggio both in theory and means of conception and in the pure and natural features, the sweet airs of the putti and women and in the folding of the draperies carried out in a relaxed and soft style" comes immediately to mind.[5] Yet the Florentine and Roman "High Renaissance" is present here as well: Raphael of course, and even, indeed in particular, Michelangelo.

The idea that Barocci was little influenced by Michelangelo often seems assumed in the literature. Further, a recent article has remarked that the figure of Judas in Barocci's *Institution of the Eucharist* (see fig. 130) – evidently an adaptation of Raphael's Heraclitus in the *School of Athens*, often believed to be a portrait of Michelangelo (fig. 183) – may represent a visual sign for Michelangelo's perceived transgressions in the field of religious art.[6] This quotation is surely significant; whatever it implies about the aged Barocci's assessment of Michelangelo, however,

183 Raphael, detail from the *School of Athens*, 1509–11, fresco. Vatican, Stanza della Segnatura.

LEFT 184 Leonardo da Vinci, *Virgin and Child with Saint Anne and a Lamb*, c. 1510–13, oil on panel. Paris, Musée du Louvre.

ABOVE 185 Michelangelo, *Holy Family* (Doni Tondo), 1503–4, tempera and oil on panel. Florence, Galleria degli Uffizi.

the figure should not obscure the fact that the young Barocci seems to have recalled the old master's figures repeatedly – as in the Vatican *Annunciation* (see fig. 17) or the Virgin from the compositional drawing for the Bonarelli *Crucifixion* (see fig. 13) – and continued a dialogue with Michelangelo through the Senigallia *Entombment* and on to the late re-elaboration of this theme in the unfinished picture for Milan (see fig. 109). At a point when he was creating an *invenzione* with which to impress his own duke and the sophisticated court of Ferrara, it would only have been natural for Barocci to demonstrate what he had learned from the leading central Italian masters as well as from Titian and Correggio. Indeed, in the *Rest*, the loosely painted, atmospheric landscape may owe as much to Raphael's experiments with highly painterly landscape in the *Madonna of Foligno* (see fig. 31) and the *Transfiguration* as it does to a specific work by Titian.[7] It is particularly Michelangelo and Leonardo, however, in addition to Raphael, whose innovations underlie Barocci's distinctive figural composition.

In paintings such as Leonardo's *Madonna and Child with Saint Anne* (fig. 184) or Michelangelo's *Doni Tondo* (fig. 185), the traditional image of the Virgin and Child with another member of their family is carefully and profoundly rethought. One need only compare the *Madonna and Child with Saint Anne* by Masolino and Masaccio with the reinterpretation of the theme by Leonardo to sense what has happened (fig. 186). Icon has become narrative, most obviously, but beyond this Leonardo negotiated with tradition with great subtlety. His tightly knit composition – the sophisticated fruit of obsessive reworkings in drawings in which figural compositions might dissolve into dense welters of lines as the painter revised and revised – is conceptualized in such a way that it becomes at once an exceptionally dynamic narrative revision of a traditional figural group and a composition in which all the principal holy figures are kept near the center of the picture. Indeed, the complex interrelation of Saint Anne and the Virgin privileges just the sort of hierarchical arrangement that defined the panel by Masolino

186 Masolino and Masaccio, *Madonna and Child with Saint Anne*, 1424, tempera on panel. Florence, Galleria degli Uffizi.

the sheet is squared and the Madonna and Child are highly worked figures highlighted with copious white heightening. The figure of Joseph is merely sketched as he hands the branch of cherries to Christ; but it is clear that he stands to the right of the group and that the action thus flows across the picture plane from right to left, as it does in Correggio's *Madonna della Scodella*. The Madonna and Christ are also envisioned in poses quite different from those they assume in the finished painting. While Christ occupies the center of the image as he receives the cherry branch from Joseph, the Virgin's figure traverses the center of the picture; her legs extend toward Joseph, while her arm reaches toward the picture's left edge to collect the cup of water. Although her figure is certainly inspired by the vigorous geometries that motivate some "High Renaissance" compositions, the narration is more lateral and less centralized than is the case in the *Doni Tondo* or Leonardo's *Virgin and Child with Saint Anne*. Barocci's revision of his compositional formula in the painting creates an image much closer to something like the *Doni Tondo* – it is in fact suggestive that the pose of the Virgin's legs in the painting was radically altered from that in the drawing and has become a close paraphrase of the legs of Michelangelo's Virgin.

Yet even in this enrichment of the Correggio composition underlying the *invenzione* of the painting, Barocci involves Correggio afresh. Throughout his elaboration of his invention, Barocci never abandons his clearest reference to Correggio's treatment of the theme – the gesture of the Madonna as she scoops water with her *scodella*. In the painting, the diagonal forward and turning impetus of the figural action that he eventually evolved is what allows him recourse to a characteristic gestural device of Correggio, the figure (here Saint Joseph) with arms outstretched, extending back into the picture plane and out toward the beholder. Perhaps the most remarkable example of such a figure is that of San Gimignano in the *Madonna of Saint Sebastian* (see fig. 132), a painting Barocci might have seen in Modena if he passed through there on his journeys to the "più chiare città d'Italia." Yet the figure of Christ in the *Madonna della Scodella* is even closer in the form and intention of his gesture to Barocci's Saint Joseph.[9] As often in Barocci, it is particularly the figure's orientation with regard to the viewer that is transformed. While Michelangelo's Christ in the London *Entombment* (see fig. 86) was carried away from the beholder and Raphael's Christ in the Baglioni *Entombment* (see fig. 87) was carried past the beholder, Barocci's Christ in the Senigallia *Entombment* was carried toward those who stood before the altar to receive Him. Likewise, while Correggio's Christ has his body turned into the picture as he receives the dates from Joseph, Barocci's Saint Joseph leaps forward toward both Christ and the viewer before the picture; the dramatic nature of his extended gesture, reach-

and Masaccio, while at the same time infusing the figures with a twisting energy that they might well have lacked in a composition that was "simply" structured to privilege a narrative reading, such as a left-to-right series of figures in action. An analogous mode of thinking informs Michelangelo's *Doni Tondo* and motivates – at least in part – the unusual invention in which Christ is handed forward from Joseph to Mary (and toward the viewer).[8]

With these considerations in mind, a preparatory drawing for the *Rest on the Return from Egypt* takes on new relevance (fig. 187). The drawing indicates a fairly advanced stage in planning:

187 Barocci, preparatory drawing for the *Rest on the Return from Egypt*, early 1570s, pen, wash, chalk, and white heightening on paper, 24.5 × 19.4 cm. Florence, Galleria degli Uffizi, Gabinetto dei Disegni, inv. 1416 Es.

ing back into the tree with one arm and extending fruit to his Son with the other, only heightens the sense that he is approaching the viewer from the shadows of the painting. In the very composition of the picture, then, as well as in his handling of color and paint, Barocci demonstrates his artistic fecundity, his understanding and mastery of both "High Renaissance" compositional innovations and aspects of Correggio and north Italian painting – and he integrates and rethinks them to forge a novel and compelling work of art and religous image.

It is this image that we should now regard, not merely as a distillation of sources, but as a composition which we are sight-reading – a musical concept that evokes vision – all the while keeping in mind the themes with which the preceding chapters have been concerned, particularly the cultivation of *vaghezze* that are not lascivious. It is as we develop our sensi-

tivity to Barocci's deployment of the artifices of representation to heighten contemplation and devotion; to his manipulation of brilliant coloring both as a *vaghezza* that even Paleotti could praise and as a distinctively pictorial device that might reveal insights about the essence of things; and finally to his association of painting with music, that we will begin to see and hear this painting.

UT PICTURA MUSICA: AN EKPHRASIS

The scene appears to be set in twilight: all is deepening blue, gold, and green, with the gray and brown of the earth the prevailing undertones. Within, the figures are grouped tightly: the vigorous linking gestures of extended arms and grasping hands that fluidly connect figures in Correggio's *Madonna della Scodella* have become one of Barocci's principal devices as well. Yet Barocci's figures are not simply linked on a strong diagonal across the picture as in Correggio; rather, they form that sort of dynamic triangle which, as has been noted, owes much to the experiments of Leonardo, Michelangelo, and Raphael in Florence at the beginning of the century. The effect, as in Leonardo's *Virgin and Child with Saint Anne* or Michelangelo's *Doni Tondo*, is to introduce far more dramatic action into a traditional devotional composition – to turn icons into *istorie* – while employing the very artifices of the new art to cluster all of the holy figures in or near the center of the composition. Here the center is held by the figure of the Madonna, but Joseph leaps toward that center as he reaches the branch of cherries forward and down to Christ, who then turns toward the center himself to lay another branch of cherries on his mother's lap. Joseph reaches back and up with his left arm but forward and down with his right to pass the fruit to Christ. Christ reaches to receive the gift with his right arm – up and back – and forward, down and toward our left with his left arm to offer the other branch to his mother. She is seated in such a way that both her thighs are angled to her left, but her upper body twists as she reaches to draw water from the stream so that it faces nearly full front (the most decorous traditional pose of an iconic figure in relation to a beholder), while her arms incline to her right and down. Her right arm, that reaches forward and down to the stream, crosses before the right leg of Joseph as he strides into the scene. The donkey in the near background is the only figure outside this tightly knit group. Yet even it is foreshortened at an angle that echoes the reciprocal gesture of Joseph and Jesus, and though the donkey's body faces into the distance, toward the setting sun, the creature's head turns to regard the action in the foreground. The arch of the tree across the top of the picture completes the integration of an almost obsessively interrelated *componimento* of figures.

188 Barocci, preparatory drawing for the donkey in the *Rest on the Return from Egypt*, charcoal on paper, 19.2 × 19.7 cm. Florence, Galleria degli Uffizi, Gabinetto dei Disegni, inv. 17871 F (r).

189 Barocci, preparatory drawing for the donkey in the *Rest on the Return from Egypt*, pen and charcoal on paper, 15.2 × 8.7 cm. Florence, Galleria degli Uffizi, Gabinetto dei Disegni, inv. 925 ORN.

As usual, drawings help to reveal the deep reflection that Barocci invested in arriving at a composition that is at once graceful, dynamic, and organized with the utmost rigor. Two drawings of the donkey in Florence and one in Amsterdam are particularly telling. In one of the Uffizi drawings, the donkey, apparently studied from the life, stands tethered and at an angle similar to that in the painting but not as sharp (fig. 188). In the other Uffizi sheet, the donkey's body has become more foreshortened – now almost identical to that in the painting – and the head has been turned to look toward us (in particular toward the interacting group of the Holy Family; fig. 189). The head is one of the darkest and most worked portions of the drawing. In the Amsterdam drawing, the donkey has been studied with tack, including a bridle (fig. 190). It faces away at much the same angle as in the painting but in the full-figure study on the same sheet, lowers its head to eat. Barocci was interested enough in this position to generate a separate study of the head at the left side of the sheet. Above this, however, he created yet another study of the donkey's head and neck, turning now to face the viewer.

This sort of painstaking planning and rethinking in the genesis of the figural composition as a whole has already been

witnessed. The highly worked drawing (see fig. 187) offers a glimpse into Barocci's trajectory as he rethought a composition initially derived loosely from Correggio to link his invention to the inventors of the *terza maniera* – only to reinscribe Correggio's presence in the painting as he developed it. What is distinctively "Barocci" in these elaborate meditations on compositional and formal sources is twofold. First, as is by now clear, it is characteristic of most of Barocci's pictures that they are products of an extraordinary amount of reflection – on narrative and the sacred image, on artistic sources, on how these sources function when one studies figures so posed and arranged from the life. When a frustrated Barocci told the rectors of the Confraternità dei Laici that he had put "twice what I promised" into the *Madonna del Popolo*, he was not simply indulging in an angry rhetorical flourish; any close reading of that painting is forced to conclude that every aspect, from the composition to the depiction of individual

190 Barocci, preparatory drawing for the donkey in the *Rest on the Return from Egypt*, chalk on paper, 17.7 × 12.1 cm. Amsterdam, Rijksmuseum, inv. RP-T-1981-29 (r).

figures to the facture and color, was considered and reconsidered to an obsessive degree.[10] The second distinctive aspect of many of Barocci's compositions emerges as the fruit of his extensive reflection in the preparatory process. In pictures such as the *Madonna del Popolo* or the *Rest on the Return from Egypt*, the arrangement of figures creates a composition full of movement and drama but also one that is carefully balanced. Most significant movements and gestures are seconded or mirrored by corresponding or reciprocal movements, and the pictorial energies so generated connect foreground and background, left and right, up and down into a tight matrix of relationships.

Look again at the Vatican *Rest* (see fig. 181). Joseph's forward gesture is matched by Christ's reciprocal backward gesture. Here, of course, the reciprocity serves an immediate practical purpose in the exchange of the cherry branch. Yet the concept of parallel or reciprocal gestures determines the entire composition. Directly above Mary's head, which turns to the viewer's left, Joseph's head – with an analogous degree of foreshortening – faces toward the right. Joseph's forward arm, reaching cherries to Christ, counterpoises Mary's forward arm which reaches for water, while his rear arm parallels her forward arm, thus creating a vigorous zigzag up and into the painting. The Virgin's left foot is turned out so that one sees the sole. Christ's right foot, just beside it, is turned out at the same angle and one sees his sole, tender, soft, and alive, yet to be torn by the nail. His leg, also, is counterpoised to that of his mother. Such devices lock the composition together tightly – geometrically, certainly, but also in terms of narrative and affect. It is impossible for the eye to "miss the point" (or points, for, as in most effective rhetoric, there are several). Even the donkey, at the margin of the composition in every way, is included, both geometrically – its body is foreshortened at an angle similar to that of Joseph or of the Christ Child's torso while its face turns to counterpoise that of Joseph and parallel that of the Virgin – and affectively. The creature has turned with interest to witness the decisive actions that build the tight group in the foreground. This donkey, interrupting its own eating to raise its head and watch, is the viewer's model within the painting. The *Rest on the Return from Egypt* may appear graceful, but its composition compels attention to a degree that would be aggressive were it not for the blandishments of Barocci's coloring and what Bellori later called the "sweet airs" of his women and children. A painting like this may begin to clarify the resonance of Lomazzo's statement that Barocci's works combined *forza* and *prontezza* in the actions of figures with *leggiadria* in coloring.[11]

Barocci's coloring, of course, forms the other fundamental characteristic of his paintings. Particularly from the later 1560s to the 1580s this coloring is so distinctive that it would be hard to mistake Barocci's paintings for anyone else's. It is precisely in the generation of tightly interlocked compositions softened by the *vaghezza* of carefully selected coloristic devices that Barocci creates what may be the most distinctive element of his painting: pictorial "music." I do not believe that it is a coincidence or a lapse when Bellori claims that Barocci made his statements about painting and music during a discussion with Duke Guidobaldo in the studio. We know that Duke Francesco Maria II, Guidobaldo's successor, visited Barocci several times in the studio to observe him paint; there is no such information regarding Guidobaldo, who indeed seems hardly to have

noticed Barocci until the early 1570s and offered him few commissions. Bellori was very well informed, as has been seen, and even seems to have known intimate details about Francesco Maria II's relations with Barocci and his comments regarding the painter. If Bellori wished to invent a studio visit in which artist and duke discussed the similarities between painting and music, he would almost certainly have relied on well attested facts – Francesco Maria II and Barocci were close, the duke occasionally visited the artist to watch him paint – to lend his story verisimilitude. He did not. Might Bellori have had evidence of an actual conversation – a supervisory visit to Barocci by a duke who had not patronized him before and then, having offered him an important commission, was concerned to observe its progress – and so specified Guidobaldo as Barocci's interlocutor instead of the expected figure of Francesco Maria II? Perhaps Barocci gestured toward the original *Rest on the Return from Egypt* for the court of Ferrara as he explained to the duke, who had asked him what he was doing (an unlikely question from Francesco Maria II, who knew the painter well), that he was "harmonizing this music."[12] Barocci would certainly have been determined to prove his abilities in this work, his first important commission from his lord and a painting destined for a highly cultured court – a court and an individual recipient deeply invested in innovative music. While most of the evidence comes from the later 1570s into the '80s, it seems that Lucrezia d'Este was involved with the remarkable evolution of music in late sixteenth-century Ferrara. The court was already known for its sophisticated *musica secreta* in the 1570s, and some of the earlier performances of the famed Ferrarese *concerto delle donne*, which evolved from this, took place in Lucrezia's chambers; she later received dedications and praise from the important, innovative madrigalists Luca Marenzio and Luzzasco Luzzaschi. Perhaps Barocci's own predilections, coupled with his knowledge of musical culture in Ferrara in the early 1570s, stimulated him to produce a sustained reflection on the relations between painting and music in the picture for Lucrezia. Certainly, the Vatican variant of the *quadretto* for Ferrara is a highly musical painting.[13]

While much of the discourse concerning art and music during the later sixteenth century was focused on color, Vincenzo Borghini's comments regarding the parallels between musical and pictorial composition discussed in the last chapter offer insights into how a contemporary might have perceived Barocci's tightly interlocked and interwoven compositions as a kind of pictorial music. For Borghini, a painter's apt arrangement of figures and objects on the picture plane and into space could be read as analogous to a composer's careful arrangement of voices in a polyphonic composition. Borghini does not explain himself in detail, but he clearly states that the painter's

concern with the interrelation of objects, their diminution in scale and clarity as they recede into space, and the careful articulation of their relative sizes one with another, all find analogies with the harmonious distribution of high and low sonorities. One might imagine that he would find parallels as well to the painter's relative distances in the varying dynamics of a work of music, and parallels to the interrelation of figures in an effective pictorial composition might be found in the interrelation not only of voices in polyphonic composition, but also of motifs clearly stated, imitated, varied, and passed from one part to another.

Indeed, this last quality was one of the salient characteristics of later sixteenth-century sacred music. The concern that sacred texts be clearly presented in liturgical music – not obscured by confusing and difficult writing and the sounding of multiple textual passages at once – is copiously documented in the period.[14] Music's dilemmas were ultimately similar to those faced in the visual arts. The sacred message – the text of the music or the significance of the edifying religious mystery and *istoria* in painting – must be enunciated clearly, effectively, and in a manner unencumbered by superfluous artifice. Further, all "lasciviousness" must be avoided. In painting, the nude body is clearly the focus of such a prohibition, though as seen, too much artifice of pose, composition, and even color could also occasion blame. For music, recourse to secular melodies as thematic sources for Mass compositions was often identified by reformers as a source of "lasciviousness," as the underlying musical motifs might make listeners remember a sensuous love song in the midst of the celebration of the Eucharist. Further, the very musical style of the secular source, even if not overtly recognized, could undermine the mood necessary for sacred devotion: "Since Masses . . . are church compositions, it is essential that their movement be different from that of French chansons and of madrigals . . . Some composers set these works in a way that upsets the entire subject of the Mass, which requires a means of movement that is grave and more filled with devotion than with worldly pleasure [*lascivia*]."[15]

As such a statement implies, with the insistence on clarity came a demand for appropriate affect. It was at times lamented that "lascivious" secular music could be effective at stirring the passions and that contemporary sacred music – even when it incorporated motifs from secular song or dance – rarely did so. Bernardino Cirillo, a bishop and rector of Loreto, in one of the earlier polemical calls for the reform of sacred music, pleaded in 1549 for musicians to consider ancient music's famed ability to move the souls of listeners and to cultivate its modal language in their sacred compositions; he added caustically that modern music only approached the power of ancient expressiveness in secular dances such as "the pavane and the gaillard,

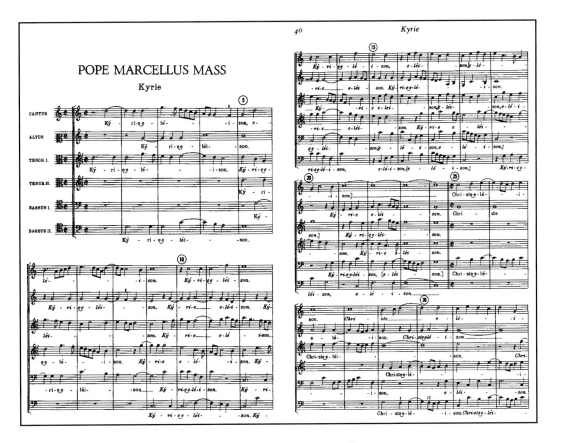

191　Palestrina, opening of the Kyrie, from the *Missa Papae Marcelli*.

at the sound of which those good ladies of San Rocco and of Piazza Lombarda begin their movements, and it almost seems that they are listening to the Dionysiac dithyramb."[16]

Beyond the obvious potential for lasciviousness in music – censured explicitly at Trent – excessive ornamentation and the overcultivation of all forms of musical artifice might also be censured, as they were in painting.[17] As with reforms in the visual arts, however, an approach to reform that depended solely on the *via negativa* was not sufficient. It was well understood that a composer might eliminate all potential lasciviousness and excessive artifice only to create a devout composition that bored and frustrated listeners. The right sorts of musical artifice, and the proper stimulation of the *affetti*, were critical. Bishop Cirillo's plea for the recovery of the "language of the ancient modes" exemplifies this recognition. Furthermore, Cirillo asked that composers learn to imitate the "sculptors and painters" in recovering the power of ancient forms.[18] One is perhaps too quick to assume in art history – despite fairly frequent protestations to the contrary – that painting and sculpture were always influenced by some ostensibly more established art form. This is usually considered to be poetry but music would qualify as well, given its venerable status as a liberal art and its traditional relationship with mathematics. Leonardo's strident dismissal of poetry and demotion of music in his attempt to establish paint-

ing as the art of arts may appear overblown, but the arguments that painting and sculpture had something to offer other art forms seems to have found receptive audiences in unexpected areas by the middle of the century.

Several pieces of Palestrina's sacred music exemplify the fusion of beauty and artifice with devotion and clarity of message that many calling for the reform of ecclesiastical music may have envisioned. Consider, for instance, the opening of the *Kyrie* from the famed *Missa Papae Marcelli*, the Mass widely (though it seems falsely) believed since the beginning of the seventeenth century to have convinced the bishops assembled at Trent not to ban modern music from churches (fig. 191).[19] The texture at the outset is primarily imitative and follows standard procedures for Renaissance polyphony. The tenor enters alone and initiates the head motif, designed to make the phrase "kyrie eleison" comprehensible: a series of repeated Ds that clearly put forth the word "Kyrie" followed by an ascending fourth to the upper G and a descending scalar pattern for "eleison." The other voices enter in overlapping fashion reiterating the same motive, the higher voices (tenor 2 and soprano) at the octave and the lower voices (basses and alto) a fifth below. The soprano, the second voice to enter, in fact dominates, ascending to the high G before descending a full octave in a run of eighth notes, which quicken the pace and add both

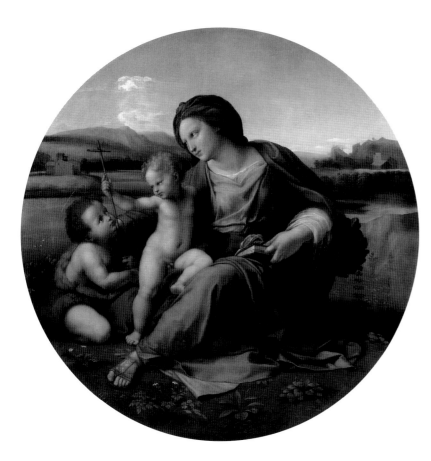

192 Raphael, *Virgin and Child with Saint John*, c. 1509–11, oil on wood (transferred to canvas). Washington, DC, National Gallery of Art.

energy and ornament. Despite the intricate counterpoint between the various voices the text is easily understood, its comprehensibility reinforced by the iterations of the opening motif transposed into one or another range, which provide coherence to the work.

If one imagines such a musical structure "transposed" to painting, one can begin to visualize the way in which dynamic postures and movements in a complex composition such as the *Madonna del Popolo* are held in tight relation through the repetition and variation of fundamental gestures. In a simpler composition such as the *Rest on the Return from Egypt* the "compositional" function of these gestures becomes dramatically evident. The arm of Joseph connects to that of Christ in a seamless exchange and imitation of a motif between voices, not unlike the transference of the opening motif of Palestrina's *Kyrie* from the tenor to the alto. Christ's other arm reverses the direction of the motif and changes the angle and the speed of its motion, thereby varying it and entering into close relationship with both the Virgin's arms. These take up the theme of Christ's gesture – with spaces or "rests" between them – and both vary and ornament it. The Virgin's left arm lies parallel to the right arm of Christ, but it is enclosed, quiet, tranquil, while

his is more animated. The Virgin's right arm, meanwhile, restates the theme – the downward and forward moving limb – with greater insistence, and embellishes it. While the resting left arm is covered by the Virgin's rich blue mantle, the mantle falls from her right shoulder as she reaches for water to reveal both just a little more of her skin – she has rolled her sleeve up slightly – and her attire of a pink robe hemmed in gold over a white sleeve ornamented with gold.

In an era during which the "question of the body" was intensely posed, such a gesture may have carried a greater charge, more *vaghezza*, than is usually realized. It seems of potential interest that in Raphael's *Alba Madonna* (fig. 192) – a devotional painting in which the Virgin's pose, particularly in the arms, is quite similar to that of Barocci's figure – the Madonna's mantle drapes her outstretched arm (and both shoulders) fully (though a touch of forearm and white sleeve is revealed within the mantle's protective outline at the Virgin's left). One hundred years after Barocci's *Rest on the Return from Egypt*, Bellori could still comment on a related motif in the painter's Loreto *Annunciation* (fig. 193). Bellori's phrasing carries significant implications: "[the Virgin] exudes complete modesty and virginal humility, with her eyes lowered and her hair simply gathered over the forehead [the heads of the Virgin in the *Annunciation* and the *Rest* are notably similar]. And without exceeding decorum, her sky blue mantle falls from her arm over the prie-dieu to the floor."[20] In a post-Tridentine religious painting, even such an apparently inconsequential gesture may be remarked and evaluated to see if it remains within the bounds of decorum. It is a kind of ornament; if handled well it may impart enjoyment, even a slight *frisson*, without becoming immodest. A distant cousin in music may be found in the embellishment of the soprano line in Palestrina's opening *Kyrie*, with the dramatic melismatic descent that ornaments and highlights "eleison"; incidentally, this is a run that reads visually to the singer as a downward diagonal.

As might be expected from one of the major musical theorists of the period, Gioseffo Zarlino has much to say about imitation, counterpoint, and appropriate ornament in *Le Istituzioni harmoniche*. Although Zarlino is relatively conservative in some respects, he endorses the current view that texts should be comprehensible in sacred music; furthermore, despite attacks, his work was consulted well into the seventeenth century and the first edition of 1558 was quickly reprinted (1562) and edited and expanded in 1573. This second edition was in turn reprinted in 1589 as part of an *opera omnia* of Zarlino's writings. While it is not necessary that he be connected to Barocci or that Barocci consulted the *Istituzioni* – as Poussin did – Barocci probably at least knew of Zarlino, for the Urbino *letterato* Bernardino Baldi, who admired Barocci, wrote a brief biography of the composer

193 Barocci, *Annunciation*, 1582–4, oil on canvas, 248 × 170 cm. Vatican, Pinacoteca Vaticana.

and theoretician.[21] In Part Three of the *Istituzioni*, Zarlino offers an extensive treatment of counterpoint; his recommendations find repeated resonances both in some later sixteenth-century sacred music and in Barocci's *componimento* of figures. Indeed, there are so many analogies that they cannot be treated exhaustively; a few points must suffice here.

Zarlino begins with the fundamental observation that the first "essential" for any good piece of musical counterpoint is the subject; the music must work in accordance with the nature of the subject and in particular the mood and the text must be clarified through musical means: "a musical composition shall complement the text, that is the words. With gay texts it should not be plaintive; and vice versa, with sad subjects it should not be gay." Within these parameters, however, the composer may – indeed should – "adorn [the composition] with various movements and harmonies to bring maximum pleasure to the audience."[22] When he turns to discuss the specific techniques of counterpoint, Zarlino analyzes two aspects relevant to a painting such as the *Rest on the Return from Egypt* – contrary motion as an essential procedure of contrapuntal writing, and various forms of imitative writing. For Zarlino, intricate forms of imitation, such as fugal writing, are what offer sophistication to otherwise correct music. Lacking this polish, merely correct compositions, "following the rules given up to now . . . will be free of reprehensible elements, purged of every error and polished, and one will hear in them only good and pleasant harmonies. Yet there will be lacking in them a certain beauty, loveliness, and elegance."[23]

Imitative writing may be strict – with the intervals of the opening motif repeated precisely by other voices (albeit in different ranges) – or free. One of the distinctive possibilities of free imitation is "imitation in contrary motion"; in Zarlino's two-voice example, the opening musical theme or "gesture" is mirrored rather than paralleled by the motion of the second voice. Contrary motion is in fact for Zarlino the basis of counterpoint; its techniques have been taught in an earlier portion of the text. It is thus one of the "rules given up to now" without which no music is completely correct. Indeed, chapter thirty-five is simply entitled "The Parts of a Composition Should Progress in Contrary Motion." Zarlino explains: "it was said above that harmony is made of opposites or contraries. This applies also to the simultaneous movement of several parts. Whenever possible . . . when the part on which the counterpoint is written, that is the subject, ascends, the counterpoint should descend, and vice versa . . ." Yet he adds:

> It is not faulty, however, to let them move in the same direction on occasion for the sake of smoother voice movement. . . . If the rule were always binding it would be a needless

restriction on a musician, preventing him from achieving grace and elegance of line and a full harmony. He could not, if compelled to observe the rule invariably, write when he chose in fugue or consequence – admirable procedures for a composer in which one part imitates another, as we shall see later.[24]

With such concepts in mind, the *Rest on the Return from Egypt* might be read musically as an intricate composition for three voices (excluding for the moment the donkey) in which the fundamental contrapuntal structure is governed by contrary motion but perfected with passages of imitation in which "parts" move in the same direction. Such a reading begins to make sense of the insistent series of related arm gestures, sometimes juxtaposed, sometimes connecting or parallel, that recur with subtle variations in angle and force at the core of the image. While these gestures might appear forced if one brings standard historiographic assumptions concerning naturalism and pictorial composition to the painting, they suddenly "sing" if one alters interpretive parameters and begins to think of pictorial composition in musical terms. This is a composition that would probably have pleased Vincenzo Borghini immensely. Even some of the unusual details of the painting begin to seem carefully calculated. Why does Joseph lean with such force out of the shadows, almost leaping forward to hand the cherries to Christ? At first glance it might even appear that he runs forward from the tree, but his left hand maintains a tight grip on a branch and his left arm is nearly at its full backward extension. Thus he cannot be running; he must rather be taking a great stride forward, reaching one branch to Christ with a full extension of the forward arm while preparing to break off another branch with the other arm. Joseph's pose, therefore, covers the greatest "range" of any in the painting and verges on strain, both physically and pictorially. Yet consider for a moment a few of Zarlino's suggestive comments about the bass line of a musical composition. He relates the bass voice to the element of earth; its deep sounds and ponderous movement "are closest to silence." It may be more than a coincidence of Barocci's choice of the direction of lighting that Joseph emerges from shadow, darkness – from that part of painting analogous to silence in music. Zarlino continues that the bass "has the function of sustaining . . . fortifying and giving growth to the other parts." The bass is the foundation of the harmony. Its movements are in general slower than those of other parts – for Zarlino the bass rarely has the decorated runs accorded the soprano, the voice he compares to flickering fire – but while writing for the upper parts, particularly the soprano, should privilege stepwise motion and elegant lines, "leaping movements, rather wider than in the other parts" are recommended for the bass.[25]

Zarlino's text, as already stressed, cannot be read as a template for Barocci's painting; many of Zarlino's instructions and interpretations, however, offer provocative analogies for some of Barocci's compositional procedures. If one were to imagine reading Joseph as the bass voice of Barocci's three-part counterpoint, his apparently forced pose suddenly takes on new significance. Closest to the shadows, as the bass voice is closest to silence, he also provides the literal sustenance for the other voices in the *istoria*, while being the foundation of the pictorial harmony; his backward–forward gesture sets into motion the fundamental compositional "motif" of the counterpoint. At the same moment, his gesture is "rather wider" than the related gestures of the other "voices" and is effected through a leap in a "part" that might otherwise be imagined to move slowly; after all, Joseph is represented as an old man. If one looks back at the opening *Kyrie* of Palestrina's *Pope Marcellus Mass* (see fig. 191) and reads forward to bar twenty-five (the beginning of the *Christe eleison*), one notices immediately that the largest leap made by the soprano is a fifth (m. 5), and that much motion proceeds relatively quickly and by steps. The base, on the other hand, leaps a fifth repeatedly, and in three instances (mm. 12, 14–15, 16) leaps whole octaves. It generally moves at a slower rhythm between these dramatic leaps but occasionally can move faster; in measure seventeen there is even a brief run of eighth-notes. Palestrina's bass is also clearly the "foundation" of his thematic writing. Its first two entries emphatically state and restate the fundamental motif of the composition, and it closes the movement with a strong, simplified restatement of the portion of the motif devoted to sounding the *eleison*.

In addition to such analogies between musical and pictorial composition, Barocci's painting may be like music even in the performative realm – that is, in aspects of his distinctive presentation of those movements of the body held by Alberti and Leonardo to be painting's fundamental means of revealing the "movements of the soul" in *istorie*. The latter part of the century seems to have witnessed the development of direct relations between the gestures and expressions effected by some notable musical performers and the content of musical form. Early in the Seicento, Vincenzo Giustiniani recalled the birth of a "new manner of singing" in the courts of Ferrara and Mantua during the 1570s; he specifically noted that the famous female singers of these courts competed not only with their voices but especially "with the actions of the face, and the glances and gestures that appropriately accompanied the music. . . ." While Giustiniani's exact accuracy and the interpretation of his statement have been much debated – with significant divergence of opinion concerning the degree of "theatricality" of the gestures he describes – one might imagine that the persuasive and fluid

language of gesture and expression in Barocci's composition could have been read, in a court setting like that at Ferrara, not only as an analogy to musical composition but as a visualization of a kind of performance as well.[26]

However, Barocci, as has been seen, was particularly concerned that all of his pictorial means, not merely those of the pose and gesture of figures, become potential bearers of meaning. These "other *vaghezze*" – still life and animal painting, landscape, color, even aspects of facture – gave to his religious paintings that "last *vaghezza* and *leggiadria*" that could attract and compel the gaze of the "simple" and the connoisseur at once, and might ravish the spirit into an ecstasy that moved from the allure of art to communion with the sacred. If *disegno* – musical as well as pictorial – structures the rigorous composition of the *Rest on the Return from Egypt*, the picture is equally informed by those lures of painting that celebrate the potential of its mimetic alchemy or that constitute "coloring" in the broadest sense. At the lower left corner of the *Rest*, for instance, lies a still life that is a prototype for the still life in the foreground of the *Visitation* (see fig. 77) and which, like its descendent, functions both as a display of the painter's art and an object lesson in reading a religious image by Barocci. The bread emerging from its sack, the canteen full of restorative drink (perhaps wine, as the Virgin chooses to obtain water in another fashion), the upturned, casually placed straw hat, and the silver cup that the Virgin's gesture brings into proximity with the other items entrance the eye with the magical quality of their illusionism and the sure, quick strokes that establish the painter's facility with the brush. Bread, wine, water, a silver cup – in the original composition (as recorded in prints) and in the replica for Count Brancaleoni, Barocci depicted the hat right-side-up (see figs 179 and 180). In the Vatican picture, which may be the "final" version of this trio of pictorial inventions, the ever-reflective painter reversed the position of the hat. Its appearance here is superficially more casual – tossed down on its crown instead of placed carefully on the ground – but its shape, for the first time, evokes that of the paten. It is one thing for bread and wine to be read as religious symbols, but a straw hat? We are reminded that in entering many of Barocci's paintings we enter a world of mystery and magic, a world of transformations.

Indeed, Cort's engraving after the Brancaleoni picture illustrates a remarkable detail, effaced from the partially ruined painting, that reveals how Barocci played up this point in the version of the composition for Piobbico, and perhaps in the original version for Ferrara as well. A group of three reeds floating in the stream just below the bread sack are pushed together by the current – under the shadow of the bank – to form a kind of cross (see fig. 180). It is not simply or exactly a cross; in fact,

194 Fra Angelico, *Noli me tangere*, c. 1441–3, fresco. Florence, San Marco (cell 1).

two reeds bisect both ends of a longer reed. Yet it is hard to avoid perceiving the fundamental pattern and "reading" its implications. Barocci always thought in details, and he returned to this one (and figured it with more univocal insistence) in the straw cross below the young bearer's feet in the Senigallia *Entombment* (see fig. 83). In the reduced-scale version of the *Rest* that Barocci invented for Anastagi, the entire lower edge of the composition was removed; less of the stream is visible and the reed cross is dispersed. Perhaps these decisions stimulated Barocci to rethink the representation of the straw hat. The choice of cherries, too, must be highly motivated. Both Barocci's pictorial model in Correggio's *Madonna della Scodella* (see fig. 182) and the textual source for the *Rest* specify a date palm as the tree that sustained the Holy Family. In more northern climes the cherry or other fruits were often substituted –

one need only think of the English "Cherry Tree Carol" – but given the presence of the *Madonna della Scodella* behind Barocci's invention, the alteration of the tree seems particularly significant. The cherries in the painting glow red in the evening light, deepening in the ripest fruits to almost black. Christ receives them – under, over, beside his little hands – and suddenly they are like glistening wounds of the Passion. Beyond analogies of shape and color, it seems no accident that many cherries hang in clusters of three and that it is a group of three that Christ presents to his mother. His triune identity is perceived even in the structure of nature.[27]

As the eye registers the import of these "other *vaghezze*," however, the viewer also begins to consider painting – facture and coloring. Beyond the realm of pictorial composition, in which a Borghini could register analogies to music, it was especially coloring through which Barocci sought uniquely pictorial means of visualizing the passions of his figures and the mood of his sacred *istorie*; it was color that also offered rich analogies with music in the period. Color could be associated both with the beauties of pictorial or musical harmonies and with the expression of the *affetti*. Barocci, like any good composer, sought to employ the full range of color's powers. In the *Rest on the Return from Egypt*, Barocci was already experimenting with the coloristic devices that he used to such effect in later paintings. Indeed, it could be argued that much of what is fundamental in this picture is structured as much through color as through composition. There are two orders or levels of color operative: the one "descriptive" or, as one might term it, "figurative" (in the sense that color forms part of the visual apparatus through which characters are represented in naturalistic fashion), and the other "figurative" or "figural" in that older sense of *figura*, signifying a form or object that points toward something else. Georges Didi-Huberman has clarified the importance of this distinction in the "transitional" period of the mid-Quattrocento, when Alberti's concept of "figure" as an important actor in a historical drama came to stand beside the venerable understanding of *figura*. In Didi-Huberman's analysis of Fra Angelico's *Noli me tangere* from San Marco (fig. 194), he notes the way in which the same pictorial sign is employed to signify stigmata and blossom. The red blossoms of the flowers between Christ and the Magdalen form clusters of five (the wounds of Christ), while at one point three cross patterns of the same color register a trio of blooms (fig. 195).[28]

Barocci's cherries in the *Rest*, or the reed cross in Cort's engraved replica of the Brancaleoni painting, are devices at once similar to and different from Fra Angelico's stigmata blossoms. They are first figural in the more modern, post-Albertian sense of the term; they represent cherries, or reeds borne along by a stream, with a mimetic illusionism that Fra Angelico's forms

195 Detail of fig. 194.

(deliberately) lack. In Barocci's paintings, it is the arrangement, shape, or color of certain illusionistically represented objects rather than their actual form that allows a viewer to begin to read them as symbols in addition to objects in a naturalistic representation. In Fra Angelico's image the unmodulated red dots do not illusionistically represent blossoms (or for that matter wounds), but the simple pictorial sign can stand for either, functioning at once as a representational device and a figure, in the older sense of the term.

By Barocci's time, of course, religious, philosophical, and artistic culture had changed radically from the 1440s. However, this should not imply that the distinctions of Fra Angelico's theological world had been forgotten, even if the weight of common usage (at least in artistic discourse) might have shifted. The 1612 *Vocabolario* of the Accademia della Crusca offers eight potential meanings for the Italian *figura*, ranging from what one might expect – a representation of the surface of something – to the distinctly unexpected (female genitalia and, in a usage the academicians noted was becoming archaic, a term for discourse, *favellare*). The first definition offered is the "descriptive" one: "Form, aspect, appearance, image, a certain quality pertaining to the surface of the body . . ." The Latin equivalents are *figura, forma, imago*. The second definition is in essence a subset of the first, particularly focused on figurative representation: "the image of something, either sculpted, or painted." The successive definition – in effect the second distinct one – reads: "mystery, or signification, appearing in disguised form in the holy Scriptures." Only this and the first definition among the eight uses of *figura* in period Italian are identified with the Latin *figura*.[29]

In Barocci's painting some of the potential double significance of *figura* still acknowledged in the *Vocabolario* remains operative and indeed animates crucial elements of both figural composition and coloring. We have seen repeatedly that Barocci strove to create images that appeared modern even as they were informed by tradition. One of his most evident strategies was to create sophisticated and modern figures, designed and colored in ways that registered his command of all the artifices offered by competing contemporary styles. It was in the composition of the figures to narrate a sacred drama that Barocci often revisited and adapted the venerable formulae of centralization, hierarchy, frontality. Paintings such as the Urbino *Immaculate Conception* (see fig. 2), the *Perdono* (see fig. 52), and even the *Visitation* (see fig. 77) exhibit this negotiation, particularly when the strata of their inventions are excavated through a study of the preparatory process. In the *Rest on the Return from Egypt* this subtle interplay between modern figures and retrospective composition is muted, but the Florence drawing (see fig. 187) indicates that, as often happened in the following decade, Barocci conceived the narration of a composition across the picture plane and then reworked it toward a grouping that stressed forward motion in or around the center of the image as the fundamental structuring device of the finished painting. In such arrangements, highly modern figures become enmeshed in a web of signification that moves beyond their narrative actions as figures in the newer sense and makes them also figures of and in a sacred geometry through which divine principles are subtly but firmly revealed.

When one considers Barocci's specific coloristic strategies in the *Rest on the Flight into Egypt*, meanwhile, it does not take long to realize that the descriptive and ornamental operations of color are fused with a quality that is more mystically figurative. This remarkable coloring, to which Barocci may have referred when he told Duke Guidobaldo that as he painted he was "harmonizing music," operates to connect figures and ground, representation and higher meaning. Yellowy gold, for instance, appears in bright streaks and patches throughout the composition, linking the straw hat to the lining and hem of the Virgin's robe to the hem of Christ's shirt and the gold-brocade pillow on which he sits to the fabric of the robe of Joseph to the richest streaks of light in the sunset sky. The world turns to gold and as Joseph reaches forward, his sleeve provides a virtual gold ground for the head of the Virgin, implicitly enshrining her face as a lovely living icon. The golden collar of her gown frames this icon of her face on its other side. Where her shadow falls across this collar on the side toward Christ and his cherries, however, the gold turns suddenly to intense red, the red of fire and of love (one may remember Zarlino's idea that the soprano voice was both the most lovely

and ornamental, and the voice most akin to fire). The effect is that of extreme reflected light – but there is no red present that would reflect in this manner. This glowing shadow seems most like a radical version of the red shadows of Andrew's robe in the *Calling of Saint Andrew*; it reveals something of the Virgin's nature, her passion, and of the way in which this character flames forth in proximity to her Son. Joseph, too, wears the mantle of this passion over his robe that is the gold of the ground of venerable pictures as well as the color of the glowing sunset. Its shadows, like those of Andrew's yellow robe in the *Calling*, are suffused with red rather than merely darker gold and black. His "fortifying," nourishing love – to adapt Zarlino once again – can be no better visualized than by those glowing embers of ardent red that flicker in the shadows of his robe, even as he leaps forward, despite his age, to serve Christ and the Virgin.

The Virgin's colors are traditionally the red of love and the blue of faithfulness. Here her dress is kept delicate, "ornamental," and except at that remarkable point at which gold turns to fire her robe is not so much red as a pink that fades almost to white in the highlights. This coloration allows for the most subtle figural *vaghezza* (in the representational sense), which hints at the beauty of the body without, as Bellori put it, "exceeding decorum." The center of the composition is not, as one might assume, the Virgin's head; it is rather her left breast, the breast over her heart and closest to Christ, turned toward him (and us) in maternal love yet discreetly concealed by the fall of her blue mantle's folds. The highlights on her pink robe over her other breast, however, have become so light that they are virtually the color of her skin. Christian viewers are privileged to see the figure of the Holy Mother, who is mystically their mother even as she is the Mother of God; this figure is delicately concealed under drapery that is neither too heavy nor too colored to wholly disguise her holy and beautiful form, nor too thin to transgress decorum. Such a subtle negotiation, however, forces Barocci to employ a very light red for the robe. The "true" red of the Virgin's robe, its traditional color and the figurative red in the mystical sense, emerges miraculously in the shadow of the golden collar.[30]

This fiery red suffuses the figural portion of the painting. Joseph's mantle, some of the shadows of his robe, and the shadows of the Virgin's hem are on fire with it, while bright spots of it flash among the cherries as they catch the light. In softer form, it also highlights the flesh tones of the figures – particularly that of Christ – at knees and elbows. Yet around these rosy accents lies gray. Gray colors or provides the undertone of much in this apparently happy painting. Gray is the tone of Joseph's hair, of the foreground earth and water, of the

body of the donkey – and blue-gray forms the base tone of all human flesh. Beneath the blood and fire of flesh's ruddy highlights lies the gray of ashes, of earth, and of death. The human figures are figuratively joined to the earth by their very color, and to the donkey, to the "Brother Ass" of Saint Francis, who reminds the Christian viewer in front of the painting of human frailty and the common ground of creatures. In essential ways, this painting expresses its devotional message through "elemental" means as well as figural drama. That is, the painting is in a profound sense a painting that appropriates the figurative language of the elements to speak of sacred things. Earth, water, air, and fire are all here, and they interpenetrate one another to form a unified composition that "sounds" all of them at once. One recalls Zarlino's idea that a musical counterpoint is analogous to the elements, with the bass as earth, the tenor as water, the alto as air, the soprano as fire.[31] In Barocci's painting, these distinctions are not as clear; there are only three human voices, Joseph's mantle is "on fire," all the human figures have the gray of earth and water, the blue shadows of sky, and the red of fire coursing through them, but the basic analogy, and the musical effect, is perhaps made all the stronger by the ways in which Barocci's coloring melds and fuses representationally distinct forms at the mystically figurative level.

I have noted that in the shadows of flesh the gray undertone is tinged with blue. This is the other elemental color, the color of water and air, which suffuses the painting and speaks of its essential themes. Here blue is, first and foremost, the rich color of the Madonna's mantle. Yet it is also the color of the most distant landscape in the evening light, the color of what appears to be a simple church with its belfry virtually dissolving in the haze. This church is above and behind the large expanse of the Madonna's mantle that lies over her shoulder, and directly above and behind Christ's hand as it receives the cherry branch. However, *ecclesia* is not merely shown to derive from or be symbolically identified with *Maria* by a conjunction of forms; the church building, dissolving in holy light, has taken on Mary's very color. The reach of her mantle envelops the whole sky, which reflects the robe's rich hue in a paler shade and even extends to her body itself and that of Christ. Where their bodies glow blue in shadow, it is as if the quality represented by the *manto della Madonna* – the term still connotes the color of a prized sapphire in Italy – inheres in them. This is figural painting indeed but not simply "Albertian" painting. Barocci employs all pictorial devices at his disposal to speak the mysteries of the spirit and to speak through and in figures. It is with a seamless web of coloristic polyphony, as well as a composition that fuses rigorous *disegno* with the structure of musical counterpoint, that he makes his music.

NOTES

Introduction

1 Giovanni Baglione, *Le Vite de' pittori, scultori et architetti dal Pontificato di Gregorio XIII del 1572 in fino a' tempi di Papa Urbano Ottavo nel 1642* (Rome, 1642), ed. Jacob Hess and Herwarth Röttgen, 3 vols (Vatican City, 1995), vol. 1, 134: "E dì vero egli nelle sue virtuose fatiche era vago, e divoto: e come nell'una parte gli occhi dilettava, così con l'altra componeva gli animi; & i cuori a divotione riduceva." Baglione had already described Barocci's style as "maniera sì bella, sfumata, dolce, e vaga" in recounting the unveiling of the *Visitation* (see fig. 77) for the Chiesa Nuova in Rome; see Ch. 5 for further discussion. For the date of Barocci's birth (frequently thought to be 1535), see Fert Sangiorgi, *Committenze milanesi a Federico Barocci e alla sua scuola nel carteggio Vincenzi della Biblioteca Universitaria di Urbino* (Urbino, 1982), 57–8, n. 1. See further Ch. 4, n. 39. Translations are my own unless otherwise stated. Where I have altered another translation, this has been noted.

2 Frederick Hartt, *History of Italian Renaissance Art*, 3rd ed. (New York, 1987), 670 (discussing the *Madonna del Popolo* [see fig. 24]). I do not mean to be ungenerous here; in Hartt's monumental enterprise, he could obviously spend little time re-thinking Barocci. For that very reason, his passing remark is useful in gauging the assumptions that could underlie the initial responses of an educated viewer in the 1980s (and often do still). For a recent analysis of Barocci's early modern reception see Giovanna Perini, "Appunti sulla fortuna critica di Federico Barocci tra Cinque e Settecento," in *Nel segno di Barocci: Allievi e sequaci tra Marche, Umbria, Siena*, ed. Anna Maria Ambrosini and Marina Cellini (Milan, 2005), 394–405 (394 for a taste for Barocci that "nel Settecento rococo, trova appunto un climax continentale per nulla sorprendente").

3 Giovan Pietro Bellori, *Le Vite de' pittori, scultori et architetti moderni* (Rome, 1672), ed. Evelina Borea (Turin, 1976), 30: "e Federico Barocci, che havrebbe potuto ristorare e dar soccorso all'arte, languiva in Urbino . . ." The remarks are found, tellingly, in the life of Annibale, the painter who for Bellori finally did "ristorare e dar soccorso all'arte."

4 See Andrea Emiliani, ed., *Mostra di Federico Barocci* (Bologna, 1975), and Andrea Emiliani, *Federico Barocci (1535–1612)*, 2 vols. (Bologna, 1985). See also the review of the exhibition and of Emiliani's initial catalogue: John Shearman, "Barocci at Bologna and Florence," *The Burlington Magazine* 117 (1976): 49–54.

5 Jeffrey Fontana, "Federico Barocci: Imitation and the Formation of Artistic Identity," Ph.D. diss., Boston University, 1998; Ian Verstegen, "Federico Barocci, the Art of Painting, and the Rhetoric of Persuasion," Ph.D. diss., Temple University, Philadelphia, 2001; Nicholas Turner, *Federico Barocci* (Paris, 2000); David Scrase, ed., *A Touch of the Divine: Drawings by Federico Barocci in British Collections* (Cambridge, 2006). I thank Dr Scrase for a stimulating discussion of Barocci's drawings in the Fitzwilliam Museum exhibition in Cambridge. For Verstegen's ongoing work on the use of drawings in the Barocci shop, see his "Barocci, Cartoons, and the Workshop: A Mechanical Means for Satisfying Demand," *Notizie da Palazzo Albani* 34/35 (2005–6 [2007]): 101–23. I thank Dr Verstegen for sharing this article with me before its publication.

6 Some work in dissertations, such as those of Fontana and Verstegen, has begun to shift this state of affairs. In 1975, one dissertation attempted a significant interpretation of Barocci in a Franciscan key, published as: Gary Walters, *Federico Barocci: Anima naturaliter* (New York, 1979).

7 The work of Georges Didi-Huberman has repeatedly stressed the "disconcerting" effect

243

of attentive looking; see e.g. *Fra Angelico: Dissemblance and Figuration*, trans. Jane Marie Todd (Chicago, 1995).

8 Federico Zeri, *Pittura e controriforma: l'arte senza tempo di Scipione da Gaeta* (Turin, 1957).

9 David Franklin, *Painting in Renaissance Florence 1500–1550* (New Haven and London, 2001), exemplifies the tendency to interrogate the usefulness of terms such as Mannerism and even High Renaissance, and indicates further bibliography. John O'Malley, *Trent and All That: Renaming Catholicism in the Early Modern Era* (Cambridge, Mass., 2000), offers an extensive reconsideration of the terms that have structured most modern historiography of early modern Catholicism.

10 See Stuart Lingo, "The Capuchins and the Art of History: Retrospection and Reform in the Arts in Late Renaissance Italy," Ph.D. diss., Harvard University, 1998, with further bibliography. Alexander Nagel, *Michelangelo and the Reform of Art* (New York and Cambridge, 2000), offers an insightful investigation of distinctive aspects of archaism and retrospection during the first half of the century. See also his "Experiments in Art and Reform in Early Sixteenth-Century Italy," in *The Pontificate of Clement VII: History, Politics, Culture*, ed. Kenneth Gouwens and Sheryl Reiss (Aldershot and Burlington, Vt., 2005), 385–409; *idem* and Christopher Wood, "Towards a New Model of Renaissance Anachronism," *Art Bulletin* 87 (2005): 403–32 (with responses by Michael Cole, Charles Dempsey, and Claire Farago), a significant reconsideration of the fifteenth- and early sixteenth-century situation.

11 See further Ch. 1 and Lingo, 1998.

12 The assumption has been current since Harald Olsen, *Federico Barocci* (Copenhagen, 1962); see further Ch. 1. For Barocci's will, see Luigi Renzetti, "Notizie relative a Federico Barocci e alla sua famiglia," in *Studi e notizie su Federico Barocci a cura della Brigata urbinate degli Amici dei Monumenti* (Florence, 1913), 1–12 (transcription 8–12), and Lingo, 1998, 262–6. For Barocci and the Oratorians, see Ian Verstegen, "Federico Barocci, Federico Borromeo, and the Oratorian Orbit," *Renaissance Quarterly* 56 (2003): 56–87.

13 From a letter of Francesco della Torre, printed in *Lettere volgari di diversi nobilissimi huomini, et eccelentissimi ingegni scritte in diverse materie* (Venice, 1551), libro secondo, 113r–113v. The letter concerns sacred poetry and is discussed in Nagel, 2000, 189; see Ch. 5 for extensive discussion of the meanings and connotations of *vaghezza* (n. 15 for della Torre's text).

14 Giovanni Andrea Gilio, *Dialogo nel quale si ragiona degli errori e degli abusi de' pittori circa l'is-torie* (1564), in *Trattati d'arte del cinquecento*, ed. Paola Barocchi, 3 vols. (Bari, 1960–62), vol. II, 80: "Tenga per fermo il pittor che far si diletta le figure de' santi nude, che sempre gli leverà gran parte de la riverenza che se li deve. Però compiacciasi più tosto de l'onestà e del convenevol decoro, che de la vaghezza de l'arte . . ." Vasari's comment comes in the midst of a defense of "art" against such attacks: Giorgio Vasari, *Le Vite de' più eccellenti pittori scultori e architettori, nelle redazioni del 1550 e 1568*, ed. Rosanna Bettarini, commentary by Paola Barocchi, 11 vols. (Florence, 1966–87), *Testo*, vol. III, 274–5. See Ch. 5, nn. 27 and 28 for the quotation and its implications.

15 Raffaello Borghini, *Il Riposo* (Florence, 1584) ed. Mario Rosci, 2 vols. (Milan, 1967), vol. I, 205. See further Ch. 5. Even Gilio's notorious text is not as one-dimensional as is often assumed; see Ch. 1, n. 3 for discussion.

16 See Elizabeth Cropper, "The Place of Beauty in the High Renaissance and its Displacement in the History of Art," in *Place and Displacement in the Renaissance*, ed. Alvin Vos (Binghamton, N.Y., 1995), 187–8, for a perceptive reading of an elision in Dolce's *L'Aretino* between the *macchia* left on the Cnidian Venus by a young man's ardor and the *macchia* of a loosely painted Titian landscape in which Cupid lies asleep. See further Ch. 5.

17 Baglione, 1995, 318.

18 Bellori, 1976, 206: "Chiamava però la pittura musica, ed interrogato una volta dal Duca Guidobaldo che cosa e'facesse: stò accordando, rispose, questa musica, accennando il quadro, che dipingeva." For Bellori's evident access to details concerning Barocci's life, see the opening of Ch. 9.

19 While Barocci has been celebrated principally as a religious painter from his lifetime through the twentieth century, Perini, 2005, 396, has pointed to intriguing evidence that this "devout" image of Barocci does not explain all his production. It seems that the *Flight of Aeneas* may not have been the only important "profane" painting in his *oeuvre* and that he may have occasionally produced mythological images with an erotic charge – another aspect of the search for a style imbued with *vaghezza*.

20 Charles Dempsey, *Annibale Carracci and the Beginnings of Baroque style* (1977), 2nd ed. (Fiesole, 2000), 7–10, 14–17, 26–9 (28–9 for the *Madonna del Popolo*). Others have offered sensitive readings of Barocci's art in works with other foci: see e.g. Marcia Hall, *Color and Meaning: Practice and Theory in Renaissance Painting* (New York and Cambridge, 1992), 193–8, and *idem*, *After Raphael: Painting in Central Italy in the Sixteenth Century* (Cambridge and New York, 1999), 271–4. Shearman, 1976, remains one of the best short assessments of Barocci's work and importance.

21 For details of Barocci's life and career, Olsen, 1962, and Emiliani, 1985, remain the standard sources. I am indebted to Ulrike Tarnow, who is preparing her dissertation on Barocci, for a stimulating conversation regarding his return to Urbino.

22 See Georg Gronau, *Documenti artistici urbinati* (Florence, 1936), 158: "È ben vero che da doi anni in qua noi ordinammo un quadro grande a Feder.o Barocci per mandarlo al Re et insieme con esso dui belli et buoni portanti ch'avevamo in stalla, ma il Barocci ha mandato tanto in lungo quest'opera sua che i cavalli son morti . . ." For more on the patronage of Duke Francesco Maria II and Barocci, see Stuart Lingo, "Francesco Maria II della Rovere and Federico Barocci: Some Notes on Distinctive Strategies in Patronage and the Position of the Artist at Court," in *Patronage and Dynasty: The Rise of the Della Rovere in Renaissance Italy*, ed. Ian Verstegen (Kirksville, Mo., 2007), 179–99.

23 San Filippo Neri was reputed to have experienced spiritual ecstasies while meditating before his favorite painting, Barocci's *Visitation*; see Pietro Bacci, *Vita di San Filippo Neri* (Rome, [1622] 1699), 171–2.

24 Raffaello Sozi, a Perugian chronicler who celebrated Barocci's *Deposition* for the Cathedral there (see fig. 85), asserted that viewers marveled both at Barocci as a "grandissimo imitatore di Tiziano" and at what they recognized, despite its obvious references, as his "vera maniera nuova, arteficiosa, et piena di gratia, et di bontà in tutte sue parte." See Walter Bombe, *Federico Barocci e un suo scolaro a Perugia* (Perugia, 1909), 5. In Barocci's funeral oration, Vittorio Venturelli stated that the painter "da mille forme di dipingere abbracciate da Pittori eccellenti, trasse quelle perfezioni, ch'erano in esse, dalle quali compore quella sua maniera tanto ammirata" ("Orazione Funebre per celebrare . . . Il Giorno delle Solenne Esequie all' insigne Pittore Federico Barocci Urbinate Da Vittorio Venturelli Intimo ed affetuoso suo Concittadino composta e recitata," in "Memorie d'alcuni insigni uomini d'Urbino nella pietà nelle scienze ed arti raccolte dal Dottor Antonio Rosa Patrizio di detta città," 1800, Urbino, Biblioteca Universitaria, Archivio Storico del Comune, MS Urbino 73, f. 207r).

25 Matteo Senarega to Barocci, Archivio Storico del Comune di Genova, Arch. de' Ferrari, registro no. 141, f. 131r; transcribed in Michael

Bury, "The Senarega Chapel in San Lorenzo, Genoa: New Documents about Barocci and Francavilla," *Mitteilungen des Kunsthistorischen Institutes in Florenz* 31 (1987): 355–6: "Un difetto solo ha la tavola, che per haver del Divino, lodi humane non vi arrivano: vive per questo involta fra silentio, e maraviglia. . . . e tutta insieme ricca d'artificio et di vaghezza non lascia luogo, che pur l'invidia v'aspiri. . . . Affermo di nuovo, et confesso, che come Divina rapisce, divide et dolcemente trasforma." Bellori transcribes the letter as an important element in his *vita* of Barocci. For the complete letter and discussion, see Ch. 5, n. 51.

26 The theoretical work of Philip Sohm, *Style in the Art Theory of Early Modern Italy* (New York and Cambridge, 2001), Robert Williams, *Art, Theory, and Culture in Sixteenth-Century Italy: From Techne to Metatechne* (Cambridge and New York, 1997), and a number of articles by Giovanna Perini have been particularly important. See also Sohm, "Gendered Style in Italian Art Criticism from Michelangelo to Malvasia," *Renaissance Quarterly* 48 (1995): 759–808. Charles Dempsey and Elizabeth Cropper have long advocated seventeenth-century art theory and criticism in the interpretation of the work of artists; see the introduction to Dempsey, 2000, with references. Some recent German scholarship has enlisted period theory and criticism in approaching aspects of artistic style and production; see e.g. Christoph Wagner, *Farbe und Metapher: Die Entstehung einer neuzeitlichen Bildmetaphorik in der vorrömischen Malerei Raphaels* (Berlin, 1999). The studies of Titian by Daniela Bohde, *Haut, Fleisch und Farbe: Körperlichkeit und Materialität in den Gemälden Tizians* (Emsdetten and Berlin, 2002), Nicola Suthor, *Augenlust bei Tizian: Zur Konzeption sensueller Malerei in der Frühen Neuzeit* (Munich, 2004), and Valeska von Rosen, *Mimesis und Selbstbezüglichkeit in Werken Tizians: Studien zum venezianischen Malereidiskurs* (Emsdetten and Berlin, 2001), have all probed aspects of Titian's style and facture with the riches of early modern art criticism in mind.

1 Orders of Reform

1 Norman P. Tanner, ed., *Decrees of the Ecumenical Councils*, 2 vols. (London and Washington, D.C., 1990), vol. II, 774–6. For the remark by della Torre, see Intro., n. 13 and Ch. 5, n. 15 for the text.

2 Vasari, 1966–87, *Testo*, vol. III, 274–5. See Ch. 5, nn. 27 and 28 for the text and further discussion.

3 There have been a few exceptions to the oversimplification and marginalization of Gilio's text in art history and historiography, notably Nagel, 2000, esp. 14–15, 50–51, and 201; and Charles Dempsey, "Mythic Inventions in Counter Reformation Painting," in *Rome in the Renaissance: The City and the Myth*, ed. P. A. Ramsey (Binghamton, N.Y., 1982), 55–75, in which Dempsey stresses the literary-theoretical elements of Gilio's critiques and recommendations. Already in the 1960s, John Shearman, *Mannerism* (Harmondsworth, 1967), 165–70, had noted the importance of poetic and rhetorical theory for some of the ecclesiastical reformers.

4 There has been increasing interest from Italian and German scholars in archaism in the late Renaissance, though work has often focused on the Paleo-Christian researches of the Oratorians, as exemplified in articles by Alessandro Zuccari, e.g. "Cesare Baronio, le immagini, gli artisti," in *La Regola e la fama: San Filippo Neri e l'arte*, ed. Claudio Strinati (Milan, 1995), 80–97, (with further bibliography). See more generally Ingo Herklotz, "Historia sacra und mittelalterliche Kunst während der zweiter Hälfte des 16. Jahrhunderts in Rom," in *Baronio e l'arte*, ed. Romeo de Maio (Sora, 1985), 21–74, and Christian Hecht, *Katholische Bildertheologie im Zeitalter von Gegenreformation und Barock: Studien zu Traktaten von Johannes Molanus, Gabriele Paleotti und anderen Autoren* (Berlin, 1997), esp. 335–47 (though downplaying actual archaisms in style). I have treated the subject at length in Lingo, 1998. Both Nagel, 2000, and Paul Joannides, "'Primitivism' in the Late Drawings of Michelangelo," in *Michelangelo Drawings: Studies in the History of Art, 33: Center for Advanced Study in the Visual Arts Symposium Papers* XVII, ed. Craig Hugh Smyth and Ann Gilkerson (Washington, D.C., 1992), 245–62, have argued that archaism plays a role in some of Michelangelo's art. See further below and Ch. 4.

5 Gilio, 1960–62, 110–11: "'Orsù, disse M. Troilo, avrei caro sapere come vogliono essere dipinte le sacre imagini, da che Michelagnolo ha errato . . .' Rispose M. Ruggiero: 'Difficil cosa è a volerne rendere vera et indubitata ragione che così sia e che altramente esser non possa, perché di questo non abbiamo legge alcuna né regola, se non quanto che la consuetudine de' pittori, innanzi che Michelangelo fusse, n'ha dimostrato (la quale però, come voi signori leggisti sapete, è legge), e quanto che Guiglielmo Durante nel Razionale de' divini offiii ne scrive . . .' 'Qual è questa antica consuetudine?' disse M. Troilo. Soggionse M.

Ruggiero: 'Il dipingere le sacre imagini oneste e devote, con que' segni che gli sono stati dati dagli antichi per privileggio de la santità, il che è paruto a' moderni vile, goffo, plebeo, antico, umile, senza ingegno et arte.'" The frequent assumption that reformist texts in the Tridentine era univocally privileged texts above images as guidelines for correct representation in religious imagery is called into question by the weight that Gilio, through Ruggiero, accords the "consuetudine" of early pictorial tradition. Ruggiero adds (110): "Ma fa assai a noi avere la consuetudine, che io v'ho detta c'ha forza di legge essendo per tant'anni continuata, che poi è stata mutata e guasta dai capricci de' moderni pittori . . ."

6 Ibid., 56: "Se quelli erravano nel poco, e questi errano nel molto; però sarebbe bene di quel poco e di questo molto fare regolata mescolanza e cavare un mezzo che suplisse al difetto degli uni e degli altri, acciò l'opere abbino le debite proporzioni."

7 Nagel, 2000, 14; Gilio, 1960–62, 55–6. Nagel, 1–22, offers several insights concerning Gilio and the appreciation of the archaic in the sixteenth century. Michael Cole, "The *Figura Sforzata*: Modeling, Power, and the Mannerist Body," *Art History* 24/4 (2001): 520–51, esp. 527, has called attention to Gilio's attack on the *figura sforzata*, prominent in the sophisticated art of mid-century. Cole focuses on Gilio's assertion that modern painters expend so much energy on such figures that they fail to consider the subject of the work of art. In the context of this book, another passage is esp. significant (Gilio, 111): "lasciando l'uso di farle [figures of the saints] devote, l'hanno fatte sforzate, parendoli gran fatto di torcerli il capo, le braccia, le gambe, e parer che più tosto rappresentino chi fa le moresche e gli atti, che chi sta in contemplazione."

8 Bryan D. Mahgrum and Giuseppe Scavizzi, ed. and trans., *A Reformation Debate: Karlstadt, Emser, and Eck on Sacred Images* (Ottawa, 1991), 86, quoted and discussed in Nagel, 2000, 13–14.

9 Vittoria Colonna, *Rime*, ed. Alan Bullock (Rome, 1982), 188, quoted in Nagel, 2000, 13 and n. 34, 220. Colonna: "forse sdegnando/de l'arte i gravi lumi e la fiera ombra;/basta che 'l modo umil, l'atto soave,/a Dio rivolge, accende, move . . ."

10 Francisco de Hollanda, *Da Pintura Antiga*, ed. Angel González Garcia (Lisbon, 1983), 300: "'Porém, dize-me, Messer Francisco, fezeste-la com aquella severa simpleza que tem a antigua pintura e aquelles temor d'aquelles divinos olhos que sobre o natural parecem assim como convem ao Salvador?' 'Dessa arte a fiz (Ihe

dizia eu) e nisso quis pôr todo o primor, e nenhuma cousa lhe acrescentar nem demenuir d'aquele grave rigor.' . . . 'Nao soes amigo da senhora Marquesa (dixe foão Çapata): pois que cousa tanto sua lhe nao quisestes mostrar." See Lingo, 1998, 96–100, and Nagel, 2000, 13, for discussion.

11 See Olga Melasecchi, "Una perduta *Madonna della Vallicella* di Felice Damiani per l'Oratorio di San Severino," in *La Congregazione dell'Oratorio di San Filippo Neri nelle Marche del '600, Atti del convegno, Fano 14–15 ottobre 1994,* ed. Flavia Emanuelli (Fiesole, 1996), 398, letter reproduced 407. See Hans Belting, *Likeness and Presence: A History of the Image before the Era of Art,* trans. Edmund Jephcott (Chicago and London, 1994), 484–90, for art as the *mise-en-scene* of the archaic image in post-Tridentine Italy.

12 Melasecchi, 1996, 399, letter reproduced 407–8: "simile a quello della Madonna di Roma che contiene la Madonna col figlio in braccio posta tra nube, circondata da una corona d'Angeletti, e diversi cherobinj, et abasso un coro d'angelij inginocchione, che tutto fa una compositione vaga et insieme devota." For Talpa, see Louis Ponelle and Louis Bordet, *Saint Philippe Néri et la société romaine de son temps (1515–1595),* 2nd ed. (Paris, 1958), esp. 252–4.

13 Gilio, 1960–62, 78: "Pero io dico che, se quelle parti consideriamo in piccioli fanciuletti, non ci scandalezziamo, avendo riguardo a l'innocenza e purità di quelli, senza malizia e peccato, e non potendoci per naturale istinto cadere. Ma se le miriamo negli uomini e ne le donne, n'arreca vergogna e scandolo . . ." For the putto angel and figural *vaghezza* see further Ch. 6.

14 Melasecchi, 1966, 409–10: "nel Altare grande si rappresentasse l'imagine dela Mad.a di Roma, ne la quale imagine la Mad.a Santis.a è stata presa per Protettrice di tutta la Cong.e e per segno sotto il quale noi militiamo, et a questo fine in Napoli fu fatto l'altar maggiore con l'istessa imagine totalm.e simile a quella di Roma. Stante dunque q.a intentione di rappresentar in q.a tavola la Mad.a di Roma, non bisogna partirsi dal istesso disegno ma osservarlo ad . . . e sebbene li Pittori valenti si mortificano a far l'inventione d'altri, tuttavia anco nele cose d'altri possono mostrar la loro eccellenza non solo in imitarle, ma anco in saperle migliorare. Et il nro pittore . . . di Nap.li non si è sdegnato di fare l'istesso quadro cavato dal medesimo schizzo . . ." Talpa's allusion to a *schizzo* already employed in Naples raises intriguing issues about Oratorian dissemination of such adaptations of the Madonna della

Vallicella and provides an additional context within which to read the invention of Durante Alberti's altarpiece for Santi Nereo ed Achilleo.

15 See Mark W. Roskill, *Dolce's* Aretino *and Venetian Art Theory of the Cinquecento,* 2nd ed. (Toronto, 2000) for the text, translation, and discussion. See Chs 5 and 8 for more on Dolce's positions.

16 Sozi's chronicle is cited in Bombe, 1909, 5. Sozi paired an appreciation of Barocci's emulation of Titian with an understanding that Barocci was creating a "vera maniera nuova" (see Intro., n. 24). The first documented relation between Barocci and Guidobaldo II is recorded in a letter of October 25, 1567, in which Barocci speaks of a painting by Titian and "la copia cavata da quello di mia mano," see Gronau, 1936, 110, cited in Harald Olsen, "Relazioni tra Francesco Maria II Della Rovere e Federcio Barocci," in *I Della Rovere nell'Italia delle corti,* vol. II, *Luoghi e opere d'arte,* ed. Bonita Cleri, Sabine Eiche, John E. Law, and Feliciano Paoli (Urbino 2002), 195. For Barocci's study of the Titians in the della Rovere collections, see Bellori, 1976, 181 (for Bellori's sources and reliability, see the opening of Ch. 9). Bellori's source may have been Venturelli, 1800. For the della Rovere taste for Venetian painting, see Pietro Zampetti, Dante Bernini, and Grazia Bernini Pezzini, *Tiziano per i Duchi di Urbino* (Urbino, 1976), and Jeffrey Fontana, "Duke Guidobaldo II della Rovere, Federico Barocci, and the Taste for Titian at the Court of Urbino," in Verstegen, 2007, 161–78. Fontana also hypothesized that Barocci's early interest in Titian was motivated in part by a desire to attract ducal patronage.

17 Bellori, 1976, 184. For the dating of the illness, see Olsen, 1962, 25. For the common period perception that one's native air held healing properties, see Robert le Mollé, *Giorgio Vasari: l'homme des Médicis* (Paris, 1995), 180–85.

18 Bellori, 1976, 184: "ond'egli sopra ogn'altra cosa dolente, per non poter dipingere, si raccomandò un giorno con tanta efficacia alla gloriosa Vergine, che fù esaudito. Sentendosi però alquanto meglio, fece un quadretto con la Vergine, e'l figliuolo Giesù, che benedice San Giovanni fanciullo, e lo diede in voto alli Padri Cappuccini di Crocicchia, due miglia fuori d'Urbino; là dove egli soleva trattenersi in un suo podere . . ." I have used the translation of Edmund Pillsbury and Louise Richards, *The Graphic Art of Federico Barocci* (New Haven, 1978), 15. The four-year convalescence Bellori records is hard to reconcile with what is known of Barocci's activity in the

1560s; however, this was a detail singled out in Barocci's lifetime, when Borghini, 1967, vol. I, 569, records both the duration of Barocci's convalescence and his creation of the *Madonna di San Giovanni* as a votive offering. For the dating of the *Madonna di San Giovanni,* see Olsen, 1962, 146, and Fontana, 1998, 97. For Barocci's will, see Intro., n. 12.

19 See Emiliani, 1985, for general discussion of these works. The altarpiece from Fossombrone, long considered lost, is now thought to be one in the Brera but in bad condition and heavily overpainted. I have not seen the work; good photographs reveal passages of quality but confirm heavy reworking. See most recently Maria Maddalena Paolini, "Federico Barocci, *Madonna col Bambino e i Santi Giovanni Battista e Francesco,*" in *L'Arte conquistata: spoliazioni napoleoniche dalle chiese della legazione di Urbino e Pesaro,* ed. Bonita Cleri and Claudio Giardini (Modena, 2003), 198–9, with further references. For Conventual oversight of the Capuchins (until 1611), see Lingo, 1998, 101–2, and G. Abate, "Conferme dei vicari generali cappuccini date dai maestri generali conventuali (1528–1619)," *Collectanea Franciscana* 33 (1963): 423–41. The radicality of the Capuchin reform embarrassed and angered the official reform branch of the Franciscan Order, the Observants, and concerned the papacy; thus, the new friars were placed under the unreformed wing of the Order rather than given independence or placed under the direction of the Observance. For Barocci's print of the *Stigmatization,* see Ch. 3.

20 For a modern edition see Gioseffo Zarlino, *Informatione intorno la origine dei Reverendi Frati Capuccini* (1579) in *Monumenta Historica Ordinis Minorum Capuccinorum,* 17 vols. (Assisi and Rome, 1937–86), vol. II, 494–6: "Era allora nel Duomo una parte di una palla o vogliamola dire ancona di altare vecchia . . . dipinta et dorata . . . Et erano in questa palla dipinte alquante figure di alcuni Santi, lunghe circa un piede; tra i quali . . . era posto quella del glorioso P.S. Francesco, dipinta diritta in piedi con l'habito o tonica più tosto di colore tanè o rovano, che lo vogliamo dire, che di altro colore, et con i piedi nudi calciati con scarpe di chorda, fatte a modo che ora portate voi altri R. P. Capuzzini. La quale havea il capuccio aguccio in forma di piramide, come hoggi anco usa di portare tutta la vostra Congatione, come si vede etiandio in un'altra palla di altare vecchia, nella quale è dipinto il detto Santo che riceve le stimmate da Christo, che era nel già monasterio dei Frati Zoccolanti, et anco in un'altra che si ritrova al presente, per quello che mi è stato detto, nel monasterio di

San Domenico delli R.P. dell'Ordine dei Predicatori et era dipinta questa figura con una croce in mano." When Fra Paolo copied the habit, "molto si assimigliava a quella pittura, che molte fiate havea veduto nel Duomo." For the Capuchins and archaism, see Lingo, 1998. Zarlino was also a major musical theorist; see further Ch. 9 and the Conclusion.

21 For the San Damiano revival see Lingo, 1998, 50–56.

22 Luigi Biadi, *Storia della città di Colle in Val d'Elsa* (Florence, 1859), 306: "Il secondo Altare dei Francescani, contiene dipinto in tavola il Serafico d'Assisi . . . condotta in origine dal pennello di Cimabue contemporaneo del Santo, ravvisandosi l'istesso concetto, l'istessa positura, l'istessa maniera, l'istesso colorito dell'altro S. Francesco operato dal medesimo artista . . . esistente nella Chiesa dei MM. Conventuali di S. Croce in Firenze." For the Capuchin and Franciscan revival of interest in early images of Francis and the translation of the Bardi Dossal, see Lingo, 1998, 125–42 (for the Dossal and its copy, 126–9). For Colle's cultural importance and the interests of Bishop Cosimo della Gherardesca, see Zygmut Wazbinski, "Il *Modus* Semplice: un dibattito sull' *Ars Sacra* fiorentina intorno al 1600," in *Studi su Raffaello*, ed. M. Hamoud and M. L. Strocchi, 2 vols. (Urbino, 1987), vol. I, 625–49, and *Colle di Val d'Elsa nell'età dei granduchi medicei: "La terra in città e la collegiata in cattedrale"* (Florence, 1992). Chiara Frugoni, *Francesco un'altra storia* (Genoa, 1988), 45, also dates the Colle dossal to c. 1600.

23 For a modern edition see Pietro Scarpellini, ed., *Fra Ludovico da Pietralunga: La Basilica di San Francesco d'Assisi* (Treviso, 1982); xxii for Vasari's relations with Doni. For Doni see further Ch. 3; Lingo, 1998, 145–58; and Laura Teza, "Dono Doni," in *La Pittura in Italia: il cinquecento*, 2 vols. (Venice, 1988), vol. II, 705–6.

24 For Barocci's will, see Intro., n. 12.

25 See Lingo, 1998, 262–70, for the problematic identification of Barocci as a Capuchin tertiary.

26 For Barocci's strategies in seeking recognition from Urbino, see Lingo, 2007, 179–99. In his funeral oration for Barocci, Venturelli, 1800, fol. 206r, states that the painter had visited "le più chiare città d'Italia" in his youth to study art.

27 See Olsen, 1962, 147–8, and Emiliani, 1985, vol. I, 34–43 for discussion. While the work was noted by Borghini (1967, vol. I, 568), it was Bellori who recorded its execution for Pietro Bonarelli. David Scrase, "Recent Discoveries at the Fitzwilliam Museum, Cambridge," in *Dal disegno all'opera compiuta*, ed.

Mario di Giampaolo (Perugia, 1992), 86, notes that the discovery of drawings for Barocci's *Deposition* on the verso of two sheets of studies for the Urbino *Crucifixion* could indicate that the Urbino painting should be dated slightly later than usual, with Barocci still at work on it through 1567. See also Fontana, 1998, 170, and 98, n. 114, for evidence that the Bonarelli painting postdates at least the design of the *Madonna di San Simone*.

28 Joannides, 1992, argues for the presence of archaistic elements in much of Michelangelo's later production, a hypothesis of considerable interest in the case of the *Crucifixion* drawings. Olsen had noted the relation of the Virgin's form to the late style of Michelangelo, though he did not link it to Duecento prototypes. Shearman, 1976, 53, seems to have been the only scholar to note the connection to Duecento figures. Barocci probably came to know San Francesco al Prato well during his residence in Perugia in the late 1560s; he studied Raphael's *Entombment* there (see Ch. 4). He might well have passed through Perugia before, in the course of his travels between Urbino and Rome, but there were many other old crucifixes that depicted the Virgin in similar attitudes.

29 Bellori, 1976, 182–3: "Soleva raccontare ancora che disegnando egli un'altro giorno in compagnia di Taddeo Zuccheri una facciata di Polidoro, venne à passare Michel Angelo, che andava à palazzo, cavalcando una muletta, come'era suo costume, e dove gli altri giovini correvano ad incontrarlo, e mostragli i loro disegni, Federico per timidità, si rimaso al suo luogo, senza farsi avanti. Il perché Taddeo toltagli la cartella di mano, la portò al Buonaroti, che guardò bene li disegni, trà quali vi era il suo Mosè con diligenza imitato. Lodollo Michel Angelo, e volle conoscerlo, inanimandolo à proseguire gli studij incominciati." Shearman, 1976, noted Barocci's uncanny awareness of some of the late drawings.

30 See Olsen, 1962, 49–51, and Shearman, 1976, 53. Shearman noted the similarity to Michelangelo's composition, as did Olsen in passing, 50. Joannides, 1992, 250, hypothesizes archaic sources for Michelangelo's *Annunciation* drawings, an intriguing if evocative assertion. See Emiliani, 1985, vol. I, fig. 37, for the preparatory drawing for the *Annunciation*, Berlin inv. KdZ 20448 (3755). For Venusti paintings after these compositions, see e.g. Georg W. Kamp, *Marcello Venusti: Religiöse Kunst im Umfeld Michelangelos* (Egelsbach, Cologne, and New York, 1993), figs 1 and 11.

31 Zeri, 1957, 80. For the painting in the context of other Roman Crucifixion altarpieces in the

early post-Tridentine decades, see Iris Krick, *Römische Altarbildmalerei zwischen 1563 und 1605* (Taunusstein, 2002), 267–92.

32 For the drawing of Saint John, see Emiliani, 1985, vol. I, fig. 56, Staatliche Museen, inv. I–1974 (4173), (r.).

33 Olsen, 1962, 147, who notes that the two saints were copied while the cross was in relief. Barocci later produced the high altarpiece for the Macerata Capuchins, now lost but recorded by Bellori; see Pillsbury and Richards, 1978, 21, n. 47.

34 Borghini, 1967, vol. I, 569, and Bellori, 1976, 204. Olsen, 1962, 149.

35 See further Ch. 3.

2 Vision and Icon

1 Gilles Gerard Meersseman (in collaboration with Gian Piero Pacini), *Ordo Fraternitatis: confraternite e pietà dei laici nel medioevo*, 3 vols. (Rome, 1977), vol. II, 954, 971–2.

2 For the fraternity and Misericordia iconography, see Luciana Borri Cristeli, "Iconografia della Mater Misericordiae nella committenza della fraternità aretina," *Atti e memorie della Accademia Petrarca di lettere, arti e scienze* 51 (1989): 257–89.

3 See the entry by Anna Maria Maetzke (with bibliography) in *Il Museo statale d'arte medievale e moderna in Arezzo*, text by Anna Maria Maetzke et al. (Florence, 1987), 69–70.

4 Ibid., 78–80, gives both paintings to Pecori. Nicoletta Baldini, *La Bottega di Bartolomeo della Gatta: Domenico Pecori e l'arte in terra d'Arezzo fra quattro e cinquecento* (Florence, 2004), 80–81, 246–7, assigns the design of the Monte fresco to della Gatta (commissioned 1488) and proposes Angelo di Lorentino rather than Pecori as the chief assisstant and later completer/ restorer of the fresco early in the sixteenth century. Baldini discusses the Pecori panel Misericordia at length (esp. 219–27), stresses the intervention of Niccolò Soggi and the Spaniard Fernando de Coca, and tentatively dates the painting to c. 1512–14. For the contract for the *Madonna del Popolo*, see below.

5 For the project and Vasari's text, see David Franklin, *Rosso in Italy* (New Haven and London, 1994), 255. Vasari writes: "[Rosso] fece molti disegni in Arezzo e fuori per pitture e fabbriche come ai Rettori della Fraternità . . . per i quali Rettori aveva disegnato una tavola che s'aveva a porre di sua mano nel medesimo luogo, dentrovi una nostra Donna che ha sotto il manto un popolo, il quale disegno non fu mai posto in opera è nel nostro libro."

6 See Isabella Droandi, "Le Insegne della Fraternità dei Laici nel XVI secolo: da Bartolomeo della Gatta a Giorgio Vasari," *Annali aretini* 10 (2002): 5–22.

7 See Alessandra Baroni, "Giorgio Vasari, *Madonna della Misericordia*," in *Mater Christi: altissime testimonianze del culto della Vergine nel territorio aretino*, ed. Anna Maria Maetzke (Milan, 1996), 61–2. For the background to the commission of the *Madonna del Popolo*, see Olsen, 1962, 163, and Emiliani, 1985, vol. I, 129. For Gilio on nudity in depictions of putti, see Ch. 1, and for the issue of the nude putto more generally, see Ch. 6.

8 Vasari was praising Barocci in connection with the decorations of the Casino of Pius IV, executed in the early 1560s; Giorgio Vasari, *Le Vite de' più eccellenti pittori, scultori ed architettori* (Florence, 1568), ed. G. Milanesi, 9 vols. (Florence, 1878–85), vol. III, 694.

9 For the *Rest on the Return from Egypt* see the Conclusion. On the question of ducal patronage, Olsen, 1962, 242, points out that Barocci may also have been asked to paint a portrait of Guidolbaldo II (according to Andrea Lazzari, c. 1800). For the portrait of Francesco Maria II and the patron, see Olsen, 2002, 195.

10 The correspondence between Barocci and the rectors is largely transcribed in Michelangelo Gualandi, *Nuova raccolta di lettere sulla pittura, scultura ed architettura* 3 vols. (Bologna, 1844–56), vol. I, 135–92; for the letter of October 30, see 135: "tavola, con figure che rapresentino il misterio della misericordia o altro misterio et historie della gloriossima vergine." Emiliani, 1985, vol. I, 129–34 publishes a number of excerpts from the extensive correspondence.

11 Gualandi, 1844, 137–8 (letter of November 5, 1574): "il voler fare il misterio della Misericordia non pare a me che sia sugietto troppo aproposito per fare una bella tavola, e non ci curando le S. V. che si facessi altro misterio purché fusse della gloriosa vergine ve sariano altre istorie più a proposito con più belle inventione come sarebbe la Anuntiata la Sumptione la Visitazione o altre istorie che più piacessero alle SS. vostre sopra ciò si resolveranno loro . . ."

12 The conflation of "history" and "mystery" had a long pedigree in ecclesiastical discussions of narrative art and insistence on it may well have become more pronounced as narrative painting took on greater theoretical prominence after Alberti. The *massari* of Cremona Cathedral, e.g., stress that Pordenone's *Christ Before Pilate* must represent "Como Pilato condemna Christo chel sia crucifixo e chel se lava le mane . . . cum Palazo, paiesi, prospective ed altre cose circa ciò necessarie,

Como se recercha alla representazione de uno simile *acto et misterio*" [italics mine]. The employment of *istoria* instead of *acto* in the letters documenting Barocci's *Madonna del Popolo* may indicate a greater awareness of the terms of art theory on the part of the Arezzo rectors; from his statements it certainly seems that Barocci would have understood the theoretical implications of the term *istoria*. For Pordenone's contract, see Carolyn Smith, "Pordenone's 'Passion' Frescoes in Cremona Cathedral: An Incitement to Piety," in *Drawing Relationships in Northern Italian Renaissance Art: Patronage and Theories of Invention*, ed. Giancarla Periti (Burlington and Aldershot, 2004), 105–6. The Council of Trent, too, had stressed that Christian narrative paintings were always "historias mysteriorum nostrae redemptionis"; see Tanner, 1990, vol. II, 774–6.

13 See Patricia Rubin, "Commission and Design in Central Italian Altarpieces, c. 1450–1550," in *Italian Altarpieces 1250–1550: Function and Design*, ed. Eve Borsook and Fiorella Superbi Gioffredi (Oxford, 1994), 201–2.

14 David Franklin, "A Gonfalone Banner by Vasari Reassembled," *The Burlington Magazine* 137 (November 1995): 747–50, discussing a late commission of 1570 to Vasari from the Confraternity of the Trinity in Arezzo, notes perceptively both the painter's "unwavering affection for and pride in his native town" and the investment of the *Vite* (just published in their revised and expanded version) in "continuity with the past" (750). The Martelli altarpiece was painted in *paragone* with other notable modern paintings in a major center.

15 Bellori, 1976, 198. According to Emiliani, 1985, vol. I, 123, and Olsen, 1962, the painting was cited in the "Libro delle notizie del Convento di San Francesco" but was not assigned a date. Andrea Lazzari, *Delle chiese d'Urbino e delle pitture in esse esistenti* (Urbino, 1801), 107–8, identified the worshipers as members of the Ambrosi family. While some figures appear portrait-like, others are clearly drawn from Barocci's repertoire of types. The presence of women and children might suggest that a family rather than part of a confraternity is portrayed, for it is usually assumed that confraternities had no female members. However, wives and female blood relatives of male *confratelli* were sometimes included in confraternities: see the membership lists discussed by Marzia Faietti, "Amico's Friends: Aspertini and the Confraternità del Buon Gesù in Bologna," in *Drawing Relationships in Northern Italian Renaissance Art: Patronage and Theories of Invention*, ed. Giancarla Periti (Burlington and Aldershot, 2004), 52–3. The discussion of the

Immaculate Conception here elaborates issues I first considered in "Retrospection and the Genesis of Federico Barocci's *Immaculate Conception*," in *Only Connect: Studies in Honor of John Shearman*, ed. Lars Jones and Louisa Matthew (Cambridge, Mass., 2002), 215–22.

16 Emiliani, 1985, vol. I, 123, but see the doubts expressed by Shearman, 1976, 49–54, in his review of the Barocci exhibitions of 1975.

17 Emiliani, 1985, vol. I, 123 notes the retrospection of the drawing. See Ch. 1, fig. 13 for a somewhat comparable drawing.

18 Peter Humfrey, "Altarpieces and Altar Dedications in Counter-Reformation Venice and the Veneto," *Renaissance Studies* 10 (September 1996): 380, citing M. Levi d'Ancona, *The Iconography of the Immaculate Conception in the Middle Ages and the Renaissance* (New York, 1957), 33–4, 44–5.

19 Laura Speranza, "La Madonna del Rosario: origine della devozione e diffusione del tema nell'arte del territorio aretino," in *Mater Christi: altissime testimonianze del culto della Vergine nel territorio aretino*, ed. Anna Maria Maetzke (Milan, 1996), 26–34, notes e.g. a tradition of eliding the iconography of the Misericordia with that of the Rosary. Before such paintings one tends to ask which it is but the conundrum is modern; the panel's original viewers would not have posed the question.

20 For discussion, see Carlo Bo, ed., *Galleria nazionale delle Marche, Tiziano per i duchi di Urbino* (Urbino, 1976), cat. 13, 58–9, and *Tiziano nelle gallerie fiorentine* (Florence, 1978), cat. 34, 148–50. For the letters, associated with the painting by Gronau, see Gronau 1936, 107–10. The duke's initial request is 107–8: "La figura ha da essere d'una Madonna in piedi che sotto il manto habbi numero di gente, come vederete per un poco de schizzo che se n'è fatto fare, il quale non ha però da servire per altro, che per informazione del desiderio nostro, che nel resto ne riportiamo alla diligentia e valore del S.r Titiano." Might Barocci have furnished the sketch included with the duke's letter?

21 See Stefania Mason, "Sub matris tutela: la pala di Paolo Veronese per la Scuola Grande della Misericordia," in *Per Luigi Grassi: disegno e disegni*, ed. Anna Forlani Tempesti and Simonetta Prosperi-Valenti Rodinò (Rimini, 1998), 148–55. Mason points to the mid-1400s relief of the Misericordia that once adorned the portal of the Scuola as a reference for Veronese's painting, with its elements of "arcaismo, sicuramente voluto dalla committenza (152)."

22 For *gonfaloni* with the Madonna and devotees on a cloud, see Francesco Santi, *Gonfaloni umbri*

del rinascimento (Perugia, 1976), plates I, XI, XIV–XVI. For the use of *gonfaloni* over altars, see Michael Bury, "The Fifteenth- and Early Sixteenth-Century *gonfaloni* of Perugia," *Renaissance Studies* 12 (March 1998): 67–86. For further discussion of Barocci and the *gonfalone* tradition, see "The Modern Misericordia" section below. Although art history later generically identified many Quattrocento *gonfaloni* as "Renaissance" images, sophisticated viewers of the mid- to late Cinquecento would certainly have found such pictures archaic. While Vasari acknowledged the achievements of the fifteenth century, Paolo Giovio expressed a common prejudice when he hailed "those stars of a perfect art that are named da Vinci, Michelangelo, and Raphael, risen at once out of the shadows of that age [the fifteenth century]." Paolo Giovio, "Fragmentum trium dialogorum," in *Scritti d'arte del cinquecento*, trans. and ed. Paola Barocchi, 3 vols. (Milan and Naples, 1971–7), vol. I, 19–20, quoted in Bette Talvacchia, "The Double Life of Saint Sebastian in Renaissance Art." I thank Prof. Talvacchia for allowing me to read this forthcoming article.

23 For the *mandorla* in Assumptions, see e.g. the drawing after Perugino's lost altarpiece for the Sistine Chapel (fig. 47), and his *Assumption* in the Accademia in Florence, in Santissima Annunziata in Florence, and in the Duomo of Naples; Pietro Scarpellini, *Perugino* (Milan, 1984), figs 198, 240, 262. For the *mandorla*, see Ronald Lightbown, *Mantegna: With a Complete Catalogue of the Paintings, Drawings, and Prints* (Berkeley and Los Angeles, 1986), 184–5. Ibi's *gonfalone* is discussed by Santi, 1976, 37 (pls XXVIII and XXIX).

24 In fifteenth-century *gonfaloni*, expansive gestures, such as those in Barocci's Louvre drawing, were usually reserved for interceding saints; the faithful remained humbly prayerful. Barocci acknowledges this tradition in the restrained gestures of his painting. His struggle to fashion a contemplative image that was nonetheless energized with the drama of the Virgin's theophany also led him to recall, for the mother supporting the little girl, the woman catching the swooning Virgin in the Perugia *Deposition* (see fig. 85). Barocci's rethinking of this motif may demonstrate that his oft-noted reuse of figures was more than an artistic convenience. Here, the mother's support allows the child to lean back toward our space – thus heightening the illusion that the Virgin has swept into the foreground – while not disrupting the reflective tone of the painting with the agitated movements of the child in the Louvre drawing. See further Ch. 7 for Barocci's reuse of figures.

25 In the *Immaculate Conception*, the *Perdono*, and the *Madonna del Popolo*, Barocci evolved a type of holy figure whose robe is blown across the body and flows back or off to one side. This became a characteristic figure type, repeated with variations throughout his life. In the *Immaculate Conception*, the figure attains one of its most effective manifestations.

26 A Trecento example is Orcagna's Strozzi Altarpiece of 1354–7. In Perugino's Sistine *Assumption* (see fig. 47), the *mandorla* is articulated at regular intervals with cherub heads.

27 For the painting, see the catalogue entry by Maria Rosaria Valazzi in Bonita Cleri, ed., *Per Taddeo e Federico Zuccari nelle Marche* (Sant'Angelo in Vado, 1993), 146–7. The assessment is that of Luciano Arcangeli, "Federico Zuccari," in Arcangeli et al., *Pittori nelle Marche tra '500 e '600: aspetti dell'ultimo manierismo* (Urbino, 1979), 86.

28 For the Ridolfi, see Anna Colombi Ferretti, *Dipinti d'altare in età di controriforma in Romagna, 1560–1650: opere restaurate dalle diocesi di Faenza, Forlì, Cesena e Rimini* (Bologna, 1982), 100–03. See Anna Maria Ambrosini Massari and Marina Cellini, eds., *Nel segno di Barocci: allievi e sequaci tra Marche, Umbria, Siena* (Milan, 2005), for several adaptations of Barocci's finished painting and of the Uffizi drawing, including the Patanazzi, fig. 1, 292.

29 See Emiliani, 1985, vol. II, 272–5, for general discussion; Emiliani holds that the reuse of previous Barocci inventions in a painting executed by unknown collaborators may indicate that the patrons had little to spend. Both Emiliani and Olsen, 1962, 222–4, note that little is known of the workings of Barocci's studio and his relations with collaborators. See now, however, the work on Barocci drawings and the workshop by Ian Verstegen, most recently 2005/6.

30 Letter of December 9, 1592, from Francesco Maria II to Grazioso Graziosi, published in Gronau 1936, 224–5: "Se v'imbattete nel Zuccaro pittore, diteli . . . ho veduto il quadro fatto da lui per la Compagnia della Concettione di qui, il quale mi è paruto tanto vago et bello, che me ne voglio rallegrar seco."

31 The Laici Rectors to Barocci, letter of November 12, 1574, published in Gualandi, 1844, I, 139: "vogli ancora contentarsi de venire con suo comodo sin qui nel luogo per vedere li lumi acciò meglio possi accomodarla [the painting] a satisfatione sua, et perche tanto più presto o più facilmente possiamo convenire della qualità delle figure, et sorta della istoria che vi si potriano addattare . . ."

32 Letter of November 19, 1574 (ibid., 141): "Mi rincrescie grandemente non poter contentare le S[ignori]e v[ost]re in venir io fin là per causa della mia indispositione, che non è rimedio alcuno che io possi cavalcar dua miglia bisogna haver patientia. Circa il veder il luoco per rispetto delli lumi li dico che non è difficultà alcuna, che a me basta saper se il lume, è a man dritta ò a man manca, o vero le S[ignori]e v[ost]re potranno far fare un disegno grossamente della Cappella con li suoi lumi come più piacerà a loro però si resolverano del istoria che li piacerà e del resto lasceranno la cura a me . . ." Barocci is careful to employ only *istoria* once again when describing the possible subject of the painting.

33 The contract was published in Pillsbury and Richards, 1978, 26–7. The passage (26) reads: "historia ipsius tabulae sit gloriossissimae Mariae Deiparae semper Virginis intercedentis et oranti ad Dominum Yesum Christum filium eius benedictum pro populo ibi similiter picto et representato in dicta tabula cum decoro et venustate et gratia secundum conditionem et qualitatem figuram ibi pingendarum."

34 Bellori, 1976, 188.

35 Borghini, 1967, vol. I, 569: "Nella Pieve d'Arezzo è fatta da lui la tavola della Madonna della Misericordia con molte figure appartenenti à tal misterio, & è questa opera molto nominata, e fatta con grand'arte . . ."

36 The Rectors to Barocci, letter of November 8, 1577, (Gualandi, 1844, I, 161): "studio e diligentia, et ancora una sollicitudine tale che non detragga al decoro, et alla perfectione sua . . ."

37 Barocci to the Rectors, letter of April 23, 1578 (ibid., 164–5): "essendone causa la mia indispositione . . ."

38 Ibid., letter of November 12, 1578 (ibid., 169–70): "ma io stimo molto più l'honor mio che non faccio questi denari promessomi da loro et si pure gli par lungo ad aspectare fino a tempo nuovo come ho avisato a loro Antecessori [the Rectors had changed since Barocci signed the commission] potranno dar ordine la strada che vorranno tenere che li conduchi costa che sara anco fenita hora et dubito certo che p[er] haver voluto far troppo non haro fatto niente havendo fatto nel op[e]ra el doppio di quello che io promisi."

39 See Santi, 1976, 39. Barocci could have easily seen this, one of the most important of the Perugian processional banners, associated with the Cathedral, while he was at work on the *Deposition* (see fig. 85) in Perugia in 1568–9. The *gonfalone* remained popular enough that it was twice engraved during the seventeenth century.

40 See e.g. ibid., pls I (from San Francesco in Perugia itself), XI, XIV, and XV.

41 See ibid., 24.

42 See Bury, 1998, 73.

43 For the *Entombment* see Ch. 4. For the *gonfalone*, see Santi, 1976, 16. For the "nicchia di San Bernardino," see Scarpellini, 1984, 72–4, cats 13–20, figs 14–21.

44 Shearman, 1976, 52, advanced the possibility that Arezzo's Piazza Grande is evoked.

45 For the *Madonna di Fossombrone*, see Jeffrey Fontana, "Federico Barocci's Emulation of Raphael in the Fossombrone *Madonna and Child with Saints*," in *Coming About: A Festschrift for John Shearman*, ed. Lars Jones and Louisa Matthews (Cambridge, Mass., 2001), 183–90. See Ch. 1, n. 19, for the current identification and state of the work.

46 On Raphael's sensitivity to early Christian and select medieval image types, see e.g. David Rosand, "'Divinità di cosa dipinta:' Pictorial Structure and the Legibility of the Altarpiece," in *The Altarpiece in the Renaissance*, ed. Peter Humfrey and Martin Kemp (Cambridge, 1990), 143–64. For an extended and insightful discussion of the *Entombment*, see Alexander Nagel, "Michelangelo, Raphael, and the Altarpiece Tradition," Ph.D. diss., Harvard University, 1993, and Nagel, 2000; see also Hubert Locher, *Raffael und das Altarbild der Renaissance: di "Pala Baglioni" als Kunstwerk im sakralen Kontext* (Berlin, 1994). For evidence that the *Madonna di Foligno* was originally the high altarpiece of the Aracoeli, see Christa Gardner von Teuffel, "Raffaels römische Altarbilder: Aufstellung und Bestimmung," *From Duccio's Maestà to Raphael's Transfiguration: Italian Altarpieces and Their Settings* (London, 2005), 277–81 (originally published in *Zeitschrift für Kunstgeschichte* 50 [1987]: 1–45).

47 Rona Goffen, "*Nostra Conversatio in Caelis Est*: Observations on the *Sacra Conversazione* in the Trecento," *Art Bulletin* 61 (June 1979): 198–222 remains fundamental. See more recently Peter Humfrey, *The Altarpiece in Renaissance Venice* (New Haven and London, 1993), 12–13, for historiographic overview and reflection on the use of the term.

48 Robert W. Scribner, "Vom Sakralbild zur sinnlichen Schau: Sinnliche Wahrnehmung und das Visuelle bei der Objektivierung des Frauenkörpers in Deutschland im 16. Jahrhunderts," in *Gepeinigt, begehrt, vergessen: Symbolik und Sozialbezug des Körpers im späten Mittelalter und in der frühen Neuzeit*, ed. Klaus Schreiner and Norbert Schnitzler (Munich, 1992), 312, cited by Klaus Krüger, "Medium and Imagination: Aesthetic Aspects of Trecento Panel Painting," in *Italian Panel Painting of the Duecento and Trecento: Studies in the History of Art 61. Center for Advanced Study in the Visual Arts, Symposium Papers XXXVIII*, ed. Victor Schmidt (New Haven and London, 2002), 72. Krüger makes intriguing comments concerning mimetic naturalism in religious painting and its implications. See more generally his *Das Bild als Schleier des Unsichtbaren: Aesthetische Illusion in der Kunst der frühen Neuzeit in Italien* (Munich, 2001).

49 For discussion of these works see Humfrey, 1993, 203–7 (San Giobbe), 255–6 (Basaiti), and index for Bellini's *Saint Jerome* (indexed as the Diletti altarpiece). Intriguingly, the Basaiti stood over one of the altars next to Bellini's San Giobbe *pala*. Humfrey, 188, stresses that an illusion such as that in the San Giobbe visualized the venerable belief that during Mass the host of heaven was mystically present in the space of the church. The difficulties raised in the discussion that follows might be even more pressing in devotional painting, as altarpieces were located in a sanctified, if earthly, space, while devotional paintings were frequently collocated in domestic rooms.

50 For the cloud in early modern painting, see Hubert Damisch, *A Theory of Cloud: Toward a History of Painting*, trans. Janet Lloyd (Stanford, 2002). See also John Shearman, "Raphael's Clouds, and Correggio's," in *Studi su Raffaello*, ed. M. Sambucco Hamoud and M. L. Strocchi, 2 vols. (Urbino, 1987), vol. II, 657–68.

51 See John Shearman, *Only Connect . . . Art and the Spectator in the Italian Renaissance* (Princeton, 1992), 102–4, developing his "Raphael's Clouds."

52 One can sense all the requisite building blocks of Barocci's type of the ecstatic Francis, such as the figure he used in the *Perdono*, here in a conflation of Raphael's Francis with the backward-flung arm of Saint Jerome, without the necessary mediation (often adduced) of Titian's Francis at the Frari (see fig. 45, a figure that is much quieter than Barocci's Francis in the *Perdono*). The donor of Raphael's altarpiece, Sigismondo de'Conti, was a papal secretary; Jerome is present as patron of papal secretaries (see Shearman, 1992, 104).

53 See e.g. Santi, 1976, pls XI and V.

54 See Lingo, 1998, 309–10, n. 140, for discussion and sources.

55 This composition, often said to represent the frightened Child waking from a dream of the Passion and pulling his mother's robe about him, is derived in part from Michelangelo's invention in the *Taddei Tondo*, which was intended to lend psychological and narrative interest to the simple Madonna and Child type; see Roger Jones and Nicholas Penny, *Raphael* (New Haven, 1983), 36. See also Malcolm Easton, "The Taddei Tondo: A Frightened Jesus?" *Journal of the Warburg and Courtauld Institutes* (1969): 391–3; however, Easton argues strongly against fear as the motivator of the motion of Michelangelo's figure. The movement of the Child down and forward from His mother's lap in the *Madonna di Foligno* also recalls Michelangelo's *Bruges Madonna*. See further the Conclusion for issues of imitation. Regina Stefaniak, "Raphael's *Madonna di Foligno*: *Civitas sancta, Hierusalem nova*," *Konsthistorisk Tidskrift* 69 (2000): 78, reads the Child's action as shielding Himself from the golden sun but thereby offering the Virgin an epithalamic gesture.

56 The early Franciscan writers frequently note such congruences; see Lingo, 1998, 311.

57 For Perugino's Sistine *Assumption* and variations, see n. 23 above. For Ghirlandaio's *Coronation* and its many adaptations see Jean Cadogan, *Domenico Ghirlandaio: Artist and Artisan* (New Haven and London, 2000), 255–6. The fundamental investigation of the *maniera devota* and pictorial reform of the era is Charles Dempsey, "The Carracci and the Devout Style in Emilia," in *Emilian Painting of the 16th and 17th Centuries: A Symposium* (Bologna, 1987), 75–88. The knight in the *Madonna del Popolo* may be a member of the Tuscan Order of Santo Stefano, which usually displayed a red maltese cross on a white field; the cross was sometimes framed with gold, however, and Barocci may have played on this to fill the knight's cloak with the golden light of the apparition. I thank Maurizio Arfaioli for stimulating conversations regarding orders of knighthood in early modern Italy and the possible identification of the cross on Barocci's figure.

58 The letter is published in Gualandi, 1844, I, 176–82. The passages in question (180–81) read: "ma ci sa bene male che la tavola qui non riesca di quella bona qualità che si aspettava. Et al manco in capo a dieci giorni non havessi quella incominciato a mostrare qualche pelo, si come ha incominciato a mostrare. Non sappiamo se questo sia accaduto perche le asse non erano stagionate et antique ò se per una poca diligentia vi si sia usata nel leggarla bene insieme, et dio voglia che non faccia il medesimo il tondo. Di che pensate quanto dispiacere sia hoggi in parte di questo populo. Diciamo in parte perche una parte ne sono che non li pare che sia la perdita di cosa tanto eccellente che bisogni pigliarsene grande tristezza." The rectors' anger was triggered, or given an excuse, because of a letter from Barocci, to which they allude, in which he had complained of his treatment during his trip to Arezzo to consign the altarpiece.

59 See Nicoletta Lepri and Antonio Palesati, "La Consegna della *Madonna del Popolo* del Barocci alla confraternità di Santa Maria della Misericordia," *Bollettino d'informazione: brigata aretina amici dei monumenti* 35 (2001): 46–52, for the document and its place in the reconstruction of the relations between Barocci and his patrons. The text in question (50) reads: "et auditis pluribus viris peritis et quasi universa Civitate confessi fuerunt supradict_ tabulam fuisse et ec_ pulcr_ et speciosam et fabrifact_ e cum oc_ studio et diligentia ac perfectione . . ."

60 See Emiliani, 1985, vol. II, 282–3, for discussion of this *Misericordia*.

61 Gronau, 1936, 153–4, cited in Olsen, 2002, 196–7: "haveva som[mamen]te sentito celebrar per raro pittor Federico Barocci . . . La fama di Federico è venuta per la tavola che mandò in Arezzo, giudicata tanto bella che quà hoggi gli è dato il primo luogo fra i pittori." It seems significant that Raffaello Borghini's *Il Riposo*, the first significant assessment of Barocci's career, was published in Florence in 1584 (1967, vol. I, 568–70).

62 For Florentine painters' interest in the *Madonna del Popolo*, see Dempsey, 2000, 16, with references; for the purchase by Grand Duke Pietro Leopoldo, see Emiliani, 1985, vol. I, 134, and Olsen, 1962, 165.

3 History into Mystery

1 For the *Madonna di San Simone*, see Emiliani, 1985, vol. I, 44–57. The chapel and patrons seem now to have been identified, though there remains some confusion in citations; see Marilyn Aronberg Lavin, "Images of a Miracle: Federico Barocci and the Porziuncola Indulgence," *Artibus et historiae* 54 (2006): 45, n. 1, and 47, n. 51, citing Luciano Ceccarelli, *"Poi che la gente poverella crebbe . . .": la chiesa di San Francesco d'Assisi civico "Pantheon" degli urbinati e il convento dei frati minori conventuali in Urbino*, Urbino, 2003, 39. Lavin's article appeared as I was completing final revisions of the book; I was pleased that our assessments, while reached through different means, share many points. Lavin's insistence that "Whereas Barocci's work in general is often characterized as overly florid and sentimental, it becomes increasingly evident that his style served to convey spiritual ideas of great sophistication" (9), is particularly congruent with claims I am making in this book. I thank Professor Lavin for sending an offprint of the article before the journal was easily available. For a partial transcription of Ba-

rocci's letter to the Arezzo confraternity (June 2, 1576), see Emiliani, ibid., 129.

2 For an introduction to the complex and contested history of the Porziuncola indulgence, see Lavin, 2006, with further bibliography; still useful is Raphael M. Huber, O.M.Conv., *The Portiuncula Indulgence from Honorius III to Pius XI* (New York, 1938). See also Emiliani, 1985, vol. I, 111.

3 See Lavin, 2006, 12–18, with further references, and Simonetta Prosperi Valenti Rodinò, "Il Perdono di Assisi," in *L'Immagine di San Francesco nella Controriforma*, catalogue of works by Simonetta Prosperi Valenti Rodinò and Claudio Strinati (Rome, 1982), cat. 28, 79, for discussion of the history of the indulgence and the rise of imagery to support it. (Prosperi Valenti Rodinò wrote all of the entries which will be cited from *L'Immagine di San Francesco* below.)

4 For the Porziuncola, see Federico Mancini and Aurora Scotti, eds, *La Basilica di S. Maria degli Angeli*, 3 vols. (Perugia, 1989–90). For the Conventual program of restoration, see Elvio Lunghi, "Tematiche e commitenze pittoriche," in *Assisi in Età Barocca*, ed. Alberto Grohman (Assisi, 1992), 367–89, and Ch. 1.

5 *L'Immagine di San Francesco*, cat. 112, 176–8.

6 See most recently Lavin, 2006, 27–33, 44; see also *L'Immagine di San Francesco*, cat. 94, 171, and cat. 111, 175.

7 For the paintings in San Francesco, see Franco Paliaga and Stefano Renzoni, *Le chiese di Pisa* (Pisa, 1991), 35–43. For Vanni's altarpiece and questions concerning its date, see *L'Immagine di San Francesco*, cat. 68, 88, and Cristiana Garofalo, "Francesco Vanni," in Massari and Cellini, 2005, 355.

8 Tiberio d'Assisi had produced a fresco cycle of the Perdono for the Franciscan chapel of the Terziari in San Fortunato, Montefalco (1512) that places the vision itself over the altar (not, of course, the church's high altar). See Lavin, 2006, 13 and figs 11–12, with further references.

9 See e.g. Francesco Providoni's *Holy Trinity with the Madonna, Saint Gregory the Great and the Souls in Purgatory*, discussed by Fiorella Pansecchi, cat. 103, *Pittura del Seicento: Ricerche in Umbria* (Venice, 1989), 331–3.

10 Bernardino da Colpetrazzo, O.F.M. Cap., *Historia fratrum minorum capuccinorum (1525–1593)*, published in *Monumenta Historia Ordinis Minorum Capuccinorum*, vols. I–II (Assisi, 1939–40), and vol. IV (Rome, 1941); vol. II, 509–10: "Di poi se n'è venuta in tanta cognitione ogni persona che questo sia il vero habito di San Francesco che insino ai moderni depintori depingono hora li Santi del Ordine col capuc-

cio aguzzo, perché vedono che in tutte le chiese antiche si vede depinto San Francesco et altri Santi del Ordine con l'istessa forma del habito . . ." For more on the Capuchins, see Intro. and Ch. 1. For Capuchin polemics concerning the authentic habit and their impact on late sixteenth-century painting, see Lingo, 1998, esp. Ch. 2.

11 For further discussion of this phenomenon and its implications, see Ch. 8. Murillo later used a similar device in his great *Perdono* but there the composition again returns to an angled narration, with Francis at the left, much as in Barocci's early drawing for the Urbino painting. Such a choice further emphasizes the distinctiveness of Barocci's ultimate decisions (for a color plate of the Murillo, see Lavin, 2006, fig. 13).

12 Titian's standard is rarely discussed at much length. For an introduction, see Raffaella Pozzi, "Stendardo processionale," in *Ancona e le Marche per Tiziano 1490–1990* (Ancona, 1990), 121–5, and most recently, Paolo dal Poggetto, *La Galleria Nazionale delle Marche e le altre collezioni nel Palazzo Ducale di Urbino* (Urbino and Rome, 2003), 194–6. For Barocci's membership in the confraternity of Corpus Domini, see Bramante Ligi, *Memorie ecclesiastiche d'Urbino* (Urbino, 1938), 326, and Luigi Moranti, *La confraternità del Corpus Domini di Urbino* (Ancona, 1990), 35. A number of authors, including Emiliani, 1985, vol. I, 107 note the relation of Barocci's final figure to Titian's model. Emiliani also notes the connection between Barocci's drawing and the figure of Christ in Raphael's *Transfiguration*.

13 Borghini, 1967, vol. I, 569.

14 For the reliquary, see Elisabeth Taburet-Delahaye, cat. 101 in *Enamels of Limoges 1100–1350*, ed. John P. O'Neill (New York, 1996), 306–10; the image is identified as "one of the earliest representations of the Saint" along with a similar work now in the Musée de Cluny. For the cross, see Marie-Madeleine Gauthier, "L'art de l'émail champlevé en Italie à l'époque primitive du gothique," in *Il Gotico a Pistoia nei suoi rapporti con l'arte gotica italiana* (Rome, 1972), 271–93.

15 The *Stigmatization* is found in the left lancet of the first window to the viewer's right on entering the Basilica. See Egidio Giusto, O.F.M., *Le vetrate di San Francesco in Assisi: studio storico-iconografico* (Milan, 1911), esp. 216–19.

16 See e.g. Elisabetta Cioni, *Il Sigillo a Siena nel medioevo* (Siena, 1989) cat. 45. This seal, now in Siena's Museo Civico, came from the convent of the Osservanza, where it was conserved with a *memoria* stating that it had

belonged to San Bernardino at the period he served as Vicar General of the Observants (1438–42). For discussion of the Ghent seal (particularly its unusual figuration of the *Stigmatization* as a dream vision, a feature of some early Stigmata imagery), see Chiara Frugoni, *Francesco e l'invenzione delle stimmate. Una storia per parole e immagini fino a Bonaventura e Giotto* (Turin, 1993), 163.

17 Paolo Pino, *Dialogo di pittura* (Venice, 1548), in *Trattati d'arte del cinquecento,* ed. Paola Barocchi, 3 vols. (Bari, 1960–62), vol. I, 115: "et in tutte l'opere vostre fateli intervenire almeno una figura tutta sforciata, misteriosa e difficile, acciò che per quella voi siate notato valente da chi intende la perfezzion dell'arte." See Cole, 2001, for a useful discussion of issues raised by this figure type in the late sixteenth century.

18 For the decree of the Council, see Tanner, vol. II, 774–6. Federico Borromeo, *Della Pittura Sacra, libri due*, ed. Barbara Agosti (Pisa, 1994), includes chapters entitled "Dei corpi atletici" or "Delle figure lascive."

19 Carole Evelyn Voelker, *Charles Borromeo's "Instructiones Fabricae et Supellectilis Ecclesiasticae," 1577: A Translation with Commentary and Analysis* (Ann Arbor, Mich., 1977), 229.

20 See Steven Ostrow, *Art and Spirituality in Counter-Reformation Rome: The Sistine and Pauline Chapels in S. Maria Maggiore* (Cambridge and New York, 1996), 11, for a brief discussion.

21 For further discussion of the issue of the nude infant or putto, see Ch. 7.

22 For discussion of Cesi, see Alberto Graziani (with essays by Francesco Abbate and Mario di Giampaolo), *Bartolomeo Cesi* (Milan, 1988).

23 Gaspare Celio, *Memoria delli nomi dell'artefici delle pitture che sono in alcune chiese, facciate, e palazzi di Roma* (Naples, 1638) ed. Emma Zocca (Milan, 1967), 15: "La pittura dell'altare maggiore ad'olio, con il Santo, che riceve le stimate, e Sisto Quinto, del Cavalier Gaspare Celio." See further Olga Melasecchi, "Gaspare Celio, *San Francesco che riceve le stimmate tra Sisto V e un compagno*," in *Roma di Sisto V*, ed. Anna Maria Affanni, Mario Bevilacqua, and Maria Luisa Madonna (Rome, 1993), cat. 11a, 163. Melasecchi points out that what may be Celio's first payment, in 1591, refers only to a "giovane pittore." Celio was just 20 then, so the altarpiece may be one of his first fully independent paintings. One wonders if the Franciscan Pope Sixtus v himself insisted on the unusual creation of a "stigmatization from above," with a figure of Saint Francis who not only occupies the center of the image but is presented frontally, with little torsion.

24 Charles Hope, "Altarpieces and the Requirements of Patrons," in *Christianity and the Renaissance: Image and Religious Imagination in the Quattrocento*, ed. Timothy Verdon and John Henderson (Syracuse, 1990), 535–72.

25 See the contracts cited in ibid., 565 nn. 8 and 11, 566 n. 13, and 567 n. 19, which contain stipulations that the preeminent figure should be "nel mezzo di detta tavola," or "in cuius tabule medio."

26 Ibid., 554: "quando vado a dir messa al altar de la capella di miser Broccardo et che digo Memento et che vedo la immagine de esso miser Broccardo, e me contamino tuto perché el se fa reverentia a essa figura et non alla immagine de la Madona: et quando el Vescovo fo qua, fece ben ogni cosa, salvo che questa chel doveva far meter da parte dicta immagine de esso miser Broccardo et non far chel stesse in mezzo de la palla, et chi la rasasse zò o imbrattasse, faria par ben." I have slightly adapted Hope's translation; where he employed "I feel thoroughly contaminated" I have maintained the literal "I am thoroughly contaminated."

27 For discussion of the print, see Pillsbury and Richards, 1978, 102. Barocci painstakingly corrected for the image reversal that characterizes prints when he engraved the plate for the print after the *Perdono*. It is notable that Barocci's actual altarpieces of the *Stigmatization* (Fossombrone, 1570s, Emiliani, 1985, vol. I, 120–21; and Urbino, c. 1594–5, ibid., vol. II, 296–301; see fig. 8 here) place the seraph in the center but move Francis off slightly toward the viewer's right. Barocci's evident penchant for a left-to-right narrative arrangement in his painted *Stigmatizations* further points up the distinctiveness and deliberateness of the compositions of the etched *Stigmatization* and the *Perdono*. For drawings in which Barocci analyzed the difficult pose of the Francis of the *Perdono*, see ibid, vol. I, p. 110, figs 192–4 (Uffizi 11441 F, 11406 F, and Dresden, Staatliche Kunstsammlungen, inv. C 216).

28 For a discussion of the representation of the Porziuncola here as a Doric or Tuscan structure, see the concluding section of Ch. 7.

29 For Colonna's comments, see Ch. 1, n. 9.

30 See the opening of Ch. 5 for the full passage and discussion. Shearman, 1976, 50, remarked on the "dry, almost brushless textures" of the *Perdono* and offered important observations concerning Barocci's technical flexibility. Jeffrey Fontana, 1998, 166, 252–3 has noted the impact of Titian's late style on the figure of Christ in the Bonarelli painting.

31 Daniele Barbaro, *I Dieci libri dell'architettura tradotii e commentati da Daniele Barbaro* (Venice,

1556), bk 7, ch. 5, 188, quoted in Alexander Nagel, "Leonardo and *sfumato*," *RES* 24 (Autumn 1993): 17. Nagel's article offers several important observations and insights concerning Leonardo's practice and its implications (including the ways in which Venetian bravura brushwork, apparently the opposite of *sfumato*, may be read as an unexpected consequence of possibilities Leonardo's technique made available).

32 See Joseph Koerner, *The Moment of Self-Portraiture in German Renaissance Art* (Chicago and London, 1993), 80–126, esp. 99–107.

33 Andrea Lazzari, *Memorie di alcuni celebri pittori d'Urbino* (Urbino, 1800), 10. While such a decision would make the surface smoother than the surrounding canvas, Lavin, 2006, 45 n. 12, with further references, notes that Barocci did this on more than one occasion.

34 Alessandro Zuccari has written extensively on the Oratorian study of image traditions and its import for some of their own commissions; see his "Immagini e sermoni dell'Oratorio nei dipinti della Chiesa Nuova," in *La Congregazione dell'Oratorio di San Filippo Neri nelle Marche del '600*, ed. Flavia Emanuelli (Fiesole, 1996), 171–97, and Ch. 1, n. 4 for references.

35 Letters concerning the commission are transcribed in Gronau, 1936, 156–7, and indicate the spread of Barocci's *fama* beyond the confines of the Marche and Tuscany by the early 1580s. The Oratorian project to employ the best painters in Italy created a kind of sacred gallery that was a holy version of the princely galleries of the d'Este, the Medici, and other noble families. The Duke of Urbino's minister in Rome, Baldo Falcucci, alluded to this specifically when he wrote: "La Congregatione dei preti di pozzobianco luogo di molta nobiltà et divotione hanno molti quadri et di bonissima mano nella lor fabrica nuova, ne vorebbono anco uno di ms. Federigo Barozzi. . . . et non può riportar' se non honore che si veda un'opera sua tra tante altre et tutte di huomini principalissimi." In these very years the Grand Duke of Tuscany had come to desire a painting by Barocci for precisely the same reasons: having "quadri di tutti i più famosi pittori che sono stati moderni, cosi desiderava grandemente haver qualcosa di esso Federico" (letter from Simone Fortuna to the Duke of Urbino, transcribed in ibid., 153–4).

36 A drawing in Würtzburg (Emiliani, 1985, vol. I, 132, fig. 226) shows Barocci experimenting with subtle variations in profile views for the face of the praying noblewoman at the extreme left of the *Madonna del Popolo*. Here too the figure in the painting resembles an updated

version of a Quattrocento portrait and indicates that Barocci was reflecting on the profile in the years before he received the commission for the Roman altarpiece. The one type of representation in which the strict profile remained fairly common during the late sixteenth century was the donor portrait in altarpieces – and here the images of donors often appear somewhat archaic next to the other figures in the images. A major example of this phenomenon in Barocci's early work occurs in the *Madonna of San Simone* (see fig. 177). For further discussion of the *Visitation*, see Ch. 7.

4 Legacy of the Renaissance

1 Franklin, 2001, expresses well the increasing discomfort with the historiography of the High Renaissance and of Mannerism. For further discussion, and particular stress on Cinquecento art and the desiring beholder, see Cropper, 1995, 159–205, and Cropper's introduction to Craig Hugh Smyth, *Mannerism and Maniera* (2nd ed., Vienna, 1992), 12–21. For further discussion of perceptions of crisis in religious painting and issues raised by the increasing artistic investment in the lovely body, see Chs 5 and 6.

2 For discussion of aspects of Barocci's color and their sources, see Ch. 8.

3 Nagel, 2000.

4 For the history of the commission, see Emiliani, 1985, vol. I, 150–67, and the detailed reconstruction of events, with documents, by Emilio Vecchioni, "La 'Chiesa della Croce e Sagramento' in Sinigaglia e la 'Deposizione' di Federico Barocci," *Rassegna marchigiana* V (1926–7): 497–503. For further discussion of the *Madonna del Popolo* and Barocci's relations with the Fraternità dei Laici in Arezzo, see Ch. 2. Barocci had agreed to 400 scudi for the *Madonna del Popolo*, which was larger than the Senigallia painting and involved more figures (see Pillsbury and Richards, 26, for the relevant passages in the contract).

5 See Humfrey, 1996, with further references. See also Stefania Mason Rinaldi, "Un percorso nella religiosità veneziana del Cinquecento attraverso le immagini eucaristiche," in *La chiesa di Venezia tra riforma protestante e riforma cattolica*, ed. Giuseppe Gullino (Venice, 1990), 183–94.

6 Vecchioni, 1926–7, 499.

7 For the Perugian years, see Bombe, 1909. In Barocci's funeral oration, Vittorio Venturelli asserted that the painter had visited "le più chiare città d'Italia" in his youth; see Ch. I, n. 26.

8 For the *gonfaloni*, see Ch. 2. The fact that the chapel is dedicated to San Bernardino, but Barocci's altarpiece depicts the *Deposition* with San Bernardino as witness, exemplifies the phenomenon noted above (increasingly frequent in the second half of the century) in which Christological themes could take precedence over representations of an altar's titular saint. See Humfrey, 1996, for discussion.

9 See Thomas Greene, *The Light in Troy: Imitation and Discovery in Renaissance Poetry* (New Haven, 1982), for Renaissance *imitatio*.

10 The inventory of Barocci's studio made after his death indicates that he owned numerous drawings after Raphael and states that he actually possessed a number of Raphael's drawings; see *Studi e notizie su Federico Barocci*, ed. Brigata Urbinate degli Amici dei Monumenti (Florence, 1913).

11 The fundamental discussion of these issues in relation to Raphael's panel is Nagel, 2000, esp. 113–40. See also Locher, 1994. Both Nagel and Locher discuss the ideation of Raphael's work at length.

12 Nagel, 2000, esp. 25–112. I am aware that there are still art historians who contest the attribution of this work to Michelangelo. This is not the place to attempt to resolve the debate, particularly as it is not directly relevant to my arguments – the work tends to be dated to the 1520s or slightly later by those contesting the attribution and often given to Bandinelli, so in any case it predates Barocci. I would say, however, that the arguments against Michelangelo's authorship tend to be stylistic – the panel doesn't seem "good" enough – and give little consideration to the work's conceptual invention. It is clear that Barocci's principal response was to Raphael in Perugia and it is not certain that he would have seen the Michelangelo, though it seems to have been in Rome in the Farnese collection at least by the mid-seventeenth century: see Michael Hirst, "The *Entombment*," in Michael Hirst and Jill Dunkerton, *Making and Meaning: The Young Michelangelo* (London, 1994), 60 and 80 nn. 24–7. I treat it here as an example (with the Pontormo from the Capponi chapel, which Barocci probably did see) of sixteenth-century attempts to confront the challenge of a narrative altarpiece of the Passion, indicative of cultural concerns and experiments that laid the groundwork for Barocci's own essay.

13 For discussion of similar narrative strategies, see Ch. 3.

14 Nagel, 2000, 55–82, which also discusses the relation of Michelangelo's composition to images of the Man of Sorrows and Lorenzo Monaco's *Arma Christi* (fig. 94).

15 For a discussion of these images, see Shearman, 1992, 33–6.

16 See Nagel, 2000, 136–7, for the reception of Raphael's altarpiece and its final removal from the church.

17 For documentation of Barocci's first trip to Florence, see Jeffrey Fontana, "Evidence for an Early Florentine Trip by Federico Barocci," *The Burlington Magazine* 139 (July 1997): 471–5. For the visit during 1579, see Bellori, 1976, 188 (see further Lingo, 2007). For the intended placement of Michelangelo's painting, see Alexander Nagel, "Michelangelo's London *Entombment* and the Church of Sant' Agostino in Rome," *The Burlington Magazine* 126 (1994): 164–7. Pontormo's altarpiece is briefly discussed in relation to the innovations of Michelangelo and Raphael in Nagel, 2000, 139–40.

18 John Shearman, *Pontormo's Altarpiece in Santa Felicità* (Newcastle-upon-Tyne, 1971), and 1992, 87–94, maintained that Christ's body is being lowered forward and down toward the actual altar. Leo Steinberg, "Pontormo's Capponi Chapel," *Art Bulletin* 56 (1974): 385–99, however, interpreted the bearers as angels who will lift the body of Christ toward the figure of God the Father that was originally depicted in the cupola of the chapel. The liturgical associations of the altar with the tomb of Christ seem to argue in favor of the first reading. This compelling visual association of action in an altarpiece and the altar/tomb was pursued and developed later in Guercino's *Burial of Saint Petronilla* for Saint Peter's, Rome: see Leo Steinberg, "Guercino's *Saint Petronilla*," in *Studies in Italian Art and Architecture, 15th through 18th centuries: Memoirs of the American Academy in Rome, 25*, ed. Henry Millon (Rome, 1980), 207–42.

19 The relation of Lotto's painting to that of Raphael is the subject of some debate; see Peter Humfrey, *Lorenzo Lotto* (New Haven and London, 1997), 33–4. Lotto is rarely considered in discussions of Barocci but Fontana, 1999, 171–5, argues persuasively for the impact of some Lottos in the Marches which Barocci could have seen in the 1560s or even earlier.

20 For Raphael's graphic study of Michelangelo see most recently Francis Ames-Lewis, "Raphael's Responsiveness to Michelangelo's Draftsmanship," in *Reactions to the Master: Michelangelo's Effect on Art and Artists in the Sixteenth Century*, ed. Francis Ames-Lewis and Paul Joannides (Aldershot and Burlington, 2003), 12–30.

21 See Joseph Connors, "Borromini, Hagia Sophia and San Vitale," in *Architectural Studies in Memory of Richard Krautheimer*, ed. Cecil L.

Striker (Mainz, 1996), 47. Connors notes Barocci's search for a strong connection with viewers: "It was an unusually site-specific painting, and it got more so as the artist proceeded from sketches to the final work. The saint is shown flung upside down, hovering for a split second in mid-air before plummeting into the well, the same one that stood behind the altar. . . . The pilgrim's march through the church and arrival at the altar, where he could see the saint being martyred before his eyes and drink from the very well, must have been a vivid experience indeed." I thank Prof. Connors for calling my attention to this article.

22 Victor Stoichita, *Visionary Experience in the Golden Age of Spanish Art*, trans. Anne-Marie Glasheen (London, 1995), 110–11, offers an evocative reading of El Greco's *Vision of Saint John on Patmos* (Toledo) that stresses the introductory function, given "the perceptual habits of all Western spectators," of a figure (or object) at the lower left margin of an image. For Michelangelo's figure (in the position of the one-who-presents), with the objects of the Passion in a drawing in the Louvre, see Nagel, 2000, 31.

23 A related natural cross appears in the sand directly beneath the kneeling Saint Andrew in the *Calling of Saint Andrew* (see fig. 167) and in the stream in Cornelis Cort's engraving after one version of Barocci's *Rest on the Return from Egypt* (see fig. 180). See Ch. 7 and the Conclusion for further discussion of Barocci's employment of still life and the depiction of objects to intensify his sacred *istorie*. In many cases, Barocci's recurrent strategy utilized apparently casual or coincidental groupings of objects to lead the attentive viewer into contemplation of the *misterio* in all holy *istorie*.

24 Vecchioni, 499–500 (letter of Barocci to the confraternity, January 9, 1582): "Non voglio ancho restare raccomandarle di accomodare di darle [the altarpiece] il lume al proposito come de già altre volte si è ragionato, perchè come le pitture non hanno il suo lume non mostrano mai quello che sono."

25 Gabriele Paleotti, *Discorso intorno alle imagini sacre e profane*, in *Trattati d'arte del cinquecento*, ed. Paola Barocchi, 3 vols. (Bari, 1960–62), vol. II, 414: "Ci sono che dipingono il Salvatore nostro in croce con quattro chiodi, altri con tre solamente, e noi in questa diocese di Bologna ne abbiamo veduto ne l'uno e l'altro modo, se bene è più frequente quello delli tre chiodi."

26 See most recently Eva-Bettina Krems, *Raffaels römische Altarbilder: Kontext, Ikonographie, Erzähl-*

konzept. Die Madonna del Pesce und Lo Spasimo di Sicilia (Munich, 2002); see also Christa Gardner von Teuffel, "Lo Spasimo di Sicilia," in *Raffaello in Vaticano*, ed. Fabrizio Mancinelli (Milan, 1984), 272–7.

27 See Bettina-Krems, 2002, esp. 201–25, Nagel 2000, esp. 36–43, and Harvey Hamburgh, "The Problem of Lo Spasimo of the Virgin in Cinquecento Paintings of the Descent from the Cross," *Sixteenth Century Journal* 12 (1981): 45–75.

28 See Emiliani, 1985, vol. II, 388–94, for the commission and references, and more generally Sangiorgi, 1982. The initial efforts of the Chapter in 1592 are documented in the *Annali della fabbrica del Duomo di Milano* (Milan, 1877–85), vol. V, 273; for Barocci as *pictor pulcherrimus* and the attempt to persuade him to paint a Nativity in 1597 see vol. IV, 317; for the initial documents of the 1600 commission, see vol. IV, 337–8. The description of the painting (337) reads: "il Sign. Tolto di croce con la Madonna e Marie e S. Michele acanto e un vescovo." The wording is ambiguous enough that it might describe a *Deposition* or a *Lamentation*; as far as I know, however, none of Barocci's surviving drawings associated with the project depict a *Deposition*.

29 Bert Meijer, ed., *Italian Drawings from the Rijksmuseum Amsterdam* (Florence, 1995), 110–11, notes the translation of the relics of San Giovanni del Buono and the former dedication of the chapel (noted also by Olsen, 1962, 218).

30 For the two letters, see Sangiorgi 1982, 31–2 and 36. The passage concerning the cartoon reads: "Quanto ai quadri da hora inanzi potrò cominciare a darvi buone nuove poi ché il signor Baroccio ha quasi stabilito il cartone, che se piacerà a Dio che si possi condurre a fine quest'opera credo che Milano ne resterà satisfacto, essendo insomma cosa stupenda."

31 Emiliani, 1985, vol. II, 392, and *Annali della fabbrica*, vol. V, 56.

32 For the complex history of the canvas during the last years of Barocci's life and the remainder of the seventeenth century, see Emiliani, 1985, vol. II. 392–4, and Olsen, 1962, 218, which presents a good summary of the negotiations with Mazzi.

33 For the immediate critical fortune of the painting, the engraving by Thomassin, and Bellori's anecdote (Bellori, 1976, 189) see Emiliani, 1985, vol. I, 158. Bellori wrote: "quest'opera per la sua bellezza, mentre veniva copiata continuamente, ebbe quasi a perdersi per la temerità di uno che nel lucidarla penetrò il colore e li dintorni e la guastò tutta." For Barocci's letter, and a fine discus-

sion of the phenomenon of tracing paintings and its many abuses, see Linda Freeman Bauer, "A Letter by Barocci and the Tracing of Finished Paintings," *The Burlington Magazine* 128 (May 1996): 355–7. I have used Bauer's translation of Barocci's opening sentences: "Ho preso gran' fastidio a sieme co' voi altri sig.ri del quadro, ch' è stato lucidato, e lavato, et non ho manchato informarmi minutamente dal mio Giovane, oltre l' littera d' V. Sig.ri, e per quanto me a detto credo sua dificil' usa conciarlo . . ." The letter is dated January 23, 1588; nearly two decades elapsed before Barocci finally executed the restoration.

34 Noted by Emiliani, 1985, vol. I, 159. For discussion see Vecchioni, 1926–7. The report stresses: "la nostra cona viene talmente danneficata dall'orina dei sorci che hormai è talmente deteriorata che se non vi si dà presto rimedio restaremo con grandissimo pregiudi-tio e danno."

35 See Catherine Puglisi, *Caravaggio* (London, 1998), 24–5, for illustration and brief discussion of Peterzano's altarpiece.

36 See Isa Ragusa and Rosalie B. Green, eds., *Meditations on the Life of Christ* (Princeton, 1961), 342–5. Nagel, 2000, 71, notes the impact of such devotional literature.

37 For discussion of the legacy of Mantegna's invention and the decorum of the foreshortened figure in religious painting see Stuart Lingo, "Putting Death into Perspective," in preparation.

38 Olsen, 1962, 218, citing Edoardo Arslan, *Le pitture del Duomo di Milano* (Milan, 1960), 35 n. 81. See Meijer, 1995, 110–11, for a discussion of the Amsterdam drawing, which is sometimes identified as the cartoon but is much smaller than the painting (105 × 77 cm). The statement from Barocci is recorded in the *Annali della fabrica*, vol. V, 56: "ho fatto il cartone, e mezzo abozato l'opera, et tutte l'altre fatiche da me solite farsi, ho compite, resta solo che vi rimette le mane."

39 For the *Assumption*, see Emiliani, 1985, vol. II, 400–09. Emiliani stresses the positive responses of early viewers of the work. The Capuchin Fra Francesco Maria, for instance, wrote cardinal Federico Borromeo on September 9, 1628 that he had seen an "Assontione" at the home of Barocci's nephew and that even with the crowding necessitated by the number of figures one could read the composition and the forms of the individual actors with surprising ease: "con tutti li dodici Apostoli il quale è fatto con tanto studio che tutti si vedano et uno non impedisce l'altro." In the same letter he described the unfinished painting for Milan Cathedral as "miracolosissima"

and a large drawing for it as an object "che vale ogni tesoro"; see Sangiorgi, 1982, 61–2; also Emiliani, 1985, vol. II, 401, for several texts and their sources. The assessment by Francesco Maria II is found in Fert Sangiorgi, ed., *Diario di Francesco Maria II della Rovere* (Urbino, 1989), 186: "Morì Federico Barocci da Urbino, pittore eccellente, d'anni 77, nella quale età l'occhio e la mano il servivano come facevano quando era giovane" (entry for October 1, 1612, f. 83r). Sangiorgi, 1982, 57–8, n. 1, argues that the "77" in the Duke's hand should be read as "79" but in the 1989 transcription he reverts to "77." See Intro n. 1 for discussion of Barocci's birth date.

5 What's in a Word?

1 Baglione, 1995, 134: "e quando si vide maniera sì bella sfumata, dolce, e vaga, diede sì gran gusto a tutti li professori, che restarono ammirati, e ciò sucese nel tempo di S. Filippo Neri, il quale dell'Imagine di quel quadro era tanto divoto per la devotione, che anch'esso in se contiene, che quasi del continuo egli stava in quella cappella a far le sue orationi." The young Baglione had participated in the decoration of the Vatican Library in the pontificate of Sixtus V in the 1580s, so had been active in Rome from the very decade in which Barocci's altarpiece arrived. For a recent study, see Maryvelma Smith O'Neil, *Giovanni Baglione: Artistic Reputation in Baroque Rome* (Cambridge and New York, 2002).

2 See Victor Stoichita, *The Self-Aware Image: An Insight into Early Modern Meta-Painting*, trans. Anne-Marie Glasheen (Cambridge and New York, 1997), 67–76; esp. 70–76; see Ch. 1, "Enshrining the Archaic," for further discussion of this and similar Oratorian projects. The wording also evokes a loose analogy with the distinction between *istoria* and *misterio* evident in Barocci's correspondence with the Rectors of the Fraternità dei Laici in Arezzo (see Ch. 2). For the *Visitation* see Ch. 3.

3 Baglione, 1995, 134: "E dì vero egli nelle sue virtuose fatiche era vago, e divoto: e come nell'una parte gli occhi dilettava, così con l'altra componeva gli animi; & i cuori a divotione riduceva." The initial assessment is found on 133: "Nondimeno [in spite of his chronic illness] Federico Barocci fu de' primi del suo tempo, & hebbe maniera vaga . . ."

4 For Dempsey's revaluation of early modern art literature as an aid in viewing period painting, see Dempsey, 2000, with further bibliography. For recent studies and revaluations of the importance of the art theory and criticism of

the sixteenth and seventeenth centuries, see e.g. Sohm, 2001, and Williams, 1997.

5 Sohm, 2001, 195. Sohm offered an initial, important examination of *vaghezza* in relation to a cluster of terms in 1995. He returned to the issue in 2001, esp. 110–12, 193–200.

6 Firenzuola, 1548, cited by Sohm, 2001, 110. Firenzuola's importance here is noted repeatedly by Sohm; Elizabeth Cropper had earlier highlighted the issue in "On Beautiful Women, Parmigianino, *Petrarchismo* and the Vernacular Style," *Art Bulletin* 58 (1976): 374–94, re-elaborated in her "The Beauty of Woman: Problems in the Rhetoric of Renaissance Portraiture," in *Rewriting the Renaissance: The Discourses of Sexual Difference in Early Modern Europe*, ed. M. Ferguson et al. (Chicago, 1986), 175–90.

7 Bembo's letter is transcribed in Giovanni Gaye, *Carteggio inedito d'artisti dei secoli XIV, XV, XVI* (Florence, 1840), 2 vols. (facsimile ed. Turin, 1961), vol. II, 71: "La invenzione, che mi scrive V. S. che io truovi al disegno, bisognerà che l'accomodi alla fantasia di lui chel ha a fare, il quale ha piacere che molto signati termini non si diano al suo stile, uso, come dice, di sempre vagare a sua voglia nella pitture." The passage from Paleotti, 1960–62, 440, is noted in Sohm, 2001, 278 n. 63; the relevant phrase is "andare vagando a capriccio." Sohm also notes Bembo's letter.

8 Agnolo Firenzuola, *Opere*, ed. Adriano Seroni (Florence, 1958), 563–4; for the English I have used Agnolo Firenzuola, *On the Beauty of Women*, trans. and ed. Konrad Eisenbichler and Jacqueline Murray (Philadelphia, 1992), 36–7. I quote the Italian of the final passage in full: "ha ottenuto l'uso del comun parlare che vago significhi bello, e vaghezza bellezza; ma in questo modo particulare non di meno, che vaghezza significhi quella bellezza che ha in sé tutte quelle parti, per le quali chiunque la mira, forza gli è che ne divenga vago, cioè disideroso; e divenutone disideroso, per cercarla e per fruirla, stia sempre in moto col core, in viaggio co' pensieri; e con la mente divien vagabondo."

9 Firenzuola, 1958, 561–9 for the various qualities; 565 for *venustà*; 564 for *vaghezza*: "e però diciamo: 'La tale è vaghetta,' quando parliamo d'una che ha un certo lascivetto, e un certo ghiotto, con la onestà mescolato, e con un certo attrativo, come ha la Fiamminghetta." At the end of the dialogue, the alluring, assertive Selvaggia – "più tosto un poco baldanzosetta che no" (533) – is said to have "una vaghezza ghiotta" (596).

10 Gian Paolo Lomazzo, *Trattato dell'arte della pittura* (Milan, 1584), in his *Scritti sulle arti*, ed.

Roberto Paolo Ciardi, 2 vols. (Florence, 1973–4), vol. II, 129 (noted in another context in Sohm, 2001, 110). Here is the passage in its larger context: "La vaghezza, ch'altro non è che un desiderio et una brama di cosa che diletta, fa gl'atti ammirativi, stupidi e contemplanti le cose che si veggono, come d'un vano che stia pavoneggiando se stesso con mille balzi, inchini, movimenti e grilli; o d'un altro che vagheggi la sua inamorata, stando in mille modi et atti a rimirare e contemplare tutte le sue parti, sin che i vicini accorgendosene se ne ridano; o generalmente di qualonque altra persona che, secondo il gusto che prende d'alcuna cosa che fa, dimena la testa, come suol un pittore quando considera e vagheggia una sua pittura." Lomazzo treats *vaghezza* in a series of chapters on the various *moti* – both "motions" (of the soul as well as the body) and qualities – of figures. *Vaghezza* heads a chapter in which it is grouped with "grazia, venustà, leggiadria, gentilezza, cortesia, lusinghe, blandizie, adulazione, amorevolezza, abbracciamento, bascio, lascivia, disonestà, festa, pompa, canto, ballo, gioco, allegrezza, tranquillità, diletto, solazzo e dolcezza": quite a cluster, extending well beyond that of Firenzuola, but a fair indication of the range of associations, at once compelling and ambivalent, that the term evoked by the 1580s.

11 *Vocabolario degli Accademici della Crusca* (Florence, 1612), s.v. *Vagare*: "andare errando, trascorrere." The Latin synonyms are identified as *vagari* and *oberrare*.

12 *Vocabolario*, 1612, s.v. *Vagheggiare*: "da Vago, per amante, fare all'amore, cioè stare a rimirar fisamente con diletto, e attenzione l'amata." The Latin analogue given is, strikingly, not a word but a phrase: "*intentè amasiam inspicere*." The quotation from Boccaccio reads: "Avea lungo tempo amata, e vagheggiata la moglie de M. Francesco." The story (the fifth of the third day) ends with the consummation of desire: Giovanni Boccaccio, *Il Decameron*, ed. Charles S. Singleton, 2 vols. (Bari, 1955), vol. I, 211–16). During the seventeenth century the dictionary's definition was elaborated, with added emphasis on the sensual qualities already evidently inherent in the 1612 *Vocabolario*. In the third edition (1691) a telling sentence was added as clarification: "Vagheggiare è, con disiderio d'avere, la cosa amata ragguardare." Sohm, 2001, 195, notes that Filippo Baldinucci, *Vocabolario toscano dell'arte del disegno* (Florence, 1681), restricted his definition to these qualities and entirely omitted the aspect of wandering. Sohm sees this as "oddly restrictive" and stresses (110) that the Crusca maintained both aspects of *vaghezza*. This is certainly

correct but it seems also true that the weight had already been given to the word's implications of desire and delight in 1612 – indeed, already in Firenzuola.

13 *Vocabolario*, s.v. *Vaghezza*: "Disiderio, voglia. Latin *voluntas, cupiditas*. Per diletto. Latin *voluptas, delectatio*. Per bellezza atta a farsi vagheggiare. Latin *elegantia, pulchritudo*." The 1691 edition again adds a clarifying sentence: "La definisce così, è adunque vaghezza una beltà attrativa inducente di sé desiderio di contemplarla, e di fruirla." It is telling that this is a passage from Firenzuola (see 1958, 564), as the editors note. While the Latin synonyms given for "bellezza atta a farsi vagheggiare" seem the least charged, the Boccaccio passage that illustrates the definition – "quanto la vostra vaghezza possa ne' cuor gentili" – illuminates the frequently close connection of *vaghezza* with corporeal beauty, especially that of women: see Boccaccio, 1955, vol. I, 395–400, for the story.

14 *Vocabolario*, s.v. *Vago*: "Che vagheggia, amante, lo'nnamorato. Latin *amasius*; Che vaga, errante. Latin *vagus*; Per bramoso, desideroso, cúpido. Latin *cupidus, avidus*; Per quello, che si compiace, si diletta; Per grazioso, leggiadro." For "grazia," s.v. *Grazia*: "Bellezza di che che sia, e avvenentezza d'operare, che alletta, e rapisce altrui ad amore." See also Patricia Emison, "Grazia," *Renaissance Studies* 5, no. 4 (1991): 425–60. For *leggiadria*, see Sharon Fermor, "Poetry in Motion: Beauty in Movement and the Renaissance Concept of *leggiadria*," in *Concepts of Beauty in Renaissance Art*, ed. Francis Ames-Lewis (Aldershot and Burlington, Vt., 1998), 124–33. In the context of the Crusca's definitions of *vago* and *vaghezza*, it is notable that Petrarch, in the *Canzoniere*, had employed *vaghezza* in relation to desire, while *vago* could connote loveliness/desirability on the one hand and "wandering" on the other; see Kenneth MacKenzie, *Concordanza delle Rime di Francesco Petrarca* (Oxford, 1912), 482–4.

15 Francesco della Torre to Donato Rullo (both friends of Flaminio and Cardinal Pole), printed in *Lettere volgari di diversi nobilissimi huomini, et eccellentissimi ingegni scritte in diverse materie* (Venice, 1551), bk 2, 113r–113v: "Ho ricevutoli versi di Marcantonio, e quando ne habia ricuperati alcuni altri che sono in mano d'uno amico mio, io vi manderò anchor quelli, che vi satisferan molto piu à mio giudicio, perche son tanto piu vaghi et piu venusti, quanto che trattano di materie piu capaci di vaghezza che per la verità queste materie della religione à trattarle vagamete si fanno spesso di sante prophane: e credo che sia difficil cosa à farlo bene, e con dignità.

Queste altre materie sono pastorali, et amorose . . ." Nagel, 2000, 189 and 277 n. 6, quotes and discusses this letter in the context of period experiments in poetry that attempted to adapt the form and language of lyric love poetry to religious subject matter, citing Amedeo Quondam, *Il naso di Laura: lingua e poesia lirica nella tradizione del classicismo* (Ferrara, 1991), for more general discussion.

16 Ibid., 191 and 278 n. 10, "Vorressimo anche ne facesti fare a Sebastianello Venetiano pittore un quadro di pittura a vostro modo, non siano cose di sancti, ma qualche pitture vaghe et belle da vedere." The letter is published in Alessandro Luzio, *La galleria dei Gonzaga venduta all'Inghilterra nel 1627–1628* (Milan, 1974), 28.

17 See Ch. 1, n. 12, for Talpa's letter. The passage reads: "simile a quello della Madonna di Roma che contiene la Madonna col figlio in braccio posta tra nube, circondata da una corona d'Angeletti, e diversi cherobinj, et abasso un coro d'angelij inginocchione, che tutto fa una compositione vaga et insieme devota."

18 *Vocabolario*, s.v *Divoto*: "Che ha divozione. Latin *devotus, humilis, pius*"; s.v. Divozione: "Affetto poi, e pronto fervore verso Dio, e verso le cose sacre, Volontà di far prontamente quello, ch'appartiene al servigio d'Iddio. Latin *devotio, humilitas, pietas*." It could be noted that the *impresa* of Saint Carlo Borromeo bore the motto *humilitas* in Gothic lettering, a possible allusion to the archaic as the humble and devout. For the possibility that *vaghezza* could be latent in the representation of certain "humble" creatures and objects, see Ch. 7.

19 Ibid., s.v. *Vagheggiare*: "Per semplicemente rimirar con diletto. Latin. *Aspicere, contemplari*. Dante *Paradiso* 10. 'E lì comincia a vagheggiar nell'arte di quell maestro.'"

20 Sohm, 2001, 195; the text is Leon Battista Alberti, *La Pittura, tradotto per M. Lodovico Domenichi* (Venice, 1547; facsimile ed. Bologna, 1988). Sohm does not believe Alberti himself employed *vaghezza*.

21 Leon Battista Alberti, *Della Pittura*, in his *Opere volgari*, ed. Cecil Grayson, 3 vols. (Bari, 1973), vol. III, 96: "E di tutte le parti li piacerà non solo renderne similitudine, ma più aggiungervi bellezza, però che nella pittura la vaghezza non meno è grata che richiesta. A Demetrio antiquo pittore, mancò ad acquistare l'ultima lode che fu curioso di fare cose assimigliate al naturale molto più che vaghe. Per questo gioverà pigliare da tutti i belli corpi ciascuna lodata parte. E sempre ad imparare molta vaghezza si contenda con istudio e con industria." I have adapted Grayson's fine English

translation of the Latin text: *On Painting and On Sculpture: The Latin Texts of De Pictura and De Statua*, ed. Cecil Grayson (New York and London, 1972), 99. Alberti's autograph Italian text is by no means a literal transposition of his Latin. This critical passage is noted in a brief and little-cited but useful article on the history of the usage of *vaghezza* in art theory and criticism: Luigi Grassi and Mario Pepe, eds, *Dizionario della critica d'arte*, 2 vols. (Turin, 1978), vol. II, 628–9.

22 Alberti, 1973, 90: painters succeed when "la loro pittura terrà gli occhi e l'animo di chi la miri." The Latin (91) is even more explicit that painting must sway the beholder, adding "*movebit*" to "*tenebit*": "Id quidem assequetur pictor dum eius pictura oculos et animos spectantium tenebit atque movebit." Klaus Krüger, *Das Bild als Schleier des Unsichtbaren: Aesthetische Illusion in der Kunst der frühen Neuzeit in Italien* (Munich, 2001), 176–80, has underscored Alberti's insistence that beauty and *vaghezza*, and the impact these have on the beholder, are fundamental to the power of modern painting and specifically religious painting.

23 Alberti, 1988, 39v.

24 Nino Sernini to Cardinal Gonzaga, letter of November 19, 1541; I have adapted the translation in André Chastel, *A Chronicle of Italian Renaissance Painting*, trans. Linda and Peter Murray (Ithaca, N.Y., 1984), 178–9. See also Bernadine Barnes, *Michelangelo's Last Judgment: The Renaissance Response* (Berkeley, 1998), 78; Nagel, 2000, 189–90; and Melinda Schlitt, "Painting, Criticism, and Michelangelo's *Last Judgment* in the Age of the Counter-Reformation," in *Michelangelo's Last Judgment*, ed. Marcia Hall (Cambridge and New York, 2005), 113–49. The original text is transcribed in Chastel, 1984, 278: "Io non trovo nissuno a cui basti l'animo di ritirare così in furia quello che nuovamente ha dipinto Michelagnolo per essere grande et difficile, essendovi più di cinque cento figure e di sorte che a ritrarne solamente una credo metta pensiero agli dipintori, anchor che l'opera sia di quella bellezza che po pensare V. Ill. S., non manca in ogni modo chi la danna; gli rmi Chietini sono gli primi che dicono non star bene gli inudi in simil luogo che mostrano le cose loro, benchè ancora a questo ha havuto grandissima considerazione, che a pena a dieci di tanto numero si vede dishonestà. . . . Ma il rmo Cornaro che è stato lungamente a vederla ha detto bene, dicendo che se Michelagnolo gli vuol dare in un quadro solamente dipinta una di quelle figure gli la vuol pagare quello ch'esso gli dimanderà, et ha ragione per essere

al creder mio cose che non si possono vedere altrove."

25 Gilio, 1960–62, 80: "Tenga per fermo il pittor che far si diletta le figure de' santi nude, che sempre gli leverà gran parte de la riverenza che se li deve. Però compiacciasi più tosto de l'onestà e del convenevol decoro, che de la vaghezza de l'arte, la quale a pochi dilettarà." Dempsey, 1982, 55–75, has stressed the range and sophistication of Gilio's critiques and their indebtedness to theories of literary decorum.

26 Gilio, 1960–62, 55–6: "perché egli [Michelangelo] più s'è voluto compiacere de l'arte, per mostrar quale e quanta sia, che de la verità del soggetto, et ha fatto come l'innamorato, il quale, per sodisfare a la sua favorita, ogni cosa stima lecita e bella; e ciò penso che da altro proceduto non sia, che, vedendosi innanzi sì largo campo da mostrare, in tanta moltitudine di figure, tutto quello che vagamente può fare un corpo umano per via di sforzi e d'altri posamenti, non ha voluto perdere l'occasione di non lasciare a' posteri memoria del suo mirabile ingegno. E questa è la maraviglia: che nissuna figura, che in questo ritratto vedete, fa quello che fa l'altra, e niuna rassimiglia a l'altra; e per questo fare ha messa da banda la devozione, la riverenza, la verità istorica e l'onore che si deve a questo importantissimo e gran mistero." Gilio here echoes Sernini's encomium (see n. 24) from an opposed perspective; indeed, Sernini concluded his letter by stressing that Michelangelo "put all of his effort into making imaginative figures in diverse attitudes" (see Schlitt, 2005, 121).

27 Vasari, 1966–87, *Testo*, vol. III, 274–5: "E nel vero non poteva e non doveva discender una somma e straordinaria virtù, come fu quella di fra' Giovanni, se non in uomo di santissima vita; perciò che devono coloro che in cose ecclesiastiche e sante s'adoperano, essere ecclesiastici e santi uomini, essendo che si vede, quando cotali cose sono operate da persone che poco credino e poco stimano la religione, che spesso fanno cadere in mente appetiti disonesti e voglie lascive; onde nasce il biasimo dell'opere nel disonesto e la lode ne l'artificio e nella virtù. Ma io non vorrei già che alcuno s'ingannasse interpretando il goffo et inetto, devoto, et il bello e buono, lascivo, come fanno alcuni, i quali vedendo figure o di femina o di giovane un poco più vaghe e più belle et adorne che l'ordinario, la pigliano sùbito e giudicano per lascive, non si avedendo che a gran torto dannano il buon giudizio del pittore, il quale tiene i Santi e Sante, che sono celesti, tanto più belli della natura mortale quanto avanza il cielo la terrena bellezza e l'opere nostre; e che è peggio, scuoprono

l'animo loro infeto e corrotto, cavando male e voglie disoneste di quelle cose, delle quali, se e' fussino amatori dell'onesto come in quel loro zelo sciocco vogliono dimostrare, verrebbe loro disiderio del cielo e di farsi accetti al Creatore di tutte le cose, dal quale perfettissimo et bellissimo nasce ogni perfezzione e bellezza. Che farebbono o è da credere che facciano questi cotali, se dove fussero o sono bellezze vive accompagnate da lascivi costumi, da parole dolcissime, da movimenti pieni di grazia e da occhi che rapiscono i non ben saldi cuori, si ritrovassero o si ritruovano, poi che la sola immagine e quasi ombra del bello cotanto gli commove? Ma non perciò vorrei che alcuni credessero che da me fussero approvate quelle figure che nelle chiese sono dipinte poco meno che nude del tutto, perché in cotali si vede che il pittore non ha avuto quella considerazione che doveva al luogo: perché, quando pure si ha da mostrare quanto altri sappia, si deve fare con le debite circostanze, et aver rispetto alle persone, a'tempi et ai luoghi."

28 Giovanni Previtali, *La fortuna dei primitivi: dal Vasari ai neoclassici* (Turin, 1964), 17–19.

29 Paleotti, 1960–62, 308–9: "Quegli che vogliono difendere simili sorti de imagini profane, siano pitture o statue o medaglie o altre, sogliono coprirsi con vari scusi, e principalmente dire che queste sono cose indifferenti e che il tutto in esse dipende dalla intenzione e dal fine che l'uomo vi ha." The passage is quoted, along with some from writers in agreement with Vasari's attacks, in Previtali, 1964, 18 n. 1.

30 Pino, 1960–62, vol. I, 118: "Come vi piace il pittor vago? Mi piace sommamente e dicovi che la vaghezza è il condimento dell'opere nostre. Non però intendo vaghezza l'azzuro oltramarino da sessanta scudi l'onzia o la bella laca, perch'i colori sono anco belli nelle scatole da sé stessi, né è lodabile il pittor come vago per far a tutte le figure le guancie rosate e' capegli biondi, l'aria serena, la terra tutta vestita d'un bel verde; ma la vera vaghezza non è altro che venustà o grazia, la qual si genera da una conzione over giusta proporzione delle cose, tal che, come le pitture hanno del proprio, hanno anco del vago et onorato il maestro." Despite his critique of facile pictorial *vaghezza*, it is notable that Pino's dialogue begins with a sensual appreciation of the beauty of women, and returns to the theme of physical beauty repeatedly.

31 Lomazzo, 1973–4, vol. II, 267: "E questo è tutto il fondamento della debita vaghezza che debbono avere i colori compartiti per le pitture; il quale tuttavolta che sarà inteso et

osservato, ne riusciranno le opere convenienti, vaghe e dillettevoli a gl'occhi." Lomazzo praises Raphael for observing this *vaghezza* with propriety; his color harmonies are lovely but he never combined colors in such a way that "potesse nascere troppo vaghezza a gl'occhi e levar alcuna parte del giudicio al riguardante." The idea that "too much *vaghezza*" can so ravish the eyes that the beholder's judgment is compromised indicates the extent of the perceived power and danger of coloristic *vaghezza* and its relation to *disegno*.

32 Agucchi quoted in Grassi and Pepe, 1978, vol. II, 628. As I have attempted to imply in the choice of "friendship" to describe the relation of *vaghezza* to *colore*, the word continued to be used to analyze other pictorial qualities even after it was closely linked to coloring. E.g. Bellori singles out the "vaghezza nella varietà dell'atto" in describing a detail from Annibale's Farnese Gallery. See ibid., 629.

33 Lomazzo, 1973–4, vol. I, 323: "a questi tempi i pittori più sono solleciti de i colori che del disegno, della vaghezza che della forza dell'arte." David Summers, "The Stylistics of Color," in *Color and Technique in Renaissance Painting: Italy and the North*, ed. Marcia Hall (Locust Valley, N.Y., 1987), 205–20, observes that the "ornaments" of coloring, such as *colori cangianti*, were *colore*'s analogues to figural nudes, serpentine figures, and wet drapery. Summers does not explicitly draw the comparison but it is easy to perceive how coloristic and figural *vaghezza* might both be thought seductive – and feminine. See further Ch. 8, and for Barocci's use of color to generate meaning. In her study of *vago* as a literary term, Angela Castellano, "Storia di una parola letteraria: it. *Vago*," in *Archivio glottologico italiano* 48 (1963): 159, points out that *vago* and *vaghezza* were already strongly associated with color in Cenino Cennini, a prehistory to the copious employment of the terms in relation to color in sixteenth-century theoretical writing. Castellano's few pages concerning the use of *vago* in writing about painting (158–63) are useful but her focus on Trecento literature leads her largely to ignore later usages in other discourses. She assumes that the word in art criticism, for instance, is employed overwhelmingly in relation to color and that its extension to color drains it of the amatory connotations it had long possessed in poetry. Her first example of this "shift" is literary, a passage from a Sacchetti *novella* in which green is noted as "il più vago colore che sia" for dressing (158). But see Johann Huizinga, *The Autumn of the Middle Ages*, trans. Rodney J. Payton and Ulrich Mammitzsch (Chicago,

1996), 142 and 326, for the importance of green in fourteenth- and fifteenth-century French courtly literature as the color of new or shifting love, a perfect match for the connotations of *vago* and *vaghezza*. The lyrics for the early modern English song "Greensleeves" employ the color in the same manner. This is absolutely not to imply that a reference to the *vaghezza* of a color in Cennini should be read as possessing "symbolic" connotations but rather to recall that late medieval and early modern delight in *vaghezza de' colori* could (as Pino and others were at pains to point out) have valences that were linked to desire, "make-up," and the body. See further the opening of Ch. 8 and n. 5 there.

34 Borghini, 1967, vol. 1, 622: "egli è pittore molto practico, e che benissimo intende le cose del disegno."

35 Ibid., 205: "Perciò ritornando nel Carmine, veggo la Portatrice del Salvador del mondo salire al cielo, dipinta in una tavola con gli Apostoli, di Mano di Girolamo Macchietti, con bella ordinanza, e le figure sono di membra e d'attitudini bene accommodate, con rilievo e con buon disegno. Tutto mi piace (rispose il Michelozzo) ma il colorito potrebbe esser più vago: siccome ancora quello della tavola di Santi Titi della Natività, che nel rimanente mi piace assai . . ." See further Ch. 6 on the distinctive characters of the interlocutors in the dialogue.

36 Ibid., 198: "Sì ma voi tacete di dire, soggiunse il Michelozzo, che il coloritto [*sic*] non è troppo commendabile."

37 See further Ch. 7.

38 Cropper, 1995, 187–8, citing Dolce in Roskill (ed. 2000, 216–17 (letter of Dolce to Alessandro Contarini)): "Ne è maraviglia, che se una statua di marmo pote in modo con gli stimuli della sua bellezza penetrar nelle midolle d'un giovane, ch'ei vi lasciò la macchia: hor, che dee far questa, che è di carne; ch'è la beltà istessa; che par, che spiri? Trovasi ancora nel medesimo quadro una macchia d'un paese di qualità, che'l vero non è tanto vero: dove al sommo d'un picciol colle non molto lontano dalla vista v'è un pargoletto Cupido, che si dorme all'ombra . . . & al d'intorno v'ha splendori e riflessi di Sol mirabilissimi, che allumano, & allegrano tutto il paese." The letter is also discussed in Roskill's intro., 35–6. I have used Roskill's translation but have rendered "pargoletto" as "little boy" in preference to his "baby," for the Cupid in the Titian painting is clearly a young boy.

39 Cropper, 1995, 189. On 188, Cropper suggests that in Dolce's description, "painting and love-making, painterly process and painterly effect,

are conjoined . . . to establish that not only beholding but also the making of a work of art are acts of love." Indeed, as noted earlier (n. 26), Gilio's *Dialogo* describes Michelangelo as behaving "like a lover" in creating the *Last Judgment*, while Lomazzo makes explicit that the painter can experience, in "considering his painting," something akin to the desire of the lover (see n. 10). See further Chs 8 and 9 for Barocci's employment of Venetian as well as central Italian stylistic modes. For *pittura di macchia*, see Paul Hills, *Venetian Colour: Marble, Mosaic, Painting and Glass 1250–1550* (New Haven and London, 1999), 201–26. A more recent, major discussion of Titian's color and facture in relation to allure and delight is Suthor, 2004. Suthor raises the importance of *vaghezza* on 31–2 (see 34 for Marco Boschini's celebration of Titian as "el pitor de la vaghezza") and returns to it in considering relations between painting and music, esp. 144–52.

40 See Chs 6, 8, and 9 for more on varied *vaghezze*. For gardens and fountains as sites of *vaghezza* in Baglione, 1995, see e.g. 61 (a fountain and water organ made for Clement VIII is a "vaghezza degna di grandissimo Pontefice"), 85 ("il vago, e real giardino"), 282 ("vago giardino"), 369 ("vaga Fonte"). For ornaments, 35 ("un nobil portone verso la piazza di Termini con vago ornamento"), and for the Palazzo del Tè, 49. For Cigoli's loggia, 154 ("vi rappresentò la favola di Psiche a fresco fatta con diverse figure, e ornamenti, molto vaga, e bella"). Concerning figures, particularly putti and nudes, the Cavaliere d'Arpino's *Saint John the Evangelist* in the Pauline Chapel in Santa Maria Maggiore is described as "con puttini, e con diversi nudi legati, opera assai vaga (372)," while Barocci's follower Antonio da Urbino (Antonio Viviani) is praised for "un'Arme del Pontefice Paolo v con diverse figure grandi maggiori del vivo, e con puttini, assai vaga" (103). One must be careful not to over-read the evidence; here and in the case of d'Arpino it is clear that Baglione considers the work *vaga*, not simply the nudes and putti. Yet it does seem that these figures generate a significant portion of the work's *vaghezza*, particularly in the case of a coat of arms. For color, see e.g. the life of Raffaellino da Reggio (one of the few painters identified as having a *vaga maniera*, see below), who had a "vaga maniera di colorire a fresco (27)," or the description of Jacopino del Conte's *Deposition* in the Oratorio of San Giovanni Decollato, Rome, "di buon disegno, e vago colorito (75)," or the life of Battista Naldini, which Baglione concludes "era vago

il suo colorito" (29). Finally, Baglione comments that the little-known Theatine painter Biagio Betti "Essercitossi anche nella vaghezza della Musica (318)."

41 For Barocci, see ibid., 133–4; for Vanni, 110: "acquistossi buon credito con quella sua maniera vaga Barocciesca, fatta con amore," and, of his altarpiece of the *Fall of Simon Magus* for Saint Peter's, "Il Vanni dipinse il suo quadro a olio sopra le lavagne, e'l colori assai vago con quella sua maniera, che recò buon diletto." It is important that *vaghezza* produces *diletto* here, as in the case of Barocci's works. Antonio Viviani (see also note above) "s'affaticava assai per imitare la maniera di Federico Baroccio suo primo Maestro, e fece di suo una maniera assai vaga" (104). Castellano, 1963, 160, notes that *vago* was being employed as a word to describe a style of writing by the late Trecento and offers examples from Sacchetti ("vago e dolce stile").

42 Baglione, 1995, 26: "Et in quei tempi non si ragionava d'altri, che di Raffaellino da Reggio; poiche tutti li giovani cercavano d'imitare la bella maniera di lui; tanta morbidezza, e unione nel colorire, rilievo, e forza del disegno, e vaghezza nella maniera havea." Sohm, 1995, 789, points out that soft, sweet styles ("morbido, dolce") were considered by Vasari to flatten and unify planes, while "rilievo" created volume and separated figures. Sohm also notes, 774 n. 39, that Vasari associates both a feminine grace and a "masculine" "force and robustness of drawing" with Leonardo's style; one may wonder if Baglione was attempting to advance an analogous claim for Raffaellino. There remains little secondary literature on Raffaellino. Sydney Freedberg, however, made the intriguing assertion that "Even late in his Roman career there is the persistent sense of Raffaellino's connection with an Emilian past, beyond Orsi, with Correggio" – that is to say with one of the painters on whom Barocci was perceived by contemporaries to have built his style; Sydney J. Freedberg, *Painting in Italy 1500 to 1600* (London, 1971; 1990), 653. Dempsey has been preeminent in asserting the distinctiveness of the Emilian, "Lombard" contribution to the reform of painting in the late sixteenth century, particularly in the case of the Carracci. His insistence on the "Lombard" coloristic contribution as distinct from that of Venice – a point with implications for Barocci's borrowings from Correggio as well as from Titian and central Italy – has been summed up in his "Introduction," 2004, 1–9. Well before Baglione and Bellori stressed Barocci's debt to Correggio, Lomazzo had already cast him as a follower of Correggio

(and Giorgione!) in 1590; Lomazzo, 1973–4, vol. I, 358. See further the Conclusion for the question of Barocci's interest in Correggio (specifically in the *Rest on the Return from Egypt*).

43 Lomazzo, 1973–4, vol. I, 358: "Dell'ultimo governatore e di Giorgione e d'Antonio da Correggio sono stati seguaci Paulo Cagliari, il Tintoretto, i Palmi, il Pordenone, i Bassani e Federico Barocci et il Peterzano, che hanno dato alle lor pitture la forza e la prontezza de i moti e la leggiadria de i colori, sí come fece Aristide, pittor antichissimo." See also 366: "Ma sopra tutti ha nobiliato le chiese con le sue opere Federico Barozzi, diligente et accurato in tutti gli studij della pittura e che ha dato sempre tanto rilievo e forza alle pitture che niuno potrà mai con parole dir tanto ch'egli co'l vero di gran lunga non lo superi." While the onset of Lomazzo's blindness in 1572 meant that he could not have studied most of Barocci's mature paintings, his statements are thus all the more indicative of period perceptions of Barocci's work rather than merely individual responses.

44 Baglione, 1995, 21: "il suo modo di dipingere era assai divoto, diligente, e vago." See 20–21 for "good manner" and "diligence."

45 See William E. Wallace, "Michelangelo and Marcello Venusti: A Case of Multiple Authorship," in *Reactions to the Master: Michelangelo's Effect on Art and Artists in the Sixteenth Century*, ed. Francis Ames-Lewis and Paul Joannides (Aldershot and Burlington, 2003), 137–56.

46 For the *Noli me tangere*, see now *Sebastiano del Piombo, 1485–1547*, ed. Claudio Strinati and Bernd Wolfgang Lindemann, Milan, 2008, pp. 354–5. Baglione appreciates the vault: "E nella divota cappella del Rosario tutta la volta con li quindici misterii ad olio con grand'affetto, e diligenza fatti" (21). For Venusti and debates concerning religious painting in the second half of the sixteenth century, see Kamp, 1993.

47 Pellegrino Orlandi, *Abecedario pittorico* (Venice, 1763), 308–9, cited in Wallace, 2003, 153.

48 See e.g. Baglione, 1995, 370–71: for the following Roman churches, an altarpiece depicting the *Annunciation* for the Aldobrandini in Santa Maria in Via was "non però di molto buon gusto" even though the frescoes d'Arpino executed for the chapel were "assai gratiose, e di bella maniera"; the large *Coronation* of the Virgin in the Chiesa Nuova (opposite Barocci's *Presentation*) was "di maniera dalla sua buona diversa"; and an altarpiece of the *Madonna and Child with Saints* in Santa Trinità dei Pellegrini was painted "non con molto gusto."

49 Ibid., 369: "E nel Pontificato di Papa Sisto V. dipinse sopra la porta di dentro, a piè delle scale del Palagio di S. Gio. Laterano, che riesce alla Scala Santa; e sono due figure maggiori del naturale, una rappresenta la Religione, e l'altra la Giustitia dalle bande dell'Arme del Pontefice, fatte con quella sua vaga maniera." For recent discussion and the illustration of a drawing possibly associated with the commission, see Herwarth Röttgen, *Il Cavalier Giuseppe Cesari D'Arpino: un grande pittore nello splendore della fama e nell'incostanza della fortuna* (Rome, 2002), 233. The other terms recur throughout the life, 367–75; see e.g. the concluding sentence: "La sua bella maniera ha fatto scuola, e ha allievi, che felicemente perpetuano la memoria del loro Maestro."

50 See further on these elements of *vaghezza*, Chs 6 and 8. In this particular case, d'Arpio's painting exhibits overt reminiscences of Barocci's *Rest on the Return from Egypt* (see fig. 181).

51 Matteo Senarega to Barocci, Archivio Storico del Comune di Genova, Arch. de' Ferrari, registro no. 141, fol. 131r; transcribed in Bury, 1987, 355–6: "Al molt'Illustrissimo S. Federico Barocci, Pittore in Urbino: Un difetto solo ha la tavola, che per haver del Divino, lodi humane non vi arrivano: vive per questo involta fra silentio, e maraviglia. Ma il Crocifisso santissimo ancorche in sembianza di già morto, spira non di meno vita et paradiso a noi; accennando quel che in effetto fù, che volontieri et di proprio beneplacito suo, per amor nostro, et per salute di tutti ha patito morte. La dolcezza poi della Madre Vergine è tale, che in un sguardo medesimo ferisce, et sana, muove a tenerezza, et consola e par appunto che quel divino spirito penetrando le ferrite di Christo vi entri dentro à riconoscere se debba ò piu traffiggerla la morte dell'amato figlio o ricrearla del genere humano la salute; cosi da varii affetti sospinta, piena di stupore, et di pietà abbandonasi nel novello figlio che anch'egli da meraviglia et charità compunto teneramente le corrisponde. In San Sebastiano poi si veggono espressi i veri colori, et numeri dell'arte, ove forse non mai arrivano gli antichi, non che i moderni, e tutta insieme ricca d'artificio et di vaghezza non lascia luogo, che pur l'invidia v'aspiri. Ma questi Angioli benedetti, che vivi effetti non fanno anch'essi di maraviglia et di pietà. Affermo di nuovo, et confesso, che come Divina rapisce, divide et dolcemente trasforma." The letter concludes with the promise of a rich reward to Barocci, who has "consumati tanti sudori" in producing such an extraordinary work. Bellori's transcription is only slightly edited; with the exception of a handful of emended

words ("vedono" for "veggono," e.g.) the changes involve only punctuation. The content and art critical words of all Senarega's sentences are preserved unaltered (it is telling that Saint Sebastian, the male nude, is singled out for presenting the "numeri dell'arte"). For the translation, I have used Pillsbury and Richards, 1976, with alterations.

52 See Ch. 1, n. 12 for text and discussion and also above.

53 See Michael Baxandall, *Painting and Experience in Fifteenth-Century Italy: A Primer in the Social History of Pictorial Style* (Oxford, 1972), 114–51, esp. 147–8. Baxandall notes that a "*vezzo*" was a caress, so *vezzoso* might be read as "delightful in a caressing way." By the appearance of the first edition of the *Vocabolario*, *vezzo* could signify *delizia, trastullo* but also a string of pearls or other ornament a woman wore around the neck.

54 *Vocabolario*, s.v. *Vezzoso*: "Che ha in se una certa grazia, e piacevolezza. Lat. *venustus, elegans*. Bocc. N. 81.1 'Molte volte s'è, o vezzose donne, ne' vostri ragionamenti." For *vago*, see n. 14.

55 Baxandall, 1972, 148. The word *vezzoso* appears not to have had much critical fortune as a term for discussing art, so little, in fact, that it goes unmentioned in the relatively comprehensive *Dizionario* of Grassi and Pepe. It seems that *vezzoso* was related to *vaghezza* in late Quattrocento discourse but gradually supplanted by it during the Cinquecento; however, further research would be necessary to offer any more developed discussion. While she does not analyze *vezzoso*, Castellano, 1963, 165, cites two passages in *strambotti* (a poem-type often set to music) by Luigi Pulci which pair the words explicitly: "lieta, vaga, gentil, dolce, vezosa" (CVII, 3) and "vaga, vezosa, onesta, e senza sdegno" (LXXXVI, 5) in which an antecedent to the mix of allure and "onestà" celebrated by Firenzuola in lovely young women is clear.

56 Baxandall, 1972, 150 (without translation).

57 See Lingo, 1998, esp. 286–92, for a discussion of Barocci's potential interest in the *maniera devota* of early Raphael, particularly in relation to the formal language of the *Madonna di San Giovanni*. Dempsey has written evocatively of the importance of the *maniera devota* to the Carracci in 1987, 75–87. Fra Ludovico da Pietralunga, in his late sixteenth-century guide to the Basilica di San Francesco in Assisi, writes suggestively of an altarpiece by Lo Spagna: "gli è l'altare con una tavola, opera di mano di Giovanni Spagnolo, ditto per soprannome lo Spagnia, et che fu discipulo di Pietro Peruscino. Dove che molti pittori testificano

58 et dicano, afermano che in questi nostri paesi non era et non fu il più vago pittore di lui." See Scarpellini, 1982, 32. For discussion of Fra Ludovico's work, see Ch. 3.

58 Vasari, cited in Previtali, 1964, 21–2 n. 1: "fu persona che viveva con religione. . . . Dolse molto la sua morte per essere stato uomo da bene e perché molto piaceva la sua maniera, facendo l'arie pietose et in quel modo che piacciono a coloro che senza dilettarsi delle fatiche dell'arte e di certe bravure amano le cose oneste, facili, dolci e graziose." Previtali, 22, reads this passage as another indication that Vasari became more prudent in 1568 in his judgments of conservative devotional painters. In the 1550 edition, he had concluded of Sogliani: "la maniera sua molto piacque allo universale, facendo egli arie pietose e devote secondo l'uso degli ipocriti."

59 Vasari, 1966–87, *Testo*, vol. III, 271: "et infinite figurine, che in una gloria celeste vi si veggiono, sono tanto belle che paiono veramente di paradiso, né può, chi vi si accosta, saziarsi di vederle."

60 Ibid: "Gesù Cristo incorona Nostra Donna in mezzo a un coro d'Angeli et infra una multitudine infinita di Santi e Sante, tanti in numero, tanto ben fatti e con sì varie attitudini e diverse arie di teste che incredibile piacere e dolcezza si sente in guardarle . . . perciò che tutti i Santi e le Sante che vi sono non solo sono vivi e con arie delicate e dolci, ma tutto il colorito di quell'opera par che sia di mano d'un santo o d'un angelo . . . et io per me posso con verità affermare che non veggio mai questa opera che non mi paia cosa nuova, né me ne parto mai sazio."

61 Krüger, 2001, 186, has noted Paleotti's praise for Fra Angelico, citing Paolo Prodi, *Ricerche sulla teorica delle arti figurative nella riforma cattolica* (Bologna, 1984), 57 (in the original edition, 164). For Spranger's close adaptation of Fra Angelico in the *Last Judgment*, see Zeri, 1957, 52 and fig. 50. Zeri is at pains to distinguish this imitation from the more typical act of copying an icon and to stress its links to "l'alone quasi leggendario che già cominciava a circolare intorno al nome del 'Beato' pittore." A brief recent discussion of Spranger's painting, now in the Galleria Sabauda, Turin, is found in Carla Enrica Spantigati, Paola Astrua, and Anna Maria Bava, *The Galleria Sabauda of Turin: Selected Works* (Turin, 2006), 34. For the Fra Angelico (now in the Staatliche Museen of Berlin and sometimes thought to be painted by Zanobi Strozzi) see John Pope-Hennessy, *Fra Angelico* (Ithaca, 1974), 221.

62 Bacci, 1699, 171–2, recounts how once when San Filippo entered "nella Cappella della Visitazione dove si tratteneva volentieri, piacendogli assai quell'immagine del Barocci, e postosi a serdere secondo il solito suo sopra una sedia piccola, fu rapito, non accorgendosene, in una dolcissima estasi." While his paintings proclaim Barocci to be a highly self-conscious artist, aware of the critical possibilities of stylistic choices, Bellori implies that he may also have discussed theoretical issues. In describing Barocci's routine during the many years of his illness, Bellori, 1976, 201, notes: "E perché egli dormiva pochissimo, la sera in casa sua nella stagione del verno, si faceva adunanza de' principali, e virtuosi della Città, dove si vegliava sino alle otto hore della notte . . ." Such artistic, literary, and perhaps musical evenings probably included critical discussion. While Bellori is a fairly late source and one with strong ideological motivations, he seems remarkably well informed regarding anecdotal biographical details; see further the opening of Ch. 9.

6 *Figures of* Vaghezza

1 This phenomenon seems to be increasingly acknowledged (explicitly or implicitly) in the literature. Michael Camille, *The Gothic Idol: Ideology and Image-Making in Medieval Art* (Cambridge and New York, 1989), highlighted the significance of the Pygmalion myth by the late Middle Ages. Victor Stoichita, *A Short History of the Shadow* (London, 1997), offers extended analyses of Pliny's narrative of the foundation of both two and three-dimensional art in the story of the daughter of the potter Butades, who drew the profile of her departing lover by lamplight on a wall; her father then made from this outline a sculptural relief (Pliny, *Historia Naturalis*, XXXV, 43); see also Maurizio Bettini, *The Portrait of the Lover*, trans. Laura Gibbs (Berkeley, Los Angeles, and London, 1999) for this and related narratives, including that of Narcissus (analyzed by Stoichita, 1997, esp. 29–41). For Narcissus see also Stephen Bann, *The True Vine: On Visual Representation and the Western Tradition* (Cambridge and New York, 1989), esp. 105–56 (emphasizing, however, the related theme of metamorphosis). Alberti locates the origin of painting with Narcissus in *De Pictura* (1435), 1972, 61–3. Jean-Luc Nancy, "Visitation," in Nancy, *The Ground of the Image*, trans. Jeff Fort (New York, 2005), 121–2, stresses that the outline traced by Butades' daughter should not be read simply as a proleptic commemoration, a "recollection" of one no longer present, but as an attempt to fix the shadow as the double of the presence of the beloved. The reading has fertile resonances with Bettini's exploration of early Greek beliefs concerning shadow, shade, and trace.

2 Cropper, 1995, 159–205. See also the recent work of Stephen Campbell, esp. "Eros in the Flesh: Petrarchism, the Embodied Eros and Male Beauty in Italian Art, 1500–1540," *Journal of Medieval and Early Modern Studies* 35 (2005): 629–62, and *The Cabinet of Eros: Renaisssance Mythological Painting and the Studiolo of Isabella d'Este* (Cambridge and New York, 2006). For Petrarch and Simone Martini, see Bettini, 1999, 3–5, with references. For Donatello, see Shearman, 1992, 112 (the story is Vasari's). For Michelangelo, see Anton Francesco Doni, *I Marmi* (Venice, 1552), ed. E. Chiorboli, 2 vols. (Bari, 1928), vol. II, 20–23.

3 For Shearman see Ch. 1, n. 3.

4 Aldrovandi: "molto dottamente mostra V.S. Ill.ma i varii e diversi effetti che dalle pie e divote imagini causar si possano. A questo proposito adunque non restarò di dirle di quella statua di Venere Gnidia, di marmo pario formata, la qual fu collocata nel suo tempio, sì come testifica Luciano, e fu tanto bella che fece quasi impazzire Caricle, vedendo che egli, quando la vidde, disse: 'O fortunatissime deorum Mars, qui propter hanc victus fuisti!'; et accorrendo la baciò a piene labia, stendendo quanto più gli era possibile il suo collo. E dalla bellezza di questa statua impazzito, stando tutto il giorno in quel tempio, subito levato correva a quella et ogni ora più s'accendeva il suo amore verso tanto bella e graziosa statua. E se una statua di marmo scolorita faceva questo effetto, che dovranno poi fare le colorite e dipinte al vivo?" Ulisse Aldrovandi, *Avvertimenti del Dottore Aldrovandi all'Ill.mo e R.mo Cardinal Paleotti sopra alcuni capitoli della pittura* [1581], in *Trattati d'arte*, ed. Paola Barocchi, 3 vols. (Bari, 1960–62), vol. II, 515.

5 Dolce's letter was published in *Lettere di diversi eccellentissimi huomini*, ed. Lodovico Dolce (Venice, 1559); see Ch. 5, n. 38 for the Italian and Cropper's discussion, 1995, 187–90.

6 See e.g. Julius von Schlosser's fundamental *La letteratura artistica* (German ed. 1924), trans. Filippo Rossi (Florence, 1996), 351. Scholars have begun to offer more nuanced readings of Borghini's positions and importance, e.g. Thomas Frangenberg, *Der Betrachter: Studien zur florentinischen Kunstliteratur des 16. Jahrhunderts* (Berlin, 1990), esp. 77–102, and Marcia Hall, *After Raphael: Painting in Central Italy in the Sixteenth Century* (Cambridge and New York, 1999), 247–8. It is still common, however, to see Borghini simply grouped with ecclesiastical critics such as Gilio and Paleotti.

For the earliest debates surrounding Michelangelo's *Last Judgment*, see Ch. 5.

7 Borghini, 1967, vol. I, 78–82. The attacks are leveled, predictably, by "il Vecchietti," the character most exercised by perceived lapses of decorum in religious works. Vecchietti notes specifically the "dishonesta grandissima" of Pontormo's nudes, and when Sirigatti (a collector and amateur sculptor) interjects that painters portray nudes "per mostrar l'eccellenza dell'arte in varie attitudini," Vecchietti counters: "Questo è l'error commune di tutti i pittori." He later adds that "Giovanandrea Gilio da Fabriano in quel suo dialogo degli errori de'pittori sopra il Giudicio di Michelagnolo" explained much of what need be said before Pontormo's frescoes. For occasional artisitic critiques of Bronzino, see e.g. 194 (the *Resurrection*), 196 (the *Martyrdom of Saint Lawrence*), and 203 (the *Noli me tangere*). For more on the characters in the dialogue, see below. Stephen Campbell has offered a nuanced account of Bronzino's imitation and adaptation of Michelangelo in "Bronzino's *Martyrdom of Saint Lawrence*: Counter Reformation Polemic and Mannerist Counter Aesthetics," *RES 46. Polemical Objects* (Autumn 2004): 99–121.

8 Borghini, 1967 vol. I, 109–10: "Io mi son fermo, disse il Michelozzo, dinanzi alla tavola del Bronzino, dove egli ha effigiato Christo nel Limbo, e sento grandissimo piacere nel rimirare le dilicate membra di quelle belle donne. Di già habbiam noi ragionato, rispose il Vecchietti, quanto mal fatto sia le figure sacre fare cosi lascivie. Hora di piu vi dico che non solamente nelle Chiese, ma in ogni altro publico luogo disconvengono; percioche danno cattivo esempio, e nella mente vani pensieri inducono: e gli artefici, che l'hanno fatte, nella vecchiezza dal tardo pentimento della coscienza sentono rodersi il cuore, come ben confessa Bartolomeo Ammannati Scultore in una sua lettera stampata, à gli Accademici del disegno, dove dice have malamente adoperato nell'haver fatto molte statue ignude, e si accusa non degno di scusa; ma domanda à Dio perdono, e conforta gli altri à non cadere in così grave fallo. Perciò quanta poca laude meriti il Bronzino in cotesta opera, voi medesimo dilettandovi nel rimirare quelle donne lascive il confessate; e io son sicuro che ciascuno che si ferma attento à rimirare questa pittura; considerando la morbidezza delle membra, e la vaghezza del viso di quelle giovani donne, non possa fare di non sentire qualche stimolo della carne, cosa tutta al contrario di quello, che nel santo Tempio di Dio far si doverebbe."

9 While the angel is androgynous and cast into a pose that recalls a famous female nude, Bronzino clearly conceived the figure as male; both angels reveal their genitals in the highly finished *modello* in the Uffizi (Gabinetto Disegni e Stampi 13843F): see Maurice Brock, *Bronzino*, trans. David Poole Radzinowicz and Christine Schultz-Touge (Paris, 2002), 276 for illustration. This presentation was evidently thought to require adjustment in the finished painting. The quotation is Borghini, 1967, vol. I, 116: "Ambidue [the two panels by Santi di Tito, his *Resurrection* and *Supper at Emmaus*], rispose il Vecchietti, estimo degne di lode; sì per l'osservatione della sacra historia; sì per l'honestà, e sì per le cose del pittor proprio, che vi sono bene accommode. L'haver parlato della Resurettione, soggiunse il Michelozzo, mi ha fatto ricordare d'una tavola del Bronzino nella Nuntiata dimostrante tal misterio. Digratia non ne parliamo, replicò il Vecchietti, perche vi è un Agnelo tanto lascivo, che è cosa disconvenevole. S'io havessi cotesta bella figura in casa, disse il Michelozzo, io la estimerei molto, e ne terrei gran conto per una delle piu dilicate, e morbide figure, che veder si possano . . ." It should be noted that Michelozzo does not always criticize Santi; see e.g. his generally favorable response to the *Raising of Lazarus* in Santa Maria Novella as "molto bello" as well as "molto honesto" (106). In Book II, however, Michelozzo was not able to resist disparaging the *colorito* as "non . . . troppo commendabile" (198).

10 For an ecclesiastical theorist such as Paleotti, "lasciviousness" and nudity were condemned in the domestic sphere as well. See Stefania Biancani, "La Censura del nudo nel discorso di Paleotti e nella trattistica post-tridentina a Bologna," in *Bartolomeo Cesi e l'affresco dei canonici lateranesi*, ed. Vera Fortunati and Vincenzo Musumeci (Fiesole, 1997), 204–15. Yet even Vecchietti is not presented by Borghini as adhering to such views. The dialogue is set at his villa and begins with a tour of his extensive collections, which include nudes (among them Michelangelo's *Leda* cartoon). Indeed, despite his heated condemnation of nudity in any "public" works, Vecchietti praises Giambologna's *Rape of the Sabine* and even dedicates to it a sonnet, celebrating it as a work sculpted with great *vaghezza*. The historical Vecchietti was an important proponent of Giambologna. See Borghini, 1967, vol. I, 12–15 and 165–69.

11 For the full quotation and discussion, see Ch. 5, esp. n. 27.

12 Borghini, 1967, vol. I, 187: "me ne passero alla tavola del Bronzino rappresentante Christo nel Limbo, in cui veggo una bellissima dispositione, attitudini gratiose, membra bene intese, colori vaghissimi, belle carnagioni, teste molto ben fatte, ritratte dal naturale, e tutta molto studiata, e fatta con grand'arte. Io non ho sopra questa che dir cosa alcuna, rispose il Michelozzo, oltre à che veggo M. Baccio molto compiacersi in rimirarla, talche ancor io, come bella, e vaga la riguardo. Io mi compiaccio à rimirar quelle bellezze, soggiunse incontanente il Valori, che à noi dal sommo donatore di tutti i beni furono donate, perche con mezi convenevoli le rimirassimo: e considero à così dono quanto al donatore siamo obligati. Ma voi non lasciate di dire l'opinion vostra se contra à cose così belle havete che dire; mi piace la vostra platonica opinione, replicò il Michelozzo, e se ciascuno con tale intentione le rimirasse, non accaderebbe far le pitture sacre altramente; ma non so come questa continenza, e questo santo pensiero in altri trapassasse, ò trapassato lungamente (mirando cose che tanto allettano il senso) si durasse. Non traviamo dal nostro dritto sentiero, disse il Vecchietti, che il camino è ancor lungo, e il tempo è breve. Eccoci M. Ridolfo dinanzi alla tavola della Resurrettione del Salvadore di Santi Titi."

13 Ibid., 536–7: "In Santa Croce alla Cappella degli Zanchini fece poi la tavola . . . dipignendovi Christo disceso al Limbo per trarne i Santi Padri, dove sono ignudi bellissimi, e maschi, e femine in diverse attitudini, e gratiose . . . e la tavola tutta di bella maniera, di buon disegno, e di vago colorito."

14 Ibid., 537: "È di sua mano parimente la tavola della Resurretione del nostro Signore posta dietro al coro della Nuntiata alla Cappella de'Guadagni, in cui si vede un'Angelo di tutta bellezza. In casa Iacopo Salviati è in un quadro fatto da lui Venere con un Satiro pittura bellissima." See Brock, 2002, 285, for discussion of the juxtaposition of the description of the Annunziata altarpiece and the domestic painting. Brock interprets this as reinforcing the notion that the angel would be beautiful in a home but is out of place in a church. Given the trajectory of the discussions, however, I would stress that the juxtaposition is markedly ambivalent and does not point to a univocal conclusion. For Bronzino's altarpieces and the issues of decorum, see ibid., 268–303.

15 See Francesco Bocchi, *Opera di M. Francesco Bocchi sopra l'imagine miracolosa della Santissima Nunziata di Fiorenza . . .* (Florence, 1592), esp. 71. For the work and Bocchi's ties to reform thinkers, see Wazbinski, 1987, vol. I, 625–48.

16 Francesco Bocchi, *Le Bellezze della Città di Fiorenza* (Florence, 1591) intro. John Shear-

man, (facsimile ed. Farnborough, 1971), 226–7: "E il Cristo effigiato con dignità, di colorito lieto, morbido, e dolce.... Sono lodati due Angeli, e si come sono di sembiante bellissimo, ammirati; uno de' quali alza la pietra del sepolcro con movenza graziosa: e l'altro, come conviene, è di bellezza rara, e conforme à sua natura di vero angelica." For Shearman's description of Bocchi's taste and *campanilismo*, see his intro. (n.p.).

17 Dolce, in Roskill, 2000, 165 (slightly adapted). For the Italian see 164: "Ma questa honestà usò sempre il buon Rafaello in tutte le cose sue, in tanto, che, quantunque egli desse generalmente alle sue figure un'aria dolce e gentile, che invaghisce e infiamma: nondimeno ne i volti delle sante, e sopra tutto della Vergine, madre del Signore, serbò sempre un non so che di santità e di divinità (e non pur ne' volti, ma in tutti i lor movimenti) che par, che levi dalla menti de glihuomini ogni reo pensiero." The passage focuses on the decorum requisite in art "in publico, e massimamente in luoghi sacri e in soggetti divini." The conjunction of the "aria dolce" of Raphael's female figures with the effect that this *dolcezza* "che invaghisce e infiamma" is held to produce, may call to mind Baglione's conjunction of *dolce* and *vaga* with *sfumata* to define Barocci's style. See Edoardo Zamarra, "*Dolce, soave, vago* nella lirica italiana tra XIII e XVI secolo," in *Critica letteraria* 13 (1985): 71–118, for the intertwined usages of these terms, which Zamarra underscores as "elementi costitutivi chiave, da un punto di vista sia quantitativo sia qualitativo, del linguaggio poetico amoroso" (118).

18 Gilio, 1960–62, 78: "Pero io dico che, se quelle parti consideriamo in piccioli fanciuletti, non ci scandalezziamo, avendo riguardo a l'innocenza e purità di quelli, senza malizia e peccato, e non potendoci per naturale istinto cadere. Ma se le miriamo negli uomini e ne le donne, n'arreca vergogna e scandolo." For Corsi's text, see Paola Barocchi, "Un 'Discorso sopra l'onestà delle Imagini' di Rinaldo Corsi," in *Scritti di storia dell'arte in onore di Mario Salmi*, ed. Valentino Martinelli and Filippa M. Aliberti, 3 vols. (Rome, 1961–3), vol. III, 190: "salvo nei pargoletti maschi, ove il dono dell'innocenza supplisce per ampio e ricco ornamento." Tellingly, Corsi adds: "Non così nelle femine giamai, alle quali si deve perpetua riverenza et onestà."

19 For the protoadolescent figure in Barocci's work and the question of homoerotic desire, see below, esp. n. 26.

20 Francesco Scannelli, *Il Microcosmo della pittura* (1657; facsimile ed., Milan, 1966), 294: "e tutti sono talmente espressi alla più rara verità uni-formi, con formazione come di carne palpitante, e viva, che del continuo stanno per sicura attestatione d'un compendio della più esquisita bellezza, e stimo, che si possa anco dire con ogni ragione, che tali figure contengano in eccellenza l'antiche, e moderne perfettioni, non potendo essere riguardato da professori, ed intelligenti della Pittura senza l'indurre moltiplicati gli effetti dello stupore e quelli, che gli hanno osservati non cessano di predicarli per i veri prodigi della Pittura."

21 Having described Correggio's "scherzo" of putti as a "pellegrino concetto" arising from a "raro gusto" that performed "delle più esquisite operationi," Scannelli argues that such demonstrations found ancient precedents (ibid., 293): "e di ciò fino a tempi antichi n'habbiamo chiare le prove, mentre raccontano, che i migliori dipinti, che furono a quei tempi osservati in opera pregiatissima, erano fra gli altri bellissimi oggetti due putti, ne' quali vogliono, che gli stessi riguardanti venissero a riconoscere la di loro sicurezza, e propria simplicità all'attione, ed età conveniente." While the text's marginal gloss simply indicates "Plin cit.," Scannelli is probably referring to the *Natural History*, XXXV, 70, in which Pliny describes the achievements of Parrhasius: "he also painted . . . two children in which the carefree simplicity of childhood is clearly displayed" ("pinxit . . . et pueros duos, in quibus spectatur securitas aetatis et simplicitas"); see Pliny, *Natural History*, vol. IX, trans. H. Rachham (Cambridge, Mass, 1961), 312–13.

22 Jack Spalding, *Santi di Tito* (New York, 1978), 65.

23 For the record of artistic response to the *Visitation*, see Baglione, 1995, 134, and a letter from Grazioso Graziosi to the Duke of Urbino, transcribed in Gronau, 1936, 157. For the period perception that the Oratorians were filling their church with "molti quadri," all "di huomini principalissimi," see ibid., 156–7. The correspondence of Clement VIII concerning the *Institution of the Eucharist* (transcribed in ibid., 31–2 and 176–86) is usefully discussed in Emiliani, 1985, vol. II, 377–80.

24 For analysis of Barocci's difficulties and strategies during these years, see Lingo, 2007, 179–99.

25 Scannelli, 1966, 290–91: "rassembra un vivo ritratto della più delicata, e fina bellezza, che rapisce gli animi de' riguardanti, e gl'induce innamorati, e stupefatti a languire ogni volta, che s'affissano debitamente a considerarla."

26 One must proceed with caution here, for recent scholarship has established the potential erotic appeal of the young adolescent "boy" (*fanciullo, garzone*) in Italian homoerotic culture of the fifteenth to seventeenth centuries. While Barocci's serving boys (or even Correggio's *donzella*) could be objects of desire, however, their great youth tended to mitigate the possibility of an overly sexual response in at least most viewers. Admittedly, in a striking early modern apologia for man–boy relations, the Venetian Antonio Rocco's *L'Alcibiade fanciullo a scola* of c. 1630, boys as young as nine are considered desirable, and Rocco goes so far as to say "some full, round little boys excite you from infancy on"; quoted in Michael Rocke, *Forbidden Friendships: Homosexuality and Male Culture in Renaissance Florence* (New York and Oxford, 1996), 95. Hence even putti could be objects of desire; the difficulties of avoiding "lasciviousness" while cultivating figural *vaghezza* constituted a complex and treacherous terrain for artists. However, not only Gilio, who regarded the nudity of infants as "innocent," but indeed most period readers would probably have found Rocco's assertion extreme. Rocke's study of same-sex relations between men in Florence (which tended to be characterized by intercourse between a dominant older male and a "passive" younger male) concludes that the younger partner was usually between twelve and eighteen years old. The copious documentation indicates that less than 5 percent of "younger partners" were twelve or under, while the number jumped significantly between the ages of twelve and thirteen, and continued to rise sharply until sixteen; see ibid., 88 and 116, and Appendix B.2, 243. While Rocke's study focuses on Florence and the period before 1542, he notes (87–9, 95) that preliminary work indicates that situations in other Italian (and perhaps some north European) cities appear similar in important respects to the picture emerging from the rich documentation in Florence, and that this pattern of behavior continued at least through the seventeenth century.

27 For the difficulty in identifying representations of Michelangelo's lost work, see Kathleen Weil-Garris Brandt, "Sogni di un *Cupido dormiente* smarrito," in *Giovinezza di Michelangelo*, ed. Kathleen Weil-Garris Brandt, Cristina Acidini Luchinat, James David Draper, and Nicholas Penny (Milan, 1999), 315–23. Brandt also discusses a surviving antique exemplar, inventoried in the Medici collection in Florence by 1553, that is similar to Barocci's invention. Ian Verstegen, "The Apostasy of Michelangelo in a Painting by Federico Barocci," *Source* 22 (Spring 2003): 27–34, has noted the evident quotation of Raphael's Heraclitus from the *School of Athens* (see fig. 183) as the figure of

Judas in Barocci's completed *Institution of the Eucharist* and hypothesizes that the figure stands as a sign of the ambivalent legacy of Michelangelo in the minds of "reform" painters. The presence of this figure is clearly intriguing and Barocci's thinking about Michelangelo was probably complex. See further Ch. 4 and the Conclusion.

28 Bellori, 1976, 198: "disse il papa che non gli piaceva il Demonio si dimesticasse tanto con Giesù Cristo, e fosse veduto su l'altare..." (English from Pillsbury and Richards, 1978, 20). The letters recounting the pope's analysis of the two *modelli* with which he was presented are transcribed in Gronau, 1936, 181–5.

29 For the most recent discussion of painting and drawing, see Turner, 2000, 17. For the erotic in the context of religious painting in Cinquecento Rome, with particular reference to Salviati, see Alessandro Nova, "Erotismo e spiritualità nella pittura romana del Cinquecento," in *Francesco Salviati et la bella maniera*, ed. Philippe Costamagna, Catherine Monbeig Goguel, and Michel Hochmann (Paris, 2001), 149–69. For a more general investigation of the issues, see Robert Gaston, "Sacred Erotica: The Classical *figura* in Religious Painting of the Early Cinquecento," *International Journal of the Classical Tradition* 2, no. 2 (Fall 1995): 238–64. I thank Bette Talvacchia for calling this article to my attention. For Barocci's painting see further Ch. 9.

30 Borromeo, 1994, 25.

31 Ibid; "Non è ben fatto per niun modo l'esprimere la Vergine che alatti il suo figliolo se non si fa questo con somma modestia, il che non fanno quei pittori che discuoprono la gola e il petto delle loro figure, senza necessità e con troppo brutto costume." While Borromeo is a late "reform" writer, the ideas he expresses in *Della Pittura Sacra* are generally thought to have been formed in the 1580s and '90s. Agosti, in ibid., 2, stresses how close the tenets of the treatise remain to those that were current during the 1580s in Bologna and Rome. Pamela Jones, *Federico Borromeo and the Ambrosiana: Art Patronage and Reform in Seventeenth-Century Milan* (Cambridge and New York, 1993), 21, notes that Paleotti himself mentored the young Borromeo and supervised his education at the Studio of Bologna from 1579. Barry Collett, *Italian Benedictine Scholars and the Reformation: The Congregation of Santa Giustina of Padua* (Oxford, 1985) remains the fundamental study of the Cassinese Benedictines.

32 See Roberto Zapperi, *Eros e controriforma: preistoria della galleria Farnese* (Turin, 1994).

33 For a discussion of the chapel's sculpture see Sylvia Pressouyre, *Nicolas Cordier: recherches sur la sculpture à Rome autour de 1600*, 2 vols. (Rome, 1984), vol. II, 375–84. The sculptural program may indicate a "gendered allocation" of the display of the female body. Both virtues flanking the tomb of Clement's mother Luisa Deti are chastely clothed, even though figures of Charity were often depicted with an exposed breast, while, as seen, the two figures flanking the tomb of the pope's father Silvestro Aldobrandini reveal elements of the *vaghezza* of the youthful female form.

34 For more on Senarega's letter and Dolce's celebration of the ability of painting to render flesh, see Ch. 5.

35 See the letters excerpted in Emiliani, 1985, vol. II, 377–80. For the Duke's letter (August 31, 1603), 377: "a noi i lumi sono parsi molto stravaganti."

36 See Ch. 4, n. 24 for the letter; the phrase reads: "perchè come le pitture non hanno il suo lume non mostrano mai quello che sono."

37 For the *Nativity*, the *Saint Jerome*, and the *Beata Michelina*, see Emiliani, 1985, vol. II, 318–29, 302–5, 368–71.

7 Other Vaghezze

1 For Aertsen and the issue of *parerga* in the late sixteenth century see Stoichita, 1997, 3–29, esp. 17 for Vasari (1878–85, ed. Milanesi, vol. VII, 455) and 23–4 for the *parergon* in ancient, early modern, and postmodern criticism. For Barocci it might be relevant that Pliny's well known reference to embellishments "quae pictores parergia appellant" occurs in the life of Protogenes, just before the description of a dog (one of Barocci's preferred *parerga*), "mire factus," in one of the master's most important paintings, and one displayed in a prominent religious site: "qui est Romae dicatus in templo Pacis"; Pliny, *Historia Naturalis*, XXXV, 101–3 (Loeb ed., 336–7).

2 For the passage in Dolce, see Ch. 5, nn. 38 and 39 and Cropper, 1995, 188.

3 Gilio, 1960–62, 10. The full passage reads: "'O, disse M. Polidoro, non si sono trovati artefici che l'uve hanno tanto naturali dipinte, che gli uccelli sono venuti per mangiarle, pensando che vere fussero?' 'Per certo, soggiunse M. Vincenzo, che cotesta fu opera degli antichissimi pittori; ma oggi penso che nissuno Fiammengo, che la palma protano dei paesi, né Italiano le sapesse così bene dimostrare, che quello effetto facessero che già fecero.' 'Io mi tengo da voi, disse M. Silvio, perché, se riguardiamo a la sorte de' fiori, de' frutti, d' erbe, d' uccelli, d' animali, che si veggono ne le loggie del palazzo del Papa, del Ghisi et in altri palazzi di Roma, ancor che belle e vaghe paiano, nondimeno non mostrano quel colore naturale né quella vaghezza che dovevano mostrare quelle che M. Polidoro dice.'" The speakers refer to Raphael's Logge at the Vatican and the Loggia of the Villa Farnesina. For the description of spring, see 5–6.

4 Paleotti, 1960–62, 215–16: "Parimente dunque ufficio del pittore sarà usare li stessi mezzi nella sua opera, faticandosi per formarla di maniera, che ella sia atta a dare diletto, ad insegnare e movere l'affetto di chi la guarderà."

5 Ibid., 216: "Ma noi ... abbiamo per fine ... di spiegare la grandezza di questo diletto e farlo conoscere molto maggiore che forse non suole essere communemente stimato."

6 Paleotti's reflections occupy pp. 216–18. For a more general discussion of this passage in the context of his theories, see Pamela Jones, "Art Theory as Ideology: Gabriele Paleotti's Hierarchical Notion of Painting's Universality and Reception," in *Reframing the Renaissance: Visual Culture in Europe and Latin America 1450–1650*, ed. Claire Farago (New Haven and London, 1995), 127–39.

7 Paleotti, 1960–62, 218–19: "E perché la legge cristiana non vieta alcuna sorte di queste dilettazioni, purché siano adoperate col debito modo, perciò che non distrugge le cose della natura, ma le dà perfezzione, servendosi di esse come di gradi e mezzi per giungere al fine alto della beatitudine eterna: però dalle imagini sacre, di che parliamo, può parimente un cristiano godere di ciascuna di queste tre sorti di dilettazioni, del senso, della ragione e dello spirito. Quanto al senso, è cosa manifestissima a tutti che, essendo il senso del vedere più nobile degli altri, riceve dalle pitture per la varietà de' colori, per l'ombre, per le figure, per gli ornamenti e per le cose diverse che si rappresentano, come monti, fiumi, giardini, città, paesi et altre cose, meraviglioso piacere e ricreazione. Del diletto razionale ... essendo detto de' savii che, sì come l'uomo fra tutti gli altri animali nasce attissimo ad imitare, così egli per naturale instinto sente grandissimo diletto e gusto della imitazione.... E questa imitazione, che nella pittura si scorge così evidentemente, tanto maggiormente suole recare diletto, quanto pare che subito renda le cose presenti agli uomini, se bene sono lontane, et a guisa della omnipotente mano di Dio e della natura sua ministra pare che in un momento faccia nascere e produca uomini, animali, piante, fiumi, palazzi, chiese e tutte l'istesse opere che si veggono in questa gran machina del

mondo. . . . Resta la terza dilettazione, che nasce dalla cognizione spirituale, la quale non è dubbio che, sì come ha oggetto più desiderabile . . . tanto maggiore e più perfetta dilettazione apporta. . . . Da che vogliamo concludere che, oltre le due precedenti, che si sogliono da ciascuno facilmente prendere, seguita questa terza ancora, la quale, quanto è più dell'altre eccellente, tanto più suole svegliarsi negli animi nobili per mezzo delle pie imagini, dicendo un autore: '*Pictae tabulae delectatio, si consiliio regeremur, ad amorem caelestem erigere et originis nos deberent admonere; nam quis unquam, rivi appetens, fontem odit?*'" (the Latin quotation, taken somewhat out of context, is from Petrarch, *De remediis utriusque fortunae*, 1, ch. 40).

8 Marc Fumaroli, *L'Ecole du silence: le sentiment des images au XVIIe siècle* (Paris, 1994), 414. See 411–14 for an insightful discussion of the *Visitation* and its impact on Reni.

9 See Connors, 1996, 43–8, esp. 47, for a reconstruction of the shrine's arrangement. Given the proximity of well and altar, Barocci's dramatic image would have struck pilgrims with particular force. See Ch. 4, n. 21.

10 Bellori, 1976, 190.

11 For the squared drawing (private collection) see Emiliani, 1985, vol. I, fig. 339. This study also indicates that another critical decision came late. In the drawing, the ruler's gesture of condemnation – which is also in spite of itself similar to a gesture of consecration – takes place just beside one of the halberd points in the surface pattern of the painting. In the final composition, the hand is apparently (again in the surface pattern of the picture) transfixed by the halberd just at the point at which the nail of crucifixion would have left its mark on the hand of Christ. Barocci's intense experimentation with surface patterns here, as in the *Madonna del Popolo*, is further evidence of his frequent recourse to this strategy as a means of suggesting relationships to a beholder that could not be perceived by the actors in the space of the scene. For further discussion of Barocci's use of cherries in the *Rest on the Return from Egypt* see the Conclusion.

12 This is but one of numerous instances in which what appears to be a more or less facile recycling of motifs proves, with the evidence of preparatory sketches, to have been a deeply reconsidered adaptation, "returned" to only after long deliberation (see above and Ch. 2, n. 24 for other examples and discussion). Such an observation will, I hope, go some way toward freeing Barocci from the implication, present in much of the literature, that his

inventions became increasingly formulaic as his career developed.

13 For the design process for the *Disputà* and the question of the monstrance, see J. A. Gere and Nicholas Turner, *Drawings by Raphael from the Royal Library, the Ashmolean, the British Museum, Chatsworth and Other British Collections* (London, 1983), 109–16.

14 Joseph Connors and Louise Rice, eds, *Specchio di Roma Barocca: una guida inedita del XVII secolo* (2nd ed., Rome, 1991), 111: "Il avoit coutume de faire toujours entre dans son tableau quelque chose qui y donnoit de l'agrément, que les autres taschent d'emprunter de la liberté qu'ils donnent à leurs figures. On a de luy par exemple un tableau du martyre de St. Vital à Ravenne où est un pie qui bat de l'aile avec un petit enfant qui luy porte une cerise dan le bec, qui marquee le talent qu'il avoit de donner de la grace aux moindres choses." For the date of the manuscript and the writer's identity and religious and cultural views, see x–xviii. The intriguing figure of Capponi, who is celebrated as "successeur du fameux Aldrovandi dans sa profession d'enseigner à Bologne," seems to have been Giovanni Battista Capponi (1620–75), physician, anatomist, antiquarian, professor, and member of several Bolognese academies. Giovanni Battista lived too late to have "succeeded" Aldrovandi at the university directly, as Aldrovandi died in 1605, but in 1671 he was given the sole chair of natural history in the university, which had been Aldrovandi's; see M. Capucci, "Capponi, Giovan Battista," in *Dizionario biografico degli italiani*, 19 (Rome, 1976), vol. XIX, 52. Giovanni Fantuzzi, *Notizie degli scrittori bolognesi* (Bologna, 1781–94), vol. III, 85–90, notes (as Capucci has observed) the existence of the *diatriba*. Capponi also composed lost works on errors in Latin and Tuscan writers.

15 Matthew 19:14, *The New Jerusalem Bible* (New York, 1993). See also Mark 10:13–16, Luke 18:15–17.

16 I Corinthians 13:11.

17 For Scannelli's passage, see Ch. 6, n. 25.

18 Baglione, 1995, 156: "Fece da giovane la porta della vigna del Duca Altemps . . . e è ricca di lavoro, e assai vaga"; and 48: "E la Fontana a monte Citorio, nella strada, fatta fare dal Cardinal Santa Severina, è sua bella, e vaga architettura."

19 Ibid., 60: "con vaga balaustrata tutta di marmo ricca." For Sant'Anna, a "vago edificio," 9.

20 Ibid., 175. The entire passage reads: "E Bramante Lazzeri da Castel Durante, Baldassare da Siena, Raffaello da Urbino, Giulio Romano, e Michelagnolo Fiorentino ne hanno rinovata la

vera magnificenza dell'antica architettura; ne' compartimenti delle cui opere è grand'arte, le modenature hanno molta gratia, mostrano ne' membri unione, e vaghezza, e le proportioni da essi furono ottimamente intese si, che ad essempio loro, hoggi da' buoni Maestri sono con bella simmetria, e con vaga corrispondenza generosamente intrapresi, e felicemente terminati i lavori, e gli edifici."

21 Bellori, 1976, 181: "Partitosi Battista da Urbino, Federico si trasferì à Pesaro in casa del Genga, che gli diede commodità di studiare nella galeria del Duca le pitture che vi erano di Titiano, e di altri primi maestri; e nel tempo stesso gl'insegnava geometria, architettura, prospettiva, nelle quali discipline divenne erudito."

22 Venturelli, 1800. A typescript redaction of the manuscript is conserved in Rome, Bibliotheca Hertziana, Ca BAR 1880 321 (penciled pagination 19). Barocci could be concerned enough about the maintenance of particular spatial effects that he would at times sign his autograph prints in perspective. Michael Cole has recently commented on this in an analysis of Barocci's manipulation of space in his print of the *Annunciation*: Michael Cole, ed. *The Early Modern Painter-Etcher* (University Park, Penn., 2006), 100 (for illustration, 99, cat. 10,).

23 Shearman, 1976, 51. Much of the background view in the *Madonna Albani* appears to be borrowed from the *Flight of Aeneas*: not only does the Tempietto reappear but also the foreshortened view of an entablature, upheld by a Tuscan or Doric column, which serves in both compositions to point the eye towards the temple and deeper into the background.

24 For the English, see *Sebastiano Serlio on Architecture*, trans. and ed. Vaughan Hart and Peter Hicks, 2 vols. (New Haven and London, 1996), vol. I, 396 (with citation of further literature on period perceptions of the round temple). For the Italian, see *Sebastiano Serlio: L'architettura. I libri I–VII e Extraordinario nelle prime edizioni*, ed. Francesco Paolo Fiore, 2 vols. (Milan, 2001), vol. II, 2: "Et per che la forma rottonda é la piu perfeta di tutte le altre, io da quella cominciaro."

25 Serlio, Bk Four, ch. 6; 1996, vol. I, 281. The Italian (vol. I, IV, 19) reads: "Gli antiqui dedicarono questa opera Dorica a Giove, a Marte, ad Hercole, e ad alcuni altri Dei robusti. Ma dopo la incarnation de la salute humana devemo noi Christiani procedere con altro ordine, percio che havendosi ad edificare un Tempio consacrato a Giesu Christo Redentor nostro, o san Paolo, o san Pietro, a san Giorgio, o ad altri simili santi . . . che habbiano havuto

del virile, e del forte ad esponere la vita per la fede di Christo, a tutti questi tali si convien questa generation Dorica."

26 See Pollio Vitruvius, *Ten Books on Architecture*, trans. Ingrid Rowland, with commentary by Thomas Noble Howe, Ingrid Rowland, and Michael J. Dewar (New York and Cambridge, 1999), 55 (Bk Four, 1.6). The idea that the Orders were gendered is not inconsequential to Barocci's architectural reflections. For issues of character, gender, and meaning in the orders, see Joseph Rykwert, *The Dancing Column: On Order in Architecture* (Cambridge, Mass., and London, 1996), and John Onians, *Bearers of Meaning: The Classical Orders in Antiquity, the Middle Ages, and the Renaissance* (Princeton, 1988).

27 For Bramante's employment of Doric and the varied imperatives that might underlie it, see Onians, 1988, 235–45.

28 For Zorzi's *Memoriale*, of April 1, 1535, see Manfredo Tafuri and Antonio Foscari, *L'Armonia e i conflitti: la chiesa di San Francesco della Vigna nella Venezia del' 500* (Turin, 1983), 208–10. The passage (210) reads: "Similmente luodo gli ordeni delle colonne et pilastri, essendo designati secondo le regole dell'arteficio dorico: il qual approbo in questa fabrica, per esser convenevoli al Santo, a chi e dedicata la Chiesa, et alli frati, che hanno a ufficiar in essa." For the origins of San Salvatore and debates on its appropriate architectural articulation, see Linda Pellecchia, "The First Observant Church of San Salvatore al Monte in Florence," *Mitteilungen des Kunsthistorischen Institutes in Florenz* XXIII, 3 (1979): 273–97.

29 Onians, 1988, 311, calls attention to the Franciscan reform preference for the Doric, tracing it from San Salvatore, through San Francesco della Vigna, to Santa Maria degli Angeli; "Even the enormous Basilica of Santa Maria degli Angeli outside Assisi, designed in 1569 by Alessi, keeps within a somber Doric mode, quite exceptionally for a church of such importance and in contradiction of its architect's recommendation in another context of Corinthian for the Virgin. The restraint must certainly be a concession to the association of the site as the place where Saint Francis first founded his order with a group of friars living in wattle-and-daub huts. The unusual design of the building, with a Doric entablature running uninterrupted across the façade and down the side, taking no account of the transept and creating a structure like an early Doric temple, must be an attempt to recapture in masonry the essence of primitive Franciscanism."

30 Serlio, 1996, vol. 1, 216–18.

31 Ibid., 340.

32 Ibid., 256. Vignola allows for a single-toros base in one of his renditions of the Doric.

33 Onians, 1988, 311.

34 Fra' Antonio da Pordenon[e], "Libri tre ne' quali si scuopre in quanti modi si può edificare un Monasterio sia la chiesa . . . conforme all'uso della nostra Religione," 1603, Venice, Biblioteca Marciana, MS Ital. IV, 5070, f.2v. The entire quotation may position Fra' Antonio as a moderating voice in the polemics glimpsed behind the text of his treatise: "è cosa nota che vi è necessario il fabricare; et ben che a noi non si convenga d'osservar il dorico nel ionico, tutta via per decoro della Religiosità, conviensi pur haver qualche commodità." See further Lingo, 1998, 75–80.

35 Vitruvius, Bk Four, 1.1–4; 1999, 54–5.

36 The foreground column shaft and base, just beside the principal actors, are elegant. If one follows Serlio, however, the column base must still be Doric. Serlio's Ionic, Corinthian, and Composite all have more complex base moldings. See Serlio, 1996, vol. 1, 281 (Doric), 320 (Ionic), 340 (Corinthian), and 366 (Composite).

37 Pordenone, 1603, revised version: Class. IV 140 5071, f.2v: "et ben che a noi non si convenghi di osservare tutte le Regole dell'Architettura, ma solim quelle della simplicità et povertà." The measurements for the Doric column are given on f.6v. See Lingo, 1998, 77–8.

38 See Ch. 1, n. 9 for a poem by Colonna registering this perception.

39 Baglione, 1995, 59, singles out for particular praise the "vaghissimi ornamenti di pietri" in the Cappella Aldobrandini.

40 See Onians, 1988, 38–9, 210–14, 221–3, 226–42.

41 See Tim Carter, *Music in Late Renaissance and Early Baroque Italy* (Portland, 1992), 54–5, for a summary of the views of Giovanni Maria Artusi (*L'Artusi, overo Delle imperfettioni dell' moderna musica*, 1600, ff. 68v–69v – sweet and somewhat sad), Scipione Cerreto (*Della prattica musica vocale, et strumentale*, 1601, 104–5 – pleasing, more honest than lascivious, very devout, serious), and Nicola Vicentino (*L'antica musica ridotta alla moderna prattica*, 1555, ff. 44v–46r – pleasing and devout, more honest than lascivious). Frederick Hammond, "Poussin et les modes: le point de vue d'un musicien," in *Poussin et Rome*, ed. Olivier Bonfait et al. (Paris, 1996), 75–91; 79–80 discusses these issues in relation to Poussin's famous letter concerning the modes and painting (see Ch. 9) and adds the assertion found in Girolamo Diruta, *Il Transilvano* (1593), that the Dorian is "pleasing and serious."

8 Colors of Vaghezza

1 Dolce in Roskill, 2000, 155 (Italian 154): "Cosi la principal difficultà del colorito è posta nella imitazion delle carni, e consiste nella varietà delle tinte, e nella morbidezza. Bisogna dipoi sapere imitare il color de' panni, la seta, l'oro, e ogni qualità . . . Saper fingere il lustro delle armi, il fosco della notte, la chiarezza del giorno, lampi, fuochi, lumi, acqua, terra, sassi, herbe, arbori, frondi, fiori, frutti, edifici, casamenti, animali, e si fatte cose tanto a pieno, che elle habbiano tutte del vivo, e non satino mai gliocchi di chi le mira."

2 Ibid., 217; for the Italian and discussion see Ch. 5, n. 38.

3 Benedetto Varchi, *Lezzione nella quale si disputa della maggioranza delle arti . . .* (1546), in *Trattati d'arte del cinquecento*, ed. Paola Barocchi, 3 vols. (Bari, 1960–62), vol. 1, 40: "Argomentano ancora dalla vaghezza e dal diletto, che si cava maggiore della pittura che della scultura, rispetto massimamente a' colori."

4 Vasari, 1966–87, *Testo*, vol. V, 101–2.

5 Dolce in Roskill, 2000, 155. For the Italian, 154: "Ne creda alcuno, che la forza del colorito consista nella scelta de'bei colori: come belle lache, bei azurri, bei verdi, e simili; percioche questi colori sono belli parimente, senza, che e'si mettano in opera: ma nel sapergli maneggiare convenevolmente." Dolce's discussion of color in the *Dialogo*, esp. 151–7, is augmented by his remarks two years later in the *Letter to Gasparo Ballini*; ibid., 207–9. For the fraught relation between lovely coloring and perceptions of "feminine" enhancement of beauty, see Jacqueline Lichtenstein, *The Eloquence of Color: Rhetoric and Painting in the French Classical Age* (Los Angeles, 1993). For an argument that Dolce's attitude to coloring ultimately asserted the fundamental importance of color even to the affect of paintings on beholders, see Hills, 1999, 220.

6 Moshe Barasch, *Light and Color in the Italian Renaissance Theory of Art* (New York, 1978), esp. 107.

7 Dolce in Roskill, 2000, 207 (*Letter to Gasparo Ballini*): "Non dico però, che i bei colori non adornino: ma se aviene, che sotto il colorito, e insieme col colorito, non si contenga la bellezza e perfettion del disegno, la fatica è vana; e è a punto, come le belle parole senza il sugo e il nervo delle sentenze." Dolce elaborates that without *disegno* even well managed coloring is akin to the application of cosmetics by less than attractive women; well applied cosmetics will in fact enhance beauty in the structure of a face but no amount of skill in applying them can entirely disguise poor proportions or deformities.

8 Paleotti, 1960–62, 497: "quanto all'affetto, che elle [paintings] fossero figurate in maniera che operassero due cose, l'una nel muovere il senso, l'altra nell'eccitare lo spirito e la divozione." For Paleotti on the audience for religious painting and the unique challenges posed for painters, see 493–503.

9 Ibid., 498: "confessio et pulchritudo in conspectu eius, sanctimonia et magnificentia in sanctificatione eius." Barocchi identifies the citation as Psalm 95:6 (in the Vulgate).

10 Ibid., 500: "diciamo . . . che con l'artificio et accuratezza del disegno, e col fare l'opere sue ben finite, aggiungesse ancor quella grazia tanto commendata da Apelle; onde con la vaghezza e varietà de' colori, or chiari, or scuri, or delicati, or rozzi, secondo la qualità de' soggetti, e con la diversità d'ornamenti, leggiadria de' paesi, dove il luogo comporta, et altre belle invenzioni traesse gli occhi degl'imperiti a rimirarle." While it could usually be assumed that the "unlearned" were also the poor, period artistic theory employed this as a category which could cut across class lines; Armenini, in particular, comments on the relatively unsophisticated tastes of most aristocrats and notes that artists must employ "vivid tints" to make their paintings please such important if "unlearned" patrons; Giovanni Battista Armenini, *On the True Precepts of the Art of Painting*, ed. and trans. Edward J. Olszewski (New York, 1977), 176.

11 Dolce in Roskill, 2000, 113 (trans. slightly adapted). For the Italian, 112: "Perche le imagini non pur sono, come si dice, libri de gl'ignoranti: ma (quasi piacevolissimi svegliatoi) destano anco a divotione gl'intendenti: questi e quelli inalzando alla consideratione di cio, ch'elle rappresentano."

12 For related phenomena in Barocci's work see below. Hills, 1999, esp. 224, offers intriguing observations concerning the transformation of substances in Titian's paintings and some of its possible cultural contexts. For Cropper's contention, see Ch. 5, esp. n. 38.

13 John Shearman has argued that *cangianti* should not be considered mere representations of shot silk and that only a minority of changeables actually register that phenomenon; see his "Le funzioni del colore," in *Michelangelo: La Cappella Sistina. Documentazione e interpretazioni*, ed. Kathleen Weil-Garris Brandt, 3 vols. (Novara, 1994), vol. III, 159–65.

14 See Hall, 1992, for the history of the use of *colori cangianti* and their importance in sixteenth-century painting. For *cangianti* in the *Madonna del Popolo*, see below.

15 See Hall, 1992, esp. 92–122, and John Shearman, "Leonardo's Color and Chiaro-scuro," *Zeitschrift für Kunstgeschichte* 25 (1962): 13–47.

16 For these and related issues, see Patricia Rubin, "The Art of Colour in Florentine Painting," *Art History* 14 (June 1991): 175–91, esp. 183–9.

17 Summers, 1987, 213. In her discussion of *vago*, Castellano, 1963, 164, offers a description of the plumage of male pheasants from Giovanni Pietro Olina's *Uccelliera overo discorso della natura e proprietà di diversi uccelli* (Rome, 1622) in which rich and shifting colors, including a "cangiante verde e oro" constitute a *vaghezza dei colori* (facsimile ed. Florence, 2000, 49), while the shells of snails are praised by Daniello Bartoli (*La Ricreazione del savio* [1659], I, 11, not I, 13, as in Castellano) for "la bizzarria delle invenzioni . . . la vaghezza degli ornamenti, la disposizione dei colori." The association of *vaghezza* here with ornament, with its feminine connotations and its potential to be read as a product of artifice, is overt. The nature of Bartoli's text, a religious *apologia* employing science and natural history, should be noted, but there is a tradition of regarding him as an impressive stylist; see Bartoli, *La Ricreazione del savio*, ed. Bice Mortara Garavelli, preface by Maria Corti (Parma, 1992), ix.

18 Lomazzo, 1973–4, vol. II, 268 (in a chapter on "a quali sorti di genti convengano particolarmente i colori"): "E generalmente in questa parte vi si ha d'avere certa discrezione e giudicio, come, per esempio, non converrebbe dare color cangiante alla Nostra Donna, per niun tempo, come molti fanno, attribuendolo di più anco a Cristo et a Dio Padre, e pur non vi è che gl'avvertisca." Martin Kemp, *The Science of Art: Optical Themes in Western Art from Brunelleschi to Seurat* (New Haven and London, 1990), 266, argues (principally from visual evidence) that Lomazzo here identifies an established practice. See also Verstegen, 2002, for recurrent discussion of color, esp. 79–85 for issues of decorum.

19 Lomazzo, 1973–4, vol. II, 175. Here is the passage in full, as it indicates both Lomazzo's sense of the power of *cangianti* and of the need for care in its application: "Per essere andato tanto avanti l'uso della vaghezza, non solo di puri coloriti, ma ancor dietro alla fila essendosigli aggiunti i cangianti, cioè cangia colori, sí come quelli che vengono da la lucidezza delle pietre, non voglio lasciare di ragionar anco di questi; non già perciò che consenta ad alcuni che gli usano fuori di proposito, ma affine solamente che si adoprino al loco dove si richieggono, come nelle vesti lucide che si danno alle Ninfe de i prati, de i fonti e simili, et ancora a certi angeli, i cui vesti si riflettono non altrimenti che l'arco d'Iride. Ora questo è il maggior diletto e piacere che con colori si possa porgere a i risguardanti e chiamasi via del far i cangianti, cioè un panno di seta solo che ne i lumi abbia un colore di una spezie e nel'ombra uno d'un'altra; con la qual diversità si viene a dar la somma et ultima vaghezza e leggiadria alla pittura." Summers, 1987, 213, discusses Lomazzo's views. For the view that *cangianti* may be appropriate for the vestments of "certi angeli," see below. See also Ch. 5 for Lomazzo's employment of *vaghezza*.

20 Hall, 1992, 21. See also Rubin, 1991, 191, n. 34. Both Hall and Rubin note the passage from Cennini (Cennino Cennini, *The Craftsman's Handbook: "Il Libro dell'Arte,"* trans. D. V. Thompson (New Haven, 1933), 77). For the Italian, see Giuseppe Tambroni, ed., *Di Cennino Cennini, Trattato della Pittura* (Rome, 1821), 73: "Se vuoi fare un vestire d'angelo, cangiante, in fresco . . ."

21 The cleaning is documented in Stefano Scarpelli, "Nota sul restauro," in *L'Onestà dell'invenzione: pittura della riforma cattolica agli Uffizi*, ed. Antonio Natali (Milan, 1999), 43–9.

22 Verstegen, 2001, 81–3 and 157–63, has noted the frequency with which Barocci avoids or downplays *cangianti* but through the juxtaposition of separate draperies generates some of the coloristic interest of shifting color.

23 Hall, 1992, notes repeatedly a Venetian opposition to much employment of *cangiantismo*. See also Summers, 1987, 205–20, for Venetian critiques of Michelangelo's color, which relied heavily on *cangiantismo*. Veronese's spectacular "painterly" passages of *colore cangiante* occur frequently (though far from exclusively) in the drapery of angels.

24 Bellori, 1976, 181, notes Barocci's early study of Titian.

25 Cristoforo Sorte, *Osservazioni sulla pittura*, in *Trattati d'arte del cinquecento*, ed. Paola Barocchi, 3 vols. (Bari, 1960–62), vol. I, 294: "E stimo io che non avrebbe usati colori fissi e di corpo, ma dolci e soavi, atti a dimostrare una sopraumana sostanza et una pura e semplice divinità" and "Inoltre è da sapere che le cose divine, che alcuna volta appaiono, sono sempre accompagnate da un graziosissimo splendore et adombrate da una luce dolcissima, la quale non spaventa, non fa timore, ma empie l'uomo di meraviglia e di riverenza." Stoichita, 1995, 84, notes Sorte's text (and quotes excerpts) and offers discussions of period perceptions of the representation of theophany throughout the book; for shifting techniques, see 99–102. See also the studies

of clouds, perspective, and theophany in Damisch, 2002; John Shearman, "Correggio's Illusionism," in *La Prospettiva rinascimentale: codificazioni e trasgressioni*, ed. M. Dalai Emiliani (Florence, 1980), 281–94; and Shearman, 1987.

26 For the *Perdono*, see Ch. 3. While Barocci often depicts the garments of holy figures consumed by light to some degree as they trail back toward heaven from the forward-moving figure – or foreground angels that become cloud angels and ultimately formless, luminous vapor as one moves toward the source of heavenly light (as articulated by Raphael in the *Sistine Madonna*) – he never actually portrays any figure of a saint, of the Virgin, or of Christ as corporeally compromised by the form-dissolving power of heavenly light.

27 Sorte, 1960–62, 295–6; the passage reads, more fully: "Benché io stimo che molti pittori non siano così sciocchi, che non sappiano molto bene tutte le ragioni da noi dette, ma io penso che gli mettano i colori così fissi e facciano uno umano corpo così semplice e così sodo, come sarebbe quello d'ogni puro uomo, a bella posta, per dar di subito negli occhi a' riguardanti, cioè agli ignoranti che s'appagano solamente della pienezza e della vaghezza de' colori, senza passar più là di quello che sia quella imagine, e basta che paia loro bella. Ma a me parrebbe che converebbono più tosto sodisfare a coloro che sono di cognizione et intendono la verità . . . Dico bene che a questo bellissimo artificio, fra quante pitture mi ricordo d'aver vedute, s'è grandemente appressato M. Paolo Caliari nella Pala di S. Georgio qui in Verona . . . perciò che alle figure fatte in quelle nubi ha maravigliosamente dato il suo decoro, così in aver fatte esse figure de colori dolci, e divinamente illuminate dal sopraceleste splendore, come anco nell'aver intesa la prospettiva della distanzia, così nelle figure lontane come in quelle che sono nel piano che rappresenta com'è il naturale, le quali sono molto ben intese."

28 Giulio Romano's letter of Sept. 12, 1542 to the superintendents of the Compagnia della Steccata is transcribed and the project discussed in Konrad Oberhuber, "Giulio Romano pittore e disegnatore a Mantova," in *Giulio Romano*, ed. Ernst Gombrich et al. (Milan, 1989), 135: "io volevo ogni cosa e le carne et li panni al tutto fossi in color de fiamma et tanto più abbagl[i]ate e annichilate q[uan]to erano più lontane; et q[u]elle che son qua da la fiam[m]a come adam et Noe et quelli altri patriarchi si potevano fare li colori manifesti et terminati."

29 Dempsey, 2000, 28, seems to have been one of the few observers of Barocci who has com-

mented on the distinctive mix of definition and haziness in the *Madonna del Popolo*. While the focus of his discussion is elsewhere, he recognizes perceptively the way in which Barocci's coloring and technique conjure the actual visual experience of witnessing an apparition, rather than merely representing the apparition: "A work like the seminal *Madonna del Popolo* produces a puzzling, and even contradictory, series of effect upon the viewer, for on the one hand Barocci has portrayed a complex grouping of vigorously drawn and naturalistically conceived figures convincingly disposed within a deep ring of space, but on the other hand there is a strong sense of something indefinable which interferes with our vision, a shimmering veil blurring our focus and denying a complete perceptual grasp of the reality represented."

30 Hall, 1992, 195, traces Barocci's intense interest in reflected lights to his probable acquaintance with the writings of Leonardo. There is a long tradition that Barocci had access to the *Treatise on Painting* (Codex Urbinas Latinus 1270), Francesco Melzi's compilation of a vast number of Leonardo's notes, which came to the Vatican in the seventeenth century from the collection of the dukes of Urbino. However, the treatise does not seem to have been compiled until the mid-sixteenth century and it remains unclear when it came into the possession of the della Rovere; it is first recorded in an inventory drawn up in 1631, the year after the death of the last duke, Francesco Maria II della Rovere; see Claire J. Farago, *Leonardo da Vinci's Paragone: A Critical Interpretation with a new Edition of the Text in the Codex Urbinas* (Leiden and New York, 1992), 160, with notes to further literature. Nonetheless, the codex contains Leonardo's long *paragone* of poetry, music, and painting, which does seem of potential importance to Barocci's thought (see the end of Ch. 9 for discussion and n. 51 for Barocci's knowledge of the treatise). In the context of concerns about the decorum of *cangiantismo* and its relation to reflected lights, a passage on Andrea del Sarto's famed *Madonna del Sacco* in Bocchi, 1971, 229–30, is intriguing: "Bellissimo è un panno bianco, che [the Virgin] tene à collo, che par vero del tutto, anzi, se vi fosse un vero appiccato, appresso questo parrebbe finto, tale è l'arte, con cui è fatto, tale l'industria, che'l mostra di rilievo: sono l'ombre oscuramente rosette, forse per lo copioso color rosso della vesta, che nella bianchezza è riflesso, ò perche è cangiante, come di fare alcuna volta de' Pittori si costuma: ma con tanta proprietà del ver è stato effigiato, che da

arte nessua meglio esprimere si potrebbe." Bocchi here seems to express a delicate reservation about the *cangianti* "used sometimes by painters" (evidently on the garments of the Virgin) and advances the idea (or the hope) that the color change del Sarto registered in the shadows of the Virgin's robe actually derives from reflection.

31 See Alberti, 1972, 46, and 1973, 74.

32 For the drawing (Uffizi, 11331 F) see Emiliani, 1985, vol. I, 193, fig. 404. A related strategy informs the *Noli me tangere* (for a color reproduction of the version in the Uffizi, see ibid., vol. II, 238). Here the Magdalen is a remarkable figure of *vaghezza* but, though her left forearm is revealed, she remains chastely clothed, indeed swathed in a luxurious golden mantle that overlays her loveliness with its own, less charged *vaghezza*. Under this, Mary wears a garment that appears to be a soft pinkish red. This brightens to pure white in expansive highlights at her side, however, and darkens to red over her shadowed chest, perhaps registering her fervor as she recognizes her Lord.

33 For the English I have used Armenini, 1977, 176. For the Italian see Paola Barocchi, ed., *Scritti d'arte del Cinquecento*, 3 vols. (Milan and Naples, 1971–7), vol. II, 2273–4: "conciosiaché, se ben l'istorie e l'invenzioni per soggetto fossero dilettevoli da sé stesse, se il colorito, ch'è il modo di spiegarle, non aggradisce a gli occhi de'riguardanti, non potrà mai produr questo effetto, perché da' colori uniti e bene accordati si viene a partorir quell bello, che gli occhi rapisce de gl'ignoranti, e di nascoso entra nella mente de' savii." Armenini has just stressed that color in painting is akin to the rhetorical "color" in poetry discussed above. In both painting and poetry, color is an essential "ornament" that is inextricably linked to the purpose of the form: "Conciosiacosaché, sì come è intento principalissimo del poeta il dilettare col variar tuttavia nel suo poema con diversi colori, così i medesimi modi si devono cercare con i diversi e bei colori."

34 Gilio, 1960–62, 27: "Parrà per aventura al pittore grave di fare isprimire a le figure coi colori l'allegrezza, la malenconia, la languidezza, l'audazia, la timidità, il riso, il pianto e l'altre passioni de l'animo. Ma se rettamente considera il caso e la forza de l'arte, troverà che vagamente et agevolmente far si possono." Silvio goes on to enumerate examples of expressive painting such as the representation of emotion in the face (e.g. through tears). While the affecting portrayal of a weeping face certainly involves effective coloring, Gilio generally seems to employ "color" in a fairly

generic manner in the *Dialogo*, without all the complexity one tends to associate with *colore* or *colorito* as employed by some period art theorists. His discourse does not fully parallel, much less "explain," Barocci's distinctive coloristic strategies – but it seems to indicate a developing conditioning among observers that would allow pictorial strategies such as Barocci's to register effectively.

35 Lomazzo, 1973–4, vol. II, 177, quoted and discussed in Jonas Gavel, *Colour: A Study of its Position in the Art Theory of the Quattro- and Cinquecento* (Stockholm, 1979), 154: "Perché tutti i colori hanno una certa qualità diversa fra di loro, causano diversi effetti a chiunque guarda."

36 Paleotti, 1960–62, 227: "Resta la terza parte, non solo propria, ma principale delle pitture, che è di movere gli animi de' riguardanti . . ."

37 Aldrovandi, 1960–62, 512–13. Here is the entire passage: "E dico . . . che non ci è cosa al mondo che meglio possa rappresentare tutte le cose dal grande Iddio prodotte, che la pittura istessa per mezzo della varietà de' colori, i quali dalla varia mistione di Quattro elementi in tutti i corpi misti si veggono, essendo il colore oggetto proprio delvedere, come dice il Filosofo, non si potendo vedere cosa alcuna, se non in quanto è colorata. Il colore veramente è un accidente nelle cose, che dà gran giovamento a intendere le sostanze. Diceva Aristotile, *quod accidentia maxime conferunt ad quod quid erat esse*. Questo colore è un accidente inseparabile dalla sostanza, senza la cui notizia non si può venire alla cognizione di qual misto, essendo scala e mezzo, insieme con gli altri accidenti, in conseguire la cognizione perfetta di ciascuna specie; le quali per mezzo delle prime sostanze, chiamate individui, si conoscono, e sono dette sostanze seconde, che sono oggetto dell'intelletto; e le prime sono oggetto del senso del vedere, come colorate, non altrimenti. Quanto sia necessario accidente il colore quindi è manifesto, che non ci è cosa in questo mondo basso, che non abbia bisogno di esser descritta e depinta mediante i colori, avanti si possa conseguire la cognizion d'essa."

38 Borromeo, 1994, 33–4: "I colori sono a guisa di parole, che intese sono dai nostri occhi non meno agevolmente che quelle della lingua dalle orecchie da ciascuno di noi, e il disegno delle figure che si esprimono dir si potrebbe che fossero i concetti e gli argomenti. E perciò la pittura è un certo ragionamento e sermone il quale infino dagl'ignoranti è inteso, e non per questo è men caro agl'uomini scienziati . . . E sì come nell'oratore molto importa che le cose

da lui proferite abbiano in se stesse affetto e vigore, e possino muovere gl'animi, così sarà importante cosa che i colori e i dissegni siano abili a generare nelle menti umane i divoti pensieri, e il timere e il dolere, quando sia bisogno che noi l'abbiamo."

39 Antonio Calli, *Discorso de' colori di Antonio Calli: Lezzione degna e piacevole all'illustrissimo Signor Giacomo Soranzo* (1595), in Barocchi, 1971–7, vol. II, 2332. Little is known about Calli and Barocchi describes the *Discorso* as *rarissimo* (2355). Here is the full passage: "Dilettan dunque i colori e muovono l'affetto. Ma perché il dilettare et il muover l'affetto paiono una medesma cosa, per chiarezza è da dirsi che, quando non entran nell'animo e solo con la presenza loro traon la vista sì che non si sazia di mirarli, applaudendo solo a quell'armonia o del sol colore o dei più ben composti insieme, si chiama dilettare, poi che non altera l'animo di passione che molto l'ingombri, ma più tosto son gli occhi che participan esso del lor piacere. Dove quando l'animo si muove ad affetto, toglie essi occhi dall'oggetto, et affissandosi nella simbologia e significazione di quelli, tutto s'empie della giudicata et ad esso presentata passione."

40 Bellori, 1976, 192 (English in Pillsbury and Richards, 1978, 18): "Ma l'angelo . . . non solo ne' dintorni e nella formazione sua si dimostra agile e lieve, ma il colore stesso palesa la spiritale natura, temperato soavissimamente nella sopraveste gialla e nella tonaca di un rosso cangiante, con l'ali cerulee, quasi iride celeste." The poor condition of the painting obscures some of the impact of what Bellori saw, though cleaning has revealed fine passages.

41 Hills, 1999, 224; see 198–9 for the importance of the *Hypnerotomachia Poliphili* in this process.

42 Ibid., 207–8 for more examples. Hills supports the view that Titian completed Giorgione's *Venus* and believes the younger painter added the "mosaic" border to the red robe.

43 Marilyn Aronberg Lavin, review of *Federico Barocci*, by Harald Olsen, *The Art Bulletin* 46 (June 1964): 254.

44 In Marilyn Lavin's review of Harald Olsen's first study of Barocci, *Federico Barocci, a Critical Study in Italian Cinquecento Painting*, in *The Burlington Magazine* 99 (May 1957): 166, she singles out the *Madonna del Rosario* (and the later *Beata Michelina*) as revolutionary works: "Never before had such a degree of blissful ecstasy been isolated as the essential subject of large altar-pieces."

45 Krüger, 2001, esp. 172–89 (for Alberti, 176–80). Krüger, 174, highlights tensions created by ret-

rospective leanings: "Rubens malte seine Darstellung der *Madonna Santissima* weniger *nach* dem alten Gnadenbild, als vielmehr *gegen* dieses." One can point to similar tensions in Barocci's struggle to ideate the *Madonna del Popolo*. It is not surprising that ambitious artists of the late sixteenth century resisted abstractly reductive parameters for images. Barocci, however, did not resist a more fertile process of exchange between presents and pasts. For a sustained critique of the usual "linear" view of the transformation of ways of thinking about and producing images in the late medieval and early modern periods, see Nagel and Wood, 2003, with responses by Michael Cole, Charles Dempsey, and Claire Farago.

9 Ut Pictura Musica

1 Bellori, 1976, 206: "Quanto il colorito, dopo il cartone grande, ne faceva un'altro picciolo, in cui compartiva le qualità de' colori, con le loro proportioni; e cercava di trovarle trà colore, e colore; accioche tutti li colori insieme havessero trà di loro concordia, e unione, senza offendersi l'un l'altro; e diceva che si come la melodia delle voci diletta l'udito, così ancora la vista si ricrea dalla consonanza de' colori accompagnata dall' armonia de' lineamenti. Chiamava però la pittura musica, ed interrogato una volta dal Duca Guidobaldo che cosa e'facesse: stò accordando, rispose, questa musica, accennando il quadro, che dipingeva." I have adapted the translation in Pillsbury and Richards, 1978, 24.

2 Rennselaer W. Lee, *Ut Pictura Poesis: The Humanistic Theory of Painting* (New York, 1967). The literature on the nineteenth- and twentieth-century developments of the theme of *ut pictura musica* is vast. See recently Simon Shaw-Miller, *Visible Deeds of Music: Art and Music from Wagner to Cage* (New Haven and London, 2002), who traces, 245–6, n. 1, the origin of the specific paraphrase of Horace's dictum to an article by the critic Louis Viardot pointedly entitled "*Ut Pictura Musica*," in the inaugural issue of the *Gazette des Beaux-Arts*, 1 (Jan. 1859): 19–29. Indeed, Viardot believed that he was creating something new in forming his analogy (19): "On fera quelque jour un livre sur le parallèle de la peinture et de la musique. Mais aujourd'hui, traitant pour la première fois une question toute neuve, nous nous contenterons d'indiquer les points intéressants de comparaison entre ces deux arts."

3 Bellori, 1976, 180: "seguitando le memorie della sua vita raccolte dal signor Pompilio Bruni, che humanissimamente ce ne hà fatto dono, e il quale essendo artefice di strumenti matematici, mantiene ancora la scuola, e'l nome de' Barocci in Urbino." Barocci's family had made a reputation as crafters of clocks and precision instruments. Bellori offers a brief synopsis; see further Roberto Panicali, *Orologi e orologiai del rinascimento italiano, la scuola urbinate* (Urbino, 1988). A recent assessment of Bellori's scholarship is Janis Bell, "Introduction," in Janis Bell and Thomas Willette, eds., *Art History in the Age of Bellori: Scholarship and Cultural Politics in Seventeenth-Century Rome* (Cambridge and New York, 2002), 1–52. Bellori's account of Barocci's preparatory method is analyzed and critiqued in Pillsbury and Richards, 1978, 7–10. See further Thomas McGrath, "Federico Barocci and the History of *Pastelli* in Central Italy," *Apollo* (November 1998): 3–9.

4 For the duke's diary entry, see Ch. 4, n. 39. Bellori, 1976, 199, had written: "giungesse all'ultima vecchiezza . . . con l' acume della vista tanto perspicace, che non adoperò mai occhiali, e hebbe ogni senso intiero." While Bellori's sentence seems remarkably informed, the duke's precise reference concerning his painter's age corrects Bellori's assumption, ibid., that Barocci lived to the age of 84. For questions about Barocci's birthdate and the reading of the diary text, see Ch. 4, n. 39, and Intro. n. 1.

5 See Ch. 5, n. 51.

6 Verstegen, 2001, 167–74, began to reflect on the question of music and discussed in particular some of those in Barocci's milieu who might have inflected his understanding of and views on music.

7 There is a large literature on these portraits. A recent review concludes that the portraits represent Venice's leading composers: Luigi Beschi, "L'immagine della musica in Paolo Veronese: una proposta per la lettura del concerto delle *Nozze di Cana*," *Imago Musicae* XVI/XVII (1999/2000): 171–91. According to Beschi (176), the identification of the portraits as those of Titian, Veronese, Jacopo Bassano, and Tintoretto first occurs in Marco Boschini's *Le ricche minere della pittura veneziana* (Venice, 1674), 61. In the eighteenth century, Anton Maria Zanetti claimed that he had seen documents at the monastery of San Giorgio Maggiore that confirmed the identifications but these have never come to light; Beschi therefore deems the assertion suspicious. Beschi's re-identification of the portraits, while intriguing, does not seem more convincing visually than the traditional identifications.

8 E. Scatassa, "Chiesa del Corpus Domini in Urbino," *Repetorium für Kunstwissenschaft*, XXV, no. 1 (1902): 438–46. See Fontana, 1998, 20–21 n. 27 and 36–7 n. 74, for the dating of the *Saint Cecilia*.

9 See Marzia Faietti, "La trascrizione incisoria," in *L'Estasi di Santa Cecilia di Raffaello da Urbino nella Pinacoteca Nazionale di Bologna* (Bologna, 1983), 186–205; see also Roger Jones and Nicholas Penny, *Raphael* (New Haven and London, 1983), 152. An extended iconographic comparison is undertaken in Thomas Connolly, *Mourning into Joy: Music, Raphael, and Saint Cecilia* (New Haven and London, 1994), 238–61. The sources for Barocci's painting are treated in Emiliani, 1985, vol. 1, 5, and Turner, 2000, 17.

10 For vocal and instrumental music, see Stanislaw Mossakowski, "Raphael's 'Saint Cecilia': An Iconographical Study," *Zeitschrift für Kunstgeschichte* 31 (1968): 1–26, esp. 4–5. The association of certain instruments with elevated or base qualities, and with Apollonian or Dionysiac music, is addressed at length in *Imago Musicae* VII (1990), esp. in Nicoletta Guidobaldi, "Images of Music in Cesare Ripa's *Iconologia*," 41–68, and Nico Staiti, "Satyrs and Shepherds: Musical Instruments within Mythological and Sylvan Scenes in Italian Art," 69–114. NB: the iconography of particular instruments in the sixteenth century, while often significant, can be inconsistent.

11 For the lira da braccio, see Sterling Scott Jones, *The Lira da Braccio* (Bloomington and Indianapolis, 1995), and Emanuel Winternitz, "The Lira da Braccio," in Winternitz, *Musical Instruments and their Symbolism in Western Art* (New Haven and London, 1967, reprint 1979), 86–99. The instrument in Raimondi's engraving is rendered schematically; it might be a vielle, because the drone strings characteristic of the lira are not clearly depicted, but given the date of the engraving and the esteem in which the lira da braccio was then held, the lira seems the more likely choice. Raphael's Apollo in the *Parnassus* plays a lira in preference to the *all' antica* lyre that appears in a Raimondi print of the *Parnassus* often held to record (like Raimondi's *Saint Cecilia* print) a preliminary stage in the design of a Raphael composition (see Emanuel Winternitz, "Musical Archaeology in the Renaissance in Raphael's *Parnassus*", in ibid., 185–202).

12 For the drawing, identified as Barocci's by Cristel Thiem, see Harald Olsen, "Ein Kompositionsskizze von Federico Barocci," *Jahrbuch der Staatlichen Kunstsammlungen in Baden-Württemberg*, VI (1969): 49–54.

13 The Magdalen was associated with both music and dance before her conversion; see H. Colin Slim, "Mary Magdalene, Musician and Dancer," in his *Painting Music in the Sixteenth Century: Essays in Iconography* (Aldershot and Burlington, 2002), 460–73 (first published 1980). She could also be associated with music after her conversion; see e.g. Nico Staiti, *Le Metamorfosi di santa Cecilia: l'immagine e la musica* (Innsbruck and Lucca, 2002), 43–7. The "bacchic" image of some saints (occasionally, of angels) had numerous antecedents in fifteenth-century *all'antica* religious imagery; see Louis Marin, "The Iconic Text and the Theory of Enunciation: Luca Signorelli at Loreto (c. 1479–1484)," in Marin, *L'Opacité de la peinture: essais sur la representation au Quattrocento* (Florence, 1989), 15–49 (first published 1983). Marin also raised issues concerning the representation of music through vision and music's relation to sight, themes that will become fundamental to the discussion below.

14 Connolly, 1994, 253–5, argues that Raphael's saint does not primarily contemplate the music of the angelic singers (or even look at them) but rather sees a vision of heaven which we are not privileged to discern. It was frequently asserted in the period that vision was the primary or superior sense; see e.g. ibid. and Baxandall, 1972, esp. 103–8, 153. Connolly notes that Dante's ascent in the *Paradiso* takes him through the glorious sounds of heavenly music to the final beatific vision, in which sound falls silent and is replaced by sight; that this was an easily accessible, vernacular celebration of music and vision and a powerful "picture" of the ultimate superiority of the visual, may have been important for Barocci. Leonardo also stressed the superiority of the visual in his *paragone* of poetry, painting, and music: see further below. The trumpet and viol as in Barocci's drawing were rarely if ever played together; I thank Bob Kendrick for clarifying this. Their principal valences here, then, must be symbolic.

15 For the *Madonna di San Simone* see Emiliani, 1985, vol. 1, 44–57. For the identity of the patrons, see Ch. 3, n. 1.

16 For the contract (transcribed in Pillsbury and Richards, 1978, 26–7) see Ch. 2, n. 33.

17 Quoted in Winternitz, 1979, 75 (trans. adapted); Marin Mersenne, *Harmonie universelle* (Paris, 1636–7), 211–12: "Si les hommes de condition touchoient ordinairement la Symphonie, que l'on nomme *Vielle*, elle ne seroit pas si mesprisée qu'elle est, mais parce qu'elle n'est touchée que par les pauvres, & particulierement par les aveugles qui gaignent leur vie avec cet instrument, l'on en fait moins d'estime . . ."

18 For the association of shawms and other instruments with shepherds and for *Nativities* in which shepherds do not play their instruments, see Staiti, 1990, and Staiti, "Identificazione degli strumenti musicali e natura simbolica delle figure nelle 'adorazioni dei pastori' siciliane," *Imago Musicae* v (1988): 75–107. Shawms were part of court and city culture as well; their loud tone was well suited to dance music and fanfares. Here, however, they were played by professionals and Castiglione argues that courtiers should play stringed instruments but avoid wind instruments, "quelli che Minerva refiutò ed Alcibiade, perché pare ch' abbiano del schifo"; Baldassare Castiglione, *Il Libro del cortegiano*, ed. Walter Barberis (Turin, 1998), 138. Minerva discarded her *auloi* because they distorted her face.

19 Most scholarship on painting–music relations in the sixteenth century has focused on iconography. A notable exception was published after I had drafted this chapter: Michael Cole, "Harmonic Force in Cinquecento Painting," in *Animationen / Trangressionen: Das Kunstwerk als Lebewesen*, ed. Ulrich Pfisterer and Anja Zimmermann (Berlin, 2005), 73–94. Cole stresses that likening art to music underscored the affective powers of the visual. See also Suthor, 2004, 115–64, for extensive discussion of Titian and music, and consideration of the analogy between painting and music in early modernity.

20 Sohm, 2001, 138–9, notes that Castiglione describes the styles of musical performers and then proceeds immediately to discuss the style of painters. Sohm's stress on the "performative" aspects of painting and particularly music in sixteenth-century discussions of style is fundamental; however, the period drew no absolute distinction between composer and performer. Marchetto Cara, e.g., noted for the "plaintive sweetness" of his singing by Castiglione (Sohm, 139), was also a famed composer of secular songs, often plaintive love songs: see William F. Prizer, *Courtly Pastimes: The Frottole of Marchetto Cara* (Ann Arbor, Mich., 1980).

21 The point is equally valid whether one sees the figures as portraits of painters or of composers, who were, after all, usually skilled performers on a variety of instruments. See n. 7 on the identity of the musicians in Veronese's painting. Pino's statement is discussed by John Gage, *Color and Culture: Practice and Meaning from Antiquity to Abstraction* (London and Boston, 1993), 230. For the text, see Pino, 1960–62, 107: "Cotesto operare è pratica, il qual atto non merta esser detto mecanico,

imperò che l'intelletto non può con altro meggio che per gli sensi intrinseci isprimere e dar cognizione della cosa ch'egli intende. . . . Et avenga ch'alcuni dicano l'operar esser atto mecanico per la diversità de' colori e per la circonscrizzione del pennello, così nel musico alciando la voce, dimenando le mani per diversi istromenti, nondimeno tutti noi siamo liberali in una istessa perfezzione." Barocchi notes similar arguments in Varchi, 1960–62, 405. In the context of Pino's analogy between painters and musicians, his description of painting's "operar" as "la diversità de' colori e . . . la circonscrizzione del pennello" sounds close to Bellori's "come la melodia delle voci diletta l'udito, così ancora la vista si ricrea dalla consonanza de' colori accompagnata dall'harmonia de' lineamenti."

22 See Katherine A. McIver, "Maniera, Music, and Vasari," *The Sixteenth Century Journal*, XXVIII (Spring 1997): 45–55 (Garofalo's self-portrait is fig. 1, 49). For the viol at court and as a preferred instrument of amateur, "gentlemanly" music-making, see Ian Woodfield, *The Early History of the Viol* (New York and Cambridge, 1984), esp. 182–90. For Castiglione and the courtier and music, see James Haar, "The Courtier as Musician: Castiglione's View of the Science and Art of Music," in Haar, *The Science and Art of Renaissance Music*, ed. Paul Corneilson (Princeton, 1998), 20–37; first published in Robert W. Hanning and David Rosand, eds, *Castiglione: The Ideal and the Real in Renaissance Culture* (New Haven, 1983), 165–89. McIver, 54–5, discusses Vasari and color "harmony" and the number of artists he associates with music. Leonardo had already made much of the relation between pictorial and musical harmonies; see below and n. 42. Suthor, 2004, 116–19, stresses Vasari's particular importance in the articulation of associations between pictorial color and music.

23 For analysis of the *Madonna del Popolo*, see Ch. 2. Dempsey, 1982, and Williams, 1997, 85–100, offer nuanced discussions of the decorum of religious pictures in the late sixteenth century.

24 See Ch. 5, n. 51.

25 See James Haar, *Essays on Italian Poetry and Music in the Renaissance, 1350–1600* (Berkeley, 1986), and Claude V. Palisca, *Humanism in Italian Renaissance Musical Thought* (New Haven and London, 1985), esp. 333–433, with further bibliography.

26 See Staiti, 1990. Howard Mayer Brown, *Sixteenth-Century Instrumentation: The Music for the Florentine Intermedii* (American Institute of Musicology, 1973), touches on some of these issues; see e.g. 57, describing a chorus of shep-

herds and shepherdesses joined by bagpipes in the 1586 Florentine *intermedii*. Brown's appendices concerning the instrumentation of the *intermedii* make clear the flexibility of instrumentation. However, a character such as Apollo usually appears accompanying himself on the *lira* (e.g. Appendices III. A2, 95, and III. F.1, 96) or the figure of "Harmony" who opens the famed 1589 *Intermedii* for the Wedding of Ferdinand I de' Medici to Christine of Lorraine sings to bass lutes and *chitarroni* and is followed by a chorus of the Sirens who guide the celestial spheres, accompanied by harp, lute, lira da braccio, and viol (Appendices VII. A1, A2, 108).

27 Castiglione, 1998, 137 (trans. mine): "Ma sopra tutto parmi gratissimo il cantare alla viola per recitare; il che tanto di venustà ed efficacia aggiunge alle parole, che è gran maraviglia." The "viola" could be a viol or a lira da braccio. As Castiglione had specified earlier in the paragraph that singing songs from a part-book or to viol (lira) accompaniment makes for excellent music, his particular praise for "il cantar alla viola per recitare" seems to indicate a poetic recitation, in a period attempt to imitate concepts of ancient spoken/chanted "bardic" poetry with accompaniment. The specification of the instrument includes but goes beyond the realm of iconography. Strings were often considered "higher" instruments than winds, certainly; but Cole, 2005, 89 and 93–4 n. 47, notes further the possibility of analogies between the heart (*cordis*) and the strings of instruments, the music of which "could entwine the listener."

28 Vincenzo Borghini, "Selva di notizie" (1564), Florence, Kunsthistorisches Institut, Ms. K 783 (16); excerpts transcribed in *Scritti d'arte*, 1971–7, vol. I, 648: "Ora io dico che nella pittura è una parte ch' in certo modo corrisponde a questa [vocal music] . . . (parlo dove è istoria, come de' poeti dove era poema, e non di una figura sola): questo è un'armonia, una composizione, un'atta et accomodata disposizione delle parti l'un' co l'altra, talché non si dien noia fra loro e faccin el tutto ben disposto e composto, non confuso et aviluppato, e come le voci alte e basse composte insieme con ragione e con regola fanno una dolcissima armonia e consonanzia, così nella composizione della tavola vi sia una composizione delle cose grandi colle piccole, delle cose lontane colle dapresso, che ne risulti una consonanzia et armonia piacevolissima a l'oc[c]hio . . ." Borghini's language here is close to much in period music theoretical discourse. It should be noted that the passage stands within a discussion of poetry and painting.

29 Ibid., 649–50; for Fra Francesco's letter, see Ch. 4, n. 39. Borghini calls for "una gentile e discreta distribuzione delle figure e delle cose in una tavola; le quali saranno disposte in modo che l'una figura non impedisca o noì l'altra, né una alzi il braccio che cuopra il viso a una figura principale, e simil cose, et in soma ch'e' non paia il pittore aver gittate le figure in sulla sua tavola come getta il contadino che semina a ventura il grano nel campo, ma sien poste con giudizio, con regola e con grazia. E di tutte queste cose insieme ne nasce un'armonia e musica, dirò così, pittoresca, la quale dove non si troverrà, ancor che per altro le figure particulari sien bone, la pittura o la tavola non si dirà buona lei, perché gli mancherà la sua principal parte . . ." Cole, 2005, 77–80, offers a number of insights into the affective potential of careful figural composition and its relations to music; in this regard, Bellori's assertion that Barocci specified musical analogies for painting both in color and in the *lineamenti* is important.

30 Borghini, in *Scritti d'arte*, 1971–7, 648–9, is particularly interested in perspective and spatial effects and recognizes the contributions of both *disegno* (proper proportioning of pictorial elements in space) and *colore* (on which he does not elaborate but by which he appears to mean the adjustment of color and light in atmospheric perspective to aid in registering relative distance). Despite recognizing a role for *colore* in an *ut pictura musica*, Borghini, perhaps predictably for a Florentine intellectual, decisively privileges *disegno*. In the *Madonna del Popolo*, Barocci obviously makes use of both skills in equal measure.

31 See further the Conclusion and Lewis Lockwood, ed., *Giovanni Pierluigi da Palestrina: Pope Marcellus Mass* (New York, 1975). Of course, musical motifs tended not to have the specific narrative significance of many visual gestures. The analogies I am advancing should not be pushed too far and I would not wish to imply that every musical motif in a successful piece carried forward the "*istoria*" of the words in a manner analogous to Barocci's representation of gesture. Against such an oversimplification one could immediately point out that many Masses (though not the *Pope Marcellus*) were based on motifs from popular songs, which seems to fit ill with the "point" of the sacred music. It would be incorrect to conclude, however, that such musical motifs were always meaningless and their potential ability to sway listeners should not be discredited, particularly if several period reformers and theorists are to be believed (see the Conclusion, esp. at n. 15 for

further discussion). For more discussion of the affecting power of various musical devices, see below.

32 See e.g. the *Deposition* (fig. 85), the Senigallia *Entombment* (fig. 83), the *Visitation* (fig. 77), and the Urbino *Last Supper* (fig. 134), a partial list with only some of the obvious examples. For an extended "musical reading" of an individual painting, the Vatican's *Rest on the Return from Egypt* (fig. 181), see the Conclusion.

33 For the modes and *genera* (diatonic, chromatic, and enharmonic) see most recently Claude Palisca, "Humanist Revival of the Modes and Genera," in Palisca, *Music and Ideas in the Sixteenth and Seventeenth Centuries*, ed. Thomas J. Mathiesen (Urbana and Chicago, 2006), 71–98; see also Palisca, 1985, esp. 37–8, 280–333; Anne E. Moyer, *Musica Scientia: Musical Scholarship in the Italian Renaissance* (Ithaca, N.Y., and London, 1992); and for a detailed study of the technical and expressive issues, Karol Berger, *Theories of Chromatic and Enharmonic Music in Late 16th-Century Italy* (Ann Arbor, Mich., 1980). Berger, and Palisca, 1985, 377–96, discuss some late sixteenth-century attempts to create pieces that adhered closely to theories of expression then being articulated. Castiglione, 1998, 100, already stressed the remarkable affecting power of music: "Per il che se scrive Alessandro alcuna volta esser stato da quella [the power of music] cosí ardentemente incitato, che quasi contra sua voglia gli bisognava levarsi dai convivii e correre all'arme; poi, mutando il musico la sorte del suono, mitigarsi e tornar dall'arme ai convivii."

34 The full text is given in C. Jouanny, ed., *Correspondence de Nicolas Poussin*, Archives de l'Art Français, n.p., vol. v (Paris, 1911), 370–75, trans. in Blunt, *Nicolas Poussin*, 2 vols. (New York, 1967), vol. I, 367–70. The differences between the ancient Greek modes and the medieval ecclesiastical modes were not always clearly understood in Renaissance musical theory; it was specifically in the work of some late sixteenth-century theorists devoted to the "renaissance" of the principles of ancient music that the distinctions were explored carefully and expressed insistently; see Palisca, 1985, 280–332.

35 See Gavel, 1979, 154; for more on Lomazzo on color, see Ch. 8.

36 See Leslie Korrick, "Lomazzo's *Trattato . . . della pittura* and Galilei's *Fronimo*: Picturing Music and Sounding Images in 1584," in *Art and Music in the Early Modern Period: Essays in Honor of Franca Trinchieri Camiz*, ed. Katherine A. McIver (Aldershot and Burlington, 2003), 196 and 210 n. 13, for Lomazzo and the argu-

ment for late sixteenth-century antecedents to Poussin's formulation.

37 Both texts are quoted by Sohm, 2001, 130 (I have adjusted the translation of Poussin's *ton* to "mode" rather than "key" as the usual modern concept of key developed after Poussin wrote). The letter is dated March 24, 1647: "je le prie de croire que je ne suis point de ceux qui en chantant prennent toujours la même ton, et que je sais varier quand je veux." Andre Félibien, *Entretiens sur les vies et sur les ouvrages des plus excellens peintres anciens et modernes*, 6 vols. (Trevoux, 1725), vol. IV, 116.

38 Gioseffo Zarlino, *The Art of CounterPoint: Part Three of Le Istitutioni Harmoniche, 1558*, trans. Guy A. Marco and Claude V. Palisca (New Haven and London, 1968), 19; Italian in Gioseffo Zarlino, *Le Istitutioni harmoniche* (Venice, 1558; facsimile ed. New York, 1965), 155: "E tanto più sono vaghe, quanto più si partono dalla semplicità, della quale i nostri sentimenti non molto si rallegrano . . . poi che amino maggiormente le cose composte, che le semplice. Per la qual cosa intraviene all'Udito intorno li suoni, udendo le consonanze prime, quello che suole intravenire al Vedere intorno a i principali colori, de i quali ogn'altro color mezano si compone: che si come il Bianco, e il Nero li porgono minor diletto, di quello che fanno alcuni altri colori mezani, e misti; cosi porgono minor diletto le consonanze principali, di quello che fano le altre, che sono men perfette." A recent discussion of Poussin's letter, its relation to Zarlino, and its ideas is Sohm, 2001, 134–43; see also Elizabeth Cropper, *The Ideal of Painting: Pietro Testa's Düsseldorf Notebook* (Princeton, 1984), 137–46.

39 See Ch. 8 for color modes; n. 19 for Lomazzo's remark. Suthor, 2004, 144–5, reads Zarlino's association of subtly mixed colors with *vaghezza* particularly in terms of the indefinable qualities of such tones. Here the shifting, indeterminate quality of sophisticated color mixing provokes pleasure and stimulates what Dolce (see ibid., 146) would identify as an insatiable desire to look.

40 See esp. Palisca, 1985, esp. 1–22. I do not wish to imply that proportional analogies, which after all were not mere abstractions but were fundamental to the notion of music as an image of cosmic organization, simply faded away. Pythagorean ideals of absolute proportion still exerted considerable influence in the work of Zarlino; the period from the 1550s to the 1580s might best be described as holding the different theoretical positions in an increasingly tense "harmony"; see e.g. Moyer, 1992, esp. 202–24. Even the color intervals that could be seen as analogous to those of music

might be conceived in Pythagorean terms, as with Arcimboldo; see below, n. 41.

41 See esp. Austin Caswell, "The Pythogoreanism of Arcimboldo," *Journal of Aesthetics and Art Criticism* 39 (Winter 1980): 155–61, and Gage, 1993, 230–31. Arcimboldo's interest is recorded in Gregorio Comanini's *Il Figino overo del fine della pittura* (1591), in *Trattati d'arte del cinquecento*, ed. Paola Barocchi, 3 vols. (Bari, 1960–62), vol. III, 237–379.

42 Leonardo da Vinci had implicitly connected such an enterprise to painting when he investigated the creation of a *glissando* flute capable of infinite modulations of pitch. One might term this quality "aural *sfumato*"; if painting could represent an infinite range of color and light and shade, Leonardo may have reasoned, music must advance beyond intervals so distinct that they were the equivalent of harsh, unmodulated coloring and approach the infinite pitch flexibility of the human voice itself. Needless to say, Leonardo was a polemical proponent of painting as superior to music, a distinctive position; see further below. For Leonardo's creation of the *glissando* flute see Emanuel Winternitz, *Leonardo da Vinci as a Musician* (New Haven, 1982), 192–3. Daniel Arasse, *Léonard de Vinci: le rythme du monde* (Paris, 1997), 222, invents the term "*sfumato sonore*." For the madrigal and modality, see Susan McClary, *Modal Subjectivities: Self-Fashioning in the Italian Madrigal* (Berkeley, 2004); 11–37 provide an introduction to issues concerning modes in late sixteenth-century music. See also the review by Anthony Newcomb in *Journal of the American Musicological Society*, 60 (2007): 201–17; 210–17 fault aspects of the book and offer significant further bibliography on modality in the madrigal, while assessing McClary's fundamental contentions as "utterly convincing." See also Palisca, 2006: "The Poetics of Musical Composition" (49–70); "Humanist Revival of the Modes and Genera" (71–98); and "Theories of the Affections and Imitation" (179–202).

43 Adrian Petit Coclico, *Compendium musices* (Nürnberg, 1552), cited in Annette Otterstedt, *The Viol: History of an Instrument*, trans. Hans Reiners (Kassel, 2002), 193. Coclico notes that his teacher Josquin instructed pupils in the art of ornamenting through diminution (adding fast passages and leaps between the written notes of a musical line), indicating that the taste for such play characterized the most avant-garde music early in the century. In the second half of the century, the bass viol became one of the leading instruments for this sort of virtuosity.

44 Ibid., 196, citing Silestro Ganassi, *Opera intitulata Fontegara* (Venice, 1535), ch. 2: "Adunque la galanteria vivace e augmentata sara quella che fara il variare duna terza o piu o manco . . . la suave over placabile sara quella che variara uno semituono." Ganassi's treatise is the first known Italian text on virtuoso recorder playing; Ganassi also wrote a critical early treatise on the viola da gamba. See P. Artuso, "Ganassi, Silvestro," *Dizionario Biografico degli Italiani* (Rome, 1999), vol. LII, 135–6. Ganassi is mentioned by both Dolce and Pino, who assert that he painted "commendably" as well as being a remarkable musician (an intriguing mirror to the excellent painter who was also a fine amateur musician). For discussion see Dolce, in Roskill, 2000, 240.

45 Nicola Vicentino, *Ancient Music Adapted to Modern Practice*, ed. Claude Palisca and trans. Maria Rika Maniates (New Haven and London, 1996), 270. For notes on Vicentino's career, association with the d'Este, and theoretical positions, see Maniates's introduction, xi–lxiii. For the Italian, see Nicola Vicentino, *L'Antica musica ridotta alla moderna prattica* (Rome, 1555), facsimile ed. Edward Lowinsky (Basel, London, and New York, 1959), 86r: "perche la musica fatta sopra parole, non è fatta per altro se non per esprimere il concetto, e le passioni e gli effetti di quelle con l'armonia." Palisca, 2006, 179–202, revisits these issues in "Theories of the Affections and Imitation."

46 Vicentino, 1996, 149–50; Italian, Vicentino, 1959, 48r: "cosi avviene al compositore di Musica, che con l'arte puo far varie commistioni, di Quarte, e di quinte d'altri Modi, et con varij gradi adornare la compositione proportionate secondo gli effetti delle consonanze applicati alle parole."

47 Vicentino, 1996, 150; Italian, Vicentino, 1959, 48r: "come faranno sonnetti, Madrigali, ò Canzoni, che nel principio, intraranno con allegrezza nel dire le sue passioni, e poi nel fine saranno piene di mestitia, e di morte, e poi il medesimo verrà per il contrario; all'hora sopra tali, il Compositore potrà uscire fuore dell'ordine del Modo, e intrerà in un'altro, perche non havrà obligo di rispondere al tono, di nissun Choro, ma sarà solamente obligato à dar' l'anima, à quelle parole, e con l'armonia di mostrare le sue passioni, quando aspre, e quando dolci, e quando allegre, e quando meste, e secondo il loro suggietto; e da qui si caverà la ragione, che ogni mal grado, con cattiva consonanza, sopra le parole si potrà usare, secondo i loro effetti, adunque sopra tali parole si potrà comporre ogni sorte de gradi,

e di armonia, e andar fuore di Tono e reggersi secondo il suggietto delle parole . . ."

48 Vicentino, 1996, vii.

49 Gioseffo Zarlino, *On the Modes: Part Four of Le Istituzioni Harmoniche, 1558*, ed. Claude Palisca and trans. Vered Cohen (New Haven and London, 1983), 95. Zarlino, 1965, 339: "Et debbe avertire di accompagnare in tal maniera ogni parola, che dove ella dinoti asprezza, durezza, crudeltà, amaritudine, e altre cose simili, l'harmonia sia simile a lei, cioè alquanto dura, e aspra; di maniera però, che non offendi. Simigliantemente quando alcuna delle parole dimostrarà pianto, dolore, cordoglio, sospiri, lagrime, e altre cose simili; che l'harmonia sia piena di mestitia." For the distortion of mode in madrigals for expressive effect, see McClary, 2004, and 113–19 for an analysis of Cipriano da Rore's *Mia benigna fortuna*, from his second book of madrigals, 1557.

50 Viardot, "Ut Pictura Musica," 26, advances just such an argument when he sketches the historical and regional development of European painting and music since the Middle Ages and concludes: "C'est dans les contrées méridionales, en Italie et en Espagne, que la peinture semble ne pouvoir se passer des actions humaines, et qu'aussi la musique semble ne pouvoir se passer de la voix et du geste de l'homme; que toute peinture est histoire ou portrait, et toute musique chant ou danse. Et c'est, au rebours, dans les pays du nord, l'Allemagne et les Flandres, que l'art de peindre s'attache indifféremment à tous les objets que la nature offre à son imitation, pouvant même se passer de l'être humain, et qu'aussi la musique, pouvant se passer du chant des voi et du mouvement des danses, entre dans le domaine plus vaste et plus libre de l'instrumentation." For translation and discussion see Andrew Kagan, "Ut Pictura Musica, I: to 1860," *Arts Magazine*, LX (May 1986): 91. Viardot, 25, noted that "la musique instrumentale" was particularly the arena in which "l'expression des passions humaines cède la place au caprice intime et personnel du compositeur, où l'art des sons devient plus libre de toutes conditions, de tous liens et de toutes règles."

51 *Codex Urbinas*, cited in Farago, 1992, 197; Italian, 196: "La pittura serve a più degno senso che la poesia, e fa con più verità le figure de l'opere de natura ch'el poeta. Et è molto più degne l'opere de natura che' lle parole, che sono hopera de l'homo perché tal proportione è da l'hopere de li homini a quelle della natura qual è quella che è da l'homo a Dio. Adonque è più degna cosa l'imitare le cose di natura, che è le vere similtu-

dini in fatto che con parole imitare li fatti e parole de gli homini. Et se tu, poeta, voi descrivere l'hopere de natura cola tua semplice professione, fingendo diversi siti e forme de varie cose, tu sei superato dal pittore con infinita proportione di potentia." The *Codex Urbinas*, compiled around the mid-sixteenth century, is first recorded in an inventory of the books of Duke Francesco Maria II della Rovere drawn up in 1631 after the Duke's death; see ibid., 160. It remains unknown when the manuscript might have entered the library of the dukes but it is tempting to believe that Barocci knew it. Francesca Fiorani, in particular, would argue that aspects of Barocci's coloring point to some knowledge of the text and I would add that Leonardo's *paragone* is particularly suggestive for what we can divine of Barocci's *ut pictura musica*. I thank Professor Fiorani for a stimulating discussion on Barocci and Leonardo.

52 Farago, 1992, 219; Italian, 218: "Ma della poesia, la qual s'habbia a stendere alla figuratione d'una predetta bellezza con la figuratione particulare di ciascuna parte, della quale si compone in pittura la predetta armonia, non ne rissulta altra gratia che si faccessi a far sentire nella musicha ciascuna voce per sè sola in vari tempi, delle quali non si componerebbe alcun concento. Come se volessimo mostrare un volte a parte a parte, sempre ricoprendo quelle che prima si mostrano, delle quali dimostrationi l'obblivione non laccia comporre alcuna proportionalita d'armonia perché l'occhio non le abbraccia con la sua virtu vissiva a un medesimo tempo. Il simile accade nelle bellezze di qualonque cose finta dal poeta, le quali, per essere le sue parti dette separatamente in separati tempi, l' memoria non ne ricceve alcuna armonia." The notion that music's ability to sound more than one part or voice at a time makes it superior to poetry and similar to painting is a conceit which Leonardo repeatedly employed.

53 Ibid., 241, slightly altered; Italian, 240: "La Musica non è da essere chiamata altro che sorella della pittura con ciò sia ch'essa è subbietto dell'audito, secondo senso a l'occhio, e compone armonia con le congiontioni delle sue parti proportionali operate nel medessimo tempo. . . . Ma la pittura eccelle e signoreggia la Musica, perch'essa non more imediate dopo la sua creatione, come fa la sventurata musica, anzi resta in essere, e ti si dimostra in vitta quel che infatto è una sola superfitie. O maravigliosa scientia, tu risservi in vitta le caduche belezze de mortali! Le quali hanno più permanentia che l'opere de natura, le quali

al continuo sonno variate dal tempo . . ." Leonardo's assumption that vision is superior to hearing is fundamental for his elevation of painting above both poetry and music and is restated numerous times, e.g. 208, "L'occhio, che si dice finestra de l'anima, è la principal via donde il commune senso pò più coppiosa et magnificamente considerare le infinite opere de natura, et l'orecchio è il secondo, il quale si fa nobbile per le cose raconte le quali ha veduto l'occhio."

54 Leonardo in ibid., 222.

55 Ibid., 249; Italian, 248: "E per questo il poeta resta in quanto alla figuratione delle cose corporee molto in dietro al pittore, et delle cose invissibili rimane indietro al musico." See also Winternitz, 1982, 218.

56 See e.g. Gilio, 1960–62, 18–19, and Paleotti, 1960–62, 425–52. The range of attitudes to *grotteschi* is discussed in Nicole Dacos, *La Découverte de la Domus Aurea et la formation des grotesques à la renaissance* (London and Leiden, 1969), 121–35; see also André Chastel, *La Grottesque* (Paris, 1988), Philippe Morel, *Les qrotesques: les figures de l'imaginaire dans la peinture italienne de la fin de la renaissance* (Paris, 1997), esp. 115–22, and Hellmut Wohl, *The Aesthetics of Italian Renaissance Art: A Reconsideration of Style* (Cambridge and New York, 1999), 212–21.

57 A few male figures – Christ on the Cross, San Vitale, and San Lorenzo – inevitably appeared in loincloths, as expected. See Ch. 6 for Barocci's negotiation of the issues of figural *vaghezza* in his mature work.

58 For color see Paleotti, 1960–62, 218, 228, and esp. 500; see Ch. 8 for more disussion. The passage on the office of the painter is on 408: "essendo l'officio del pittore l'imitare le cose nel naturale suo essere e puramente come si sono mostrate agli occhi de' mortali, non ha egli da trapassare i suoi confini, ma lasciare a' teologi e sacri dottori il dilatare ad altri sentimenti più alti e più nascosti."

59 Philostratus, *Life of Apollonios of Tyana*, trans. F. C. Conybeare (Cambridge, Mass., 1912), VI: 19. Krüger, 2001, 177–80, explores implications of Philostratus's assertion in Alberti and early modern artistic theory. See also the extensive discussion of mimesis and fantasia in Stephen Campbell, "'*Fare una cosa morta parer viva*': Michelangelo, Rosso, and the (Un)Divinity of Art," *The Art Bulletin* 84 (December 2002): 596–620. Campbell, 615 n. 15, points to the long tradition of such claims for painting in the period. Paolo Pino, for instance, stresses "la pittura è propria poesia, cioè invenzione, a qual fa apparere quello che non è"; Pino, 1960–62, 115.

Conclusion

1 Bellori, 1976, 203: "Per lo Duca Guidobaldo padre di Francesco Maria colorì un quadretto da camera, con la Vergine che si riposa dal viaggio d'Egitto: siede, e con la tazza prende l'acqua da un rivo che sorge, mentre San Giuseppe abbassa un ramo di pomi, porgendone à Giesù Bambino, che ride, e vi stende la mano. Questo fù mandato in dono alla Duchessa di Ferrara; e perche l'inventione piacque, ne replicò alcuna altra, e una ne dipinse à guazzo grande al naturale, che dal Conte Antonio Brancaleoni fù mandato alla Pieve del Piobbio [*sic*] suo castello." English (adapted) in Pillsbury and Richards, 1978, 23. The "Duchess of Ferrara," Lucrezia d'Este, was actually the sister of the Duke of Ferrara and became Duchess of Urbino on her marriage to Francesco Maria II. Bellori appears to mistake the cherries for apples. However, it should be noted that two prints that document the original version, in which Christ kneels – the Raffaello Schiaminossi engraving of 1612 (reproduced Olsen, 1962, fig. 122b) and an anonymous chiaroscuro woodcut (reproduced Pillsbury and Richards, fig. 80) – both seem to show Christ with an apple as well as cherries. Bellori was probably consulting these prints; see further below, nn. 4 and 27. The first replica mentioned is assumed by Pillsbury and Richards to be the painting now in the Vatican.

2 For Duke Guidobaldo's patronage strategies and his late interest in Barocci's work, see Fontana, 2007, and Lingo, 2007.

3 Bellori, 1976, 201: "E perche egli dormiva pochissimo, la sera in casa sua nella stagione del verno, si faceva adunanza de'principali, e virtuosi della Città, dove si vegliava fino alle otto hore della notte." For Anastagi, see Giovanna Sapori, "Rapporto preliminare su Simonetto Anastagi," *Ricerche di storia dell'arte* 21 (1983): 77–85.

4 For discussion of the issues, focused on Correggio's *Madonna della Scodella*, see David Ekserdjian, *Correggio* (New Haven and London, 1997), 222–5. For the Pseudo-Matthew, see Jan Gijsel, ed., *Pseudo-Matthaei Evangelium textus et commentarius*, in *Corpus Christianorum: Series Apocyphorum*, vol. IX (Turnhout, 1997), 458–67. For Borghini's description of the painting, Borghini, 1967, vol. I, 569: "e al Signor Duca Guidobaldo un quadretto entrovi la Vergine gloriosa, che torna d'Egitto, e detto Signore il donò alla Duchessa d'Urbino, e hoggi si trova in Ferrara." In Correggio's *Madonna della Scodella*, the Child is clearly not the infant of the *Flight*. In the Barocci this distinction is less

clear. However, his Child appears older than the infants often depicted in Flights into Egypt. Christ is certainly cognizant and active; in the original invention, as seen in Schiaminossi's 1612 engraving (see n. 1) and the chiaroscuro woodcut (see Pillsbury and Richards, 1978, 108–9, for discussion and reproduction), he kneels to receive the fruit from Joseph and presents it to the Virgin with courtly grace and decorum. One can imagine the appropriateness of such a detail to a ducal commission and a diplomatic gift to another court. It seems telling that the figure of Christ is the most changed in the Vatican and Piobbico revisions. For the *Madonna del Popolo*, the *Immaculate Conception*, and the *Perdono* see Chs 2 and 3.

5 Bellori, in Pillsbury and Richards, 1978, 24; Italian in Bellori, 1976, 206: "Si assomigliò esso in parte al Correggio, ò sia nell'idea, e modo del concepire, ò ne' lineamenti puri, naturali, e nelle arie dolci de'putti, delle donne, nelle piegature de' panni, con maniera sempre facile, e soave." Fontana, 1998, critiques the idea that Correggio's work exercised a formative influence on Barocci. He accepts the *Madonna della Scodella* as relevant for the *Rest* but downplays the extent of Barocci's imitation; see esp. 109–13, 254–7 for the *Rest*; 114–75 for the wider issue of Correggio's influence. I have reached related conclusions concerning the *Rest* while approaching the issue from a different direction. For discussion of the Senigallia *Entombment* and Barocci's response to Michelangelo and Raphael, see Ch. 4.

6 Verstegen, 2003.

7 Barocci was probably unaware that this background was probably painted by Dosso Dossi in collaboration with Raphael; see recently Arnold Nesselrath, "Raphael and Pope Julius II," in Hugo Chapman, Tom Henry, and Carol Plazzotta, eds, *Raphael: From Urbino to Rome* (London, 2004), 288, and Andrea Bayer, ed., *Dosso Dossi: Court Painter in Renaissance Ferrara* (New York, 1998), 61–2.

8 For Leonardo's approach to drawing, Ernst Gombrich, "Leonardo's Method of Working Out Compositions," in *Norm and Form: Studies in the Art of the Renaissance I*, 2nd ed. (London and New York, 1971), 58–63, remains important. Students of Shearman will sense my debt to his understanding of some early sixteenth-century innovations in pictorial composition in my discussion of Leonardo's *Virgin and Child with Saint Anne*. An early drawing, Uffizi 1419E, offers some evidence that Barocci may have seen Michelangelo's *Doni Tondo* during his trip to Florence in the late 1550s; see Fontana, 1997, 474 and fig. 35.

9 Raphael's work contains antecedents of such gestures, and Fontana, 1998, 112, offered the intriguing observation that the figure of Joseph in a print by Bonasone after an invention by Raphael may have stimulated Barocci's thinking as he composed his figure. Bonasone's print was based on a Raphael workshop painting that, as Fontana noted, Barocci may have seen in Rome; see Jürg Meyer zur Capellen, *Raphael: A Critical Catalogue of his Paintings*, trans. and ed. Stefan B. Polter, 2 vols. (Landshut, 2001 and 2005), vol. II, 275–7 for the painting (illustrated 277). Fontana also noted, 254–7, the preservation of the Madonna's gesture "as an anchor" connecting Barocci's composition to Correggio's, and wondered whether Lucrezia d'Este might have had a taste for Correggio and might have appreciated such a quotation in a painting that Barocci evolved away from its Corregesque source in most other respects.

10 Letter of November 12, 1578, in Gualandi, 1844–56, vol. 169–70: "havendo fatto nel opra el doppio di quello che io promisi." See Ch. 2, n. 38.

11 See Ch. 5, n. 43. For all that Lomazzo's comment is applied to a number of diverse painters, it may have more relevance to early perceptions of Barocci's work than modern criticism assumes.

12 Bellori, 1976, 206: "Chiamava però la pittura musica, ed interrogato una volta dal Duca Guidobaldo che cosa e' facesse: sto accordando, rispose, questa musica, accennando il quadro, che dipingeva." For Bellori's reliability on certain points of fact, see the opening of Ch. 9.

13 See Anthony Newcomb, *The Madrigal at Ferrara 1579–1597*, 2 vols. (Princeton, 1980), vol. I, esp. 9–13, 101–3, and *ad indices*.

14 For a selection of late sixteenth- and early seventeenth-century texts, see Lockwood, 1975, 10–32.

15 Vicentino, 1959, 84v, cited in Lockwood, 1975, 17: "perche le Messe, e Psalmi essendo Ecclesiastici, è pur il dovere, che il proceder di quelle sia differente, da quello delle Canzoni Franzese, e da Madrigali, et da Villotte. Avenga che alcuni compositori, compongano, alla riversa del suggetto, della Messa, perche quella vuole il proceder con gravità, e più pieno di devotione, che di lascivia . . ."

16 Bishop Bernardino Cirillo, letter to the philologist and editor Ugolino Gualteruzzi, 1549, cited in Lockwood, 1975, 13.

17 For the statement of the Council of Trent see Tanner, 1990, vol. II, 737 (trans. slightly altered): "And they should keep out of their churches the kind of music in which a lasciv-

ious and impure element is introduced into the organ playing or singing" (Ab ecclesiis vero musicas eas, ubi sive organo sive cantu lascivum aut impurum aliquid miscetur"). For frustration that artifice was compromising musical clarity and affect, see texts such as the letter of Bishop Cirillo, in Lockwood, 1975, 14, on unclear and over-complex imitative writing, and Agostino Agazzari's *Del sonare sopra il basso con tutti gli strumenti*, 1607, excerpted in ibid., 28–9. Agazzari's text offers something of a *précis* of the debates of the previous fifty years. It should be noted, however, that Craig Monson, "The Council of Trent Revisited," *Journal of the American Musicological Society* 55 (Spring 2002): 1–37, points out that the statement at Trent was much reduced during the Council's deliberations and that it is easy to exaggerate period ecclesiastical concerns.

18 Cirillo groups artists here with writers and scientists; ibid., 13.

19 Monson, 2002, has effectively disproved this myth. However, Lockwood, 1975, 29 n. 1, points out that as early as Agazzari's *Del sonare* the story had gained currency. See ibid., 30–32, for other early seventeenth-century assertions that Palestrina "saved" modern sacred music.

20 Bellori, in Pillsbury and Richards, 1978, 18; Italian in Bellori, 1976, 192: "Espose il Barocci le dolci arie bellissime della Vergine, e dell'Angelo: quella in faccia, questi in profilo; l'una spira tutta modestia, e humiltà verginale, gli occhi inclinati, e raccolti semplicemente i capelli sopra la fronte; senza che le accresce decoro il manto di color celeste, spargendosi dal braccio sù l'inginocchiatore à terra." I am not implying that Barocci saw Raphael's *Alba Madonna*; for the patronage and location of this work before it is first documented in 1610 in the church of Santa Maria del Monte Albino south of Naples, see *Raphael: From Urbino to Rome*, 258.

21 See Claude Palisca, "Introduction," in Zarlino, 1968, xiii–xxvi, for Zarlino's position in the musical discourses of the late sixteenth century; xxiv for reprinting and editions. A more recent discussion of Zarlino's position (which notes the influence exerted by *Le Istituzioni* during the late sixteenth and seventeenth centuries, 180) is Cristle Collins Judd, *Reading Renaissance Music Theory: Hearing with the Eyes* (Cambridge and New York, 2000), 179–261. For Baldi's biography of Zarlino, see Bernardino Baldi, *Le Vite de' matematici: edizione annotata e commentata della parte medievale e rinascimentale*, ed. Elio Nenci (Milan, 1998), 542–58; in the opening of the

vita of Zarlino, Baldi asserts that he knows the composer personally and has spoken with him at length: "Né credo di dovere scrivere di lui menzogne, poichè da la bocca sua propria ho inteso gran parte de le cose che appartengono a l'historia sua."

22 Zarlino, 1968, 51–2; Zarlino, 1965, 172; the final of six elements that are necessary to a composition is "che l'harmonia, che si contiene in essa, sia talmente accommodata alla Oratione, cioè alle Parole, che nelle materie allegre, l'harmonia non sia flebile; e per il contrario, nelle flebili, l'harmonia non sia allegra." For Zarlino, the very first requirement of composition is that the composer, like a poet, both instruct and delight. "Cosi il Musico, oltra che è mosso dallo istesso fine, cioè di giovare, e di dilettare gli animi de gli ascoltanti con gli accenti harmonici, hà il Sogetto, sopra il quale è fondata la sua cantilena, laquale adorna con varie modulatione, e varie harmonie, di modo che porge grato piacere a gli ascoltanti."

23 Zarlino, 1968, 126 (adapted), Zarlino, 1965, 212: "Et quantunque, osservando le Regole date di sopra, non si ritrovasse nelle compositioni alcuna cosa, che fusse degna di riprensione, essendo purgate da ogni errore, e limate; ne si udisse in esse, se non buona, e soave harmonia; li mancherebbe nondimeno un non so che di bello, di leggiadro, e di elegante . . ."

24 Zarlino, 1968, 74–5; Zarlino, 1965, 184: "Si è detto di sopra, che l'Harmonia si compone di cose opposte, o contrarie; onde intendendosi etiandio delli Movimenti, che fanno le parti cantando insieme, però si debbe osservare quanto piu si puote (il che non sarà fuori delle osservanze de gli Antichi) che quando la parte sopra laquale si fà il Contrapunto, cioè quando il Sogetto ascende, che il Contrapunto discenda; e cosi per il contrario . . . ancora che non sarà errore, se alle volte insieme ascenderanno, overo discenderanno; per accommodar le parti della cantilena, che procedino con acconzi movimenti. . . . percioche sarebbe un voler legare il Musico senza proposito ad una cosa non molto necessaria, e levargli il modo di procedere con leggiadria, e eleganza, e l'uso insieme del cantare con harmonia: conciosiache, se fusse bisogno di osservare sempre cotal

cosa, non potrebbe (quando gli occorresse) usare il procedere per Fuga, o Consequenza; ilche è molto lodevole in un Compositore; e si usa quando una parte della cantilena segue l'altra, nel modo che altrove vederemo."

25 Zarlino, 1968, 178–9; Zarlino, 1965, 239: "il Basso hà tal proprietà, che sostiene, stabilisce, fortifica e da accrescimento alle altre parti . . . Quando adunque il Compositore componerà il Basso della sua compositione, procederà per movimenti alquanto tardi, e separati alquanto, over lontani più di quelli, che si pongono nell'altre parti; accioche le parti mezane possino procedere con movimenti eleganti, e congiunti; e massimamente il Soprano: percioche questo è il suo proprio." For Vincenzo Borghini on pictorial composition and music, see Ch. 9.

26 For a recent study, with review of debates and references, see Paola Besutti, "'Pasco gli occhi e l'orecchie': la rilevanza dell''actio' nella produzione e nella ricezione musicale tra cinque e seicento," in Alessandro Pontremoli, ed., *Il volto e gli affetti: fisiognomica ed espressione nelle arti del rinascimento* (Florence, 2003), 281–300, citing Giustiniani, *Discorso sopra la musica de' suoi tempi* (1628), 281: "L'anno santo 1575 o poco dopo si cominciò un modo di cantare molto diverso da quello di prima. . . . E era gran competenza fra quelle dame di Mantova et di Ferrara, che facevano a gara, non solo quanto . . . alla disposizione delle voci, ma . . . principalmente con azione del visio, e dei sguardi e de' gesti che accompagnavano appropriatamente la musica e li concerti." Noble dance had long been a field of intersection between music and carefully calculated movement; see recently Jennifer Nevile, *The Eloquent Body: Dance and Humanist Culture in Fifteenth-Century Italy* (Bloomington and Indianapolis, 2004), esp. 75–103.

27 While Bellori is usually assumed to be mistaken when he identifies the fruit as apples rather than cherries, I have noted that two prints which document the original invention for Duke Guidobaldo appear to depict a larger fruit, probably an apple, with the cherries in Christ's hand (see n. 1). Beyond the possibility that he was relying on these prints for his description, Bellori's identification of the fruit

as apples (and the probability that an apple may have been included in the painting for Ferrara) reveals both a period perception that a variety of fruits might be appropriate in a *Rest* and the assumption that these fruits could, even should, be symbolic. Ekserdjian, 1997, 222, notes Netherlandish paintings in which apples (reminding one of the Fall) or even bunches of grapes, with their overt Eucharistic connotations, are the fruits of choice. A particularly compelling *Rest* in which grapes play the salient role is Gerard David's little painting in the National Gallery of Art, Washington, D.C. For the reed cross in the Senigallia *Entombment*, see Ch. 4; for Barocci's manipulation of still life elements for signifying effect, see Ch. 7.

28 Didi-Huberman, 1995, 13–22, with incisive observations throughout; for an introduction to the question of *figura*, see esp. 1–60. However, if Alberti was distinctive in his insistence on a new kind of "figurative" painting, the word itself had long been understood to carry either meaning; see e.g. the several passages from Dante, Petrarch, and Boccaccio employed in the 1612 *Vocabolario* of the Accademia della Crusca (s.v. "*figura*") to illustrate the "descriptive" meaning of the term.

29 *Vocabolario*, s.v. *figura*. Definition one: "Forma, aspetto, sembianza, immagine, una certa qualità intorno alla superficie del corpo, procedente da concorso di lineamenti. Lat. *figura, forma, imago.*" The following definition is: "Per impronta, o immagine di qualunque cosa, o scolpita, o dipinta. Lat. *imago, statua.*" At this point *figura* is further defined: "Per misterio, significazione, che hanno copertamente in se le sacre scritture, ilche pure in Lat. dicon *figura.*"

30 This strategy offers analogies to the coloring of the Magdalen's garments in the *Noli me tangere*; see Ch. 8, n. 32. As the painting is not in perfect condition, the flat bright red of the Virgin's collar in shadow should be read with some caution; it lacks the detail of the related collar in the *Madonna del Gatto* (see fig. 137). The intensity of the red here, however, seems highly suggestive.

31 See n. 25 for Zarlino on the character of the voices.

SELECTED
BIBLIOGRAPHY

Agostini, Grazia, et al., eds. *Tiziano nelle gallerie fiorentine*. Florence, 1978.

Alberti, Leon Battista. *On Painting and On Sculpture: The Latin Texts of De Pictura and De Statua*, ed. Cecil Grayson. New York and London, 1972.

—. *Della Pittura*, in *Opere volgari*, ed. Cecil Grayson. 3 vols. Vol. III. Bari, 1973.

—. *La Pittura, tradotto per M. Lodovico Domenichi*. Venice, 1547. Facsimile ed. Bologna, 1988.

Aldrovandi, Ulisse. *Avvertimenti del Dottore Aldrovandi all'Ill.mo e R.mo Cardinal Paleotti sopra alcuni capitoli della pittura*, in *Trattati d'arte del cinquecento*, ed. Paola Barocchi. 3 vols. Bari, 1960–62. Vol. II, 511–17.

Ames-Lewis, Francis. "Raphael's Responsiveness to Michelangelo's Draftsmanship," in *Reactions to the Master: Michelangelo's Effect on Art and Artists in the Sixteenth Century*, ed. Francis Ames-Lewis and Paul Joannides. Aldershot and Burlington, Vt., 2003, 12–30.

Armenini, Giovanni Battista. *On the True Precepts of the Art of Painting*, ed. and trans. Edward J. Olszewski. New York, 1977.

Bacci, Pietro. *Vita di San Filippo Neri*. Rome (1622), 1699.

Baglione, Giovanni. *Le Vite de' pittori, scultori et architetti dal Pontificato di Gregorio XIII del 1572 in fino a' tempi di Papa Urbano Ottavo nel 1642* (Rome, 1642), ed. Jacob Hess and Herwarth Röttgen. 3 vols. Vatican City, 1995.

Baldi, Bernardino. *Le Vite de' matematici: edizione annotata e commentata della parte medievale e rinascimentale*, ed. Elio Nenci. Milan, 1998.

Baldini, Nicoletta. *La Bottega di Bartolomeo della Gatta: Domenico Pecori e l'arte in terra d'Arezzo fra quattro e cinquecento*. Florence, 2004.

Baldinucci, Filippo. *Vocabolario toscano dell'arte del disegno*. Florence, 1681.

Bann, Stephen. *The True Vine: On Visual Representation and the Western Tradition*. Cambridge and New York, 1989.

Barasch, Moshe. *Light and Color in the Italian Renaissance Theory of Art*. New York, 1978.

Barnes, Bernadine. *Michelangelo's Last Judgment: The Renaissance Response*. Berkeley, 1998.

Barocchi, Paola. "Un 'Discorso sopra l'onestà delle Imagini' di Rinaldo Corsi," in *Scritti di storia dell'arte in onore di Mario Salmi*, ed. Valentino Martinelli and Filippa M. Aliberti. 3 vols. Rome, 1961–3. Vol. III, 173–91.

—, ed. *Scritti d'arte del Cinquecento*. 3 vols. Milan and Naples, 1971–7.

Baroni, Alessandra. "Giorgio Vasari, *Madonna della Misericordia*," in Anna Maria Maetzke, ed. *Mater Christi: Altissime testimonianze del culto della Vergine nel territorio aretino*. Milan, 1996, 61–2.

Bauer, Linda Freeman. "A Letter by Barocci and the Tracing of Finished Paintings," *The Burlington Magazine* 128 (May 1996): 355–7.

Baxandall, Michael. *Painting and Experience in Fifteenth-Century Italy: A Primer in the Social History of Pictorial Style*. Oxford and New York, 1972.

Bell, Janis, and Thomas Willette, eds. *Art History in the Age of Bellori: Scholarship and Cultural Politics in Seventeenth-Century Rome*. Cambridge and New York, 2002.

Bellori, Giovanni Pietro. *Le Vite de' pittori, scultori et architetti moderni* (Rome, 1672), ed. Evelina Borea. Turin, 1976.

Belting, Hans. *Likeness and Presence: A History of the Image before the Era of Art*, trans. Edmund Jephcott. Chicago and London, 1994.

Berger, Karol. *Theories of Chromatic and Enharmonic Music in Late 16th-Century Italy*. Ann Arbor, Mich., 1980.

Beschi, Luigi. "L'Immagine della musica in Paolo Veronese: una proposta per la lettura del concerto delle *Nozze di Cana*," *Imago Musicae* XVI/XVII (1999/2000): 171–91.

Besutti, Paola. "'Pasco gli occhi e l'orecchie': la rilevanza dell' 'actio' nella produzione e nella ricezione musicale tra cinque e seicento," in Alessandro Pontremoli, ed. *Il Volto e gli affetti: fisiognomica ed espressione nelle arti del rinascimento*. Florence, 2003, 281–300.

Bettini, Maurizio. *The Portrait of the Lover*, trans. Laura Gibbs. Berkeley, Los Angeles, and London, 1999.

Biadi, Luigi. *Storia della città di Colle in Val d'Elsa*. Florence, 1859.

Biancani, Stefania. "La Censura del nudo nel discorso di Paleotti e nella trattistica post-tridentina a Bologna," in Vera Fortunati and Vincenzo Musumeci, eds. *Bartolomeo Cesi e l'affresco dei canonici lateranesi*. Fiesole, 1997, 204–15.

Bo, Carlo, ed. *Galleria Nazionale delle Marche, Tiziano per i Duchi di Urbino*. Urbino, 1976.

Bocchi, Francesco. *Le Bellezze della Città di Fiorenza*. Florence, 1591. Facsimile ed. Introduction by John Shearman. Farnborough, 1971.

—. *Opera di M. Francesco Bocchi sopra l'imagine miracolosa della Santissima Nunziata di Fiorenza . . .* Florence, 1592.

Bohde, Daniela. *Haut, Fleisch und Farbe: Körperlichkeit und Materialität in den Gemälden Tizians*. Emsdetten and Berlin, 2002.

Bombe, Walter. *Federico Barocci e un suo scolaro a Perugia*. Perugia, 1909.

Borghini, Raffaello. *Il Riposo* (Florence, 1584), ed. Mario Rosci. 2 vols. Milan, 1967.

Borghini, Vincenzo. "Selva di notizie" (1564), Ms. K 783 (16). Florence, Kunsthistorisches Institut. Excerpts transcribed in *Scritti d'arte del cinquecento*, ed. Paola Barocchi. 3 vols. Milan and Naples, 1971–7. Vol. I, 611–73.

Borromeo, Federico. *Della Pittura Sacra, libri due* (Milan, 1624), ed. Barbara Agosti. Pisa, 1994.

Brandt, Kathleen Weil-Garris. "Sogni di un *Cupido dormiente* smarrito," in Kathleen Weil-Garris Brandt, Cristina Acidini Luchinat, James David Draper, Nicholas Penny, eds. *Giovinezza di Michelangelo*. Milan, 1999, 315–23.

Brock, Maurice. *Bronzino*, trans. David Poole Radzinowicz and Christine Schultz-Touge. Paris, 2002.

Brown, Howard Mayer. *Sixteenth-Century Instrumentation: The Music for the Florentine Intermedii*. American Institute of Musicology, 1973.

Bury, Michael. "The Senarega Chapel in San Lorenzo, Genoa: New Documents about Barocci and Francavilla," *Mitteilungen des Kunsthistorischen Institutes in Florenz* 31 (1987): 327–56.

—. "The Fifteenth- and Early Sixteenth-Century *gonfaloni* of Perugia," *Renaissance Studies* 12 (March 1998): 67–86.

Camille, Michael. *The Gothic Idol: Ideology and Image-Making in Medieval Art*. Cambridge and New York, 1989.

Campbell, Stephen. "*Fare una cosa morta parer viva*': Michelangelo, Rosso, and the (Un)Divinity of Art," *The Art Bulletin* 84 (December 2002): 596–620.

—. "Bronzino's *Martyrdom of Saint Lawrence*: Counter Reformation Polemic and Mannerist Counter Aesthetics," *RES 46. Polemical Objects* (Autumn 2004): 99–121.

—. "Eros in the Flesh: Petrarchism, the Embodied Eros and Male Beauty in Italian Art, 1500–1540," *Journal of Medieval and Early Modern Studies* 35 (2005): 629–62.

—. *The Cabinet of Eros: Renaisssance Mythological Painting and the Studiolo of Isabella d'Este*. Cambridge and New York, 2006.

Carter, Tim. *Music in Late Renaissance and Early Baroque Italy*. Portland, Or., 1992.

Castellano, Angela. "Storia di una parola letteraria: it. *Vago*," *Archivio glottologico italiano* 48 (1963): 126–69.

Castiglione, Baldassare. *Il Libro del cortegiano*, ed. Walter Barberis. Turin, 1998.

Caswell, Austin. "The Pythogoreanism of Arcimboldo," *Journal of Aesthetics and Art Criticism* 39 (Winter 1980): 155–61.

Ceccarelli, Luciano. *"Poi che la gente poverella crebbe . . ."*: la chiesa di San Francesco d'Assisi civico "Pantheon" degli urbinati e il convento dei frati minori conventuali in Urbino. Urbino, 2003.

Celio, Gaspare. *Memoria delli nomi dell'artefici delle pitture che sono in alcune chiese, facciate, e palazzi di Roma*. Naples, 1638. Facsimile, ed. Emma Zocca. Milan, 1967.

Cioni, Elisabetta. *Il Sigillo a Siena nel medioevo*. Siena, 1989.

Cleri, Bonita, ed. *Per Taddeo e Federico Zuccari nelle Marche*. Sant'Angelo in Vado, 1993.

Cole, Michael. "The *Figura Sforzata*: Modeling, Power, and the Mannerist Body," *Art History* 24/4 (2001): 520–51.

—. "Harmonic Force in Cinquecento Painting," in Ulrich Pfisterer and Anja Zimmermann, eds. *Animationen/Trangressionen: Das Kunstwerk als Lebewesen*. Berlin, 2005, 73–94.

—, ed. *The Early Modern Painter-Etcher*. University Park, Penn., 2006.

Colle di Val d'Elsa nell'età dei granduchi medicei: "La terra in città e la collegiata in cattedrale." Florence, 1992.

Colpetrazzo, Bernardino da, O.F.M. Cap. *Historia fratrum minorum capuccinorum (1525–1593)*, in *Monumenta Historia Ordinis Minorum Capuccinorum*. 17 vols. Assisi and Rome, 1937–86. Vols I and II, Assisi, 1939–40; vol. IV, Rome, 1941.

Connolly, Thomas. *Mourning into Joy: Music, Raphael, and Saint Cecilia*. New Haven and London, 1994.

Connors, Joseph. "Borromini, Hagia Sophia, and San Vitale," in Cecil L. Striker, ed. *Architectural Studies in Memory of Richard Krautheimer*. Mainz, 1996, 43–8.

—, and Louise Rice, eds. *Specchio di Roma Barocca: una guida inedita del XVII secolo*. 2nd edition. Rome, 1991.

Cristelli, Luciana Borri. "Iconografia della Mater Misericordiae nella committenza della fraternita aretina," *Atti e memorie della Accademia Petrarca di lettere, arti e scienze* 51 (1989): 257–89.

Cropper, Elizabeth. "On Beautiful Women, Parmigianino, *Petrarchismo* and the Vernacular Style," *Art Bulletin* 58 (September 1976): 374–94.

—. *The Ideal of Painting: Pietro Testa's Düsseldorf Notebook*. Princeton, 1984.

—. "The Beauty of Woman: Problems in the Rhetoric of Renaissance Portraiture," in M. Ferguson et al., eds. *Rewriting the Renaissance: The Discourses of Sexual Difference in Early Modern Europe*. Chicago, 1986, 175–90.

—. "The Place of Beauty in the High Renaissance and its Displacement in the History of Art," in Alvin Vos, ed. *Place and Displacement in the Renaissance*. Binghamton, N.Y., 1995, 159–205.

Damisch, Hubert. *A Theory of Cloud: Toward a History of Painting*, trans. Janet Lloyd. Stanford, Cal., 2002.

Dempsey, Charles. "Mythic Inventions in Counter Reformation Painting," in P. A. Ramsey, ed. *Rome in the Renaissance: the City and the Myth*. Binghamton, N.Y., 1982.

—. "The Carracci and the Devout Style in Emilia," *Emilian Painting of the 16th and 17th Centuries: A Symposium*. Bologna, 1987, 75–88.

—. *Annibale Carracci and the Beginnings of Baroque Style* (1977). 2nd edition. Fiesole, 2000.

—. "Introduction," in Giancarla Periti, ed. *Drawing Relationships in Northern Italian Renaissance Art: Patronage and Theories of Invention*. Aldershot and Burlington, Vt., 2004, 1–9.

Didi-Huberman, Georges. *Fra Angelico: Dissemblance and Figuration*, trans. Jane Marie Todd. Chicago, 1995.

Droandi, Isabella. "Le Insegne della Fraternità dei Laici nel XVI secolo: da Bartolomeo della Gatta a Giorgio Vasari," *Annali aretini* 10 (2002): 5–22.

Easton, Malcolm. "The Taddei Tondo: A Frightened Jesus?" *Journal of the Warburg and Courtauld Institutes* (1969): 391–3.

Ekserdjian, David. *Correggio*. New Haven and London, 1997.

Emiliani, Andrea. *Federico Barocci (1535–1612)*. 2 vols. Bologna, 1985.

—, ed. *Mostra di Federico Barocci*. Bologna, 1975.

Emison, Patricia. "Grazia," *Renaissance Studies* V, no. 4 (1991): 425–60.

Faietti, Marzia. "La Trascrizione incisoria," in *L'Estasi di Santa Cecilia di Raffaello da Urbino nella Pinacoteca Nazionale di Bologna*. Bologna 1983, 186–204.

—. "Amico's Friends: Aspertini and the Confraternità del Buon Gesù in Bologna," in Giancarla Periti, ed. *Drawing Relationships in Northern Italian Renaissance Art: Patronage and Theories of Invention*. Aldershot and Burlington, Vt., 2004, 51–74.

Farago, Claire J. *Leonardo da Vinci's Paragone: A Critical Interpretation with a New Edition of the Text in the Codex Urbinas*. Leiden and New York, 1992.

Fermor, Sharon. "Poetry in Motion: Beauty in Movement and the Renaissance Concept of *leggiadria*," in Francis Ames-Lewis, ed. *Concepts of Beauty in Renaissance Art*. Aldershot and Burlington, Vt., 1998, 124–33.

Ferretti, Anna Colombi. *Dipinti d'altare in età di Controriforma in Romagna, 1560–1650: opere restaurate dalle diocesi di Faenza, Forlì, Cesena e Rimini*. Bologna, 1982.

Firenzuola, Agnolo. *Opere*, ed. Adriano Seroni. Florence, 1958.

—. *On the Beauty of Women*, trans. and ed. Konrad Eisenbichler and Jacqueline Murray. Philadelphia, 1992.

Fontana, Jeffrey. "Evidence for an early Florentine trip by Federico Barocci," *The Burlington Magazine* 139 (July 1997): 471–75.

—. "Federico Barocci: Imitation and the Formation of Artistic Identity." Ph.D. diss., Boston University, 1998.

—. "Federico Barocci's Emulation of Raphael in the Fossombrone *Madonna and Child with Saints*," in Lars Jones and Louisa Matthews, eds. *Coming About: A Festschrift for John Shearman*. Cambridge, Mass., 2001, 183–90.

—. "Duke Guidobaldo II della Rovere, Federico Barocci, and the Taste for Titian at the Court of Urbino," in Ian Verstegen, ed. *Patronage and Dynasty: The Rise of the Della Rovere in Renaissance Italy*. Kirksville, Mo., 2007, 161–78.

Frangenberg, Thomas. *Der Betrachter: Studien zur florentinischen Kunst-literatur des 16. Jahrhunderts*. Berlin, 1990.

Franklin, David. *Rosso in Italy*. New Haven and London, 1994.

—. "A Gonfalone Banner by Vasari Reassembled," *The Burlington Magazine* 137 (November 1995): 747–50.

—. *Painting in Renaissance Florence 1500–1550*. New Haven and London, 2001.

Frugoni, Chiara. *Francesco un'altra storia*. Genoa, 1988.

—. *Francesco e l'invenzione delle stimmate: una storia per parole e immagini fino a Bonaventura e Giotto*. Turin, 1993.

Fumaroli, Marc. *L'Ecole du silence: le sentiment des images au XVIIe siècle*. Paris, 1994.

Gage, John. *Colour and Culture: Practice and Meaning from Antiquity to Abstraction*. London and Boston, 1993.

Gardner von Teuffel, Christa. "Lo Spasimo di Sicilia," in Fabrizio Mancinelli, ed. *Raffaello in Vaticano*. Milan, 1984, 272–7.

—. "Raffaels römische Altarbilder: Aufstellung und Bestimmung," *From Duccio's Maestà to Raphael's Transfiguration: Italian Altarpieces and their Settings*. London, 2005, 271–331. First published, *Zeitschrift für Kunstgeschichte* 50 (1987): 1–45.

Gaston, Robert. "Sacred Erotica: The Classical *figura* in Religious Painting of the Early Cinquecento," *International Journal of the Classical Tradition* II, no. 2 (Fall 1995): 238–64.

Gauthier, Marie-Madeleine. "L'Art de l'émail champlevé en Italie à l'époque primitive du gothique," in *Il Gotico a Pistoia nei suoi rapporti con l'arte gotica italiana*. Rome, 1972, 271–93.

Gavel, Jonas. *Colour: A Study of its Position in the Art Theory of the Quattro- and Cinquecento*. Stockholm, 1979.

Gaye, Giovanni. *Carteggio inedito d'artisti dei secoli XIV, XV, XVI* (Florence, 1840). 2 vols. Facsimile ed. Turin, 1961.

Gere, J. A., and Nicholas Turner. *Drawings by Raphael from the Royal Library, the Ashmolean, the British Museum, Chatsworth and other British collections*. London, 1983.

Gilio, Giovanni Andrea. *Dialogo nel quale si ragiona degli errori e degli abusi de'pittori circa l'istorie* (1564), in Paola Barocchi, ed. *Trattati d'arte del cinquecento*. 3 vols. Bari, 1960–62. Vol. II, 1–115.

Giusto, Egidio, O.F.M. *Le Vetrate di San Francesco in Assisi: studio storico-iconografico*. Milan, 1911.

Goffen, Rona. "*Nostra Conversatio in Caelis Est*: Observations on the *Sacra Conversazione* in the Trecento," *Art Bulletin*, 61 (June 1979): 198–222.

Gombrich, Ernst. "Leonardo's Method of Working out Compositions," *Norm and Form: Studies in the Art of the Renaissance I*. 2nd edition. London and New York, 1971, 58–63.

Grassi, Luigi, and Mario Pepe, eds. *Dizionario della critica d'arte*. 2 vols. Turin, 1978.

Gronau, Georg. *Documenti artistici urbinati*. Florence, 1936.

Gualandi, Michelangelo. *Nuova raccolta di lettere sulla pittura, scultura ed architettura*. 3 vols. Bologna, 1844–56.

Guidobaldi, Nicoletta. "Images of Music in Cesare Ripa's *Iconologia*," *Imago Musicae* VII (1990): 41–68.

Haar, James. *Essays on Italian Poetry and Music in the Renaissance, 1350–1600*. Berkeley, 1986.

—. "The Courtier as Musician: Castiglione's View of the Science and Art of Music," in James Haar. *The Science and Art of Renaissance*

Music, ed. Paul Corneilson. Princeton, N.J., 1998, 20–37. First published in Robert W. Hanning and David Rosand, eds. *Castiglione: The Ideal and the Real in Renaissance Culture*. New Haven, 1983, 165–89.

Hall, Marcia. *Color and Meaning: Practice and Theory in Renaissance Painting*. New York and Cambridge, 1992.

—. *After Raphael: Painting in Central Italy in the Sixteenth Century*. Cambridge and New York, 1999.

Hamburgh, Harvey. "The Problem of Lo Spasimo of the Virgin in Cinquecento Paintings of the Descent from the Cross," *Sixteenth Century Journal* 12 (1981): 45–75.

Hammond, Frederick. "Poussin et les modes: le point de vue d'un musicien," in Olivier Bonfait et al., eds. *Poussin et Rome*. Paris, 1996, 75–91.

Hecht, Christian. *Katholische Bildertheologie im Zeitalter von Gegenreformation und Barock: Studien zu Traktaten von Johannes Molanus, Gabriele Paleotti und anderen Autoren*. Berlin, 1997.

Herklotz, Ingo. "Historia sacra und mittelalterliche Kunst während der zweiter Hälfte des 16. Jahrhunderts in Rom," in Romeo de Maio, ed. *Baronio e l'Arte*. Sora, Italy, 1985, 21–74.

Hills, Paul. *Venetian Colour: Marble, Mosaic, Painting and Glass 1250–1550*. New Haven and London, 1999.

Hirst, Michael, and Jill Dunkerton. *Making and Meaning: The Young Michelangelo*. London, 1994.

Hollanda, Francisco de. *Da Pintura Antiga*, ed. Angel González Garcia. Lisbon, 1983.

Hope, Charles. "Altarpieces and the Requirements of Patrons," in Timothy Verdon and John Henderson, eds. *Christianity and the Renaissance: Image and Religious Imagination in the Quattrocento*. Syracuse, N.Y., 1990, 535–72.

Huber, Raphael M., O.M.Conv. *The Portiuncula Indulgence from Honorius III to Pius XI*. New York, 1938.

Humfrey, Peter. *The Altarpiece in Renaissance Venice*. New Haven and London, 1993.

—. "Altarpieces and Altar Dedications in Counter-Reformation Venice and the Veneto," *Renaissance Studies* 10 (September 1996): 371–87.

Joannides, Paul. "'Primitivism' in the late drawings of Michelangelo," in *Michelangelo Drawings: Studies in the History of Art, 33. Center for Advanced Study in the Visual Arts Symposium Papers* XVII, ed. Craig Hugh Smyth and Ann Gilkerson. Washington, D.C., 1992, 245–62.

Jones, Pamela. *Federico Borromeo and the Ambrosiana: Art Patronage and Reform in Seventeenth-Century Milan*. Cambridge and New York, 1993.

—. "Art Theory as Ideology: Gabriele Paleotti's Hierarchical Notion of Painting's Universality and Reception," in Claire Farago, ed. *Reframing the Renaissance: Visual Culture in Europe and Latin America 1450–1650*. New Haven and London, 1995, 127–39.

Jones, Roger, and Nicholas Penny. *Raphael*. New Haven, 1983.

Jones, Sterling Scott. *The Lira da Braccio*. Bloomington and Indianapolis, 1995.

Judd, Cristle Collins. *Reading Renaissance Music Theory: Hearing with the Eyes*. Cambridge and New York, 2000.

Kagan, Andrew. "Ut Pictura Musica, I: to 1860," *Arts Magazine* LX (May 1986): 86–91.

Kamp, Georg W. *Marcello Venusti: Religiöse Kunst im Umfeld Michelangelos*. Egelsbach, Cologne, and New York, 1993.

Kemp, Martin. *The Science of Art: Optical Themes in Western Art from Brunelleschi to Seurat*. New Haven and London, 1990.

Koerner, Joseph. *The Moment of Self-Portraiture in German Renaissance Art*. Chicago and London, 1993.

Korrick, Leslie. "Lomazzo's *Trattato . . . della pittura* and Galilei's *Fronimo*: Picturing Music and Sounding Images in 1584," in Katherine A. McIver, ed. *Art and Music in the Early Modern Period: Essays in Honor of Franca Trinchieri Camiz*. Aldershot and Burlington, Vt., 2003, 193–214.

Krems, Eva-Bettina. *Raffaels römische Altarbilder: Kontext, Ikonographie, Erzählkonzept. Die Madonna del Pesce und Lo Spasimo di Sicilia*. Munich, 2002.

Krick, Iris. *Römische Altarbildmalerei zwischen 1563 und 1605*. Taunusstein, 2002.

Krüger, Klaus. *Das Bild als Schleier des Unsichtbaren: Aestetische Illusion in der Kunst der frühen Neuzeit in Italien*. Munich, 2001.

—. "Medium and Imagination: Aesthetic Aspects of Trecento Panel Painting," in Victor Schmidt, ed. *Italian Panel Painting of the Duecento and Trecento. Studies in the History of Art 61. Center for Advanced Study in the Visual Arts, Symposium Papers XXXVIII*. New Haven and London, 2002, 57–81.

La Via, Stefano. *Il Lamento di Venere abbandonata: Tiziano e Cipriano de Rore*. Lucca, 1994.

Lavin, Marilyn Aronberg. Review of Harald Olsen, *Federico Barocci*, *The Art Bulletin* 46 (June 1964): 251–4.

—. "Images of a Miracle: Federico Barocci and the Porziuncola Indulgence," *Artibus et historiae* 54 (2006): 9–50.

Lazzari, Andrea. *Memorie di alcuni celebri pittori d'Urbino*. Urbino, 1800.

—. *Delle chiese d'Urbino e delle pitture in esse esistenti*. Urbino, 1801.

Le Mollé, Robert. *Giorgio Vasari: l'homme des Médicis*. Paris, 1995.

Lepri, Nicoletta, and Antonio Palesati, "La Consegna della *Madonna del Popolo* del Barocci alla confraternità di Santa Maria della Misericordia," *Bollettino d'informazione: brigata aretina amici dei monumenti* 35 (2001): 46–52.

Lichtenstein, Jacqueline. *The Eloquence of Color: Rhetoric and Painting in the French Classical Age*. Los Angeles, 1993.

Lightbown, Ronald. *Mantegna: With a Complete Catalogue of the Paintings, Drawings and Prints*. Berkeley and Los Angeles, 1986.

Ligi, Bramante. *Memorie ecclesiastiche d'Urbino*. Urbino, 1938.

Lingo, Stuart. "The Capuchins and the Art of History: Retrospection and Reform in the Arts in Late Renaissance Italy." Ph.D. diss. Harvard University, 1998.

—. "Retrospection and the Genesis of Federico Barocci's *Immaculate Conception*," in Lars Jones and Louisa Matthew, eds. *Only Connect: Studies in Honor of John Shearman*. Cambridge, Mass., 2002, 215–22.

—. "Francesco Maria II della Rovere and Federico Barocci: Some Notes on Distinctive Strategies in Patronage and the Position of the Artist at Court," in Ian Verstegen, ed. *Patronage and Dynasty: The Rise of the Della Rovere in Renaissance Italy*. Kirksville, Mo., 2007, 179–99.

Locher, Hubert. *Raffael und das Altarbild der Renaissance: di "Pala Baglioni" als Kunstwerk im sakralen Kontext*. Berlin, 1994.

Lockwood, Lewis, ed. *Giovanni Pierluigi da Palestrina: Pope Marcellus Mass*. New York, 1975.

Lomazzo, Gian Paolo. *Scritti sulle arti*, ed. Roberto Paolo Ciardi. 2 vols. Florence, 1973–4.

Lunghi, Elvio. "Tematiche e commitenze pittoriche," in *Assisi in Eta Barocca*, ed. Alberto Grohman. Assisi, 1992, 367–89.

MacKenzie, Kenneth. *Concordanza delle Rime di Francesco Petrarca*. Oxford, 1912.

Maetzke, Anna Maria. *Il Museo statale d'arte medievale e moderna in Arezzo*. Florence, 1987.

Mancini, Federico, and Aurora Scotti, eds. *La Basilica di S. Maria degli Angeli*. 3 vols. Perugia, 1989–90.

Marin, Louis. "The Iconic Text and the Theory of Enunciation: Luca Signorelli at Loreto (c. 1479–1484)," *L'Opacité de la peinture: essais sur la representation au Quattrocento*. Florence, 1989, 15–49. First published, *New Literary History* XIV (Spring 1983): 553–96.

Mason, Stefania. "Sub matris tutela: la pala di Paolo Veronese per la Scuola Grande della Misericordia," in Anna Forlani Tempesti and Simonetta Prosperi Valenti Rodinò, eds. *Per Luigi Grassi: Disegno e disegni*. Rimini, 1998, 148–55.

Massari, Anna Maria Ambrosini, and Marina Cellini, eds. *Nel segno di Barocci: allievi e sequaci tra Marche, Umbria, Siena*. Milan, 2005.

McClary, Susan. *Modal Subjectivities: Self-Fashioning in the Italian Madrigal*. Berkeley, 2004.

McGrath, Thomas. "Federico Barocci and the History of *Pastelli* in Central Italy," *Apollo* (November 1998): 3–9.

McIver, Katherine A. "Maniera, Music, and Vasari," *The Sixteenth Century Journal* XXVIII (Spring 1997): 45–55.

Meditations on the Life of Christ, ed. Isa Ragusa and Rosalie B. Green. Princeton, 1961.

Meersseman, Gilles Gerard (in collaboration with Gian Piero Pacini). *Ordo Fraternitatis: confraternite e pietà dei laici nel medioevo*. 3 vols. Rome, 1977.

Meijer, Bert, ed. *Italian Drawings from the Rijksmuseum Amsterdam*. Florence, 1995.

Melasecchi, Olga. "Gaspare Celio, *San Francesco che riceve le stimmate tra Sisto V e un compagno*," in Anna Maria Affanni, Mario Bevilacqua, and Maria Luisa Madonna, eds. *Roma di Sisto V*. Rome, 1993, cat. 11a, 163.

—. "Una perduta *Madonna della Vallicella* di Felice Damiani per l'Oratorio di San Severino," in Flavia Emanuelli, ed. *La Congregazione dell'Oratorio di San Filippo Neri nelle Marche del '600: Atti del convegno, Fano 14–15 ottobre 1994*. Fiesole, 1996, 397–416.

Mersenne, Marin. *Harmonie universelle*. Paris, 1636–7.

Meyer zur Capellen, Jürg. *Raphael: A Critical Catalogue of his Paintings*, trans. and ed. Stefan B. Polter. 2 vols. Landshut, 2001 and 2005.

Monson, Craig. "The Council of Trent Revisited," *Journal of the American Musicological Society* 55 (Spring 2002): 1–37

Moranti, Luigi. *La Confraternità del Corpus Domini di Urbino*. Ancona, 1990.

Morel, Philippe. *Les Grotesques: les figures de l'imaginaire dans la peinture italienne de la fin de la Renaissance*. Paris, 1997.

Mossakowski, Stanislaw. "Raphael's 'Saint Cecilia': An Iconographical Study," *Zeitschrift für Kunstgeschichte* 31 (1968): 1–26.

Moyer, Anne E. *Musica Scientia: Musical Scholarship in the Italian Renaissance*. Ithaca, N.Y., and London, 1992.

Nagel, Alexander. "Leonardo and *sfumato*," *RES* 24 (Autumn 1993): 7–20.

—. "Michelangelo's London *Entombment* and the Church of Sant' Agostino in Rome," *The Burlington Magazine* 126 (March 1994): 164–7.

—. *Michelangelo and the Reform of Art*. New York and Cambridge, 2000.

—. "Experiments in Art and Reform in Early Sixteenth-Century Italy," in Kenneth Gouwens and Sheryl Reiss, eds. *The Pontificate of Clement VII: History, Politics, Culture*. Aldershot and Burlington, Vt., 2005, 385–409.

—, and Christopher Wood. "Towards a New Model of Renaissance Anachronism," *Art Bulletin* 87 (September 2005): 403–32, with responses by Michael Cole, Charles Dempsey, and Claire Farago.

Natali, Antonio, ed. *L'Onesta dell'invenzione: pittura della riforma cattolica agli Uffizi*. Milan, 1999.

Nevile, Jennifer. *The Eloquent Body: Dance and Humanist Culture in Fifteenth-Century Italy*. Bloomington and Indianapolis, 2004.

Newcomb, Anthony. *The Madrigal at Ferrara 1579–1597*. 2 vols. Princeton, 1980.

—. Review of Susan McClary, *Modal Subjectivities: Self-Fashioning in the Italian Madrigal, Journal of the American Musicological Society*, 60 (2007): 201–17.

Nova, Alessandro. "Erotismo e spiritualità nella pittura romana del Cinquecento," in Philippe Costamagna, Catherine Monbeig Goguel, and Michel Hochmann, eds. *Francesco Salviati et la bella maniera*. Paris, 2001, 149–69.

Olsen, Harald. *Federico Barocci*. Copenhagen, 1962.

—. "Relazioni tra Francesco Maria II Della Rovere e Federcio Barocci," in *I Della Rovere nell'Italia delle Corti*, vol. 2, *Luoghi e opere d'arte*, ed. Bonita Cleri, Sabine Eiche, John E. Law, and Feliciano Paoli. Urbino 2002, 196–204.

O'Malley, John. *Trent and All That: Renaming Catholicism in the Early Modern Era*. Cambridge, Mass., 2000.

O'Neill, John P., ed. *Enamels of Limoges 1100–1350*. New York, 1996.

Onians, John. *Bearers of Meaning: The Classical Orders in Antiquity, the Middle Ages, and the Renaissance*. Princeton, 1988.

Ostrow, Stephen. *Art and Spirituality in Counter-Reformation Rome: The Sistine and Pauline Chapels in S. Maria Maggiore*. Cambridge and New York, 1996.

Otterstedt, Annette. *The Viol: History of an Instrument*, trans. Hans Reiners. Kassel, 2002.

Paleotti, Gabriele. *Discorso intorno alle imagini sacre e profane*, in Paola Barocchi, ed. *Trattati d'arte del cinquecento*. 3 vols. Bari, 1960–62. Vol. II, 117–509.

Palisca, Claude V. *Humanism in Italian Renaissance Musical Thought*. New Haven and London, 1985.

—. *Music and Ideas in the Sixteenth and Seventeenth Centuries*, ed. Thomas J. Mathiesen. Urbana and Chicago, 2006.

Panicali, Roberto. *Orologi e orologiai del rinascimento italiano, la scuola urbinate*. Urbino, 1988.

Paolini, Maria Maddalena. "Federico Barocci, *Madonna col Bambino e i Santi Giovanni Battista e Francesco*," in Bonita Cleri and Claudio Giardini, eds. *L'Arte conquistata: spoliazioni napoleoniche dalle chiese della legazione di Urbino e Pesaro*. Modena, 2003, 198–9.

Pellecchia, Linda. "The First Observant Church of San Salvatore al Monte in Florence," *Mitteilungen des Kunsthistorischen Institutes in Florenz* XXIII, 3 (1979): 273–97.

Perini, Giovanna. "Appunti sulla fortuna critica di Federico Barocci tra cinque e settecento," in Anna Maria Ambrosini Massari and Marina Cellini, eds. *Nel segno di Barocci: allievi e sequaci tra Marche, Umbria, Siena*. Milan, 2005, 394–405.

Pillsbury, Edmund, and Louise Richards. *The Graphic Art of Federico Barocci*. New Haven, 1978.

Pino, Paolo. *Dialogo di pittura* (Venice, 1548), in Paola Barocchi, ed. *Trattati d'arte del cinquecento*. 3 vols. Bari, 1960–62. Vol. I, 93–139.

Poggetto, Paolo dal. *La Galleria Nazionale delle Marche e le altre collezioni nel Palazzo Ducale di Urbino*. Urbino and Rome, 2003.

Ponelle, Louis, and Louis Bordet. *Saint Philippe Néri et la société romaine de son temps (1515–1595)*. 2nd edition. Paris, 1958.

Pordenon[e], Fra' Antonio da. "Libri tre ne' quali si scuopre in quanti modi si può edificare un Monasterio sia la chiesa ... conforme all'uso della nostra Religione," 1603. Venice, Biblioteca Marciana, Ms. Ital. IV, 5070: rev. version, class. IV 140 5071.

Pozzi, Raffaella. "Stendardo processionale," in *Ancona e le Marche per Tiziano 1490–1990*. Ancona, 1990, 121–5.

Pressouyre, Sylvia. *Nicolas Cordier: recherches sur la sculpture à Rome autour de 1600*. 2 vols. Rome, 1984.

Previtali, Giovanni. *La fortuna dei primitivi: dal Vasari ai neoclassici*. Turin, 1964.

Prodi, Paolo. *Ricerche sulla teorica delle arti figurative nella riforma cattolica*. Bologna, 1984.

Prosperi Valenti Rodinò, Simonetta, and Claudio Strinati. Catalogue of works in *L'Immagine di San Francesco nella controriforma*. Rome, 1982.

Puglisi, Catherine. *Caravaggio*. London, 1998.

Renzetti, Luigi. "Notizie relative a Federico Barocci e alla sua famiglia," in *Studi e notizie su Federico Barocci a cura della Brigata urbinate degli Amici dei Monumenti*. Florence, 1913, 1–12.

Rinaldi, Stefania Mason. "Un percorso nella religiosità veneziana del cinquecento attraverso le immagini eucaristiche," in Giuseppe Gullino, ed. *La Chiesa di Venezia tra riforma protestante e riforma cattolica*. Venice, 1990, 183–94.

Rocke, Michael. *Forbidden Friendships: Homosexuality and Male Culture in Renaissance Florence*. New York and Oxford, 1996.

Rosand, David. "'Divinità di cosa dipinta': Pictorial Structure and the Legibility of the Altarpiece," in Peter Humfrey and Martin Kemp, eds. *The Altarpiece in the Renaissance*. Cambridge, 1990, 143–64.

Rosen, Valeska von. *Mimesis und Selbstbezüglichkeit in Werken Tizians: Studien zum venezianischen Malereidiskurs*. Emsdetten and Berlin, 2001.

Roskill, Mark W. *Dolce's* Aretino *and Venetian Art Theory of the Cinquecento* (New York, 1968). 2nd edition. Toronto, 2000.

Röttgen, Herwarth. *Il Cavalier Giuseppe Cesari D'Arpino: un grande pittore nello splendore della fama e nell'incostanza della fortuna*. Rome, 2002.

Rubin, Patricia. "The Art of Colour in Florentine Painting," *Art History* 14 (June 1991): 175–91.

—. "Commission and Design in Central Italian Altarpieces, c. 1450–1550," in Eve Borsook and Fiorella Superbi Gioffredi, eds. *Italian Altarpieces 1250–1550: Function and Design*. Oxford, 1994, 201–29.

Rykwert, Joseph. *The Dancing Column: On Order in Architecture*. Cambridge, Mass., and London, 1996.

Sangiorgi, Fert. *Committenze milanesi a Federico Barocci e alla sua scuola nel carteggio Vincenzi della Biblioteca Universitaria di Urbino*. Urbino, 1982.

—, ed. *Diario di Francesco Maria II della Rovere*. Urbino, 1989.

Santi, Francesco. *Gonfaloni umbri del rinascimento*. Perugia, 1976.

Sapori, Giovanna. "Rapporto preliminare su Simonetto Anastagi," *Ricerche di storia dell'arte* 21 (1983): 77–85.

Scannelli, Francesco. *Il Microcosmo della pittura* (1657). Facsimile ed. Milan, 1966.

Scarpellini, Pietro, ed. *Fra Ludovico da Pietralunga: La Basilica di San Francesco d'Assisi*. Treviso, 1982.

—. *Perugino*. Milan, 1984.

Schlitt, Melinda. "Painting, Criticism, and Michelangelo's *Last Judgment* in the Age of the Counter-Reformation," in Marcia Hall, ed. *Michelangelo's Last Judgment*. Cambridge and New York, 2005, 113–49.

Schlosser, Julius von. *La letteratura artistica* (German ed., 1924), trans. Filippo Rossi. Florence, 1996.

Scrase, David. "Recent Discoveries at the Fitzwilliam Museum, Cambridge," in Mario di Giampaolo, ed. *Dal disegno all'opera compiuta*. Perugia, 1992, 85–7.

—, ed. *A Touch of the Divine: Drawings by Federico Barocci in British Collections*. Cambridge, 2006.

Serlio, Sebastiano. *Sebastiano Serlio on Architecture*, trans. and ed. Vaughan Hart and Peter Hicks. 2 vols. New Haven and London, 1996.

—. *L'Architettura: I libri I–VII e Extraordinario nelle prime edizioni*, ed. Francesco Paolo Fiore. 2 vols. Milan, 2001.

Shaw-Miller, Simon. *Visible Deeds of Music: Art and Music from Wagner to Cage*. New Haven and London, 2002.

Shearman, John. "Leonardo's Color and Chiaroscuro," *Zeitschrift für Kunstgeschichte* 25 (1962): 13–47.

—. *Mannerism*. Harmondsworth, 1967.

—. *Pontormo's Altarpiece in Santa Felicita*. Newcastle-upon-Tyne, 1971.

—. "Barocci at Bologna and Florence," *The Burlington Magazine* 117 (January 1976): 49–54.

—. "Correggio's Illusionism," in *La Prospettiva rinascimentale: codificazioni e trasgressioni*, ed. M. Dalai Emiliani. Florence, 1980, 281–94.

—. "Raphael's Clouds, and Correggio's," in M. Sambucco Hamoud and M. L. Strocchi, eds. *Studi su Raffaello*. 2 vols. Urbino, 1987. Vol. II, 657–68.

—. *Only Connect ... Art and the Spectator in the Italian Renaissance*. Princeton, 1992.

—. "Le funzioni del colore," in Kathleen Weil-Garris Brandt, ed. *Michelangelo: La Cappella Sistina. Documentazione e interpretazioni*. 3 vols. Novara, 1994. Vol. III, 159–65.

Slim, H. Colin. *Painting Music in the Sixteenth Century: Essays in Iconography*. Aldershot and Burlington, Vt., 2002.

Smith, Carolyn. "Pordenone's 'Passion' Frescoes in Cremona Cathedral: An Incitement to Piety," in Giancarla Periti, ed. *Drawing Relationships in Northern Italian Renaissance Art: Patronage and Theories of Invention*. Aldershot and Burlington, Vt., 2004, 101–28.

Sohm, Philip. "Gendered Style in Italian Art Criticism from Michelangelo to Malvasia," *Renaissance Quarterly* 48 (1995): 759–808.

—. *Style in the Art Theory of Early Modern Italy*. New York and Cambridge, 2001.

Sorte, Cristoforo. *Osservazioni sulla pittura*, in Paola Barocchi, ed. *Trattati d'arte del cinquecento*. 3 vols. Bari, 1960–62. Vol. I, 271–301.

Spalding, Jack. *Santi di Tito*. New York, 1978.

Speranza, Laura. "La Madonna del Rosario: origine della devozione e diffusione del tema nell'arte del territorio aretino," in Anna Maria Maetzke, ed. *Mater Christi: Altissime testimonianze del culto della Vergine nel territorio aretino*. Milan, 1996, 26–34.

Staiti, Nico. "Identificazione degli strumenti musicali e natura simbolica delle figure nelle 'adorazioni dei pastori' siciliane," *Imago Musicae* V (1988): 75–107.

—. "Satyrs and Shepherds: Musical Instruments within Mythological and Sylvan Scenes in Italian Art," in *Imago Musicae* VII (1990): 69–114.

—. *Le Metamorfosi di santa Cecilia: l'immagine e la musica*. Innsbruck and Lucca, 2002.

Stefaniak, Regina. "Raphael's *Madonna di Foligno*: *Civitas sancta, Hierusalem nova*," *Konsthistorisk Tidskrift* 69 (September 2000): 65–98.

Steinberg, Leo. "Pontormo's Capponi Chapel," *Art Bulletin* 56 (1974): 385–99.

—. "Guercino's *Saint Petronilla*," in Henry Millon, ed. *Studies in Italian Art and Architecture, 15th through 18th centuries: Memoirs of the American Academy in Rome, 25*. Rome, 1980, 207–42.

Stoichita, Victor. *Visionary Experience in the Golden Age of Spanish Art*, trans. Anne-Marie Glasheen. London, 1995.

—. *The Self-Aware Image: An Insight into Early Modern Meta-Painting*, trans. Anne-Marie Glasheen. Cambridge and New York, 1997.

—. *A Short History of the Shadow*. London, 1997.

Studi e notizie su Federico Barocci, ed. Brigata Urbinate degli Amici dei Monumenti. Florence, 1913.

Summers, David. "The Stylistics of Color," in Marcia Hall, ed. *Color and Technique in Renaissance Painting: Italy and the North*. Locust Valley, N.Y., 1987, 205–20.

Suthor, Nicola. *Augenlust bei Tizian: Zur Konzeption sensueller Malerei in der Frühen Neuzeit*. Munich, 2004.

Tafuri, Manfredo, and Antonio Foscari. *L'Armonia e i conflitti: la chiesa di San Francesco della Vigna nella Venezia del' 500*. Turin, 1983.

Tanner, Norman P., ed. *Decrees of the Ecumenical Councils*. 2 vols. London and Washington, D.C., 1990.

Teza, Laura. "Dono Doni," in *La Pittura in Italia: il cinquecento*. 2 vols. Venice, 1988. Vol. II, 705–6.

Turner, Nicholas. *Federico Barocci*. Paris, 2000.

Varchi, Benedetto. *Lezzione nella quale si disputa della maggioranza delle arti . . .* (1546), in Paola Barocchi, ed. *Trattati d'arte del cinquecento*. 3 vols. Bari, 1960–62. Vol. I, 1–82.

Vasari, Giorgio. *Le Vite de' più eccellenti pittori scultori e architettori, nelle redazioni del 1550 e 1568*, ed. Rosanna Bettarini, commentary by Paola Barocchi. 11 vols. Florence, 1966–87.

Vecchioni, Emilio. "La 'Chiesa della Croce e Sagramento' in Sinigaglia e la 'Deposizione' di Federico Barocci," *Rassegna marchigiana* V (1926–7): 497–503.

Venturelli, Vittorio. "Orazione Funebre per celebrare . . . Il Giorno delle Solenne Esequie all' insigne Pittore Federico Barocci Urbinate Da Vittorio Venturelli Intimo ed affetuoso suo Concittadino composta e recitata," in *Memorie d'alcuni insigni uomini d'Urbino nella pietà nelle scienze ed arti raccolte dal Dottor Antonio Rosa Patrizio di detta città*, 1800. Urbino, Biblioteca Universitaria, Archivio Storico del Comune, MS. Urbino f.206r.

Verstegen, Ian. "Federico Barocci, the Art of Painting, and the Rhetoric of Persuasion." Ph.D. diss., Temple University, Philadelphia, 2001.

—. "Federico Barocci, Federico Borromeo, and the Oratorian Orbit," *Renaissance Quarterly* 56 (2003), 56–87.

—. "The Apostasy of Michelangelo in a Painting by Federico Barocci," *Source* 22 (Spring 2003): 27–34.

—. "Barocci, Cartoons, and the Workshop: A Mechanical Means for Satisfying Demand," *Notizie da Palazzo Albani* 34/35 (2005/6): 101–23.

—, ed. *Patronage and Dynasty: The Rise of the Della Rovere in Renaissance Italy*. Kirksville, 2007.

Vicentino, Nicola. *Ancient Music Adapted to Modern Practice*, trans. Maria Rika Maniates and ed. Claude V. Palisca. New Haven and London, 1996.

—. *L'Antica musica ridotta alla moderna prattica* (Rome, 1555). Facsimile, ed. Edward Lowinsky. Basel, London, and New York, 1959.

Vitruvius Pollio. *Ten Books on Architecture*, trans. Ingrid Rowland, with commentary by Thomas Noble Howe, Ingrid Rowland, and Michael J. Dewar. New York and Cambridge, 1999.

Vocabolario degli Accademici della Crusca. Florence, 1612.

Wagner, Christoph. *Farbe und Metapher: Die Entstehung einer neuzeitlichen Bildmetaphorik in der vorrömischen Malerei Raphaels*. Berlin, 1999.

Wallace, William E. "Michelangelo and Marcello Venusti: A Case of Multiple Authorship," in Francis Ames-Lewis and Paul Joannides, eds. *Reactions to the Master: Michelangelo's Effect on Art and Artists in the Sixteenth Century*. Aldershot and Burlington, Vt., 2003, I 37–56.

Walters, Gary. *Federico Barocci: anima naturaliter*. New York, 1979.

Wazbinski, Zygmut. "Il *Modus* Semplice: un dibattito sull' *Ars Sacra* fiorentina intorno al 1600," in M. Hamoud and M. L. Strocchi, eds. *Studi su Raffaello*. 2 vols. Urbino, 1987. Vol. I, 625–49.

Williams, Robert. *Art, Theory, and Culture in Sixteenth-Century Italy: From Techne to Metatechne*. Cambridge and New York, 1997.

Winternitz, Emanuel. *Musical Instruments and their Symbolism in Western Art*. New Haven and London, 1967, reprint 1979.

—. *Leonardo da Vinci as a Musician*. New Haven, 1982.

Woodfield, Ian. *The Early History of the Viol*. New York and Cambridge, 1984.

Zamarra, Edoardo. "*Dolce, soave, vago* nella lirica italiana tra XIII e XVI secolo," *Critica letteraria* 13 (1985): 71–118.

Zampetti, Pietro, Dante Bernini and Grazia Bernini Pezzini, *Tiziano per i Duchi di Urbino*. Urbino, 1976.

Zapperi, Roberto. *Eros e controriforma: preistoria della galleria Farnese*. Turin, 1994.

Zarlino, Gioseffo. *Informatione intorno la origine dei Reverendi Frati Capuccini* (1579), in *Monumenta Historica Ordinis Minorum Capuccinorum*. 17 vols. Assisi and Rome, 1937–86. Vol. I, 483–526.

—. *Le Istitutioni Harmoniche* (Venice, 1558). Facsimile ed. New York, 1965.

—. *The Art of CounterPoint: Part Three of Le Istitutioni Harmoniche, 1558.* Trans. Claude V. Palisca and Guy A. Marco. New Haven and London, 1968.

—. *On the Modes: Part Four of Le Istituzioni Harmoniche, 1558.* Trans. Vered Cohen and ed. Claude V. Palisca. New Haven and London, 1983.

Zeri, Federico. *Pittura e controriforma: l'arte senza tempo di Scipione da Gaeta.* Turin, 1957.

Zuccari, Alessandro. "Cesare Baronio, le immagini, gli artisti," in Claudio Strinati, ed. *La Regola e la fama: San Filippo Neri e l'arte.* Milan, 1995, 80–97.

—. "Immagini e sermoni dell'Oratorio nei dipinti della Chiesa Nuova," in *La Congregatione dell'Oratorio di San Filippo Neri nelle Marche del '600*, ed. Flavia Emanuelli. Fiesole, 1996, 171–97.

PHOTOGRAPH CREDITS

INDEX

emotion
 and color 201–4, 205, 221–2
 and music 219–20, 234–5
Empoli, Jacopo d' 66
Emser, Hieronymus 16
Este, Lucrezia d' 225, 234

facture, and *vaghezza* 134–5, 189, 192–3
Falucci, Baldo 252n35
Federico Gonzaga, Duke of Mantua 128
Félibien, André 219
Fenzone, Ferraù 77–8, *77*
figura
 definition 241
 serpentinata 16, 195
 sforzata 16
 vaga 149–63
Firenzuola, Agnolo 126–7, 129
Flaminio, Marcantonio 128
Florio, John 138–9
Fortuna, Simone 61, 252n35
Francesco I, Grand Duke of Tuscany 61
Francesco Maria, Fra 217
Francia, Francesco 139
Francis, St
 habit 67, 75, 83
 images 21–4, *23*, 58–60, *59*, 75, 82–3, 169
 and Porziuncola indulgence 64–8, 75, 83
 stigmatization 75, 79–80
Franciscans
 and architecture 21, *21*, 181–5
 Conventual 19, 20, 22–4, 63–7, 75, 186
 golden age 4–6, 78
 and Immaculate Conception 40
 Observant 20, 21, 22, 64–6, 181–2, 184–5
 as patrons of Barocci 6, 7, 19, 39, 63
 and Porziuncola indulgence 64–8, 75
 reform *see* Capuchins
 seals 77, *77*
Fraternità di Santa Maria della Misericordia
 see Confraternity of the Laici, Arezzo

Ganassi, Silvestro 220
gaze, of animals and children 176–7
Genga, Bartolomeo 177
genre painting 165, 167
Gentileschi, Orazio, *Stigmatization* 76, *77*
gesture 29, 34, 44–6, 116–17, 127, 157–8, 169
 in *Madonna del Popolo* 50–1, 56–8, 218, 236
 in music 218
 in *Rest on the Return from Egypt* 231–3, 236, 238

Ghirlandaio, Domenico, *Coronation of the Virgin* 58, *58*
Giambologna, *Rape of the Sabine* 261n10
Gilio, Giovanni Andrea 6, 7, 77–8, 91
 and color 132, 202
 and Michelangelo's *Last Judgment* 14, 130–1, 149, 150, 258n39
 and nudity in religious art 17, 38, 130–1
 and *stile devoto* 14–16
 and *vaghezza* 166
Giorgione 216
 Sleeping Venus 205, *206*
Giotto 23
 Stigmatization 66
Giovio, Paolo 248–9n23
Giustiniani, Vincenzo 239
glory of angels 24, 215
 and Vallicella Madonna 17, 48, 128, 138
gonfaloni (banners) 44, *44*, *50*, 96, 249n24
 and *Madonna del Populo* 49–52, 57
Gonzaga, Cardinal Ercole 130
grotteschi 127, 223
Guercino (Giovanni Francesco Barbieri), *Burial of Saint Petronilla* 253n18
Guido da Siena, *Saint Francis Dossal* 75–6, *76*

harmony 177, 209, 216, 217, 219–23
heaven and earth hierarchy 55–7, 68, 69, 71–5, 230
Hollanda, Francisco de 16
Holy Sacrament, devotion to 92–4
homoeroticism, and *vaghezza* 149, 262n26
Honorius III, Pope 64

Ibi, Sinibaldo, *Gonfalone of Saint Ubaldo* 44, *44*
iconography
 of Assumption 44
 of Immaculate Conception 40
 of interceding Madonna 49, 52
 of Misericordia 13, 31, 33–9, *34*, *36*, *37*, *38*, 39–41, 44, 56
 of *parerga* 168–9
 of *Perdono* 64–76
 see also cloud; *mandorla*
illusionism, pictorial 54–5, 83–4, 94, 143, 163, 166, 178, 239–41
indulgence, Porziuncola 64–6, 67–8, 75, 83
Ingres, Jean Auguste Dominique, *Vision of Louis XIII* 56
innocence
 and children and animals 176–7
 and figural *vaghezza* 149–57

istoria
 and Alberti 98–101, 104, 216
 and architectural order 180–4
 and *Entombment* 92–113
 and *Lamentation–Entombment* 116–21
 and *Madonna del Popolo* 39, 48–52, 57, 63
 and *misterio* 48–9, 63, 81, 92–113
 and *parerga* 165–8, 175
 and *Perdono* 71, 72–5, 82
 and Raphael 98–101
 and right-to-left narration 68–9, 100–1
 and Titian 56–7
 and *vaghezza* 139
 and Vanni 67, 75
 and *Visitation* 84–9, 125, 168

Jacopino del Conte, *Deposition* 258n40
Junius, Franciscus 165

Karlstadt, Andreas 16

lamb, in *Circumcision* 165–6, *167*
Landino, Cristoforo 129, 138–40
Lazzari, Andrea 84
Leonardo da Vinci 83–4, 91–2, 102, 194, 267n30
 Madonna and Child with Saint Anne 229–30, *229*, 231
 and music and poetry 222–3, 235, 272n42
light, Barocci's use of 2, 94, 108, 161–2, 197–8, 200–1, 242
Locadel, Francesco 92
Lomazzo, Gian Paolo 135, 258nn39, 42
 and beauty 127, 132–3
 and color 190, 195, 202, 219, 233
Lorentino, Angelo di *36a*
Lotto, Lorenzo, *Entombment* 102–3, *103*
Ludovico da Petralunga, Fra 24, 259–60n57
Luzzaschi, Luzzasco 234

Maderno, Stefano 160
Madonna della Misericordia 13, 31, 33–9, *34*, *36*, *37*, *38*, *41*, *47*, 56
 and divine judgment 50–2
 and *gonfalone* imagery 44, 49–52
 and *Immaculate Conception* 39–48
 and *Madonna del Popolo* 48–61, 216
 modern 48–61
Madonna della Vallicella 17–18, 48, 86, 125, 128, 138
Malchiostro, Broccardo 81

mandorla 44–6
maniera devota 60, 139
maniera moderna 91–2
maniera vaga 135–41, 172; see also vaghezza
mannerism 3–4, 91–2, 157, 194
Mantegna, Andrea
 Dead Christ 116, 117
 Entombment 100–1, 103–6, 109
Marenzio, Luca 234
Mariani, G. B. 182
Martini, Simone 143
Masolino and Masaccio, Madonna and Child
 with Saint Anne 229–30, 230
Master of Saint Francis, Crucifix 26–7, 27
Mazzi, Ventura 113, 118
Meditationes Vitae Christi 116
Melzi, Francesco 267n30
Mersenne, Marin 214
Michelangelo Buonarotti
 and archaism and modernity 16, 92, 103
 and Barocci 26–7, 92, 157, 228–9, 231
 and color 190, 193–4, 196
 and Dolce 19
 works
 Annunciation 27–8, 28
 Bruges Madonna 250n55
 Christ on the Cross between the Virgin
 and Saint John 27
 Dawn 143
 Entombment (unfinished) 94, 96, 101–2,
 104–6, 108–9, 117, 230
 Holy Family (Doni Tondo) 229–30, 229,
 231
 Last Judgement 14, 130–1, 130, 140,
 144–5, 258n39
 Libyan Sibyl 77
 Medici Madonna 105
 Night 143
 Pietà (1538–40) 112, 112
 Punishment of Haman 150–2, 152
 Rondanini Pietà 110, 110
 Sleeping Cupid 157, 157
 Taddei Tondo 250n55
Milan, and Lamentation–Entombment 113–16, 121
mode
 architectural 181–7, 220–1
 and color 220
 musical 187, 218–21
modernity, and vaghezza 128–32
modernity and tradition 7–8, 9, 17–18,
 24–31, 82, 206–7
 and architectural detail 177–87
 and Barocci see Barocci: Immaculate
 Conception; Lamentation–Entombment;
 Madonna del Popolo; Madonna of the

Rosary; Perdono; Rest on the Return from
 Egypt; Visitation
and Madonna della Misericordia 48–61
and Michaelangelo 16, 92, 103
and putti 152–4
and Raphael 52–3, 98–101
and use of color 204–7
Monaco, Lorenzo, Arma Christi 101, 101
mosaic tradition 204–6, 204
mundane, sanctification 169–75
Murillo, Bartolomé Estaban, Perdono 251n11
music
 artists as musicians 210, 216–17
 and color 219–23, 233–4
 and composition 217–18, 241–2
 and emotion 234–5
 and mode 187, 218–19
 and poetry 212–13, 217
 representation 210–16, 222
 and vaghezza 8, 135, 209–23
music theory, 16th-century 216–21, 234, 236–8
mystery, in narrative art 48–9, 63, 81,
 92–113, 187, 248n12

Naldini, Battista 258n40
narrative art
 and icon see altarpieces, and narration
 left-to-right narration 87, 88, 106, 230
 and mystery 48–9, 63, 81, 92–113, 187,
 248n12
 right-to-left narration 68–9, 100–1
naturalism 34, 37, 40, 52, 91, 138–9, 198, 201,
 221–2
 and Alberti 129
 and Senigallia Entombment 104, 108
Neri, S. Filippo, and Visitation 125, 139, 141,
 168–9, 244n23
nudity 14, 16, 144–5, 147
 and beauty 130, 132–3
 and children 149, 176, 262n26
 female 158–60, 162
 and putti 17, 38, 40, 149–54

Oratorians
 and archaism 7, 17–18, 86
 as patrons of Barocci 7, 63, 84–6, 89, 128,
 150, 168
Orcagna, Strozzi altarpiece 249n26
Orlandi, Pellegrino 137

Pagani, Cigoli and Gregorio 61
painter as performer 216–17

painting, brushless 84; see also brushwork
Paleotti, Cardinal Gabriele 79, 108, 176,
 263n31
 and color 191–2, 202, 223
 and Fra Angelico 140
 and grotteschi 127
 and parerga 166–7
 and vaghezza 132, 144, 177
Palestrina, Giovanni Pierluigi da, Missa Papae
 Marcelli 218, 235–6, 235, 239
Paolo da Chioggia 20–1
parerga
 and vaghezza 165–8
 in Visitation 168–9
 see also animals; architecture; children;
 color
Passignano, Domenico 61, 66
Patanazzi, Alfonso, Misericordia 47
patrons of Barocci 9, 152
 della Rovere family 24, 225–6, 233–4
 see also Capuchins; Franciscans; Oratorians
Pecori, Domenico 38
 Madonna of the Misericordia 36, 36
Penni, Giovan Francesco 211
periodization, and Barocci 3
Perugia
 and Barocci 94–6, 225–6
 San Francesco al Prato 26
Perugino 139
 Assumption of the Virgin 58, 58, 249nn23, 26
Peterzano, Simone, Lamentation–Entombment
 116, 116
pietism, and devotional art 13
Pietro Leopoldo, Grand Duke of Florence 61
Pino, Paolo 77, 132, 190, 216
Pius v, Pope 140
poetry, and music 212–13, 217, 222, 235
Pontormo, Jacopo 145
 Entombment 94, 98, 102, 106
Pordenone, Fra Antonio da 185, 186
Pordenone, Giovanni Antonio da, Christ
 before Pilate 248n12
Porziuncola (Assisi) 64–5, 182, 184, 186
Poussin, Nicolas 218–19
profil perdu 86, 87–9, 204
proportion, in music and painting 219
Proto-Baroque 2, 3
protoadolescence 149, 154–7
Pulzone, Scipione 3, 152
 Crucifixion 28, 29
putti
 and mandorla 46
 and modernity and tradition 152–4
 and nudity 17, 38, 40, 149–54
Putti, Andrea 66

Index compiled by Meg Davies (Fellow of the Society of Indexers)